MICHELANGELO

III. THE MEDICI CHAPEL

THE MEDICI CHAPEL

By CHARLES DE TOLNAY

PRINCETON UNIVERSITY PRESS • PRINCETON

MCMLXX

SECOND PRINTING, WITH FOREWORD, 1970

PUBLISHED WITH THE ASSISTANCE OF A GRANT AWARDED BY
THE AMERICAN COUNCIL OF LEARNED SOCIETIES
FROM A FUND PROVIDED BY
THE CARNEGIE CORPORATION OF NEW YORK

To R. B. de T.

FOREWORD

THE five volumes of this series, written between 1940 and 1959 and published between 1943 and 1960, are reissued here without modification except for the replacement of a number of photographs.

Addenda and corrigenda for these five volumes will appear as an appendix in the sixth volume, now in preparation, on Michelangelo as architect.

The author wishes to express his special thanks to Princeton University Press and to its Director, Mr. Herbert S. Bailey, Jr., for the decision to reissue this work, which has been long unavailable.

CHARLES DE TOLNAY

Firenze
Casa Buonarroti
October 1968

ACKNOWLEDGMENTS

THE author wishes to express his sincere thanks to Comm. Giovanni Poggi and Professor Mary Pittaluga in Florence, and Dr. Abraham Flexner of Princeton, N.J., and New York, who have kindly facilitated his research.

He is particularly indebted to the Carnegie Corporation of New York, which through the American Council of Learned Societies has again generously supported the publication of this third volume, and to the Institute for Advanced Study, and its Director Dr. Frank Aydelotte, which has facilitated the realization of this project.

Other acknowledgments are mentioned in their appropriate places in the notes and in the critical section.

The author wishes to express his warmest thanks to Dr. Charles Sleeth, who kindly lent his assistance for the English wording, to Miss Ruth Wood and Mr. Richard Boudreau, who were also helpful in many ways, and finally to Mrs. Elizabeth Weatherby for preparing the index.

Gratitude is also due to Miss Margot Cutter, Fine Arts Editor, and Mr. Datus C. Smith, Jr., Director, of Princeton University Press for their valuable editorial help, and to Professor Clarence Kennedy and Mr. E. Harold Hugo of the Meriden Gravure Company for the careful supervision of the printing of the collotype reproductions.

CONTENTS

INTRODUCTION

THE contents of this volume embrace the history of the Medici Chapel, its interpretation from the point of view of form and subject matter, and the analysis of the other works which the master executed or projected during the approximately one and a half decades of his occupation with the Medici tombs. This period from 1520 to 1534 is here conceived as a single phase in Michelangelo's artistic development.

Excluded from this context are the works made immediately after the Sistine Ceiling, which stylistically still belong to the earlier period. These are the three statues for the Tomb of Julius II (Moses and the two Slaves in the Louvre), and the projects for the façade of San Lorenzo. These works will be treated in subsequent volumes, the former in connection with the history of the Julius Tomb, the latter in the characterization of Michelangelo as an architect.

The short account of Michelangelo's life begins with the time immediately after the completion of the Sistine Ceiling, and follows his vicissitudes up to the time when he left forever his native city of Florence.

The master was forty-five years old when he began work on the Medici monuments, fifty-nine when he left Florence permanently. This period of artistic maturity, the very zenith of life, during which other artists usually do their greatest works, lies in Michelangelo's case under an unlucky star. It is a period of frustrated creative capacity, a time from which nothing is preserved but projects which were never executed, or remained unfinished—not to speak of unsuccessful works (Christ of the Minerva, *Noli me tangere*). This fact has both external and internal reasons. The rivalry and jealousy of Michelangelo's patrons, who continually added more tasks and did not allow the completion of tasks already assigned, and his own docility in accepting new tasks until the total was beyond human power to accomplish, prevented him from creating in this period any work which can be compared in completeness and magnitude with the Sistine Ceiling.

The epoch of the titanic flight toward heaven is finished. The excess of energy seems to have dried up. In the period of the Sistine Ceiling he glorified the world-creating power; now, enveloped in dreamlike and resigned reflection, he passively contemplates the universal world force whose instrument he feels himself to be. In this resignation there is revealed a new wisdom. The form language teeming with power is replaced by a more tender, refined, slim, rhythmic form. Quiet melancholy or resigned grief appears in the faces, instead of the passions of the *furor divinus*. An autumnal mood lies over these creations. The sun is already sinking, and the shadows of the approaching evening of life gather on the horizon. The master feels himself old—he is grown old before his time. His thoughts are concentrated on death. Yet he does not separate death from life; he sees its unity with life, and it becomes for him the maternal womb of true life. "Se la vita ci piace, essendo anco la morte di mano d'un medesimo maestro, quella non ci

dovrebbe dispiacere" (Vasari 1568, p. 252), he is supposed to have said, in serene acceptance of death.

It was a fortunate constellation that this inner spiritual attitude of Michelangelo was given the opportunity of expressing itself in an appropriate substratum, through the execution of a funerary chapel. The Medici Chapel gave Michelangelo the chance to eternize in plastic symbols his philosophy of death.

At the end of this period, unexpectedly, he is once again to be rejuvenated. A miraculous spring breaks upon him, giving back to him youthful fire, and enthusiasm, in his association with Cavalieri.

The Medici Chapel was widely known and highly prized already during Michelangelo's life. His contemporaries (Varchi, Cellini, Vasari, Doni, Condivi) never tired of praising the "divine beauty" of the statues, though to be sure in undifferentiated, general laudatory terms. Vasari made the first noteworthy attempt to characterize the interior architecture in terms of its innovative character, and to show how Michelangelo therein emancipated himself from the traditional Vitruvian laws. Interest and admiration continued to be lively in the following centuries. The fullest descriptions of the Chapel, in many ways supplementing those given by Michelangelo's contemporaries, come from the seventeenth (Bocchi-Cinelli 1677), the eighteenth (Richardson 1728), and the early nineteenth centuries (Moreni 1813). It was in the early eighteenth century (1722-1728) that Ferdinando Ruggieri first published, in beautiful engravings in his monumental work, plans, sections, and elevations of the architectonic forms of the Medici Chapel, after the statues of the tombs had already been diffused, in good engravings, since 1570 (Cornelius Cort).

Real scholarly research, in this as in other fields, began only in the second half of the nineteenth century. Important documents for the history of the Chapel began to be published individually after the middle of the eighteenth century (Bottari 1754, Moreni 1813, and Gaye 1840), and later Gotti (1875) and K. Frey (1896) brought together the archival material relating to the Chapel. This was supplemented by Gronau (1911) and the author (1934). Particularly successful efforts toward the clarification of the problem of the history and chronology of the tombs have been made by von Geymüller, Köhler, and Popp. The grouping of the projects has been carried out chiefly by Berenson, von Geymüller, Burger, Thode, and Popp; the aesthetic analysis, chiefly by Wölfflin, Riegl, and Dvořák; the interpretation of the meaning of the tombs, by a whole series of investigators, whose names will be mentioned in a later chapter. Especially important is the great monograph of A. E. Popp, *Die Medici Kapelle*, Munich, 1922. Many of the earlier views are corrected in this book, and despite the fact that it contains a few hypotheses which are no longer tenable, it is an admirable effort to clarify the history and the genesis of the artistic idea of the Chapel.

The present essay is different in two respects from earlier works on this theme. The attempt has been made here to clarify a series of unsolved problems connected with the

chronology and genesis of the artistic idea, with the help of sketches and documents which were unknown to the earlier scholars; these documents and sketches were in part first published and interpreted by the author in two earlier articles (*Arch.Buon.*, 1928 and *Cappella Medicea*, 1934). Secondly, the attempt has been made to interpret not only the individual tombs and the individual figures, but to understand the whole Chapel (i.e. the space, the architectural articulation, the statues, and the decoration) as the embodiment of a single representative idea. It has been shown that the Medici Chapel is not an ordinary burial chapel, but the unified representation of a sphere, of the dwelling place of departed souls. That this is the underlying theme, as the author became immediately aware upon his first visit to the Chapel (1921), he has here attempted to demonstrate through an analysis of the whole and of the details.

The Critical Section summarizes the results of the author's past research and the most important results attained by former investigators. The Appendix contains a series of unpublished documents.

The Illustrations consist of three main sections: in the first the reproductions of the architecture of the Chapel and the original sculptures of Michelangelo made during this period are united. It is hoped that the new photographs, made under the author's direction, and complementing the already existing ones, will give a more adequate idea of the quality of the works. In the second section are reproduced in chronological order the drawings of Michelangelo made during this period. The third section presents copies of Michelangelo's lost works, the works which may have influenced his conception, and the most important of those which show the influence of his ideas on contemporary and later artists.

THE MEDICI CHAPEL

IN THE TEXT, numbers in parentheses not otherwise identified (as V, 2) refer to chapters and paragraphs in the Critical Section of the present volume. Numbers such as (No. 48) refer to the Catalogue of Drawings. References including the designation "Vol. I," "Vol. II" (as Vol. I, p. 41) refer to the first two volumes of this work, *The Youth of Michelangelo* and *The Sistine Ceiling*. Marginal numbers on the text pages refer to the Illlustrations.

I. LIFE (1512-1534)

THE artists of the early sixteenth century stood economically and socially under the protection of patrons (either powerful individuals, of high social rank, or corporations). They produced works of art usually for specific commissions, so that they had the advantage of knowing from the beginning the place for which the work was intended, the specific task which they had to solve, the subject matter of the work, and the personal taste of the patron. The disadvantage lay in the position of social subordination imposed upon the artist and his greater artistic dependence on the patron, though, to be sure, the patrons of the Renaissance were usually extraordinarily broadminded. But work without a concrete commission, purely from a creative urge, or for the market, for later sale to any taker, was an exceptional phenomenon (I, 1).

Michelangelo also, as has been related in the previous volumes, had been since his youth under the protection of powerful patrons, and from the time that he became connected with the Papal court under Julius II, it was to his interest to serve at all times the ruling Pope, who could entrust to him great artistic tasks commensurate with his powers. This practical interest, however, conflicted, after the death of Julius II, with Michelangelo's moral and material obligations to the deceased Pope and to the work which he had begun for him—a conflict from which Michelangelo suffered greatly during the years that are treated here: "e' non si può lavorare con le mani una cosa, e col ciervello una altra" (Milanesi, p. 450), he complained.

After the completion of the Sistine Ceiling, Michelangelo was for a short time without work (October 1512; Milanesi, p. 46), but inwardly he must already have resolved to resume work on the Julius Tomb and to complete it. Only three and a half months after the unveiling of the Ceiling, the Pope died (February 21, 1513). The heirs, Cardinal Santiquattro (Lorenzo Pucci) and Cardinal Aginensis (Grossi della Rovere), made a new second contract with Michelangelo (May 6, 1513), in which the latter bound himself to finish the work in seven years in accordance with a modified and enlarged project (Milanesi, pp. 428, 491, 635). The next three years, up to the end of 1516, Michelangelo worked in Rome, in his house in the Macello dei Corvi (Milanesi, p. 491) and in a house in the Regione di Trevi (near Santa Maria del Loreto), almost exclusively on this task. He made the statues of Moses and of the two Slaves now in the Louvre (Milanesi, pp. 391, 115; Steinmann, *Bibl.*, p. 440). His aim seems to have been to accomplish the great project at this time (I, 4). He accepted only small commissions on the side (the Christ for the Minerva, contract 1514 [Milanesi, p. 641], and a painting for Pier Francesco Borgherini, which commission he transferred to Andrea del Sarto [Milanesi, p. 129, and Frey, *Briefe*, 43 and 63]).

Worthy of note is the fact that the artist stayed away from the Papal court during these three years, despite the fact that Leo X Medici, ruling Pope since March 11, 1513, second son of Lorenzo Magnifico, was a friend of his youth. In June 1515, Michelangelo

had not yet entered the service of Leo X, but he believed that he would "soon do so" (Milanesi, p. 115). In December 1515, when Leo X sojourned in Florence en route back from Bologna where he had met Francis I of France, he conferred upon Michelangelo's family the title of *Conti Palatini* (Frey, *Briefe*, p. 27).

Michelangelo must have felt that he could not stay away from the Papal court permanently without endangering his future career. His decision to work also for Leo X is clearly reflected in the third contract for the Tomb of Julius II, of July 1516 (Milanesi, pp. 644*ff*). He obligated himself to finish the work in nine years, but at the same time the project was reduced by approximately half from the earlier plan, and he received the permission to execute the work wherever he pleased, in Florence, Pisa, or Carrara. The facts that the time was prolonged from seven to nine years, whereas the size of the work was reduced by half, and the choice of the place of execution was left to him, seem all to be indications that Michelangelo wanted to insure a certain freedom of movement for himself, so that he could execute other works.

To the Epicurean Leo X the sweet and serene art of Raphael had the greatest appeal. The serious and grandiose art of Michelangelo doubtless attracted him less. Moreover, Raphael's amiable, courtly personality made him a congenial member of the circle of the humanists, poets, and musicians who surrounded the Pope (1, 2), while Michelangelo's intractable personality inspired fear, a fact to which several letters from Sebastiano del Piombo testify. On October 27, 1520 (Milanesi, *Corr.*, p. 20), for example, he writes that the Pope speaks of Michelangelo as of a brother, almost with tears in his eyes, remembering that they were brought up together; and then adds, "but you inspire fear in everyone, even the Popes" (1, 3). Leo X is also reported to have said, "Michelagnolo . . . è terribile, non si pol pratichar con lui" (Gaye II, p. 489). Hence in the Papal court only Raphael was given work to do, even after Michelangelo entered the Pope's service; during Leo's Papacy, Raphael executed the frescoes of the Stanza dell' Incendio, the cartoons for the tapestries of the Sistine Chapel, and the decorations of the loggie. He became (August 1515) the superintendent of the building of the new St. Peter's. Raphael's art forms an appropriate background for the brilliant court life of Leo X.

On the other hand, the Pope wanted to make use of Michelangelo's genius, too, for the glorification of his family, but at the same time to keep him as far as possible from the Vatican. This double purpose was well served by the idea of having Michelangelo execute the façade of the burial and parish church of the family, San Lorenzo in Florence, thus permitting Raphael to work in Rome unimpeded (1, 5). At first Michelangelo probably did not want to accept this project (Condivi) since he could hardly fulfill his old obligations (Julius Tomb). He changed his mind, however, and himself asked Domenico Buoninsegni to discuss the project with Cardinal Giulio (Frey, *Briefe*, p. 47). Another architect, Baccio d'Agnolo, is mentioned also as collaborator (Vasari, ed. Mil., VII, p. 357, and Frey, *Briefe*, pp. 35*f*, 39*f*). Michelangelo, however, soon became dissatisfied with this arrangement; evidently he wanted to have the whole commission alone,

but declared that he did not wish to go to Rome to meet the Pope, and that Baccio d'Agnolo should take charge of the project (Frey, *Briefe*, pp. 47*ff*). Urged by Buoninsegni and Baccio d'Agnolo (Frey, *Briefe*, pp. 47*ff*), he finally went to Rome for a short stay in December 1516 (Milanesi, p. 564, and Tolnay, *G.d.B.-A.*, p. 27), where on the basis of a drawing of the façade he was charged by Leo X (without contract, however) to have the marble cut (Milanesi, p. 414). From February to mid-March 1517 he was in Carrara, where he made contracts with the stonecutters for the columns and the figures of the façade (Milanesi, pp. 661-662). In the meanwhile, Baccio made in Florence a model, which Michelangelo on his return declared to be childish ("cosa da fanciulli") and decided to remake ("rifare") (Frey, *Briefe*, pp. 61, 63). Unsatisfied, he executed in Carrara, with the assistance of Giovanni Grassa, a new clay model (Milanesi, pp. 381-382). At the beginning of May 1517, this clay model, representing an enlarged project, was ready (Milanesi, p. 382, and Frey, *Briefe*, p. 68). In June Michelangelo gave orders for the work on the foundation (Frey, *Briefe*, p. 77), which was finished in December (Milanesi, pp. 571-572). Then he made a second model in wood with the assistance of Pietro Urbano, which was ready in December 1517 (Milanesi, pp. 414, 565, 567, and Frey, *Briefe*, p. 86). Finally, on the basis of this wood model, on January 19, 1518, a contract was signed by Leo X and the artist, in which the latter bound himself to execute the work in eight years (Milanesi, p. 671). It is a façade conceived as a framework for sculptures—"d'architettura e di scultura lo spechio di tutta Italia" (Milanesi, p. 383), as the artist called his project—with four marble figures and two reliefs in the lowest zone, four bronze seated figures on the front and one each at the right and left in the second zone, four marble statues at the front and one on each side in the third zone, and five rectangular and two round reliefs at the top. This is a richness of plastic decoration such as had not been known since the Gothic cathedrals, and it may be said that it is in some way a pendant to the Julius Tomb, which according to the reduced project of 1516 was also a façade.

According to the third contract, the Julius Tomb was to be finished in 1525, and the façade of San Lorenzo at the beginning of 1526. In other words, simultaneous execution was intended, and conflict was inevitable. In order to execute the façade, Michelangelo was obliged to move to Florence, where he intended to work at the same time on the Julius Tomb. He had his Roman blocks for the Julius Tomb sent to Florence, planning to return them to Rome when they were finished (Milanesi, p. 414).

It was probably in February 1518, shortly after the signing of the contract for the façade, that the artist received a letter from Cardinal Giulio, who ordered in the name of the Pope that the marble for the façade should be extracted, not in Carrara, but in Pietrasanta, on Florentine soil (Daelli, no. 12; Wolf, p. 72; cf. a different presentation in Milanesi, p. 415). In Pietrasanta near Seravezza no marble had as yet been quarried (Milanesi, p. 415). Here it was first necessary to build a road leading from Seravezza to the coast, in order to transport the marble blocks from the quarry. Michelangelo re-

quested the Pope and the Cardinal to appoint him superintendent of the construction, because, as he said, the road should be routed to the places where the best marble quarries were located, and he alone understood this (Milanesi, p. 134). On March 15, 1518, he made a contract with the stonecutters in Pietrasanta (Milanesi, p. 673), who had been sent from Florence, and who, according to Michelangelo (Milanesi, p. 137), understood nothing of their work. Michelangelo wrote in desperation to his brother: "I have undertaken to arouse the dead, if I want to subdue these mountains and bring art to this place" (I, 6) (Milanesi, p. 137; and the same expression, "domesticare e' monti," in Milanesi, p. 394).

The Carrarese, however, had no intention of losing their chief source of income, and prevented the transportation of the hewn blocks. They bribed the Ligurian bargemen, who declared a strike (Milanesi, pp. 134f). From Genoa to Pisa it was impossible for Michelangelo to hire barges to transport his blocks from Avenza (port of Carrara) to Florence (Milanesi, pp. 135, 136, 385). In consequence of the difficulties that he found in Pietrasanta, Michelangelo himself regretted that he had left Carrara; this, he said, was his ruin (Milanesi, p. 137f): "Oh maledetto mille volte el dì e l'ora che io mi parti' da Carrara!" In September 1518, he reported, however, that the road was almost finished (Milanesi, p. 394). Despite his desperation over the great costs, despite his admitted lack of any prospect of success, he wanted to go on with the work (Milanesi, p. 134).

In the months of November and December 1518, in Rome, apparently under the leadership of Jacopo Sansovino, intrigues arose against Michelangelo which influenced Cardinal Aginensis to demand that one of the promised figures for the Julius Tomb be finished by spring (Frey, *Briefe*, p. 135). Also the Marchese di Massa denounced Michelangelo to the Pope, and declared that the artist was responsible for the opposition of the Carrarese. (After January 15, 1519, Michelangelo seems, however, to have again established relations with the Carrarese [Frey, *Briefe*, p. 134, and Milanesi, p. 689]).

In 1519, the Opera di Santa Maria del Fiore of Florence needed marble for the repaving of the floor of the Cathedral, and Cardinal Giulio ordered that it be brought from Pietrasanta. Michelangelo took this as a personal insult and declared that the Cardinal could not have the blocks from Pietrasanta until he, Michelangelo, made an accord with the Pope (Milanesi, p. 415). Thereupon the Cardinal promised that he would ask the Pope to release him from his obligations concerning the façade, on the condition that Michelangelo should give an account of the money he had already received. In 1520, Michelangelo wrote a comprehensive report of the whole history of the façade (Milanesi, pp. 414ff), in which he gave an account of the money, and declared that he did not know why ("e non so perchè ancora") the work had been taken from him. On March 10, 1520, the contract for the façade was annulled, releasing the artist from his obligations (Milanesi, p. 581). "I have lost three years at this," he says, "I am ruined" (Milanesi, p. 416).

[6]

The real reasons why the Lorenzo façade was provisionally abandoned—that Cardinal Giulio did not definitively give up the project, but only postponed its execution, is known through a letter (Milanesi, p. 421)—are nowhere mentioned. In his mistrust, Michelangelo attributed it to doubt of his ability to complete the work soon (Milanesi, p. 581), but the most probable assumption is that as a result of the threat of war the Papal treasury was depleted, and the Cardinal therefore wanted to bind him to a less expensive task for the time being, namely, to the funeral chapel of the Medici. Originally the plan was for a relatively modest free-standing tomb, and no one could guess that this project would grow under Michelangelo's hand into a monumental undertaking.

On account of the "vituperio grandissimo" (Milanesi, p. 416) which Michelangelo thought he had suffered through being discharged from the façade project, he at first seems to have refused to accept the new commission. He asserted that the Cardinal should build what he liked, "e così me lascia in mia libertà e disobrigo, che io non abbia più a rendere conto a nessuno di cosa che io abbia avuto a far seco" (Milanesi, p. 581). The history of the Medici Chapel is recounted below (Chap. VIII).

The annulment of the contract for the façade of San Lorenzo took place about one month before Raphael's death (April 6, 1520), which left the road to the Papal court open; but Michelangelo apparently had no intention of succeeding Raphael at the Vatican. Insulted by the affair of the façade, he preferred to remain in Florence. His Roman friends urged him to move to Rome, especially the ambitious Sebastiano Luciani (later called Piombo), who cherished hopes that Michelangelo would support him in obtaining a commission to paint the Sala di Costantino in the Vatican (Milanesi, Corr., p. 6). Michelangelo did in fact intervene for Sebastiano in a curious letter (June 1520) to Cardinal Bernardo Dovizi Bibbiena, formerly patron of Raphael, in which he ironically depreciated himself (Milanesi, p. 413). The work was assigned, however, not to Sebastiano but to the pupils of Raphael (Milanesi, Corr., p. 6). Thereupon Sebastiano and Leonardo Sellaio declared that Michelangelo himself should really have been given the commission to execute. The Pope himself was now eager to have Michelangelo do the paintings in the Vatican, and had Sebastiano write the proposal to him on September 6, 1520 (Milanesi, Corr., pp. 12ff); but Michelangelo apparently declined.

During the pontificate of Leo X Michelangelo created no complete work (with the exception of the unsuccessful Christ of the Minerva). First he worked on the Tomb of Julius II without finishing it; then he wasted his time on the project for the façade and on procuring marble for it in Pietrasanta.

Not until November 1520 did Michelangelo accept the commission for the Medici Chapel, about eight months after the beginning of the construction. He desired first to be freed from the Julius commission, and said that if he were released from it, he would work for the Pope "ogni qualunque cossa" (Milanesi, Corr., p. 18). Then,

however, he accepted the Medici Chapel unconditionally, as he had the façade before, without having settled the matter of the Julius Tomb, and seems to have rushed into the new task with great enthusiasm.

On December 6, 1521, Leo X died and Cardinal Giulio failed to be elected as his successor, thus weakening the power of the Medici. The newly elected Pope, Hadrian VI (January 1522-September 1523), was a Puritan Netherlander, unkindly disposed to art and to Italian life in general. It was during his pontificate that, in September 1522, the heirs of Julius II made complaints against Michelangelo, and demanded restitution of the money they had paid him, with interest (Milanesi, p. 422). Hadrian VI ordered in a *motu proprio* (1522) that Michelangelo should fulfill his obligations with regard to the Julius Tomb. Michelangelo's Roman friends, and especially Jacopo Salviati, tried to mediate an agreement (Frey, *Briefe*, p. 193). Cardinal Giulio, on the other hand, requested that Michelangelo continue his work on the Medici Chapel. Michelangelo declared that he should work on the Tomb of Julius, and could work for the Cardinal only if the latter would procure for him a release from the other duty (Milanesi, p. 422). It was fortunate for Michelangelo that Hadrian's pontificate lasted only about a year and a half. Shortly after the death of the Pope, on November 3, 1523, Michelangelo made a new contract with stonecutters in Carrara (Milanesi, p. 698), indicating that he had reached an agreement with Cardinal Giulio. When, on November 19, 1523, the Cardinal was elected Pope (he reigned under the name of Clement VII), Michelangelo was full of hope for the future of the arts in Florence (Milanesi, p. 423). In December he went to Rome for an interview with the Pope (1, 8). But at the same time (ca. December 22, 1523), the heirs of Julius II insisted again upon the completion of the work, declaring that Michelangelo had received the greatest part of his fees. Michelangelo's friend Fattucci denied this, and asked Michelangelo to send him an account of his work for Julius II and of the money he had received (Frey, *Briefe*, p. 198). The account is preserved in two copies (Milanesi, pp. 426 and 429).

Again in March 1524, there were negotiations between the heirs of Julius and Fattucci (Frey, *Briefe*, pp. 215 and 216). In a crisis of discouragement, Michelangelo refused to accept any provision from the Pope and suddenly left the house near San Lorenzo (Frey, *Briefe*, pp. 218f). In August 1524, however, he asked for payment of the provision and expressed a desire to return to the house near San Lorenzo (Milanesi, p. 438). In January 1525, Fattucci desired to renew the negotiations for the settlement of the Julius Tomb controversy (Frey, *Briefe*, pp. 242f). This was again without result, because in April the heirs seem to have threatened a lawsuit. In desperation, Michelangelo declared that he did not want any litigation, because for him it was as if he had already lost his case. He was ready to admit that he was in the wrong. He wanted to sell everything and return the money and asked, through his friend Giovanni Spina, that the Pope settle the controversy in this manner (Milanesi, p. 442). In August 1525, there were again negotiations between the heirs and Fattucci (who was designated in the

meanwhile by Michelangelo as his agent in the controversy, Milanesi, p. 699). The heirs did not wish to spend any more money (Frey, *Briefe*, p. 256). It was at this time, September-October 1525, that the idea of reducing the Julius monument to a small wall tomb like the tomb of Pope Pius II first emerged (Milanesi, pp. 447 and 450). The heirs agreed, and a new contract was to be drawn up (Frey, *Briefe*, p. 267). About a year later, October 1526, Michelangelo sent a drawing according to the new reduced project (Frey, *Briefe*, p. 289). The effect on the heirs was catastrophic. They again threatened a lawsuit. Thereupon Michelangelo begged the Pope for permission to work henceforward on the Julius Tomb (Milanesi, p. 454). Clement VII had already told Fattucci, about a year earlier, that Michelangelo should not bind himself to work on the Julius Tomb, but should only see that its execution was carried out by others. It would be sufficient if people said that Michelangelo was busy with it. The Pope wanted Michelangelo for his own works and added to the task of the Medici Chapel several others (Frey, *Briefe*, pp. 260ff). Clement VII evidently wanted to spur Michelangelo on to the work by constantly offering him new projects, although the Medici Chapel was still far from completion. The result was the opposite: the artist, instead of being inspired, was irritated. In January 1524, the Pope suggested a new building for the Medicean Library (I, 10). In May 1524, he wanted Michelangelo to erect his own and Leo X's tombs also in the Medici Chapel. In October 1525, he made a fantastic proposal for a colossus, forty braccia high, made in pieces, to be erected near the Palazzo dei Medici. Michelangelo's detailed reply, full of irony, is preserved (Milanesi, pp. 448f, and Gotti I, pp. 168f). At the same time, the Pope suddenly wanted a ciborium "sopra l'altare" in the Church of San Lorenzo (Frey, *Briefe*, pp. 260ff).

Already in June 1526, the hostility between the Pope and the Emperor had become acute (Pastor IV, 2, p. 240). In July the Pope sent word to Michelangelo that the expenses for the Libreria (not yet for the Medici Chapel) should be reduced (Frey, *Briefe*, p. 287; the correct interpretation of the letter by Popp, *Med.Kap.*, pp. 113f). In October and November 1526, Michelangelo was discharging stonecutters (Frey, *Briefe*, p. 289 and Milanesi, p. 455).

On September 20, 1526, Colonna, in the service of the Emperor, attacked the Papal palace, without taking the Pope himself prisoner. In January 1527, the fortification of Rome against the imperial army was begun. On May 6, 1527, occurred the siege of Rome by the imperial forces, and on May 7 the city was sacked.

In the meanwhile, on April 26, 1527, there had been an uprising in Florence against the Medici, which, however, had been suppressed. But after the sack of Rome, the heads of the Medici party had to leave the city (Cardinal Hippolito de' Medici and Cardinal Passerini). On May 21, 1527, the republican régime in Florence was set up. Already before April 1527, no work was being done in the Medici Chapel. On April 29, Michelangelo gave the key of the Chapel to his friend Piero Gondi so that he could hide his belongings there (Milanesi, p. 598).

When the city of Rome was sacked, the Pope fled to the Castel Sant' Angelo, but was compelled to surrender the fortress to the imperial forces on June 7, 1527, and was held there as prisoner until December 6th. During the night of December 6th-7th, he escaped to Orvieto, whence he did not return to Rome until October 1528. While he was still in Orvieto, at the beginning of 1528, he sent word to Michelangelo asking him if he had been working and if he would work for him, because he could send him immediately five hundred ducats and then pay him "alli giornate" (Frey, *Briefe*, p. 294).

But Michelangelo had in the meanwhile changed. The Florentine republican in him had awakened. On August 22, 1528, he received from the republican government a commission for the colossal group of the Hercules, which had originally been intended for him, but was then given by the Pope to Bandinelli (cf. below pp. 98*ff*). On October 3, 1528, he was called in as an expert in the matter of fortifying the city (cf. letter of N. Paganelli, Frey, *Briefe*, p. 296). On January 10, 1529, he became a member of the "Nove della Milizia," or fortifications council (Milanesi, *Prosp.Cron.*, p. 366). On April 6, 1529, he was nominated "governatore e procuratore generale sopra le fortificazioni di Firenze" (Milanesi, p. 701, and Gotti II, pp. 62*ff*). In June 1529, he inspected the citadels of Pisa and Livorno (Gaye II, pp. 184*ff*. and 194). On July 28, 1529, he went to Ferrara to study the fortifications there (Gaye II, p. 197*f*). On August 9, he was recalled to Florence (Gaye II, pp. 198*ff*). From October 10, 1529, Florence was besieged by the combined troops of the reconciled Emperor and Pope, under the leadership of Philibert of Orange and the Marchese del Vasto.

Michelangelo's activity as master of the fortifications is treated in the context of his architectural works (I, 7). In his plan for fortifying the city, he was opposed by the gonfaloniere Niccolò Capponi (Busini, *Lettere*, p. 115). The latter, who was suspect, was replaced in April 1529 by the gonfaloniere Francesco Carducci. The position of "condottiere e governatore generale" of the Florentine troops was held by Malatesta Baglioni, who later betrayed the city into the hands of the Medici. Michelangelo seems to have had a premonition of his treachery, which he mentioned to the Signoria, but the latter reproached him for being too suspicious (Busini, p. 104). Thereupon Michelangelo fled, on September 21, 1529, according to Varchi, with Rinaldo Corsini and his pupil, Antonio Mini, about three weeks before the siege began. On September 23, 1529, he arrived in Ferrara (where he refused to accept the hospitality of the Duke), and continued his journey to Venice, where he arrived September 25th. He did not yet feel safe, and so wanted to continue his flight as far as France. On the day of his arrival in Venice, he sent a letter to Battista della Palla, agent of Francis I in Italy, in whose company he wanted to go to France (Milanesi, p. 457). The French ambassador in Venice, Lazare de Baïf, wrote a letter to Francis I and another to the Maréchal de Montmorency, asking them to seize the opportunity of attaching Michelangelo to the French court. The French king offered Michelangelo a pension and a house, but when

his letter reached Venice, Michelangelo was no longer there (*G.d.B.-A.*, XIII, 2, 1876, pp. 275*ff* and Dorez, *Nouv. Recherches*, 1917, pp. 211*ff*).

On September 30, 1529, five days after Michelangelo's arrival in Venice, the Signoria decreed that those who had fled would be declared rebels, and their property would be confiscated if they did not return before October 7th (Gotti II, p. 64). The Florentine ambassador in Ferrara informed the Florentine Republic (October 13, 1529) that the artist heard of the decree too late, and that he would be ready to return under the condition of clemency (Gaye II, 209). The Republic agreed (October 20, 1529) and sent the stonecutter Bastiano di Francesco to Venice with a safe-conduct. The same man also brought eleven letters from friends of Michelangelo, who implored him to return (Gotti I, p. 195). The most beautiful letter, full of noble patriotism, was that of Giovanni Battista della Palla (October 24, 1529), and may have influenced Michelangelo to return (I, 9) (Gotti I, pp. 195*f*). But he was in no hurry. Della Palla came to Lucca to meet him but had to wait there a long time. He wrote again to Michelangelo begging him to return (Frey, *Briefe*, p. 301). On November 9, 1529, Michelangelo went to Ferrara; about November 20, he came back finally to Florence, and three days later it was decided that he should be barred from membership on the Consiglio Maggiore for three years, "potendo non di meno ogni anno una volta cimentare una provisione" (Vasari, ed. Mil., VII, pp. 370*ff*; Gaye II, pp. 209-217; Frey, *Briefe*, pp. 301-303). From now on his behavior was valiant. On August 2, 1530, Malatesta Baglioni betrayed the city, and on August 12, 1530, Florence capitulated, and the power returned to the hands of Clement VII. The Papal commissary was Baccio Valori. At first the administration of the city was also in the hands of Francesco Guicciardini and Roberto Acciaiuoli (Pastor IV, 2, p. 393). Baccio Valori, himself a Florentine, began his reign of terror. All great Florentine patriots whom he could get his hands on were arrested by his order, although it was he who had signed the document of capitulation with the Florentines and in it had personally granted amnesty to the enemies of the Medici among the Florentine citizens. One of the first who was imprisoned was the noble Battista della Palla. Michelangelo, who understood the dangerous situation in good time, had meanwhile gone into hiding.

That Michelangelo in the Pope's time of distress went over into the hostile camp, and remained there even when the Pope after his imprisonment and humiliation offered him money and requested him to continue to work for him, might well have appeared to the Pope as ingratitude. After the reconquest of Florence, the Pope in his first anger had a search made for Michelangelo. But his anger did not last long, and already in November 1530, in three letters (November 11, 19, and 25), he ordered that Michelangelo be treated in the most friendly manner (Gaye II, pp. 221*f*). Later he said to Sebastiano: "Michelangelo is wrong; I have never done any injury to him" (April 29, 1531; Milanesi, *Corr.*, p. 42).

Baccio Valori, the new commissary of Florence, who was a cultivated man and the son of a member of the Platonic Academy, wanted to exploit his power, and asked Michelangelo for a sculpture (Frey, *Briefe*, p. 324) and also a project for a house. Another henchman of the Pope, the Marchese del Vasto, also wanted to have his tribute, and asked for a painting (Frey, *Dicht.*, p. 507). Michelangelo executed for him the cartoon for the *Noli me tangere*.

In 1530, Michelangelo plunged "con diligentia et sollicitudine" again into the work of the Medici Chapel (Gaye II, p. 221). The Pope provided him the customary provision of fifty scudi a month (Gaye II, p. 222). He seems to have worked so hard that he became ill, and his friends feared for his life. Giovanni Battista Mini wrote on September 28, 1531 (Gaye II, p. 229): "Michelangelo mi parse molto istenuato e diminuito dele charne . . . viverà pocho se non si rimedia, e questo è che lavora assai." The Pope sent him word that he did not wish "che ve fachinasti tanto" (Milanesi, *Corr.*, p. 70).

In consequence of the many commissions, especially from the political powers of the moment, Michelangelo complained to the Pope and asked for his help (October 26, 1531; Frey, *Briefe*, p. 311); whereupon the Pope, on November 21, 1531, issued a breve in which he forbade him under penalty of excommunication to do anything except the work for him and that for the Julius Tomb (Bottari, *Lettere*, VI, pp. 54ff).

In the years from 1527 to April 1531, one hears nothing of the heirs of Julius. But in April 1531, Sebastiano reported that the Duke Francesco Maria of Urbino, one of the heirs, was still angry (Milanesi, *Corr.*, p. 42). In June of the same year the desperate artist apparently offered to return the house in Rome, to repay two thousand ducats, and to finish the monument in three years, an offer which Clement VII and Sebastiano del Piombo considered too generous (Milanesi, *Corr.*, p. 54). Michelangelo stated that the only alternative was to complete the monument or return the money to the heirs, and since the Pope would not permit him to work on the monument, he wanted to repay two thousand ducats and to hand over the already finished statues and all the models and drawings. He said there were many younger artists who could do the work better than he (Milanesi, p. 458). Michelangelo's attitude was that of a man of honor, whereas the stand of the Pope and Sebastiano del Piombo was diplomatic. Their less scrupulous point of view had the morally positive quality, however, that it was motivated by a friendly wish to ease Michelangelo's situation.

Ca. November 1531, Sebastiano reported that the heirs wanted to annul the old contract for the Julius Tomb and make a new one, since they wanted to spend no more money on it. They desired that the new, simplified project (i.e. that of 1525-1526) of the tomb should be executed (Thode, *Reg.*, p. 415). Further negotiations concerning the Julius Tomb are reported in December 1531 (Milanesi, *Corr.*, p. 74), and in March and April 1532 (Milanesi, *Corr.*, pp. 82 and 94).

At the beginning of April 1532, Michelangelo went to Rome, where a new contract,

the fourth, was drawn up (Milanesi, pp. 702*ff*) and was ratified on June 14 (Frey, *Dicht.*, p. 510). According to this contract, Michelangelo had to make a new model or drawing; he had to deliver all the statues and drawings which he had made for the monument; he obligated himself to pay two thousand ducats in the three coming years and to bear all future expenses of the work; the house in Rome remained his property. The Pope was to permit him during each of the three coming years to work for about two months in Rome on the tomb. Michelangelo had the right to let sub-contracts for the work to other artists. The monument was to be erected in San Pietro in Vincoli.

This fourth contract shows the power of the Pope, who assured Michelangelo's time and labor for his own tasks, without entirely forfeiting the appearance of a legal settlement. Michelangelo was not even present at the conclusion of the contract, but by order of Clement VII left on that day to return to Florence (Milanesi, p. 489).

In Florence, Michelangelo at first tried to procure the two thousand ducats which he wanted to repay to the heirs. He wanted to sell one of the houses which he owned in Florence (Frey, *Dicht.*, pp. 509*f*). He announced his intention of coming to Rome for a longer stay, to work there on the Tomb of Julius II. In August 1532 (Frey, *Briefe*, p. 330), he left for Rome, where he remained until the early summer of 1533. It was at this time that he made the acquaintance of Cavalieri (cf. below). At the end of June 1533, he returned to Florence for a stay of four months (Milanesi, p. 470); here he was again occupied with the Medici Chapel, with the direction of the works for the Libreria Laurenziana, and with the Pergamo of the Church of San Lorenzo. Inwardly, however, he was already divorced from all these works in Florence, and had made up his mind to go to Rome to live permanently (Frey, *Dicht.*, p. 515). From the end of October 1533 until May 1534, he was again in Rome. There are no reports from this period; probably he spent his time chiefly with Cavalieri. (According to Vasari 1550, and Condivi, it was at this time that Clement VII proposed to him that he execute, on the altar wall of the Sistine Chapel, the Last Judgment.)

In May or June 1534, he returned to Florence to visit his father and to be near him at his death. Lodovico died in the summer of 1534, aged ninety-one years (Milanesi, p. 153); the artist perpetuated his memory in a touching poem (Frey, *Dicht.*, LVIII). He made arrangements for a dignified funeral in the Church of Santa Croce (Gotti II, p. 81), the parish church of the quarter where so many generations of Buonarroti had lived since the early thirteenth century. Around September 20, 1534, he left Florence and went through Pescia and Pisa back to Rome (Milanesi, p. 471), where he arrived September 23, two days before the death of Clement VII. He felt himself liberated from his past, and he never returned again to Florence.

Concerning the workshops and dwellings of Michelangelo during this period, some facts are known. In 1513-1516, he seems to have lived in Rome in his house in the Macello dei Corvi, near the Foro Traiano (Milanesi, p. 491). (In one later note he signed

"Michelagniolo al Macel de'," followed by a small sketch of a raven.) Another house in the Regione di Trevi, near Santa Maria del Loreto, was to be placed at his disposal according to the third contract (1516) for the Tomb of Julius II (Milanesi, p. 644*ff*).

In Florence he had three workshops: one in the Via Mozza (today Via San Zanobi). He bought the land from the Cathedral chapter on April 17, 1517 (Milanesi, p. 141), and built there a workshop for his works for the façade of San Lorenzo, but he used the atelier also for the works for the Julius Tomb in 1519 (Milanesi, p. 579). To enlarge his atelier, he bought on July 14 and November 24, 1518, another plot of ground nearby and wanted to acquire gratis the adjoining piece of land (Milanesi, pp. 575*f*; Gaye II, p. 254; Milanesi, p. 393). In 1519, May-June, a house was built on the Via Mozza (Milanesi, pp. 578-579), and in 1521 he intended to buy another house on the same street (March, 1521; Milanesi, p. 417). The ground plan probably of the house on the Via Mozza is preserved in a red-chalk sketch of the Archivio Buonarroti (published in Tolnay, *Arch.Buon.*, Fig. 76) and in a pen sketch of the Casa Buonarroti (Frey, *Handz.*, 293b). There is also preserved a sketch by Michelangelo showing the plan of the plot of ground near the Via Mozza (Frey, *Handz.*, 108). In January 1533, Michelangelo intended to sell the house on the Via Mozza with the marble in it, so that he could repay his debt to the heirs of Julius II (Frey, *Briefe*, p. 337).

Another house was given him near San Lorenzo, according to the contract of January 19, 1518, for the façade of San Lorenzo (Milanesi, p. 671). In an attack of pessimism over the Julius Tomb affair, Michelangelo suddenly left this house in March 1524 (cf. above and Frey, *Briefe*, pp. 218, 219, 220), but in August 1524, he asked to be allowed to return to it (Milanesi, p. 438), and on October 26, the house was again let to him (Frey, *Briefe*, p. 237).

The third workshop was on the Piazza Ognissanti and is mentioned for the first time in December 1518 (Milanesi, p. 398); it was built for the execution of the sculptures for the façade of San Lorenzo.

Michelangelo's prestige was already so great in the 1520's that his advice on artistic matters was sought from great distances: the construction superintendents of the Church of San Petronio in Bologna requested, July 2, 1522, his judgment concerning the projects for the uncompleted façade (Gotti I, p. 176 and II, p. 60); Martino Bernardini of Lucca asked (May 20, 1519) for Michelangelo's opinion about a church which was to be erected in Lucca, the models of which (one by Baccio [Bigio?], the other by Donato [Benti?]) he would send to Michelangelo (Gotti I, 145).

In addition to the works which were actually begun and in part executed, there are numerous reports of commissions which Michelangelo could not execute, but which testify to his fame, not only as a sculptor and painter, but also as an architect. Especially numerous are the commissions for tombs. In this genre Michelangelo seems, especially

since his work on the Medici Chapel, to have been considered the leading artist. In 1518, Pietro Soderini asked his advice about an altar and the frame for the relic of the head of St. John the Baptist, and also for two tombs to be erected in San Silvestro in Capite, in Rome (Frey, *Briefe*, pp. 101ff). On March 17, 1522, Frizzi asked for a drawing for a tomb in Bologna (Frey, *Briefe*, p. 189). On January 5, 1525, the Duke of Suessa begged a sketch for his and his wife's tomb (Frey, *Briefe*, pp. 244, 248 and Milanesi, *Corr.*, p. 32). In October 1525, the Canon of San Petronio in Bologna, Bartolomeo Barbazza, wanted to execute the tomb of his father, for which Michelangelo some years earlier had sent him a drawing (Frey, *Briefe*, p. 259). In 1531, Orlando Dei from Lyons asked advice for the monument of the Prince of Orange (Frey, *Briefe*, p. 307), and in the same year also Cardinal Cybo asked for a drawing or a model for his tomb (Gotti I, p. 212).

Among the paintings, it is known that Michelangelo accepted on October 20, 1515 (Milanesi, p. 129), a commission from his friend Pier Francesco Borgherini. Later he transferred the execution, as stated above, to Andrea del Sarto (Frey, *Briefe*, p. 43), and since Borgherini was unsatisfied, Sebastiano wanted to execute the commission (Frey, *Briefe*, p. 63). It is not known what this painting represented; perhaps a Flagellation of Christ, because Sebastiano executed a fresco of this subject, after a small drawing by Michelangelo, for the same patron (Milanesi, *Corr.*, p. 32). In 1522, Leonardo Sellaio asked for a drawing for a painting which should be executed by Ghobo (Frey, *Briefe*, p. 194). The Cardinal Grimani, Patriarch of Aquileia, sent a request (through B. Angiolini) in June 1523 (Frey, *Dicht.*, pp. 505, 506 and Gotti II, p. 61), for a work, either in painting or sculpture or bronze. In May 1525, Fra Zanobi de' Medici, from San Miniato al Tedesco, asked for a drawing representing a Virgin with the Archangel Michael (Gotti I, p. 177; Frey, *Briefe*, p. 253). In 1529, the Prior of San Martino in Bologna, Fra Giampietro Caravaggio, asked for a painting or a cartoon representing a Virgin with four saints for Matteo Malvezzi. The painting should be eight braccia high and five braccia wide. In the letter (Archivio Buonarroti), the Prior made an outline of how he wished the painting to be. At the end of 1530, Malvezzi still hoped to get the cartoon from Michelangelo (Frey, *Briefe*, pp. 297ff). In 1531, the Marchese Federigo Gonzaga asked for a work by Michelangelo for the Palazzo del Te. Michelangelo answered that he could not accept any commission until he had executed the Pope's wishes, whereupon Federigo asked Clement VII to give Michelangelo permission to execute this work (Gaye II, pp. 227f, and Pastor IV, 2, p. 760). On July 1, 1531, Michelangelo offered to give a painting to Cardinal Salviati (Gotti I, p. 212).

Commissions for sculptures are mentioned in May 1522, when the Cardinal Fiesco asked Michelangelo for a statue of the Virgin (Frey, *Briefe*, p. 192); in 1523, the Senate of Genoa asked Michelangelo for a statue of Andrea Doria (Gotti I, p. 177; on November 17, 1527, Andrea Doria wrote again on this matter).

Among the architectural works, it is mentioned that in 1520, Michelangelo made a

model for the *ballatoio* of the cupola of the Cathedral of Florence (Vasari, ed. Mil., v, p. 353). On June 16, 1523, Michelangelo sent a project for a villa with a garden in Marmiruolo for the Marchese of Mantua (Milanesi, *Prosp.Cron.*, p. 364). On February 8, 1525, Cardinal Santiquattro asked, through Fattucci, for a sketch by Michelangelo for the façade of his palace (Frey, *Briefe*, p. 247). In October 1529, Michelangelo is said to have executed a project for the Ponte del Rialto in Venice, at the wish of the Doge (Pietro Lando; by error the biographers say Andrea Griti). In 1531 or 1532, Baccio Valori asked for a design for a house (Frey, *Briefe*, p. 323). In 1533, the Bishop of Pistoia, Cardinal Lorenzo Pucci, asked Michelangelo to come to his villa in Igno to make projects for a church and a bridge there (Milanesi, *Prosp.Cron.*, p. 381).

At the same time, Michelangelo was very celebrated as an architect of fortifications, having begun his activity in that field in the autumn of 1528.

The great art patrons of Europe, as can be seen from the above list, were already vying with one another for the acquisition of one of Michelangelo's works. It is a sign of the great independence of his spirit that he complied with very few of these flattering requests. But while he was letting the great ones go away empty handed, he had time to furnish drawings to a simple artisan, Valerio Belli, "che taglia le corniole." In a matter that lay close to his heart, he himself made the offer: when the members of the Florentine Academy, on October 20, 1519, petitioned Leo X for the remains of Dante to be brought to Florence from Ravenna (Gotti II, 82), Michelangelo offered to erect a "worthy monument" for the "divine poet" in an honorable place in Florence.

Concerning Michelangelo's social relationships during this period, our information is but fragmentary. From the preserved documents it can be seen that the circle of his friends was steadily expanding, and that during this time he was rising socially from the bourgeois milieu into that of the aristocracy and the high dignitaries of the Church.

At the beginning of this period in Rome, between 1513 and 1516, he was a member of an informal society which seems to have met for convivial evenings at regular intervals, composed mostly of Florentines, among whom we find no intellectually prominent personalities. Members of this group were Giovanni Gellesi (through whose letter of 1515 [Frey, *Briefe*, p. 23, cf. also pp. 30-31] we know of the existence of the group), Changiano, Giovanni Spetiale, Bartolomeo Verazzano, and probably also Sebastiano del Piombo. During Michelangelo's absence his place was taken by Domenico Buoninsegni (later, in 1525, Michelangelo quarreled with Buoninsegni; see Frey, *Briefe*, p. 248). Michelangelo appears to have enjoyed the meetings of such groups. In a letter of 1525, to Sebastiano del Piombo, he explains why he liked to spend his time in company (Milanesi, p. 446). Michelangelo was invited to dinner by friends, "di che ebbi grandissimo piacere, perchè usci un poco del mio malinconico, overo del mio pazzo: e non solamente n' ebbi piacere della cena che fu piacevolissima, ma n' ebbi ancora e molto più che di quella, de' ragionamenti che vi furno." At the end of this

period, in the winter and spring of 1533 in Rome, we find him in friendly association with a socially high and cultivated elite. Besides Bartolomeo Angiolini, writer of madrigals and sonnets, and besides Cavalieri, the Roman nobleman (cf. below), his friends were the heads of the Florentine *fuorusciti*, opponents of Duke Alessandro de' Medici, who were active toward the restoration of the republican régime—Cardinals Ridolfi, Salviati, and Gaddi. He seems to have been also an intimate friend of Cardinal di Cesis, whom he visited in Pescia in September 1534. Some of these friends he had already known for a long time: Bartolomeo Angiolini wrote him a letter in 1521 (Frey, *Dicht.*, p. 504), and Cardinal Salviati in 1525 (Frey, *Briefe*, p. 254). Another intimate friend was Giovanni Francesco Fattucci, *cappellano* of the Cathedral of Florence, mentioned already in 1522 (Milanesi, p. 419); in the years 1525-1526 he was procurator for Michelangelo in the affair of the Julius Tomb in Rome (Milanesi, p. 699).

It is not strange that so outstanding and original an artistic personality should have had more enemies than friends in the circle of contemporary artists. The grandiose commissions which Michelangelo received aroused jealousy, and his creative power engendered envy and fear.

The hostile powers were gathered under the banner of Raphael, forming a clique whose center was the Papal court itself, and whose intrigues against Michelangelo were so successful that he had in fact to work far from Rome during these years. Raphael was celebrated as the great star of the age, and his qualities were set up as superior to those of Michelangelo. Through his magical personality Raphael bound to himself a great host of young artists, who saw to it that his fame was widely spread. Michelangelo, solitary by nature, had no such aura. Also he had too much integrity to form a party about his person. In Papal Rome there was only one artist of importance who considered himself as the defender, indeed the "avenger" of Michelangelo—the Venetian Sebastiano Luciani, later called Sebastiano del Piombo. Jealousy and hate for Raphael and his party (which he called the "synagogue") were the reasons which made him turn against Raphael, whose friend and collaborator he had formerly been, and drove him to the banner of the absent Michelangelo. Alone, and not altogether without success, he founded the Michelangelo party in Rome. He and Leonardo Sellaio kept Michelangelo informed, through letters, about artistic events in Rome, about the works that Raphael had completed, about the commissions of the Raphael party, and about the latest gossip at the Papal court. To be sure, these reports were not objective; they were written with the intention of flattering or soothing Michelangelo, and whatever Raphael and his clique made was described as unsuccessful (cf. e.g. Frey, *Briefe*, p. 132).

Sebastiano del Piombo's close association with Michelangelo began in 1515-1516, and continued until 1533, when it came to an abrupt and lamentable end (I, 11). Their correspondence between 1518 and 1533 is in part preserved (there are alto-

gether thirty-eight letters from Sebastiano, and six from Michelangelo to him). It shows that Sebastiano eagerly concerned himself in Rome with the private affairs of the great master. He negotiated with the heirs of Julius II concerning the completion of the Tomb; he reported the opinions of the Papal court concerning the work in the Medici Chapel and concerning the Christ of Santa Maria sopra Minerva. As a reward for his zealous endeavors, he asked for Michelangelo's protection at the Papal court and also begged for sketches that he could use in his own work. Within his generation Sebastiano was one of the most important artists in Rome, and the most important portrait painter. Unfortunately, he did not recognize the limitations of his talent, and his great ambition was to compete with the great painters of histories. Already in his first Roman work, the frescoes of the lunettes of the Villa Farnesina (1511), certain motifs show clearly the influence of Michelangelo's Sistine Ceiling. But they are completely subordinated to a conception which still is Venetian. In the Farnesina he worked side by side with such eminent artists as Raphael, Sodoma, and Peruzzi. He wanted, however, to paint in such a prominent place as the Vatican, and this may have been the reason why his friendship with Raphael was broken. At this moment he attached himself to Michelangelo, who procured several important commissions for him: the frescoes in San Pietro in Montorio, and the Raising of Lazarus for Cardinal Giulio de' Medici. The commissions for the Sala di Costantino, for which Michelangelo also intervened in Sebastiano's favor, were nevertheless not given to him. The break with Raphael is visible in his works. He gave up Raphael's ideal of form, and began to adopt Michelangelo's motifs in greater measure, attempting a synthesis between the Venetian mood-painting and the plastic and animated figures of the Sistine Ceiling. He did not progress beyond the assimilation of this work, and the works which Michelangelo did in the 1520's remained a closed book to him. Even from the Sistine Ceiling he took only positions and gestures, and the compositions of his works remained either Venetian, or Middle Italian, or (a remarkable fact) archaizing Nordic. The total structures of the Lamentation over Christ (in Leningrad), the Raising of Lazarus (in London), and the Birth of the Virgin (Rome, Santa Maria del Popolo), with their high horizons, with their groups of figures which are arranged as if in layers one above the other, are clearly inspired by Geertgen and Dürer, and are in just that respect more "advanced" than the contemporary Italian paintings. These compositions anticipate by about twenty to twenty-five years the works of the Mannerists, Battista Franco, Marcello Venusti, Daniele da Volterra. Indeed, in a certain sense they anticipate even the late style of Michelangelo, the Last Judgment and the frescoes of the Cappella Paolina.

The relations between Sebastiano and Michelangelo have previously been described as a completely one-sided affair, and the extent of Michelangelo's influence on Sebastiano has been until quite recently exaggerated. Vasari, and after him the later historians, supposed that Michelangelo gave Sebastiano sketches not only of individual

figures but also of whole compositions; sometimes, indeed, his personal collaboration in Sebastiano's pictures was assumed, a suggestion which closer investigation, however, proves to be unfounded. Apparently Michelangelo gave Sebastiano only sketches and studies of individual figures which he had drawn originally for his own works, and which Sebastiano could then use with slight modifications for his compositions. He seems to have made no *ad hoc* studies for Sebastiano. This method is the same which Sebastiano in his turn recommended to Michelangelo when he suggested that the latter should add a halo to his Ganymede to make a St. John of the Apocalypse for the lantern of the Medici Chapel (cf. below).

The first work which shows the influence of Michelangelo in great measure is the Lamentation over Christ (1516), now in Leningrad. The head and gestures of Nicodemus, and the two figures beside the sepulcher, are reminiscent of the Sistine Ceiling. It is possible that Sebastiano used studies of hands by Michelangelo (the hands of Christ recall the hands of the Christ of the Pietà in St. Peter's). The structure of the composition, the disposition of the figures within a right-angled triangle, the representation of the sepulcher at the right and Golgotha at the left in the second plane, the group of the Virgin supported by St. John and a woman, seem to go back to Dürer's woodcut of the Burial of Christ (about 1498). Thanks to the mood-landscape of the background, which is Venetian, the whole remains fundamentally North Italian, despite the Nordic composition and the Michelangelesque gestures.

The Flagellation of Christ, in San Pietro in Montorio (1516-1524), is a work whose connection with Michelangelo is assured by documentary evidence. Vasari says that the figure of Christ was executed after a "piccolo disegno" of Michelangelo, and even the completed figure was shaped in outline by Michelangelo. From the correspondence we know that on August 9, 1516, Sellaio asked Michelangelo to send the drawing for Sebastiano's fresco ("avete a mandare el disegno a Bastiano," Frey, *Briefe*, 30f). On August 16, 1516, the receipt of the sketch was acknowledged (Frey, *Briefe*, 32). On the basis of the sketch, Sebastiano made probably several drawings, then a small clay model of the Christ, and finally a cartoon of the whole composition. Vasari says: "dal piccolo disegno di Michelagnolo ne fece per suo commodo alcun' altri maggiori." One of these drawings is still preserved in the British Museum. In the weight of the proportions and in the greater dynamics of the movement, it seems to be closer to the prototype (that is, Michelangelo's sketch) than the executed work. Michelangelo apparently did not place an *ad hoc* sketch at Sebastiano's disposal. The idea he presented can approximately be identified on the basis of a drawing in the collection of Sir Robert Witt (1, 12). *132* This is the sketch of a slave for the Julius Tomb of ca. 1532, which in motif is related to the Christ in San Pietro in Montorio. Common features are the pose of the upper body, the head in profile and inclined to the right, and the arms bound behind the back. This sketch probably reverts to another by Michelangelo of ca. 1516. Michelangelo's "piccolo disegno," of 1516, therefore, was probably not a flagellated Christ,

but a slave for the Julius Tomb, which in general was suited to the requirements of the fresco in San Pietro in Montorio. Sebastiano then transformed this into his Christ. The motif of movement is quite unusual for a flagellated Christ. It breaks with all traditional representations of the Christ bound to a column (or of St. Sebastian, which formally is the same). In the second half of the Quattrocento, the flagellated Christ was always a contrapposto figure standing quietly in front of the column, and participating only passively in the event. Sebastiano's Christ comes forward in active movement, which, however, does not seem to be a reaction to the blows of the scourges, not a shrinking in pain (as, for example, in Donatello's Scourged Christ), but an attempt to free himself from the column. The figure seems to be unconscious of the torment of the scourges. It is completely out of relation to its environment, as if alone and concerned with trying to loose the fetters. This conception of Christ, so strange in a picture of the flagellation, is explained by the above-mentioned fact that Michelangelo's drawing represented a slave of the Julius Tomb. On other occasions also Sebastiano seems to have used studies which had been made for a different purpose by Michelangelo.

Concerning the Raising of Lazarus (1517-1519), Vasari says that it was made "sotto ordine e disegno in alcune parti di Michelagnolo." From a letter of Sebastiano (Milanesi, *Corr.*, p. 26), however, it appears that the picture was not made "sotto ordine" of Michelangelo, since the latter saw only "l'opera principiata," and remembered the picture so imperfectly that he had to ask Sebastiano for information about "l'animo et la intentione dell' opera" (Milanesi, *Corr.*, p. 2). The composition has nothing of Michelangelo in it. The structure is again Nordic. Sebastiano may have used a drawing by Michelangelo for the Lazarus, possibly a sketch for an Ignudo of the Sistine Ceiling (cf. Sebastiano's sketches for this figure in Bayonne and London). Aside from this, however, the borrowed motifs in the picture are numerous, and all go back to the Sistine Ceiling, so it is possible that the master gave him detail studies which he had made for the Ceiling. The left hand of Christ is, in mirror image, borrowed from God the Father in the Creation of Adam, his right hand from God the Father in God Dividing Heaven and Water. The old man kneeling at the left in front of Christ is freely adapted from the Eve of the Creation of Eve. The gesture of the woman behind Lazarus is, in mirror image, adapted from the Adam of the Expulsion from Paradise. The head of the youth in the lower right corner was created under the influence of the Adam in the Creation of Eve.

The Pietà in Viterbo was made, according to Vasari, after a cartoon by Michelangelo. This is again an exaggeration, for the composition, with the horizontally outstretched Christ, is not at all in Michelangelo's manner. The Madonna shows the influence of the Cumaean Sibyl (legs and drapery), and of the Prophet Isaiah (right arm). (Possibly the Vita Contemplativa of the Julius Tomb [1513] served as model. The figure strangely anticipates the Rachel of the Tomb of Julius II, made around 1545.) In the figure of

Christ, only the left hand is made in imitation of Michelangelo: it is a copy of the hand of Adam in the Creation of Adam.

The Pietà in Ubeda (1533-1534) shows the influence of the Pietà of St. Peter's. According to the contract, Sebastiano had to make a "Nostra Donna che avesse il figliuol morto in braccio a guisa di quella della Febre," i.e. Michelangelo's Pietà in St. Peter's. The left hand of the Virgin is evidently inspired by Michelangelo's work. There is a drawing by Sebastiano in the Louvre for the Christ, and another drawing in the Casa Buonarroti (Frey, *Handz.*, 15) with the same motif. Both seem to revert to a lost drawing by Michelangelo. Frey, *Handz.*, 15, seems to be a more exact copy of the prototype. This would be again a proof that Michelangelo did not put at the disposal of Sebastiano an *ad hoc* study, but the sketch of a torso which he made originally for his own purpose (I, 13).

The Birth of the Virgin, in Santa Maria del Popolo, which Sebastiano began in 1532, and which was finished by Salviati only in 1554, seems also not to be made after a compositional sketch by Michelangelo, but to revert to Dürer's woodcut of 1502-1503. The idea of putting the Virgin in the second plane, and of composing groups of figures in the first plane at the top and bottom, derives from Dürer. In the figures themselves he again incorporated motifs from the Sistine Ceiling. In one of his letters of 1532, Sebastiano asked Michelangelo for "un pocco de lume . . . facto grosso modo; a me mi basta solamente chiarirmi come la intenderesti vui circha l'inventione . . ." (Milanesi, *Corr.*, p. 88). However, Michelangelo seems not to have made a compositional sketch for this painting.

We have already mentioned that Sebastiano anticipated the late compositions of Michelangelo by his assimilation of the blocklike figure groups of certain northern compositions. He seems to have influenced Michelangelo, moreover, by the technique of his drawings, in which the outlines are emphasized, and the inner modeling is made by a soft chiaroscuro. This is already the technique of the drawing for the Flagellation of Christ of 1516 in the British Museum, a technique which we find in Michelangelo about ten years later, at a time when he was in relationship with Sebastiano. Since it does not appear in his earlier drawings, the assumption of the influence of Sebastiano should not be discarded.

To summarize, Vasari's accounts seem consistently exaggerated. They contain only so much of truth: that Michelangelo often helped his friend with sketches which he had made for his own use. That Sebastiano especially wanted to have detail studies by Michelangelo is apparent from one of his letters, of July 15, 1532 (Milanesi, *Corr.*, p. 100): "Pregovi arecordative di portarmi qualche cossa figure o gambe o corpi o brace, che tanto tempo le ho desiderate, come vui sapete." These sketches were used by Sebastiano as a point of departure in his compositions.

Common distaste for Raphael and his circle, and common interests bound the two artists together. However, their characters were completely different: Michelangelo al-

ways magnanimous and truth-loving, Sebastiano petty, ambitious, and intriguing. So it is not strange that an apparently small external cause became the grounds for a complete breach. Sebastiano del Piombo advised Paul III that Michelangelo ought to paint the Last Judgment in oil. Michelangelo considered this an insult, which he could never forgive.

Michelangelo seems to have had, with the one exception of Sebastiano del Piombo, no intimate relationship with the outstanding artists of his time. Among the painters of the older generation, it is attested that he had some relations with Luca Signorelli. To this great artist, who had some influence on Michelangelo's youthful works, Michelangelo made a loan in 1513, which Signorelli did not repay. In 1518, Michelangelo applied to the Capitano di Cortona for reimbursement (Milanesi, p. 391; Frey, *Briefe*, pp. 90 and 91). Among the great painters of his own generation, some rapport must have existed with Andrea del Sarto, because in August 1516, Michelangelo recommended him for the execution of a painting for Pier Francesco Borgherini, for which he had made the cartoon (Frey, *Briefe*, p. 43). We learn from a letter of Borgherini, however, that he was not satisfied with Andrea del Sarto (Frey, *Briefe*, p. 63). Among the painters of the younger generation, Michelangelo seems to have held in high esteem Giovanni da Udine, with whom he was in relationship from about 1522 (Frey, *Briefe*, p. 191), and Pontormo from about 1529-1530, whom he recommended for the execution of two of his cartoons (*Noli me tangere*, Venus and Cupid). Among the unimportant painters, he was in intimate relationship from December 1523 (Frey, *Briefe*, pp. 197ff) with his pupil, Antonio Mini.

Relations with the celebrated sculptor, Jacopo Sansovino, are known between 1517 and 1525, but these were not happy. Jacopo Sansovino wrote a bitter letter, full of jealousy, because Michelangelo did not charge him with the execution of the reliefs for the façade of San Lorenzo (Frey, *Briefe*, p. 72; cf. also *ibid.* pp. 59 and 65; Gotti I, p. 136). Despite this complaining letter, Michelangelo later recommended Jacopo Sansovino for the execution of the tomb of the Duke of Suessa, for which Jacopo Sansovino thanked him in a letter of February 22, 1525 (Frey, *Briefe*, p. 248).

Andrea Sansovino offered his services to collaborate on the Medici Chapel, January 1, March 2, November 22, and December 5, 1524 (Frey, *Briefe*, pp. 202f and 239), but Michelangelo seems not to have answered.

That Bandinelli was an enemy of Michelangelo is well known.

Benvenuto Cellini, in 1529, when he was in Florence, was in relationship with Michelangelo, and got from him the sketch representing an Atlas bearing the earth. He states, however, that he did not use this sketch, but made his wax model independently of it (*Vita di B. Cellini*, Lib. I, chap. VIII).

Among the less prominent sculptors, Michelangelo was in relation with Silvio Falconi, who lived in his house in Rome in the Macel de' Corvi in 1513 (Milanesi, p. 640). Vettorio Ghiberti wrote him letters in 1521 (Frey, *Briefe*, p. 183 and Vol. I), and

Montorsoli helped him in 1532 on the works of the Julius Tomb (Frey, *Briefe*, p. 335), and in 1533, in Florence, on the Medici tombs (Milanesi, *Corr.*, pp. 104 and 108). Another sculptor whom Michelangelo, in 1533, summoned from Loreto was Tribolo (Frey, *Dicht.*, p. 516). Michelangelo gave him the allegorical figures of Earth and Heaven for the Medici Chapel to work on (Vasari, ed. Mil., VI, pp. 64f). In October 1533, Michelangelo made two small models for Tribolo (probably for the two allegorical figures—Milanesi, p. 470).

Relationships existed between Michelangelo and the gem cutter Valerio Belli in 1521 (Gotti I, p. 145 and Vol. I), and with the goldsmith Piloto, mentioned in 1522 (Milanesi, p. 418) and 1526 (Frey, *Dicht.*, p. 506). To these two he furnished drawings.

Because of his inability to do justice simultaneously to the various tremendous tasks, it is understandable that Michelangelo in his letters of this period should complain of feeling old and ill-humored—he felt that his creative power grew weaker during these years: "If I work one day I must rest four," he says in July 1523 (Milanesi, p. 420); "My powers are small, I am old" (October 24, 1525; Milanesi, p. 450).

That the projects and fragments of this period are not inferior to the Sistine Ceiling in grandeur of conception, that a new spirit is revealed in them, Michelangelo himself was apparently not aware. For the retrospective observer, these projects and fragmentary works are in some respects more precious than a completed great work such as the Julius Tomb would have been. For they gave Michelangelo the opportunity to plan monuments which embodied the status of his spiritual development at the time, while the Julius Tomb, conceived already in 1505, could never completely belie its early origin, and would have expressed Michelangelo's development probably in a less direct way.

The deeper historical significance of the "unhappy years" that have been treated here lies in the fact that in all the uncompleted projects the wealth and mobility of Michelangelo's spirit becomes more tangible.

In the heart of the fifty-seven-year-old artist, who seemed to believe himself to have arrived at the end of his life span, a new love arose. But this love was chaste ("casto amor," Frey, *Dicht.*, XLIV). It was the religious adoration of beauty as a divine idea in human form, the mystic worship of God in the flesh.

Beautiful youths had already been objects of Michelangelo's admiration; in 1522, he wrote love letters to a certain Gherardo Perini; nor was the friendship with Cavalieri exclusive, since approximately one year after Michelangelo made his acquaintance, in 1534, he wrote love poems to a certain Febo di Poggio. In 1544, he was charmed by the beauty of a young lad, Cecchino Bracci (I, 14). But these were ephemeral friendships, unworthy of his love. Cavalieri, who in addition to great physical beauty also possessed moral noblesse, was a worthy friend, and the friendship was enduring. It lasted

more than thirty years, and even after Michelangelo's death, Cavalieri remained faithful to the memory of the master.

It was probably in August 1532, during Michelangelo's sojourn in Rome, that he first met Cavalieri, a young Roman of noble family, mentioned in the contemporary documents as "Thomas Cavalerius, Patritius Romanus, de regione Sancti Eustachii" (I, 15). None of the relations which he had had up to this time had such a decisive importance in his life. This friendship immediately took on immoderate dimensions, and became a passion which carried him away. Already the first letters which he wrote to Cavalieri were ardent love-confessions. In the first letter, of the end of 1532 (Milanesi, p. 462), he described his passion as follows: "Inconsideratamente . . . fui mosso a scrivere a vostra Signoria, . . . come se creduto m'avesse passare con le piante asciutte un picciol fiume. . . . Ma poi che partito sono dalla spiaggia, non che picciol fiume abbi trovato, ma l'oceano con soprastante onde m'è apparito innanzi; tanto che se potessi . . . alla spiaggia ond' io prima parti, volentieri mi ritornerei. Ma poiche son qui, faréno del cuor rocca e anderéno inanzi. . . ."

Passion makes him blind. Cavalieri becomes for him an idol, on which he confers all the virtues. He has a "smisurato amore" (Milanesi, p. 467) for him; his heart is in Cavalieri's hands: "il mio [cuore è] nelle mani di colui" (Milanesi, p. 469). Cavalieri's name feeds his body and soul: "il nome vostro nutrisce il corpo e l'anima, riempiendo l'uno e l'altra di tanta dolcezza, che nè noia nè timor di morte . . . posso sentire" (Milanesi, p. 467). He calls Cavalieri "luce del secol nostro, unica al mondo" (Milanesi, p. 462).

In Cavalieri's perfect body, Michelangelo sees an image of universal beauty. Cavalieri is for him "l'immortal forma" (Frey, *Dicht.*, CIX, 105) or the "forma universale" (Frey, *Dicht.*, LXXIX). He loves in him with enthusiastic delight the divine idea of which he is the incarnation, and contemplating his beautiful features he feels himself ascending to God (Frey, *Dicht.*, LXIV and LXXIX). The pure ideal beauty of which he had dreamed all his life appeared in a living being before his eyes. To a letter of Cavalieri in which the latter says that he feels himself just born (Symonds II, p. 400), he replies: "Non che appena mi parete nato, . . . ma stato mille altre volte al mondo" (Milanesi, p. 463, and another version of the same letter, p. 464). It is the divine idea of beauty, which here is incarnated anew. For the divine idea is always expressed in mortal form for man. Only by the help of a beautiful body can the soul rise to spiritual contemplation of the idea and of God: "Nè Dio, suo gratia, mi si mostra altrove,/ Più che 'n alcun leggiadro e mortal velo;/ E quel sol amo, perch' in lui si specchia" (Frey, *Dicht.*, CIX, 105; cf. also Frey, *Dicht.*, LXIV). He kneels in homage before this image of eternal beauty; he humbles himself as if before an idol. This was an exaltation, but the aging master approved it because it brought him a miraculous spiritual rejuvenation, a new springtime of the heart. Earlier emotions, ecstasies and oppressions of youth, which

had died in his ascetic service to art, were reborn. Now it was an exalted feeling of a mystic union of two beings to a higher entity and an ascension to God (Frey, *Dicht.*, CIX, 19; XLIV, XLV, LXIV); now it was a recognition of his "infelice stato" and of the tragic dualism between him and his friend (Frey, *Dicht.*, XLV, XLVII, XLIX, LXVII).

From the time of this association Michelangelo felt unhappy and exiled in Florence. "Se io desidero . . . senza alcuna entermissione giorno e notte di esser costà [Rome], non è per altro che per tornare in vita la qual cosa non può esser senza l'anima" (Milanesi, p. 469). He wanted to get away from the slavery in which he was bound in Florence, and to live in freedom near his beloved one. The trips of the artist to Rome became indeed more frequent after he became acquainted with Cavalieri, and in September 1534, he went to live there permanently. In Rome he hoped to be free from his past.

II. THE CHURCH OF SAN LORENZO AS MAUSOLEUM
OF THE MEDICI FAMILY

THE Church of San Lorenzo was one of the glories of the Medici family. Giovanni d'Averardo de' Medici, together with seven other leading families of the Quarter of San Lorenzo, commissioned Brunelleschi, the greatest architect of the early Renaissance, to make a project for the new church, on the basis of which the building was begun in the summer of 1421. At first only the southern sacristy, later called the Sagrestia Vecchia, was constructed. Soon, however (ca. 1425), the construction came to a stop, until in 1442 the son of Giovanni d'Averardo, Cosimo de' Medici, called *pater patriae*, undertook to pay the building expenses, and thus made possible the continuation of the work. Thereupon the transept was erected. In 1464, Cosimo died. Then at the instigation of Cosimo's son, Piero, the longitudinal naves were executed (II, 1).

It was only natural that the spacious and noble new building of Brunelleschi, which was erected through the munificence of three generations of Medici, was chosen by the family as a sort of family mausoleum.

In the most honorable place, in the center of the crossing, below the dome and in the crypt (II, 2), the old Cosimo was buried, the most celebrated member of the family, and the most generous patron of the Church. In a somewhat less prominent place, in the Sagrestia Vecchia, the parents of Cosimo (Giovanni d'Averardo and Picarda Bueri) were buried, beneath a marble table in the center of the room, and the sons of Cosimo (Giovanni and Piero) in the richly ornamented porphyry sarcophagus made by Andrea del Verrocchio.

After the early death of two other members of the family—namely, Cosimo's great-grandson, Giuliano de' Medici, Duke of Nemours (d. 1516), and Cosimo's great-great-grandson, Lorenzo, Duke of Urbino (d. 1519)—Pope Leo X and Cardinal Giulio de' Medici thought of erecting a second mausoleum in the Church (II, 3) for these younger members of the family, who were at the same time the first members to be elevated to ducal rank and the last secular male descendants of the direct line of Cosimo. It was proposed to bury four members of the family in the new sacristy—that is, besides the two just mentioned, the two grandsons of Cosimo, Lorenzo il Magnifico (d. 1492) and his brother, Giuliano the Older (d. 1478), who previously had been buried only provisionally in the Sagrestia Vecchia (II, 4). Already in 1520, Cardinal Giulio expressed his desire also to be buried in the new mausoleum.

The basic idea of the disposition of the tombs in the Church is thus completely clear. In the center the *pater patriae* was to rest, at the left of him his two parents and his two sons, at the right of him his two grandsons and the last two secular male representatives of his line.

Pope Leo X, very probably on the advice of the Cardinal Giulio (Regent of Florence), chose as the proper place for the new burial chapel the northern sacristy, called the Sagrestia Nuova, a counterpart to the Sagrestia Vecchia.

III. THE EXTERIOR

AN attempt to determine the history of the construction of the Medici Chapel may be made on the basis of the style of the exterior.

It is quite visible from the outside that the walls in the lowest zone were made in the *1, 166, 167, 168* Quattrocento at the same time as the north wall of the transept. There are the same blind arcades, the same pilasters between them, and the same cornice (the blind arcades exist on the east and north walls only).

In a somewhat later period a second zone was built to the height of the second zone of the Church. The cornice of this second zone, whose consoles are decorated with acanthus leaves, was executed as a continuation of the cornice of the north wall of the *1* Church, but in details of ornamentation it reveals a difference in technique and style. While the acanthus leaves on the consoles of the Church wall, four leaves on each console, placed side by side in the same plane, show the rough technique of the first Renaissance, which accentuates the concavities, the acanthus leaves on the consoles of the Chapel, five leaves to each console, are placed in such a way that the central leaf overlaps those next to it, so that they are in two planes; moreover, they are executed in a more refined technique, which accentuates the plastic convexities. It is evident that the second cornice is a copy of the one on the Church wall to which it corresponds.

To a third architectonic period belongs the zone of the pendentives and of the lu- *171, 172* nettes, with its four large rectangular windows. This also seems to have been constructed before Michelangelo's activity on the building began, because he had the win- *174* dows half walled up. The only parts of the edifice executed under Michelangelo's *1, 170* direction are the calotte of the dome, and the lantern above it (III, 1).

The changes which Michelangelo effected in the well-advanced construction of the building were not important. They were limited to the reduction of the window space in the drum and on the northern and western sides of the second zone. These changes are of no artistic importance for the external aspect of the building since they were entirely determined by the interior structure and the lighting of the Chapel.

The calotte of the dome differs from that of the Sagrestia Vecchia in that Michelangelo repeated the round outline of the interior, instead of covering it with a cone-shaped roof as Brunelleschi had done. Through the artist's preference for the rounded *169* outline, the dome of the Medici Chapel was conceived in the spirit of the early Cinque- *1* cento, and recalls the Roman domes of Bramante.

The calotte is crowned by a lantern whose design is characteristic of Michelangelo's *170* genius. On eight small columns, between which are tall and narrow windows, there is a cornice which projects over each of the columns, thereby accentuating their plastic *rilievo*. Above this cornice is a small attic with little oculi in the axis of the windows below, and with C-shaped volutes over each column. This attic is crowned by a concave cone decorated with small lion heads as conduits for the rain water. At the top is a gilded polyhedron surmounted by a cross, made by the goldsmith Piloto (Vasari 1568,

¹ p. 125). This gives the effect of an upward movement of the columns and an airy hovering of the cone and the cross. The rational relationship between the supporting and the supported parts is abandoned in order to achieve the effect of an upward movement and of an airy hovering at the top. If one compares this lantern with those of Brunelleschi (Sagrestia Vecchia and Santa Maria del Fiore), which nevertheless obviously provided the stimulus to Michelangelo, the novelty of the idea here is at once apparent. In Brunelleschi's work the pear-shaped roof rests directly on the pillars. It is noteworthy that Michelangelo repeated his idea later in the lantern of St. Peter's (cf. the engraving of Lafreri), with this difference, that the columns in each case are paired and placed on high bases and that the elegant and thin forms in Florentine style are supplanted by the monumental and large proportions of Roman art.

The result of the above investigation of the construction can be corroborated by the few historical facts which are known concerning the building of the exterior. It is known that Pope Leo X and Cardinal Giulio, in March 1520, had the construction of the Chapel walls continued, and without Michelangelo (III, 2). Michelangelo seems at first to have refused to take over the construction, on account of the decision of the Cardinal not to continue the project of the façade of San Lorenzo (Milanesi, p. 416). Leo X issued the breve by which Michelangelo was relieved from all obligations concerning the façade on March 10, 1520 (Milanesi, p. 581). Only at the beginning of November 1520 (probably before November 6, date of the Cardinal's departure for Rome)—that is, about eight months after the beginning of the construction—Michelangelo declared himself ready to accept the commission (III, 3). The inconsistencies in the third zone of the building, consequently, are explained by the fact that this part was executed during the eight months before Michelangelo took charge. It is not known who supervised the construction during that period.

IV. THE INTERIOR

ALREADY Vasari stated (1568, p. 127) that Michelangelo made the interior of the Chapel in imitation of the Sagrestia Vecchia: "egli la volse fare ad imitazione della Sagrestia Vecchia, che Filippo Brunelleschi haveva fatto, ma con altro ordine di ornamenti." This is in fact obvious, but the interior decoration shows that Michelangelo must have studied also other interiors belonging to this bichrome style (IV, 1).

The Chapel has a simple square ground plan and a rectangular choir on the north side. This plan deviates from that of the Sagrestia Vecchia only by the fact that in the middle of the walls there are shallow recesses, whereas the walls of the Sagrestia Vecchia are flat. On the other hand, the walls in the choir of the Sagrestia Nuova are flat, while in the choir of the Sagrestia Vecchia there are small round niches. However, that Michelangelo originally followed the Sagrestia Vecchia even in these respects is proved by a red-chalk drawing in the Archivio Buonarroti, the only original ground plan for the Chapel which is still preserved (IV, 2). Here the walls of the Chapel proper are flat, and in the choir there are three round niches.

The elevation of the Sagrestia Nuova differs essentially from Brunelleschi's sacristy in having between the first and the lunette zones an intermediate zone, which increases the height, and slenderizes the proportions. The total space is animated by a tendency, or a tension, upwards, which imparts a peculiar spiritual character to the room, in contrast to the earth-bound quality of the old sacristy. It will become apparent that this upward tendency is related to the ideas expressed by the Chapel. But first the sources of the elevation must be investigated.

The room is articulated by a gray-black *pietra serena* system of giant pilasters and architraves, which divides the walls into three superposed zones. The lower and the intermediate zone are further divided by Corinthian pilasters into three bays—a larger one in the center, and smaller ones at the sides. In the central bay of the intermediate zone there is always an arch. In the third zone there are the lunettes and the pendentives, which form the transition from the rectangular plan to the round plan; above this hovers the cupola, decorated with coffers (*casettoni*).

The prototype for the pure, severe *pietra serena* articulation of the lower zone with the gigantic pilasters and the central arch is undoubtedly the altar wall of the Sagrestia Vecchia by Brunelleschi. Michelangelo has extended the system of a threefold division to the other walls as well, thus unifying and systematizing the articulation of the whole Chapel. This was already his idea in the ground plan sketch of the Archivio Buonarroti. The only new addition is the strip of *pietra serena* beside the central pilasters. This served to give a straight outline as a frame for the sepulchral monuments and for the choir.

The second zone, with its more delicate pilasters and *pietra serena* tabernacle windows, is—as stated above—lacking in the Sagrestia Vecchia. It is present, however, in the Sagrestia di Santo Spirito by Giuliano da Sangallo and Cronaca, and the inspiration

[29]

seems to come from there. Above an order of colossal pilasters there rises a second order of smaller pilasters, and in the middle of the fields *pietra serena* windows with triangular pediments. The particular form of these windows in the Sagrestia Nuova is rather exactly copied from the windows in San Salvatore presso San Miniato by Cronaca.

Up to this point the *pietra serena* articulation corresponds to the Florentine tradition. The first decided deviation is in the lunettes. According to the Florentine Quattrocento the lunettes were usually decorated with round oculi (e.g. Cappella Pazzi, Sagrestia di Santo Spirito and Sagrestia di Santa Felicità). Instead, Michelangelo used here a rectangular window of completely original form. The frame of this window converges, and a powerful segment pediment crowns it. These windows seem to rise dynamically to the upper limits of the field—they stop only on meeting with the arc of the lunette. It is unlikely that Michelangelo's purpose was to accentuate the effect of perspective in the Baroque manner. It seems much more probable that he wished to emphasize thereby the vertical upward-growing of the windows. They appear optically to hold the cupola in a hovering position, and if one looks at the entire wall, the lunette window itself seems to hover lightly.

An original red-chalk drawing (No. 80) of this window frame is preserved, and shows even more plainly Michelangelo's intention of giving dynamic vitality to the architectonic forms. Vertical forces seem to rise up along the sides of the frame; they are interrupted by the horizontal frame, but break through it and continue their course even into the pediment (IV, 3).

The pendentives are ornamented with the traditional tondi frames. The dome, instead of the usual ribbed cupola, is, as has been mentioned above, coffered in the ancient style. It produces the effect not of a burden, however, but of a hovering form. Originally, the cupola was intended to be adorned with paintings of garlands, birds, and masks. These, executed in part by Giovanni da Udine but later covered over with whitewash, would have added even more to the effect of lightness.

With the exception of the dynamic lunette windows, the *pietra serena* system corresponds to the rational principles of Florentine architecture: the supporting and burdening forces of the walls are symbolized by the system of the pilasters and entablature. But this rational system is interpenetrated in the lowest zone by an irrational architectonic system—of white marble. Florentine Quattrocento buildings usually had *pietra serena* framed windows or arcades in the bays of the lowest zone. Nowhere can one find the contrast between white marble and *pietra serena*, a contrast which would have been even more powerful in the Sagrestia Nuova if the upper and middle zones had been decorated with frescoes as originally planned.

In the lateral bays there is always a low door, and a tabernacle niche above it. The idea of placing a niche above a door comes from the choir wall of the Sagrestia Vecchia. The forms themselves, however, are completely new and will be described in a later chapter.

In the central bays of the lateral walls there are small "façades" with extremely deli-cate fluted double pilasters between three slender niches. The small façades seem to have been inspired by certain ancient sarcophagi, with two lateral niches crowned by segment pediments, and a central niche or door, which in the ancient examples was usually crowned by a triangular pediment (e.g. sarcophagi in Florence, Baptistry, s. side). Also the influence of the altar and tomb architectures of the Florentine sculptors of the second half of the fifteenth century is apparent, especially in the delicate fluted marble pilasters and in the capitals with masks (see, for example, A. Rossellino and B. da Majano, altar in the Cappella Piccolomini, Naples, Monte Oliveto; B. da Majano, Cappella di San Bartolomeo, San Gimignano, Sant' Agostino; *idem*, Cappella di Santa Fina, San Gimignano, Collegiata) (IV, 4).

The bodies and legs of the sarcophagi follow with characteristic modifications an an-cient type: the porphyry bathtub which stood in the sixteenth century before the Pan-theon. This shape had been adopted for sarcophagi since the second half of the fifteenth century (cf. A. Rossellino, tomb of Cardinal Jacob of Portugal, Florence, San Miniato al Monte; and A. Rossellino and B. da Majano, tomb of Cardinal Piccolomini, Naples, Monte Oliveto). Michelangelo, however, gave an angular form to the rounded body of the sarcophagus. He also changed the form of the legs a little, harmonizing them with the body of the sarcophagus by means of a new articulation. Completely new are the forms of the sarcophagus covers, composed of two volutes, or rather of a broken seg-ment. This new element is of significance for the interpretation of the content (see be-low).

This architecture is not set before the wall, but seems to penetrate the space, giving rise to a dynamic conflict, the white marble architecture pressing dynamically against the *pietra serena* frame. The conflict between white marble architecture and *pietra serena* frame, however, is held in check by the motionless, cool, and noble quietness of the latter. In the total effect there is nothing of Baroque flowing movement.

The central bay of the entrance wall was left unfinished. Two original project draw-ings exist (Nos. 58 and 59), which will be mentioned later. Now it is important only to observe that Michelangelo wanted to put on this wall, together with the double tomb of the Magnifici, the Virgin and the two patron saints of the Medici family. The altar was erected on the opposite side.

The new sacristy was conceived not only as a burial chapel, but also as a room where masses were to be said for the souls of the buried. Consequently it was important to erect an altar. Traditionally, part of the altar was a sacred image, with the Virgin and the pa-tron saints of the family. Here, however, the sacred image is lacking. The altar has the form of a mensa, and the celebrating priest stood behind it, facing into the Chapel, ac-cording to the early Christian tradition. It was perhaps the wish of the Pope and Car-dinal that the altar be like the one in the old St. Peter's Basilica. The sacred image had to be erected on the opposite wall, which was at the same time reserved for the tombs

[31]

of the Magnifici. By this arrangement a unity of point of view for all the statues was attained. Only the point behind the altar (i.e. outside the room of the Chapel) gives a unified view of the monuments (IV, 5). The two Dukes on the lateral monuments, like the priest behind the altar, look toward the Virgin.

The project of the mensa apparently goes back to Michelangelo. Originally it was differently planned. Three rapid sketches (Nos. 82 and 83), which have until now been considered as projects for the dome of Santa Maria del Fiore (von Geymüller) or as projects for the drum of the Medici Chapel (Frey), seem to be in reality projects for the altar. The dating of the sketches in April 1520 is assured by a fragment of a letter by Michelangelo on one of them. This is a simple mensa, enclosed by little columns, with a square field in the middle, and oblong lateral fields. In the square there is an enclosed circle. The lateral pilasters in the executed altar are not unlike the columns of the drawings, but there is a noteworthy innovation in the fact that between the pilasters and the central field there are inverted balusters. They symbolize the elastic forces which seem to be subjugated by the crystalline forms which surround them. The structure becomes again a symbol of the typical conflict in Michelangelo between force and mass.

The candelabra above the pilasters were also made according to Michelangelo's design. The one on the left side was destroyed during the eighteenth century and replaced by a copy. Fortunately there is in the Uffizi a drawing probably by Dosio, made from the altar, in which the original of this candelabrum is visible. It is decorated by a mask, not by birds as in the copy (IV, 6, 7).

As stated above, the place of the priest behind the mensa is the only spot from which the whole spatial composition can be perceived. This space seems not to have been built for men; it is an autonomous sphere whose real inhabitants are the statues. The ordinary man is a stranger in it. Only when he leaves it, and looks into it from the "outside" (i.e. from behind the mensa), does it reveal its unity to the beholder. This "transcendental" viewpoint is the presupposition also of some other works of Michelangelo, as for example the Capitol, which reveals its unity only from the stairway of the Senatorial Palace. The architecturally formed space is here conceived as an ideal precinct, independent of the world of contingency.

The lighting has great importance for the effect of this space. Michelangelo modeled the light of the Chapel, so to speak. It is noteworthy, above all, that the light streams down from the very top, from the lantern, the four lunette windows, and from the two northern and two western windows of the middle zone (the other windows of which are blind). The choir is windowless. The lighting creates, in the first place, the effect of a deep crypt, into which the light slants down from far above. Secondly, it creates in the lower zone a harmonious blending of light and shade into a half-tone, without black shadows. It is a diffused, equal, and soft gleam, which gently envelops the forms, and at the same time reveals the richness of their modeling. The only exceptions are the cornices, under which black shadows gather. This diffuse silvery light is an unreal light, which helps to transport the beholder from the everyday world into an ideal cosmos (IV, 9).

[32]

V. PROJECTS FOR THE TOMBS

IN attempting to establish the sequence of the project drawings for the tombs, in order to determine the course of development of Michelangelo's artistic idea, two facts must be borne in mind: first, that the material is only fragmentarily preserved and that, as a consequence of the gaps, the development may sometimes seem rather abrupt, when in truth it was probably not so; secondly, that the artist was dealing with several ideas at the same time and that he often anticipated later ideas in earlier sheets. The sequence of development which we seek to reconstruct here does not necessarily coincide with the chronological order of the drawings. Nevertheless a sequence can be set up which in its essential features makes clear the inner evolution of the artistic idea, and which above all makes comprehensible the manner in which Michelangelo arrived at his definitive solution.

It is known from a letter of November 28, 1520, written by Cardinal Giulio to Michelangelo (published in Frey, *Briefe*, p. 161), that the latter had—characteristically for a sculptor—originally planned for a tomb to be placed in the center of the Chapel. Indeed there still exist a series of sketches of isolated free-standing tombs made by Michelangelo. But until recently the criteria were lacking to enable us to establish which of them should be considered as projects for the Medici tombs and which for other sepulchral monuments (v, 1). This problem can be clarified by three letters of Domenico Buoninsegni, who served as negotiator between Cardinal Giulio and Michelangelo, which complete the one just mentioned and which were unknown to the earlier authors (v, 2). From these it appears that Michelangelo was occupied with the project of the free-standing tomb for about one month (from November 23 until after December 28, 1520), and therefore did not abandon the idea of a free tomb immediately after having received the letter of November 28, as had been supposed. In the letters are mentioned three different projects for free-standing tombs, proposed by Cardinal Giulio: a tomb four braccia long on each side, a more monumental tomb six braccia long on each side, and finally a tomb in the form of a Janus Arch, an *arcus quadrifrons*.

In the letter of November 28, 1520 (Frey, *Briefe*, p. 161), Cardinal Giulio acknowledged receipt of the drawing for the free-standing tomb, sent to him by Michelangelo. He praised the idea of putting the four tombs (i.e. of the two Magnifici, Lorenzo and Giuliano, and of the two Dukes, Lorenzo the Younger, Duke of Urbino, and Giuliano the Younger, Duke of Nemours) in the center of the Chapel and agreed that the sarcophagi should be three braccia long. But he could not imagine how in a tomb four braccia long both the sarcophagi and the ornamentation could be placed "et poi avanzare 8 braccia per ogni verso della cappella" (v, 3).

On December 14, 1520, Buoninsegni wrote to Michelangelo: "I have spoken with the Cardinal about your plan to place the tombs in the center of the Chapel and he is pleased with this idea. But he doubts that the space of the Chapel will be filled, for he thinks that four braccia of length would not be enough. I have told him that even if the

tombs were six braccia, there would be still seven braccia left on each side to go around. He tells me to ask you to send him a little sketch of only one of those four faces, made to show how you intend them to be, if they are placed in the center. He also says whether you want to place them in the center, as you say, or on the walls of the Chapel, he leaves it to you and says that you should decide the way which seems the best to you" (Appendix). On December 17, 1520, Buoninsegni repeated his request (Appendix).

On December 28, 1520, Buoninsegni replied to Michelangelo (who on December 21 had sent the plan for the enlarged free-standing tomb) that the Cardinal "now doubts if there would be enough space left around the tomb. And that is why he suggested that in the whole structure of the tomb an arch could be hollowed out in the center. Each side of the tomb should have an arch, the passages of which would intersect in the center, so that one could walk under the archways. And the Cardinal planned to have his own grave on the floor in the center, and the other tombs, it seems to him, should be located above the mentioned arches. Nevertheless, he says you know better than he does, and he leaves it to you" (Appendix).

These letters of Buoninsegni are important because they make it possible to choose from among the preserved drawings those plans which were designed for the free-standing tomb of the Medici Chapel, and offer at the same time some new criteria to determine the stages of the development of the artist's idea. Moreover, it is revealed in these letters that at the same time that Michelangelo was planning for the free-standing tomb, the Cardinal suggested wall tombs. Therefore these two ideas occupied Michelangelo almost simultaneously. Finally, one learns from the third letter that the Cardinal wanted to have his tomb also in the Chapel.

Yet there remain difficulties in determining which drawing refers to which project. First of all, Michelangelo's drawings are free hand, so that the measurements are only approximate. Secondly, it is not known what was the proposed ratio between the length of the sarcophagus and the length of the entire monument when the monument was enlarged to six braccia. Since the sarcophagi which exist today are somewhat more than four braccia (ca. 2.48m.), it is clear that there was a change in the proportions. Finally, it is difficult to determine which part of the sarcophagi should be measured to determine the length.

81 One of the extant sketches (No. 51) may be associated with the first project for the free-standing tomb because in it the proportional relationship of three to four between the length of the sarcophagus and that of the tomb corresponds approximately to the proportions mentioned in the letter of November 28 (quoted above). Here the structure of the tomb and the form of the sarcophagus with its flat cover are further from their definitive form than in all other preserved sketches. Consequently, Popp's opinion that this drawing should be considered related to the first project for the isolated tomb seems to be correct. However, it seems not to be actually the first project itself, as will be shown later.

The structure of this monument (No. 51), which does not have a traditional derivation, may be better understood if one imagines it to be located in its proper place in the center of the Sagrestia Nuova. The project is nothing but a transferring of the wall division to the plastic mass of the monument, which reflects on its four sides the division of the walls and the proportions of their three fields, and in its pediment the arch of the central field. There is no doubt that Michelangelo planned a tripartite division of the walls from the beginning, since the prototype of his Chapel was, as stated above, the Sagrestia Vecchia where the choir wall is similarly divided. Moreover, the early ground plan in the Archivio Buonarroti also shows the tripartite division. In the fifteenth cen- 79 tury when a free-standing monument was located in the interior (e.g. the sarcophagus of Giovanni d'Averardo de' Medici in the Sagrestia Vecchia, or the Santo Sepolcro by Alberti in San Pancrazio in Florence), these monuments had no direct relationship with the architecture of the interior. With Michelangelo the structure of the monument for the first time reflects its surroundings. It belongs to its environment, as vegetation belongs to the soil in which it grows. His composition is chiefly characterized by an upward movement in the central field (which is notably higher than the lateral fields) and a downward movement in the lateral fields, emphasized by the poses of the two mourning statues. The forms are delicate, the profiles tender, and the whole structure seems to hover, since the base is concealed by the *cassone*. The project, altogether only four braccia wide, was evidently very small. It had a somewhat playful quality, and the Cardinal was therefore understandably dissatisfied.

In the projects for the free-standing tomb which followed, Michelangelo departed from this original conception, led by his and the Cardinal's desire to monumentalize the tomb. To the second monumentalized project of the isolated tomb, the length of which was enlarged to six braccia, two groups of sketches seem to correspond: one in which the length of the sarcophagus is in proportion to the whole length as four to six; in other words, the sarcophagus is enlarged one braccio, or to approximately the measurements of the executed sarcophagus (ca. 2.48m.). To this version belongs sketch No. 54. Even though the structure of the whole is closely related with the first project 85 (three distinct zones, one above the other, with the third zone vertically divided into three fields), the proportional relationship between the length of the sarcophagus and the tomb is four to six. Whereas in the first project (No. 51) the three zones are strongly 81 separated and are connected only through the mourning youths in the lateral fields, there is in the enlarged project a stronger tendency to unite the zones. Instead of the horizontal cover of the sarcophagus there now appears a split segment which rises in a gentle curve and connects the lowest zone with the intermediate zone. In the center (above the empty space) there now appears a tondo which connects the intermediate zone with the upper. In this case there is no doubt that the plan is for a free monument, since the side views of the sarcophagi at the right and left are visible.

It is difficult to determine the place of No. 56, right upper sketch, in these projects. 86

[35]

The ratio of the length of the sarcophagus and of the monument is three to four, a fact which would indicate an early date, around the time of No. 51. But the structure of the monument with the omission of the intermediate zone, and the form of the sarcophagus lid consisting of two C-shaped volutes, in the center of which is a tondo, would indicate a later stage, of the time of the monumentalized project, No. 54. This contradiction may be explained by the fact that the drawing shows two versions, one above the other. Michelangelo drew first a sarcophagus of the early type with a horizontal lid. At that time an intermediate zone existed above the sarcophagus. Later, possibly about the time of No. 54, he transformed the sarcophagus, omitting the intermediate zone.

The second group of sketches for the monumentalized tomb consists of projects in which the sarcophagus seems to have the original length of only three braccia in relationship to the whole length of six braccia. A transitional sketch, in which Michelangelo seems to have found the new form of the sarcophagus, although the proportions are not yet three to six, is No. 53. Here an earlier version of the sarcophagus appears again, with a flat lid which Michelangelo later changed by doubling the height, so that the lid touches the bottom of the upper zone. The width rather than the length seems to be presented to the spectator. The sarcophagus has the architectonic function of connecting by its plastic mass the lowest and the highest zones of the monument, while the intermediate zone—originally planned—disappears. Again the sarcophagus has a split segment lid and a tondo in the center (as in No. 54), and perhaps for the first time allegorical figures appear on the lid, in the poses of the Notte and Giorno. The successive phases of the development of this idea can be followed in sketch No. 56, lower left—where the mourning figures are seated at the sides of the sarcophagus in poses resembling the Ignudi of the Sistine Ceiling; in the ground plan, probably related to this sketch, on the same sheet; and in No. 55, lower left. In these sketches the sarcophagus and the architectonic background are intimately united: the ensemble forms a body which with the double columns incloses the gigantic, rather vertical mass of the sarcophagus.

In No. 56, lower left, it is not clear whether Michelangelo projected an isolated monument or a wall tomb with three sides. The ground plan at the right of the sketch, where the four sarcophagi are clearly visible, would favor the first hypothesis; but the fact that although there are mourning youths at the sides of the monument, the sarcophagi themselves are not visible, speaks in favor of the second hypothesis. Moreover, behind these lateral youths there are apparently flat backgrounds crowned by volutes and obviously applied to the wall. If this latter hypothesis is correct, we should suppose that the one sarcophagus was intended for two members of the family.

To the project of the tomb of the *arcus quadrifrons*, various drawings are related, among which the most complete is No. 56, center (v, 4). The arch is shown flanked by large pillars and surmounted by a grandiose attica, made up of a large field in the center decorated by a tondo, double columns on both sides, and a strongly projecting cornice above. In this sketch, hastily done, the tomb of the Cardinal below the arch, as it is men-

[36]

tioned in the letter of December 28, 1520, cannot be clearly recognized. However, a sarcophagus can be seen quite clearly in two sketches of details of the same *concetto* (No. 55, center right and upper right, the latter being upside down). The tombs of the Dukes and the Magnifici, which were to be placed above the arches, are only lightly sketched with a few lines in the drawing; they are more clearly visible in other sketches where the form of the sarcophagus can be recognized: No. 54, left; No. 53, lower center and upper right (v, 5).

84

85, 83

As indicated by the quoted letters, Michelangelo occupied himself simultaneously with the idea of the free-standing monument and the types of wall monument. The latter are only derivations and adaptations of the three types of free-standing monuments which have already been treated. It is only by this derivation that the origin of their structure can be explained, for it is essentially different from the traditional Florentine wall tombs in the form of niches. The arched framework forming a niche and enclosing the figures and sarcophagi of the Quattrocento tombs is always lacking in Michelangelo's wall tombs. On the contrary, he uses the motifs of his projects for free-standing tombs (sarcophagi before the bases of the monuments, small niches with tabernacles, double pilasters, entablature, and attica) and makes these wall tombs similar to high reliefs. Moreover, in Michelangelo's wall tomb projects, the figures and sarcophagi are in a new relationship to the architectural structure. The architecture of the tomb is not merely a frame for the figures, each of which belongs in its own niche (Quattrocento), but an autonomous plastic mass filled, like the figures, with its own forces and tensions.

The first preserved project of a wall tomb for the Medici Chapel is No. 52; it was developed from the earliest of the free tomb projects (No. 51). The lightly sketched forms of the latter are strengthened by more powerful profiles. Michelangelo slightly modified the upper zone by raising the lateral parts to the same height as the central part. But the similarity of all the essential parts is easily recognized: the basis which serves as a background for the sarcophagus, the intermediate zone with its rectangular field (perhaps planned for an epitaph) framed by two nude mourning youths, and finally the upper zone divided into three parts, the large central niche of which is surmounted by a heavy segment.

82

81

It should be noted that Michelangelo originally drew the left sarcophagus, with a lower niche, crowned by a triangular pediment above. This project seems to have been intended to fill out the lateral fields according to the Archivio Buonarroti ground plan (v, 6). Michelangelo then made the right half of the drawing, forming a double tomb, to be placed in the central field of the side walls instead of the lateral fields. He then repeated in the left half the upper zone of the right half with the crowning segment in order to unify the whole. Another project for a double tomb may be seen on No. 51, upside down, where the lids of the sarcophagi are triangular (v, 7).

79

81

89 The last preserved project for the wall tombs (No. 57), the one most like the com-
pleted work, is developed from Michelangelo's idea of the enlarged free tomb (cf. the
83 form of the sarcophagus and the outstretched figures in No. 53) and includes also the
89 motif of the twin pilasters of the third free tomb project. Here Michelangelo decided to
place a single sarcophagus in the middle of the lateral walls, but seems nevertheless to
have been still thinking of a double tomb (v, 8). The seated figure which flanks the
sarcophagus at the left seems to be a portrait statue of the deceased. To balance this
figure on the other side one must suppose, as Berenson did, that another seated figure
was planned. Thus this plan, although it shows only one sarcophagus, seems to have
been intended still for the double tombs of the Capitani. The fact that the Capitani are
located in the lowest zone with the allegories of the times of day and the river gods, fa-
vors the hypothesis that these seated figures were portraits of the empirical personalities
of the deceased, and not yet images of their souls. That their souls attain immortality
is emphasized by the two empty thrones in the attica (v, 9) and by the trophies in the
center. The introduction of twin pilasters to frame the middle field and of a majestic
attica enlivens the whole façade with a powerful dynamism which englobes the figures.
From the heavy base surge forces which rise along the twin pilasters through every ob-
stacle—inert and heavy figures on the curved lid of the sarcophagus and the heavy hori-
zontals of the entablature—to terminate at the top in the agitated form of trophies and
the richly sculptured thrones of the attica. This project is a grandiose unity animated
by inherent forces which no exterior obstacle seems able to limit. The basic independ-
ence of this conception, where Michelangelo gave free rein to his inspiration, explains
why it could never be realized when the real frame—i.e. the central bay of the lateral
walls of the Chapel (v, 10)—had to be taken into account.

8,9 In the course of the execution, then, the artist had to modify the project by subordi-
nating it to the given architectural field, which he could do only by reducing the length
and the height of his monument. He had to reduce the central niche to the width of the
lateral niches, and to decrease the attica by about half of its height. Michelangelo en-
dowed this architecture with a new dynamic significance: instead of the liberated forces
89 soaring (No. 57), they are now imprisoned on all sides by the *pietra serena* system. The
conflict, so typical of Michelangelo, between the immanent *élan* toward freedom and
the harsh yoke imposed on this *élan* by exterior limits dominates the conception of the
tomb here. The architecture of the tomb is no longer an isolated monument placed
against a wall but forms an integral part of the articulation of the whole edifice.
 The tomb architecture is given an affinity to the figures, but at the same time it is an
effective contrast to them. In consequence of its hard and sharp forms, its straight hori-
zontal and vertical lines, which are emphasized even more by the metallic sharpness of
the profiles, it accentuates the animation of the statues. In the motionless, rigid frame-
work of this architecture even the slightest organic life would have a heightened effect
(v, 11).

[38]

What is new in Michelangelo's conception is the fact that the monument and the figures are treated as if they were modeled from a single plastic mass. It had been traditional to treat architecture and figures separately (e.g. A. Sansovino, tomb of Cardinal Ascanio Sforza, Rome, Santa Maria del Popolo). The architecture with its niches formed a frame and background in which isolated figures were located. There is no interference between the two. With Michelangelo the tomb architecture is a mass with emphasized projections and recesses, animated by its inner forces, and the figures seem incarnations of the vital energies potentially present in this mass itself. He drew from an imaginary block of marble the artistic forms latent within it. In his conception, the whole monument was an enormous monolith, the original size of which can be seen on the low marble base. He penetrated into this imaginary block by successive parallel layers corresponding to the actual structure of stone. From this point of view it is significant that even the niches are not round but flat. The conception of the monument as a high relief modeled from one imaginary block explains the visual unity of the whole, in spite of the interference between architecture and figures.

The conception of the decoration of the entrance wall, opposite the altar, with the Magnifici tombs, can be reconstructed approximately on the basis of two rapid sketches in ink, on the same sheet, recto and verso (Nos. 58 and 59). The idea of these sketches, *90,91* with the three zones, one above the other, was developed from the earliest free-standing project (No. 51) and the double tomb project (No. 52). But these sketches were not in- *81,82* tended for the lateral walls, as is No. 52. The difference in the conception consists in the fact that whereas in the lateral walls the center was emphasized by a pillar which served as base for a standing figure, on the wall facing the altar Michelangelo placed in the center a large tabernacle niche, obviously destined for the Virgin. The drawings have a much more majestic effect than the project for the double tomb. On a low marble *90* postament stand the two sarcophagi of Lorenzo il Magnifico and Giuliano. They have curious forms. They look almost like boats which terminate in volutes, and between the volutes the convex lids are stretched. Above these is a tripartite intermediate zone, in the center of which is a seated figure with outstretched arms (barely hinted at by means of a few strokes) representing, as the inscription explains, Fame, and holding two epitaphs in the lateral fields, which are framed by festoons. The upper zone is also tripartite. In the central field is an enormous niche framed by columns and crowned by a segment pediment with broken architrave. It is already almost exactly the segment pediment of the executed tabernacles of the lateral fields. In the center on a low base is a seated figure, obviously the Virgin. At the right and left are niches, one on each side, again framed, apparently, by columns, with round medallions at their tops. In the niches are lightly sketched standing figures, probably the patron saints of the family. In comparison with Nos. 51 and 52, from which this sketch was developed, the effect is much more monumental: the lateral fields have been enlarged and raised to the archi-

[39]

trave at the top, increasing thereby the vertical movement of the central niche, whereas in Nos. 51 and 52 the mourning youths gave the lateral fields a downward movement.

91 Sketch No. 59, on the verso, seems to be the first draft of this conception. Here the central niche is crowned by a segment pediment which originally did not have the broken architrave (only in a *pentimento* did Michelangelo attempt to change it), and must be consequently considered as the earlier phase of the idea. Also the fact that the figure in the niche is here standing favors this dating. Yet it seems that after having fin-
90, 91 ished No. 58, Michelangelo corrected No. 59 by inserting a column at the left side of the middle niche, a column which rises from the first zone through the intermediate zone up to the tabernacle niche. In other words, he tried to lower this niche and to suppress the intermediate zone, which is definitely a later phase. Probably at the same time he sketched the two seated figures above the sarcophagi—the figures of the patron saints (v, 12).

219, 220, 221 Several free copies of the Magnifici tombs are preserved (Louvre, Éc. d. Beaux-Arts, Munich, Oxford, Albertina); there is in Christ Church College, Oxford, an unpublished
218 drawing (DD 27) which corresponds in structure to these copies, but which does not yet contain statues. These are all free paraphrases of Michelangelo's idea and cannot be used directly for the reconstruction of the entrance wall. They show, however, that the intermediate zone was finally suppressed on these wall tombs (v, 13).

 The described development is typical of Michelangelo's manner of creation. Starting
79 with a traditional scheme, he was compelled by an inner urge to unfold completely all the inherent possibilities. Only after arriving at the limit of this traditional solution did he impart a new spiritual content, transforming all the existing elements. This was the development of the Sistine Ceiling, which he first planned to execute as a simple deco-rative system according to tradition and later transformed into a ὑπερουράνιος τόπος; and of the Last Judgment, which he first conceived as a representation of the act of judgment only to transform it into a revelation of cosmic fate. He always conceived his ideas on the basis of Renaissance conceptions but, not content with this solution, was in each case again and again impelled to recreate his works according to his new idea.

 There are a few original drawings by Michelangelo for several parts of the architec-
107 ture of the Chapel. There is a drawing (No. 76) of the profile of the base of the columns of the Magnifici tombs. The inscription, "el modano delle colonne della sepultura dop-pia di Sagrestia," is a testimony that in this monument columns rather than pilasters were planned.
104 No. 72, right center, shows a study in red chalk probably for the bases of the double
105 pilasters of the executed tombs. The other studies on this sheet, as well as on No. 73, were made at the same time, but seem not to have been used by Michelangelo in the execution. These are splendid red-chalk sketches, in which the individual parts of the bases show in a completely new manner the effect of the weight of the pilasters which

they bear. Hard and soft members alternate. The convex members seem to be conceived as elastic cushions which sink down under the weight of the hard concave members, rich in tension. The total form depends upon the opposing forces of pressure and resistance. In one of the drawings (No. 72, bottom right) the very original profile has been given *104* the appearance of a human face.

No. 81 is a red-chalk drawing for the attica of the monuments of the Dukes. The *108* thrones above the double pilasters, and the central part of the attica with crouching figures barely sketched, can be recognized. This sketch is obviously later than No. 57, *89* where the backs of the thrones and the attica are much higher. Here the attica is already reduced and the trophies suppressed. The backs of the thrones also are reduced, but in the execution they are suppressed completely. It is noteworthy that the crouching youths are no longer situated in the lateral fields of the attica, but are transferred to the central field.

The pen sketches of capitals on No. 75 seem to be not by the hand of Michelangelo. *106* According to Popp (*Med.Kap.*, p. 129), who considers these sketches as originals, the one at the bottom right is a project for the capital of the Magnifici tomb (cf. copies), that at the left top for the *pietra serena* system.

Drawing No. 93 seems to be related to the frieze of masks just above the sarcophagi. *134* This frieze was executed by Silvio Cosini and Francesco da Sangallo (cf. Milanesi, p. 596, and Vasari 1568, p. 333).

The drawings on No. 91, top, are related to the masks on the capitals of the double *135* pilasters above the Giorno (Popp, *Med.Kap.*, p. 156). The sketches seem at first glance *191* to be caricatures, but they are distinguished from the caricatures of the Renaissance by the fact that they do not pointedly reproduce the abnormalities of real physiognomies; that is, they are not interpretations of real faces (Leonardo), but embody particular psychic conditions of man: panic terror in the listening one at the top left, malicious joy in the one at the top right, and pessimistic skepticism in the one at the bottom. The executed masks on the capital above the Giorno lack the vitality and the profound psychic characterization of Michelangelo's sketches.

Cosini's frieze is an egg-and-dart frieze in which the eggs are replaced by masks. The *196-200* frieze makes a ghostly impression; the masks seem to laugh scornfully. It is scorn of the fear of death on the part of mortals. A poem by Michelangelo which suggests this interpretation will be quoted in connection with the interpretation of the content.

VI. THE COMPOSITION OF THE STATUES

A STYLISTIC analysis must consider first of all that the motifs of the movements of the figures were determined from the first according to a unified project, in which the statues of the tombs were already placed in a corresponding contrast: on one hand, a harmonious adaptation of the figures to the cover of the sarcophagus (Aurora and Crepuscolo, cf. Nos. 52 and 57); on the other, a contrast between the curves of the statues and that of the sarcophagus (Notte and Giorno, cf. No. 53). These motifs, which up to now were thought to belong to two different stylistic periods, can, as has just been stated, be seen already in the drawings of 1520; therefore the possibility of a change in the project for the motifs of the figures in the winter of 1525-1526 (Popp) must be excluded.

The idea of outstretched figures on the sarcophagi reverts to antiquity, and was known through the Middle Ages and the Renaissance. In the Middle Ages and the Renaissance, however, the figures of the dead were stretched out horizontally, symmetrically disposed, with legs parallel, on the horizontal lid of the sarcophagus. The principal view of such figures, being of the side and of the body in its narrowest aspect, was unsatisfactory—and this the Quattrocento artists sought to remedy. They turned the head of the deceased toward the spectator (Donatello). They attempted to reduce the emphasis on the horizontal position of the body by curving the shroud (Antonio Rossellino). Sometimes they even elevated the inner side of the lid of the sarcophagus, so as to turn the figure diagonally towards the spectator (Desiderio da Settignano), but they retained the immobile horizontal position of the figure.

Andrea Sansovino was probably the first to break with this tradition; he went directly back to the reclining figures of antiquity (Ariadne, Vatican). The figure is asleep, or resting; it leans on one arm. The body is turned toward the spectator, and the legs are bent. The outline of the figure has become more animated. At the same time it has received a plastic *rilievo*. The difficulty remained, however, of connecting this half-upright figure with the flat, horizontal lid.

At this point Michelangelo started his work. He projected (in No. 52) figures in half-upright positions, supported on the elbow (in contrast with Sansovino's figure, however, the head does not rest on the arm, but falls forward on the breast). He solved in a sovereign manner the problem of the horizontal supporting surface by placing two concave volutes over the lid of the sarcophagus. These form a sort of couch, and with their double wave movement accompany the rhythm of the body.

However, he was apparently still not satisfied and concentrated even more intensively on ancient models. On No. 52, upside down, he sketched a figure on a convex lid, a motif clearly inspired by the river gods of the Septimius Severus Arch. In the ancient arch the figures recline on a curved surface, which may have suggested to Michelangelo the use here of convex volutes. He had already used the motif of the river

god of the Septimius Severus Arch twice, with variations, in the Sistine Ceiling: in one of the pairs of bronze-colored nudes (cf. Vol. II, Figs. 206-207), a motif he used again almost exactly in No. 57; and in one of the lunette figures (cf. Vol. II, Fig. 161), which in its pose anticipates the Crepuscolo motif in the sketch on No. 52. *216* *89, 244*

The motif of the Notte also goes directly back to antiquity—that is, to a Leda sarcophagus (Robert II, 3, 4, 6) or an ancient gem, which also served Michelangelo as a model for his Leda composition of 1529-1530. He had already used the motif of the bent leg of the ancient Leda in one of the bronze nudes of the Sistine Ceiling (cf. Vol. II, Fig. 218), and it is found in the sketch of the free-standing tomb in No. 53. The torsion of the upper body of the same bronze nudes of the Sistine Ceiling appears in the Giorno (the motif reverts to the Child of the Virgin of the Stairs). It seems to be beyond doubt, therefore, that Michelangelo's new formulation of the problem of the reclining figures was carried out with direct reference to ancient models. *251* *250* *249* *83* *253* *254*

The seated figures of the fifteenth century are represented in attitudes of rest. In his, Michelangelo sought to express potential movement by introducing contrapposto. He developed two main types of seated figure: the type with crossed legs (e.g. Isaiah, Sistine Ceiling; Lorenzo de' Medici), and the type in which one leg is planted vertically and the other drawn back (e.g. probably the bronze statue of Julius II, Bologna; Ezekiel, Sistine Ceiling; Moses of the Julius Tomb; Giuliano de' Medici) (VI, 3). The two seated figures of the Medici Chapel are representative of the two basic types, and the way for them had long been prepared in Michelangelo's work. *255* *256* *257, 258, 259*

The motif of the Virgin with the Child is also prepared by figures of the Sistine Ceiling. The seated posture with the crossed knees comes from the Erythraean Sibyl; the pose of the upper body, inclined somewhat forward, with the hand leaning on the seat, is anticipated in the Ignudi of the Sistine Ceiling above the Prophet Joel; the pose of the Child, finally, is almost exactly taken over from the Christ Child in the Jacob-Joseph lunette of the Ceiling. *261* *262*

The two figures on each of the sarcophagi form counterparts (VI, 2). The outlines correspond to each other, but are inverted. Within the symmetrically corresponding entire form, there appear asymmetrical contrasts (which in No. 52, No. 57, and in the bronze nudes of the Ceiling, were lacking). Even the fact that in each case one figure is masculine and the other feminine serves to create contrast. Moreover, the pair of counterparts on one tomb contrast with the pair on the other tomb. The relationship of the Aurora and the Crepuscolo to the sarcophagus lid is different from that of the Notte and the Giorno. Aurora and Crepuscolo have a total silhouette which can be compared to an S-shaped volute, of which the lower curve clings to the segment lid. Notte and Giorno have a silhouette forming a C-shaped volute, so that their curves contrast with the curves of the sarcophagus lid (VI, 6). *8, 9* *82, 89*

[43]

9 Aurora and Crepuscolo correspond in mirror image symmetrically: the outstretched leg, the supporting arm, and the lowered head are alike in each case. The two upper limbs, on the contrary, are dissimilar. The updrawn left leg and the bent left arm of the Aurora suggest an upward movement. The tired right arm of the Crepuscolo, resting on his upper thigh, and his bent right leg suggest a downward movement. It is a curve which leads from right to left; but both figures seem to bear down with the full weight of their body on the sarcophagus.

8 In Giorno and Notte there is also a general correspondence in the double torsion of the bodies. In one figure the lower part of the body is turned outward and the upper part inward, while in the other figure it is the reverse. However, not one of the individual members corresponds symmetrically to its counterpart in the other figure. The torsion of the body of Giorno toward the wall, and the opposite torsion of the body of Notte toward the spectator, together create the effect of a rotatory movement (VI, 1). Although the masses of their bodies are increased as compared to Aurora and Crepuscolo, their weight does not seem to bear directly on the sarcophagus but rather to hover above it. The "uncomfortable position" of these figures has often been criticized on the alleged ground that they seem to be slipping off the sarcophagus. However, if one considers the figures as artistic patterns, there appears to be in their position an inevitable necessity. One figure presupposes the other by symmetrical correspondence, and they are bound to each other as a pair. They hold each other in equilibrium.

Aurora and Crepuscolo are composed like high reliefs. There seems to be an invisible disc behind the two figures. Giorno and Notte, in consequence of their spiral structure, are more spatial; but at the same time they are confined somewhat in the manner of a relief, by reason of their closed outlines. This compositional principle of symmetrical correspondence of the whole, together with asymmetrical contrasts in details, had already been developed in the Tomb of Julius II (Slaves) and in the Sistine Ceiling (Ignudi). The only new addition here is that the counterparts are crowned by a third figure. This crowning seated figure is located in a different plane, behind the others; it is constructed with delicate forms, and seems to hover above the other figures. At the same time it is inseparable from them, for it is a synthesis of their contrasts. The downward flowing movement from right to left of the Aurora and Crepuscolo is epitomized in Lorenzo's sinking back and in his turning to the left; and the rotatory movement from Notte to Giorno finds its synthesis in the erect torsion of Giuliano to the right.

The form and proportions of the figures of the Medici Chapel show new characteristics in comparison to Michelangelo's earlier works. The powerful bodies terminate in delicate hands and feet and in small heads. Earlier, Michelangelo had made head, hands, and feet large, with the torso somewhat smaller (Marble David, Moses). The tendency to slimness, the sharp termination of the forms, the transformation of the circular forms into ovals, is particularly conspicuous in the figures of Giuliano and the

Virgin. Another characteristic is the fact that every figure in the Medici Chapel has a curved axis, around which, for the most part, they move spirally, in contrast to the early figures which were constructed centrifugally on a vertical axis. It is informative from this point of view to compare the Moses with the Giuliano, or the Virgin of Bruges 258, 259 with that of the Medici (VI, 4). 49

The treatment of the surfaces also shows a significant transformation. It becomes more synthetic; the mass is treated as a soft substance, the individual muscles seem to flow into each other. The sharp and rich articulation of the earlier works is avoided.

On the whole, it can be said that whereas previously Michelangelo's forms derived tension from an internal force which at the same time remained imprisoned within them, the figures are now like vehicles through which a force passes, coming from without and again going outward. This is a change of artistic conception: the mature Michelangelo no longer sees the single body as an individual center of force, but he conceives of the universal, cosmic life-force, which uses the individual body as its instrument. The individual body shares in the universal life. Thus the Promethean creator of individual vital organisms becomes the seer of universal forces and laws.

The change from broad to slender proportions is analogous to the form-ideal of the contemporary Mannerists (Pontormo, Rosso, Parmigiano). It has been even asserted that in the figures made ca. 1530, there "is an unconscious concession to Mannerism" (VI, 5). To this, however, there are chronological objections, since the earliest Florentine Mannerist works conceived in slender proportions were executed about the same time as Michelangelo's figures (ca. 1525-1530). The change of style may with more probability be explained by the fact that Michelangelo, having returned to Florence, where during the second half of the Quattrocento a preference for delicate and slender forms prevailed, performed his works in the Florentine idiom (cf. also the *pietra serena* architecture). This is all the more probable in view of the fact that when Michelangelo returned in 1534 from Florence to Rome, the broad proportions suddenly reappear in his work (cf. the figures of the Last Judgment). The verticalism, the slenderness of proportions, and the spiritualizing tendency, return once more in Michelangelo's last works, e.g. the Pietà's in Florence and in the Palazzo Rondanini, but here he renounces the beauty of the treatment of surfaces and the elegance of the proportions, the curves and ovals of the Medici period, in order to concentrate exclusively on the expressive value of the forms.

It is not possible to reconstruct the course of Michelangelo's work on the statues on the basis of the drawings, since only a very few studies are preserved (the numerous studies ascribed to Michelangelo are almost without exception merely copies). It must be assumed that Michelangelo at first made rapid sketches of the entire motif. Such are preserved for Crepuscolo—No. 52, upside down; for Notte—Nos. 53 and 94; and for the 82, 83, 129 Virgin—No. 88. On this sheet there are two sketches in pen, one showing the Virgin in 128

frontal view, which was developed from the Virgin of the Julius Tomb in 1513 (cf. Beckerath drawing). The Mother, sitting upright, looks into the distance, and seems with prophetic foresight to anticipate the catastrophe. The position of the Child's head and arms are anticipated by the Doni Virgin; but here the Child clings in fear to the Mother while looking down in terror, and with an abrupt movement attempts to free itself from the Mother's arms. In contrast with the innocent Child of the Madonnas of Michelangelo's youth, the Christ Child also has here taken on a prophetic nature. Both Mother and Child are seers of fate, but they react to it differently.

The other sketch on this sheet, obviously drawn somewhat later, shows the loving and solicitous Mother, looking down with tenderness on the Child, whose body she touches gently. Her head, inclined in profile and covered with a cloth, recalls the Virgins of Donatello and Giovanni Pisano. The pose of the Child already anticipates the last version.

Both sketches are modeled with splendid long and loose hatchings. These are mostly vertical or diagonal, and slightly curved, and constitute a sort of veil which is laid over the forms, indicating the planes of the entire plastic mass. At the same time they set it at a distance, deprive it of weight, and impart to it the character of a vision.

After the rapid sketches Michelangelo very probably executed detail studies for the separate parts of the body, of which only a study, probably for the hand of the Giuliano, 47 is preserved, in the Archivio Buonarroti (No. 99). Some idea of the lost studies can be 130 had from No. 98, a study of the left leg of the Leda, almost identical in pose with the leg of the Notte.

Not one head study is preserved. Quite probably the scarcity of drawings for the Medici Chapel is to be explained by the fact that these were the drawings which Michelangelo gave to his pupil, Antonio Mini, before the latter went to France.

After the studies and before Michelangelo started on the execution in marble, he made small, and then large models for the figures.

Already in two letters of 1520 (Appendix), a model is mentioned. This seems to be not a model for the graves, concerning the form of which the negotiations were not yet finished, but probably a small model of the architecture of the Chapel, probably with the *pietra serena* articulation.

About 1520 or 1521, Michelangelo made an offer to the Cardinal to execute large models of "terra di cimatura" (Milanesi, p. 421), which the Cardinal at the time seems not to have accepted. From April to November 1524, work was done on the clay models (Milanesi, pp. 592-595), eight of which were finished in March 1526 (Frey, *Briefe*, pp. 277ff). In the middle of the sixteenth century the large models of the river gods still stood below one of the tombs of the Chapel (cf. Doni, *I marmi*, p. 24).

A description of the technique and the material of these large models is given by Vasari (ed. Mil., I, p. 153; II, p. 110). The bony structure was first built up of wood, and

hay and tow were then wound around it. Then a mixture of clay and glue was smeared on the skeleton, and this was modeled. One of these models is preserved in a fragmentary condition in the Accademia in Florence. It is incorrectly set up; it should be sup- ported on its right arm, as various copies of the sixteenth and seventeenth century show. Doubt has been cast on the model by several scholars; it was ascribed to Ammannati, but incorrectly; not only the documents but also old bronze copies (mentioned in the Medici inventories 1553 and 1559), and paintings of the sixteenth and seventeenth century representing this model as a work of Michelangelo, testify that it is one of the models executed by the artist. In all probability this is one of the river gods for the Lorenzo tomb (more exactly, that below the Crepuscolo). On the other side there had to be a counterpart.

The earliest version of the river gods can be found on No. 52. The second version is No. 57, where the poses are those of the Adam in the Creation of Adam of the Sistine Ceiling. The model of the Accademia would be the third version. The reconstruction of the river gods of the tomb of Giuliano is possible on the basis of a working sketch made by Michelangelo for a stonecutter (No. 95) (VI, 46).

If we complete in imagination the monument of Lorenzo by adding the river gods below the Allegories, the downward movement would be continued to the bottom through these river gods. Conversely, the river gods of the Giuliano tomb prepare the upward movement of the Notte and Giorno. In each case the sarcophagus would be framed by figures forming a semicircle, above which the seated figure would hover. This composition can be seen in a schematic sketch, representing the marble blocks of the tomb of Lorenzo. The sketch, which had not been mentioned up to now in the literature and will be reproduced in Vol. IV, is on the verso of a letter addressed to Michelangelo by Piero da Pistoia, called Pietro Urbano, *garzone* of Michelangelo. It is dated March 31, 1525 (Archivio Buonarroti, Cod. x, fol. 627 verso).

The margin notes read: *61-64*, *269*, *265, 266* (top paragraph); *82*, *89*, *131* (second paragraph).

[47]

VII. PROJECTS FOR PAINTINGS IN THE MEDICI CHAPEL

ALREADY in September 1526, a plan to decorate the cupola of the Chapel with paintings by Giovanni da Udine was considered. These paintings were executed by him in 1532 and 1533. They represented "bellissimi fogliami, rosoni ed altri ornamenti di stucco e d'oro" in the coffers, and on the ribs "fogliami, uccelli, maschere e figure"— all probably symbols of eternity and happiness beyond the grave. The decoration, however, when executed, disappointed the Pope because of its paleness. Later—in 1556— Vasari ordered it to be covered with whitewash (VII, 1).

Besides this decoration of the cupola, there were planned large histories ("storie grande da una banda," 1531), probably to fill the choir walls and perhaps also for the three small lunettes surmounting the tombs. These plans were never carried out. There exist, however, sketches by Michelangelo which have been associated (by Popp) with these lunette frescoes (VII, 3). Two of the compositions can be found in No. 107, in which the general outline of the compositions is well adapted to the forms of the lunettes. The approximate date of the drawings as determined by their style (ca. 1530) also agrees with the period in which the project of the frescoes was discussed.

The sketches in red chalk represent two episodes of the Brazen Serpent: the upper one, the multitude attacked by the serpents; and the lower one, salvation through the Brazen Serpent. Since this latter composition faces toward the right, it must have been intended for the lunette above Duke Giuliano, while the other scene was obviously planned for the one above Duke Lorenzo (VII, 4). In this latter sketch the crowd attacked by the serpents appears to be an inextricable interlacing of nude bodies, the center of which moves like a whirlwind. Two smaller groups are on either side of the central one (VII, 5), and at each end is a group of fleeing figures with diverging movements that rush toward the periphery of the composition. The whole gives the effect of a mighty explosion caused by the rotatory movement in the center. In contrast to this centrifugal composition, the figures in the other are grouped centripetally, compressed in a half circle around a central axis formed by three nudes, the whole giving almost the effect of a compact cloud formed by human bodies.

As always with Michelangelo, the purely narrative elements are suppressed. The serpents assailing the crowd in the first composition are barely visible, while in the scene of salvation neither the Brazen Serpent nor Moses—who accomplishes the miracle —are included. The artist emphasized, instead, the inner significance of the events— horror and flight before fate in the first, and hope and wonderment for salvation in the second.

It has been observed (Popp) that both compositions are derived from drawings representing battle scenes which Michelangelo sketched a few years earlier. Thus the group at the left in the upper composition reverts to the magnificent pen drawings,

150

Nos. 96 and 106, sketched with violent strokes of hatching, which represent groups of *142,143* soldiers fallen or fleeing before an impetuous horseman. These two drawings belong by their style to the years around 1525. The lower sketch is anticipated by the early *150* drawings Nos. 24 and 25. No. 24, on green prepared paper, the same as that used for *Vol. I, 115, 116* sketches of the Sistine Ceiling (No. 36), is probably a first project for the central group of the Battle of Cascina (cf. Vol. I, p. 187). Around 1525, Michelangelo took up this sheet again and added a pen sketch of a leg and repeated, in black chalk in a later style, the nude figure seen from the back which he had sketched ca. 1504 on the recto.

One should not conclude from the affiliation of Biblical scenes to the battle scenes that in the beginning there was another program of heroic action for the Medici Chapel, and that following the wish of the Pope these heroic scenes were transformed into religious ones, since, as we have seen, the battle scenes date from a period in which Michelangelo could not have thought of the frescoes in the Medici Chapel.

The third lunette above the *sepoltura di testa* was to be decorated with a fresco representing the Resurrection of Christ (according to Popp). This theme fits well with the consecration of the Chapel to the Resurrection.

There exist three drawings by Michelangelo from this period representing the Resurrection of Christ (No. 108, red chalk ca. 1524-25; No. 109, black chalk ca. 1526; *144,145* No. 110, black chalk ca. 1531-1532). *146*

In the sketch No. 108 the sudden movement of Christ seems to be the *causa efficiens* *144* of the soldiers' movements, some of whom are crouching or outstretched around the tomb, while others are fleeing. Trembling at the call of freedom, Christ leaps from the sarcophagus (seen in a diagonal) with an impetuous movement, turning his head upward with a longing expression, and raising both arms over his head in a gesture which resembles that of God the Father Separating Light and Darkness on the Sistine Ceiling. It is a violent thrust toward light and freedom, the dramatic effect of which is heightened by the diagonal of his body which seems to spring from the tomb like an arrow, while the terrified soldiers fall backwards in a confused and obscure mass. This is not the victorious Christ after death who stands quietly on the sepulcher holding the standard of victory in his hand—for Michelangelo the scene becomes a "diagram" of a purely internal, spiritual longing: the whole composition is a symbol of the liberation of the soul from the shackles of earthly existence.

The same idea is realized more fully in the second drawing (No. 109). The figure of *145* Christ is almost identical but the twist of his body is less pronounced, thereby intensifying his movement heavenward. The keepers of the tomb are more numerous, their bodies form an opposition to the central figure. Some lie on the ground as if overcome by a heavy sleep brought on by debauchery, others have already awakened and try to flee in terror; and it is from this heavy atmosphere of "drunkenness" that the supple yet powerful body of Christ frees itself in a sudden movement. Here we see the same spiritual *élan*, visible in the first drawing, but in addition, the thick earthly atmos-

[49]

phere that reveals the true cause of the flight of this soul. The contrast is further expressed by the unreal light which seems to fall from above on the scene, enveloped by a kind of misty atmosphere.

146 In the third drawing (No. 110) can be seen the immaterial, slim body of Christ, with eyes closed in ecstasy and with his arms crossed in front of his neck, softly floating through the air like a flowing veil. This appearance of "light" pushes into the periphery of the composition the obscure cloud of the soldiers—the Ascension of Christ becomes here a transfiguration of terrestrial man to ethereal spirit which blinds and terrifies human beings. For them it is not a divine revelation, but the sudden appearance of a foreign principle which threatens their very material existence (VII, 6).

These three drawings are, in an objective language, subjective confessions of the supreme spiritual longing of Michelangelo: "L'anima, della carne ancor vestita, con esso è già più volte asciesa a Dio" (Frey, *Dicht.*, LXIV).

The three drawings are executed in a technique which recalls that of the North Italian drawings of the early sixteenth century, with which Michelangelo probably became acquainted at this time through Sebastiano del Piombo, who was a Venetian by birth. It is characteristic of Michelangelo's drawings that the outlines remain still vigorous but that the modeling by a delicate *sfumato* becomes extremely soft, accentuating the quality of the skin. The shadows, which in the earlier chalk drawings had been executed by means of hatchings, Michelangelo now renders by rubbing the chalk with his finger. The softened light comes from above and the bodies seem to rise toward it from a shadowy sphere. However, in spite of the sweetness of chiaroscuro, these drawings are not pictorial in the Venetian sense. With the latter it was the surrounding atmosphere which softened the forms, sometimes even absorbing the outlines; with Michelangelo the forms always remain plastic with emphasized contours and are lighted by a sort of inward irradiation.

A fresco was also planned for the lantern of the cupola; this is known through a letter of Sebastiano del Piombo of July 17, 1533 (Milanesi, *Corr.*, p. 104). According to the letter, Pope Clement VII left the choice of the subject matter to Michelangelo, but Sebastiano thought that Ganymede would look well there, adding that Michelangelo could give him (Ganymede) a halo, so that he would appear as St. John of the Apocalypse being borne to heaven. This joke reveals that Sebastiano, too, like Michelangelo, believed in the ambivalence of ancient mythology and Christian themes. (The Ganymede mentioned by Sebastiano refers to the famous drawing which Michelangelo had
154 done for his friend Tommaso Cavalieri around the end of 1532, and which is known only through copies.)

147 A red-chalk sketch in the Archivio Buonarroti (No. 103; on the recto there is an unpublished *ricordo* which can be dated with some probability in 1531, which may be also the date of the sketch) is apparently a study for a soldier of the Ascension (VII, 7). To be sure, the figure does not embody lack of understanding of the miracle, as does the figure

at the right on No. 110, which has a similar pose, but an incipient comprehension of it. *146*
The figure looks down at the empty tomb. Its movement is not a suspicious drawing
back, but only a slight recoil of amazement. With the fine legs which seem rather to
hover over the ground than to stand, with the slender torso which appears as if illumi-
nated by inner light, this tender figure stands on the same level of spiritualization as
the risen Christ of the whole composition on No. 110. The gloomy expression of the
face, with contracted brows, in the first version of the head, reveals that this figure orig-
inally was planned to represent a person who did not comprehend the miracle. But in
the new version of the face there is an expression of spiritual presentiment. In the Con-
version of St. Paul, Michelangelo used once again the motif of this soldier, in the chief
figure at the left, but here again expressing spiritual blindness.

There exists a copy of the drawing just mentioned in the Casa Buonarroti (Frey, *148*
Handz., 155c). The weaknesses of draftsmanship are conspicuous. The fine elastic con-
tours appear heavy and lame; the effective graphic abbreviations of the original, for ex-
ample in the torso, have been filled out by the copyist with unskillful use of details.
Moreover, there has been added to the model a theatrical gesture of the left hand.

It has been mentioned already that the building of the Sagrestia Nuova (begun and partly erected under Brunelleschi in the early fifteenth century) was continued from a time not later than March 1, 1520, at the order of the Cardinal Giulio (Cambi xxII, p. 161 and document of the Archivio Capitolare), at first without Michelangelo, who seems to have accepted the commission only in the month of November.

The artist made a small model of the whole building, probably with the *pietra serena* articulation, which is mentioned December 17, 1520, as "presso che finito" (Appendix), and on December 28, 1520, as "finito" (Appendix) (vIII, 1).

One learns that already in December 1520 (December 14 and 28, Appendix) work was being done on the *pietra serena* ("macigno") articulation, disagreements arising between Michelangelo and the *muratori* and *scarpellini* (December 14 and 17, 1520, Appendix) on account, probably, of the difficulty in making the wall recesses and of the execution of the *pietra serena* system (December 28, 1520).

Further disagreements occurred in April 1521, when Michelangelo was staying in Carrara, between Stefano di Tommaso Lunetti, Michelangelo's deputy during his absence, and Domenico Buoninsegni, plenipotentiary of the Cardinal (cf. Milanesi, p. 411) about the manner of execution of the entrance door (Frey, *Briefe*, pp. 171-174). Despite these difficulties the work progressed, and on April 20-21, 1521 (Frey, *Briefe*, pp. 171-173f), the work was done as far as the great *pietra serena* architrave.

Concerning the further course of the construction work, i.e. the execution of the *pietra serena* system of the intermediate zone, of the *pietra serena* windows in the lunettes, and the execution of the cupola, we have no documentary information except a letter of Sebastiano del Piombo from August 16, 1533 (Milanesi, *Corr.*, p. 114), in which reference is made to "l'alogare l'opera de macignio in cottimo" and to the nomination of a "soprastante a l'opera de macignio." If these sentences refer to the *pietra serena* system of the lunette zone of the Chapel, one should conclude that it was by that time not yet executed (vIII, 2).

The cupola is mentioned for the first time in the correspondence in January 1524 (Frey, *Briefe*, pp. 207f), but it must already have been constructed, since there was a question at that time of its decoration in stucco (this may refer to the coffers).

In January 1524, the lantern of the cupola was also finished (Milanesi, p. 424; date proposed by Thode). The "palla di rame dorato" at the top of the lantern was finished at the end of 1525 (Gronau, *J.d.p.K.*, 1911, Bh., p. 72).

Concerning the decoration of the cupola, we learn that Michelangelo sent a drawing to the Pope (Frey, *Briefe*, p. 211) in January 1524, that in February 1524, a scaffold was set up in the Chapel for the execution of the stucco work (Milanesi, pp. 585f), and that in the month of March work was done on the stucco decoration (Milanesi, pp. 588, 590). On April 18, 1526, the question was first raised of inviting Giovanni da Udine to

do the painted decoration of the cupola (Frey, *Briefe*, p. 280), which work, however, as has been mentioned above, was started only in October 1532 (Frey, *Briefe*, p. 331) (VIII, 3).

Since the *pietra serena* articulation of the lowest zone had been made for the actual tombs, the beginning of its execution before December 14, 1520 (Appendix), gives at the same time a *terminus ante quem* for the definitive project of the tombs (VIII, 6). Even though the project was established at so early a date, the actual work on the tombs was begun only in March 1524 (Milanesi, p. 584), and the reason for this delay can be attributed not only to the financial straits of the Cardinal but also to the slow progress of extracting and cutting the marble blocks in Carrara and to the difficulty of transporting these blocks to Florence.

On April 10, 1521, Michelangelo went for about twenty days to Carrara "per allogare a cavare e' marmi" (Milanesi, p. 582). "Là [i.e. Carrara] feci tutte le misure di dette sepulture di terra e disegniate in carta" (another proof that the definitive project must be dated early; cf. also Milanesi, p. 694). In other words, Michelangelo determined the measurements of the blocks for the tombs, i.e. for both the architecture and the figures, from clay models and drawings (VIII, 4). While in Carrara he made contracts with two companies of stonecutters for the extracting and the cutting of the blocks for the architecture and the figures. Namely, on April 22, 1521, he made a contract with Pollina, Leone, Il Bello, and Quindici, and on April 23 a contract with Marcuccio and Francione (Milanesi, pp. 694f, 696; cf. also p. 582). He gave the first company on account one hundred gold ducats, for which they were to extract about two hundred carrate of marble, with the special condition that they make "delli dicti marmi figure tre . . . ed delli altri marmi del quadro quanto potranno" (Milanesi, pp. 694f). To the second company he gave on account fifty gold ducats, for which they were to extract about one hundred carrate of marble, "et spetialmente fare delli dicti marmi una figura di Nostra Donna a sedere secondo è disegnata, et più altre figure . . ." (Milanesi, p. 696).

The information concerning the extraction and the cutting of the marble in Carrara is supplied chiefly by seventeen letters from Domenico di Giovanni di Bertino, called Topolino, Michelangelo's agent in Carrara (Appendix), which were unknown to the earlier scholars, and by the unpublished letters of the two companies in Carrara which were cutting the marble for Michelangelo (Appendix). On some important points, these letters complete previously known facts, and show first of all that there was no such long interruption in the work in Carrara as had been formerly believed (Popp): namely, from August 1521 (Milanesi, pp. 583 and 421) to January 1524 (Milanesi, p. 560). This supposition was made for lack of any document concerning the extraction and cutting of marble at that time, and was based on Cardinal Giulio's lack of money and Michelangelo's reference in a later letter (Milanesi, p. 421) to the wavering attitude of the Cardinal.

Letters from the company of Marcuccio and Francione from July 10, 1521 (Appen-

dix) show that they were extracting figures, i.e. probably the "Nostra Donna a sedere" which Michelangelo especially stipulated. On November 11, 1521 (Appendix), they reported that they had not yet been able to extract the six carrate "per lo mal tempo." On November 18, 1521 (Appendix), Topolino was visiting them, and they declared that all the marble they extracted would be at the disposition of Michelangelo. The company of Pollina, Leone, Il Bello, and Quindici wrote on September 24, 1521 (Appendix), that "le figure sono cavate" and that they were now beginning the cutting. (These may be the three figures that Michelangelo especially stipulated, Milanesi, p. 694.) Topolino also reported in mid-December 1521 (Appendix) that "qua si lavora sollecito." He mentioned the cutting of a block four braccia long, one and one-fourth braccia wide, and two-thirds of a braccio thick. This is probably one of the blocks of the double pilasters. The measurements are almost identical with another block for this purpose which is mentioned in March 1524 (Milanesi, p. 584). On December 1, 1522, Topolino reported that Marcuccio and Francione were working and had extracted several marble blocks. At the same time he complained about the company of Leone and Quindici, saying that he had paid them off because they made "stranezze."

The letter of Marcuccio of January 16 (Appendix) and the letter of Topolino of March 17, 1523 (Appendix), mention a temporary interruption in the transportation of the marble because of the bad condition of the roads, from which it is clear that the interruption of the work to which Michelangelo's letter alludes (Milanesi, p. 421) was only for a relatively short time, and could only have occurred after January 1523. In the last mentioned letter Topolino reported that he had made an agreement (i.e. a new one) with Leone and Quindici.

On March 17, 1524 (Appendix), Topolino wrote that "in breve tempo ogni cosa sara finita" with the exception of the two sarcophagus lids, which had not yet been extracted. From later letters it appears that this report was too optimistic. The marble was, with the exception of nine pieces, at the "marina" (i.e. Avenza), and Michelangelo was to procure additional barges to transport it to Pisa. On June 6, 1524 (Appendix), Topolino repeated, "qua si lavora forte . . . si caverà presto ogni cosa," and again on May 23, 1525, he said, "gli scarpellini lavorono forte."

On January 11, 1525, the company of Marcuccio and Francione had finished the work with which they were charged, except for one piece. This fact was also reported by Topolino on March 4, 1525. (They were still working on the remaining block on January 24, 1526: Appendix.)

By November 3, 1525 (Appendix), the other company (Leone and Quindici) seems to have progressed so far that they asked advice of Michelangelo as to what they should do next. They were also working on one figure as late as January 24, 1526 (Appendix).

In the meanwhile, in Florence, Michelangelo executed, with the help of the woodworker (*legnaiuolo*) Bastiano, full-size models. He began one of these on January 12, 1524 (Milanesi, p. 583; cf. also pp. 560, 584 and 585), and it was finished March 12,

1524 (Milanesi, p. 587). (This could have been only a model of the architectural parts of the tomb, because the models for the figures were executed in clay. Payments for the material necessary for the models are noted in Milanesi, pp. 589*ff.*) We learn that from April to November 1524 work was done on the models, evidently on the other wooden model and on the clay models of the figures (Milanesi, pp. 592-595). In March 1526, eight clay models of figures were finished (Frey, *Briefe*, pp. 277*ff*).

The finer execution of the rough-hewn blocks in Florence was begun on March 29, 1524 (Milanesi, p. 584), under the supervision of Andrea Ferrucci da Fiesole, a stone-carver (*scarpellino*).

The construction of one of the tombs was already so far advanced by June 7, 1524, that it would not have been possible to change the structure and the location (Frey, *Briefe*, p. 230) "per averne quasi fatta di quadro una." Consequently, the supposition that in the winter of 1525-1526 Michelangelo changed his project (Popp) is untenable. On June 17, 1526, the architecture of the tomb was "squadrata tutta, o poco manca" (Milanesi, p. 453; the correct date is given by Frey, *Reg.*, p. 127 and Frey, *Briefe*, p. 285). The blocks for the covers of the sarcophagi were cut August 13, 1524 (Appendix), but on August 10, 1525, they seem to have been still in Carrara (Appendix). One of the covers was already extracted and almost cut by June 21, 1524 (Appendix); on August 10, 1525 (Appendix), this cover still had to be brought to the "marina" (Avenza) where it was on October 18, 1525 (Frey, *Briefe*, p. 258). As for the other cover, the block of marble had not yet been found on January 24, 1526 (Appendix). The setting of the second tomb was not even begun by September 29, 1531 (Gaye II, p. 229), and was to be done during the coming winter. On August 16, 1533 (Milanesi, *Corr.*, p. 114), the two tombs seem to have been finished, since in this letter reference is made to the beginning of the Magnifici tombs.

Therefore, between the construction of the two tombs at least six years elapsed. Which one was executed first and which later cannot be directly deduced from the letters, and the sequence must be determined on the basis of a stylistic comparison. Köhler observes (p. 102) that "the architecture of the Lorenzo tomb is by a seemingly irrelevant motif richer in decoration than the Giuliano tomb, since the 'dolphins' over the *190* lateral tabernacles are lacking in the latter. This cannot be explained by chance, be- *191* cause corresponding to this simplification a difference also exists in the shape of the profiles. . . . It is therefore clear that there took place an intentional transformation of the rich modeling of the individual forms to simpler and larger forms, which can only be explained by supposing a certain lapse of time between the execution of the two tombs." This conclusion is confirmed by the different forms of the narrower sides of the sarcophagi. Those of the Lorenzo tomb have rich ornamental motifs finely executed, *188* while these same motifs on the Giuliano tomb are simpler and somewhat more roughly *189* executed. This tendency toward simplification is also indicated by the fact that the small side of the base of the Giuliano sarcophagus lacks the patera which adorns the corre- *187,186*

[55]

sponding base of the Lorenzo sarcophagus. There are many other small differences between the two tombs, but in general it can be said that the execution of the tomb of Lorenzo is at the same time richer and more carefully done than that of Giuliano, with the exception of the attica.

191 Of the atticas, conversely, that of Giuliano is the more richly and finely executed. From this it must be concluded that both atticas were apparently set only in 1533, and then the earlier executed stones were set in the tomb of Giuliano, the later ones in the *190* tomb of Lorenzo. That the tomb of Lorenzo was in fact not completely constructed in June 1525 was indicated by the above-quoted sentence: "squadrata tutta, o poco manca" (Milanesi, p. 453), wherein "poco manca" might apply to the attica.

 With the exception of this difference in the ornamental decoration, the architecture *8,9* of the two tombs is identical. The supposition of the modification of the project during the construction—that is, an elevation of the first cornice in the winter of 1525-1526 (Popp)—does not seem to be convincing, nor does the hypothesis that the highest zone of the tomb is unfinished because the backs of the thrones of the attica are here lacking (VIII, 7).

181 As for the tabernacles over the doors there was probably a change of plan, suggested by documents as well as by a stylistic analysis. Before February 9, 1524 (Frey, *Briefe*, p. 211), Michelangelo sent a drawing of the tabernacle and the door to the Cardinal, who approved it. The extraction of the marble in Carrara was made according to this project, and on March 25, 1524 (Appendix), several pieces were already roughly cut; but on April 21, 1524 (Appendix) we learn that the work could not be continued because the notebook (*memoriale*) sent by Michelangelo had not yet arrived at Carrara. On August 2, 1524 (Appendix), Topolino wrote to Michelangelo: ". . . e' marmi della porticciola sono presso che assommati e saranno belli. . . ." On November 22, 1524 (Frey, *Briefe*, p. 239), information was sought from Rome concerning the doors and tabernacles. Since on January 1 (Frey, *Briefe*, p. 242), January 21 (Frey, *Briefe*, p. 245), January 28 (Frey, *Briefe*, p. 246), and February 8, 1525 (Frey, *Briefe*, p. 246), they kept asking Michelangelo why he had not made the doors, it may be concluded that he modified the project. Meanwhile on March 4, 1525 (Appendix), the marble for the doors was found (extracted?), but it was not possible to begin the cutting since the notebook containing the measurements had not yet arrived; and since in this letter the doors were mentioned for the last time, its date is only a *terminus post quem* for the definitive project. In fact, there is a stylistic difference between the architectonic system of the tombs and that of the tabernacles which does not seem to have existed in the first proj- *102* ect. There is a drawing (No. 79), representing probably the first idea for the tabernacle, in which the niche is lower than in the final execution, so that the door under it must have been a little higher than, and the cornice as high as, that of the tomb. Conse- *4,5* quently the different heights of the cornices on the tombs and tabernacles can probably

be explained by the fact that the cornices of the tabernacles were lowered and the cornices of the tombs were left unchanged and were not, as was supposed, raised during the execution.

Already in April 1521, Michelangelo ordered at Carrara the blocks for three figures and for the Madonna (Milanesi, pp. 582, 694, and 696). On June 18, 1521, marble blocks for the figures were shipped from Carrara to Pisa. On July 10 of the same year Marcuccio and Francione in Carrara were charged by Michelangelo, through Baccio da Montelupo, to cut the blocks of the figures (Appendix). On August 16 following (Milanesi, p. 583), the stonecutters were paid. On September 24, Leone, Quindici, etc. began to cut (*abbozzare*) the figures (Appendix).

A document of April 21, 1524 (Appendix), gives a *terminus post quem* for the real beginning of Michelangelo's work on the figures; it says explicitly that Michelangelo had "cominciato a lavorare" and that he was still lacking four pieces of marble. On June 21, 1524 (Appendix), four big blocks of marble are mentioned, probably the very ones he lacked in April. On July 23, 1524 (Milanesi, p. 594), marble arrived in the Sagrestia, probably those blocks about which Michelangelo complained in the letter of August 13, 1524 (Appendix). From the documents it can be indirectly seen that between this last letter and the following one of August 24 (Appendix), Michelangelo again ordered four blocks for the four Allegories, since Topolino hoped "che aremo in pochi dì marmi per le figure nude." These nude figures could not have been the river gods, since we know that the blocks for them were not yet extracted in April 1524 (Frey, *Briefe*, p. 223 and Appendix), and the information which in all probability refers to the extraction of the marble for the river gods dates from August 10 to October 24, 1525 (Appendix from August 10; Frey, *Briefe*, p. 257 from September 6; Frey, *Briefe*, p. 261 from October 14; Frey, *Briefe*, p. 258 from October 18: by this time the blocks had arrived at the port; Milanesi, p. 450 from October 24); Michelangelo wrote that the blocks were unsatisfactory. A last bit of information of June 17, 1526 (Milanesi, p. 453), confirms that at that time Michelangelo had not yet begun the river gods. Consequently the blocks for the *figure nude* could only have been for the Allegories, none of which could have been begun by Michelangelo before August 24, 1524. (The supposition, therefore, that Michelangelo had already begun one of the Allegories—namely, the Aurora—in 1521 [Popp, p. 135] is not acceptable. Between Aurora and Crepuscolo there is not, even stylistically, enough difference to justify such an early date for the former.) When the marble for the nude figures arrived in Florence is not known. Only three blocks were usable since on August 7 (?), 1524, Topolino mentioned a "figura istorta" in San Lorenzo (Appendix), and on October 27, 1524, Michelangelo took one from his own supply in Via Mozza ("che mi serve per una figura di quelle che vanno in su cassoni delle sepulture dette che io fo," Milanesi, p. 597), and this block was already "appuntato un poco," i.e. already prepared, probably for another figure. One year later, on Octo-

ber 14, 1525 (Frey, *Briefe*, p. 261), Michelangelo was working simultaneously on four figures, none of which, as we have said, was a river god. On October 24, 1525 (Milanesi, p. 450), he wrote to Rome that the four figures which he had begun were not yet finished and that there was still much to do on them. On March 10, 1526 (Frey, *Briefe*, pp. 276f), they were almost finished. (In this letter Sellaio wrote, moreover, that Michelangelo promised to finish eight figures by September, four of which were near completion. From this we see that Michelangelo had not begun eight figures [as Popp supposes, p. 136] but only four, and that he promised to finish the other four by September.) The next letter, of June 17, 1526 (Milanesi, p. 453, the correct date is in Frey, *Briefe*, p. 285), informs us that at that time Michelangelo was working on six figures; consequently he must have begun two more between March 10, 1526, and June 17, 1526. Since in this last letter (Milanesi, p. 453) Michelangelo wrote that "fra quindici dì faro cominciare l'altro Capitano: poi mi restera di cose d'importanza, solo e' quattro Fiumi," one can deduce that among the eleven figures which he wanted to execute himself, those six already begun must have been the four Allegories, one Duke, and the Virgin. (According to Popp the figures begun were the six principal ones and two less *57-60, 71* important: namely, the Apollo-David of the Bargello and the Crouching Youth in Leningrad.)

Which were the four figures that were mentioned in the letters of October 14 and 24, 1525, and March 10, 1526, and which were the other two begun later? Among the first four should be an Allegory, according to Michelangelo's own statement; that is to say, the one begun on October 27, 1524, with his marble from the Via Mozza. Since in the case of each tomb the Allegories are, in their conception, intimately related to each other and to the seated figure above, we can reason that among those four figures there was at least one more Allegory, the one corresponding to the first mentioned on October 27, 1524, and the statue of the Duke to be placed above these—that is, three figures of one of the tombs. The fourth figure must have been the Virgin, with which Michelangelo was occupied for a very long time; already in 1521 he had ordered the block for it. Therefore the two figures begun later—namely, between March and June, 1526— could only have been the other two Allegories, to which must have been added next the figure of the corresponding Duke. We know moreover from a letter of July 25, 1533 (Milanesi, *Corr.*, p. 108), that only at that time was Montorsoli charged to finish the statue of Giuliano. Therefore, the two Allegories begun later are those for the tomb of Giuliano—namely, Notte and Giorno. Consequently the first four figures begun by Michelangelo are the Virgin, Aurora, Crepuscolo, and Duke Lorenzo (the latter not yet finished in September 1531; cf. Gaye II, p. 229).

The conclusions drawn from the documents can be corroborated by a stylistic and technical comparison. In a stylistic analysis it must be borne in mind first of all, as mentioned above, that the motifs of the action of the figures were already decided from the first according to a unified project, in which the statues of the tombs were already set in

contrast: first, a harmonious adaptation of the figures to the cover of the sarcophagus (Aurora and Crepuscolo); and secondly, a contrast between the curves of the statues and that of the sarcophagus (Notte and Giorno). These two motifs, which up to now were thought to belong to two different stylistic periods, can however both be seen already in the drawings of 1520 (Nos. 52 and 53); and we must exclude the possibility of a change in the project for the motifs of the figures in the winter of 1525-1526. In a stylistic comparison of the two tombs, however, a certain development between them becomes apparent in the way in which the figures are cut from their blocks. While the figures of the tomb of Lorenzo do not completely fill out the blocks, so that parts remain unused, those on the tomb of Giuliano are inspired by the form of the block so strongly that they fill it out completely. This relationship between the figure and the block becomes evident if one observes the Allegories from the side. In the Aurora and the Crepuscolo a relatively large piece of unused marble is left behind their backs; in the Notte the figure already takes up so much of the block that only a small part of the superfluous marble remains. In the Giorno not even a little remains: here the conception of the figure conforms so well to the block that the whole of the material is completely used. The same difference in the relationship between figure and block can be seen in the statues of the Dukes. While in the statue of Lorenzo the complicated position of the torso inclined toward the right required the removal of much more marble from the left side, the upright position of Giuliano is completely restricted to the block and presents on both sides a closed contour. In the Virgin the relationship between figure and block is similar to that of the tomb of Lorenzo. The base, where the original width of the block can still be seen, shows that in the execution of this figure Michelangelo took away much superfluous marble at the right and moreover had to place over the original base another one about fifteen centimeters smaller. If, nevertheless, the statue of the Virgin resembles, in the treatment of details, those on the tomb of Giuliano, which were executed later, it is because it was executed very slowly. On September 29, 1531, this figure is mentioned as not yet finished (Gaye II, p. 228).

Since Michelangelo, as the documents show, worked simultaneously on several figures and since the lengths of time taken to complete them vary, it is no wonder that also in the figures begun early there are characteristics in the plastic treatment of the surface which are much more developed. On June 16, 1531 (Milanesi, *Corr.*, p. 50), several figures are mentioned as being finished; however, only one figure could have been meant since the next letter, of August 19, 1531 (Milanesi, *Corr.*, p. 66), says that Michelangelo had finished a second figure and was about to begin the third. The figure completed on June 16, 1531, must have been the Aurora, the least developed in surface treatment, and the second figure, finished on August 19, was probably the Notte, whose polished surface still greatly resembles that of the Aurora. On September 29 the figures of "le due femine" were finished and also one of the "vechi," which should be identified with the Crepuscolo, judging from the technical procedure (Gaye II, p. 229). After Sep-

[59]

38-11 tember 29, 1531, probably in the winter of 1531-1532, the statues of Lorenzo and the
49-56 Virgin were finished. On July 25, 1533 (Milanesi, *Corr.*, p. 108), Montorsoli was
42-48 charged to finish the figure of Giuliano. Since Giorno is not mentioned in any docu-
31-37 ment and since it shows besides a more developed style, it must be supposed that it was
finished last.

The genesis of the architecture of the Medici Chapel and the chronology of its tombs
and statues having been clarified, there remains to be considered the content expressed
therein.

IX. EARLIER INTERPRETATIONS

THE problem of explaining the Medici Chapel had been posed already by the contemporaries of Michelangelo, and from that time to the present has continued to draw the attention of writers and scholars.

In the lifetime of Michelangelo, two interpretations prevailed: one corresponded to the Renaissance tradition, according to which the burial monuments were glorifications of the greatness of the empirical personality of the deceased; the other corresponded to the tradition of the late Middle Ages, revived in the early sixteenth century, according to which a burial monument had to express the transience of earthly existence—it had to be a *memento mori*.

Disregarding the autograph notes of Michelangelo himself, in which he jotted down in a few words the program of his tombs, and to which we will return at the end of our interpretation, the earliest explanation is that of Varchi (*Due lezzioni*, Florence, 1549, p. 117, written in 1546). Varchi praises the "altissimo concetto" (sublime concept) which the artist expressed in his statues as Dante did through his poetry (drawing for the first time, incidentally, the parallel between Dante and Michelangelo). According to Varchi, who expressly states that the interpretation which he gives is his own, the artist wanted to express by the Allegories the idea that for each of the Dukes a hemisphere would not suffice for a tomb, but only the whole world. The sarcophagi are symbols of the earth, and they are covered by the four Allegories as the earth is covered by the four times of day. So the artist emphasized in his tombs the greatness of the deceased. Varchi imposed the old program of the glorification of the dead on Michelangelo's composition, and overlooked what was new in the Medici tombs.

Varchi's interpretation was followed by Vasari (1550 and 1568, pp. 131f); according to him also, the earth as tomb would not suffice to express the greatness of the deceased, and therefore Michelangelo gave, as a grave, to each of them "tutte le parti del mondo" (all the parts of the world, i.e. the whole universe). This sentence is not clear; Vasari was apparently only trying to surpass even Varchi in his courtly compliment (IX, 1).

In contrast to these interpretations is that of Condivi (1553, p. 136), according to whom the Allegories signify "il tempo che consuma il tutto" (Time which devours all). Michelangelo's idea was to express the transience of all earthly things (IX, 2). Condivi's interpretation influenced the most detailed description of the Chapel in the seventeenth century, that of Bocchi-Cinelli (1677) (IX, 3), that of the eighteenth century by Jonathan Richardson, father and son (1728) (IX, 5), that of the early nineteenth century by Domenico Moreni (1813) (IX, 6), and those of several modern scholars, as Wölfflin, Springer, and Popp (IX, 7).

In the early nineteenth century, writers and scholars began to read into the monuments different meanings which no longer corresponded to the two chief iconographic traditions of burial monuments, but to the leading spiritual trends of their own period.

So, under the influence of the ideas which led to the French Revolution and to the revolutions of the first half of the nineteenth century, a romantic-patriotic content was proposed. Michelangelo wanted to express in the Allegories his grief as a patriot for the loss of the liberty of Florence—Guillaume (1876) and Ollivier (1892); and, furthermore, in the statues of the Dukes his hatred for the tyrants of the Medici—Niccolini (1825). Springer refuted these views, showing that the epigram of the Night (Frey, *Dicht.*, CIX, 17) was written by Michelangelo long after he executed the statue, and so cannot be used to interpret the figure (IX, 8). Moreover, the composition of the monuments was planned about nine years before Florence lost her freedom, and at that time the artist had not hated the Medici as tyrants.

Under the influence of the cult of genius, other scholars held that Michelangelo expressed in the statues only his own subjective melancholy and suffering. The artist "opened his soul" through the statues (Justi, Burger, and Pasquier).

Under the influence of modern positivism, an attempt was made to find in old texts the program illustrated in the tombs. According to Brockhaus, this source is the Hymns of St. Ambrosius for the morning and evening masses, the liturgy explaining all the details of the Chapel. The Hymns, however, cannot be connected with the figures and the ornaments, and Brockhaus's interpretation is arbitrary (IX, 9). Steinmann thought he had found the explanation in a carnival song of the fifteenth century. Again the connection was completely arbitrary, as Wickhoff has shown. According to Oeri, the real source is Plato's *Phaedo*, Chaps. 15-16, an opinion which is, as the author has shown (*Cappella Medicea*), partly convincing; Borinski and Panofsky tried to complete these latter interpretations by passages from the Neoplatonists of the Renaissance (IX, 10).

An attempt will be made here to arrive at an interpretation through an analysis of the form as expressive language, and through Michelangelo's own writings, which are the surest basis for grasping the ideas of the artist concerning death and the life beyond the grave.

X. CONTENTS

THE Sagrestia Nuova was intended to embody a single representative idea. This, however, was not expressed with perfect clarity, since the execution remained incomplete.

Nevertheless, a visitor in this quiet room, slender and high in its proportions and lighted by a pale diffused light, feels himself carried away from empirical reality and removed to another world, a sort of holy crypt.

2-6

The burial chapels of the fifteenth century had also sometimes a unified iconographic program. They represented the kingdom of heaven (x, 1). But artistically they do not create the impression of a unified sphere: first, because they are open at one side (in the direction of the church), i.e. they do not enclose the beholder within their realm; and secondly, because the individual tomb monuments and altars, though to be sure they commemorate the single idea, are merely set up in the chapel as isolated works—they do not grow together with it into a single organism.

The Medici Chapel is based on a more comprehensive idea. The whole Chapel was intended to be an abbreviated image of the universe, with its spheres hierarchically ranged one above the other. The lowest zone, with the tombs, is the dwelling place of departed souls, the realm of Hades. The intermediate zone, with its rational architecture, was intended to incarnate the terrestrial sphere. The zone of the lunettes and of the cupola was intended to represent the celestial sphere. The gradation of the lighting, which is admitted in largest quantity in the celestial zone and penetrates the terrestrial zone through smaller openings, while the zone of Hades has absolutely no direct source of light, can also be best understood in connection with this content.

3

7

In the lowest zone the rational system of *pietra serena* pilasters is interpenetrated by an irrational architecture. Here the real walls seem to have disappeared and in their places emerge strange white marble architectures. Solid spatial confinement—presupposition of all Renaissance architecture—is eliminated. Two completely different architectural systems interpenetrate. Empirical reality seems to have vanished, and a second, dreamlike realm, the realm of Hades, appears.

4,5

The tomb architectures do not remain behind the ideal plane indicated by the architectonic frame, as in the Quattrocento tombs, but project in a plastic manner into the space of the Chapel. Yet this latter is not conceived in the Baroque manner as an *espace milieu* of the tombs and sculptures, but it is, so to speak, a vacuum, completely subordinated to, and dominated by, the artistic space of the sculptures and tombs.

In the lateral bays there are always low doors and tabernacle niches above them. The doors have a curious form: they are enclosed by a molded frame, the profiles of which are unbroken even at the bottom where the threshold would normally be. Thus they seem merely to serve as bases for the tabernacles above, and only incidentally as doors. Among the eight small doors of the Chapel, only one was a real entrance, five were blind, and two open on small sacristies beside the choir (x, 2). From inside the Chapel,

182

181

with the entrance door closed, it is hard to tell which is the exit since all doors look alike. These are apparently the doors of Hades, the descent through which is described by Virgil as easy, the ascent as extremely laborious (*Aeneid*, VI, 126-129):

> ". . . facilis descensus Averno . . .
> sed revocare gradum superasque evadere ad auras,
> hoc opus, hic labor est."

In the tabernacle niches, to be sure, one recognizes the traditional frame, formed from pilasters and pediment, but this frame is apparently deformed, and Michelangelo makes the cause of the deformation visible: he symbolizes it in the narrow, delicately profiled band, which seems to push the pilasters apart at the bottom, and which at the top, breaking through the horizontal cornice, penetrates into the pediment (x, 3). The niche appears to grow, as if pulled apart by this force, while the door seems to shrink. In the soft volutes on either side of the door the down-pushed superfluous matter swells. The architectonic forms live; they have become almost anthropomorphic.

In the central bays of the lateral walls there are small "façades," horizontally articulated into three zones, one above the other, two main zones and an attica, and vertically articulated into three fields. In these "façades" the proportions of the niches are completely different from those of the tabernacles in the lateral fields. They are small and delicate. If one looks at the whole decoration of the wall, the lateral fields seem to draw nearer and the central field seems to recede. At the same time the relative scale of the statues in the central field seems to be enlarged as a consequence of the small architecture.

The lowest zone of the "façades" is decorated with simple rectangular panels, before which in each instance a sarcophagus stands on a rectangular marble base. It is interesting to observe that in No. 57 the legs of the sarcophagus do not yet stand on the axes of the double pilasters, and that the heads and upper bodies of the reclining figures do not yet function as a transition from the legs of the sarcophagus to the double pilasters of the main zone. The verticals, i.e. symbols of upward movement, are dominant in the final version.

A strongly projecting cornice, below which deep shadows gather, and where the egg-and-dart ornamentation is transformed into a frieze of masks, closes this zone, above which rises the main zone, articulated by delicately fluted double pilasters with richly decorated capitals composed of masks and shells, and by three slender niches between them. The lateral niches are emphasized by segment pediments, while the central niche curiously enough is without architectural accent. The eye of the spectator is consequently led from the sides to the center.

The tripartite attica projects above the double pilasters in the form of blocks, which in the project drawings were originally empty thrones, and which now, deprived of their backs, have the aspect of ancient burial altars. By means of these projections not

[64]

only is the horizontal articulation carried out along the complete breadth, as in the altars of the fifteenth century, but also the vertical articulation is led all the way to the top. The two basic directions interpenetrate so as to form an indivisible dynamic organism, in which the double pilasters function as muscular tensions. Because of the diminished height, the attica no longer appears as a separate zone but seems merely to round off the main zone. The monument consists only of two main zones, one above the other.

All the decorative elements of this architecture come from ancient burial altars and sarcophagi. It is not known whether Michelangelo was aware of the special significance of these various decorative motifs: whether, for example, the fantastic dolphins or sea dragons (Lorenzo tomb) should be interpreted as reminders of the long journey to *190* Hades, the garlands and oil jars as symbols of immortality, the shells as symbols of eternal life, the trophies as symbols of the ultimate triumph over perishableness, the masks as keepers of the realm of the dead, and the frieze of laughing masks as a symbol of the *196-200* derision of the fear of death. The latter interpretation is supported by one of Michelangelo's later poems, Frey, *Dicht.*, LVIII:

> " 'l ben morto in ciel si ridi
> del timor della morte in questo mondo."

It is possible that Michelangelo used these motifs simply in a general way as symbols of death and immortality, since he found them already in ancient sarcophagi and burial altars associated with death and eternal life. For example, the garlands and oil jars are *192, 193* quite exact imitations of ancient prototypes (x, 4).

To sum up: the tomb architecture is an idealized palace façade, the house of the dead (*domos aidos*) decorated with the emblems of death. This conception may have been familiar to Michelangelo from ancient urns and sarcophagi in the form of houses, especially from one sarcophagus which already in Dante's time stood at the south entrance *293* of the Baptistry in Florence and which Michelangelo must consequently have known.

What is most striking in the composition of the Ducal tombs is a certain contrast be- *8, 9* tween the outstretched figures on the sarcophagi and the seated figures of the dead, in the niches above them. The former with their superhuman bodies weigh down the covers of the sarcophagi, the force of their weight and movement seeming to split apart the covers, forming an empty space in the middle while the ends curl up in volutes (x, 5).

In the form and profile of the sarcophagi Michelangelo emphasized the hardness and solidity of the material: the sharp, fine profiles of the covers, as well as the angular shape of the sarcophagus body, giving it the aspect of metal rather than marble. In emphasizing the metallic character of the sarcophagi, the artist makes more evident the destructive power of the Allegories of the Times of Day.

On the other hand, the seated figures of the dead seem to belong to a different hu-

manity; their bodies are slimmer, more delicate, and of smaller proportions. They seem to hover, and this effect is emphasized by the ascending movement of the double pilasters beside them. They appear not merely as a crowning of the triangle formed with the figures below; they belong to a zone and a plane clearly separated from that of the 4,5 Allegories, architecturally expressed by the horizontal series of niches which, diminishing from the lateral fields towards the center, direct the eye to the seated "Capitano." It is an equilibrated system of plastic masses of different weights on different planes, in which the figures assume the place or zone allotted them by their apparent weight.

The compositional relationship of the Capitani to the Times of Day recalls certain 292 Roman sarcophagi (e.g. Palazzo Mattei) of the third century A.D. (x, 6). The bust of the dead enclosed in a clipeus is carried by two genii beyond the sphere of earthly existence symbolized by the reclining figures of Gaia and Poseidon. In his earlier drawings Michelangelo even represented a clipeus or a tondo between the reclining Allegories, and it is important to note that the covers of the sarcophagi are split only in those drawings where the clipeus appears. In the final version he suppressed the clipeus, transforming the bust of the dead into a full figure; but the idea and the inspiration for the compositional pattern, nevertheless, evidently derive from the ancient sarcophagi.

To summarize: it is as if the sarcophagi were split apart by the weight of the outstretched figures, and as if the images of the departed souls had risen to their "light seats" through these openings. Freed from the tomb, they hover in eternal youth in a sphere upon which Time and Fate cannot trespass.

This analysis of the composition is confirmed by a consideration of the single figures. The outstretched figures on the tombs seem oppressed by a deep grief which paralyzes their physical being. Their movements are not motivated by a definite action but are rather projections of psychic states.

10-16 The Aurora is a young woman with fully developed virginal forms, resting outstretched on a sheet. She is leaning on her right elbow, and the left leg is pressing on a cushion, which seems to indicate that she is about to turn on her couch or to rise. She seems awakened, and is making the first unconscious movements, but psychic lassitude seems to paralyze her. Her head sinks back, her hands bend at the wrist, falling pas- 12-14 sively in purposeless gestures. Hopelessness is written in the straight lines of her contracted eyebrows, and a groan seems to come from her slightly parted lips. The weighty mourning veil, the strange volutes of her diadem which painfully compress her forehead, seem to be materializations of her heavy thoughts. The ribbon below her breasts seems to be a symbol of her fettered state on the couch. It is the tossing of the body in psychic torment; it is the awakening of someone who is aware of the futility of existence and of the trials which await him at the new day.

17-21 The Crepuscolo has a calmer reclining pose. He rests exhausted, making no attempt to rise up. He has the muscular yet flabby body of an aged man, the forms of which

seem to flow down unhindered like lava. He has abandoned all vain struggle. The hands lie in complete passivity, as does the crossed right leg. His bearded face, with the high forehead and with deep-set and shadowed eyes, shows an expression of resignation: hopelessly he looks on his vainly lived life. Again the movement is purposeless and aimless. The pose and the forms of the body incarnate directly a psychic condition. *20*

The Notte is a woman of mature body which already shows signs of decline; she is characterized as a mother. In an involved position—which brings out the rhythmic beauty of the outlines resulting from the alternation of slim and powerfully developed parts—she seems to be petrified in a dream. The body is cramped, the hands bent at the wrist. The expression of the face, with heavy eyelids, dilated nostrils, and beautiful, curved, sensual lips, suggests that she is possessed by a dream. Sleep is not repose, but unfulfilled desire. The frightening creatures of night which disturb the rest of the soul appear below the sleeper. An owl watches; a terrifying satyr mask (symbol of fallacy— Ripa) with two goatlike teeth (symbol of sensuality) snores. A bouquet of poppies below the left foot seems to be a symbol of dream or fertility. These are not the emblems which allegorical figures usually hold in their hands; they are symbols into which the stone couch itself, below the left arm and leg, has been transformed. *22-30* *24-26* *30, 29*

The Giorno has a Herculean body in the prime of life. The upper part of the body rolls abruptly toward the wall, a rotatory movement which is emphasized by the position of the two arms, which together describe a circle around the body. The torsion is so violent that it seems to jerk the left leg forcibly upward. Above the mighty shoulder the head turns toward the spectator, full of rage and contempt. Even stronger than the effect of this double torsion is that of the dynamic swelling of the gigantic body; the back and the muscular shoulder seem to be the results of a volcanic eruption released from within. Again the whole figure is the incarnation of a psychic eruption, and not merely a body animated by anger. *31-37* *36* *31*

The inertia and grief of these outstretched figures which dominate the sepulchers, enclosing the perishable cadavers of the dead, express mourning for the transitoriness of life. The Aurora mourns in pain, the Crepuscolo in hopeless resignation, the Giorno in rebellion, and the Notte in unfulfilled desire. This interpretation is supported by Michelangelo's own note (No. 72), from which it is clear that he wanted the figures to represent transitoriness and fleetingness, "veloce corso" (x, 7). *104*

We know that the figures were to be completed compositionally by two river gods at the bottom of each Ducal monument. From Michelangelo's poetry we know that he identified rivers with tears, i.e. with suffering mourning, e.g.:

(Frey, *Dicht.*, CIX, 91)
"Rendete a gli occhi miei, o fonte o fiume,
L'onde della non vostra e salda vena."

[67]

(Frey, *Dicht.*, XCIX)

> "Ben doverrieno al sospirar mio tanto
> Esser secche oramai le fonti e' fiumi,
> S'i' non gli rinfrescassi col mio pianto."

The identification of the four rivers of Hades with the tears of humanity goes back to Dante, *Inferno,* XIV, 103*ff,* where Virgil declares the origin of the Hades rivers to be the "lagrime goccia" of humanity, personified by the statue of the old man of Crete. In his commentary on this passage in Dante, Landino clearly states, "le lachrime fanno e' fiumi infernali, cioè le miserie humane, le quali generano le pene che ci affliggano. . . ." He even describes the four aspects of grief in connection with the four rivers of Hades: Acheron signifying repentance (*pentimento*); Styx, sorrow (*tristitia*); Phlegeton, passion (*ardore*); Cocytus, weeping (*pianto*). Since, as we have seen, there is in Michelangelo's poetry a similar association of tears with rivers, it seems quite probable that he intended the four river gods to represent the four Hades rivers and thus to express, like the four Times of Day, the lamentation over the transitoriness of life (x, 8). Thus all figures surrounding the sarcophagi had to be mourning figures—the whole zone symbolizing in general the realm of transience.

38, 42 In contrast to the figures below, the statues of the dead seem already beyond their sufferings. They are physically detached from the sepulchers and are seated in niches above them. In all earlier sepulchral monuments the images of the dead were represented as outstretched on the sarcophagi. The tomb of Pope Innocent VIII by Pollaiuolo, exceptionally, shows the image of the Pope twice: once as a seated figure giving the Papal blessing, and once reclining on the sarcophagus—that is, once in the execution of his mission in earthly life and once as a corpse. Michelangelo suppressed completely the outstretched figure of the dead and imparted new significance to the seated figure. It is no longer a portrait of the empirical personality of the deceased but the image of his immortal soul in the existence beyond the grave. Thus Michelangelo consciously breaks with the tradition of the portrait-like naturalism of tomb statues. The faces of the Dukes conform to a general type of beauty, and do not recall their actual features—a fact observed already by Michelangelo's contemporaries. Niccolò Martelli explained it in a letter written in 1544, in the following way (x, 9):

> ". . . Havendo [Michelangelo] . . . à scolpire i Signori illustri della felicissima casa de' Medici, non tolse dal Duca Lorenzo, ne dal Sig. Giuliano il modello apunto come la natura gli avea effigiati e composti, ma diede loro una grandezza, una proportione, un decoro . . . qual gli parea che più lodi loro arrecassero, dicendo che di qui à mille anni nessuno non ne potea dar cognitione che fossero altrimenti. . . ."

Also the costume of the Dukes is not that of their own time, but that of Roman Emperors. The strange passivity in their limbs reminds one that their bodies no longer

belong to this life. They seem to be no longer the masters of their own powers, but passive media, held upright only by powers working from outside themselves. Of both it may be said that only the soul is living, while the body is dead.

The body of Lorenzo would collapse if his left elbow were not supported on the obolus-box, while his right hand is turned passively outward in a gesture employed elsewhere to express sleep or death (Virgin of the Stairs; Pietà, Florence, Duomo). The face of Lorenzo is an idealized head of a youth, of the type of the marble David and of some of the Ignudi of the Sistine Ceiling. But the noble features are no longer so sharply defined as in the earlier works. The pupils are no longer engraved, so that his look has something dreamy and vague about it. He holds his fingers to his mouth, a gesture of contemplation in silence (VI, 28). He contemplates the spiritual vision of the Madonna. Paradoxically, he is wearing a lion-head helmet, symbol of power or of Fortitude, contradicted, however, by his sad face and inactive hands. The obolus-box below his elbow, decorated with the head of a bat, the bird of the underworld, is evidently a symbol signifying that he is already in the realm of Hades, which is also considered the realm of riches.

The body of Giuliano seems to respond to a sudden call. He is inclined slightly forward, and is held upright by the magic of the Madonna at whom he is looking. His bony, delicate hands with their long, slender fingers rest powerless in complete passivity on the baton (of a *Capitano della chiesa*), which has become superfluous. This symbol of power is no longer used by him to command, but only to support his lifeless hands. In his left palm he is holding passively several oboloi, again signifying that he is already dead. His youthful face, framed by flamelike hair, is also reminiscent of the marble David, but nothing of the strength of will and the passion of the David head is here. Inscribed in a pointed oval, with a slightly receding chin, with softly curved lips, with a delicate nose, with eyes which seem absorbed and no longer focus on physical things, it is the face of a "shade," without will or energy. The strange transparent cuirass, which at the same time covers and reveals the body, making visible the muscles, the nipples, and the abdomen, is adorned on the breast and the back by fantastic masks with bats' ears, and appears to be the "eternal garment" of the departed soul.

The gaze of both Capitani is turned toward the Virgin, creating a spiritual link between the main figures of the Chapel. This was a decisive innovation, for no such spiritual connection between the figures on the different tombs existed in earlier chapels; and it became the model for many of the burial chapels of the seventeenth century. In the Baroque, however, the portraits of the empiric personalities of the dead are represented, in an attitude of Christian devotion, with folded hands turned towards the altar in fervent prayer. They are not, as with Michelangelo, images of departed souls, in calm, stoic contemplation of the supreme truth.

The manner of contemplating the Virgin differs in the two statues. Lorenzo is sunk in quiet meditation, while Giuliano, apparently awakened by a sudden call, contem-

plates the Divine with a longing expressed in his noble face. The difference corresponds to the two main ways of approaching the Divine, as described in Lorenzo de' Medici's "Altercazione" (Chap. IV, 91-95)—through the intellect and through desire: "Due ala ha la nostr' alma pura e bella/ Lo intelletto e'l disio, ond'ella è ascesa/ Volando al sommo Dio . . ." (X, 10).

To these figures of the Capitani could be applied Virgil's sentences (*Georgics*, Book II, 490*ff*) (X, 11):

"Felix, qui potuit rerum cognoscere causas,
atque metus omnis et inexorabile fatum
subiecit pedibus strepitumque Acherontis avari";

or Michelangelo's own words, from one of his poems (Frey, *Dicht.*, LIX):

"Beata l'alma, ove non corre tempo,
Per te s'è fatta a contemplare Dio."

The Capitani were to be flanked by two nude figures, to be placed in the niches on either side. The figures flanking Giuliano are mentioned by Michelangelo and Vasari as representing "el cielo" (heaven) and "la terra" (earth). We even know that Tribolo began the latter figure but never finished it. We do not know what the figures flanking Lorenzo were to represent. Vasari's description of these figures is a courtly compliment to his patrons, the Medici, and contributes nothing to the understanding of Michelangelo's intentions. Important only is his remark that these figures were to be nudes. Such pairs of nude figures accompany also the Prophets and Sibyls of the Sistine Ceiling, where they are clearly intended to be the genii of the seers. By analogy we may suppose that the flanking nudes in the Medici tombs were also intended to embody the genii of the Capitani. According to Plato and the Neoplatonism of the Renaissance, man has two contrasting souls, "due anime contrarie, l'intelletiva, la quale è celeste, e la sensitiva, la quale è terrena" (Varchi). "El cielo" would be an incarnation of the first, "la terra" of the second. Each of the Capitani was consequently to be accompanied by the spirits of his inner nature. Heaven and Earth were neither decorative figures, nor conventional allegories, but projections of the inner nature of the Capitani. Lorenzo was accompanied probably by Knowledge and Will (cf. Pomponazzi), of which Intellect (i.e. Lorenzo) consists (X, 12).

90, 91 For the reconstruction of the *sepoltura di testa* there exist, as stated above, two authentic sketches in London. In both, the sarcophagi of the two Magnifici without allegorical figures appear at the bottom, followed by an intermediate zone, which Michelangelo very probably would have eliminated in the final version in order to harmonize the structure with the tombs of the Dukes (cf. copies). Finally comes the tripartite zone, in the middle niche of which the Virgin was to stand, while the lateral

[70]

niches were to hold the statues of the patrons of the Medici family, Sts. Cosmas and Damian. It is noteworthy that in the Magnifici tomb the segment is above the central niche to emphasize the importance of the Virgin.

The Virgin is seated on a narrow, high block, with one leg crossed and hiding the *49-56* other, which rests on the ground, producing an effect of hovering. The Virgin belongs to the type of the Madonna del Latte (the Virgin with the Suckling Child). The unusual motif of the Child turning his back to the spectator, unknown in Italian art before Michelangelo, appeared first in his Virgin of the Stairs.

An idealized cloth of a soft, transparent material covers the forms without hiding them, almost as though modeling for a second time, and in a more impressive manner, the essential forms of the body, limbs, and breast. Around the shoulders Michelangelo put a shawl with heavy circular folds in order to emphasize the opening from which a long neck and small head rise. The head-covering which continues and emphasizes from behind the ascending curve of the neck, at the same time encloses the silhouette of the face from the front to form a complete oval.

The child, with a Herculean and muscular body, seated astride the Virgin's knees, *55, 56* turns around toward her with a violent movement to attach himself to her breast. The juice of life flowing in him seems to swell his body with new forces, while the mother, offering her body to the child, sacrifices all her strength, thereby becoming more and more ethereal. Her serious, noble face is marked by an expression of pensiveness and *53, 54* suffering. Michelangelo brings out only the essential parts of the face. In this purified ensemble only the mouth and chin retain a sensual trait—the quivering of the love of the mother giving suck to her child.

Mother and son seem to be one being. They form a single organism that encloses in an impressive synthesis the life-process itself: eternal wasting away and eternal renewal.

It is interesting to note that Cesare Ripa in his *Iconologia* (Padua, 1625, p. 382), *264* illustrated the notion *Idea* by a woodcut of a woman holding a child in the same way as the Medici Virgin. According to the text the child is the personification of nature to whom the mother, i.e. the *idea*, gives milk. The contrast in Michelangelo's group between the spiritual principle of motherhood and the material or vegetal growth of the child is here grasped, but expressed in the abstract symbolism proper to Mannerism, completely lacking the concrete human quality of Michelangelo's group.

Not only do the single statues, the architecture of the tombs and their decoration, point to the meaning of the realm of death, but the artistic effect of the entire lower zone likewise emphasizes the fact that it is Hades, deep under the earth. This impression is created—as stated above—by the narrow proportions and exceptional height of the *2* room, and by the fact that the light is admitted only from above. It is an unreal light which bathes the forms in a pale, sweet shimmer evenly diffused.

The interpretation of the upper zones is more difficult, because the frescoes which were intended to decorate them were either not executed or later whitewashed (x, 13).

[71]

3 The second zone is distinguished from the lower, first, by the different character of
its architectonic forms. Within the *pietra serena* order there are here normal *pietra*
184 *serena* windows, whose design is in close conformity with the Florentine tradition.
This dry, rational architecture stands in contrast to the highly imaginative architecture
of the lower zone, as if Michelangelo wanted to express thereby that it is the sphere of
everyday life. The criterion of the degree of "reality," however, is not determined by
closeness to the empirical world, but by closeness to the Idea; and hence this rational
architecture, in consequence of its shallow forms, looks less "real," i.e. less substantial,
than the dream architecture of the lower zone. The frescoes which were intended to
adorn the lunettes in the central fields of these zones were probably to represent the
150 Punishment and Healing of the People by the Brazen Serpent, and the Resurrection of
144, 145 Christ (above the Magnifici tomb). The scenes of the Brazen Serpent above the tombs
of the Dukes are Old Testament prototypes of judgment and salvation. The Resurrec-
tion of Christ is—as mentioned above—a particularly appropriate ornament for a room
dedicated to resurrection. The scene of action in all three instances is the terrestrial
world.

3 The third zone, that of the large lunettes, is characterized by the dynamic windows
with converging frames, which give the effect of hovering forms and are thus especially
suitable as an ornament for the "celestial sphere." The wall surfaces of the lunettes were
possibly also intended to be decorated by frescoes (cf. Vasari, *Carteggio*, ed. Frey, I, p.
714), but there is no record of what these frescoes were to represent—possibly garlands,
birds, and masks, as in the cupola.

7 The painted decoration of the cupola, consisting of garlands, birds, and masks, is
mentioned by Vasari. These are allusions to celestial bliss and immortality. The As-
sumption of St. John of the Apocalypse, on the ceiling of the lantern, would also have
been fitting decoration for this celestial sphere.

The conception of death and of life beyond the grave as expressed, according to the
above analysis, in the Chapel agrees entirely with the ideas expressed by Michelangelo
in his poetry. There is "the firm faith" ("credenza ferma," Frey, *Dicht.*, LVIII) that "the
soul lives outside of its body" ("che l'alma vive del suo corpo fora," Frey, *Dicht.*, LXXIII,
13 and 14) and that the life in the beyond brings "divine peace" to the soul ("divina
pace," Frey, *Dicht.*, LVIII; or "vera pace," Frey, *Dicht.*, LXXIII, 14). Divine peace is one
in which "Fortune and Time do not attempt to penetrate" ("fortuna e'l tempo dentro
a vostra soglia non tenta trapassar") and where the eyes contemplate God (Frey, *Dicht.*,
LXXIII, 15). In the words put in the mouth of the dead Cecchino Bracci, Michelangelo
sums up his idea of death: "that the soul lives, I who am dead now have the certitude,
and that while I was living it was dead" (Frey, *Dicht.*, LXXIII, 48). The idea of the
apotheosis is clearly expressed in the words, "Tu se' del morir morto e fatto divo"
(Frey, *Dicht.*, LVIII).

[72]

The poems quoted were written, it is true, after the execution of the Chapel, but two prose projects for poems (Frey, *Dicht.*, XVII, XVIII) dating from this time show that Michelangelo's thoughts on death were already established. The first lines of Frey, *Dicht.*, XVII:

> "El Dì e la Notte parlano e dicono:
> Noi abbiamo col nostro veloce corso condotto alla morte
> il duca Giuliano"

104

give absolute evidence that Giorno and Notte symbolize the destructive force of Time, which annihilates the empiric personality of Giuliano—as on the tomb. The lines which follow would make no sense if it were supposed that the reference is still to Giuliano's terrestrial personality; the allusion must rather be to the immortal soul of the Duke and to his power over inexorable Time, an idea which again is in accord with that expressed in the tomb:

> "è ben giusto, che e' ne faccia vendetta come fa
> E la vendetta è questa:
> Che avendo noi morto lui,
> Lui così morto ha tolta la luce a noi, e cogli occhi chiusi ha
> serrato i nostri, che non risplendon più sopra la terra."

The last epigrammatic line: "Che avrebbe di noi dunque fatto, mentre vivea?" ("What would he have done with us when alive?") is evidently a playful enigma. The answer can only be that the Duke Giuliano would have done nothing with Giorno and Notte because the text clearly shows that his act against them was only possible because they brought him to his death (x, 14).

The other bit of prose, Frey, *Dicht.*, XVIII, written on one of the projects for the *sepoltura di testa* (No. 58), also agrees with the concept expressed in the tombs:

90

> "La fama tiene gli epitaffi a giacere;
> non va né innanzi né indietro,
> perchè son morti, e 'l loro operare fermo."

This would signify that by death the instability of terrestrial life is overcome and eternity is thereby attained ("giacere" symbolizes this immovable state after death).

The similarity of the fundamental ideas with the thoughts of Plato concerning death and immortality is obvious (x, 15). In *Phaedo*, Plato describes the life of the soul in the realm beyond the grave. The soul, freed from the bodily prison, returns to that world for which it was always longing and where it again finds its true home. In this true world from which it was exiled, the soul can finally contemplate the Ideas, i.e. the essence of existence (as Michelangelo's Dukes contemplate the Virgin). To demonstrate the rebirth of the soul after the death of the body Plato introduces, among others,

the argument of a natural law, the so-called generation of contrasts, according to which, given two contraries, there necessarily exist also two contrary generative processes. As an example, he shows that the state of wakefulness follows upon a state of sleep and that the generative processes of these two states are awakening and falling asleep. This explains—as Oeri has observed—why Michelangelo did not represent these four states of the soul in the Allegories in their successive order but in contrasting pairs. Further, we find in *Phaedo* the description of the four rivers of Hades symbolizing eternal fluctuation; Michelangelo wanted to place the river gods, as stated above, at the base of his monuments.

It is not surprising to find the fundamental theme of *Phaedo* in the Medici Chapel when one realizes that this Chapel was consecrated to the Resurrection of Christ, prototype of resurrection. Now the Neoplatonic philosophy of the Renaissance considered the Platonic doctrine of the rebirth of the soul as found in the *Phaedo* as a prophecy of the Christian doctrine of resurrection. In his commentary on *Phaedo*, Ficino says (*Opera Omnia*, Basel, 1539, p. 488): "sicut ex viventibus fiunt mortui, sic ex mortuis viventes quandoque resurgere. Ubi videtur mortuorum resurrectionem vaticinari." The two doctrines being already approximated, only a step was required to represent the Platonic rebirth in the Chapel consecrated to the resurrection.

In the funerary monuments of the Florentine Quattrocento the idea of transience and of the life of the soul in the other world is gently avoided. The deceased is represented outstretched on the sarcophagus in serene sleep, as in the Middle Ages, and the figures, reliefs, and ornaments which surround him transform the place of transience into an image of budding life. Delicately and finely executed garlands, vines, and playing putti angels adorn the shining white marble monuments, and radiate the cheerfulness and optimism of eternal youth and spring.

The plain, severe Medici Chapel, on the other hand, carries the beholder out of this world into the realm of departed souls, and summons him to serious meditation on death and the immortality of the soul. The thought of transience and of eternal life becomes here the real substratum of the modeling. The impression that this world of departed souls is the true reality is produced in the beholder above all by the supernatural dimensions of the statues—which confront him without mediation, whereas in the Quattrocento the artists always inserted figures on a smaller scale (putti) to make a transition between the beholder and the large figures—and by the placing of these statues above the level of the beholder's head. They consequently dominate and subdue him, making him feel that he himself belongs to an unreal realm of shadows.

In summary, the Medici Chapel is not an ordinary building destined merely to contain tombs, but a unit, expressing a definite idea-content. It is an abbreviated image of the universe. From ancient times religious architecture had signified more than a simple shelter for divine service. We know, for example, that already the Egyptian

temple expressed in abbreviated form the universe, and that church architecture of the Middle Ages represented the Heavenly Jerusalem. Michelangelo goes back to this old tradition, but fuses the ancient conception of Hades with the Christian Beyond. In this new realm the souls of the dead attain for the first time since antiquity the dignity of philosophic contemplation of the supreme truth. The burial chapel becomes thereby the sanctuary of the true life of the soul.

XI. THE TOMBS OF POPES LEO X
AND CLEMENT VII

THE projects for the tombs of Leo X and Clement VII, the two Medici Popes, belong only indirectly to the history of the Medici Chapel, since Michelangelo never seriously intended to erect them inside the Sagrestia Nuova.

The suggestion of erecting these burial monuments in the Chapel came from Cardinal Salviati in May 1524 (Frey, *Briefe*, p. 228). (We know, however, from a letter of 1520 that Cardinal Giulio already at that time wanted to be buried in the Chapel; cf. Appendix No. 3.) Cardinal Salviati's first idea was to erect three double tombs on three walls of the Chapel, for the Magnifici, the Dukes, and the Popes. Only six days later the idea was modified (Frey, *Briefe*, p. 229) to provide a separate monument for each of the Popes, while the Dukes and the Magnifici were to be buried in double tombs. The tombs of the Popes were to have the places of honor, those of the Magnifici the least important places, in an arrangement which would have placed tombs against all four walls.

These suggestions from Rome show that they did not know to exactly what point the work in Florence had progressed. Michelangelo could not have considered them seriously, since, as we know, the blocks for the architecture of one of the Ducal tombs were by that time almost finished. He therefore made a counterproposal (of which we learn indirectly through a letter, Frey, *Briefe*, p. 230): namely, to erect the Papal tombs not in the Chapel but in "the *lavamani* where the stairs are," referring, as Popp has shown, to the small room on the left side of the choir of the Sagrestia Vecchia.

A project drawing based on this proposition arrived in Rome on June 25, 1524 (Frey, *Briefe*, p. 231) (XI, 2). It is still preserved in Dresden, and has been identified by Popp (XI, 2a). It shows a modest monument with a niche for a seated statue in the center below, and at the right and left of the upper zone tabernacles with segment pediments; in the center at the top, the coat-of-arms of the Medici and four candelabra. The motif of the tabernacle niches with segment pediment as lateral accents had already been used by Michelangelo in the second project for the façade of San Lorenzo, and before him by Giuliano da Sangallo.

There exists in the Casa Buonarroti an original sketch by Michelangelo (No. 63) showing the same idea: the central niche at the bottom, two tabernacles with segment pediments to the right and left at the top. This project, however, seems to have been made for much larger dimensions (cf. the standing figures in the lateral fields of the lower zone). Moreover, the whole structure is set on a high base. At the left side in the lower zone the profile of a sarcophagus is visible; this should be completed by another at the right side. According to Frey, it is a sketch for a free-standing monument; according to Popp, it is a project for a wall monument, more specifically the first version for the Dresden drawing, which is only a reduction of this project. Popp could not explain,

however, the curved lines at the left which signify evidently a sarcophagus. Most probably it is neither a free-standing monument nor a wall monument, but a monument with three sides, and probably should be identified with the tomb project for Bartolomeo Barbazza and his family in Bologna, which in 1525 Tribolo was charged to execute after Michelangelo's drawing, but which was never finished. The blocks in Carrara and two big putti were cut and sent to Bologna, and put in a chapel in San Petronio. Barbazza and Tribolo were not sure from the drawing, which the correspondence shows Michelangelo had made "some years" earlier (Frey, *Briefe*, p. 259, from October 3, 1525, and Vasari, ed. Mil. VI, p. 59), whether or not the tomb was meant to project farther from the wall than seemed to be indicated. They asked Michelangelo for information. Michelangelo replied on October 29, 1525, sending a profile and a ground plan of the tomb. The uncertainty as to how far the tomb should project from the wall is understandable, for in the sketch the sarcophagus appears at the side. The *concetto* of the Barbazza tomb, thereafter, was used by Michelangelo for the Dresden drawing of the tombs of the Medici Popes.

The idea of placing the Papal tombs in the small sacristy with the *lavamani* was not considered entirely satisfactory in Rome. The room of the *lavamani* was too dark and small for two Popes. Also it was feared that the tombs of the Dukes would appear more beautiful than those of the Popes. On July 21, 1524 (Frey, *Briefe*, p. 233), about one month after the submission of the project, it was suggested from Rome that the monuments should be erected in some place in the Church of San Lorenzo—for example, in the choir. For this version Michelangelo made a great sketch, No. 66 (preliminary *96* studies for the same are Nos. 65 and 65a, the latter hitherto unpublished). Popp *95, 325* (*Münchner Jahrb.*, p. 400) reconstructed this version (XI, 2b). It would have been an architectonic disguising of the choir walls of San Lorenzo, with the tombs on the central axis of the lateral walls, the sarcophagi organically embodied within the architectonic decoration.

About two years later, in June 1526, there had still been no decision concerning the placement of the Papal tombs. The Pope repeated that he considered the *lavamani* too small, and asked Michelangelo for new proposals (Frey, *Briefe*, p. 284). Then, after the death of Clement VII in September 1534, Alfonso Lombardi was charged with the execution of the monuments, according to Michelangelo's sketches, in the Church of Santa Maria Maggiore.

Michelangelo now gave Lombardi his projects for the Julius Tomb (1525-1526) (Nos. 67 and 68)—that is, monuments in the form of triumphal arches (XI, 2c). The *121, 122* drawings on No. 67 were begun with the upper left sketch, which shows the articulation of Roman triumphal arches (like those of Septimius Severus and Constantine) and is not yet adapted well to a tomb. It differs from the ancient prototype in two ways: in the proportional relationship between the central and lateral fields (the latter are much

[77]

taller than in antiquity); and secondly, in the fact that the lateral fields project, as can be seen in the entablature. The effect of the opening is reduced in favor of the compact masses.

In the second sketch, at the left bottom, the structure is better adapted to the scheme of a tomb. Michelangelo reverts to the type of the Quattrocento niche tombs, specifically to the tomb of Pope Paul II. (Cf. the drawing in the Codex Berolinensis, by Dosio, Berlin, Kupferstichkabinett.) The arch penetrates the attica; the main entablature is lowered to the spring points of the arch, and in the lateral fields there are, each time, two small niches, one above the other.

In the third sketch, to the right of the second, Michelangelo returns to the scheme of the triumphal arch, using, however, from sketch two, the lowered entablature and the arch which penetrates the attica. The lateral fields are now enlarged.

In the next sketch, on the right, Michelangelo tries to transfer the principle of the triumphal arch to a real tomb monument. By inserting continuous entablature and the larger proportions of the lateral fields of the preceding sketch into the scheme of the second sketch, he achieved a new effect: the negative forms are not only reduced, but transformed into positive ones. The main entablature separates the semicircle, making it a positive pediment. In the rapid sketch above this last drawing the central part projects and the pediment is transformed into a low segment.

122 The next step is the sketch of the Archivio Buonarroti, No. 68. It corresponds to the sketch just mentioned on No. 67, with the one difference that there are again two niches, one above the other, in the lateral fields, as in the second sketch of No. 67, and its model, the tomb of Paul II. In contrast to the latter again the negative form of the niche is transformed into a positive projection.

123 The sketches of a pupil in Oxford, Christ Church, DD 24, recto and verso, are developed from the third sketch on No. 67.

In the fall of 1525, Michelangelo decided to reduce the Julius Tomb to a modest wall tomb "come quella di Pio in Sto Pietro": (September 4, 1525, cf. Milanesi, p. 447; and October 24, 1525, cf. Milanesi, p. 450). Consequently No. 67 and the Archivio Buonarroti sketch were originally intended for the Julius Tomb of 1525, a fact which has been demonstrated in greater detail in Tolnay, *Arch.Buon.*, pp. 415ff. The sketches on No. 67 and in the Archivio Buonarroti can be dated: they must have been made after December 8, 1525 (after Fattucci sent drawings of the tombs of Paul II and Pius II to Michelangelo; Frey, *Briefe*, pp. 268, 270), and before October 16, 1526, the date when Michelangelo sent the new project of the Julius Tomb to Fattucci.

It has been shown (*Arch.Buon.*, p. 417) that these projects for the Julius Tomb were abandoned at the latest in 1532. After the death of Clement VII in 1534 Michelangelo could put his drawings at the disposition of Alfonso Lombardi to be used by the latter for the projects of the Medici Pope tombs to be erected in Santa Maria Maggiore.

These sketches are of great importance from the more general point of view of the history of tomb monuments in the late Renaissance and the Baroque. They represent a new type of tomb conceived in the spirit of triumphal arches, which influenced greatly the Roman tombs of the Cinquecento and Seicento. The tomb monument with the aspect of a triumphal arch had been attempted two decades earlier by Andrea Sansovino, in his Cardinal tombs in Santa Maria del Popolo. But he had achieved merely a compromise with the traditional Quattrocento niche tomb. The center of his composition is still the niche, completed by two lower lateral fields. It is a simple addition of three parts. This solution was now completely supplanted by Michelangelo's sketches, which revert more directly to antiquity, have a greater unity, and an emphasized plastic monumentality. Michelangelo took his point of departure from the unifying element of the triumphal arches: the continuous horizontal entablature and attica. The tripartite character of the composition is subordinated to the greater organic unity of the whole—an idea particularly favored by the Baroque, which was striving toward unity of composition. At the same time, in the last sketch of No. 67 and in that of the Archivio *121, 122* Buonarroti there is also a resemblance to the Christian altar type of the triptych, and this may also have been appreciated in the beginning of the Counter Reformation.

The influence of Michelangelo's type of tripartite tomb can be observed in Rome from the middle 1550's. The earliest examples are the three tombs, designed by Giacomo della Porta in Santa Maria sopra Minerva, of Luisa Deti (1557), Silvestro Aldo- *318* brandini, and Cardinal Alessandrino. The artist took over Michelangelo's continuous *319* horizontal entablature, rectangular central field (instead of Sansovino's arched niches), and separated segment pediment. The plastic life of Michelangelo's projects, however, with the projecting central part and receding lateral fields, is lacking.

In Santa Maria Maggiore, where, after the death of Clement VII, Alfonso Lombardi planned to execute the Papal tombs, there still stand two Papal tombs of the same Michelangelo type: those of Nicholas IV by Domenico Fontana (1581) and of Clement *320* VIII by Rainaldi (1671). Both follow Michelangelo's projects even more exactly than *321* Porta's tombs do: in the central niches there are, as in Michelangelo's design, seated statues of the Popes, where Porta had placed outstretched figures of the dead—a retrospective motif and in contradiction to the whole structure. In the tombs of Nicholas IV and Clement VIII the plastic life of Michelangelo's projects is lacking, but nevertheless there is an attempt to emphasize the central field by two columns (the entablature below the segment in Rainaldi's tomb projects), while the lateral fields are terminated by pilasters. There are not the immanent tensions of Michelangelo's project, but a certain vivacity is more superficially attained through the combination of different colored marbles.

The first sketch of No. 67 very probably determined Antonio da Sangallo and Bandi- *121* nelli to follow very closely the articulation of ancient triumphal arches in the two Medici Pope tombs in Santa Maria sopra Minerva. Its close connection with these tombs *315*

[79]

has been observed by Popp (*Med.Kap.*, p. 170). The tomb type of No. 67 also influenced

121 several later monuments. The third sketch on this sheet is reflected in a tomb in Christ

311 Church, Oxford, DD 25. In the form of a triumphal arch, it has in the central niche a Virgin, and in the lateral niches two seated statues of Popes, and is probably again a project for the tomb of the two Medici Popes. Among the later Papal tombs in the form of triumphal arches it is enough to mention those by D. Fontana of Pius V and

316, 317 Sixtus V, or those by F. Ponzio of Clement VIII and Paul V, all in Santa Maria Maggiore. Again the noble monochromy of Michelangelo's tombs is transformed into a rich and picturesque polychromy. Two unpublished drawings, probably for the tomb of Clement VII (with the Medici coat-of-arms, and with the portrait of a bearded Pope,

312, 313 who is consequently Clement VII), in Berlin and Munich, both in the style of Bandinelli but not executed by his hand, show above the tripartite lower part, which is like a triumphal arch, a rectangular central part with a coat-of-arms above, and with C-shaped volutes and candelabra above the lateral parts. This treatment of the top of the monu-

310 ment reverts also to Michelangelo, as an original sketch, preserved in the Archivio Buo-

314 narroti, testifies. The tomb of Giangiacomo de' Medici by Leone Leoni in the Milan Cathedral is a combination of a triumphal arch type with high horizontal attica and of the termination just described. The idea reverts to Michelangelo but the execution is entirely Leoni's.

Thus all three types of triumphal arch monuments of the sixteenth and seventeenth centuries—with a simple attica, with a rectangular middle field framed by two C-shaped volutes at the top, and with a segment pediment above the central field—originate in Michelangelo's projects. They are not only important for the history of the tombs of Julius II and the two Medici Popes, but they are also turning points in the history of tomb monuments in general.

XII. INFLUENCE OF THE MEDICI TOMBS

THE Medici tombs marked a turning point in the history of funerary art, determining throughout more than a century and a half the form of Italian monumental tombs. Three principal types can be distinguished in which the artistic form of the Medici tombs continued to live.

The first is a reduction of the original motif, usually adopting only the form of the sarcophagus. This type was created by Michelangelo himself in his project drawings for the tomb of Cecchino Bracci (XII, 1). Cecchino Bracci, a favorite of Michelangelo, died at the age of fifteen (1544); he was the nephew of the artist's friend, Luigi del Riccio. Michelangelo promised the latter to design an "onesto sepulcro" for Cecchino (Frey, *Dicht.*, p. 532; *Reg.*, 102, and p. 354). He used as a point of departure the idea he himself had formulated in the Medici sarcophagi, as his project drawings in the Casa Buonarroti (Nos. 69 and 70) demonstrate. The basic form of the sarcophagus is the same. *124, 125* However, the sharp-angled structure, rich in tension, is transformed into the massive and weighty late style. Also the relation of the sarcophagus to the architectural background is the same as in the Medici Chapel: the two central pilasters are on the axis of the feet of the sarcophagus. The structure of the architecture itself reverts in the executed monument to the sketches made in 1525-1526 for the Julius Tomb, Nos. 67 and *306, 121* 68, having a similar articulation into the three fields and with the central field distin- *122* guished by a segment pediment. In Nos. 69 and 70 the structure does not yet show a *124, 125* wall tabernacle tomb, but wall tombs like the early projects for the Medici tombs.

It must be assumed that Michelangelo, after the execution of these drawings (Nos. 69 and 70), continued to experiment until he arrived at a solution which corresponded on the whole to the Bracci tomb in Santa Maria in Aracoeli. The execution of the monu- *306* ment was in the hands of Pietro Urbano, who followed Michelangelo's project in general but apparently altered the individual proportions. Unlike Michelangelo are the proportions of the lateral pilasters, which are too narrow, almost Quattrocentesque, and of the lower volutes, which are too short and massive in comparison to the other parts. The total effect is greatly influenced by these faults of proportion.

Another copy of the same *concetto* is the monument of Cardinal Raffaello Riario in *309* Rome, SS. Apostoli, erected under Pope Clement VII. This monument is framed by columns which stand in front of double pilasters. The proportions are slenderer, and the lower volutes are omitted. The sarcophagus stands as in Michelangelo's drawing on a high marble base. But the treatment is polychromatic; only the central part of the monument is executed in white marble, the enframing parts in colored marble. This monument is then probably not a copy of the executed Bracci tomb, but reverts to the same lost sketch by Michelangelo. In the proportions of the enframing columns and the bottom of the tomb, it seems to follow more closely Michelangelo's sketch than does the Bracci tomb; in other respects—for example, the central field—it seems to follow Michelangelo's project less exactly (XII, 2).

The second type of tomb monument is also a reduction of the Medici tombs. It came into being by the isolation of the figural triangle of the Medici tombs from their architectural context. The earliest example is the tomb of Paul III in St. Peter's by Guglielmo della Porta (which was somewhat altered in the early seventeenth century) (XII, 3). The seated statue of the Pope is raised on a large free-standing base. Below it, and at the front of the base, there was originally a sarcophagus (today missing), with the two still existing outstretched figures. In respect to both formal composition and subject matter, Guglielmo della Porta is retrospective compared to Michelangelo. Formally there is no longer the hovering equilibrium among the three figures; in della Porta the seated statue is larger and more massive than the reclining ones. The seated figure is moreover not a portrait of the soul of the deceased, but a picture of the empirical personality, an honorific statue of the Pope; and the reclining figures are not cosmic allegories of Time, but Virtues, i.e. complements of the portrait figure. Their positions do not suggest movement, as in the allegorical figures of Michelangelo, but comfortable repose (cf. the new form of volutes of the sarcophagus lids). The iconographic derivation from the two Papal tombs by Pollaiuolo in St. Peter's, especially that of Innocent VIII, is obvious.

The development within this type in the seventeenth century is toward greater unification. In order to make the side lines of the triangle clearer, the reclining figures are changed to standing figures which lean against the sarcophagus. The strict symmetry is loosened; the individual parts are given dramatic movement. The form of the sarcophagus and the draperies of the figures become richer and more luxuriant. Instead of Michelangelo's equilibrium of plastic bodies in different planes, Bernini, in his tombs of Urban VIII and Alexander VII, attempts to create an effect of unified hollow space in which the figures freely move. The contrasts between variously colored marbles, and between bronze and marble, are used in a refined pictorial manner.

In Bernini's Papal tombs the movement seems to be not determined purely by the individual; it is borne by an invisible vital current whose vehicle is the individual man. The revelation of this victorious cosmic force, to which the individual is subordinated, seems to have been Bernini's ultimate artistic goal.

In the third and last type of tomb in which the tradition of the Medici Chapel survives, not only individual elements but the total articulation of the burial chapel is inspired by the Sagrestia Nuova. The most important example is G. A. Dosio's Niccolini Chapel in Santa Croce, Florence (in construction 1584-1585, completed as late as 1695) (XII, 4). Although its relationship with the Medici Chapel has not so far been observed, it is evident that the Corinthian giant order of pilasters which articulates the walls into three fields; the entablature consisting of architrave, frieze, and cornice, broken at the wall recesses; the placing of the tombs in the central fields of the lateral walls and of the altar on the narrow wall; the vertical and horizontal articulation into

three fields of the tombs themselves; the rectangular central niche with a seated figure above the sarcophagus; the form of the sarcophagi; and the form of the niches containing the seated figures (obviously under the influence of Michelangelo drawings such as Nos. 52 and Frey, *Handz.*, 117b); the niches in the lateral fields; and the direction 82 of the gaze of the seated figures toward the altars—all come from the Medici Chapel.

Nevertheless, here, too, the regression to types older than Michelangelo can be followed. Instead of two interlocking architectonic systems, we have here a chapel with tombs applied to the walls. The subject matter is similarly regressive. Instead of showing the metaphysical existence of the departed souls, Francavilla, the sculptor here, presented the archetypes of the Lawgiver (Moses) and the High Priest (Aaron), to recall the earthly occupations of the empirical personalities of the deceased (two of the Niccolini were churchmen, the other two, senator and lawyer). The allegorical figures in the niches symbolize virtues related to the occupations represented. The Old and New Testaments are harmonized in that the seated Old Testament figures contemplate the altars, which represent scenes from the life of the Virgin (Ascension and Coronation). Inscriptions and coats-of-arms recall the family whose mausoleum this chapel is, and whose members are assured of salvation through their Patrons and the Virtues.

The total effect of the Niccolini Chapel is completely different from the Medici Chapel. The varicolored marbles, the rich stucco, and the gilding, give to the whole an ornateness, brightness, and gaiety. It is a chapel representative of a rich family, half religious, half profane, while Michelangelo's Medici Chapel represents a single unified sphere of the beyond.

It is interesting that the idea of placing seated statues in niches in the intermediate zone was so successful that in the Cappella della Confraternità di San Luca, in SS. Annunziata (1561), there is a whole row of seated statues in niches all around the room 305 whose dependence on the Dukes of the Medici Chapel is obvious.

The tombs of the seventeenth and eighteenth centuries are, in their intention, perpetuations of the earthly life of the deceased. The irrevocable, temporal past is projected into the future. Michelangelo's idea of representing the metaphysical life of the soul after death was followed by no one.

[83]

CONCLUSION

SINCE, according to Michelangelo's Platonic conception, death is the liberation of the soul from everything that is foreign to its nature, it is not strange that the realm of death becomes for him the realm of true life of the soul. The space of the Medici Chapel is that mysterious precinct where the soul, freed from human trials and tribulations, lives in accordance with its true nature.

If the Sistine Ceiling was an evocation of the divine origin of humanity, reflecting at the same time through the *deificatio* its predestined future, then the Medici Chapel suggests the future of the soul beyond the grave, which remains, however, moulded by all its spiritual past. Actually this seems to be only a difference in aspect. In both works, past and future are symbols of an everlasting, substantial present. But the Ceiling, which sang the triumph of creative forces and of the active life, was the ideal portrait of the soul of the artist at the peak of his powers, while the Medici Chapel, full of an elegiac poetry revealing the pure contemplation of supreme truth, incarnates the psychic state of a man who has become aware of the approach of the end of his life span.

WORKS MADE DURING THE PERIOD OF THE
MEDICI CHAPEL

INTRODUCTION

ALTHOUGH Michelangelo's artistic powers in the years 1520-1534 were concentrated primarily on the execution of the Medici Chapel, he nevertheless found time to devote to other works, which in part were executed and in part remained only projects.

Aside from the master's work on the Julius Tomb and his activity as architect of the Bibl. Laurenziana and of the fortifications of Florence, which will be considered in later volumes of this work, the artist made during this period two isolated marble statues (Christ of the Minerva and David-Apollo), several projects for a marble group for the Piazza della Signoria, cartoons for three pictures (Leda, Venus and Cupid, *Noli me tangere*), and finally projects, probably for a fresco on the entrance wall of the Church of San Lorenzo, representing the Ascension of Christ. At the end of this period he made finely executed drawings of mythological subjects, intended as finished works of art, as gifts for his friend Cavalieri.

With the exception of the group for the Piazza, in which not only the artist but also the patriot Michelangelo was interested, these works obviously did not have the same importance for him as the Medici Chapel and its sculptures. They should be considered as complements of the chief work of this period, and as having freed the artist from one-sidedness. They are in part compensations of the sensual Michelangelo against the spiritual Michelangelo who alone could express himself in the Medici Chapel. They show how Michelangelo, simultaneously with his concentration on the realization of the symbols of transiency, escaped in erotic pagan subjects (Leda, Venus) into the circle of *279, 288* ideas of love. The reclining figures of the Leda and the Venus are, from the formal point of view, by-products, in which the motifs of the Notte and of one of the river gods are repeated with slight variations. But in subject matter they are outright contrasts, in that they give form to Michelangelo's philosophy of love.

A unique position among these works is occupied by the composition of the *Noli me* *290* *tangere* (1531). Undoubtedly on account of the subject matter, it is retrospective, reverting to the compositional pattern of the pictures of Creation on the Sistine Ceiling. Only the slenderness of the proportions of the figures reveals it as a work of this period.

In the isolated statues and groups of this period, Michelangelo is concerned, from the *68* formal point of view, with the solution of a single problem. The Christ of the Minerva, the David-Apollo, the Hercules and Cacus (or Hercules and Antaeus) group, and the *71, 139, 274* Ascension projects, are four variations of the *figura serpentinata*. By torsions and twist- *159, 160* ings of the torso and the extremities, the human body (or two human bodies) is transformed into a spiral pattern, in which along with the retention of the normal physiological structure of the body there is offered a continuity of plastic experiences and movements. This formal pattern is differentiated in the four cases, in accordance with the demands of the subject matter.

As the pattern of the standing spiral figure or group contains within itself all kinds of

expressive possibilities, attainable through slight variations, so does the pattern of the outstretched figure with half-raised upper body and bent leg lend itself to the expression of many kinds of subject matter. The solitude of the Notte becomes almost without change the expression of passionate surrender in the Leda. Instead of inventing anew, Michelangelo varies an already invented pattern. How these variations were accomplished in detail, the following analyses are to show. These will consider first the various versions of the *figura serpentinata*, then those of the compositions with reclining figures, and finally the *Noli me tangere* will be dealt with briefly.

22
279

XIII. THE CHRIST OF SANTA MARIA SOPRA MINERVA

THE Christ of Santa Maria sopra Minerva is Michelangelo's first departure from the style of the Sistine Ceiling, the Moses (1513-1516) and the Slaves (Louvre) of the Julius Tomb, toward the style of the Medici Chapel. The figure which stands today in Santa Maria sopra Minerva was executed between 1519 and April 1520 (unveiled on December 27, 1521). It was made only in part by Michelangelo himself. Moreover, we know from the documents that this statue is the second version. On June 14, 1514, a contract was drawn up with Michelangelo to execute a nude Christ, life-size, standing, and with the cross, but the statue was never completed because of a black vein in the marble. This first version, now lost (XIV, 2), remained in Michelangelo's house in Rome, and was later (January 1522) offered by him as a gift to Metello Vari, one of the three consignors. One drawing (No. 86) is related to it. The opinions concerning the authenticity of the sketches and concerning their chronology are various (XIV, 3).

Only the study of the torso on the recto of this sheet seems to be by Michelangelo. All the other drawings were made by a pupil, probably Pietro Urbano or Silvio Falconi (Popp). The pen drawing of the torso on the recto is over a crude sketch in red chalk made by the pupil, which Michelangelo seems to have wished to correct. The other sketches are apparently direct copies of sketches by Michelangelo (with the exception of the legs in profile on the recto and verso, which for this reason are also weaker). The torso is drawn in pen, in the technique which Michelangelo preferred in his youth. The modeling is accomplished through cross-hatchings. The convex parts are left vacant. The density and direction of the strokes determines at the same time the degree of elevation and the degree of lighting of the surface. The lines are longer than in Michelangelo's youth, are for the most part slightly curved, and make apparent in masterly fashion the rounded transitions of the surface. Light and dark are accentuated, but connected with each other by transitions, so that the surface gives the impression of a single wavy mass.

In 1518, Michelangelo ordered a new block of marble, on which he worked in 1519-1520; then Pietro Urbano worked on it in the months of July and early August 1521, and spoiled the work. He was followed by another *garzone*, Federigo Frizzi. Which parts, then, were made by Michelangelo and which by the *garzoni*? The qualitatively best parts of the figure are the torso, especially the abdomen, the back, the arms, and the knees, which we may attribute to Michelangelo. The less satisfactory parts are the drapery behind the left leg (this is especially weak—the folds are without motivation), and the attributes (the cross, the bamboo, the sponge, and the rope); also the face is conventional, as is the hair, especially at the back. All these parts seem to have been executed by pupils. The attributes are made from the same block as the figure. This is easily seen at the points where the bamboo and the cross join the base, and where the cross touches

[89]

the right leg and the hands. It is evident that they must have been planned by Michelangelo, the cross, moreover, having been stipulated in the contract. The original base is a thin strip of marble which was later placed on a second, thicker base, in imitation of a rock; this second base is probably the one made by F. Frizzi and mentioned in one of his letters (XIV, 4).

Apparently, then, Michelangelo reserved for himself the execution of those parts of the nude body that immediately strike the eye of the spectator (his special interest in the body can also be seen in the drawing, where he executed only these parts), leaving the attributes, the drapery, and the head to the *garzoni*. That he was less interested in the execution of the head is not surprising, for at this period he considered the expressive power of the whole body to be greater than that of the physiognomy alone.

The above observations seem partly to contradict the documents. Two letters are preserved which indicate the parts retouched by Pietro Urbano, and these do not completely correspond to the actual differences in quality. On September 6, 1521 (Milanesi, *Corr.*, p. 28), Sebastiano writes that Pietro Urbano "ha scortato el piede drito che si vede manifestamente ne le ditta che lui l'à mozze, ancora ha scortate le ditta de le mane, maxime quela che tiene la croce, che e la drita . . . la barba . . . ancora à moza una nara del naso. . . ." The next day, September 7, 1521 (Frey, *Briefe*, p. 178), F. Frizzi says that "el pie che viene inanzi, le mane tut' a dua . . . e masimamente la marrita [man ritta] e di poi la barba, cioè dala mascela dela gota rita" are by Pietro Urbano. Both letters, written independently, enumerate the same parts (with the exception of one of the nostrils, mentioned by Sebastiano and omitted by Frizzi). Concerning the knees of the figure, Sebastiano is full of admiration, and says: "val più e' zenocchii de quella figura che non val tucta Roma"—that is, he considers them as Michelangelo's work. The right hand, criticized in both letters, and the right foot, to a lesser degree, show the quality of Michelangelo. Consequently, it must be supposed that the artist personally retouched these parts after Pietro Urbano executed them incorrectly. This hypothesis is confirmed by a letter from Leonardo Sellaio, dated January 12, 1522 (Frey, *Briefe*, p. 187): "è vero, voi l'avete [la figura] in alchuno luogho ritocha, dove Pietro l'aveva istorpiata . . ." (XIV, 5).

The motif of the torsion of the figure, with the body turned to the right and the head to the left, a contrast here emphasized by the arm reaching across the chest, is a favorite with Michelangelo and appeared probably for the first time in his lost Giovannino, and somewhat later in the Christ Child of the Bruges Madonna and the Doni Virgin. The motif seems to revert to antiquity (there is a drawing by Pisanello in Milan [Ambrosiana], made after ancient statues, in which a child shows the same motif; cf. Vol. I, pp. 198f). In the Christ of Santa Maria sopra Minerva, Michelangelo emphasized the contrast between the directions of the movement of head and arm. This is, however, only the immediately visible composition of the figure. The opposing lines of movement are at the same time connected to a hidden spiral, which runs around the whole figure three

times. It is still indecisive at the bottom, along the leg, and is clearly developed only in the upper body. It runs its course with solemn slowness and rhythm. This structure overcomes any impression of flatness in the figure, which, indeed, is not built up by parallel flat planes but by rounded planes. It is a true round figure like the Bacchus of Michelangelo's youth. The shape of the base shows that, as in the Bacchus, Michelangelo began the statue not on one of the flat surfaces but at the corner of the block.

The subject is the Resurrected Christ with the instruments of the Passion—that is, the Man of Sorrows. In the northern countries the Man of Sorrows was represented as a bent, miserable figure. Through emphasis on the humiliation and suffering, the attempt was made to symbolize the greatness of the sacrifice. In Italy there existed already in the fifteenth century a more noble conception of the theme. The Saviour was represented as standing erect, with the cross in his hand and blood flowing from his wounds, sometimes into a chalice held by a kneeling angel. The Saviour indicates his wounds with a quiet gesture. An example of this type is Lorenzo Vecchietta's bronze figure in the Cathedral in Siena (on the ciborium); another, Giovanni Bellini's picture in London (National Gallery).

According to the contract (Milanesi, p. 641) Michelangelo was to make "one marble figure of Christ, natural size, nude, erect, with a cross in his arms, in the pose which seems proper to Michelangelo."

Michelangelo followed the contract in the erect, nude figure, with the cross. He added to the cross other instruments of the Passion—namely, the sponge, the bamboo, and the rope. The pose, for which according to the contract he had a free hand, is in fact unconventional: his Christ does not point to his wounds, shed blood, nor display his suffering. An Apollonian nude figure of noble proportions, he stands in contrapposto, holding the instruments of the Passion at the right side with both hands, pushing back the cross somewhat with the right leg, and turning his head in the opposite direction. The meaning of the gesture of the arms and the right leg is clear: he conceals the instruments of the Passion from the multitude; he does not want to remind anyone of his fate. As already in several of Michelangelo's earlier sculptures—for example, the David and the Moses—the two sides of his body are differentiated. The right side (protected by God, according to the mediaeval view) is closed in silhouette; the left side (from which evil comes, according to the Middle Ages) is open.

This is a new conception of the Saviour, who with a noble composure endures and conceals his suffering. The instruments of the Passion are incarnations of this fate, with which Christ here identifies himself. The Man and his fate are here indissolubly bound together, and stand in complete isolation.

This loneliness and stoic composure, this identification of himself with his fate, which he at the same time conceals from the vulgus, may be better understood with the help of a poem, Frey, *Dicht.*, x, in which the artist criticizes the worldly and selfish ecclesiasticism of Rome, and the practice of simony. In contrast to the Christ worshiped in Rome,

where the blood of the Saviour is sold with both hands ("e'l sangue di Cristo si vend'a giumelle"), where helmets and swords are made from chalices ("qua si fa elmi di calici e spade"), and where cross and thorns become shield and lances ("e croce e spine son lance e rotelle"), Michelangelo obviously wanted to set up the image of the true Christ, the Christ of goodness, suffering, and patience. This statue, therefore, has a special significance in a church of Rome. It is a sort of monument commemorating the true Christ in the midst of the city of greediness and corruption.

The poem is signed "Vostro Miccelangniolo in Turchia." For this reason it has been dated 1519 by some authorities, i.e. at the time of Michelangelo's invitation to Adrianople (Springer II, p. 207). Other authorities interpret the word "Turchia" in a figurative sense as meaning apostate Rome, and date the poem in the summer of 1510 (Steinmann, *Sixtinische Kapelle*, II, Reg., 55), or Easter 1512 (Frey and Thode). But in any case it was written before the execution of the statue, a fact supported also by the character of the handwriting, and bears witness to Michelangelo's critical attitude toward the worldly Roman hierarchy.

It is known that on March 10, 1519, Michelangelo commissioned F. Frizzi to execute a tabernacle for the statue according to Michelangelo's plan (Frey, *Briefe*, p. 154). Originally this tabernacle, according to the consignors, was supposed to be built in the church wall beside the door leading into the cloister. Frizzi found, however, that the light was bad there, and therefore advised that the figure should be set up by one of the columns or pilasters in the central nave. The consignors agreed, and Frizzi planned a new tabernacle with a rather shallow round niche, "so that one could see the statue better." A later letter (Frey, *Briefe*, p. 181) tells that he set up the statue near the high altar —that is, near the choir. It was set, however, somewhat too high and he wanted to make a hole in the stone base, letting down into it the small base which is immediately under the feet, so that the feet would be at eye-level and the statue at the same time would stand firm (cf. the second base).

Apparently Michelangelo was dissatisfied also with the second version, for in November 1521 (Appendix No. 41) and January 1522 (Frey, *Briefe*, p. 186) he offered to make a new (a third) statue.

It may also be remarked here that in a letter of June 1, 1532, Metello Vari calls the statue a Resurrection of Christ (Gotti I, p. 143).

In connection with the figure of the Christ in the Minerva, mention must be made of
138 a sheet in the Archivio Buonarroti, No. 101 (Cod. I, fol. 98, page 3), with two red-chalk sketches by a pupil of Michelangelo. At the right there is a figure in the attitude of the Christ of the Minerva, seen from the right side, and at the left a repetition of this sketch without the legs from the knees down. The quiet standing position of the Christ of the Minerva is here somewhat exaggerated (the contrasted torsion of the torso and the head are overemphasized, and the right leg set somewhat more forward), and the proportions are more slender in accordance with the ideal of the late 1520's. By its style, the sketch

must have been made some years after the completion of the statue, probably around 1525-1530. Michelangelo himself went over the outlines of the right leg with fiery strokes; then he seems to have been dissatisfied with the drawing and to have crossed it out. Michelangelo's strokes gave a completely new accent to the motif of the Christ of the Minerva, which had already been greatly modernized by the pupil. The new contours lengthened the leg, abolishing the original proportions, so that the torso and head seem smaller by comparison. The new leg dominates the whole figure and emphasizes its vertical axis, whereas in the prototype the gradual spiral movement of the body was effective. The outline is no longer a rhythmical enclosing of the form, as in the drawings from the period of the Sistine Ceiling, but a dynamic accompaniment of a flowing movement of the mass. This prepares the way for the group of the Vittoria (Florence, *137* Pal. Vecchio), in which group the effective force of the vertical axis and the predominance of the supporting leg is raised to a principle of composition. (With the exception of the advanced right leg, there is a correspondence in mirror image between drawing and statue.) The vertical in the group, to be sure, is carried out even more consistently. The outward and inward swingings of the contours in the drawing have vanished. The form of the leg is transformed into a continuously broadening movement of growth upwards from the narrow supporting base of the foot.

The Christ of the Minerva had a great reputation in the sixteenth and seventeenth centuries, as attested by the many copies made from it (xiv, 8). None of these captured the true spiritual content of the figure, its noble reserve, and its stoic acceptance of fate. It is nevertheless interesting to compare these copies with the original. The earliest is probably that of Beatrizet, an engraving made between 1540 and 1550. In the pose this *236* is a quite accurate copy. Beatrizet transformed the modeling of the body according to the taste of the mid-sixteenth century. Where in Michelangelo's work the modeling was rich in transitions and nuances, here the surface of the body has fallen into isolated groups of muscles, as if it were a sack full of nuts. The face has taken on a sentimental expression. The loin cloth, witness of the prudery of the Counter Reformation, was added in all copies without exception. Although the movement is exactly reproduced, the inward unity of the figure and the attributes is loosened by the treatment of the light. The figure is lighted and the cross is in shadow, a first step toward isolating the figure and the attribute.

Somewhat later (1579) is the copy of Taddeo Landini in Santo Spirito (Florence). *237* Again the pose is quite accurately copied, but now the proportions of the body become slimmer, more elegant, idealized according to the Mannerist ideal of beauty. It is noteworthy that the whole richness of modeling is now suppressed; the surface of the body has become almost flat. The face has been given a sweet expression.

A further step in the direction of elegance can be seen in the little bronze copy attrib- *238* uted to Pietro da Barga, in the Bargello. The artist moves the cross somewhat away

from the figure, thereby losing the sense of the unity of the block, and emphasizing by the contrast to the straight outlines of the cross the elegant contours of the slim right leg, which without motivation is raised on tiptoe. It is almost the movement of a dancer, as if the figure were about to make a step forward to display the cross. Thus it is the exact contrary of what Michelangelo intended: exhibition of the cross instead of concealment. The face has been given an amiable expression.

A similar separation of cross from figure is found in a somewhat later copy by an unknown artist in the Certosa di Pavia. Finally may be mentioned the copy by Prospero Clementi in the Cathedral of Reggio Emilia (reproduced in Venturi, *Storia*, x, 2, p. 564). Here the touching of the cross is transformed into the pathetic style of the early Baroque.

To summarize, the development in Italy proceeds from Michelangelo's solitary figure, which forms a mysterious unity with the instruments of the Passion, to a Christ who shows the cross to the people.

In the northern copies, on the other hand, the internal unity between Christ and the cross was preserved. Here the noble reserve of Michelangelo's figure was felt as unsatisfying, and the spiritual expression was exaggerated into the pathetic and theatrical. The known northern copies are all from the seventeenth century, later than the Italian, and this fact also explains in part the more decided transformation into the Baroque style.

239 The earliest, rather exact, northern copy is an engraving by Jacob Matham, pupil and stepson of Goltzius. Matham was one of the engravers of Rubens' compositions, and the influence of Rubens' bodily ideal is clearly visible in his work. The motif is taken over exactly, but since the figure is reproduced in perspective from below, the contrast of the double torsion is even more marked. Instead of the hard substance of the body, full of tension, the figure seems to be formed from flowing soft dough, whose surface is enriched by waves of muscles. The latter are no longer isolated, but pass by fluid transitions into one another. Pathetic pain in the expression of the face is a transformation according to the heroic ideal of Rubens. The statue directly influenced Rubens (cf. Thode, *Kr.U.*, II, p. 269; Rooses, *L'œuvre de Rubens*, II, Plate 132).

241 A second copy is by Jérome Duquesnoy, on the grave of Cardinal Antonius Triest, made in 1654-1657 (Ghent, Saint-Bavon). This copy was possibly based on Beatrizet's or Matham's engraving, because it also shows the figure in mirror image. The attitude of the left hand and the left leg is now changed. The figure clasps the cross tenderly. In the bowed head, the expression is one of pity and suffering. The treatment of the body is again soft and without tension. This statue already presupposes the style of Rubens, which it modifies, however, in accordance with a classical ideal.

242 Finally a northern copy, by an unknown artist of the end of the seventeenth century, is preserved in Bruges (Cathedral of Saint-Sauveur). This is greatly different from the prototype. The body is slender, bent in a melodious curve, the face has a pathetic, sweet expression; the figure wishes to please the spectator, and shows its feelings theatrically.

The Christ of the Minerva is one of the less outstanding works of Michelangelo. However, it is historically important as the earliest example of a new conception of forms, which Michelangelo was to develop to the full in the figures of the Medici Chapel. The connection of the powerful torso with a small head and delicate extremities, characteristic of his sculptures of the 1520's, appears here for the first time. Moreover, it is important as a document of Michelangelo's religiosity: this image of the true Christ, erected in the middle of the secularized Papal city, may be considered as an artistic counterpart to Pico della Mirandola's address to Leo X concerning the reform of ecclesiastical morals, presented to the Pope in the spring of 1517. And since Santa Maria sopra Minerva was a Dominican church, it might be supposed (cf. Thode, II, p. 322) that this image of the true Christ was made in remembrance of Savonarola, the Dominican friar.

71-76 FROM its style, this figure appears to have been executed in the middle of the 1520's. It belongs to approximately the same stylistic stage as the Crepuscolo and the Aurora, and does not yet show the slender proportions characteristic of Michelangelo's works around 1530. The designation of the figure in the sixteenth century both as David and as Apollo may well be explained by the fact that Michelangelo originally began the figure as a David and later decided to change it to an Apollo (xv, 2).

A mound below the right foot is apparently the uncompleted helmet of Goliath. The raised left hand seems originally to have held the sling, and the right hand probably the stone. (Whether Michelangelo intended this David for the upper left niche of the Mag-nifici tomb, as Popp assumes, is questionable, since only in the free paraphrases of the

218-221 Magnifici tomb are niche statues located above the statues of Sts. Cosmas and Damian.

90, 91 In the two sketches of the Magnifici tombs by Michelangelo himself, Nos. 58 and 59, there are no niche statues above the saints.)

About 1531 (cf. letter of Valori, Frey, *Briefe*, p. 324), when Michelangelo was asked to present a figure to the governor of Florence, he apparently wished to transform

74 this David into an Apollo. He began to rework the crude marble at the back of the fig-ure into a quiver, so that the raised left hand would now be drawing an arrow. Vasari in his second edition already interpreted the movement in this sense, and in a drawing at-

272 tributed to Rosso Fiorentino (New York, Collection János Scholz), which is an exact copy of the figure, the object on the back is clearly a quiver.

This is a variation of the spiral structure of the Christ of the Minerva. The left leg is the supporting leg in both figures; the torso, with the left arm reaching across the chest, is turned toward the right, and the head in the opposite direction. But also characteris-tic modifications are present: the right leg is now placed higher, the left arm is raised to the level of the neck. The right arm now runs parallel to the body. The turning and in-clination of the head is stronger. The spiral goes from the left foot over both knees and the right hand to the back, comes to the front again with the left arm, and is completed in the head. The figure is unconscious of its movement, and is isolated, in contrast to the consciousness and solemnity of the Christ of the Minerva.

Also the modeling of the surface is unified in comparison to the Christ of the Mi-nerva. The individual groups of muscles are subordinated to a softly fluctuating surface. (This unity of modeling, to be sure, is also in part due to the unfinished state of the work.) The light and the shade vibrate softly on the continuously modeled but unpol-ished surface, the texture of which is determined by the toothed chisel work. As a result of the summary treatment, the statue seems to be standing in the remote distance: it emerges like a vision.

Completely different from the earlier statue is the expression of the figure. Like the Allegories of the Medici Chapel, it is conceived not as an animated body, but as the in-

carnation of a psychic state. Instead of a normal standing position, based on the physical laws of the body, the position here is of one tossing in his sleep. The gestures seem to be unconscious reflexes, like those of a dreamer trying to drive away a nightmare. The repelling movement of the arm seems to draw after it the movement of the right leg. Freed from the physical surroundings, the figure lives in its own dream-space. A dreamy expression characterizes also the averted face. It is kept quite general in form, without individual details. Only the principal forms are marked, with utmost simplicity. All the more eloquent is the effect of the half-closed eyes and the slightly parted lips. Completely under the spell of his dream, the outer world seems not to exist for him.

If one considers that the statue was given to the hated Governor of Florence, Baccio Valori, in Michelangelo's deep humiliation, this strange conception of the theme of David as a dreamer who wants to free himself from a nightmare acquires a specific meaning. This is not David as incarnation of the civic virtues of "Fortitudo" and "Ira" (Marble David) nor as personification of the triumphant power of youth (Bronze David), but it is the representation of a victor who is ill at ease from having been victorious, who is haunted by inner torments, trying to ward off with his arm the bad dreams. This victor is vanquished by his own melancholy. Did Michelangelo desire to create in this figure a symbol of the psychic state of the new victor? One may also ask whether the ambiguity in the designation of the statue as David and Apollo may not be explained by the fact that the name David alone would have been too obvious an allusion.

The fact that form and movement seem determined completely by the dreamlike inner psychic state of the figure is characteristic of the period of the Medici Chapel. But the David-Apollo, with its forms only suggested and hinting at the intangible, is perhaps even more impressive than the somewhat more fully executed statues of the Medici Chapel.

XV. THE GROUP FOR THE PIAZZA DELLA SIGNORIA

(Hercules and Antaeus; Hercules and Cacus; Samson and the Philistines)

ON THE Piazza della Signoria in front of the entrance of the Palazzo Vecchio, and as a counterpiece to Michelangelo's marble David which had stood there since 1504, the government of the Florentine Republic wanted a second gigantic statue, executed also by Michelangelo, and representing Hercules "per essere l'uno e l'altro, e Davitte ed Ercole, insegna del Palazzo" (Vasari 1568, p. 365). Both statues were supposed to be symbols of the "governo giusto" which ruled in republican Florence: David, a symbol of valiant readiness for defense of the people against external enemies (Vasari 1568, pp. 49ff); Hercules, a symbol of the subduing and conquering of internal enemies of the "governo giusto." From ancient times Hercules had been considered as a protector of the city, and since the end of the thirteenth century he had been pictured as such on the seal of the city of Florence. The inscription of the seal gives the precise sense of the symbolic significance of Hercules as the protector of Florence: "Herculea clava domat Fiorentia prava" (the club of Hercules subdues the depravity of Florence).

In another place it has been demonstrated (cf. Vol. I, p. 94) that Michelangelo's marble David was invented already according to the ancient Hercules type, and that the figure expressed Fortitude—that is, above all, moral fearlessness and strength. The counterpiece, the Hercules, was to represent the actual victory over internal enemies, emphasizing, above all, physical strength. Both statues, David and Hercules, are only personifications of two aspects of the same idea of the "governo giusto."

The realization of this task, set by the republican city-state and a symbol of that city-state, would of course be close to the heart of Michelangelo as a Florentine patriot and a Guelph. In fact, he made every effort to gain the commission for himself when his right to it was contested, but in the end it turned out otherwise: the commission was taken from him and given to his archenemy, Bandinelli. But this final decision was only the last chapter of a struggle lasting almost a quarter of a century between two historical-political powers, the city of Florence and the Medici Popes. In the conflicts and tensions are reflected, in abbreviated form but with extraordinary sharpness, the contradictory tendencies of the republican Florence on the one hand, and on the other the world power of the Papacy—which wished to suppress the sovereignty of Florence and so wanted to prevent its symbolization by the most popular and greatest son of the Florentine city-state. The Medici Popes sought to hinder his execution of this work precisely because of its political significance. In their view, it threatened to become a declaration in stone of the Florentine urge for independence, which they wanted at all costs to suppress. At the same time, they were aware that it would have been undiplomatic to prevent entirely the erection of a Hercules before the Palazzo della Signoria, and thus to oppose the will of the people. A compromise seemed to be indicated. They agreed to let the monument be executed: not, however, by the republican Michelan-

gelo, but by an artist hated in the city, an artist whose opportunism was well known, Baccio Bandinelli. A Hercules statue by Bandinelli, the Medici Popes doubtless thought, would contain no threat to the power of their house. But apart from these political considerations, the Curia wished, already under Julius II, to secure Michelangelo for the glorification of the Papacy and to release him for no other task. The final granting of the commission to Bandinelli, after the fall of the last Florentine Republic, is a testimony to the victory of the Medicis over the will of the Florentine people.

The earliest reports concerning the project are the letters of Pietro Soderini, Gonfaloniere of the Republic of Florence, admirer and friend of Michelangelo. In May 1508, he asked that a marble block be reserved in Carrara for the statue for the Piazza in Florence, which, as we learn by a later letter from him, was to be executed by Michelangelo. It is consequently clear that the idea of the commission came from the government of republican Florence. It is to be supposed also that Michelangelo would have accepted this commission with enthusiasm, but he was at that time in Rome in the service of Julius II, and according to another letter, the Pope refused to let him go to Florence or to Carrara. Whether political considerations already influenced the Pope's decision, or whether it was simply jealousy, not wanting anyone else to have Michelangelo's services, cannot be determined. So much is clear, that already at the very beginning of the history of this project there was a conflict between the two opposing political powers—a conflict of which Michelangelo became to some extent a victim, being in the service of the Pope and thus not free to follow the dictates of his heart.

About 1515, the block was quarried in Carrara, and Michelangelo sought to win the favor of Pope Leo X and Cardinal Giulio in order to obtain the commission. At that time, Florence had again been under the rule of the Medici. But Leo X, in 1515, commissioned Bandinelli to execute a Hercules, "vicino al Palazzo, sotto un arco della Loggia [dei Lanzi]," nine and a half braccia high. Bandinelli wished to excel Michelangelo's David in this figure, as he himself boastfully narrated. The figure was unsuccessful, however, and Bandinelli damaged his reputation in the eyes of the citizens of Florence (Vasari 1568, p. 365). It should be noted that this Hercules by Bandinelli was not made from the block destined for the companion piece of the David, but the fact that Leo X commissioned this provisory statue from Bandinelli indicates that he already intended to commission the definitive statue from him later, and to give him the large block for that purpose.

Ten years later, in 1525, the conflict between the Medici Pope, now Clement VII, and the will of the Florentine people was renewed. In that year, indeed, Clement VII gave the commission to execute the block to Bandinelli, who he must have known was despised in Florence (cf. Vasari 1568, p. 367). At the same time, however, the Signoria approached Michelangelo and declared that it was the general desire of the Florentine people that he should make the statue. The commission was so close to the artist's heart that he offered to make the Signoria a present of the statue if the Pope

[99]

would release him for the work (Milanesi, p. 452). Then, however, Clement VII warned Michelangelo that he must work for him alone (Cambi, and Frey, *Briefe*, p. 266), and had the block turned over to Bandinelli.

In 1528, shortly after the expulsion of the Medici from Florence (in 1527), the republican government decided that the block, which in 1525 had already been begun and roughly hewn to about half the height of the Hercules by Bandinelli, should be taken from him and given to Michelangelo, with the stipulation that he should make of it two figures however he wished. According to Vasari, Michelangelo at this time changed his plan and decided to make a Samson with one Philistine, but soon it was impossible for Michelangelo to continue the work because of the approaching danger of war between Florence and the Pope, who was aided by the imperial armies.

After the fall of the Florentine Republic in 1530, when the Medicis ruled again, Clement VII ordered Bandinelli to execute the group, which was unveiled May 1, 1534. Apparently even during this period, Michelangelo did not resign himself to defeat; he made a last project, Samson with two Philistines, but it is not likely that he had an opportunity to show it to the Pope.

Thus the final commission of the group to Bandinelli was a further index of the victory of the Medici over the sovereign will of the Florentine people and its exponent, Michelangelo (XVI, 1).

The commission was for a gigantic group in marble, in contrast to Michelangelo's youthful work of Hercules, which was a single figure (today lost, cf. Vol. 1, pp. 197*ff*). Thus the two works have artistically nothing in common.

The artistic task of creating a standing free-statue group composed of two figures of equal value was something new for Michelangelo. (The Bacchus and the Bruges Madonna are not group compositions in this sense, because each contains only one principal figure; and the artistic problem of the Pietà in St. Peter's, the only earlier group made up of two equally large figures, is completely different because one of the figures is seated with the other outstretched on her lap, so that the problem of the connection of the two bodies is simplified.)

The standing free-statue group in marble had no important tradition in Italy during the early Renaissance. All the important marble statues were isolated figures, and the relatively few group statues were mostly executed in bronze. The task of hewing out two figures of equal size from a marble block was so complicated that it was avoided as far as possible.

The problem of connecting two equally large figures was solved in the fifteenth century by simply placing the figures side by side or one behind the other (cf. Donatello's Judith, Verrocchio's Christ and St. Thomas—both in bronze). Even where the subject matter suggested a more intimate connection of the two figures, as in the theme of Hercules and Antaeus, the artists of the fifteenth century preserved the isolation of the two

bodies. The connection is brought about in a purely external manner, through the motif of embracing. The total silhouette, with the widely outstretched legs of the Antaeus, is open. (Examples: the Hercules and Antaeus groups of Pollaiuolo in the Bargello, and his painting in the Uffizi; of Francesco da Sant' Agata [Bode, *Kleinbronzen*, no. 75]; of Antico, Vienna, Kunsthistorisches Museum [Bode, *op.cit.*, no. 31]; and various other small bronze groups by unknown masters [Bode, *op.cit.*, no. 88].) In none of these works are the two bodies intertwined so as to be fused into a higher unity, and subordinated to a closed silhouette. This intertwining of the two bodies in a spiral form is the new element in Michelangelo's projects for the Piazza della Signoria, an *139, 140* element which was to have important consequences. The artist seeks to present to the eye the highest degree of movement and plastic richness, at the same time preserving the continuous transitions of the rounded planes and of the closed silhouette. Approaches to this kind of composition can be observed, as stated above, in Michelangelo's youthful works, the Bacchus and the Doni Madonna, but the principle is only fully developed in the isolated statues treated in the preceding chapters and in this group. It is the characteristic both of Michelangelo's drawings for this group (Nos. 91 and 92) *139, 140* and of the two models (Casa Buonarroti, and Samson and Philistines preserved only in *274-278* copies). It is important to note that the rising spiral movement in all the drawings and models encounters an equally strong movement in the opposite direction: the energies remain imprisoned within the frame of the group, and no free escape of energy at the top is permitted.

Michelangelo's development of this idea between 1508 and about 1530 can be followed in the projects, in one original model, and various copies.

Nothing is preserved of Michelangelo's *concetto* in 1508, when the project was first proposed. Although Vasari suggests that it was a question of a Hercules and Cacus, it seems more probable, as will immediately be shown, that Michelangelo at that time wished to make a Hercules and Antaeus. The group representing a father with his dead son in his arms in the second plane of the Deluge of the Sistine Ceiling seems to be a *Vol.* II, *37* modified version of the lost first project. (Naturally it must be supposed that the embraced figure who in the fresco, as the dead son, is completely passive must in the original group, as Antaeus, have defended himself actively.) That the motif in the Deluge is a modification of a plastic *concetto* inserted into the fresco is suggested by the isolation of the group in the composition and its statue-like structure. As in the group compositions of the Quattrocento, this first version of Michelangelo was still developed in parallel planes; as there, the two bodies are not yet entwined, so that the revolving movement is lacking. But in contrast to the earlier groups, where as stated above the silhouette is spread out widely, Michelangelo's group seems to form a closed compact mass inscribed in the rectangular shape of the marble block (XVI, 2a).

For the second version of 1525, there are preserved three rapid sketches, two on No. *139, 140* 92 and one on No. 91. These sketches show the decided transition from the group

conception conceived in parallel planes of the Sistine period to a spatially three-dimensional plastic conception, attained by the intertwining of both figures into a sort of
139 spiral. The earliest sketch seems to be No. 92, left. Pollaiuolo's motif (derived from antiquity) of Antaeus pressing his hand on the top of Hercules' head to defend himself, is adopted here; however, the two figures form a compact mass, the legs of Antaeus violently encircling the body of Hercules, and the upper body twisting away: Antaeus coils around Hercules like a snake. The spiral movement upward is, however, closed off by a contrary movement in the arm of Antaeus which pushes Hercules' head down-
140 ward. In No. 91, the latest of the sketches, where the motif of Hercules is identical, the doubly twisted Antaeus forms together with Hercules a great spiral. In both cases, as in the version of 1508, the composition is planned for a rectangular block. These are bold inventions of a new sort of group composition in spiral form, which, as will be shown, had great influence on the group statues of the late sixteenth and early seventeenth centuries (XVI, 2b).

In spite of the closed silhouette, neither the version of 1508 nor that of 1525 is suitable for execution in marble, for the two feet of Hercules would not form a sufficiently solid base. This consideration must have led Michelangelo to give up the subject of Hercules and Antaeus in the third version of 1528, and in place of it to turn to Hercules and Cacus or else Samson with one Philistine, which would permit, by a downward shift of the center of gravity, a more static and solid construction, better adapted to marble. The adversary now lies on the ground, and himself forms a sort of base. This
274-276 idea appears in the original clay model of the Casa Buonarroti, representing Hercules and Cacus or Samson Fighting a Philistine, which probably should be identified with the version of 1528. The vanquished one cowers now on the ground, embracing the legs of the victor. The torsion of the body of the vanquished is the beginning of a spiral which is continued in the figure of the victor. This is obviously a further development of the sketch No. 91, adapted, however, to the requirements of a marble group. In con-
137 trast to the group of the Vittoria, both the figures are now included in the spiral composition, whereas in the Vittoria the cowering figure was frontally composed, a fact which speaks against the hypothesis that the clay model represents a companion piece to the Vittoria for the Tomb of Julius II, and in favor of the hypothesis that the clay model is related to the group of the Piazza della Signoria (XVI, 2c).

The last version, the date of which is unknown, but which was probably made around
277, 278 1530, is known only through copies, and represents Samson with two Philistines. It is a further development of the idea of 1528. The group again is composed in a triangular block, as in 1528, of which the proportions, however, are different. Putting two vanquished below the victorious Samson, Michelangelo secures to the group statically even more solidity than in 1528. All three figures together form a spiral movement, which this time turns in the opposite direction, from right to left. In the arm of Samson, raised for the blow, there is again a countermovement (XVI, 2d).

[102]

In order to appreciate properly the boldness of these *concetti* in the plastic art of the period, it is sufficient to compare them with the executed group by Bandinelli, which stands at the Piazza della Signoria. The principle of construction of Bandinelli's group is still completely Quattrocentesque: the figures are not yet bound by a spiral; instead of continuous rounded planes, parallel planes in gradation are used. Even Vincenzo Danti, who made Michelangelo's theory of art the basis of a treatise, is in his two groups, which were created under the influence of the Vittoria, still completely retrospective (Honor Conquering Infamy, Bargello, and Virtue Subduing Vice, Bargello).

In Giambologna's works, however, there is a conscious use of the revolving movement of Michelangelo's compositions (cf. his Virtue Overcoming Vice, Bargello, and Rape of the Sabines, Loggia dei Lanzi and Naples, Museo Nazionale). In these groups the upward spiral is adopted, but Giambologna lets it come freely and unhindered to a culmination at the top; also the silhouettes of his groups are not closed in a blocklike way, but formed into ornate branches, as it were, by outreaching extremities. The idea of the revolving group with free termination of the upward movement is still predominant in Gianlorenzo Bernini's Pluto and Proserpina (Rome, Galleria Borghese); but in Bernini there appears also the genuine high Baroque group, no longer composed from the mass of the body, but from the optic interplay between space and bodies, where the spiral movement is abandoned (e.g. the Vision of St. Theresa, Rome, Santa Maria della Vittoria; and the Prophet Habakkuk, Rome, Santa Maria del Popolo). The group composition inaugurated by Michelangelo disappears now, to return once more in the early eighteenth century.

After the solemn and noble revolving figure of the Christ of the Minerva, after the dream-enveloped, unconscious movements of the David-Apollo, follows the group of the Piazza, where the spiral movement is the expression of the most violent exertion and most concentrated will of two adversaries, and where nevertheless the two figures finally become a higher super-personal unity, an expression of the eternally struggling life force itself. Thus the spiral serves, in each case, a different theme.

XVI. THE ASCENSION OF CHRIST

IN THE Archivio Buonarroti, on the verso of a letter by Bartolomeo Angiolini of
September 1532, there is a drawing of the Ascension of Christ, No. 113 (XVII, 2). The
Christ of this drawing was developed later by Michelangelo (in mirror image) in one
of the ascending souls of the Last Judgment: the figure at the left edge of the second
zone of the fresco.

The figure of the Ascension sketch shows an expression of rapture. A kind of whirl-
wind, rising from below, seizes the body, throwing it off its original course of move-
ment—indicated by the extended left leg—bending back the torso and hurling the right
arm up in front of the face, as if it were pulled up by an invisible hand. So violent is
this movement that the right leg is jerked upward as if by an involuntary reflex.

The figure is drawn *dal di sotto in su*, an indication that Michelangelo planned the
Ascension for a high place. It is apparently a first draft for a monumental fresco. Since
there is another Ascension drawing on the verso of the plan for the reliquary balcony
of the entrance wall of the Church of San Lorenzo (XVII, 1), it is tempting to suppose
that Michelangelo intended this composition for the large lunette of the entrance wall,
above the reliquary balcony. As it is, this delicate balcony is an inadequate crowning
for the two gigantic Quattrocentesque columns. Its miniature scale would be justified
only if it had formed, as it were, an attica-like transition between the lower zone and a
large fresco in the lunette. A painting in the lunette would have meant that the entrance
wall was crowned as a whole, in typical Michelangelesque fashion, by a weighty head-
piece. It is known from the correspondence that the Pope intended that the walls of the
choir of San Lorenzo should be decorated by frescoes. It is altogether possible that at
the same time he conceived the plan of having the lunette over the entrance wall also
adorned with a wall painting (cf. Frey, *Briefe*, pp. 272, 274). Iconographically it would
have been an innovation to place the Ascension on the entrance wall, which was tradi-
tionally reserved for the Last Judgment. For Michelangelo, however, who shortly after-
wards painted the Last Judgment on the altar wall of the Sistine Chapel, such a disre-
gard of tradition is entirely possible.

The drawing of the Archivio Buonarroti was the model for a free copy now in the
Casa Buonarroti (on the back of Frey, *Handz.*, 20, the sketch for the whole composition
of the Last Judgment). The extended left leg and the greatly shortened and twisted
torso have been repeated from the earlier sheet. The other members are changed. The
raised right arm reaches aloft and forms a continuation of the extended left leg; the
bent right leg is no longer shown in frontal view, but in three-quarter profile. The con-
trasts are toned down. The movement has become more unified. The spiral which goes
through the figure of the Archivio Buonarroti has been transformed into a unified
vertical movement.

The sketch of the Archivio Buonarroti seems also to have been the prototype for the

[104]

Ascension of Christ by Giorgio Vasari in Santa Maria Novella. The spiral movement is eliminated. The figure stands on a cloud; the raised hand imparts a blessing. The figure is changed into a devotional image for public worship, whereas Michelangelo's drawing embodied the solitary psychic drama of rapture. The manner in which Vasari departed from his prototype is characteristic of the spirit of the art of the Counter Reformation.

XVII. THE LEDA

AFTER the four spiral compositions of the period of the Medici Chapel, there remain to be considered the two compositions with reclining figures. Both are variations of motifs which Michelangelo had already created in certain statues of the Medici Chapel.

279-285 The Leda was originally made by Michelangelo for Duke Alfonso I d'Este, for one of the rooms in his ducal palace. The painting was commissioned ca. July 1529, finished ca. October 1530. Michelangelo first made a cartoon, then himself executed the painting in tempera on panel. The eventful story of the cartoon and painting, which Michelangelo finally refused to deliver to the Duke and gave instead to his *garzone*, Antonio Mini, is narrated in the notes (XVIII, 1).

22 Compositionally, the Leda is closely related to the Notte; both works go back to the same ancient prototype. The reclining position in profile, with the bent, upraised left leg, the torso describing a curve, with bent head, correspond in both works. It is noteworthy that Michelangelo represented Leda with closed eyes and passive hands. Also the entire silhouette of the Leda has been given the quality of an "arabesque," through emphasizing the beauty of the rhythmic contours. In two respects the artistic problem was different from that of the Notte. Formally it was no longer a question of a counter-piece, but of a work complete and balanced within itself. Moreover, the problem here was to compose the figure together with the swan. Michelangelo rounded out the work to a self-sufficient unity by representing the left arm as hanging down from a high cushion, thereby extending the silhouette and creating a kind of formal balance to the left leg. The content seems to have determined the abandonment here of the double torsion of Notte, rich in tension—an expression of the inability to find rest in sleep. The Leda sleeps in relaxation, the torso in pure profile, the legs, turned away somewhat, enclosing the body of the swan. The swan seems to be an incarnation of the dream of the figure. The attitude of the arms and the hands shows that the figure sleeps in solitude. This is precisely the innovation as against the ancient prototype. In the ancient sarcoph-
281 agus reliefs and gems, the mythical action is presented as an external physical event (XVIII, 3). The swan lights with outspread wings on Leda, rounding off her silhouette. He is of equal value with Leda. In Michelangelo's work, however, Leda predominates, the swan seeming to take on form only secondarily, so to speak, as a sort of fulfillment of her dream wishes. The mythical event is transformed into an inner psychic process.

The representation, so obviously sensual and daring in its subject matter and objective motif, is, in consequence of the seriousness of the face and the sense of deep loneliness surrounding the figure, removed into the sphere of austere purity. The action is spiritualized, because physical love is conceived as merely a reflex of an internal dream-event, and it is at the same time removed from the earthly and elevated to the universally valid and eternal, by means of the statuesque unchangeable pose and the marble substance of the body. Michelangelo renounced the sensual beauty of the epidermis,

and the transitoriness of movement: he has created an archetype of the act of love. The representations of the reclining Venus by Giorgione and Titian shows the sensual conception of a similar theme. The nude female figures of the Venetian artists are conscious of their seductive beauty, and offer the splendor of their flesh.

Love and night were synonyms for Michelangelo, and there is probably no better explanation for the content of this picture than the verses which the artist himself wrote on this theme (Frey, *Dicht.*, LXXVIII):

> "O nott', o dolce tempo, benchè nero,
> Con pace ogn'opra sempr'al fin assalta.
>
> .
>
> Et dall'infima parte alla più alta
> In sogno spesso porti, ov'ire spero."

With regard to the prolepsis, the verses, Frey, *Dicht.*, CIX, 20, may be quoted:

> "Ma l'ombra sol a piantar l'uomo serve.
> Dunque le notti più ch'i dì son sante. . . ."

Not only the expressed idea, but also the solemnity of the rhythm and the holy purity of the conception in these verses correspond to the painting.

XVIII. VENUS AND CUPID

AFTER the Leda, Michelangelo once again dealt with the theme of love, in a cartoon for a Venus and Cupid, which he made about 1532-1533 for his friend Bartolomeo Bettini, who then had the cartoon executed as a painting by Pontormo (XIX, 1). The original cartoon and Pontormo's painting are lost, but the idea can be reconstructed on the basis of an original sketch, a copy of the cartoon (Naples), and several copies of Pontormo's painting.

In the Leda the act of love was sublimated as a dream-event. In the Venus, the theme is the psychic process of falling in love—that is, love's attack on the heart ("assalto d'amore").

In the small rapid sketch (No. 122), which seems to be the first *pensiero* for this painting, the outstretched figure of Venus is in the pose of one of the river gods of the Lorenzo tomb. It has masculine forms. This fact does not contradict, however, the interpretation as a Venus, because it is known that Michelangelo almost always drew his female figures after male models (cf. the drawings for the Libyan Sibyl, Oxford and New York). The small left-hand figure is clearly characterized as Cupid by its wings. The supposition that the sketch represents David and Goliath should therefore be abandoned. In the sketch, Cupid approaches Venus, who seems to make a gesture to repel him, thus representing the defense against the attack of love suggested in some of Michelangelo's love poems; for example, Frey, *Dicht.*, XXIV: "Fuggite, amanti, Amor, fuggite 'l fuoco;/ L'incendio e aspro, e la piaga e mortale. . . ." The beauty of the composition of this little sketch lies in the symmetrical rounding of the great curve described by the outstretched figure, through the figure of Cupid. In an equilibrated composition, tension is incarnated.

In the painting the tension between the approaching Cupid and the defensive gesture of Venus is abandoned. The little Cupid has already attacked Venus; approaching from behind, he has climbed up on her body and embraces her. This attack is only a symbol of what has actually happened to Venus. She twists on her couch, and points with the index finger of her left hand to the inner wound in her heart. With the other hand she points to the altar of love, which completes the composition at the left as the Cupid had done in the sketch, and whose symbolic objects seem to make visible the consequences of love. Bow and arrows symbolize the wounds which love inflicts; the roses in a vase, the transitory nature of its joys; the masks, probably, the deceptiveness of the joys; and the outstretched boy lying inside the altar, death by the wounds of love.

The painting was intended to adorn the middle of one of Bartolomeo Bettini's rooms, whose lunettes were supposed to contain three pictures by Bronzino, representing Dante, Petrarch, and Boccaccio, i.e. the portraits of the poets who sang of love in *lingua toscana* (Vasari 1568, p. 376). Michelangelo's Venus seems consequently to represent the love goddess of the Tuscan poets.

She is a heroine of powerful bodily structure. Beauty is here united with strength and magnitude. There is nothing of the gracious and charming quality of Venus as represented by the earlier Florentine painters, Botticelli and Piero di Cosimo. Seriousness, even suffering, is mirrored in the face, and a holy austerity in the body. Inwardly wounded and at the same time tense with the emotion of love, she holds herself in a strangely hovering position. This is not a representation of the *amor purus* of religious-spiritual love, nor of the *amor mixtus* of sensual love, the *voglia sfrenata*, as Michelangelo calls it (Frey, *Dicht.*, LXXIX, verses 12-14). It is rather the moment before the differentiation into spiritual and sensual love, the moment of being wounded by love as a cosmic force. It is the conception of the glow of love as a psychic tragedy which fetters the free human being, a conception of which Michelangelo sang in many of his poems, e.g. Frey, *Dicht.*, XXIV, XLII, LXI. The sketch and the painting show two phases of one and the same process: in the sketch, defense against the attack of love; in the picture, surrender. But even in surrender, the soul seems to be filled by a high emotion; the painful wound lifts the heart to metaphysical heights.

XIX. *NOLI ME TANGERE*

WHEREAS the cartoons of the Leda and the Venus are so closely related to certain figures of the Medici Chapel that they can be considered variants of the latter, Michelangelo reverts in his cartoon for the *Noli me tangere* to a compositional pattern used already in the Sistine Ceiling.

The cartoon, which Michelangelo had to execute at the request of the Governor of Florence, Nicolas von Schomberg, for one of the commanders of the imperial army, Alfonso Davalos, was finished in the autumn of 1531. By the wish of the master, Pontormo (the same young Florentine artist who also executed the Venus) was to do the painting in Michelangelo's workshop. This last condition obviously means that he was to paint under Michelangelo's supervision. Michelangelo apparently executed the commission without enthusiasm, for he is said not to have "fornito a suo modo" the cartoon, and to have made it "in furia." Possibly he was reluctant, as a Florentine republican, to deliver a work of his own hand to the commander of the hostile and victorious army. On the other hand, he could not decline the commission, since he was in the service of Clement VII, and since the new governor applied personally for the execution of the cartoon (xx, 1).

In view of the fact that the cartoon was made for Alfonso Davalos, the Marchese del Vasto, it may be asked whether Michelangelo, in the choice of the theme, did not also think of a political significance, in addition to the religious content. Was the picture not intended to be a sort of warning that occupied Florence was not to be touched by sinful hands?

290, 291 The cartoon is now lost. Only two copies, one by Battista Franco, the other from the workshop of Pontormo, give a vague idea of the composition (xx, 2). The figures in these two copies are identical except for slight variations in the drapery, and probably go back to Michelangelo. The landscapes differ in the two copies: that of Battista
291 Franco is a copy after Dürer's engraving of St. Eustachius; that of the workshop of
290 Pontormo shows a view of the walls of Florence.

Magically attracted, the Magdalene approaches the vision of Christ with the uncertain steps of a somnambulist. She spreads out her arms as if she wished to embrace the Saviour, who however seems to withdraw with a repelling gesture, and is to her unattainable. In earlier treatments of this theme, the Magdalene kneels on the ground. In Michelangelo's composition, the magical attraction of the two figures is developed from the Creation of Adam in the Sistine Ceiling. In the gesture of Christ there is also probably a reminiscence of earlier representations of the Virgin in the Annunciation (cf. Botticelli, Annunciation, Florence, Uffizi). The broad format of the earlier compositions is transformed into a tall format, corresponding to Michelangelo's predilection for slender proportions about 1530.

In itself a relatively unsuccessful work, the cartoon of the *Noli me tangere* is the first great devotional composition by Michelangelo, a type of picture which is particularly significant in the last phase of his development.

[110]

XX. DRAWINGS FOR CAVALIERI

MICHELANGELO made several drawings for his friend Cavalieri in 1532-1533. According to Vasari (1568, pp. 245f), these sheets were supposed to serve as models, so that Cavalieri by their aid could learn to draw. This immediate purpose may in part explain the strangely cool, objective treatment of the forms. They are drawn with closed contours, without passion, and show a careful treatment of chiaroscuro. The classical equilibrium of the compositions, which recalls the style of ancient reliefs, and the classical subject matter, derived from ancient myths (the master following these myths more exactly than he did in his youth), may be in part explained by the artist's desire to cater to the taste of his friend, who was a great amateur of classic art (XXI, 1).

But these sheets, which at first sight appear to be the most objective of all Michelangelo's creations, are nevertheless at the same time subjective confessions of love. The ancient myths are here symbols which once again communicate the glow of his passion for Cavalieri, so often expressed in love poems and letters.

All the drawings made for Cavalieri are in black and red chalk, a technique which was especially suited to the expression of the sensual beauty of the epidermis.

Besides the Tityos and three versions of the Phaeton, whose compositions are preserved in originals, and besides the Ganymede, the Children's Bacchanal (XXI, 10) and the Saettatori (XXI, 11), which are known through contemporary copies, Vasari mentions among the drawings for Cavalieri certain "teste divine," i.e. idealized heads (XXI, 2), and a portrait of Cavalieri "in un cartone grande naturale," which are now lost. The portrait of Cavalieri, according to Vasari a unique work, since Michelangelo "never made portraits," must also be considered as an ideal portrait. Indeed, according to an old description, Cavalieri was represented as "vestito all' antica," and held in his hand "un ritratto, o medaglia" (an indication that the portrait was half-length, not merely the head). Like the other Cavalieri sheets, it must have been executed in outline and chiaroscuro with great care, for the anonymous describer is surprised by the "diligentia usata da Michelagnolo nel ritratto di detto Messer Tommaso" (XXI, 3).

At the end of the year 1532 (since Cavalieri thanks him for these drawings January 1, 1533), Michelangelo made a gift to his friend of two drawings, probably the Tityos and Ganymede, which form companion pieces and complete each other from the point of view of content. *155* *154*

Resembling a river god, the youthful and athletic Tityos is outstretched on a rock *155* which signifies Tartarus. A tree trunk, with the bizarre aspect of a lion's head with its jaws open, seems to stand guard in this solitary place. An immense vulture with outspread wings, which extend the whole length of Tityos' body, has descended upon him, but does not devour his liver like the vulture of the fable. He is only the incarnation of fear, of the suffering which love brings to Tityos—symbol of the defenseless state of one who loves. Thus the Greek myth becomes a personal confession: "My nourishment is nothing but that which burns, and by that from which others die I must live" (Frey,

Dicht., LI; cf. also Frey, *Dicht.*, LII). Or again: "I live on my death . . . and he who does not know how to live on fear and death, let him come into the fire in which I am consumed" (Frey, *Dicht.*, XLI) (XXI, 5).

Antiquity had already so interpreted the Tityos myth. Lucretius (*De Rerum Natura*, III, 997) says, indeed, "He is Tityos for us whom love prostrates in sickness, and whom the vulture [of love] devours, or else whose heart a shameful ardor lacerates with anxieties."

154
299, 300
301

The other drawing, sent with the Tityos to Cavalieri, is a Ganymede known only through copies. Antiquity (marble groups in Venice and in the Vatican, stucco on the ceiling of the Basilica di Porta Maggiore) and the Renaissance (B. Peruzzi in the Farnesina) had joined the figures of Ganymede and the eagle in a superficial manner. Michelangelo makes of them an indissoluble group. He confers on the eagle an anthropomorphic expression of passion: the bird seizes avidly in his talons the delicate body of the youth, and the bird's neck is stretched around his torso. The spread wings extend the whole width of the sheet. The boy submits passively to the abduction and seems to be plunged in a dream of delights. From a distance the pair seem to form a single winged being—expression of that mystic union of which Michelangelo speaks in some of his poems (e.g. Frey, *Dicht.*, XLIV): "One soul in two bodies became eternal, both rising to heaven with the same wings" (XXI, 4). The two drawings show the two aspects of Michelangelo's love for Cavalieri: Tityos the tortures of love, and Ganymede the mystic union and rapture.

151

Between June and September 1533, Michelangelo sent his friend three versions of the Fall of Phaeton. On the first (No. 117) there is an inscription by Michelangelo saying that he would create another version, if Cavalieri was not satisfied with this one, and

152

send it to him the next day. The second version (No. 118), which Cavalieri received the

153

next day, also has an inscription promising yet another variant. This last seems to be identifiable as No. 119 (XXI, 6).

151

In the first version (No. 117), at the top, Jupiter is seated on an eagle, in the act of hurling his thunderbolt. Below, in the center of the sheet, is the entangled mass of the chariot and the four horses, the latter disposed like the spokes of a wheel in motion, from which the body of Phaeton is flung violently down head first. On the ground can be distinguished the river Eridan, a bearded old man, half outstretched, gazing gravely at the catastrophe; the three Heliads, desperate sisters of Phaeton, who are metamorphosed into poplars; and finally, in the center at the back, the lover of Phaeton, Cygnus, already transformed into a swan. The three parts of the composition form, as it were, three distinct acts of a drama, which follow each other in implacable order: above, the cause; in the center, the effect; and below, the consequences of that effect. Michelangelo has abandoned intentionally the tradition of the Quattrocento in the figuration of

297

this scene. He omitted the whole first part of the myth: the representation of Phaeton in the palace of the Sun asking his father, Phoebus, if he is really his son, and demand-

ing, in order to confirm his parentage, permission to mount the chariot of the sun. Moreover, the woodcuts of the *Metamorphoses* of Ovid did not represent the metamorphoses, and frequently showed certain ancient personifications as elements of a landscape. Thus Jupiter became a cloud, and Eridan a real river. Michelangelo returned to the ancient conception. He followed Ovid very closely, as the following details will show. In Ovid, Jupiter turns, holding the thunderbolt poised beside his right ear (*Metamorphoses*, II, 311); Eridan is personified (II, 325); the Heliads are described as in process of transformation into poplars (II, 340); and Cygnus is transformed into a swan (II, 368). Michelangelo follows the poet, moreover, in his conception of the group of horses and of Phaeton. Indeed, Ovid says that when Jupiter struck the chariot with his thunderbolt, the terrified horses sprang in the opposite direction (II, 315). A few verses earlier, he gives an explanation of this movement (II, 70): "The sky draws along the stars of the empyrean and makes them revolve with great speed"—however, the chariot of Phoebus does not obey the general movement. It accomplishes its course in the opposite direction to their rapid circuit. This is exactly what Michelangelo represents: the chariot is abruptly halted in its advance, and the horses are carried away in the opposite direction by the revolving movement.

The artists of Roman antiquity had already tried to represent the movement of chariot and team in opposite directions; an example is the celebrated Phaeton sarcophagus *294* in the Uffizi, which was known already in the second half of the fifteenth century—there is a drawing of it by a pupil of Ghirlandaio in the Codex Escurialensis. Inspired partly by this sarcophagus or by ancient gems, Michelangelo unified the movement, making a *295* real whirlwind, thus approaching even closer the spirit of Ovid's text. He renounced all details and elements of landscape described by the poet, retaining only the essential scene—the tragic fate of Phaeton, which he rendered with utmost sobriety. Such simplification was unknown even to ancient sculpture. There different phases of the myth were united in the same relief, assembled with complete indifference to their logical succession, and the figure of Jupiter with his thunderbolt—who was nevertheless the cause of Phaeton's fall—was invariably omitted.

Michelangelo was the first to represent a drama by showing its events in their inevitable succession. Thus the Fall of Phaeton becomes in a way symbolic of fate, the gesture of Jupiter paralleling that of the judging Christ in certain Last Judgments, such as those in the Campo Santo in Pisa and in the medallion by Bertoldo di Giovanni.

In the second version, Michelangelo departs from the text of Ovid. Now he accentu- *152* ates the central axis, placing in line the fulminating Jupiter, the overturned chariot, the falling Phaeton, who is framed by the horses, grouped two on each side, in severe symmetry, and at the bottom, Eridan, framed by the Heliads. Eridan, now no longer resembling an ancient river god, raises his arms in the desperate gesture of one of the Heliads in the preceding drawing. Cygnus has disappeared. All these changes in the composition

tend to heighten dramatically the vertiginous fall of Phaeton, now become the sole theme.

153 The third version is a synthesis of the two first drawings. Jupiter is again seated on an eagle with outstretched wings as in the first drawing, but the torsion of his body is more pronounced, so that his back becomes visible. He is the apex of a triangle which spreads out at his feet in the group of Phaeton and the four horses (Phaeton is shifted to the left, as in the first drawing), the group seeming to be a materialization of the murderous rays of the thunderbolt. The composition is closed at the bottom by Eridan and the Heliads. Eridan is again represented as an ancient river god, leaning with his right arm on a large vase from which water flows in a cascade; a second vase is placed behind *295* his feet—motifs which seem to be inspired by an ancient gem representing the Fall of Phaeton. His bearded head has an expression of resignation and sadness. Behind him appears the genius of a spring with a vase on his back, a figure inspired by an ancient *Vol. 1, 89, 90* fountain sculpture once in the Giardino Cesi in Rome (where it was copied in the sketchbook of Heemskerk, 1532-1536) (XXI, 7).

This accumulation of the symbols of rivers and springs signifies sadness and tears. In one of his poems (Frey, *Dicht.*, XCIX), quoted above, Michelangelo speaks, in fact, of the "fountains and rivers renewed by my tears." The Heliads, with their desperate gestures, recall those in the first drawing, but their metamorphosis is not represented, so as not to divert attention from the principal subject.

It is evident that Michelangelo intended to symbolize in these drawings the fate of the "presumptuous" lover, annihilated by the fire of love as Phaeton by the thunderbolt of Jupiter (XXI, 8). Phaeton, and Icarus, had already been described by Landino (Commentary on Dante, *Inferno* XVII, 1, 106) as symbolic of "tutti quelli e' quali mossi da troppa presuntione di se medesimi et da temerità ardiscono a fare imprese sopra le forze e le facultà loro"; and Michelangelo himself speaks in several of his poems of the destroying fire of love and of the fall of the lover (e.g. Frey, *Dicht.*, CIV).

Michelangelo's love for Cavalieri corresponds curiously, in form and language, to the pattern of friendship prevailing in the milieu of Lorenzo de' Medici half a century earlier. So, for example, Giovanni Cavalcanti is so closely united with Marsilio Ficino that "they have only one soul"; Benivieni calls Pico della Mirandola his "signore" and addresses passionate sonnets to him in the style of Petrarch, recalling sometimes the amorous poems of Michelangelo to Cavalieri (XXI, 9). But Michelangelo's feeling for Cavalieri is distinguished, apart from its impassioned gravity, by a constant sense of fatality, and the Cavalieri drawings seem chiefly significant as a new expression of the idea of inexorable fate.

When a friend told Michelangelo of an artist who boasted that he had surpassed the ancients although he only copied ancient works, Michelangelo is supposed to have said: "Chi va dietro a altri, mai non li passa innanzi, e chi non sa far bene da se, non può servirsi bene delle cose d'altri" (Vasari 1568, pp. 263*f*). This conception of the imitation

of the ancients is fully confirmed by the drawings just described. Michelangelo makes ample use of antiquity, but his drawings are by no means servile copies. Antiquity was indifferent to the causal succession of events. Michelangelo, in his drawings for Cavalieri, inserts ancient myths in the fear-inspiring clockwork of causal development and thus marks them with the seal of fatality. Every element of his composition is determined by the preceding one, and determines the following. The successive moments are so many phases of a necessary, fatal evolution.

By this revelation of the fateful power standing above the individual will, these sheets are direct precursors of the frescoes of the last phase of Michelangelo's life in Rome: the Last Judgment and the frescoes of the Cappella Paolina.

CONCLUSION

THE Platonic cult of beauty of Michelangelo, i.e. his admiration of earthly beauty as a divine idea, attains its ultimate spiritualized formulation in the works of the period covered by this volume. The types of beauty which he now modeled are still reminiscent of those of the time of the Sistine Ceiling, in that they also represent the universally valid beauty, purified of the accidental, as a fully developed, powerful life. But alongside the strength and magnitude, they have a delicacy which the earlier works showed not at all or at least only exceptionally. From this point of view the works between 1520 and 1534 grow organically out of the earlier phase of his development. On a more mature contemplative level Michelangelo strives toward the same ideal. The new features which now reveal themselves in the proportions of the figures, in their more complex and at the same time more continuous movements, in the expression of a resigned emotion, are subordinate to the still unchanged ultimate goal. Essence and beauty are to him still identical.

One would thus be reluctant to agree with the earlier view, which may be summarized as follows: about 1520 there was a break in Michelangelo's development; his works up to this date were executed in the pure style of the High Renaissance, "which does not yet know or does not yet recognize the dissonant"; "the Medici Chapel with the conscious use of dissonance on a large scale prepares the ground for the Baroque" (Wölfflin), or (and this is essentially the same) the "equilibrating tendency" of the High Renaissance is now definitely overcome, and "optic effects replace the tactile effects," subordination replaces coordination, depth of space replaces surface, and unity replaces the isolation of specific motifs (Riegl). As, on the one hand, the Sistine Ceiling already transcends the equilibrated style of the High Renaissance (as Dvořák observed), so, on the other hand, the Medici Chapel with its whole severe reserve and immobile quietness is not yet a work of the Baroque. It is rather a new formulation of Michelangelo's personal style, attained by a dynamic vitalization of the language of the Florentine Renaissance and its transformation according to the requirements of a new spiritual *concetto*.

Yet it is true that in surmounting the static canon of the Renaissance these works of Michelangelo became in several respects a model for the works of the Mannerists and later of the Baroque artists. Michelangelo was in direct relationship with Pontormo, Rosso, Bronzino, but we know that in each case Michelangelo was the giver; he furnished them drawings and cartoons. The essential quality of his style was not comprehended by these younger artists. They used in a somewhat superficial way his dynamism as a decorative pattern, overlooking the fact that the animating cause of his dynamism of forms is for Michelangelo always an internal psychic-spiritual state. For this reason it is difficult to follow the view which designates these works of Michelangelo (especially those made around 1530) as Manneristic.

A real break with the past was to take place in Michelangelo only when he was no

longer able to identify essence with beauty, and was consequently compelled to renounce the archetypes of beauty, in order to express the newly recognized truth (religious, and no longer philosophic) in new forms. This, however, was not to take place until his last Roman period.

Already within the period now being treated, there appear some signs which herald this religious conversion of the master. The pontificates of Leo X and Clement VII are the time of a religious transformation in Europe. It is the time of the ecclesiastical reform movements, of attempts to put an end to the abuses of the secularized ecclesiastical life, the epoch of the foundation of the Oratory of Divine Love and of the new orders (e.g. the Order of the Theatines), and finally the period of the Reformation. Michelangelo was not entirely a stranger to these great spiritual movements, even in his Platonic period. His Christ of the Minerva, at least, is, as stated above, an attempt to erect the monument of the true Christ in the middle of the secularized Papal city.

CRITICAL SECTION

INTRODUCTION TO THE CRITICAL SECTION

IN THIS section, we attempt to bring together the essential information concerning the Medici Chapel, as well as concerning those works executed during this period of the artist's life but not in connection with the Julius Tomb, to which a later volume will be devoted. These data are based upon the author's research carried out for the most part in Italy, and upon the results obtained by previous scholars. Some facts mentioned previously in the text will be here repeated, accompanied by documentary proofs, bibliography, or both.

I. NOTES ON CHAPTER I: LIFE

1. The best surveys of the dates on this period in Michelangelo's life can be found in Frey, *Reg.* and Thode, *Reg.*

Concerning the artistic tasks and the patrons in the Renaissance, cf. M. Wackernagel, *Der Lebensraum des Künstlers in der florentinischen Renaissance*, Leipzig, 1938.

2. Concerning the court life of Leo X, cf. Pastor IV, 1, pp. 425*ff*.

3. "Quando parla di vui [Leo X] par rasoni d'un suo fratello quassi con le lacrime agli occhi, perchè m'à detto a me vui sette nutriti insiemi et dimostra conoscervi et amarvi: ma facte paura a ognuno insino a' papi" (Milanesi, *Corr.*, p. 20).

Leo X said also to Sebastiano: "Guarda lopere di Rafaelo, che come vide le opere di Michelagnolo subito lassò la maniera del Perosino [Perugino], et quanto più poteva si acostava a quella di Michelagnolo; ma è terribile, come tu vedi, non si pol pratichar con lui." This judgment, however, was made after the death of Raphael, October 15, 1520 (Gaye II, p. 489; here erroneously dated in 1512).

4. The history of the Tomb of Julius II will be treated in Vol. IV. Here only the biographically interesting facts are mentioned.

5. Concerning the façade of San Lorenzo, cf. the author in *G.d.B.-A.*, XI, 1934, pp. 24*ff*.

6. "Io ò tolto a risucitar morti a voler domesticar questi monti e a mettere l'arte in questo paese" (Milanesi, p. 137).

7. Concerning Michelangelo as master of the fortifications of Florence, cf. the author, *Art Bulletin*, XXII, 1940, pp. 130*ff*. A detailed report of the flight of Michelangelo in 1529 is given by Varchi, *Storia fiorentina*, ed. L. Arbib, Florence, 1843, II, pp. 192*ff*. A special chapter will be devoted in Volume IV to Michelangelo's political ideals and his attitude before, during, and after the siege.

8. Concerning the court life of Clement VII, cf. Pastor IV, 2, pp. 537*ff*.

9. Giovanni Battista della Palla wrote in his letter the following beautiful sentences: "Torniate alla patria per conservarvi lei, gli amici, l'onore et le facultà, et per godervi et per fruire quelli tempi già da voi aspettati e desiderati. . . . Veggo in questi cittadini . . . una unione et ardore mirabile alla conservazione della libertà" (Gotti I, pp. 195*f*).

10. Concerning the Libreria Laurenziana, cf. the author in *G.d.B.-A.*, XIV, 1935, pp. 81*ff*.

11. The relationships between Michelangelo and Sebastiano have been treated, in the same sense as here, by the author in *Sklavenskizze*, pp. 70*ff*. There he tried to show that Michelangelo did not collaborate personally on any work of Sebastiano, and that he seems not to have made compositional sketches *ad hoc*, but to have sent sketches which he had first used for his own purposes. That article (pp. 75*f* note) also enumerates the motifs borrowed by Sebastiano from the Sistine Ceiling. The conclusions drawn were accepted by Dussler (*Sebastiano del Piombo*, Basel, 1942; reviewed, with distortion of

the author's intentions, by Hans Tietze in *Art Bulletin*, XXVI, 1944, pp. 129*ff*), and by R. Pallucchini (*Sebastiano Viniziano*, Milan, 1944; informatively reviewed by J. Wilde, *Burl.Mag.*, 1946, 2, pp. 256*ff*), who, however, apparently based his work on Dussler without knowing the present author's article.

12. The drawing in the collection of Sir Robert Witt was first attributed to Michelangelo by the author in *Sklavenskizze*, pp. 70*ff*. This drawing was formerly attributed to Bandinelli, under whose name it was conserved in the Witt Collection.

13. Panofsky, "Die Pietà von Ubeda," *Festschrift für Julius von Schlosser*, Vienna, 1927, pp. 150*ff*.

14. The first association with a young man of which we have a record is that with Giovanni da Pistoia (Frey, *Dicht.*, IX and LXVIII). This friendship was during the period of the execution of the Sistine Ceiling. The association with Gherardo Perini is recorded in 1522 (Milanesi, p. 418), that with Febo di Poggio in 1534 (Frey, *Dicht.*, CIII and CIV and p. 526), that with Cecchino Bracci in 1544 (Frey, *Dicht.*, LXXIII).

15. The documents concerning Tommaso Cavalieri are best assembled by Steinmann-Pogatscher, *Rep.f.Kw.*, XXIX, 1906, pp. 496*ff*.

The moral noblesse of Cavalieri is apparent, apart from his correspondence, in the magnanimous spirit of his testament, February 27, 1580.

Concerning the palace of the Cavalieri in Rome and their situation, cf. Steinmann, *Sixtinische Kapelle*, II, p. 470 n. 2.

The friendship with Cavalieri produced the most perfect expression of Michelangelo's Platonic conception of beauty and love.

II. NOTES ON CHAPTER II: THE CHURCH OF SAN LORENZO AS MAUSOLEUM OF THE MEDICI FAMILY

1. Concerning the history of the Church of San Lorenzo, cf. C. von Fabriczy, *F. Brunelleschi*, Stuttgart, 1892; von Stegmann-von Geymüller, *Die Architektur der Renaissance in Toscana*, Munich, 1885*ff*, I, pp. 10*ff*; Limburger, in Thieme-Becker, *Allgemeines Künstlerlexikon*, sub *Brunelleschi*; Marangoni, *La Basilica di S. Lorenzo*, Florence, 1922.

2. The tomb of Cosimo de' Medici is situated in the crypt below the intersection of the nave and transept. Exactly above the grave, in the floor of the church, there is a commemorative device composed of red, green, and white marble plates with the Medici arms and an inscription. The inscription reads:

> "Cosimus Medices hic situs est decreto publico
> Pater Patriae
> Vixit annos LXXV, Menses III Dies xx."

3. Evidence that the idea of the erection of the Sagrestia Nuova reverts to Leo X and Cardinal Giulio is offered by Cambi, *Croniche fiorentine*, published in *Delizie degli eruditi toscani*, XXII, Florence, 1786, p. 161. The reference is quoted below.

4. The bodies of the two Magnifici were transferred into the Sagrestia Nuova on June 3, 1559 (cf. Agostino Lapini, *Diario fiorentino*, ed. Corazzini, Florence, 1900, p. 124).

III. NOTES ON CHAPTER III: THE EXTERIOR

1. That the lower part of the Chapel structure up to the height of the first cornice was erected in the early fifteenth century, simultaneously with the north wall of the transept, was observed by von Fabriczy, *op.cit.*, p. 173 n. 1. It has been overlooked *166-168* hitherto that the second and third zones of the exterior, including probably the drum, belong to a period before the time when Michelangelo took over the direction of the *171, 174* building. It has also not been observed that the windows of the third zone (in the interior, the windows of the lunettes) have been partly filled in, probably under the direction of Michelangelo (possibly to bring out the diffuse lighting effect in the interior). This fact also favors the hypothesis that this part of the building was made before Michelangelo took over the direction.

166-168 In 1938-1939, several small houses which blocked the view of the Chapel were razed, so that it was for the first time possible to take photographs of the whole exterior of the Medici Chapel (cf. our Figs. 166, 167, 168).

2. Cambi, *op.cit.*, p. 161, reports that in March 1520, the Medici Chapel was already under construction: "L'anno 1519 [i.e. 1520], del mese di Marzo al'uscita di detto anno [i.e. March 25] Papa Lione fece cominciare alla Chiesa di S. Lorenzo una Sacrestia di verso la via della Stufa, che vera un poco di porticiuola per comodità del popolo andare in Chiesa, che detta Sacrestia fussi a riscontro della vecchia Sacrestia di detta Chiesa per farvi drento la Sepoltura di Giuliano suo fratello, e del Ducha Lorenzo suo nipote morti e dicevasi la faceva fare Messer Julio Arcivescovo di Firenze, ed ezian Cardinale ancora per se."

The fact that the work was begun on March 1, 1520, is confirmed by a document in the *Archivio Capitolare*, with the same date: "per secondare i desiderj di Mons. nostro Reverendissimo accordò a Mess. Gio. Batista Fiegiovanni le distribuzioni del Coro, e della Sagrestia ne' giorni feriali, e quando i lavoratori lavoravono alla muraglia ordinata di fare dal detto Reverendissimo Cardinale della nuova Sagrestia; quando lavoravano, e non la notte" (published in Domenico Moreni, *Memorie istoriche dell' Ambrosiana Imperial Basilica di S. Lorenzo di Firenze*, I, Florence, 1816, p. 204 = Cianfogni, Vol. II). Köhler (p. 92) and Popp (p. 109) have both referred to this document.

3. Before September 6, 1520, Leo X seems to have asked through Sebastiano del Piombo if Michelangelo would take over the work on the Chapel (Milanesi, *Corr.*, pp. 12ff). Popp (*Med.Kap.*, pp. 109ff) has shown that Michelangelo probably decided to accept the direction of the work between October 27, 1520 (cf. Milanesi, *Corr.*, p. 18, where it is not yet considered) and November 6, 1520, date of the trip of Cardinal Giulio to Rome. Consequently, as Popp has emphasized, Michelangelo took charge about eight months after the work on the building was begun.

IV. NOTES ON CHAPTER IV: THE INTERIOR

1. The fact that Michelangelo used other buildings in the bichrome style, besides the Sagrestia Vecchia, as models for the articulation of the interior of the Sagrestia Nuova, has not hitherto been observed.

2. The groundplan sketch for the Sagrestia Nuova in the Archivio Buonarroti (Cod. I, fol. 98, folded sheet, p. 2) has been identified as such and published by the author in *Arch.Buon.*, p. 379. The two lateral chapels, each with three apses, also in red chalk, and the black-chalk scratches at the right top are not by Michelangelo. On the recto (p. 1) there is an undated *ricordo* written in red chalk. On p. 4 at the top left is a ground plan in ink of a choir, probably of the Sagrestia Vecchia, done by a pupil. It shows the choir with the three niches and the screen. Below this sketch there is in Michelangelo's hand a red-chalk sketch of a choir, also with three niches. This little sketch can serve as a further proof that Michelangelo did take as his point of departure the Sagrestia Vecchia.

In the above-mentioned article (*Arch.Buon.*, pp. 379*ff*) an attempt was made to reconstruct the structure of the walls corresponding to the ground plan of the Archivio Buonarroti.

3. In the Uffizi in Florence are preserved two drawings of the lunette windows. The first drawing is probably by a stonecutter; the second probably by G. A. Dosio.

These lunette windows were probably executed after 1533 cf. the letter by Sebastiano del Piombo from August 16, 1533 (Milanesi, *Corr.*, pp. 112*ff*).

4. The reconstruction of the thrones of the attica of the monuments of the Dukes by Popp (*Med.Kap.*, pp. 58 and 155*f*) is based on free paraphrases, and not on original drawings by Michelangelo. It is highly unlikely that Michelangelo wanted in the final execution to make high backs for the thrones, which would have penetrated into the upper part of the *pietra serena* cornice, since the pronounced projection of the cornice would have made this impossible. The small volute in the center of the attica can also be explained only by the fact that Michelangelo considered this the termination of the upper part of the monuments.

5. Justi (pp. 234*f*) and Tolnay (*Arch.Buon.*, p. 391) emphasize the fact that only the point behind the altar affords a view of the unity of the composition of the Chapel.

6. The left candelabrum was broken in the eighteenth century. Gori (in his edition of Condivi, p. 110) notes that this broken candelabrum was restored by order of the Electress of the Palatinate, ca. 1741, by Ticciati. Bottari says (cf. Fanfani, *Spigolature*, p. 81) that the candelabrum which was worked by Ticciati had not been broken but was still only rough-cut. Cf. also Thode, *Kr.U.*, II, pp. 111*f*.

The drawing in the Uffizi, probably by G. A. Dosio, representing the altar with the original left candelabrum has not been noticed hitherto. Concerning the inscription of the altar, cf. Thode, *Kr.U.*, II, pp. 111*ff*.

7. The holy water basin in one of the corners of the Chapel seems to reproduce a project of Michelangelo. A block for the holy water basin ("pila") was ordered by Domenico Buoninsegni in Carrara, and Topolino reported on April 21, 1524 (Appendix), that the block for it had not yet been found. Hence the measurements and probably also the project for the "pila" revert to Michelangelo. (A. Venturi, "Pile d'acquasanta disegnate da Michelangelo," *L'arte*, xxv, 1922, pp. 200*ff*, who did not know this document, doubted that the holy water basin of the Medici Chapel reverts to Michelangelo, and thought that of the Sagrestia Vecchia to be more likely by him.) The prototype of Michelangelo's design was probably the fifteenth century holy water basin of the entrance of the Church of S. Marco in Florence (left side).

8. The *pietra serena* bands enframing the niches must have been made at the same time as the shallow niches themselves and the *pietra serena* articulation, since they form the corners of the niches and are continued in the *pietra serena* cornice. Consequently they cannot be considered as the result of a change in the project, and as having been executed after the *pietra serena* system, as Popp assumes.

9. The statues have no lighted and shaded sides. The contrast of light and shadow is suppressed. Michelangelo arrived at a more homogeneous lighting by opening the windows of the intermediate zone on the northern and western walls of the Chapel, where less sharp light penetrates, and closing the windows of the intermediate zone on the eastern and southern walls, where more light would have penetrated. By this means he obtained better lighting for the normally darker Giuliano and Virgin walls, which face respectively toward the west and the north.

1. The sequence of the projects here proposed seems to correspond to the general evolution of Michelangelo's ideas but does not correspond exactly to the factual chronology of execution; for from the manner in which the sketches were drawn side by side or overlapping on the individual sheets, it is clear that Michelangelo worked simultaneously on several solutions of the problem. Sketches Nos. 51 and 52, for instance, show *81, 82* that Michelangelo had in mind the free-standing monument, the wall monument with the double sarcophagi, and perhaps in addition the wall monument with the single sarcophagus. He experimented at the same time with different forms of the sarcophagus. It may be that before November 23, 1520, he was considering only a free-standing monument, but after receiving the letter of November 28, in which the Cardinal presented new suggestions, he apparently experimented with at least three types of monuments at once. There is, however, a development, proceeding from Nos. 51 and 52, and terminating with No. 57. *89*

The most detailed investigations concerning the sketches of the monuments were made by Berenson, von Geymüller, Burger, Thode, and Popp. Whereas the scholars before Popp were somewhat too generous in their attributions, including drawings made by pupils and drawings made by Michelangelo but intended for other tombs (e.g. the Bracci tomb, 1544-1545), Popp on the other hand was too exclusive. She discarded all the drawings except three, Nos. 51, 52, and 57, which alone she considered to be projects *81, 82, 89* by Michelangelo for the Medici tombs. The other drawings are, according to her, for the most part projects for the tombs of Pope Paul III and C. Bracci and should be dated much later. (The author agreed with this opinion in his first article, *Arch.Buon.*, but corrected his view in his second article, *Cappella Medicea*.)

Berenson and Burger overlooked the fact that the criterion for the determination of the chronology of the sketches is the proportional ratio between the sarcophagus and the whole monument. Both gave consequently a completely arbitrary chronology. They considered the earliest free-standing monument (No. 51) to be the latest and supposed *81* the drawings for the Magnifici tombs to be projects for the tombs of the Dukes. Popp *90, 91* was the first to take into account the proportional ratio between sarcophagus and tomb in determining the chronology. But—as stated above—she oversimplified the development by discarding all but three drawings, No. 51 (free-standing tomb), No. 52 (double *81, 82* wall tomb), and No. 57 (wall tomb for one of the Dukes). Popp rightly connected Nos. *89* 58 and 59 with the Magnifici monuments. *90, 91*

2. The three letters of Buoninsegni to Michelangelo were first published by the author in *Cappella Medicea*. Cf. Appendix Nos. 1-3.

3. Since the width of the whole Chapel is ca. twenty braccia, the measurements of the first project drawing of Michelangelo, as given in the letter of November 28, 1520, are correct: the monument four braccia wide, and the empty space around the monument

eight braccia on either side (8+8+4=20). The objection of the Cardinal is consequently without foundation.

86, 88 4. Sketch No. 56, center, with the project of the Janus Arch tomb, shows a horizontal line below the arch. This, however, should not be interpreted as an architrave (Panofsky), which would presuppose a massive structure, but as an auxiliary line used for the execution of the drawing. Michelangelo's architraves always have several (usually four) horizontal lines.

83-86 5. All the drawings for the free-standing tomb (with the exception of No. 51) were considered by Popp as projects for the tomb of Paul III and were dated ca. 1551. To complete our demonstration, the arguments which have been given by Popp to show that there is no relationship at all between these sketches and the Medici tombs should be refuted. These arguments are: (a) *The projects are too big for the Medici Chapel.* But the letter of Buoninsegni (Appendix) which mentions a tomb six braccia long shows that this opinion is unfounded. (b) *The sarcophagus with the curved outline is typical of Michelangelo's late style.* On the contrary, during the entire Quattrocento
116 artists preferred the curved outline of the sarcophagus; and sketch No. 61, lower right, which was made in 1518, shows that Michelangelo used this form of sarcophagus even before the Medici Chapel. (c) *There is an intimate relationship between the style of this group of sketches and the drawing of 1544-1545 for the tomb of Cecchino Bracci*
124, 125 (Nos. 69 and 70). On the contrary, there is a stylistic difference between the angular and dynamic forms and the clear-cut and sure lines of the first, and the curved and wavy forms and the "pictorial" and uncertain manner of treatment of the latter. Moreover,
83 on the verso of No. 53 are fragments of sonnets (Frey, *Dicht.*, XXIV) in a style of handwriting characteristic of the artist around 1520 and not 1544, the time of Bracci's tomb.

82 6. The fact that the left half of No. 52 was probably originally planned by Michelangelo for the lateral fields, in concordance with the plan in the Archivio Buonarroti, has been shown by the author in *Arch.Buon.*, pp. 379*ff.*

227 7. Another double tomb project is Frey, *Handz.*, 214b. Here the river god below the
82 sarcophagus is almost identical in pose with the river god in No. 52, but not so well drawn. In our opinion, this drawing is not by Michelangelo.

89 8. That No. 57, despite the fact that it contains only one sarcophagus, was probably conceived as a double tomb, was first observed by Berenson.

 9. Borinski, *Rätsel*, p. 135, interprets the empty thrones in the attica as the "astral seats of the souls." Cf. also Panofsky, *Iconology*, p. 212.

 10. In all these sketches, four chief types of sarcophagi can be distinguished. Type I is a *cassone*-like sarcophagus with flat lid and legs which are treated as separate pieces
81, 82 and support the body of the sarcophagus (Nos. 51 and 52, left). Type II is a *cassone* with diagonal legs, which form part of the body of the sarcophagus itself; this type recalls the old Florentine arcosol graves which Michelangelo followed already in his sketches of
114, 82 1518 for San Silvestro in Capite in Rome (No. 62). To this second type belong No. 52,

right, No. 53 (the first version), and No. 56, top right. Type III is characterized by ver- *83, 86*
tical legs which are part of the body of the sarcophagus, and is derived from the type of
ancient porphyry bathtub later transformed into a sarcophagus for Pope Clement XII, *209*
in S. Giovanni in Laterano, which stood in the sixteenth century and earlier before the
entrance of the Pantheon and had already served as prototype for some Quattrocento
monuments—for example, that of the Cardinal of Portugal, in S. Miniato, Florence, by
Antonio Rossellino. Of this type Michelangelo made three variants: (a) with triangular
lids (No. 51, upside down), (b) with a broken segment lid (No. 51, left top, and No. *81, 85*
54), and (c) with a lid composed of two volutes (No. 52, upside down, where only one *82*
lid is drawn, No. 56, top right, and No. 57). Type IV is higher than it is wide, has curved *86, 89*
sides, a closed segment lid, and diagonal feet of zoomorphic character (Nos. 53, 56, and *83, 86*
55). It should be noted that types I to III can all be found on the recto and verso of one *84*
sheet (Nos. 51 and 52). Consequently, Michelangelo experimented simultaneously *81, 82*
with all three, so that no conclusion as to chronology can be drawn from them. Type IV,
however, is an original development, and may be considered as somewhat later.

To complete the discussion, two other projects, found on the same sheets but which
cannot be connected with any of the projects mentioned in the correspondence, may be
considered. One is a small wall tabernacle tomb with a flat-lidded sarcophagus at the
bottom and with double columns supporting the powerful entablature. It appears on
three sheets (Nos. 53, left, 54, center, and 60). The latter drawing shows two versions, *83, 85, 119*
one above the other, the first of which is connected with the two other sketches. Popp,
who observed this connection, thought this was a project for the Cecchino Bracci monu-
ment of 1544-1545, but the sketch on No. 54 is below the project of the free-standing *85*
monument and consequently made before it. Also these sketches show the style of ca.
1520. So they are probably also related to the Medici tombs, but they look like small
wall tabernacle monuments and not like free-standing ones. The hypothesis is attractive
that this may be a project for the tomb of Cardinal Giulio on the entrance wall. We
know from the letter quoted above that the Cardinal wanted to be buried also in the
Chapel, already at an early stage (1520). It may be noted in support of this hypothesis
that on the ground plan in the Archivio Buonarroti there is a monument planned on
the entrance wall (E. Wind's observation).

A second project which is not mentioned in the correspondence is an octagonal struc-
ture (No. 56, left, and No. 55, ground plan). (It should be noted that the ground plan *86, 88, 84*
does not correspond completely to the sketch, having only one column where the sketch
has double columns; it is probably another version of the same idea.) In No. 56 there *86, 88*
are double columns in the lowest zone, which support a strongly projecting cornice,
above which there is an attica with oculi, and finally a polygonal dome. The drawing
was evidently earlier on the sheet than the sketch of a free-standing monument which
overlaps it, so it may have been made as early as 1518, and may be related to the cibo-

[129]

rium project for San Silvestro in Capite in Rome. (In Thode's opinion No. 61 is also related to this ciborium.) In this case this sketch should be discarded from the projects for the Medici Chapel. It is of some importance, however, for Michelangelo's work on the Medici Chapel as it anticipates the structure of the lantern.

121 No. 67, also, which until now has been connected with the tombs of the Dukes (Burger) or with the monuments of the Medici Popes (Popp), may be discarded from among the projects for the Medici Chapel. These are sketches which Michelangelo made in 1525-1526 for the Tomb of Julius II, when he decided to sell all the blocks already prepared for this monument, and to reduce it to a small wall tomb like that of Pope Pius II or Paul II formerly in St. Peter's, as has been shown by the author in *Arch.Buon.*, pp. 409*ff*.

11. The tombs are composed of two different sorts of marble: whereas the architectural parts are made of white marble with gray veins, the sarcophagi and the sculptures are made of a somewhat yellowish marble in ivory tone without veins. This contrast between the cold tone of the architecture and the warmer tone of the figures again emphasizes the lifelike quality of the latter.

12. According to Popp (pp. 33, 128), the decoration of the entrance wall at the time

82 when Michelangelo projected the double tombs (No. 52) should be reconstructed on
90 the basis of No. 58, yet without the sarcophagi; and the decoration of this wall, when Michelangelo projected on the lateral walls the tombs of the Dukes with one sarcoph-
89 agus—as seen in No. 57, which is according to Popp a single tomb—should be recon-
90 structed on the basis of the entire drawing No. 58. The last version, corresponding to
91 the executed lateral tombs, should be reconstructed on the basis of No. 59.

175 The marble *cassone* which is today on the entrance wall was made from a design by Michelangelo, as shown by the letter from Vasari to Gondi of October 5, 1569 (cf. Vasari, *Carteggio*, II, p. 461): "et per dare fine a un' cassone, che è di marmo, il quale haveva fatto Michelagnolo Buonarruoti per mettervi i corpi di Lorenzo Vecchio et Giuliano suo fratello, padre di dua papi, Sua Eccellenza (duca Cosimo) l'ha fatto murare in detta sagrestia, et addì 22 di Maggio, come sà la S.V., che fù presente quando questi corpi furono scassati per metterli in detto cassone di marmo. . . ."

13. Other architectural drawings which have been considered related to the Medici Chapel are either copies (like Frey, *Handz.*, 90, copy of the entrance wall by Vincenzo
228 Danti [Popp]; Frey, *Handz.*, 214a, dated 1524, by the same artist [Popp]; Frey, *Handz.*,
227 214b, project for the double tomb, probably a copy—the river god is like that in No. 52; Frey, *Handz.*, 265, free paraphrase of the entrance wall) or they are by Michelangelo but made for other projects (like Frey, *Handz.*, 173, drawing for the *ballatoio* of the Dome
124,121 of Florence; No. 69, projects for the monument of Cecchino Bracci; No. 67, projects for the Tomb of Julius II, 1525).

VI. NOTES ON CHAPTER VI: THE STATUES

1. The rotatory movement of Notte and Giorno has been observed by Riegl, *Barock-kunst in Rom*, Vienna, 1923 (2nd edition), p. 33.

2. The best analyses of the composition of the Ducal tombs can be found in Wölfflin, *Klassische Kunst*, pp. 177*ff*, and Riegl, *op.cit.*, pp. 30*ff*.

3. Concerning the two chief types of seated figures in Michelangelo, cf. W. Hager, *Die Ehrenstatuen der Päpste*, Leipzig, 1929, pp. 36*ff*. Concerning the seated figures by Michelangelo, cf. also Vol. II, pp. 54*ff*.

4. Cf. also Popp's fine analysis of the style of the figures of the Medici Chapel, *Med. Kap.*, pp. 94*f*, and that of Guillaume, in *G.d.B.-A.*, XIII, 2, 1876, pp. 86*ff*.

5. Cf. W. Friedländer, "Die Entstehung des antiklassischen Stiles in der italienischen Malerei um 1520," *Rep.f.Kw.*, XLVI, 1925, pp. 55*ff*.

6. Giorno and Notte do not rest directly on the lid of the sarcophagus, but on the rude *32, 22* marble. Their blocks do not fit exactly the shape of the sarcophagus cover. From this fact, Grimm (*J.d.p.K.*, I, 1880, pp. 17*ff*) concluded that these statues were planned for larger and more curved bases, probably in the form of the lids of the tomb of Paul III *322* by Guglielmo della Porta. Grimm believed that the lost wooden model of the sarcophagus had such lids, and that the present sarcophagus was not made in accordance with Michelangelo's plans. This hypothesis is improbable, first, because according to the documents the sarcophagi and the lids were broken in Carrara in 1524, i.e. in a period when Michelangelo supervised the work; secondly, because in sketch No. 53 the motif *83* of the Notte appears already on a convex lid; and thirdly (a fact to which Köhler called attention), if the Notte were to be put on a lid like that of della Porta's, the figure would have to lean farther back, and the lock of hair hanging before the right shoulder would no longer be vertical. Grimm's opinion was followed also by Gottschewski, "Michelangelos Medicigräber; Vortrag in der Sitzung des Kunsthistorischen Instituts zu Florenz, May 15, 1907," *Mitteilungen des Kunsthistorischen Instituts*, I, Florence, 1911, p. 81. Kriegbaum, *Michelangelo*, 1940, takes up the idea of Grimm (whom he does not quote) in a slightly modified form, and maintains (p. 38) that Giorno and Notte were not made for the present sarcophagus because their composition contradicts the form of the lid. The right feet of the figures stand up in the air. According to their blocks, the figures were intended to lie on horizontal surfaces, like the sarcophagus lids in the drawing copies of the Magnifici tombs. They should have been placed foot to foot on *220, 221* such horizontal sarcophagus lids, with Giorno at the left and the Notte at the right. They were intended originally, according to Kriegbaum, to decorate the sarcophagi of the Magnifici, and only later were used for the tomb of Giuliano. This hypothesis, however, contradicts the prose fragment of Michelangelo, Frey, *Dicht.*, XVII, where Giorno and Notte are mentioned together with the Giuliano. That a horizontal position could not have been intended for the figures is proved by the fact that the braid of Notte

would then have hung diagonally, as stated above. Finally, the drawing copies of the Magnifici tombs which Kriegbaum uses for the reconstruction are free paraphrases, and not authentic drawings of the master.

According to Kriegbaum, the present position of the Times of Day may perhaps go back to Tribolo. It is he who set up the statues diagonally on the lids, whereas Michelangelo (according to Kriegbaum) wanted to mount them exactly parallel to the walls of the tomb. But Giorno and Notte are placed parallel, and Aurora and Crepuscolo, which are diagonal, were originally made (cf. the blocks) to be placed in this way. (Cf. the sketch of the blocks, mentioned on p. 47.)

<p align="center">A U R O R A</p>

Length of the block: 203 cm.
Depth of the block: ca. 62 cm.

10-16

7. CONDITION: Perfectly preserved. The feet and the cloth lying on the couch are not completely finished.

8. HISTORY: Concerning the date of execution of the figure, cf. Chap. VIII. The figure is first mentioned together with Notte in the letter from Giovanbattista di Paolo Mini to Bartolomeo Valori of September 29, 1531 (Gaye II, pp. 228f). Mini saw at that date "le dua femine" (the name of Aurora is not mentioned, although the Notte's is).

Vasari 1550 and 1568, p. 133, gives a fine description of the motif (cf. below).

In Doni, *I marmi*, Venice, 1552-1553, Part III, pp. 22ff, the Aurora is the statue which speaks.

Condivi 1553 does not mention the figure.

Borghini, *Riposo*, 1584, Book I, pp. 65f, mentions Aurora and criticizes the fact that she has no attributes. He overlooked her emblems.

Bocchi-Cinelli, *Le bellezze della città di Firenze*, Florence, 1677, pp. 533f, gives the first detailed analysis.

9. SUBJECT: The figure has several emblems, namely the veil which seems to be a symbol of mourning (cf. Steinmann, *Geheimnis*, p. 92), and the small band below the breasts, a motif which Michelangelo used in other figures—for example, the Slaves on the Tomb of Julius II—to express slavery.

The fact that the body is that of a girl (in contrast to that of the Notte, characterized as a mother) was first commented upon by Bocchi-Cinelli, *op.cit.*, p. 533, and among the modern scholars by Brücke, *Deutsche Rundschau*, LXII, 1890, pp. 260ff.

Vasari 1550 and 1568, p. 133, says that the Aurora is a figure "da fare uscire il maninconico dell' animo. . . ." Then he gives a description of the pose: "nel destarsi . . . si storce con amaritudine . . . in segno del gran dolore. . . ." The melancholy character of the figure has been emphasized frequently since Vasari; only Justi (p. 253) gives a different description, which is not, however, convincing: "Aus schwerem Schlaf erwachend, hat sie die Last der Träume abgeschüttelt, fühlt sich im Schimmer des neuen Tages verjüngt."

Steinmann, *Geheimnis*, p. 89, supposes that the figure is a personification of the melancholic humor. Panofsky, *Iconology*, p. 207, holds that the figure represents the sanguine mood, the element air, and the season of spring.

A detailed analysis of the pose of the figure is given by von Kleinenberg, *Z.f.Ae.u.Kw.*, XXIII, 1929, pp. 113*ff*. He notes that the original position of the figure was recumbent, and then she turned toward the spectator, as if she wished to rise, but through depression of her soul she seems paralyzed and sinks back again.

The two sides of the figure are contrasted. The left side shows a rising movement, the right a down-flowing movement.

Thode, *Kr.U.*, I, pp. 526*ff*, gives a survey of the earlier interpretations.

10. ANALOGIES: The motif reverts to ancient river or mountain gods on the triumphal *243* arch of Septimius Severus. Michelangelo used this motif on the Sistine Ceiling in the *244* figure at the left of the Abia lunette (cf. Steinmann, *Geheimnis*, p. 89). (The raised left arm in mirror image is prepared, according to Steinmann, by the youth in the Eleazar-Matthan lunette.) The bronze nude above the Haman spandrel of the Ceiling also an- *247* ticipates the legs of the figure; cf. Vol. II, p. 70. Among the sketches for the Medici *82* tombs, the motif of the figure appears first in No. 52; cf. Popp, p. 143.

11. COPIES: cf. p. 155.

CREPUSCOLO

Length of block: 195 cm.
Depth of block: ca. 80 cm.

12. CONDITION: Perfectly preserved; unfinished in different degrees on the head, *17-21* hands and feet.

13. HISTORY: Concerning the date of execution of the figure, cf. Chap. VIII. In the letter from Giovanbattista di Paolo Mini to Bartolomeo Valori of September 29, 1531 (Gaye II, pp. 228*f*), the sentence: "e di presente finiva uno di que' vechi che io non credo si posa vedere meglio" refers probably to Crepuscolo (cf. also Steinmann, *Geheimnis*, p. 96).

Varchi, *Due lezzioni*, Florence, 1549 (written 1546), p. 117, mentions the Crepuscolo briefly. (Concerning his interpretation of the Allegories, see text, p. 61.)

Vasari 1550, pp. 131*f*, briefly mentions the Crepuscolo.

Condivi 1553, does not mention the figure.

Vasari 1568, p. 133, briefly mentions the figure.

Borghini, *Riposo*, 1584, Book I, pp. 65*f*, mentions the Crepuscolo briefly.

Bocchi-Cinelli, *Le bellezze della città di Firenze*, Florence, 1677, pp. 529*ff*, gives a detailed analysis of the figure: "Ha figurato il Buonarroto la disposizione dell' huomo, quando vuol dopo le fatiche del giorno prender quiete, e nel riposo si adagia."

14. SUBJECT: The figure is without emblems. Through the forms of the body and the pose of the limbs alone the symbolic meaning is expressed, as Bocchi-Cinelli has already

noticed. According to Steinmann, *Geheimnis*, pp. 98*ff*, the figure represents the phlegmatic humor. According to Panofsky, *Iconology*, pp. 207*f*, the figure expresses the melancholic humor, the element earth, and the season of autumn.

Thode, *Kr.U.*, I, pp. 524*ff*, gives a survey of the earlier interpretations.

Modern scholars have followed, in the description of the pose of the figure, Bocchi-Cinelli (quoted above); thus Wölfflin, *Klass.Kunst*, p. 174; Kaiser, p. 214; Burger, p. 374; von Kleinenberg, pp. 113*ff*.

246 15. ANALOGIES: The figure is developed from the bronze nude of the Sistine Ceiling above the spandrel representing Ezechias (cf. Vol. II, p. 70). This bronze nude reverts
243 to ancient fluvial or mountain gods in the triangles of the triumphal arch of Septimius Severus.

The motif appears already in Michelangelo's project drawing for the double tomb,
82 No. 52. The sketch is drawn inverted. It was recognized as the first idea of the Crepus-
89 colo by Thode and by Popp. On No. 57 the figure on the sarcophagus anticipates also the pose of the statue.

16. COPIES: cf. p. 155.

<div align="center">NOTTE</div>

Length of the block: 194 cm.
Depth of the block: 63 cm.

22-30 17. CONDITION: The cloth on the forehead of the mask is damaged. The left arm from the shoulder downwards, and the left hand, are unfinished. (The left hand, bent at the wrist, seems to be holding the sheet; the right hand, behind the head, a poppy.) Unfinished is also the braid of the hair. Otherwise the statue is finished and polished.

Kriegbaum, *Michelangelo*, p. 39, supposes that the left arm was damaged during the work, and that the original left arm did not extend down, but to the side in the plane of the upper body, like the left arm of the Leda. This hypothesis seems to be unlikely, because of the muscles of the shoulder. But that this left arm was considered strange already in the sixteenth century is shown by the statement by Doni (*I marmi*, Venice, 1552-1553, Part III, p. 23) that the left arm was originally in another position and was reworked by Michelangelo. Doni says: "e la Notte riposì giù la testa, & nel muover che la fece la guasto la prima attitudine del sinistro braccio, che Michelagniolo gli haveva sculpito, cosi fu forzato a rifarne un' altro come voi vedete, in un' altra attitudine che stessi più vaga, più comoda, e meglio; che da se aconciata non s'era. . . . Ecco qui il luogo dove questa figura della Notte haveva il suo primo braccio accomodato . . . ecco l' altro che gli sculpì di poi; parvi egli un maestro questo? a rimutare tutto un braccio da la spalla a una figura finita e stabilita. . . ."

18. HISTORY: Concerning the date of execution of the figure, cf. Chap. VIII. The figure is mentioned for the first time in Michelangelo's autograph note, Frey, *Dicht.*, XVII (written ca. 1523, according to Frey).

<div align="center">[134]</div>

It is mentioned again in a letter from Giovanbattista di Paolo Mini to Bartolomeo Valori of September 29, 1531 (Gaye II, pp. 228f): "rimasi d'andare a vedere le dua femine, chosì feci altro dì, e infati sono cosa di grande maraviglia, e so che V.S. vide la prima, che figura per la Notte cho la luna in capo el n cielo notturno."

In 1536, J. Fichard, in his travel notes, mistakes the Notte for Minerva (cf. *Rep.f.Kw.*, 1891, XIV, p. 378).

It is then the subject of an epigram by Giovanni Strozzi which was written, as Frey has shown (*Dicht.*, CIX, 16, and p. 409) in 1545. Michelangelo answered shortly afterward in his own beautiful epigram (Frey, *Dicht.*, CIX, 17), in which the Notte speaks:

"Caro m'è'l sonno et piu l'esser di sasso,
Mentre che'l danno et la vergogna dura.
Non veder, non sentir m'è gran ventura;
Pero non mi destar, deh! parla basso."

It is quite probable that the "danno et la vergogna" are allusions to the political situation in Florence under Duke Cosimo I Medici, since it is known that a year before Michelangelo composed this epigram, he had offered to make an equestrian monument in bronze at his own expense for the French King, which he would erect on the Piazza della Signoria if the King would restore to Florence its old freedom (Gaye II, p. 296).

In his *Due lezzioni*, p. 117, published in 1549, but written in 1546, Varchi mentions the four Allegories, the two Capitani, and the Virgin. His attempt to interpret the monuments is admittedly his own and not Michelangelo's.

Vasari, in his first edition, 1550, pp. 131f, took over, with slight transformations, Varchi's interpretation. He gives (pp. 133f) a detailed description of the Notte, emphasizing that the figure expresses grief and melancholy (because of the death of the Duke): "Et che potrò io dire della Notte, statua unica o rara? Chi è quello che abbia per alcun secolo in tale arte veduto mai statue antiche o moderne cosi fatte? Conoscendosi non solo la quiete di chi dorme, ma il dolore e la maninconia di chi perde cosa onorata e grande. . . . Nella qual figura quelle sonnolenzia si scorge che nelle imagini addormentate si vede."

Doni, *I marmi*, Venice, 1552-1553, Part III, pp. 23f, mentions the Notte and says that the position of her left arm was reworked by Michelangelo (cf. above).

Condivi 1553, pp. 134f, emphasizes the unity of idea expressed by all four figures, which signify, according to him, time which consumes all: "il tempo, che consuma il tutto." He gives a description of the Notte and her attributes, saying that Michelangelo also wanted to make a mouse symbolizing Time which devours all things but that he did not execute it. "Et per che tal suo proposito meglio fusse inteso, messe alla Notte, ch' e fatta in forma di donna di maravigliosa bellezza, la civetta et altri segni, accio accomodati, così al Giorno le sue note. Et per la significatione del tempo voleva fare un

topo, havendo lasciato in sù l'opera un poco di marmo, il quel poi non fece, impedito; percioche tale animaluccio di continuo rode et consuma, non altrimenti chel tempo ogni cosa divora."

Vasari 1568, pp. 133*ff* (cf. Vasari 1550).

In 1574 an anonymous French traveler notes an anecdote concerning Michelangelo in which the Notte especially is mentioned (cf. *Voyage d'Italie*, British Museum, Ms. Fr. Lansdowne 720, published by J. P. Richter, *Rep.f.Kw.*, III, 1880, pp. 289*f*): "They tell the following saying about Michelangelo: as answer to the question of one of his friends who, impressed by his works and especially by the statue of the Notte in ecstasy, wanted to know how it was possible for Michelangelo to execute such works of art: 'I have not executed that,' answered Michelangelo. 'The statue which you see was already in the marble block which I had, and I had no trouble at all. I had only to cut away the little pieces which were around it. As proof that this is indeed so, you may take such a marble block, or a stone, no matter whether big or small; I assure you there does not exist even one of them in which there is not present some image or statue. That which matters is only recognizing it clearly.'"

In 1584 Borghini, *Riposo*, p. 20, mentions a copy in the original size in plaster (*gesso*) of the Notte and of the three other Allegories in the house of Ridolfo Sirigatto. On p. 65 he describes the Notte, praising especially the attributes (*insegna*), mentioning the moon on the forehead, and the owl.

In the same year, Lomazzo (*Trattato della pittura*, Milan, 1584, Book VII, Chap. 29, p. 660) mentions the Notte: "Et in altro modo [che in antiquità] fù [la Notte] dormendo scolpita in marmo ignuda maggior del naturale, insieme con l'Aurora, da Michel Agnolo, insieme con altre figure nella Sacristia Ducale di Fiorenza."

The most detailed description in the seventeenth century is that of Bocchi-Cinelli, *op.cit.*, p. 526. Here the flowers below the left foot are interpreted as "festone di frutte."

19. SUBJECT: That the body is characterized as the body of a mother was observed by Bocchi-Cinelli, *op.cit.*, p. 533, and among the modern scholars by Brücke, "Nacht u. Morgen Michelangelo's," *Deutsche Rundschau*, LXII, 1890, pp. 261*ff*. Michelangelo wanted probably to express thus the fertility of night.

The figure is not a simple allegory but an incarnation of the properties of night. It is an enlargement of a sleeping human figure to a cosmic symbol.

The emblems are not held by the figure, but are cut out of the block that remained around it, and so are subordinated to it. This is in contrast to the usual allegorical representations of the Renaissance where the figure holds the attributes. The significance of the emblems is not clarified in all instances. Moon and star on the diadem, and owl as bird of the night are obvious attributes, but the nature of the garland near the owl cannot be determined because Michelangelo left it unfinished. Usually it is interpreted as a garland of poppies, which were in the Renaissance an emblem of fertility. Lomazzo, *Trattato*, Book VII, Chap. 20, speaking of Ceres, says: "Un mazzetto di papavero in

mano, il quale è segno di fertilità." (Steinmann, *Geheimnis*, p. 86, called attention to this reference.)

The mask below the left arm is usually interpreted as a symbol of dream (e.g. Steinmann, *Geheimnis*, p. 86) or deceit (Panofsky, *Iconology*, p. 224). The expression and the goat's teeth may be interpreted as allusions to the sensual character of the dreams. It is a kind of complement and at the same time contrast to the dreams of the woman.

That Michelangelo wanted to give the figure other meanings was supposed by several scholars. Steinmann, *Geheimnis*, pp. 82*ff*, assumed that the Times of Day implied the action of the elements and the humors and connected the Notte with the sanguine temperament, the element air, and spring. Panofsky, *Iconology*, pp. 207*f*, agrees with Steinmann insofar as he also believes that there are several meanings in the figure, but according to him the Night would express the phlegmatic temperament, the element water, and winter.

Indirectly the later poems of Michelangelo in which he speaks of Notte can be used for the interpretation of this figure (Frey, *Dicht.*, LXXVIII) as well as the Leda:

> "Et dall' infima parte alla più alta
> In sogno spesso porti, ov' ire spero."

Frey, *Dicht.*, CIX, 20:

> "Ma l'ombra sol a piantar l'uomo serve.
> Dunque le notti più ch'i dì son sante"

Thode, *Kr.U.*, I, pp. 531*ff*, gives a survey of the earlier interpretations.

20. ANALOGIES: Michelangelo's figure is not inspired by the ancient personifications of Night, a fact which was first observed by Borghini and Lomazzo. (Concerning the ancient personifications of Night, cf. Piper, *Mythologie der Kunst*, I, 2, pp. 347*ff*.) Michelangelo's figure follows quite closely the ancient Leda type. In the Codex Pighi- *250, 281* anus, in Berlin, there is a drawing of the sixteenth century after a lost ancient Leda sarcophagus, of which the motif is the prototype of Michelangelo's figure. This drawing is published in Adolf Michaelis, "Michelangelo's Leda und ihr antikes Vorbild," *Strassburger Festgruss an A. Springer,* Stuttgart, 1885, pp. 31*ff*, and Robert, *Die antiken Sarkophagreliefs,* II, 3. The same Leda motif can be found also in an ancient mosaic in Pesaro, published by P. Marconi, *Boll.d'arte*, 1933, pp. 445*ff*. (The supposition of Hekler that the prototype of the Notte was the ancient Ariadne statue is unconvincing.) The general pose—the outline of the silhouette—is almost identical with that of the ancient Leda type. What is absent in the ancient figure is the torsion of the upper body which is accompanied in Michelangelo's figure by a new pose of the arms. The figure seems not to have attained peace even in sleep, but to be tossing from unfulfilled desire. But overlying this is the pattern of the whole, consisting of a rhythmic alternation of small and large forms, bound by undulating outlines.

Michelangelo reverted a second time to the same ancient model in his Leda, but *279-285*

there he wanted to represent the body relaxed. There, indeed, there is no torsion. The breast is seen in profile, as in the ancient model. The figure differs from the prototype chiefly in the greater emphasis given to the passive abandon, and the more intimate connection between figure and swan.

The type of the head of the Notte resembles an ancient gem representing a maenad (Furtwängler, *Antike Gemmen*, II, p. 197) which was well known in the fifteenth century, as several copies of it testify (e.g. Vienna, Kunsthistorisches Museum, Planiscig, *Katalog*, no. 391; and London, Victoria and Albert Museum, no. 8717).

249 The motif of the legs is anticipated by one of the bronze nudes of the Sistine Ceiling (cf. Vol. II, p. 70).

21. COPIES: cf. p. 155.

<div align="center">GIORNO</div>

Length of the block: 285 cm.
Depth of the block: ca. 82 cm.

31-37 22. CONDITION: Perfectly preserved. The head, especially the hair and beard, and the right hand are unfinished.

23. HISTORY: Concerning the date of execution of the figure, cf. Chap. VIII. The figure is mentioned for the first time as "el Dì" in Michelangelo's autograph note, Frey, *Dicht.*, XVII, written, according to Frey, ca. 1523.

It is not sure whether the letter from Giovanbattista di Paolo Mini to Bartolomeo Valori of September 29, 1531 (Gaye II, pp. 228*f*), refers to the Giorno or (as we believe) to the Crepuscolo when he says: "e di presente finiva uno di que' vechi che io non credo si posa vedere meglio. . . ."

In his *Due lezzioni*, p. 117, Florence, 1549 (written in 1546), Varchi mentions briefly "e'l giorno" (concerning the interpretation of the Allegories by Varchi, see text, p. 61).

Vasari, in his first edition, 1550, pp. 131*f*, also mentions briefly "il Giorno." Cf. also Vasari 1568, p. 133.

Condivi 1553 omits to mention the figure.

Borghini, *Riposo*, Florence, 1584, Book I, pp. 65*f*, mentions the figure as "il Giorno."

Bocchi-Cinelli, *Le bellezze della città di Firenze*, Florence, 1677, pp. 524*f*, gives the first detailed analysis of the figure.

24. SUBJECT: The figure has no emblems. There is drapery on the right leg. Bocchi-Cinelli, *loc.cit.*, emphasized the point that the strength and activity of the figure well represent its symbolic meaning.

According to Steinmann, *Geheimnis*, pp. 102*ff*, the figure represents the choleric humor, the element of fire, and the season of summer. Panofsky, *Iconology*, pp. 207*f*, follows this interpretation.

Steinmann, *Geheimnis*, p. 103, interprets the pose erroneously as a transitory movement. "Man meint . . . der zornige Gigant müsse aufspringen und um sich schlagen,"

whereas Michelangelo represented a psychic state which can never be transmuted into direct action.

Thode, *Kr.U.*, I, pp. 529*f*, gives a survey of the earlier interpretations. To these can be added that of Justi, *Ma.N.B.*, p. 257, who says that the figure represents "trotzige Abkehr von der Welt." V. von Kleinenberg, *Z.f.Ae.u.Kw.*, XXIII, 1929, pp. 113*ff*, gives a detailed analysis of the pose.

25. ANALOGIES: Cicognara and Stendhal emphasized the influence of the Torso Belvedere on the treatment of the muscles, an opinion which was adopted by Steinmann, *Geheimnis*, pp. 102*f*. *252*

The surprising anticipation of the upper part of the body, the back, the pose of the arms, and the turning of the head, by the Christ Child of Michelangelo's earliest marble work, the Virgin of the Stairs, was noted in Vol. I, p. 131. One of the bronze nudes of the Sistine Ceiling also prepares the motif of the Giorno, cf. Vol. II, p. 70. *253*

25a. COPIES: cf. p. 155.

LORENZO DE' MEDICI

Height: 178 cm.
Width of base: 68 cm.
Depth of base: 73 cm.

26. CONDITION: Perfectly preserved. The details of the armor, the helmet, and the bat *38-41*
head on the coin box seem to have been executed by Giovanni A. Montorsoli. He also apparently cut away part of the base so that the right foot extends beyond, a thing which Michelangelo, who always carefully preserved the original size of the block, would never have done. The face, hands, and armor are not polished. Already Vasari (1568, p. 383) mentioned Montorsoli's collaboration concerning the Capitani: "Ma nel condurre le statue del duca Lorenzo e Giuliano si servì molto del frate nel rinettarle e fare certe difficultà di lavori traforati in sotto squadra. . . ." Thanks to Comm. Giovanni Poggi the back view of the statue is here published after a photograph taken from the original. It *39*
was previously reproduced, in a photograph made after a cast, by John Goldsmith Phillips, *Bulletin of the Metropolitan Museum of Art*, I, 1942 (Summer), pp. 56*f*.

27. HISTORY: Concerning the date of execution, cf. Chap. VIII. According to several scholars (cf. Steinmann, *Geheimnis*, p. 116) this figure was executed last of all the figures in the Chapel, an opinion which seems to be unconvincing (cf. text).

The statue was erected in its niche (the back of the niche had been broken to make space for it) before September 1534 at the advice of Michelangelo before he left Florence. (Cf. Vasari 1568, p. 384: "Havendo Michelagnolo finiti con l'aiuto del frate [i.e. Montorsoli] e posti su le statue del duca Lorenzo e Giuliano, . . . andò a Roma.")

28. SUBJECT: Concerning Lorenzo de' Medici, Duke of Urbino (1492-1519), cf. Pastor IV, 1, p. 62, and Steinmann, *Geheimnis*, pp. 115*f*. Lorenzo was a nephew of Pope Leo X and the son of Piero de' Medici. He is known in literature by the dedication of Machia-

velli's *Il principe*. His actual personality does not agree with the silent thinker that Michelangelo portrayed him to be. Since it is known that Giuliano became melancholy at the end of his life, Grimm (*Preuss.Jahrb.*, XLIII, 1879, pp. 1*ff*) supposed that the names of the statues were interchanged. But in the autograph manuscript of Michelangelo (Frey, *Dicht.*, XVII) Giuliano is mentioned together with Giorno and Notte, so the figure above Aurora and Crepuscolo must be Lorenzo.

The features of Duke Lorenzo are known through several contemporary portraits. The most celebrated was that made by Raphael, the original of which is now lost but known through a copy in the corridor between the Uffizi and Pitti. (Concerning the Raphael portrait, cf. Gaye II, p. 146; Vasari, ed. Mil., IV, p. 352; and A. Venturi, *Del ritratto di Lorenzo de' Medici, Duca d'Urbino*, Modena, 1883.) Another smaller portrait, erroneously attributed to Bronzino, is in the Uffizi. All of these portraits show the Duke with a short, full beard, a long nose and bulging eyes, in no way resembling the noble, regular features given to him by Michelangelo. This discrepancy was noted as early as 1544 by Nicolo Martelli in a letter to Rugazzo quoted in the text, p. 68. Lorenzo was a Capitano of the Church, but Michelangelo represented him without the baton, an emblem which he gave to Giuliano. He is represented in the armor of ancient emperors. He wears an unusual helmet in the form of a stylized lion's mask. (Concerning the animal mask as headgear in Etruscan art, cf. Petersen, *Z.f.b.K.*, IX, 1897-1898, pp. 294*f*.) The expressive function of this helmet was noticed by von Kleinenberg, *Z.f.Ae.u.Kw.*, XXIII, 1929, p. 131: "Die Schwere des Helmes . . . zeigt die schwer lastende Wucht der Gedanken." The figure of Fortitude by Andrea Sansovino, on the tomb of Cardinal Basso in Santa Maria del Popolo, wears a casque in the form of a lion's head and holds a baton. Thus Michelangelo seems to have taken over the attributes of Fortitude, one for Lorenzo (the helmet) and the other for Giuliano (the baton).

The coin box below the left elbow decorated with a bat head has been interpreted in various ways. Most scholars have seen in it an allusion to the parsimony of the Duke, e.g. Steinmann, *Geheimnis*, p. 121 note: "Die Möglichkeit, dass in dem Kästchen, welches man sich mit Schätzen gefüllt denken kann, die Eigenschaft des Geizes ausgedrückt werden soll, möchte ich nur andeuten"; Panofsky, *Iconology*, p. 211: "His elbow rests on a closed cash-box, a typical symbol of the Saturnian parsimony"; Mackowsky, p. 182: "Lorenzo's Kassette bedeutet Habsucht und Geiz." However, since the figure is not an exact interpretation of the character of the deceased, it seems more likely that the coin is, as in antiquity, an emblem of death (cf. text, p. 69).

The gesture of the left hand, with the fingers touching the mouth, is one which expresses contemplation in silence. It reverts probably to the Christian Orient. Its role in the early Middle Ages has been treated by A. Grabar, "Une fresque visigotique et l'iconographie du silence," *Cahiers archéologiques*, I, 1945, pp. 124*ff*. The object in the left hand was interpreted as a "crumpled handkerchief" (Panofsky, p. 211) or as a money bag (Mackowsky, p. 182).

According to Jonathan Richardson, father and son, *Traité de la peinture et de la sculpture*, Amsterdam, 1728, III, 2, p. 137, Michelangelo wanted to represent in Lorenzo the contemplative life, an interpretation which was followed by almost all later scholars (cf. Thode, *Kr.U.*, I, pp. 522*f*; Borinski, *Rätsel*, pp. 96*ff*, and Panofsky, *Iconology*, pp. 208*ff*). In the sixteenth century the figure was called "Il Pensieroso" (Vasari 1568, p. 133). In the seventeenth century, Bocchi-Cinelli, p. 534, described Lorenzo as "figurato per lo Pensiero."

Steinmann, *Geheimnis*, p. 122, maintained that Michelangelo had synthesized in the Duke the two temperaments which are represented in the Allegories below him. But at the same time, he accepted the interpretation of Richardson. Only Popp, p. 164, and the author in *Cappella Medicea*, pp. 288*ff*, emphasized that the contrast between active and passive life does not underlie Michelangelo's conception. However, Popp failed to give a positive interpretation.

29. ANALOGIES: The motif of the bent wrist with the hand twisted outward was used by Michelangelo in other statues to express passivity in death or sleep, e.g. in the Christ Child of the Virgin of the Stairs (Wölfflin, *Jugendwerke*, p. 7), in the sleeping Adam in the Creation of Adam of the Sistine Ceiling, and in the dead Christ in the Pietà in the Cathedral in Florence (cf. Vol. I, p. 131).

The motif of the seated figure is developed from the Prophet Isaiah of the Sistine *255,256*
Ceiling (cf. Vol. II, p. 148).

30. COPIES: cf. p. 155.

GIULIANO DE' MEDICI

Height: 173 cm.
Width of base: 56.5 cm.
Depth of base: 76 cm.

31. CONDITION: Michelangelo himself seems to have executed the hands. For the right *42-48*
hand a drawing (in mirror image) in the Archivio Buonarroti has been identified by *47*
the author in *Arch.Buon.*, p. 431. The knees and the face were also executed by him.
The execution of the small details on the armor (e.g. the fringes) seems to have been
made by Giovanni A. Montorsoli (cf. Vasari 1568, p. 384). The modeling of the cuirass
and of the mask on the breast seems to be by Michelangelo. It is known through Vasari
and from a letter of Sebastiano del Piombo of July 25, 1533, that Montorsoli worked on
the statue: "Et perchè mi pare che si facia un gran romore per chè havete messo el fratte
[i.e. G. A. Montorsoli] in opera, su la figura del Ducca Juliano, io l'ò facto intendere a
Nostro Signore et mostratoli la vostra lettera" (Milanesi, *Corr.*, p. 108). It was apparently Montorsoli who cut away a part of the base in the front and at the right side, preserving, however, a piece below each foot (cf. Montorsoli's S. Cosmas).

The back view of the statue, which shows the splendidly modeled back and the inter- *43*
esting unfinished mask, is, thanks to Giovanni Poggi, here published after a photograph

taken from the original. (It was previously reproduced from a photograph made after the cast by John G. Phillips, *Bulletin of the Metropolitan Museum of Art*, I, 1942 [Summer], pp. 58*f*).

32. HISTORY: Concerning the probable date of execution, cf. Chap. VIII. The statue was erected in its niche before September 1534 at the advice of Michelangelo before he left Florence (cf. Vasari 1568, p. 383).

With regard to the genesis of the idea of the statue of Giuliano, four drawings by Tintoretto are of interest (Oxford, Christ Church College, L 1 recto and verso, and L 2 recto and verso). These drawings are made after a small model of the Giuliano, a model which cannot have been a reduced copy of the marble sculpture, since it shows the figure in the nude and in a sitting position which is somewhat different from that of the executed statue (the right foot is supported on an object, and the torso is turned more to the left). The small model which Tintoretto used was probably a copy of the original model of Michelangelo. Colvin (*Oxford Drawings*, II, p. 17) even assumed that it was the original model itself. Colvin's hypothesis was followed with caution by von Hadeln, *Zeichnungen des Giacomo Tintoretto*, Berlin, 1922, p. 26 and Plate 7. He says: "Soll man an eine freie Umbildung von der Hand eines Nachahmers, etwa des Daniele da Volterra, glauben, oder wie Colvin in hypothetischer Form getan, an ein Original-modell Michelangelos? Auch mir scheint es, dass es sich eher um ein Präludium als um einen Nachklang der in der Marmorstatue niedergelegten Idee handelt."

In all probability the small model which Tintoretto used was an already slightly transformed copy of the original model. The exaggerated musculature, the strong torsion of the upper body, and the attitude of the legs, correspond to the taste of the middle of the century. On the other hand, the Oxford sketches in at least one point afford an insight into the genesis of the idea. They show that in the small plastic models Michelangelo represented the figures nude, and clothed them only later, in the execution—the same method used in his drawings.

33. SUBJECT: Concerning Giuliano de' Medici, Duke of Nemours (1479-1516), cf. Pastor IV, 1, p. 61; Fischel, "Portraits des G. de' Medici, Herzogs von Nemours," *J.d.p.K.*, XXVIII, 1907, pp. 117*ff*; Steinmann, *Geheimnis*, p. 107 note. Giuliano was the brother of Leo X. Michelangelo had known him since his early youth when he lived as a guest of Lorenzo Magnifico in the Palazzo Medici. Later the artist mentions him in a letter written to his father as the latter was fined by the newly restored government of Florence in 1512 for sixty ducats. Cf. Vol. II, p. 246. "Io scriverò dua versi a Giuliano de' Medici" (Milanesi, p. 47).

Later, living at the Court of Urbino, Giuliano was in intimate relation with Castiglione, in whose *Cortegiano* the Duke is one of the protagonists. He is here called "nobilissimo ingegno" and "protettore delle donne," and is commended for his liberality. He was also a friend of Bembo and is mentioned in Bembo's *Della volgar lingua*. His poems are published by G. Fatini, *G. de' M., Poesie*, Florence, 1939. He was a melan-

choly character, and the fact that Michelangelo represented Lorenzo as melancholic led H. Grimm (*Preuss.Jahrb.*, XLIII, 1879, pp. 1*ff*)—as stated above—to suppose that the names of the two Dukes had been confused. This hypothesis, however, contradicts Michelangelo's own note (Frey, *Dicht.*, XVII) where Giuliano is mentioned together with Giorno and Notte, the two figures below him on the monument.

The features of Giuliano are known through several portraits. One is attributed to Raphael (probably a copy after him) in the Metropolitan Museum (Bache Collection), New York, another copy by Allori in Florence in the Uffizi. Also in the Uffizi is another smaller portrait of Giuliano by an unknown artist.

The portraits show the Duke with a short full beard and with a relatively large and curved nose. They have nothing in common with the features in Michelangelo's statue where he is represented as a beardless youth with curled hair and with a small and fine nose. Three medallions, all from 1513 (published by Fischel, *J.d.p.K.*, XXVIII, 1907, p. 123), show the young Giuliano beardless, but here too there is only a similarity in the long neck, whereas the large aquiline nose and the projecting chin are completely different from Michelangelo's figure.

In the lifetime of Michelangelo it was already known that he did not strive for actual likenesses. Cf. the letter of Nicolo Martelli to Rugazzo, July 28, 1544 (published in *Il primo libro delle lettere di Nicolo Martelli*, Florence, 1546, folio 4912; quoted in the text, p. 68).

The baton in the lap of the statue is the "bastone di Santa Chiesa," according to Bocchi-Cinelli, *op.cit.*, p. 528. However, Lorenzo was also a Capitano of the Church and yet he does not have this emblem.

The palm of Giuliano's left hand is filled with coins (although it has been stated *46* [Borinski, *Rätsel*, p. 157, and Panofsky, *Iconology*, p. 211] that he holds only two). These have been variously interpreted. Steinmann, *Geheimnis*, p. 122, no. 3, believed them to be, like the baton, symbols of highest power, at the same time recognizing in them a possible direct allusion to the magnanimity of the Duke. This latter interpretation was taken over by Mackowsky, p. 180, and Panofsky, *Iconology*, p. 211. For our interpretation of the coins as oboloi of the departed souls, cf. text, p. 69.

According to J. Richardson, father and son, *Traité de la peinture et de la sculpture*, Amsterdam, 1728, III, 2, pp. 136*ff*—whose interpretation was followed by Bottari (ed. Vasari, Rome, 1760, pp. 54*f*), Moreni (*Delle tre sontuose Cappelle Medicee*, 1813, p. 48), and by almost all modern scholars (cf. Thode, *Kr.U.*, I, pp. 521, 537, and Panofsky, *Iconology*, p. 211)—Giuliano should be considered as representing the *vir activus*. Concerning the literary sources of *vita activa* and *vita contemplativa*, cf. Borinski, *Rätsel*, pp. 96*ff*. Steinmann, *Geheimnis*, pp. 106 and 122, followed this interpretation but enlarged upon it by suggesting that each of the Capitani is a kind of synthesis of the two temperaments which are represented, according to him, in the Allegories on the sarcophagi.

Only Justi, *Ma.N.B.*, pp. 228*f*, Popp, *Med.Kap.*, p. 164, and the author, *Cappella Medicea*, 1934, pp. 288*ff*, have not followed this interpretation. Justi observed rightly that "[Giuliano] fasst seinen Commandostab etwas lässig, ja weniger fasst als an den Händen hingleiten lässt, als wolle er ihn fallen lassen." Popp (p. 164) expressly stated that "Der Gegensatz von Aktivem (Giuliano) und Passivem (Lorenzo) liegt den beiden Statuen [der Duchi] nicht zugrunde." And the author, *Cappella Medicea*, 1934, p. 288, emphasized: "*Giuliano*, benchè il suo busto eretto sembri rispondere ad un subito richiamo, non ci da altra impressione che di una contemplazione pacata e passiva. . . . Non si tratta dunque, come finora si credeva, di figure simboleggianti la vita attiva e la vita contemplativa, ma delle immagini delle anime trapassate. . . ." Obviously erroneous is von Kleinenberg's statement (p. 132) that Giuliano is the "vollendeter Typus [des] gewaltigen Kraftmenschen. [Ein Feldherr] der mit Schwert und Geld, mit Gewalt und Bestechung zu siegen gewohnt ist."

According to Bocchi-Cinelli, *op.cit.*, p. 528, Giuliano is a representation of Vigilance (*vigilanza*). For our interpretation, cf. text, p. 69.

Thode, (*Kr.U.*, I, pp. 523*ff*) gives a survey of the earlier interpretations.

34. ANALOGIES: The pose and gestures of the Giuliano are developed from the Prophet Joel of the Sistine Ceiling and the Moses, and these figures in turn probably go back to the lost bronze statue of Julius II in Bologna. (The connection of the Giuliano with the Moses motif has been frequently emphasized, e.g. Steinmann, *Geheimnis*, p. 114, and Vol. II, p. 148.)

257-259

The supposition of Steinmann (*Geheimnis*, p. 114) that the first inspiration for the motif of the Dukes goes back to the two Byzantine reliefs of the façade of St. Mark's in Venice, representing St. George and St. Demetrius, is unconvincing. Neither in the pose nor in the costume is there a real similarity. The military garment of the Dukes reverts rather to ancient Roman imperial statues.

35. COPIES: cf. p. 155.

THE VIRGIN

Height of the figure: 226 cm. (with base).
Height of the base: 31 cm.
Width of the block at the base: 95.5 cm.
Depth of the block at the base: 90 cm.

49-56

36. CONDITION: Unfinished, except for the Child, which has not, however, been polished. (The back view of the statue is, thanks to Giovanni Poggi, here published after a photograph taken from the original.)

50

37. HISTORY: Concerning the date of execution, cf. Chap. VIII. Varchi, *Due lezzioni*, Florence, 1549 (written in 1546), p. 117, supposes an influence of Dante in the motif of the suckling Child. He mentions especially *Paradiso*, XXIII, 121-123, and *Paradiso*, XXX,

[144]

82-84. The relationship is not convincing, but it is interesting that here for the first time a parallel is drawn between Dante's poetry and Michelangelo's plastic work.

A. F. Doni, *Disegno*, Venice, 1549, p. 48, says: "La stanza dove lavora [Michelangelo], che v' è una Madonna, che scese di Paradiso a farsi ritrarre." This note is important as proof that in 1549 the Virgin was still in Michelangelo's workroom, and not yet in the Chapel.

Vasari 1568, p. 131, gives a description of "La Nostra Donna," and of the Child "chiedendo il latte." Then comes an important sentence: "gradinata nella imperfetione della bozza la perfettione dell' opera." The perfection of the artistic idea is, according to Vasari, independent of the perfection of the execution. This is the earliest appreciation of the "unfinished" in Michelangelo's works.

Condivi 1553, p. 136, says about the Virgin: "Ci son poi altre statue . . . tutte . . . divine più che humane, ma sopra tutte una Madonna col suo figliolino a cavalcioni sopra la coscia di lei. . . ."

Borghini, *Riposo*, 1584, Book II, pp. 163*f*, gives a short description influenced by Vasari: "La Madonna non finita col bambino in collo; . . . è pure di Michelagniolo, il che ben dimostra per l'eccellenza sua."

Bocchi-Cinelli, *Le bellezze della città di Firenze*, Florence, 1677, pp. 536*ff*, again repeats Vasari's idea that the figure, though unfinished, is divinely perfect, and gives a detailed analysis of the figure.

39. SUBJECT: This Virgin belongs to the type of the Madonna del Latte. Michelangelo was the first Italian artist to represent the Child with his back turned to the spectator. The motif was known in northern Gothic Virgins (cf. Koechlin, *Ivoires gothiques*, Plate 106, no. 635), but there can be no direct connection with Michelangelo's group. Michelangelo invented the motif in his Virgin of the Stairs (cf. text, p. 71). The fact that the Virgin and Child expresses the polarities of the idea of the life process which renews itself eternally was noted by the author in *Cappella Medicea*, p. 290.

The figure has usually been misinterpreted. Characteristic is the description of Justi, pp. 262*ff*: "Knechtgestalt einer Tagelöhnerin . . . Kälte und Härte der bildnerischen Sprache." Walter Friedländer, "Die Entstehung des antiklassischen Stiles," *Rep.f.Kw.*, 1925, pp. 55*ff*, tries to show that the slender proportions of the Medici Virgin and the Vittoria are under the influence of Florentine Mannerism: "Sie sind [the slender proportions] die typischen Ausdrucksformen der manieristischen Seite von Michelangelos Kunst." The Vittoria is "eine unbewusste Konzession an den Manierismus." But the slender proportions are a general Florentine trait, quite visible throughout the Quattrocento. There is no necessity to suppose Mannerist influence.

40. ANALOGIES: There are two preparatory sketches for the Virgin, made ca. 1524 (cf. Popp) on No. 88. In the upper sketch the Virgin's pose recalls that of the Virgin of the *128* Julius Tomb of 1513. That the motif of the Christ Child is anticipated by the child in *262* the Joseph lunette was pointed out by the author in Vol. II, p. 177.

In the project drawing of the Magnifici tombs, No. 59, the position of the Virgin is still quite different from the execution. The legs are here parallel, whereas in the executed statue the legs are crossed.

40. TECHNIQUE: Since the block was originally much larger than the actual group, as can be seen on the base (cf. also the rear view), it may be supposed that originally Michelangelo wanted to execute a quite different group. On the left side he preserved the original outline of the block; on the right he cut much of the material away. So he arrived at the slender proportions.

Kriegbaum, *Michelangelo*, also assumed an essential change in the plan of the figure. He believed, however, that the left arm of the Virgin, in the new version laid against the Child, was originally stretched forward, but that the original direction of the Virgin's glance was not altered, so that she now "stares into vacancy." However, Michelangelo never did plan outstretched arms in marble sculptures (Kriegbaum appeals to the inaccurate drawings, by pupils, of the Magnifici tombs, which have no documentary value). Furthermore, Kriegbaum's interpretation of the Virgin's gaze is a misunderstanding of the melancholy contemplation of the Madonna.

41. COPIES: cf. p. 155.

MODEL OF THE RIVER GOD

Florence, Accademia delle Belle Arti.

Clay, tow, wood and wool.

Greatest length: 1.80 cm. According to a document quoted below, the whole figure was four braccia (2.32 m.) long.

42. CONDITION: The head, the left arm, the right forearm, the right leg below the knee, and the left foot are lacking. The left breast was somewhat damaged and was probably restored October 13, 1590, as such a restoration is mentioned (cf. Gottschewski).

43. HISTORY AND ATTRIBUTION: The river gods are mentioned for the first time on April 4, 1524 (Frey, *Briefe*, p. 223). On October 14, 1525 Fattucci asks Michelangelo when he intends to begin the *fiumi* (Frey, *Reg.*, p. 109, no. 114, and *Briefe*, p. 261). Michelangelo answers on October 24, 1525, saying that he has not yet begun the river gods because the marble blocks for them are unsatisfactory (Milanesi, p. 450). In June 1526, the four river gods which Michelangelo himself intends to execute are not yet begun (Milanesi, p. 453; the correct date is given in Frey, *Reg.*, p. 113, no. 127). (Cf. also text, pp. 57f.)

Michelangelo executed large clay models for at least two of his river gods, and they were apparently placed in the mid-sixteenth century below Aurora and Crepuscolo, i.e. the two earlier Allegories, since such models are mentioned by Doni, *I marmi*, Venice, 1552-1553, Part III, p. 24: "Che stupende bozze di terra son queste qui basse?" asks the Foreigner. The Florentine answers, "Havevano a esser due Figuroni di marmo che Michelagniolo voleva fare."

[146]

One of these models is preserved in the Accademia delle Belle Arti, Florence, and was *61-64* discovered by Gottschewski and Adolf Hildebrand, *Münchner Jahrb.*, I, 1906, pp. 43ff. Geisenheimer (cf. Gottschewski, pp. 83ff) discovered in the Archivio dell' Accademia del Disegno documents concerning this model. On April 28, 1583, Bartolomeo Ammannati announced to the *proveditore* of the Accademia, Cristofano di Papi, that he intended to make a gift to the Accademia of the "modello di terra cotta cimatura di braccia 4, di mano di Michelagniolo Buonarroti," declaring that he received the model as a gift from Grand Duke Cosimo. The gift was immediately accepted by Papi, and on the same day four porters transported Michelangelo's model to the Accademia.

On July 13, 1586, the model is again mentioned in the inventory of the Accademia as a work of Michelangelo.

On August 9, 1589, a wooden base for the model was paid for.

Further mentions are under November 25, 1589; February 1590; October 13, 1590; June 28, 1591; and 1791.

In the painting of Nicodemo Ferruzzi in the Casa Buonarroti representing artists with the works of Michelangelo (cf. Steinmann, *Porträtdarstellungen*, Plate 97), there *269* is in the lower right corner a portrait of Ammannati holding the model of the river god, indicating that at the execution of the painting the model was considered a representative work of Michelangelo. In another painting of the Casa Buonarroti by C. Allori, *270* representing Michelangelo meditating on Poesy, the river god appears again in the lower left corner as a kind of insignia.

These are further proofs for the thesis of Gottschewski that the model in the Accademia is identical with the river god of Michelangelo.

44. The clay model in the Accademia is today incorrectly placed on its base, as Wilde has shown. The outside of the right leg should be flat on the ground and the right elbow should also touch the ground. The correct position can be reconstructed on the basis of several copies and paintings of the sixteenth and seventeenth centuries (cf. J. Wilde, *Belvedere*, 1927, p. 143 note), for example: a fresco by Jacopino del Conte, Oratorio di San Giovanni Decollato, Rome; and one of the ceiling paintings of the Sala del Cinque- *267* cento, representing Volterra, in the Palazzo Vecchio by Vasari. (Vasari himself tells that he came as an apprentice to Michelangelo in 1525. Since that was the time when Michelangelo was probably preparing his models of the river gods, the young Vasari could have studied them, and might have used one of Michelangelo's drawings of the models for the painting of the Palazzo Vecchio.) Another copy of the river god, in the correct position, discovered by J. Wilde, exists in a painting by Simon Vouet representing the *268* Temptation of St. Francis, Rome, San Francesco in Lucina (reproduced in H. Voss, *Die Malerei des Barock in Rom*, Berlin, n.d., p. 139).

45. The attribution of the clay model to Michelangelo was not accepted by Frey, *Handz.*, Text, pp. 215-218. According to him the quality is too poor. The attribution was also questioned by Popp (*Med.Kap.*, pp. 150f). According to the latter, this model

is a fragment of a festival decoration made in 1565 by Ammannati on the occasion of the marriage of Duke Cosimo to Princess Giovanna d'Austria in Florence. For this occasion Ammannati made a Neptune fountain with four river gods, two of which were male and two female. Popp states that the clay model of the Accademia should be identified with one of these river gods. It shows, according to Popp, not an outstretched figure, but a seated figure on a high base (an interpretation which we have seen above, through the copies, to be incorrect). Popp holds that the modeling is not at all in Michelangelo's style, and is very close to the style of the old river god and the satyrs of Ammannati's fountain in the Piazza della Signoria: "alles flach, linienhaft, unkörperlich," like Ammannati. This festival decoration is mentioned by Lapini, *Diario*, p. 148; by V. Borghini, letter published in Bottari, *Raccolta*, I, 1754, pp. 86*ff*; and by Vasari, ed. Mil., III, p. 930. The description given by Vasari, who speaks of youthful river gods, does not fit the clay model. Stylistically, in the richness of the modeling of the torso and legs, the river god is a far cry from the simple surfaces of Ammannati's sculptures. Consequently Popp's identification seems unlikely.

265, 266 Popp (p. 152) also attributes the small bronze copies in the Bargello to Ammannati. They were cast, according to her, from original models by this artist.

46. Three versions of river gods projected by Michelangelo can be distinguished:

82 (a) The first is on the project drawing for the double wall tombs, No. 52, below the *227* left sarcophagus. (There is also a river god in an identical pose in Frey, *Handz.*, 214b, which seems, however, to be only a school piece.) The outstretched figure has the chest turned in a frontal position, the right leg slightly bent. This motif is developed from the outstretched woman in the first plane at the left of the Deluge of the Sistine Ceiling. Michelangelo repeated the same motif in the bronze nudes above the Judith and Holofernes spandrel of the Ceiling (cf. Vol. II, Figs. 196, 197) and somewhat modified in the Adam of the Creation of Eve.

89 (b) The second is the river god, No. 57, below and beside the sarcophagus done before February 1521. The upper part of the body is somewhat erect. The figure leans on the right arm, which seems to be supported by a vase. The left arm is outstretched (perhaps also supported by a vase); the right leg is slightly bent, as in the first version. This motif is developed from the Adam of the Creation of Adam in the Sistine Ceiling and *151* reverts to antiquity. Michelangelo used it later, in 1533, for the river god in his first version of Phaeton.

(c) The third version was conceived sometime in 1525, or in any case, before March 1526. The river gods of the tomb of Duke Lorenzo (third version) should be recon-*61* structed on the basis of the clay model of the Accademia described above. In 1552, this model, with its corresponding figure, was in its place and was described by Doni, *I marmi* (cf. above).

Michelangelo himself used the motif somewhat later in a sketch for his Venus and *286* Cupid composition, No. 122. Here the position of the two legs is taken over, but the

position of the arm which should support the body is changed. It is no longer visible in the frontal view, and the elbow no longer touches the ground, but seems to be supported by an invisible object. By means of this transformation the artist accentuated the curve of the body.

The motif of this version was developed from the second version in such a way that the spatial values are more emphasized. The right leg is now outstretched on the ground, but bent into the depth. The left leg, somewhat raised, is also bent in a diagonal direction. The left arm, which is holding the vase, is no longer parallel to the surface of the composition, but comes out diagonally from the depth. The silhouette of the whole is more concentrated and massive than the earlier version.

The river gods below the tomb of Giuliano, of the same period, can very probably be reconstructed on the basis of a guide drawing, No. 95, made by Michelangelo for *131* the stonecutters. The drawing represents two sketches of a river god seen from two different angles. (That these are two sketches of the same figure was observed for the first time by Meder.) Yet they are not completely alike in each sketch. This fact can be explained by supposing that Michelangelo corrected himself while executing this sheet. The right-hand sketch gives the main view of the figure; this, then, would be the river god below the Giorno. Both legs are now bent so that the figure is only three braccia, in contrast to the river gods of the Lorenzo tomb, which were four braccia long at the bottom. The torsion of the body approximately corresponds in mirror image with the torsion of the Giorno.

The motif of the left-hand sketch was used by Michelangelo in his second version of the Phaeton, as has been observed by Popp. There is a free copy of this sketch in one *152* of Vasari's paintings in the Sala del Cinquecento.

If we take this third version as definitive, then the two river gods of the Lorenzo sarcophagus would have continued the down-flowing movement of the Aurora and Crepuscolo, while the two below the Giuliano sarcophagus would have shown curves suggesting an upward movement, the continuation of which is represented by the Giorno and the Notte.

47. Wölfflin (*Klass.Kunst*, p. 180, n. 1, and *Beilage zur Allgemeinen Zeitung*, 1907) emphasized the fact that in the existing system there would be no place for the river gods. When they were conceived, the Allegories were placed somewhat higher. Also Gottschewski believes that the river gods were suppressed by Michelangelo in the last version, since they would have exceeded the limits of the tomb architecture, whereas in No. 57 they remain inside the architectural frame. This supposition, however, is un- *89* likely; first, because the reduction of the monument to its actual size was already decided in 1521, whereas the models for the river gods of the Lorenzo tomb were executed in 1525-1526; and second, because the Allegories also surpass the architectural limits (the cornice), so there is no reason to suppose that Michelangelo would have shrunk from such an idea in connection with the river gods. (For sketch, see p. 47.)

48. The tentative reconstruction of the river gods by Steinmann (*Z.f.b.K.*, XVII, 1906, pp. 39*ff*), on the basis of two small models of river gods in the Bargello which he attributed to Tribolo, was refuted with good arguments by Popp (*Med.Kap.*, pp. 148*ff*). Popp showed that these models, as well as three similar models in Berlin, Kaiser Friedrich Museum, are not by Tribolo, but by Giovanni da Bologna, and served as models for the fountain in the Giardino Boboli. (The identification of two of the Berlin models with Giovanni da Bologna was first made by Fritz Goldschmidt, *Amtl.Ber.d.kgl.Museen*, Berlin, XXXIV, 1912-1913, pp. 84*ff*.) Popp has shown in a fine analysis that these small models cannot have been made by artists working in the first half of the sixteenth century, who would have emphasized the plastic mass, but are conceived according to the early Baroque principles of the second half of the century by which equal importance in the composition was given to the intervals between the masses.

Popp's attempt to reconstruct the development of the idea of the river gods (*Med. Kap.*, pp. 144*ff*), in spite of several fine observations, can hardly be accepted. According to Popp, there were five versions of the river gods:

82, 89 The first, No. 52, and the second, No. 57, seem to be correct. The third version, of 1524, is represented by the two models for the tomb of Lorenzo, which according to Popp are lost and should be reconstructed on the basis of drawings by a pupil, Frey, *Handz.*, 146, 149, 216-218. These drawings, all by the same hand, have nothing to do with the river gods, and one of them, Frey, *Handz.*, 146, is a copy after the Notte. Popp refuses, as stated above, to accept the model of the Accademia as Michelangelo's model

131 for the Lorenzo tomb. The fourth version, of the winter 1525-1526, is No. 95, a project for the river god on the tomb of Giuliano. The fifth should be dated after 1532 and before 1534. Popp believes that the river god of the tomb of Giuliano (fifth version) can

286 be reconstructed on the basis of the Venus and Cupid drawing, No. 122, and that this figure is a transposition of the motif of the river gods from winter 1525-1526 into the new style of uninterrupted curves without contrappostal contrast.

The river gods of the Lorenzo tomb (fifth version) should be reconstructed, accord-

153 ing to Popp, on the basis of the river god of the last Phaeton drawing, Windsor, No. 119. Her argument is that in one of the copies of the Ducal tombs—namely, that in the Louvre (Popp, Plate 29)—the river gods repeat the pose of the river god in the last Phaeton drawing. She supposes that the Louvre drawing is a copy of the Lorenzo monument. Though the position of the legs of the Capitano resembles Lorenzo's, the figure holds the baton of a Captain of the Church, like Giuliano, so it seems to be a kind of

89 synthesis of the two. The Allegories of this copy are inspired by those on No. 57, and the river gods by the last Phaeton drawing. Consequently, this drawing is a *pasticcio* which has no documentary value. There is no documentary proof for Popp's supposition that Michelangelo made new projects for the river gods between 1532 and 1534.

49. The copy of one of the Ducal tombs in the Albertina, which Steinmann (*Z.f.b.K.*, XVII, 1906, pp. 39*ff*) tried to use for the reconstruction of the river gods, is completely

[150]

unreliable in all its details, as can be seen by comparison of the Allegories and the seated figure with those of the executed tombs, and cannot therefore be used for the reconstruction of the river gods.

50. SUBJECT: According to the oldest interpretation by Gandolfo (published in Varchi, *Opere*, II, pp. 645*f*), the river gods below Lorenzo represented the Tiber and the Arno. This interpretation was taken up again by Steinmann, *Geheimnis*, p. 66, who, however, adds: "Den Fiumi einen besonderen Sinn beizulegen, sind wir nicht berechtigt." Popp (*Med.Kap.*, pp. 163*ff*) interprets the four river gods as the four world rivers; they are symbols of the earth, i.e. space. They were in her opinion the earliest examples of the theme of the four world rivers, so often found in Baroque art. According to Kraus (in Sauer, *Gesch.d.christl.Kunst*, II, 2, pp. 602*ff*) the river gods are symbols of the four rivers of Paradise.

In contrast to these interpretations, Oeri (*op.cit.*) emphasized that Michelangelo's river gods symbolized the four rivers of Hades, as described in Plato's *Phaedon*, Chap. 61. This interpretation was accepted by Borinski, p. 118, the author in *Cappella Medicea*, p. 305, von Simson, *Apotheose*, pp. 106*ff*, and Panofsky, *Iconology*, p. 204. The water, being a flowing element, could be appropriately associated with transitoriness.

The river gods are not only symbols of the underworld, but at the same time mourning figures. River is identified by Michelangelo in his poetry, with tears, a tradition which reverts to Dante, who said that the rivers of Hades are the tears of humanity (cf. the text).

Concerning the iconography of the river gods in the sixteenth century, cf. Lomazzo, *Trattato*, Book VII, Chap. 16 (ed. Rome, 1844, III, pp. 137*ff*).

51. TECHNIQUE: Concerning the technique of the model of the Accademia, cf. Vasari's descriptions, ed. Mil., I, pp. 153*ff*, and II, pp. 110*f*. Cf. also Gottschewski, *op.cit.* The bony structure was first built up of wood and then hay and tow were wound around it. Then a mixture of clay and wool and glue was smeared on the skeleton, and this was modeled.

52. COPIES: A small-scale copy was preserved in the collection of the Medici, according to the inventory of 1553: "Un torso di bronzo ritratto da uno fiume di Michelagniolo" (Müntz, p. 51). Gottschewski, *Riv.d'arte*, IV, 1906, pp. 73*ff*, and *Münchner Jahrb.*, I, 1906, pp. 43*ff*, who called attention to this note, rightly emphasized that the reference is clearly to a copy after Michelangelo. The same small model is mentioned again on June 13, 1559, in the inventory of Duke Cosimo's "Scrittoio" (which contained the rare and small pieces of his collection): "Un torso di bronzo ritratto da un Fiume di mano di Michelagniolo" (Müntz, p. 53). Gottschewski identified this piece with a small bronze torso in the Bargello. He called attention also to a copy of this little *265, 266* torso, also in the Bargello, completed by the head and a vase which gives evidence that it is indeed the torso of a river god.

For other copies in painting, cf. p. 147.

Leningrad, Eremitage.

Height: 54 cm.

57-60 (Back and side views published here for the first time in photographs taken from the original.)

53. CONDITION: Unfinished. Worked with toothed chisel.

54. HISTORY: According to records relating to the eighteenth century, the statuette originally formed part of the Medici collections. In 1787, it was acquired by the Lyde Brown Collection. Then it came into the Academy of Arts in St. Petersburg, from which it was transferred to the Hermitage in 1851 (cf. *Illustrated Catalogue of the Eremitage*, Leningrad, 1939, no. 17).

Thode, *Kr.U.*, II, pp. 284f, dated the figure rightly in the period of the Medici tombs, refuting with good arguments the dating proposed by Frey, *Michelangelo*, pp. 314ff, in ca. 1497-1500. Popp, *Med.Kap.*, p. 142, recognized that the figure was planned for the upper entablature of the tomb of Lorenzo in the Medici Chapel, an opinion which she

89 supported by the similar crouching youths above the entablature of drawing No. 57. Popp dated the statue ca. 1524. Wölfflin (quoted in Popp, *Med.Kap.*, p. 183) observed, without knowing the destination of the figure, that the profile should be considered as the chief view. Wittkower (*Burl.Mag.*, 1941, I, p. 133) attributed the figure to Pierino da Vinci (?).

As shown in the text, there is no place in the executed monument for such figures, and so it must be supposed that Michelangelo gave up the plan of putting such figures on the Ducal tombs. It may be that he intended to use them in the entablature of the Magnifici tombs. The date proposed by Popp, ca. 1524, seems to be correct, since the modeling of the figure is most similar to that of the Crepuscolo.

The irregular treatment of the toothed chisel work and certain weaknesses in the modeling of the feet, the hair, and the hands, argue for the supposition that the execution was in the hands of a pupil. According to Kriegbaum, *Michelangelo*, this pupil was Tribolo.

55. SUBJECT: In the older literature the figure is interpreted as an isolated genre figure. Wölfflin, *Klass.Kunst*, p. 183, says, "Das Werk sieht aus wie die Lösung einer bestimmten Aufgabe; als ob es ihm [Michelangelo] wirklich darum zu tun gewesen sei, einmal mit dem mindesten Mass von Auflockerung und Zerstückelung des Volumens eine möglichst reiche Figur herauszubringen."

Panofsky, *Iconology*, p. 212, following a suggestion of Borinski, *Rätsel*, p. 135, interprets the crouching children as "unborn souls doomed to descend into the lower spheres."

Kriegbaum, *Michelangelo*, deduces from the nearness of the weapon trophies that "the completion of a battle" is represented, and interprets the figure as a young warrior, who is shielding a wound or is removing his sandal from his foot.

For our interpretation of the figure as a mourning genius, cf. the text.

56. ANALOGIES: The affinity of the motif with the ancient statue representing a youth pulling a thorn out of his foot has been emphasized several times, for example: Justi, *Ma.N.B.*, p. 289, and Frey, *Michelangelo*, p. 314. The affinity is limited to the external motif; there seems to be no direct relationship.

57. COPIES: Popp, *Med.Kap.*, p. 142, supposes that a drawing by Raffaello da Monte-lupo, Florence, Uffizi (Berenson, no. 1640), is a copy after another Crouching Youth by Michelangelo. (It seems, however, to be only a free paraphrase after Michelangelo, and not a direct copy since the position of the legs is quite different, this being a seated figure.)

Under the influence of the statuette or a drawing by Michelangelo is the drawing by *273* Pontormo of a crouching youth, Paris, Louvre.

Kieslinger, "Ein unbekanntes Werk Michelangelos," *J.d.p.K.*, XLIX, 1928, pp. 50*ff*, thought he had discovered in the statuette of a crouching girl (Munich, private collection) the pendant to the statuette in Leningrad. However, the statuette in Munich is not by Michelangelo, and also the motif is in no way related to the figure in Leningrad.

TECHNIQUE

Michelangelo used chiefly two tools in working the marble (cf. A. Grünwald, *Florentiner Studien*, Dresden, n.d., *passim*). To bring out the form in the rough he used a pointed chisel, preserving the rocky character of the stone. To bring out the fine movements of the surface he used a toothed chisel. This tool leaves furrows at equal intervals in the marble; for the most part there are four furrows. Michelangelo seems to have used at least two toothed chisels, one larger and one more delicate, with smaller teeth closer together. As the furrows prove, he worked for the most part diagonally with the toothed chisel, and often crossed his strokes so that the result is a sort of cross-hatching. By this means he attained a softness and vibrant animation of the surface, and an even distribution of light.

In Giorno some places are worked with a flat chisel, with furrows at wide intervals, *31* which gives to the surface a fibrous character. This tool was used chiefly, however, by Michelangelo's garzoni (cf. Grünwald, *op.cit.* p. 12).

The Aurora, seen from the small side, shows the skin of the block at the right side. *16* The block behind the back of the figure and below the left foot, as well as a part of the *11* headdress at the back, are worked with the pointed chisel. The right foot and the head-dress in front show the hatching of the toothed chisel. The other parts of the body are polished. It may be mentioned here that among the four Allegories, only this figure and the Notte (the two female figures) were polished.

The side view of the Crepuscolo also shows clearly the skin of the block, and again *17* the pointed chisel work on the rough block behind the figure. The pointed chisel is also

visible in the hair, and toothed chisels are used for the face, for the left foot, and for the hands.

22, 27 In the Notte, the pointed chisel is used for the rough block and for the drapery above the right leg. The whole body and the head are polished. The left hand remained unfinished and shows signs of the pointed chisel.

32, 33 In the case of the Giorno, the pointed chisel work is again used for the block and for the hair, probably also for the forehead and beard, the toothed chisel for the right foot and the inside of the right leg, as well as for the left leg. On the back and on the left shoulder small parts are made with the flat chisel.

49, 50 In the Virgin, the base and the block on which the figure is seated are worked with the pointed chisel; otherwise the toothed chisel was used. The figure has the highest quality in all parts, and was evidently executed by the master himself. The most com-
55, 56 plete portion is the Christ Child, in the middle of the composition and therefore in the center of the field of vision. The other parts are less detailed. Here one recognizes the same method as in the Christ of Santa Maria sopra Minerva—namely, that the optically most important parts should be, according to Michelangelo, completed first.

42 Of the two Dukes, Giuliano is completed in more detail than Lorenzo. Giuliano's armor, face, and hands are polished (with the exception of his ear, where the toothed
38 chisel is visible). In the Lorenzo figure neither the armor nor the hands are polished. We know from Vasari that Montorsoli, who also executed the Saint Cosmas, worked on the two statues of the Dukes. He has "rinettate" them and made "certi lavori traforati in sottosquadra." In the case of the Giuliano, his work might have been limited to the polishing of the armor and to the execution of the spiral fringes. Certainly by Michelangelo is the head, including the hair (a wonderful flamelike treatment, which
46-48 appears for the first time in the marble David), the hands (for the right hand there exists, as stated above, a beautiful drawing in the Archivio Buonarroti), and the knees, and moreover the strange mask in the center of the breast. Montorsoli seems to have also cut away a part of the base of the Giuliano, leaving, however, a piece of marble below his right foot (the same treatment of the base can be seen in Montorsoli's Saint Cosmas).

In the case of the Lorenzo, Montorsoli seems to have worked on the armor, on the abdominal parts, on the helmet, and on the fringes. By Michelangelo are certainly the small soft folds at the wrist. In the drapery behind the right leg, the sharp-lined fold at the right seems to be Montorsoli's work.

66 The figure of Saint Cosmas shows plainly that Montorsoli, even in his plastic work, was a graphic artist. He does not model the plastic forms, but draws hard lines, so to speak.

57-60 The Crouching Youth in the Eremitage is composed in a cubical block, from which Michelangelo hewed away as little material as possible. Within the narrow limits he attempted to contrive the maximum of plastic forms. Although the motif shows Michel-

angelo's invention, a garzone apparently worked on the figure: for example, on the feet, on the hands, and on the hair. This should not be surprising, since it is a secondary figure which was to be placed very high and far from the view of the beholder.

COPIES OF THE FIGURES OF THE MEDICI CHAPEL

(We enumerate in this list only the qualitatively outstanding and most interesting copies.)

(1) Three engravings by Cornelius Cort, dated 1570, representing the two Ducal 224-226 tombs and the Virgin with the two patron saints.

(2) Engravings by an anonymous master of the mid-sixteenth century, representing Crepuscolo and Aurora in a landscape. Paris, Bibliothèque Nationale.

(3) Wax models of the two Capitani. Edinburgh, National Gallery of Scotland. Cf. Thode, *Kr.U.*, I, p. 481, who rightly considers these models to be weak copies. Other scholars (e.g. Popp) considered them to be originals.

(4) Wax models of the Allegories. Oxford, Ashmolean Museum. Robinson, no. 89.

(5) Plaster models of the four Allegories, by Vincenzo Danti, 1573. Perugia, Accademia di Belle Arti.

(6) Terracotta model of the Virgin. Florence, Casa Buonarroti.

(7) Terracotta models of the Allegories and the Virgin, by Tribolo. Florence, Bargello. The model of the Notte in this series, which in the mid-sixteenth century was the property of Vasari and preserved in his house in Arezzo, is today in London, Victoria and Albert Museum. Cf. Vasari 1568, p. 361, and Rossi, *Archivio storico dell'arte*, VI, 1893, p. 13.

(8) Terracotta models of the Allegories, mid-sixteenth century. Formerly Collection Ruland, Weimar, later Collection Percy Strauss, New York. Cf. Thode, *Kr.U.*, I, p. 485, and Steinmann, *Geheimnis*, p. 85 (illus.).

(9) Clay copy of the left hand of Crepuscolo, of Notte and Aurora. Formerly Collection Hähnel, Dresden. Cf. Steinmann, *Geheimnis*, p. 83.

(10) Bronze copies of the four Allegories. Paris, Louvre. Migeon, *Catalogue des bronzes*, 1904, p. 147, nos. 134-137. Two other bronze copies after the Aurora are preserved in the Louvre. Cf. Migeon, no. 138, and Collection Thiers, no. 78.

(11) Bronze copy of the Aurora. Vienna, Kunsthistorisches Museum. Cf. von Schlosser, *J.d.k.Slg.*, Vienna, XXXI, 1913-1914, p. 106.

(12) Drawings by Tintoretto after the Allegories and Duke Giuliano. Oxford, Christ Church; Florence, Uffizi; Berlin, Kupferstichkabinett. These drawings were, at least partly, made after models of Daniele da Volterra. Cf. von Hadeln, *Zeichnungen des Giacomo Tintoretto*, Berlin, 1922, pp. 24ff.

(13) Drawing of the sixteenth century representing the Virgin seen in profile. Paris, Louvre.

(14) Painting by Vasari after the Aurora. Rome, Palazzo Colonna.

(15) Painting of Michelangelo in his Atelier, by Delacroix. Montpellier, Musée Fabre (with the Virgin seen in profile).

Lost copies mentioned in the literature:

(1) Copies by Daniele da Volterra after the figures of the Medici Chapel, which were acquired by Tintoretto and used by him for purposes of study. Cf. Vasari, ed. Mil., VII, p. 62; Borghini, *Riposo*, 1584, p. 551; Ridolfi, *Le maraviglie dell'arte*, Venice, 1648, II, pp. 13*f*; Boschini, *La carta del navigar*, Venice, 1660, pp. 140*f*.

(2) On the façade of the Palazzo Gussoni, Venice, Tintoretto painted *al fresco* Michelangelo's Aurora and Crepuscolo, published in engraving in A. M. Zanetti, *Varie pitture*, Venice, 1760, Plates VIII and IX.

(3) Pietro da Barga, copies after Crepuscolo and Aurora, mentioned in the inventory of Cardinal Ferdinand de' Medici, 1571-1588. Cf. Müntz, *Mémoires de l'Académie des Inscriptions et Belles-Lettres*, XXXV, pp. 147*ff*.

(4) Pietro Tacca, bronze copies after the Allegories, mentioned by Baldinucci, *Notizie*, IV, 3, ed. Classici, Vol. X, p. 428.

A series of the most important copies are listed in von Schlosser, *J.d.k.Slg.*, Vienna, XXXI, 1913-1914, pp. 105*ff*, and Thode, *Kr.U.*, I, pp. 482*ff*.

VII. NOTES ON CHAPTER VII: PROJECTS FOR PAINTINGS

1. The execution of the decorative paintings was supposed to be taken over by Giovanni da Udine. The facts are best assembled by Popp, *Med.Kap.*, pp. 158*ff*, whose findings we summarize here.

The negotiations with Giovanni da Udine began in spring (April 18) 1526, were protracted until autumn (September 12) 1526, and remained for the time being without result, since he declared that he did not have time that winter (Frey, *Briefe*, pp. 281, 283, 286*ff*; Milanesi, p. 453). After the fall of the Florentine Republic, before December 15, 1531, the negotiations were resumed (Milanesi, *Corr.*, p. 78). Ca. October 7, 1532, Giovanni da Udine arrived in Florence in Michelangelo's absence (Frey, *Briefe*, pp. 331, 333). He seems to have begun his work, but apparently interrupted it in August 1533 (Frey, *Dicht.*, p. 519, no. 62). The work was nearly terminated by the death of Clement VII (Vasari, ed. Mil., VI, pp. 560*ff*). At that time the work on the decoration of the cupola was almost finished. According to Vasari, Giovanni da Udine would scarcely have had to work two weeks longer to finish it. He executed in the coffers "fogliami, rosoni ed altri ornamenti di stucco e d'oro," and on the vertical and horizontal ribs "fogliami, uccelli, maschere e figure."

Concerning the ceiling of the lantern, Michelangelo, before August 17, 1533, asked the Pope what representation he wished for it (Milanesi, *Corr.*, p. 106). Concerning the proposition of Sebastiano del Piombo, cf. p. 50.

The decoration of Giovanni da Udine did not please the Pope because of its subdued colors (objection of the Pope, July 17, 1533, Milanesi, *Corr.*, p. 106, and Vasari, ed. Mil., VI, p. 561).

Figural compositions were also desired by the Pope, but Giovanni da Udine objected that his talent as an artist was not suited to making figures. On December 25, 1531, he wrote: "Che 'l ci era da fare storia grande da una banda; per le quali la mia perfexione non è da scultore, fate mi fare cose che siano da me" (Frey, *Briefe*, p. 320). The expression "da una banda" signifies "on one side of the chapel," i.e. probably in the choir, and not as Popp supposes (*Med.Kap.*, p. 158) in the sense of "da ogni banda."

Concerning the plans for completion of the decoration by Vasari, cf. p. 168.

2. A hitherto unpublished drawing, probably by Giovanni da Udine, in the Casa Buonarroti, a project for a coffer of a dome, may with some likelihood be connected *113* with the decoration of the dome of the Medici Chapel. According to Vasari, however, the figures were on the ribs, whereas in this drawing they are in the coffer. A change of project should therefore be supposed.

3. In the lunette above the tomb of the Magnifici there would have been depicted, according to Popp (*Med.Kap.*, pp. 159*f*), the Resurrection of Christ; cf. the drawings, Nos. 108, 109 and 110. That the two sketches on the sheet No. 107 were probably in- *144-146*

150 tended for the decoration of the lunettes above the Ducal tombs was also first suggested by Popp, *Med.Kap.*, pp. 159*f*. Panofsky (*Iconology*, p. 203) agrees for one of the lunettes with Popp's opinion. In the other lunette there would have been, according to him, a fresco representing the story of Judith. He connects with this latter lunette the apocryphal drawing, Frey-Knapp, no. 306. (The hypothesis of Popp, that the small lunettes above the sepulchers should have been decorated by historical frescoes, seems to the author after a recent view of the Chapel to be somewhat doubtful, since the scale of the figures of these frescoes would have been too small.)

4. Popp supposes, contrary to the author's opinion, that the salvation scene was intended to be placed above Lorenzo and the Attack of the Serpents above Giuliano.

150 5. One of the smaller groups of No. 107, that at the right of the center, anticipates the Samson and Philistine group.

149 6. There is an interesting copy by Marcello Venusti (Cambridge, Mass., Fogg Museum), uniting in one composition motifs of the second and the third drawing of the Resurrection. This painting was published and analyzed by the author in *Art in America*, XXVIII, 1940, pp. 169*ff*.

147 7. The sketch in the Archivio Buonarroti, No. 103, has been identified and published by the author in *Arch.Buon.*, p. 442.

VIII. NOTES ON CHAPTER VIII: HISTORY OF THE EXECUTION OF THE CHAPEL

1. The "modello" mentioned in the letters of December 17 and 28, 1520 (Appendix), must have been a model of the whole Chapel, since we know that Michelangelo's offer to make large models of the architecture of the tombs in wood and of the figures in clay, in 1521, was refused by the Cardinal (Milanesi, p. 421). He executed the large models, then, much later, between January 12, 1524, and March 1526.

2. Popp (*Med.Kap.*, p. 113) supposes that the cupola was finished already in 1521, because according to her up to 1524 no work was done in the Chapel. It is possible, however, that the Chapel was provisionally roofed with wood, and that the execution of the cupola proceeded slowly until 1524.

3. The roofing of the cupola does not seem to have been perfectly satisfactory, as witnessed by an undated letter, probably of November 1532 (Appendix), in which the Prior Battista Figiovanni reports the danger that rain water will run into the "tribuna" (probably the cupola). In another letter, of November 1532, it is mentioned that the lantern needs repairing because of the leakage of rain water (Frey, *Briefe*, p. 333). In summer 1533, there is a question of putting "doccie" (drain pipes) on the lantern (Milanesi, *Corr.*, pp. 110f, and Frey, *Dicht.*, p. 519, no. 62).

4. Several *memoriali*, i.e. notebooks, with sketches of marble blocks, usually with their measurements, from the hand of Michelangelo, are preserved in the Archivio Buonarroti. Among these the most important for the history of the Medici Chapel is that in Codex I between folios 103 and 104. It consists of twenty-nine pages (of which pages 18, 19, 21-24, 26-29 are blank). Here are the blocks for the marble architecture of the tombs, for the figures (page 14), and probably for a river god (page 10).

On page 1, at the top left, is the following mutilated text by Michelangelo: ". . . che io o avuti al *Leone*; quelli che aranno un 'emme' nel mio segno, sono di quelli ch'io o avuti dal *Mancino*; quelli che ara (nno) un 'cha,' sono di quelli ch'io (o av)uti da *Chagione*; quelli che aranno un ('bi') sono di quelli ch'io avuti dal *Bello*. Uno pezo ch'ara nel segnio 'lo', o avuto da *Lotte*." (The names of these stonecutters are known from the correspondence.) At the bottom right there is the following text of the notary: "Io Calvano di St (efano) da Carrara fo fede come in questo libro di f (?) bensi si contengono tutti li pezi di marmi che mo. Michelangiolo ha avuto da diverse persone [disse, canc.] come di sopra si contiene nella memoria scripta per mano di divino maestro Michelangiolo che t (?) cosi nota hora tutti e pezi 'M'. Di volonta di divino mo. Michelangiolo, Mancino (e) Chagione ho scripto il nome mio in senno (di) fatica."

On page 25 of the *memoriale* is written in Michelangelo's hand: "sei figure, cinque di due br. l'una, e una di mancho un pocho e uno sportello d'un braccio e quarto per ogni verso, tucti questi sette pezzi sono 4 carrate.—E tre figure a Grocta Cholonbara di dua braccia e mezzo l'una, chon tre altri pezzi, (tu)cti tre carrate.—Dua pezzi di dua

[159]

carrate l'uno, dua quadroni di tre carrate amendua, uno quadrone di dua carrate, una lapida d'una carrata con un altro pezecto in tutto carrate dicciasecte."

At the back of the notebook (on p. 29) there is written the signature of Calvano and by a later hand, probably by Michelangelo's great-great-grandson: "Dinanzi sono delli di pietre da cavarsi delle cave alla Sagrestia di So. Lorenzo e di altre fabriche (per servirsi di Michelangniolo) con qualche piante e altrivo d'architettura e alcuni modani."

Other *memoriali* are in Cod. I, fols. 104 and 114, and Cod. XIII, fol. 141 (cf. Tolnay, *Arch.Buon.*, pp. 458ff).

To supervise the measurements and the quality of the blocks, Michelangelo took with him to Carrara the garzone Scipione from Settignano (cf. Milanesi, p. 582, from April 10, 1521, and the unpublished letter from July 7, 1521, Appendix). Michelangelo also took to Carrara another garzone, Raffaello Battista della Palla.

5. There are two unpublished letters from April 25 and July 1, 1521, by Donato Benti from Seravezza (Appendix). (Donato Benti was, from July 1, 1521, the "riveditore de' marmi" of Michelangelo in Seravezza.) These letters complete the letter of July 7, 1521, published by Pini, Plate 124. They are concerned with the extraction of columns in Seravezza, the purpose of which is difficult to determine. Most probable would be the assumption that columns for the façade of San Lorenzo are here still in question, except for the fact that in 1520 the contract for the façade had already been annulled. The columns were probably not intended for the Magnifici tombs, since the extraction of columns is mentioned also in the letters from Topolino of August 13, 1524 (Appendix), and January 24, 1526 (Appendix). It is moreover not likely that marble for the Medici tombs was extracted in Seravezza, because all the other marble for these tombs came from Carrara.

6. Geymüller and Köhler, who did not yet know the letter of December 14, 1520 (Appendix), but who had recognized the relationship of the tomb architecture and the *macigno* architecture, already dated the definitive project of the tombs correctly in the winter of 1520 or, at the latest, in the spring of 1521 (that is, Michelangelo's trip to Carrara in April 1521 should be considered as a *terminus ante quem*). Michelangelo went to Carrara to have marble cut for the sepulchers, so he must at that time have established the definitive measurements. From July 20 to July 29, 1521, Michelangelo was again in Carrara to inspect the blocks; and on August 16, 1521, the marble arrived in Florence (Frey, *Reg.*, 42, 45, 46). Independently of Geymüller and Köhler, Popp arrived at the same conclusion.

7. Finishing off the attica with the backs would have been impossible because the cornice in *pietra serena*, which was already finished in April 1521, projects so much that the backs of the thrones could not lean against it. (The "thrones" today are only as high as the reduced attica and have the aspect of burial altars.) From a purely artistic point of view it also seems unlikely that Michelangelo conceived the architecture of the tomb as penetrating into that of the *pietra serena*, since the conflict, typical of Michelangelo,

190, 191

between the enframing architectural system and the enclosed system would have been destroyed. Such a penetration of the tomb into the architecture of the chapel cannot even be deduced from No. 57, where the high backs of the thrones—which are, however, *89* parts of an attica of the same height—can still be seen. And it is not by chance that in the attica today there is a console in the place of the trophies, since it is a form always used by Michelangelo as a symbol of pressure exercised on a body.

8. The vases in the tabernacle niches are of two types: (a) simpler vases with ordinary handles, and (b) richer vases with dolphins as handles. *234*

Type (a) can be found in the two tabernacles at the right and left of the Lorenzo tomb. Type (b) can be found in the two tabernacles of the entrance wall. On the other hand, types (a) and (b) alternate on the wall of the tomb of Giuliano and on the altar wall. From this one can perhaps conclude that the tabernacles of the wall of Lorenzo and of the entrance wall were put in place first, and those of the wall of Giuliano and of the altar wall, later. The Medici coat-of-arms is lacking on the vases of three tabernacles: at the left and right of Lorenzo, and at the left of the altar.

IX. NOTES ON CHAPTER IX: EARLIER INTERPRETATIONS

1. Besides the interpretations quoted in the text, other older references to the Medici Chapel are: Anton Francesco Doni, *I marmi*, Venice, 1552-1553 (written probably before 1548). Doni gives no interpretation of the content of the Chapel, but the marble statue of Aurora becomes a living being and one of the protagonists of his first dialogue. Here, it seems, Doni takes up the idea of Giovanni Battista Strozzi and of Michelangelo, in whose epigrams on the Notte, in an analogous manner, the Notte herself speaks. While Aurora is animated, the visitors in the Chapel feel that they are of marble in comparison with her. The Foreigner (Peregrino) says, indeed (p. 24): "Io son marmo, ella [i.e. Aurora] è carne." This is the highest praise for a statue, according to the conception of the mid-sixteenth century. It signifies that art is victorious over nature. Since Michelangelo's Battle of Cascina, it had become a fashion to represent statues acting as living beings in the compositions, a device especially popular in the middle of the century, and spreading also to the northern countries (cf. Frans Floris and Marten van Heemskerk). Rubens was the first to criticize the manner as unnatural.

2. From the last quarter of the sixteenth century commentators discussed the question of whether the meaning of the Allegories had been clearly expressed. Borghini, *Riposo*, Florence, 1584, Book I, p. 65, seems to have been the first to raise the problem, praising the Notte chiefly because her pose and the emblems clearly express the idea of night. He emphasized that Notte was represented differently in antiquity, but that Michelangelo apparently considered the ancient emblems unsuitable for a plastic work. He criticized the three other Allegories because they have no emblems, maintaining that were they not known through tradition to represent the times of the day, their meaning could not be determined. This criticism is taken up by the Richardsons in the eighteenth century, and by Quatremère de Quincy in the early nineteenth century.

3. Bocchi-Cinelli, *Le bellezze della città di Firenze*, Florence, 1677, pp. 519*ff*, gives the same explanation of the four Allegories (p. 524) as Condivi: "Con grave considerazione, e da Filosofo più tosto, che da scultore, sopra due Sepulture ha figurate il Buonarroto quattro figure, le quali tutte quattro significano il Tempo." The Giuliano is, according to him, a personification of "Vigilanza" (p. 528), while Lorenzo personifies "il Pensiero" (p. 534).

4. F. L. del Migliore, *Firenze illustrata*, Florence, 1684, p. 164: ". . . a' sepolcri a diacere son quattro statue, alludenti al dolore, ed al pianto, che si presume ne facesse il Popolo tocco dalle loro [*sc.* the Dukes] beneficenza, simboleggiate per i termini, in cui sono scompartite l'ore del viver nostro, cioè l'Aurora, Giorno, Notte, e Crepuscolo."

5. Jonathan Richardson, father and son, *Traité de la peinture et de la sculpture*, Amsterdam, 1728, III, 2, pp. 136*ff*, follow Bocchi-Cinelli. The Allegories are for them "le Temps divisé en quatre figures." They say: "Il se peut que Michelange ait eu dessein

de représenter le Temps par où ces Héros [i.e. the Capitani] ont passé pour arriver à l'Immortalité dont ils sont aujourd'hui en possession." Then they give (p. 137) a new interpretation of the two Dukes (probably inspired by Bocchi-Cinelli): "Il a voulu représenter la Vie Active, par la Statue de Julien, & la Vie Contemplative, par celle de Laurent; pour désigner, par-là, leur caractère en particulier." This interpretation of the Dukes has been repeated, since the Richardsons, many times.

6. Domenico Moreni, *Delle tre sontuose Cappelle Medicee*, 1813, p. 48: "Un giudizioso spettatore le considererà piuttosto come l'emblema del continuo cangiamento delle cose terrene e della brevità della vita umana."

7. Wölfflin, *Beilage zur allgemeinen Zeitung*, 1907, No. 74: "Und wenn die Figuren nichts bedeuten als die Zeit, wie Condivi berichtet—gibt es einen eindrücklicheren Gedanken als das ewig gleich bleibende Kommen und Gehen der Tage und die Vergänglichkeit des Irdischen?"

8. Concerning the epigrams on the Notte by Giovanni Battista Strozzi and Michelangelo, Chantelou, in his *Journal* on Bernini's trip to France, says that these verses were composed at a time when tyranny prevailed in Florence. This seems to be the first time that a political interpretation was given to one of the figures of the Chapel, and initiates the patriotic political interpretations of the nineteenth century (cf. *G.d.B.-A.*, xv, 1877, p. 316).

9. Brockhaus, in spite of his erroneous conclusions, was the first to attempt to explain all the elements of the Chapel, including the architecture and its decoration, as a unified idea, the earlier interpretations having been limited to the figures alone. (Vasari describes the architecture but does not give an interpretation of it.)

10. Surveys of the earlier interpretations are to be found in Thode, *Kr.U.*, I, pp. 509*ff*, and A. Pasquier, in *La Belgique artistique et littéraire*, XXXII, 1913. These surveys do not yet include the interpretations of Popp, *Med.Kap.*, pp. 163*ff*; von Kleinenberg, *Z.f.Ae.u.Kw.*, XXIII, 1929, pp. 113*ff*; Tolnay, *Cappella Medicea*; von Simson, *Apotheose im Barock*, 1936, pp. 108*ff*; and Panofsky, *Iconology*, 1939, pp. 199*ff*.

1. Examples of burial chapels of the fifteenth century representing the kingdom of heaven are the Cappella Piccolomini, by A. Rossellino and B. da Majano, Naples, Monte Oliveto; Cappella di Santa Fina, by B. da Majano, San Gimignano, Collegiata; and Cappella di San Bartolo, by B. da Majano, San Gimignano, Sant' Agostino.

Brockhaus, *Forschungen über Florentiner Kunstwerke*, Leipzig, 1902, tried to interpret according to a unified idea some Quattrocento rooms, as for example the Sagrestia Vecchia, which he holds to be an illustration of the Te Deum, the significance of all the decorative elements being to proclaim the praise of God.

2. The original entrance door to the Medici Chapel was the left door on the wall of the Magnifici tombs (today closed). The present entrance door was in the sixteenth *164* century a blind door (see the early seventeenth century plan of the Chapel by Matteo Nigetti). The doors on the walls of the Ducal tombs are also blind. Another proof of *165* this fact is the mid-sixteenth century ground plan of the Medici Chapel (incidentally the oldest preserved plan of the last version of the Chapel), which has been recently acquired by Mr. Janos Scholz of New York. The present entrance door is here also closed, and behind it there was a staircase leading up to the cupola. The following inscription is found at this point on the plan: "Qui si va sulla chupola chon una scala a gola."

The original entrance door to the Chapel bears the inscription on the plan: "Porta che [va] in Chiesa."

There was another staircase in the *lavamano* at the left of the Choir: "Qui si va per un altra scala in su a chupola."

The following inscription is found in the center of the sheet: "Pianta de (l)la Sagrestia di mano di Michelagnolo. e questa parte che non e fornita non ci si po (andare, canc.) ire che tengono ser (r)ato per rispetto della Chapella del Pontormo che dipigneva. Vero è che la a (?) scoperta ma non sapranno per questo et io (?) non o voluto mendare a fatichar nissuno per che non è chosa d'importanza."

Since the "Chapella del Pontormo" (i.e. the Choir of the Church) was executed between 1546 and 1556, we must suppose that this plan was executed shortly after 1556. It is also possible that it was drawn around 1563 when Vasari was occupied with the idea of having the decoration of the Chapel finished (cf. Vasari, *Carteggio*, I, pp. 731*ff* and III, p. 59). The character of the inscription on the sheet resembles somewhat the handwriting of Vasari.

It is interesting to note that the plan already contains the architectural articulation *90* of the Magnifici tombs according to the articulation of drawing No. 58, i.e. with six *218-221* columns, and not with only four columns, as it appears in the unreliable drawings of the Magnifici tombs, which were made by pupils.

3. Concerning the composition of the tabernacles, cf. the fine analysis by Popp, *Med. Kap.*, p. 45.

4. All the motifs which Michelangelo used for the decoration of the Chapel go back to the ancient death cult. On antique tomb altars and sarcophagi can indeed be found the tabernacle niches, jugs, shells, garlands of acorns, dolphins and ram skulls. The garlands with jugs suspended above them in the center, as they are seen in the lateral fields of the upper zones of the Ducal tombs, are made in direct imitation of Roman garland sarcophagi, like those in Berlin (Caffarelli sarcophagus) and in Leningrad, reproduced *192* in W. Altmann, *Architektur und Ornamentik der antiken Sarkophage*, Berlin, 1902, pp. 66 and 67.

Concerning the meaning of the dolphins in antiquity, cf. R. Weynand, *Bonner Jahrbücher des Vereins von Altertumsfreunden im Rheinlande*, 1902, pp. 219*ff*: "Sie rufen die Vorstellung vom Jenseits und der grossen Reise dorthin hervor."

The trophies can also be found on ancient tomb altars where they served as emblems of the triumph over death, i.e. immortality (cf. Carcopino, *La basilique*, p. 358). It is likely that they have the same significance for Michelangelo. Two trophies have been discovered by Giovanni Poggi, and are now exhibited in the passageway between the Medici Chapel and the Chapel of the Princes. They are probably the trophies made by Silvio Cosini, mentioned as "fine di quelle sepolture" by Vasari, 1568, p. 333.

The empty thrones (cf. the drawing, No. 57) were interpreted by Borinski, *Rätsel*, *89, 108* p. 118, as "die zur Aufnahme der Seligen bestimmten Throne (die platonische Vorstellung von Sternenthronen der Gerechten)." Cf. also Panofsky, *Iconology*, p. 212, who says: "The empty throne is one of the oldest symbols for the invisible presence of an immortal (Hetoimasia)."

The candelabra on the altar of the Medici Chapel may also have a symbolic meaning. *206, 207* In antiquity candelabra were considered as the bearers of the flame of pure faith (cf. Carcopino, *op.cit.*, pp. 217*f*) or as symbols of the soul imagined as flame (cf. Leopold, *Mélanges*, p. 175 n. 4). This conception recurs in Plautus, Terence, Cicero, Virgil.

Only the candelabrum at the right side of the altar is original. The other, broken in the eighteenth century, is a copy. A copy after the original left candelabrum is preserved in a drawing probably by G. A. Dosio (Florence, Uffizi), representing the altar of the *208* Medici Chapel, where fortunately the one at the left is executed in detail. The candelabrum at the right is decorated by a pelican giving its blood to its young (symbol of the sacrifice of Christ), a phoenix (symbol of resurrection), masks with dolphins and bowls of fruit (the masks probably signify deceit [cf. C. Ripa]; the dolphins are symbols of the journey to Hades; the fruits were used in the catacombs as symbols of the delights of eternal life) and masks and two swans (the latter symbols of lust).

Below the main cornice of the monument is a frieze of Gorgon masks (cf. Vasari *196-200* 1568, p. 333). In ancient Rome they had the function of "encouraging the initiated to cross the ocean to the isles of the chosen ones" (cf. Carcopino, *op.cit.*, p. 708). Michel-

angelo's Gorgon-masks seem to laugh mockingly. It is probable that he wanted to express derision of the fear of death (cf. Michelangelo's poem, Frey, *Dicht.*, LVIII: "'l ben morto in ciel si ridi/ del timor della morte in questo mondo"). Borinski (*Rätsel*, p. 118), however, tries to interpret the masks according to Dante, *Inferno*, IX, 52ff.

There exists a drawing in red chalk in the British Museum made ca. 1525 (for the date, cf. Popp) with four studies of caricaturized heads which Michelangelo used for this frieze of masks, No. 91. The studies were described by Wittkower as "physiognomic experiments" made by Michelangelo (*Journal of the Warburg Institute*, I, 1937, pp. 183ff). A further, hitherto unpublished, caricature by Michelangelo can be found on the drawing No. 65a.

135

325

H. Brockhaus tried to interpret all decorative elements in the Chapel from the Ambrosian morning and evening hymns but this interpretation is forced in view of the antique (and not Christian) character of the decorations of the Chapel.

5. The relation between the Allegories and the cover of the sarcophagus is dynamic: weight and movement of the Times of Day seem to be the tangible cause of the splitting of the sarcophagus lid. The same conflict between form and energy is here expressed in anthropomorphic language, which Michelangelo in his later period expressed in purely architectonic language, for example, in the Porta Pia, where the segment seems to break apart under the weight of the heavy triangular pediment. Bernini, in his tomb of Pope Urban VIII, interpreted under the influence of Michelangelo the empty space of the sarcophagus also as an opening, from which here a skeleton rises.

323

6. The connection of the composition of the Ducal tombs with this group of ancient sarcophagi has already been treated by the author in *Cappella Medicea*, pp. 292ff.

7. Since the four elements are according to the Neoplatonism of the Renaissance co-essential with the four humors and these with the four seasons and the four times of day, Panofsky (*Iconology*, pp. 199ff) believes that each of the Times of Day represents at the same time a season, a humor, and an element. Steinmann (*Geheimnis*, pp. 82ff) had already tried to connect each Time of Day with a humor, but his identifications differ from Panofsky's.

According to Steinmann, the Aurora personifies also the melancholic humor; according to Panofsky, the sanguine humor, the element air, and the season of spring. The Crepuscolo is according to Steinmann a representation of the phlegmatic humor; according to Panofsky, the melancholic, the element earth, and the season of autumn. The Notte is according to Steinmann the sanguine humor, whereas for Panofsky it is the phlegmatic humor, the element water, and the season of winter. Giorno should be considered according to both Steinmann and Panofsky as a representation of the choleric humor, and the latter considers the figure at the same time as a personification of the element fire, and the season of summer.

Both interpretations seem somewhat artificial. That of Steinmann contradicts the literary tradition, as Panofsky has shown. That of Panofsky is hard to reconcile with the

visible facts. It is difficult, for instance, to see in Aurora an incarnation of the sanguine temperament, or to see in the Notte a personification of the phlegmatic humor. (Somewhat more appropriate are the identifications of Crepuscolo with the melancholic temperament, and of Giorno with the choleric.) Also the emblems give no hint in support of this interpretation of a fourfold significance of each figure.

Lately, Kriegbaum (*Michelangelo*, p. 15) has proposed a new interpretation of the Ducal tombs. The Allegories of the Times of Day and the river gods are said to be symbols of the temporal rule of the Dukes, referring, that is, to their duchies. Aurora and Crepuscolo are said to be allegories of the mountains of Lorenzo's duchy, the river gods representing its boundary rivers. This interpretation of the Allegories as geographical localities, however, is in contradiction to the literary tradition, from which it is clear that Michelangelo gave the figures a philosophical meaning; moreover, it cannot be supported by the emblems and the conception of the form, which holds to the universal and thus contradicts such a materialistic implication.

8. The river gods of the Medici Chapel at the bottom of the Ducal monuments have been identified with the four rivers of Hades, as described in Plato's *Phaedo*, by Oeri, *op.cit.*; the author, *Cappella Medicea*, p. 305; and Panofsky, *Iconology*, pp. 206ff. Panofsky quoted in connection with the river gods Dante's commentary by Landino (cf. the Dante edition of Venice, 1529, pp. LXXIvf).

9. The Capitani were placed in their niches while Michelangelo was still in Florence, as testified by Vasari 1568, pp. 384 and 428.

The letter of Niccolò Martelli quoted in the text is published in *Il primo libro delle lettere di Nicolo Martelli*, Florence, 1546, p. 49 recto: Letter from Martelli to Rugasso, July 28, 1544.

Fischel (*J.d.p.K.*, XXVIII, 1907, pp. 117ff) attempted to show that the medallion portraits of Duke Giuliano (1513) resemble Michelangelo's statue, but the latter does not have the long aquiline nose and the sharply projecting chin. The only point of similarity is the long neck.

Other portraits of the Dukes are reproduced in E. Heyck, *Florenz und die Mediceer*, Leipzig, 1902, p. 113 (portrait of Giuliano) and p. 114 (portrait of Lorenzo).

The dead are not glorified as renowned human beings. Indeed the inscriptions are lacking (the fields for the names, at the bottom on the front of the tombs, are empty). The coats-of-arms of the Medici family are also not to be seen immediately. They are presented quite inconspicuously, and in small size, on the vases above the doors at the right and left. See the reproductions in Geymüller, Figs. 27 and 28.

10. Whereas in the seventeenth century (Bocchi-Cinelli), Lorenzo was considered as a personification of "Il Pensiero" and Giuliano as "La Vigilanza," since the eighteenth century (Richardson) the contrast expressed by the postures and attributes of the two Capitani has been interpreted as the antithesis between active and contemplative life, Giuliano being the *vir activus*, Lorenzo the *vir contemplativus*. But this interpretation

should be abandoned since the Capitani are images of the apotheosized souls of the deceased and not of their empiric personalities. Landino, in his *Disputationes Camaldulenses* (end of Book I), expressly states that "when our God-created souls shall return to Him, all active life in us ceases, and we shall eternally enjoy the contemplation of God." In other words, the soul beyond the grave no longer enjoys an active life, and Michelangelo followed this idea in portraying both Capitani as contemplative figures.

11. The author owes the reference to this passage in Virgil to his friend, K. Kerényi.

12. The Cielo and Terra are mentioned in Michelangelo's prose fragment, Frey, *Dicht.*, XVII, and in Vasari (cf. text).

According to M. Weinberger (*G.d.B.-A.*, 1945, p. 266), Ammannati's statue of Terra for the Palazzo Vecchio was made under the inspiration of Michelangelo's lost model for the Terra of the Medici Chapel. This hypothesis seems to be doubtful, however, since the pose of Ammannati's figure is completely un-Michelangelesque.

13. Concerning Vasari's projects for the completion of the Chapel, cf. K. Frey, *Carteggio di G. Vasari* (Ital. ed.), Munich, 1923, pp. 695ff, and Popp, *Med.Kap.*, pp. 119ff.

In a letter of February 16, 1563, Vasari (*Carteggio*, I, pp. 713 ff) speaks of frescoes to be executed for the choir, for the four large lunettes at the top, for the four tondi and the four pendentives; he speaks also of stucchi in the second zone (probably in the rectangular fields above the smaller lunettes). He does not mention that there were frescoes planned for the smaller lunettes.

14. Michelangelo's bit of prose, Frey, *Dicht.*, XVII, written according to Frey in 1523, seems until now to have been incorrectly interpreted: Springer II, p. 254; Riegel, p. 133; Frey, *Reg.*, p. 3; Justi, p. 245; and Steinmann, *Geheimnis*, p. 54.

15. The connection of the ideas expressed by Michelangelo in the Medici Chapel with Plato's *Phaedo* was first emphasized by Oeri, *op.cit.*

The main points of the author's interpretation of the Ducal tombs (*Cappella Medicea*) are taken up by Panofsky, *Iconology*, pp. 199ff. He agrees that each of the Ducal tombs depicts an apotheosis, that the river gods should be interpreted as the rivers of Hades, that Giuliano and Lorenzo represent the immortalized souls of the deceased rather than their empirical personalities, that their compositional relationship with the Times of the Day beneath them is reminiscent of the Roman sarcophagi where the image of the dead is carried beyond the sphere of earthly life symbolized by the reclining figures of Ocean and Earth, and that both of the Dukes are represented in spiritual contemplation of the Virgin.

Panofsky tries, moreover, to complete this interpretation in stating that the structure of the Ducal tombs represents the four spheres of the Neoplatonic universe through which the souls of the Dukes ascend. The rivers of Hades would stand for what Pico calls "mondo sotterraneo" (the realm of matter); the Times of Day, occupying the next higher zone, stand for the terrestrial world (the realm of nature); the zone of the immortalized souls of the Dukes would be the celestial sphere; and the attica, with the con-

summation of the apotheosis symbolized by the motifs adorning it, would be the super-celestial sphere.

However, the four zones or spheres are not distinguished in the architectural articulation and in the figural composition of the Ducal tombs. The project drawings show only two or three zones, and in the executed monuments, where the attica is strongly reduced, there are also only two great zones distinguished: above, the sphere of eternity, and below, the sphere of transiency. The zones are, moreover, not defined by emblems as representing the four spheres of the Neoplatonic universe. These emblems are even in part inconsistent with this interpretation; for instance, the dolphins on the tomb of Lorenzo decorate the zone that should be the celestial sphere, and masks can be found in both the "terrestrial" and the "celestial" spheres. It seems more plausible to consider the whole tomb structure as the "house of the dead," representing the two aspects of death: transiency (below) and eternal life (above). The emblems, all taken from the ancient death cult, appear as adequate decorations of the habitation of the dead. Cf. pp. 65f.

16. The genesis of the program can be followed in the project drawings. Michelangelo originally reverted to the burial monument traditions of both the late Middle Ages and the Renaissance. Nos. 52 and 51, with their mourning youths and mourning river gods, *82, 81* are kinds of *memento mori*, and No. 57 is a glorification of the empirical personality of *89* the deceased. In fact, the latter are represented as portraits and not yet as souls beyond the grave, and the trophies and triumphal symbols of the attica remind of the eternity of fame. On the Magnifici graves, Michelangelo represented even the figure of Fame (cf. inscription on No. 58). When, finally, Michelangelo decided to conceive the lowest *90* zone of the Chapel as Hades and to conceive the Dukes as images of their souls in the beyond, the monuments were spiritualized and filled with a completely new content.

XI. NOTES ON CHAPTER XI: THE TOMBS OF LEO X AND CLEMENT VII

1. HISTORY: We know from the letter of Buoninsegni of December 28, 1520 (Appendix), in which the Cardinal suggests an *arcus quadrifrons* for the tombs, that the latter even then wanted to be buried in the Medici Chapel. He wanted his tomb to be in the center of the structure on the floor, "e in detto mezzo disegnava [il Cardinale] che in terra fussi la sepultura sua, e le altre sepulture li pare dovrebbono stare alte sopra li detti archi." This project was already discussed in connection with the projects for the free-standing tomb (cf. pp. 36*f*).

The further history of the tombs of the Medici Popes is best recounted by Popp, *Münchner Jahrb.*, pp. 389*ff*, whose conclusions we summarize here.

On May 23, 1524 (Frey, *Briefe*, p. 228), Fattucci wrote to Michelangelo that Cardinal Salviati suggested that monuments should also be erected in the Chapel for the two Medici Popes, Clement VII and Leo X. The Cardinal proposed a double tomb with two sarcophagi for the two Popes, like the double tomb for the two Magnifici, and also a double tomb for the two Dukes. In effect he suggested three double tombs on the three walls of the Chapel, with the choir in the fourth wall. Six days later, May 29, 1524 (Frey, *Briefe*, p. 229), this suggestion was changed. Each of the Popes was now to have his own tomb with one sarcophagus. The Dukes and the Magnifici should be buried in double tombs. It is mentioned that the tombs of the Popes should be in the places of honor, and the Magnifici in the less important places. The tombs, then, would have occupied all four walls.

These suggestions, made in Rome, concerning the disposition of the tombs, could not have been taken into consideration by Michelangelo, since the marble blocks for the architecture of one of the Ducal tombs were then almost finished. Michelangelo seems to have made a proposition himself. His letter is lost, but the contents of his proposition can be gathered indirectly from Frey, *Briefe*, p. 230. He wanted to erect the tombs of the Popes not in the Chapel itself, but "in the *lavamani* where the stairs are." This very likely refers to the small sacristy on the left side of the choir of the Sagrestia Vecchia, as Popp has shown. On June 7, 1524, Fattucci answered, saying that the proposition pleased the Pope except that he thought the *lavamani* too dark, and added that he himself thought this space too small for two Popes. (According to Popp the ground plan sketch at the top left of Frey, *Handz.*, 71, is a sketch of one of these little rooms. But Wittkower, *Art Bulletin*, 1934, p. 181, has shown that this is the ground plan of the chapel which was projected in 1525 at the end of the library room of the Laurenziana. It is mentioned in a letter, Frey, *Briefe*, p. 250.)

Michelangelo sent a project drawing of his proposition, which arrived in Rome on June 25, 1524 (Frey, *Briefe*, p. 231). Apparently he also proposed that the buildings near the little room should be destroyed so as to let in more light, since the Pope agreed

that the houses should be bought in order to be razed. On July 9, 1524, Fattucci again reported that the Pope commissioned the purchase of the buildings (Frey, *Briefe*, p. 232). The Pope was pleased with Michelangelo's drawing, but Fattucci feared that the tombs of the Dukes would be more beautiful than those of the Popes. On July 21, 1524 (Frey, *Briefe*, pp. 233f), Fattucci reported that the Pope wanted Michelangelo to look around to see whether there were not a larger and more honorable space in the Church of San Lorenzo (in the choir or somewhere else in the Church) for the Papal tombs. Although the location in the *lavamani* did not displease him, he feared it would not be large enough for the Popes.

In the spring of 1525 Michelangelo seems to have asked that his drawing of June 1524 be returned to him, since it was returned on April 12, 1525, by Fattucci (Frey, *Briefe*, p. 250). On June 6, 1526, there had still been no decision. Fattucci wrote that the Pope wanted the monuments to be executed and that the *lavamani* were too small. Fattucci proposed that if there should be no place in the Church of San Lorenzo, San Giovannino could be destroyed, and a round church might be erected in its place for the monuments. But this proposition seemed too expensive to the Pope, and he requested new proposals from Michelangelo (Frey, *Briefe*, p. 284). On September 12, 1526 (Frey, *Briefe*, p. 288), Fattucci wrote that Michelangelo should finish the Medici tombs quickly, since when they were ready the Pope wanted him to execute his own and Leo X's tombs, these latter according to the Pope's ideas.

Probably in the summer of 1524 or 1526, when the project of erecting the Papal tombs in the *lavamani* had been definitely abandoned and their erection in the Church of San Lorenzo or on the spot where San Giovannino stood was being considered, the project drawing by Andrea Sansovino for the tomb of Leo X was executed (London, Victoria and Albert Museum, no. 2260). This drawing was first published by Middeldorf, *Burl.Mag.*, LX, 1934, 2, pp. 159ff. Middeldorf dates the drawing in 1521. Huntley, *A. Sansovino*, Cambridge, 1935, p. 99, dates it in 1523. The project is interesting because it is inspired by Michelangelo's first project for the Julius Tomb (1505, lost) and can be used for the reconstruction of the upper parts of that tomb. Middeldorf and Huntley overlooked this fact. Middeldorf speaks of influences by Raphael and Peruzzi, and Huntley of inspirations from Bramante, Peruzzi, Raphael, and A. da Sangallo the Younger. The influences of these masters, however, are visible only in the details, whereas the whole structure is derived from Michelangelo's Julius Tomb.

There seems to be no further change until the death of Clement VII, September 25, 1534. Bandinelli seems to have made, during Clement's lifetime, models mentioned by Vasari, ed. Mil. v, p. 90. Popp (*op.cit.*, p. 169) dates these models between May 1, 1534, the date of the unveiling of the Hercules and Cacus, and September 25, 1534, date of the Pope's death.

After the death of Clement VII, the protégé of Cardinal Ippolito de' Medici, Alfonso Lombardi, was charged with the execution of the monuments according to Michelan-

gelo's sketches in Santa Maria Maggiore. He made a model with wax figures (Vasari, ed. Mil., v, p. 90) on the basis of the sketches. In another place Vasari (ed. Mil., vi, p. 162) tells that Alfonso Lombardi, after having executed the model, changed his ideas on the advice of Michelangelo.

Finally Bandinelli succeeded in getting for himself the commission of Alfonso (who became ill as a consequence and died in 1537), and signed the contract on March 25, 1536, for the monuments, which were finally erected in the choir of Santa Maria sopra Minerva. The architectural framework for the monuments was made after drawings by Antonio da Sangallo, as Vasari reports (ed. Mil., vi, p. 163). According to a note in Bandinelli's *memoriale* (*Rep.f.Kw.*, XXVIII, 1905, p. 432, and Popp, *Münchner Jahrb.*, p. 392 note) he followed the advice of Michelangelo concerning the choice of the marble blocks.

Popp states (*op.cit.*, Figs. 12 and 13) that it was at this same time that Francesco (or Giovanni Battista?) da Sangallo made his own projects for the tombs of the Medici Popes, of which three are preserved in the Uffizi (architectural drawings 183-185).

2. THE PROJECTS FOR THE TOMBS OF LEO X AND CLEMENT VII:

(a) A drawing for the Papal tombs executed by a pupil of Michelangelo (No. 64) is preserved in Dresden and was identified with the project of the tombs for the *lavamani* by Popp (*Münchner Jahrb.*, 1927, pp. 389ff). On the top is the coat-of-arms of the Medici. The dimensions are very small, the greatest width, at the upper cornice, is six and three-quarters braccia (ca. 4.05 m.). The height is somewhat more than six braccia (ca. 3.60 m.). (The measurements can be determined on the basis of a scale of one braccio indicated at the bottom.) Popp has shown that this project finds its place in the small lateral room of the Sagrestia Vecchia where the length of the side walls is 4.23 m. A seated figure of the Pope was projected for the central niche. Its height would have been exactly that of the statues of the Dukes. This seems, therefore, to be the drawing that arrived in Rome on June 25, 1524 (Frey, *Briefe*, p. 231). That the project was somewhat celebrated is proved by a copy in Lille, Musée Wicar, made by Aristotile da Sangallo (published by the author in *Arch.Buon.*, p. 410). Here, however, the central niche is transformed into an open arch.

There exists in the Casa Buonarroti an original sketch by Michelangelo (No. 63) showing the same idea—with a central niche at the bottom, and two tabernacles with segment pediments to right and left at the top. This project seems to have been made, however, for much larger dimensions (cf. the standing figures in the lateral fields of the first zone). According to Frey, this is a sketch for a free-standing monument. At the left in the lower zone the profile of a sarcophagus is visible, a detail which supports Frey's hypothesis. Popp, who considers the drawing to be of a wall monument, could not explain these lines. It may be supposed that Michelangelo planned this monu-

mental free-standing structure originally for the tomb of Bartolomeo Barbazza in Bologna (Frey, *Briefe*, p. 259, and Vasari, ed. Mil., vi, p. 59 and text, pp. 76*f*).

In the letter from Topolino of August 13, 1524 (Appendix), mention is made that Carlino has extracted the block for one Pope and that that for the other Pope was extracted by the company of Leone and Quindici. In the letters of August 24 (Appendix) and December 6, 1524 (Appendix), these blocks are again mentioned. These two blocks must have been for the seated statues of Leo X and Clement VII, destined for the central niches of the tombs of the two Medici Popes, according to the project drawing in Dresden. One of these blocks is mentioned in Michelangelo's inventory drawn up on February 19, 1564 (Gotti ii, pp. 148*ff*), and it is this figure which must be identified with the statue of St. Gregory the Great completed by Nicolas Cordier and preserved today in the Oratorio di Santa Barbara, San Gregorio al Celio, Rome, and not, as has been supposed (Hess, *Burl.Mag.*, 1943, pp. 55*ff*), with "la figura de la Santitade de Nostro Signore" for the Julius Tomb of 1505, mentioned in a letter by Matteo di Cuccarello (Frey, *Briefe*, p. 5).

The hypothesis first expressed by Thode (*Kr.U.*, i, pp. 128, 143) and later by Panofsky (*Art Bulletin*, xix, 1937, pp. 561*ff*) that the figure of the inventory of 1564 is identical with the statue of Julius II begun by Michelangelo for his project of 1505 for the Julius Tomb and mentioned also in June 24, 1508, by Matteo di Cuccarello, cannot be maintained. The statue for the first project of the Tomb of Julius II was not a seated statue but a figure outstretched on the sarcophagus. (This problem will be treated in Vol. iv.)

Kriegbaum, in *Mitteilungen des Kunsthist. Instituts in Florenz*, vii, 1941, p. 143, states that the drawings on No. 62 are in relationship with the tombs of Leo X and Clement VII: "Aus einer Zeichnung der Casa Buonarroti ergibt sich, dass die beiden Sarkophage in die durchbrochenen Seitenwände des Chores der Sagrestia Nuova eingestellt werden sollten. . . ." However, the sketches on No. 62 seem to be more probably connected with the tombs in S. Silvestro in Capite.

(b) The second project for the Papal tombs may be dated between July 21, 1524 (Frey, *Briefe*, p. 233), date of a suggestion to put the monuments in the Church of San Lorenzo, and April 12, 1525 (Frey, *Briefe*, p. 250), date on which the first drawing was returned to Michelangelo. A drawing in the Casa Buonarroti, No. 66, seems to be related to the idea of erecting the monuments in the choir of the Church of San Lorenzo, as Popp has shown (*op.cit.*, pp. 395*ff*). The dimensions of this project fit well with those of the walls of the choir of the Church. The length of the choir walls was at that time nineteen and two-thirds braccia (cf. Michelangelo's drawing, Frey, *Handz.*, 68). To articulate architecturally the choir walls is a monumental idea, including the artist's intention of decorating also the back wall of the choir according to the same system. The whole choir would have been transformed into a unified burial chapel, with the altar on the back wall and the two tombs on the side walls (Popp). This project

is about one year later than that for the Riccetto of the Laurenziana and conceived in the same spirit.

95 A preliminary sketch for this project is preserved in the Casa Buonarroti, No. 65 (cf. Popp, *op.cit.*, p. 405). Another hitherto unpublished sketch for the same project is in 325 the Archivio Buonarroti, No. 65a.

 (c) The sketches by Michelangelo which Alfonso Lombardi very probably used for 121 his project are, according to Popp, the drawings on No. 67 in the form of triumphal arches. Another original sketch which is closely related to the sketch at the right of No. 122 67 was identified by the author in *Arch.Buon.*, p. 414, and is preserved in the Archivio Buonarroti, Cod. IX, fol. 539 verso (No. 68). (Further sketches of a similar idea are in 123 Christ Church, Oxford, DD 24 recto and verso [No. 71]. These are not by Michelangelo.) That Nos. 67 and 68 were originally destined by Michelangelo for the Julius Tomb (projects of 1525) has been demonstrated by the author in *Arch.Buon.*, pp. 415*ff*.

XII. NOTES ON CHAPTER XII: INFLUENCE OF THE MEDICI TOMBS

1. Concerning the tomb of Cecchino Bracci, cf. Steinmann, "Das Grabmal des Cecchino Bracci in Ara Coeli," *Mh.f.Kw.*, I, 1908, pp. 963*ff*, who proves that No. 69 is related to the Cecchino Bracci tomb. The sketches on the verso of this sheet (No. 70) were published for the first time by the author in *Arch.Buon.*, p. 397.

2. The idea of the threefold articulation, with a segment pediment in the middle, is perpetuated in yet another group of tombs, already mentioned: in Giacomo della Porta's tombs of Luisa Deti, G. F. Aldobrandini, and Cardinal Alessandrino, in Rome, Santa Maria sopra Minerva. Here the sarcophagus fills the breadth of the central field in a retrospective manner, as in tombs of the Quattrocento.

A further type which derives from the same idea is finally the triumphal-arch tomb, with a segment pediment above the middle field. The two most important examples are the tombs of Nicholas IV by Domenico Fontana, and of Clement IX by Rainaldi, both in Santa Maria Maggiore. In these two, there is a seated statue in the middle.

3. Concerning the tomb of Paul III, cf. Steinmann, *Das Grabmal Pauls III. in Sankt Peter in Rom*, Leipzig, 1912. The hypothesis of Popp, *Med.Kap.*, p. 126, that certain drawings representing a tomb by Michelangelo are related to the tomb of Paul III is untenable, because these drawings are all in connection with the Medici Chapel (cf. above, p. 128).

4. The Cappella Niccolini has not so far been connected with the composition of the Medici Chapel. Concerning the Cappella Niccolini, cf. W. and E. Paatz, *Die Kirchen von Florenz*, Frankfurt a.M., 1940, pp. 503, 534, 576*ff*. There are seven unpublished drawings by Dosio for the Cappella Niccolini in the Uffizi.

306
124
125

318, 319

320, 321

322

302, 303

XIII. NOTES ON THE MEDICI CHAPEL AFTER MICHELANGELO'S FINAL DEPARTURE FOR ROME

1. Shortly before Michelangelo departed from Florence at the end of September 1534, he had the Ducal statues set up in the niches of the wall tombs (Vasari 1568, p. 384). The allegorical figures were still lying on the floor of the Chapel. Neither the Dukes nor the Magnifici were as yet buried. The murder of Duke Alessandro, January 5, 1537, seems to have been the immediate occasion for putting the Chapel into shape.

2. After the work was completed, the burial, or more properly, the transference, of the dead took place. First Duke Lorenzo was interred in the sarcophagus at the left from the entrance, and above him in the same sarcophagus, Duke Alessandro. Aurora and Crepuscolo were placed on the cover (cf. the finding of March 1, 1875, published in Wilson, p. 563). Then Duke Giuliano was buried in the other sarcophagus, and Giorno and Notte placed on the cover. Although the Allegories were placed after Michelangelo's departure, their positions corresponded to his intentions: one of his prose fragments mentions Duke Giuliano together with Giorno and Notte; consequently Aurora and Crepuscolo must have been intended for the tomb of Duke Lorenzo (cf. above p. 131).

On June 3, 1559, Lorenzo il Magnifico and Giuliano il Magnifico were finally interred in the *cassone* of the entrance wall (Moreni, *Descrizione*, p. 104). The two brothers had rested previously in the Sagrestia Vecchia (cf. Paris de Grassis, sub December 2, 1515).

3. The masses for the dead, which were ordered by Clement VII, November 14, 1532, were celebrated regularly. The Chapel was made available for public use probably in 1545 (cf. Varchi, *Due lezzioni*, pp. 118f). Doni, *I marmi*, Venice, 1552-1553, Part IV, gives a description of the sacristy. By that time the allegorical figures were already set up. (Frey, *Studien*, p. 117, erroneously supposes that the altar was erected after Michelangelo's departure and is not his work. Aside from the fact that the style supports the attribution to him, it is also described by Bocchi as his work. Cf. also Popp, *Med.Kap.*, p. 119.)

201-203

4. On January 9, 1537, Cosimo became Duke of Florence. Unlike his predecessor, Duke Alessandro, the new Duke was a great patron of the arts. He thought immediately of having Tribolo complete the stairs of the Laurenziana and ordered him to Rome to get the plans for them from Michelangelo, and to persuade the latter to return to Florence and complete the Sagrestia Nuova (Vasari, ed. Mil., VI, p. 92, and VII, p. 236; 1568, p. 209). Between March and December 1538, Tribolo did go to Rome, but accomplished nothing. Michelangelo declared he no longer remembered the stairs.

The opening of the Chapel in ca. 1545 seems to have awakened again the desire to bring Michelangelo back to Florence. On October 2, 1546, another unsuccessful attempt was made, at the instigation of the Duke, to tempt him back (Gaye II, p. 352), but Michelangelo did not want to return.

5. Concerning the plans for completion by Vasari, cf. Vasari, *Carteggio*, I, pp. 695ff and Popp, *Med.Kap.*, pp. 119ff.

XIV. NOTES ON CHAPTER XIII: THE CHRIST OF SANTA MARIA SOPRA MINERVA

Rome, Santa Maria sopra Minerva.
Marble in the round.
H.: 205 cm.
Greatest depth of the block ca. 65 cm. (The block was flat at the back, and somewhat rounded on the other sides, as can be seen from the base.)

1. CONDITION: Polished. The right foot somewhat worn. Concerning the distinction *68-70* of the parts made by Michelangelo and those made by his pupils, Urbano and Frizzi, cf. text, p. 90.

In the seventeenth century, the figure was furnished with a metal loin-cloth. (The Anderson photographs published here, however, show the figure without this addition.)

2. HISTORY: The best survey of the history of this statue is given by Thode, *Kr.U.*, II, pp. 257*ff*, whose findings we summarize and complete here. The statue is not mentioned by Condivi. It is briefly mentioned by Vasari 1550, p. 129, and 1568, p. 129.

The commission of Bernardo Cencio, Canon of St. Peter's, Maria Scapucci, and Metello Vari Porcari, of June 14, 1514 (cf. contract, Milanesi, p. 641), is for a life-size nude standing Christ with the cross, the posture to be determined by Michelangelo himself. It was to be executed in four years for two hundred gold ducats, the artist agreeing to make at his own expense, apart from the statue, the "gocciola, dove posi detta figura" (i.e. the consol).

Metello Vari, one of the commissioners, came from a noble Roman family. He lived in the immediate vicinity of the Minerva, and was the possessor of an ancient collection, which Aldroandi (*Antichità*, 1556, p. 245) briefly describes. Vari had become acquainted with Michelangelo through Jacopo Galli, the Roman banker. In the undertaking of this statue he seems to have been the driving force and to have contributed the most money.

Michelangelo began this statue, but then gave it up when a black vein appeared in the face (cf. Gotti I, p. 143). He left the unfinished exemplar in his house in Rome when he moved in 1516 to Florence (Frey, *Briefe*, p. 136). It is mentioned on December 14, 1521 (Frey, *Briefe*, p. 184), January 4, 1522 (Frey, *Briefe*, p. 186), January 12, 1522 (Frey, *Briefe*, p. 187), and January 22, 1522 (Frey, *Briefe*, p. 188). In the last of these letters, Sellaio says that he has delivered the statue to Vari, to whom Michelangelo had presented it as a gift. It was set up in Vari's house in a "corticella, ovvero orticello." Here Aldroandi (*Antichità*, 1556, p. 247) saw it and described it.

3. In connection with this first version is probably the drawing, London, Collection *126, 127* Ford (No. 86).

According to Frey, *Handz.*, 36 and 37, Berenson, no. 1543, and Thode, *Kr.U.*, III, no. 372, all the sketches are authentic. The chronology according to Frey is the following: (a) verso (Frey 37), whole figure in red chalk; (b) legs in profile in red chalk; (c) legs *127* in frontal view in the center; (d) recto (Frey 36), legs in profile; (e) Frey 36, the torso *126*

in the center, according to Frey developed from sketch (a), but nearer to the definitive solution (the figure clings more closely to the cross, the hip projects less); (f) finally Michelangelo went over this sketch, and also the legs on the verso, with pen. Frey concludes from the differences in the pose in the two drawings of the body and in the statue that these drawings are preparatory studies for the first version, and dates the sketches in 1514.

126 Popp (*Belvedere*, 1925, pp. 25*ff*) rightly pointed out that only the pen study of the torso on the recto should be attributed to Michelangelo, whereas all the other drawings were made by a pupil, according to her by Silvio Falconi.

In September 1517, Vari reminded Michelangelo of his obligation to deliver the statue. Michelangelo demanded payment of a hundred and fifty *scudi*, the contractually agreed first payment, which he had not yet received. (Cf. the letter of Sellaio, October 3, 1517, Frey, *Briefe*, p. 80.) Michelangelo got the money December 13, 1517 (Frey, *Briefe*, p. 85). In a series of letters, Vari then repeatedly urged the completion of the statue (July 26, 1518, Frey, *Briefe*, p. 107; November 24, 1518, Frey, *Briefe*, p. 125; April 6, 1519, Frey, *Briefe*, p. 142).

4. In 1518, Michelangelo ordered a new block of marble, which on December 21, 1518 (Milanesi, p. 398), was still in Pisa, but was soon to be sent. The artist began to work on the block in the second half of the year 1519, and continued until the beginning of 1520. On January 13, 1520, the statue was reported to be almost finished (Frey, *Briefe*, p. 148). On March 10, 1519 (Frey, *Briefe*, p. 154), Michelangelo commissioned Federico Frizzi in Rome to make the tabernacle. In the same letter Frizzi reported concerning the various projects for the erection of the statue. In April 1520, Michelangelo said the statue was finished and asked for payment of the balance due to him. Vari promised to pay upon delivery of the statue (Frey, *Briefe*, pp. 156-157), but Michelangelo insisted on being paid first. The patrons therefore changed their minds (October 1520; Frey, *Briefe*, p. 160) and on January 30, 1521, finally sent the money (Frey, *Briefe*, pp. 162-164). At the beginning of March 1521, the statue was sent from Florence by sea, and on March 31, 1521, arrived near Città Vecchia (Frey, *Briefe*, p. 167). In the meanwhile, Pietro Urbano went to Rome to finish the statue and put it in place (Frey, *Briefe*, pp. 165-166). However, by the middle of April the figure had not yet reached Rome (Frey, *Briefe*, pp. 168-170), and it was not until June that Urbano was able to bring it from the Ripa (Frey, *Briefe*, p. 176). In July and August 1521, Urbano was working on the statue, and spoiled the parts he was retouching. His errors are enumerated in two letters (Frey, *Briefe*, p. 178; Milanesi, *Corr.*, p. 28). Michelangelo discharged Urbano from the job in mid-August 1521 (Frey, *Briefe*, pp. 177-178), and, with Giovanni da Reggio acting as intermediary, commissioned Federico Frizzi to repair the mistakes and complete the work (Frey, *Briefe*, pp. 178-179, and Appendix No. 40). It was Federico Frizzi who put up the figure. Concerning the erection and the base, cf. Frey, *Briefe*, pp. 181*f*. The base was supposed to be without ornament, and to bear only

an inscription and a coat-of-arms. The inscription is published by Aldroandi, *Antichità*, 1556, p. 245, and Thode, *Kr.U.*, II, p. 267. The base on which the statue now stands is not identical with the one described in these letters. On December 27, 1521, the statue was unveiled (Frey, *Briefe*, p. 185).

Michelangelo seems to have been dissatisfied with the statue and offered to make a new one (Appendix No. 41). Vari thanked him for this generosity, but considered the statue a masterpiece and, as an expression of his gratitude, presented the artist with a horse (Gotti I, p. 143). In January 1522, Michelangelo again offered to make a new statue (Frey, *Briefe*, p. 186). Also, he himself retouched the parts of the statue that Urbano had mutilated (Frey, *Briefe*, p. 187).

In a series of letters, Vari then asked Michelangelo to give him a receipt (*una fede*) for the one hundred and seventy-five ducats which he had paid him: March 23, 1522 (Appendix No. 42); May 23, 1522; March 4, 1523; June 27, 1523 (Appendix No. 43); July 27, 1523; April 7, 1526 (Appendix No. 44); June 1, 1532; July 5, 1532 (Appendix No. 45); July 13, 1532; and August 2, 1532 (cf. Frey, *Briefe*, pp. 192 and 195*ff*).

5. A serious attempt to distinguish the parts made by Michelangelo from those made by Urbano and Frizzi has not been so far undertaken. Thode, *Kr.U.*, II, pp. 267 and 269, says only that "das Werk lässt keinen Zweifel aufkommen, dass es sich im wesentlichen doch um eine Arbeit Michelangelos handelt. . . . Wie weit die Hände von Urbano bearbeitet sind, vermochte ich bei der Entfernung und Dunkelheit nicht zu beurteilen."

6. SUBJECT: The subject is the Man of Sorrows. Concerning the iconography of this theme in Italy and in the northern countries, cf. p. 91. Concerning earlier iconographic stages, cf. also Thode, *Kr.U.*, II, p. 269.

A survey of earlier interpretations and appreciations can be found in Thode, *Kr.U.*, II, pp. 270*ff*. (The most adequate interpretation is that of Montégut, *Revue des Deux Mondes*, LXXXV, 1870, pp. 945*ff*.)

7. ANALOGIES: The motif of the torsion with the arm reaching across the body appears in Michelangelo's earlier works; for example, the Christ Child of the Bruges Madonna and the Christ Child of the Doni Madonna. Michelangelo used the motif for the first time probably in his lost San Giovannino; cf. Vol. I, pp. 198*f*.

The motif reverts to antiquity, as attested by a drawing by Pisanello after ancient statues, in Milan, Ambrosiana. Cf. the author in *Art Bulletin*, XXVII, 1945, p. 142.

Walter Horn (in an unpublished paper read in the Michelangelo seminar of the author, Hamburg University, 1930) drew attention to the fact that the pose of the Christ in the Minerva might have been inspired by the figure of St. Andrew with the cross in Mantegna's engraving representing the risen Christ with St. Andrew and Longinus (Bartsch, no. 6).

Concerning drawing No. 86, cf. the text and catalogue of drawings. *126, 127*

Michelangelo seems to have treated the theme a second time. In the inventory taken at his home after his death, there is mentioned a small unfinished statuette in marble

representing Christ with the cross: "una statua piccolina per un Cristo con la croce in spalla et non finita" (Gotti II, p. 150). The same statuette is also mentioned in a letter from Daniele da Volterra to Vasari, March 17, 1564. This statuette is lost.

8. Copies:

236 (1) N. Beatrizet, engraving. Bartsch, no. 23; Thode, *Kr.U.*, II, p. 269.

237 (2) Taddeo Landini, marble statue of 1579. Florence, Santo Spirito. The inscription
238 on the base published by Thode, *Kr.U.*, II, p. 268.

 (3) Pietro da Barga, bronze statuette. Florence, Bargello.

 (4) Prospero Clementi, marble statue. Reggio Emilia, Cathedral. Reproduced in Venturi, *Storia*, x, 2, p. 564.

239 (5) J. Matham, engraving. Bartsch, no. 82.

241 (6) Jérome Duquesnoy, marble statue. Ghent, Cathedral St. Bavon (on the grave of Cardinal Antonio Triest).

242 (7) Unknown artist, marble statue. Bruges, Cathedral Saint-Sauveur.

 (8) Michelange Slodtz, marble statue. Paris, Invalides Dome, chapel at the left from the choir.

Francis I asked for permission to have a cast made after the figure by Primaticcio, on February 8, 1546 (Milanesi, *Prosp.cron.*, p. 390; Dorez, *Nouv. Recherches*, 1917, p. 217).

Florence, Bargello.
Marble in the round.
H.: 1.46 cm. (including base); D. of the base: 39 cm.
H.: 1.37 cm. (without base); W. of the base: 45 cm.

1. CONDITION: Excellent; unfinished work.

2. HISTORY: In his first edition (1550, p. 141), Vasari mentions the sculpture made *71-76*
for Baccio Valori, Governor of Florence, as a "figuretta di marmo [that is, a small figure]
d'uno Apollo che cavava una freccia de'l turcasso." In the second edition (1568, p. 145),
he says that it is a marble figure three braccia high, representing an Apollo taking an
arrow from his quiver ("cavava del turcasso una freccia"). He mentions that the figure
is not completely finished, and that it is preserved in one of the rooms of Duke Cosimo I
of Florence.

The statue is mentioned (1553) as "uno Davit del Buonarroto imperfetto" in the in-
ventory of the collection of Duke Cosimo I (cf. C. Conti, *La prima reggia di Cosimo*,
Florence, 1893, I, p. 35, and *Mémoires de l'Institut National de France*, 1896, 35, p.
136).

Later the statue was in a niche of the amphitheater of the Giardino Boboli (Vasari,
ed. Mil., VII, p. 201 n. 4). From there it was transferred to the Uffizi, and finally to the
Bargello.

To judge by the style, Michelangelo probably began work on this statue in the winter
of 1525-1526. It is mentioned later in a letter from Baccio Valori to Michelangelo (Frey,
Briefe, pp. 323*ff*, undated, according to Frey written in spring or fall 1532, according to
Thode in February 1531). Valori declared that he did not wish to press Michelangelo to
finish the statue: "Inoltre io non voglio sollecitarvi della mia fighura, perche mi rendo
certissimo, per l'affetione conosco mi portate, non ha bisogno di sollecitudine."

3. SUBJECT: As to the identification of the figure, there are several opinions.

Knapp (*Michelangelo, Kl.d.K.*, pp. 173*ff*) and Mackowsky (p. 151) follow the inven-
tory of Cosimo's art treasures, inasmuch as they consider the figure as a David. The ball-
shaped elevation under the right foot, which can be interpreted as the head of Goliath,
favors this view. (Springer II, p. 237, interprets this detail as a trophy.) The right hand
in this case would hold a stone, and the left would be reaching back to the sling. Thode
(*Kr.U.*, II, pp. 285*ff*) also agrees with this view, after some hesitation. Popp (*Med.Kap.*,
pp. 141*f*) dates the figure in the winter of 1525-1526, calls it a David, and assumes that
the figure was planned for the Magnifici tomb. It is in her opinion the figure intended
for the niche at the left above St. Cosmas. Her arguments are, first, that the height of
the figure (given by her as 1.49 m.) corresponds to the niche above St. Cosmas (about
1.50 m.); secondly, that the statue cannot have come from the workshop on the Via

Mozza, since the latter remained intact until after the death of Michelangelo, and therefore can only have come from the workshop of San Lorenzo.

90, 91
219-221
The connection of this figure with the Magnifici tomb is not completely convincing, since on the two original sketches, Nos. 58 and 59, there are no niches above Saints Cosmas and Damian. The free paraphrases of the Magnifici tomb, on which Popp supports her arguments, are unreliable. On the other hand, Popp's dating (1525-1526) seems correct to us, as does the assumption that the figure originally represented a David. It seems, however, that when Baccio Valori, about 1530, asked Michelangelo for an Apollo, the latter wanted to transform to an Apollo the figure which he had begun as a David. The object on the back, which originally was to represent a sling, was now to be changed to a quiver. In a red-chalk drawing, attributed to Rosso, in the collection of
272
János Scholz (New York), which is a quite exact copy of the Bargello figure, the object at the back is quite obviously interpreted as a quiver.

4. ANALOGIES: cf. p. 96.

272
5. COPIES: Drawing attributed to Rosso Fiorentino. New York, Collection of János Scholz.

Jacopino del Conte, Annunciation to Zacharias. Rome, Oratorio di S. Giovanni Decollato. Cf. Wilde, *Mitteilungen des Florentiner Instituts*, 1932, p. 45 n. 1.

XVI. NOTES ON CHAPTER XV:
THE GROUP OF THE PIAZZA DELLA SIGNORIA

Marble group in the round, not executed.

H.: 8½ braccia; W.: 2½ braccia (Gaye II, p. 464, and Milanesi, p. 700).

1. HISTORY: The best survey of the history of this group, with references to all the documents, is given in Thode, *Kr.U.*, II, pp. 288*ff*, the results of which we summarize here.

On May 10, 1508, Pietro Soderini, Gonfaloniere of Florence, asked Alberigo Malaspina, Marchese di Massa, to reserve a marble block in Carrara, from which a statue for the Piazza in Florence was to be made (Gaye II, p. 97). In August 1508, the block was found, and the Marchese asked Soderini to have it carried away. On September 4, 1508, Soderini answered that he would send Michelangelo to Carrara, immediately after the latter's arrival in Florence, in order to prepare the block for easy transportation to Florence (Gaye II, p. 97). (From this letter it becomes clear that Michelangelo was thought of from the beginning as the artist who should execute the group.) On December 16, 1508, Soderini reported to the Marchese that the Pope had not yet given Michelangelo permission to go to Florence, so that he could not be sent to Carrara (Gaye, II, p. 107).

Vasari states in his Life of Bandinelli (1568, p. 365) that during the reign of Leo X, a block of nine and a half braccia high and five braccia wide was "cavata" in the quarry in Carrara. (This block is, as Thode supposes, probably the one mentioned in 1508.) From this block Michelangelo wanted to make a Hercules and Cacus, to be erected beside the marble David on the Piazza. He made drawings and models for the group, and tried to gain the favor of Leo X and the Cardinal Giulio for the execution of it. But as a result of the death of Leo X the marble block remained untouched.

In 1525, Clement VII chose Baccio Bandinelli as sculptor of this work. Vasari tells that it was Domenico Buoninsegni, who had become the enemy of Michelangelo, who advised Clement VII to turn the block over to Bandinelli. (Thode, *Kr.U.*, II, p. 290, observed that this statement may be incorrect.) On July 20, 1525, the Signoria of Florence had the block brought to Florence (a block of eight and one-half braccia in width and two and one-half braccia in height: Gaye II, p. 464; Milanesi, p. 700). At the same time the Signoria requested Michelangelo to take over the work, saying that it was the general desire of the Florentine people that he should be the one to execute the statue ("il Popolo desiderando lo lavorasse lui [i.e. Michelangelo]"; cf. also Michelangelo's letter, Milanesi, p. 452). In October 1525 (Milanesi, p. 452), Michelangelo wrote to Fattucci in Rome that he was willing to make the group as a gift ("farla in dono"), if the Pope would allow him. On November 10, 1525 (Frey, *Briefe*, pp. 265*f*), Fattucci wrote to Michelangelo that the Pope desired Michelangelo to work for him and to continue with the Tomb of Julius II, but not to think of public commissions nor of works

commissioned by others. At the desire of the Pope, the block was again given to Bandi-
nelli, who executed a large wax model of Hercules and Cacus. (This model was seen
later by Vasari in the *guardaroba* of Duke Cosimo.)

Bandinelli, however, was incapable of executing this model in marble, and made new
models. One of these he executed in full size. He began to rough-hew the marble block
up to the navel, "scoprendo le membra dinanzi," as Vasari says (1568, p. 368).

On August 22, 1528, the Signoria of republican Florence decided the block, already
about one-half rough-hewn by Bandinelli, should be given to Michelangelo to make a
figure joined with another, in whatever manner he pleased ("una figura insieme o con-
giunta con altra, che et come parrà et piacerà a Michelagniolo"; Milanesi, p. 700; Gaye
II, p. 98). Vasari tells the same story, adding that Michelangelo abandoned the subject of
Hercules and Cacus, and chose instead Samson with two Philistines. The threat of
war in Florence, however, prevented the execution (cf. Vasari 1568, p. 368).

After the fall of the Florentine Republic, Clement VII once again ordered Baccio
Bandinelli to complete the group. On May 1, 1534, the group was finished and unveiled.

Vasari tells (ed. Mil., VI, p. 168) that Montorsoli, commissioned by Duke Cosimo,
began a statue after the model of Michelangelo's Hercules and Antaeus, but Bandinelli
destroyed the block.

2. PROJECTS AND COPIES FOR THE GROUP OF THE PIAZZA DELLA SIGNORIA:

(a) The *concetto* of 1508 has been reconstructed in the text on the basis of the group
of the father holding his dead son in the second plane of the Deluge of the Sistine Ceil-
ing. We deduced from this group that Michelangelo intended at that time to make a
Hercules and Antaeus. In favor of our hypothesis is the sculpturesque character of the
Sistine group, and the fact that it stands isolated in the composition, like an element
inserted from another context.

139
140
(b) With the version of 1525 should be connected the red-chalk sketches Nos. 92 and
91. The dating in this year is suggested by the mask sketches by Michelangelo on No. 91.
Other sketches which have been connected with the project of 1525 are not by Michel-
angelo and should be discarded. These are: (1) Hercules and Antaeus sketch, Florence,
Casa Buonarroti: Berenson, no. 1664, Thode, *Kr.U.*, III, no. 48, Frey, *Handz.*, 176, Popp,
Z.f.b.K., 1927-1928, pp. 8*ff.* Popp attributes this sheet to Benvenuto Cellini. The Her-
cules and Antaeus sketch may be a copy after a model by Michelangelo. (2) Two wres-
tling figures, London, British Museum: Berenson, no. 1526; Thode, *Kr.U.*, III, no. 352;
Frey, *Handz.*, 297b. As Thode observed, it is not a drawing representing Hercules and
Antaeus; cf. the next sheet. (3) Two wrestling figures, Paris, Louvre: Berenson, no.
1593; Thode, *Kr.U.*, III, no. 484; Frey, *Handz.*, 33. The composition is like that on sheet
(2), and as Thode emphasized, not a representation of Hercules and Antaeus. It is not
by Michelangelo, as has already been rightly observed by Morelli, *Kunstchronik*, III,
1891-1892, p. 290. (4) Rape of a Sabine Woman, Haarlem, Teyler Museum: Berenson,

no. 1472; von Marcuard, Plate 21c; Thode, *Kr.U.*, III, no. 268; Frey-Knapp, *Handz.*, 321. Thode observed that the figure which is held in the air is a woman, and that this is therefore not a Hercules and Antaeus. Not by Michelangelo. (5) The Deeds of Hercules, with Hercules and Antaeus in the center, Windsor, Royal Library: Berenson, no. 1611; Thode, *Kr.U.*, III, no. 536; Frey, *Handz.*, 7; Panofsky, *Z.f.b.K.*, LXI, 1927-1928, pp. 221*ff*, and LXII, 1928-1929, pp. 179*ff*; Popp, *Z.f.b.K.*, LXII, 1928-1929, pp. 54*ff*. Popp has shown with excellent arguments that this sheet is a forgery of the late sixteenth century.

274-276

(c) With the version of 1528 should probably be connected the original clay model in Florence, Casa Buonarroti, published for the first time in Bode, *Toscana-Werk*, Plate 531: Thode, *Kr.U.*, III, no. 583; Wilde, *Dedalo*, VIII, 1928, pp. 653*ff*; *idem, J.d.Kh. Slg., Wien*, 1928, pp. 199*ff*; Panofsky, *Iconology*, pp. 231*ff*.

Grünwald, *J.d.A.K.*, XXVII, 1907-1909, p. 141, called attention for the first time to the fact that "von der Gruppe der Casa Buonarroti ist mehr vorhanden als die Abbildungen im *Toscana-Werk* Bodes zeigen: Kopf des Simson, sein Arm, Kopf des Philisters." Wilde, *op.cit.*, who seems to have overlooked this observation by Grünwald, made the same discovery, and joined these three fragments successfully with the group.

According to Springer, *Raffael und Michelangelo*, II, pp. 36 and 354 n. 10, the model is made for one of the Victories of the Tomb of Julius II. Thode, *Kr.U.*, II, p. 296, observed the close stylistic affinity of the model with the Vittoria: "So nahe dem Sieger verwandt, dass wir die beiden Werke einander zeitlich nahe rücken müssen." He dates the group around 1525 or 1528. Wilde, *op.cit.*, believes also that the clay model was intended as a companion piece of the Vittoria. His argument is based chiefly on a stylistic analysis and on the proportions of the model. These latter are according to him not reconcilable with the proportions of the block for the group of the Piazza della Signoria as given by Vasari. Panofsky, however, has shown that the proportions of the clay model, ca. 1:3, are consistent with the proportions of the official records of Florence (Gaye II, p. 464), where the dimensions are given as two and a half by eight and a half braccia, i.e. even slenderer than one to three. Vasari 1568, p. 365, gives on the other hand as dimensions five by nine and a half braccia, and in another place, Vasari 1568, p. 143, five by nine braccia, i.e. the proportion is one to two. This statement by Vasari is of course not of the same documentary value as the official records of Florence, with which the proportions of Bandinelli's group on the Piazza are also consistent—one to three in the front, and one to three and a half in profile.

Panofsky, moreover, observes that the clay model offers a multitude of satisfactory aspects, concluding that the composition thus seems more suitable for an open square than for one of the niches on the Tomb of Julius II. (The Vittoria group is indeed composed for one principal view.) Thus neither the measurements of the clay model nor its composition preclude its connection with the Piazza statue.

Other scholars identified the clay model with the project of the marble group on the

Piazza della Signoria, and interpreted it either as Hercules and Cacus or as Samson and one Philistine. The first opinion (Hercules and Cacus) was expressed by Thode (*Kr.U.*, II, p. 296), among others. This interpretation can be supported by the commission of August 22, 1528 (Gaye, II, p. 98, and Milanesi, p. 700), where it is mentioned that the block brought to Florence in 1525 was destined "per farne la Imagine et figura di Cacco." The second interpretation (Samson and one Philistine) was given first by Bode (*Toscana-Werk*) and Frey (*Handz.*, text to no. 157), an interpretation supported by a remark of Vasari (ed. Mil., VI, p. 128) according to which Piero Vinci wanted to execute from a marble block (three braccia wide and five braccia high) a Samson with one Philistine after Michelangelo's sketches. Panofsky, *op.cit.*, pp. 231*ff*, leaves the question open: "the head is bearded: this type is consistent with the traditional features of both Hercules and Samson." As stated above, Vasari asserted elsewhere (1568, p. 368) that ca. 1528 Michelangelo wanted to execute a Samson with two Philistines.

So there is no reason to discard this clay model from the projects for the statue of the Piazza in 1528. Whether the model represents Hercules and Cacus or Samson and one Philistine cannot be determined, because the raised right arm of the standing figure (which in the case of Samson should hold the jawbone of an ass) is lost.

COPIES: Wax. London, Victoria and Albert Museum. Thode, *Kr.U.*, III, no. 604, considers it as an original. Wilde has shown that it is a copy.

Drawing by an unknown master, sixteenth century. Florence, Uffizi, no. 18666. Published in Wilde, *op.cit.*, p. 200.

Pietro Tacca, drawing of a fountain. Florence, Uffizi. At the top, a copy of the group. Published by Jacobsen, *Misc. d'arte*, I, 1903, p. 104.

(d) Probably after 1529-1530 should be dated Michelangelo's project of Samson and two Philistines, of which the original is lost. There are several copies of this group in bronze, five of which are listed by Thode, *Kr.U.*, II, p. 297. These are: (1) Berlin, Kaiser Friedrich Museum (*Katalog der italienischen Bronzen*, no. 260); (2) Florence, Bargello (reproduced in *Misc.d'arte*, I, 1903, p. 41); (3) Florence, Bargello, a second copy; (4) Paris, Louvre, Collection Thiers; (5) London, Sale Bardini, 1899. This latter is identical with the copy formerly in the Morgan Collection, New York, now in the Frick Collection, New York; (6) Castiglioni Collection (cf. Planiscig, *Die Sammlung Castiglioni, Bronzestatuetten und Geräte*, Vienna, 1923, no. 73).

Brinckmann, *Belvedere*, XI, 1927, pp. 155*ff*, called attention to a clay model in the Musée Bonnat, Bayonne, and erroneously considered this copy as an original by Michelangelo.

Daniele da Volterra, in his Slaughter of the Innocents, Florence, Uffizi, copied the group, transforming the kneeling Philistine into a woman (cf. *Misc.d'arte*, I, 1903, p. 41).

There is a whole series of drawings made after this group. Nine sheets were listed by Ferri, *Misc.d'arte*, I, 1903, pp. 64*ff*. (He attributes the drawings erroneously to

Daniele da Volterra.) A further sheet in the Palazzo Corsini, Rome, was mentioned by Jacobsen, *Rep.f.Kw.*, xix, 1906, pp. 27*ff* and 325*f*. Jacobsen attributes all these drawings to Tintoretto. Cf. also von Hadeln, *Tintoretto-Zeichnungen*, pp. 24*ff*. Ferri-Jacobsen completed the material in *Rivista d'arte*, v, 1907, pp. 55*ff*.

XVII. NOTES ON CHAPTER XVI: THE ASCENSION
OF CHRIST

159 1. The drawing No. 112 is attributed by Berenson, no. 1713, to Montelupo. In our opinion, however, it is probably an original, of which the outlines were later traced over. Thode rightly dates the drawing ca. 1531-1532, Frey, ca. 1534-1538.

160 2. The sketch of the Ascension, Florence, Archivio Buonarroti, Cod. VI, fol. 24 verso (No. 113) was published for the first time by the author, *Arch.Buon.*, p. 446. Here is given also the dating and the hypothesis concerning the purpose of the sketch as a project for a fresco above the tribune of the relics on the entrance wall of the Church of San Lorenzo. On the recto of the sheet there is a letter by B. Angiolini of September 19, 1532 (cf. Symonds, *Michelangelo*, II, p. 390). Next to the drawing, in Michelangelo's handwriting: "Le lectere de dugento ducati."

The motif of the drawing is based on the Haman of the Sistine Ceiling. Similar is the position of the raised arm, which conceals a part of the face, creating an effect of momentaneity, as if because of the swiftness of the movement it had been impossible to grasp enough of the picture. However, whereas Haman is constructed from contrasts of direction, in the drawing of the Archivio Buonarroti all contradictory directions are subordinated to the great spiral.

161 3. The drawing of the Ascension on the verso of Frey, *Handz.*, 20 (project sketch for the Last Judgment), Florence, Casa Buonarroti, was first published by the author in *Arch.Buon.*, p. 447. In the article the author expressed his doubts about the authenticity of this drawing, and considered it as a copy of the sketch in the Archivio Buonarroti.

4. All the other drawings representing the Ascension of Christ which have been up to now attributed to Michelangelo are doubtful. These are Frey, *Handz.*, 219, 110, 8; Brinckmann, nos. 62, 61; Frey, *Handz.*, 288. The basis of these drawings is the tracing of the Tityos, Frey, *Handz.*, 219. Its copy in mirror image is Frey, *Handz.*, 110, where only the position of the arms differs from the prototype (it is borrowed from the Christ of the Minerva). A freer variation of the tracing is Frey, *Handz.*, 8 (the motif of the legs is taken over; the position of the upper body and of the arms may go back to a now lost drawing by Michelangelo, which probably represented one of the guards at the sepulcher of Christ, for the recoiling of the upper body is more appropriate to a guard than to the ascending Christ).

Also Brinckmann, no. 62, is a copy after the tracing, but the risen Christ is here transformed to the judging Christ. This drawing was the point of departure for Brinckmann, no. 61 (made by the same hand), in which the motif of the judge is even more definitely emphasized. Brinckmann, no. 62, was also the model for Frey, *Handz.*, 288 (by another hand). In the latter drawing the motif already established for the judging Christ is once more applied to the ascending Christ, whereby the whole is given a contradictory effect.

To summarize, all these drawings are direct or (through Brinckmann, no. 62) indirect copies of the Tityos tracing, Frey, *Handz.*, 219. This tracing itself, however, is not an original, but a kind of *pasticcio* of two inventions of the master. The upper body, head, and left arm are gained by the tracing after the recto drawing of the Tityos; the *155* right arm and the position of the legs (which are not in harmony with the body) are copies after No. 112. *159*

XVIII. NOTES ON CHAPTER XVII: THE LEDA

Made for Alfonso d'Este, Duke of Ferrara. Given later by Michelangelo to Antonio Mini. Now lost.

Tempera, on panel (cf. Condivi, Vasari, and Frey, *Briefe*, p. 316).

1. HISTORY: The history of the Leda has been treated in most detail by Léon Dorez ("Nouvelles Recherches sur Michel-Ange et son entourage," *Bibl. de l'École des Chartes*, LXXVII, 1916, pp. 448*ff*, and LXXVIII, 1917, pp. 193*ff*), whose findings we summarize here. Already in July 1529 (Gotti I, p. 187), when Michelangelo, entrusted with a diplomatic and military mission, was staying in Ferrara—it was during the siege of Florence—the artist had promised Duke Alfonso I d'Este to execute a painting for one of the rooms in the ducal palace. (We know that Michelangelo had met Alfonso d'Este already in 1512 in Rome; see Vol. II, pp. 6*f*.) After his return from the Venetian journey (from the end of September until November 1529) he painted the Leda picture in the free time which the fortification of Florence left to him. About October 1530, the picture was finished. On October 22, the Duke sent his ambassador, Jacopo Laschi, to Florence, with a letter to Michelangelo to fetch the picture (published in Campori, *Atti e memorie delle RR. Deputazioni di storia patria per le provincie dell' Emilia*, VI, 1881, p. 139). Vasari (1568, pp. 145*ff*) tells how the envoy through his tactlessness offended Michelangelo, so that the latter refused to give the picture to the Duke. He presented the painting later to his pupil, Antonio Mini.

In 1531, Antonio Mini, a garzone of Michelangelo (from the end of 1523 in the service of the artist, cf. Frey, *Briefe*, p. 197), had difficulties with his uncle, Giambattista, on account of a love affair, and consequently had to leave Florence (cf. Vol. I, p. 245). In order to furnish dowries for the two sisters of Mini, who were to be married, and in order to enrich Mini himself, Michelangelo gave him the Leda (the painting and the cartoon), some other cartoons, many drawings and models of wax and terracotta (Vasari 1568, p. 147; concerning the fate of the cartoons and drawings, cf. Reiset, *G.d.B.-A.*, 1877, XV, 2, pp. 247*f*, and Thode, *Kr.U.*, III, pp. 259, 265).

Mini soon departed with a young Florentine, Benedetto del Bene. At the end of November 1531, Mini arrived in Barberino di Mugello, where, however, he received no information about the chests in which he had packed his treasures (Frey, *Briefe*, pp. 313*f*). On December 1, 1531, he reached Bologna (Frey, *Briefe*, pp. 314*f*), and a few days later he wrote from Piacenza (Frey, *Briefe*, pp. 315*f*). He was full of hopes of becoming rich at the court of Francis I, through the sale of his artistic treasures. In Piacenza he met Florentines who came from the French court, and who told him wonderful things of the monarch's munificence in artistic matters. About December 20, 1531, Mini and his companion arrived in Lyons, where they were received by the Florentine, Francesco Tedaldi. Mini intended to remain in Lyons until the arrival of his chest with the Leda and then to go to the court of Francis I (Frey, *Briefe*, p. 316). On January 11, 1532,

the picture had not yet arrived, but Mini was full of hope, since the Florentines in Lyons assured him that he would get much money from the king for the picture (Frey, *Briefe*, p. 317). From a letter from Francesco Tedaldi to Michelangelo, February 11, 1532, we learn that Mini and del Bene had begun to paint a Leda (Frey, *Briefe*, pp. 322f). On February 27, 1532 (Dorez, *loc.cit.*), Mini wrote that he had entrusted the Leda, which had apparently arrived in the meantime, to the banker, Leonardo Spina, but that he intended to sell the picture later to Francis I. At the moment he was flooded with orders for copies of the Leda. On March 9, 1532, he wrote happily to Michelangelo that he had earned more in one month in Lyons than in eighteen months in Florence, and that at the moment he had orders for no less than three copies of the Leda after Michelangelo's cartoon (Frey, *Briefe*, pp. 317f). On May 8, 1532, he reported that he had been twice at the court in Paris, had had the two pictures by Michelangelo (Leda and the cartoon for it) sent to Paris, but had not been able to accomplish anything, since the king was on a long journey and would not come back for a year (Frey, *Briefe*, pp. 318f). He had left the two pictures with Giuliano Buonaccorsi, *Trésorier et receveur général des finances ordinaires et extraordinaires de Provence*. In August 1532, Mini attempted to visit Francis I in Nantes (Gotti I, pp. 201f). Apparently he was not granted an audience. Thereupon he deposited again two Ledas (Michelangelo's and Benedetto del Bene's) with Buonaccorsi. He borrowed from Tedaldi up to half of the sale price of the Leda. About a year later (i.e. summer 1533) Mini attempted to get the two Ledas back from Buonaccorsi. He was unsuccessful, since Buonaccorsi asserted he had received nothing from Mini and the two pictures had been brought to him at the request of Francis I by the poet, Luigi Alamanni. Thereupon Mini protested on August 6, 1533. Then he became ill from agitation and disappointment, and died at the end of 1533. Tedaldi, who had given an advance to Mini, as stated above, attempted together with Giambattista Mini, uncle of the deceased, to bring suit against Buonaccorsi (1539; cf. *ricordo* of Tedaldi [1540] in Gotti I, p. 201). In June 1536, Giambattista Mini visited Roberto Nasi, to ask him to intervene with Michelangelo in the matter of the Leda (Frey, *Briefe*, pp. 340f). The cartoon returned after Mini's death to Florence, to Bernardo Vecchietti (cf. Vasari 1568, p. 147; Borghini, *Riposo*, 1584, p. 13).

The further history of the Leda in the seventeenth and eighteenth centuries is covered by Dorez, *op.cit.*, 1916, pp. 468ff, and Thode, *Kr.U.*, II, p. 314.

2. SUBJECT: Condivi (1553, p. 142) says: "Principiò [Michelangelo] un quadrone da sala, rappresentando il concubito del Cygno con Leda et appresso il parto del uova, di che nacquer Castore et Poluce, secondo che nelle favole delli antichi scritto si legge."

Vasari (1550, p. 141) does not mention the prolepsis, saying only: "Diede fine a una Leda in tavola, lavorata a tempera, che era divina." Vasari (1568, p. 145), however, follows Condivi's description: "La Leda . . . che abraccia il cigno, et Castore et Polluce, che uscivano dall' uovo."

The old prints testify that the prolepsis was indeed represented in the painting. 279

3. ANALOGIES: A. Michaelis, *Strassburger Festgruss an Anton Springer*, Berlin, 1885, pp. 33ff, has demonstrated that Michelangelo was inspired in his Leda by an ancient composition. Probably he knew the sarcophagus relief which in the mid-sixteenth century was preserved in the Domus Corneliorum in Rome, and of which there exist sixteenth century drawings in the Codex Pighianus, Berlin, Staatsbibliothek, and in a manuscript in Koburg (reproduced in Robert, *Die antiken Sarkophagreliefs*, II, no. 3). There existed also other reliefs and gems with the same representation of Leda (cf. Robert, *op.cit.*, II, nos. 4 and 6).

281

Michaelis also pointed out that the Notte reverts to the same ancient Leda relief.

130

Only one original study is preserved, the study for the legs of the Leda (No. 98; identified by Popp, *Med.Kap.*). The drawings listed as original studies by Thode, *Kr.U.*, II, pp. 316f, namely, the drawings in the Louvre, Thode, nos. 479 and 500, and the Uffizi drawing, Thode no. 226, are only apocryphal works.

4. COPIES:

282

(1) The picture in London in the National Gallery, which was considered by earlier scholars as the original, is painted on linen, and therefore cannot be Michelangelo's panel (cf. Thode, *Kr.U.*, II, pp. 318ff). Roy, *G.d.B.-A.*, LXV, 1923, pp. 65ff, has proved convincingly that the London picture and probably also the cartoon in the Royal Academy, are copies by Rosso. This picture was in the collection of Francis I, in the gallery of Fontainebleau. In October 1530, after Michelangelo had finished his Leda, Rosso came to the court of Francis I. In November 1530, he was commissioned by the king to paint a large picture of which the subject is not mentioned (document published by Roy, p. 68). Roy assumes that this picture was Rosso's Leda, which later was in the possession of Buonaccorsi, as was also Michelangelo's Leda. This picture by Rosso omitted the motif of the prolepsis—that is, the Dioscuri who are born from the egg —a motif which both Condivi and Vasari describe as accompanying the principal group in the original (cf. above, p. 191). The prolepsis is lacking also in the cartoon of the Royal Academy, which according to Roy must also be ascribed to Rosso. Michelangelo's cartoon returned in the sixteenth century from France to Italy, to Bernardo Vecchietti in Florence (cf. above). In the copies of the Leda in Venice (Correr Museum), Berlin (K. Schloss), and Dresden (Gemäldegalerie), as well as in the plastic copy by Ammannati in the Bargello, the prolepsis is also lacking. It is included, however, in the engravings of Cornelius Bos and of Etienne Delaune. Apparently while still in Italy Rosso made a drawing after Michelangelo's Leda, from which he probably painted his picture before the original arrived in France (Roy). He seems then to have offered the picture to Francis I—whether as his own work or Michelangelo's is unknown—and the king then purchased it. Under these circumstances it is understandable that the king had no interest in the possession of a second Leda, which Mini offered him somewhat later.

280

283

284, 285

279

282

The picture was bought by the Duke of Northumberland, and in 1838 was offered to the National Gallery. In 1863, the picture was cleaned (*G.d.B.-A.*, 1869, 1, p. 160 [Tri-

quetti]; *G.d.B.-A.*, 1877, 2, p. 246 [Reiset]; *G.d.B.-A.*, 1876, 1, p. 159 [Mantz]). According to the earlier scholars (Reiset, Michaelis) the London picture is authentic. According to Thode (*Kr.U.*, II, pp. 318*ff*), the cartoon is the original, and the London 280 picture the copy by Benedetto del Bene. According to Dorez, the London picture is del Bene's copy, and the other three preserved copies are from the studio of Mini in Lyons. He assumes that it was in this studio that the prolepsis was eliminated, to make the execution of the Leda simpler and to free the copies from this embarrassing detail. Thode emphasizes that the London picture and the cartoon have been cut.

The most probable hypothesis is that of Roy, that the London picture is the copy made by Rosso and mentioned in 1625 by Cassiano del Pozzo as Rosso's work. The Venice and Berlin pictures are from the sixteenth century, and may probably have been executed in Lyons. The Dresden copy is a Flemish work of the school of Rubens, of about 1620-1630. The landscape in this picture is an addition by the copyist.

(2) Berlin, Schloss. The prolepsis is lacking. According to Thode, *Kr.U.*, II, p. 320, this copy is probably by Vasari.

(3) Venice, Museo Correr. The prolepsis is lacking. According to Jakobsen, *Rep.f.* 283 *Kw.*, XXII, 1899, p. 28, made by a follower of Correggio. According to Thode, *Kr.U.*, II, p. 319, probably by Pontormo. In our opinion, North Italian.

(4) Dresden, Gemäldegalerie. The prolepsis is lacking. With landscape in back- 284 ground. According to J. P. Richter, *Z.f.b.K.*, XII, 1877, p. 228, in the manner of Heemskerk. According to Woermann, *Rep.f.Kw.*, XVIII, 1885, pp. 405*f*, and Thode, *loc.cit.*, probably by Rubens. This latter attribution is the more likely. However, the painting seems not to be by Rubens himself, but only by his atelier.

(5) Engraving by Cornelius Bos. With the prolepsis. Mirror image of the painting. 279 (From this engraving there exists also a copy, not in mirror image.) Cf. Heinecken, no. 1a; Woermann, *Rep.f.Kw.*, XVIII, 1885, pp. 405*ff*; Thode, *Kr.U.*, II, p. 321.

(6) Engraving by Etienne Delaune, not in mirror image. With the prolepsis. Dumesnil, IX, no. 307; Heinecken, no. 1b; Thode, *Kr.U.*, II, p. 321.

(7) Small marble copy of the group by Bartolomeo Ammannati, Florence, Bargello. 285

By error, Vasari (1568, p. 343) describes an engraving representing the Leda by Enea Vico as a copy of Michelangelo's Leda. However, this engraving shows a different composition.

XIX. NOTES ON CHAPTER XVIII: VENUS AND CUPID

Cartoon and painting both lost.

286-289 1. HISTORY: The cartoon was probably executed around 1532-1533, as Popp, *Med.-Kap.*, pp. 146*f*, has shown.

There is a poem on this painting by an unknown author, written, according to Frey, about 1546, published in Frey, *Dicht.*, p. 271, no. CLXXIX.

Vasari (1550, p. 170) mentions the cartoon "d'una Venere, che [Michelangelo] donò a Bartolomeo Bettini, di carbone finitissimo." Concerning Bartolomeo Bettini, cf. Michelangelo's letter of February 21, 1549 (Milanesi, p. 241).

Varchi, *Due Lezzioni*, Florence, 1549, pp. 104, 278*f*, says of it: "Non dice egli che gli uomini medesimi si sono innamorati delle statue di marmo . . . benchè questo stesso avviene ancora oggi tutto il giorno nella Venere che disegnò Michelagnolo a M. Bartolommeo Bettini, colorita di mano di M. Jacopo Pontormo."

In the inventory of the *guardaroba* of Duke Cosimo I, 1553-1568, there is mentioned "uno quadro con la Venere e Cupido del Pontormo con ornamento di noce e cortina di seta verde" (published in Steinmann, *Bibliographie*, p. 432, doc. XVI).

Vasari (1568, p. 250) repeats with slight changes his sentence of the first edition: "A Bartolomeo Bettini fece e donò un cartone d'una Venere con Cupido che la baccia, che e cosa divina, hoggi appresso agli heredi in Fiorenza." The cartoon, after the death of Bettini, was in the possession of his heirs, where Vasari saw it.

Vasari (1568, p. 376), in the *Vita di Pontormo*, returns to this theme, giving also a description of the room where Pontormo's painting was to be placed. It had to be "in mezzo a una sua [*sc.* Bartolomeo Bettini] camera, nelle lunette della quale haveva cominciato a fare dipignere dal Bronzino, Dante, Petrarca, e Boccaccio, con animo di farvi gl' altri poeti che hanno con versi e prose Toscane cantato d'amore." This is an interesting account, because it shows that Michelangelo's Venus and Cupid was conceived as the "Muse" of the Tuscan poets of love, represented in the lunettes above.

Vasari continues the story of the copy by Pontormo: "Havendo intanto finito Jacopo di dipignere la Venere dal cartone del Bettino . . . ella non fu data a esso Bettino per quel pregio che Jacopo gliele avea promessa ma da certi furagrazie, per far male al Bettino, levata di mano a Jacopo quasi per forza e data al Duca Alessandro, rendendo il suo cartone al Bettino. Laqual cosa havendo intesa Michelagnolo, n' hebbe dispiacere . . . e ne vole male a Jacopo."

2. SUBJECT: According to Milanesi (Vasari, ed. Mil., IV, pp. 291*ff*, *Vita di Pontormo*), Michelangelo represented Venus-Aphrodite, the goddess of sensual pleasure. The bow and arrows on the altar represent the wounds which such love inflicts, the roses represent the transitory nature of its joys, the youthful mask the deceptiveness of fleshly joys, the satyr mask the lower desires, the reclining boy perhaps the miserable end of those who make reason the slave of desire, and the mourning veil on the altar the same. Ac-

cording to him, Michelangelo here represented the idea of his poem: "Voglia sfrenata è il senso, e non Amore, che l'alma uccide . . ." (Frey, *Dicht.*, LXXIX).

Thode (*Kr.U.*, II, p. 330) interprets in a somewhat different way: on the altar of love, the roses of sensual enjoyment; below it, the sensuality which consumes itself; the two masks, symbols of the two potentialities of love—to sink to the animal level, or to rise to the ideal.

The altar is lacking in the sketch in London, No. 122. *286*

As stated above, in connection with Vasari's description of the room of Bettini, the Venus of Michelangelo was the Venus sung by the Tuscan poets.

3. ANALOGIES: According to Thode, *Kr.U.*, II, p. 330, Michelangelo's point of departure was the representations of the reclining Venus by Botticelli and Piero di Cosimo. Much more convincing, however, is the observation of Popp (*Med.Kap.*, pp. 86 and 146*f*) that the pose of the Venus of Michelangelo is developed from the pose of the river gods of the tomb of Lorenzo de' Medici. The couch of Venus is a substitute for the vase *265-271* of the river gods. Michelangelo used the motif of the river-god Venus later in the figure of St. Paul in his fresco of the Conversion of St. Paul, in the Paolina Chapel.

The small original sketch in the British Museum (No. 122) was connected for the *286* first time with the Venus composition by Fagan, *The Art of M. B. in the British Museum*, London, 1883, no. 52.

The cartoon in the Museo Nazionale in Naples is, according to Thode, *Kr.U.*, II, p. *287* 327, the original. It was published for the first time by Steinmann, *Boll.d'arte*, V, 1925, p. 7, who leaves the question of authenticity open. In our opinion it is a copy, probably by Bronzino, of the lost original. This cartoon was at the end of the sixteenth century in the collection of Fulvio Orsini in Rome (cf. P. de Nolhac, *G.d.B.-A.*, XXIX, 1884, p. 427).

4. COPIES: Thode, *Kr.U.*, II, pp. 327*ff*, gives an enumeration of the most important copies. These are: (1) Florence, Uffizi, formerly attributed to Pontormo, now to Daniele *288* da Volterra (Popp, *Med.Kap.*, p. 146 and *Z.f.b.K.*, VII, 1924, p. 133), mentioned in the inventory of the *guardaroba* (cf. above); (2) Hampton Court, attributed to Bronzino; (3) Hildesheim Museum (without the altar and the symbols); (4) Naples, Museo Nazio- *289* nale, attributed to Bronzino; (5) Rome, Palazzo Colonna, copy by Vasari; (6) Naples, *287* Museo Nazionale, cartoon (cf. above).

In the literature there are mentioned other copies, which can no longer be identified.

In the *Vita di Giorgio Vasari*, Vasari (1568, pp. 399*f*) tells that he, Vasari, made for "Messer Ottaviano de' Medici una Venere et una Leda con i cartoni di Michelagnolo." In another place he tells that in 1542 he brought both pictures to Venice and there sold them to Don Diego de Mendoza (Vasari, ed. Mil., VII, p. 670). This copy is mentioned by Pietro Aretino, in 1542: *Il secondo libro delle lettere*, ed. Nicolini, II, p. 264.

A second Venus "col disegno di Michelagnolo" was executed by Vasari for Bindo Altoviti in 1544 (Vasari, ed. Mil., VII, p. 673). Probably the same copy is mentioned in

a letter to Francesco Lioni in Venice, July 21, 1544 (Vasari, *Carteggio*, I, pp. 131*f*). Cf. Kallab, *Vasaristudien*, p. 69 n. 91. C. C. Ratti, *Instruzione di quanto può vedersi di più bello in Genova*, Genoa, 1780, I, p. 120: in the palace of Pietro Gentile, there was a Venus and Cupid by Marcello Venusti after Michelangelo's design; F. Titi, *Descrizione delle pitture . . . in Roma*, Rome, 1763, p. 333, a fresco of a Venus attributed to Michelangelo in the Palazzo Barberini; Vesme, *La Reggia Pinacoteca di Torino* (in *Le Gallerie Italiane*, III, Rome, 1897, p. 52, no. 437): "Venere nuda stesa in terra . . . in tavola di Michelangelo Buonarroti." This painting was burned by order of Carlo Emanuele III; cf. Thode, *Kr.U.*, II, p. 326. Further information concerning copies in: F. M. Clapp, *Jacopo Carucci da Pontormo*, New Haven, 1916, pp. 142*ff*.

XX. NOTES ON CHAPTER XIX: NOLI ME TANGERE

Cartoon by Michelangelo, now lost.

1. HISTORY: Michelangelo was commissioned to make the cartoon of *Noli me tangere*, 290, 291 through mediation of Nicolas von Schomberg, Archbishop of Capua and Governor of Florence for Clement VII, by the Marchese del Vasto, Alfonso Davalos, one of the commanders of the imperial armies.

The work is first mentioned in three letters by Figiovanni to Michelangelo, in the first of which (April 11, 1531; published in Frey, *Dicht.*, p. 508, *Reg.* 25) Michelangelo had already consented to make the painting. According to Figiovanni, it was to be painted on canvas or wood. In the second letter, undated, written probably in the late summer or fall of 1531 (published in Frey, *Dicht.*, p. 508, *Reg.* 27), Figiovanni announced that the Marchese del Vasto (who ordered the picture) was very soon to arrive in Florence and wished to see the picture and the statues of the Medici Chapel. By that time the cartoon was finished. From a third letter by Figiovanni, written shortly after October 27, 1531 (published in Frey, *Dicht.*, p. 509, *Reg.* 28, and Frey, *Briefe*, p. 310), it is learned that Michelangelo desired that Pontormo should execute the picture in Michelangelo's house.

On November 26, 1531, Antonio Mini wrote to Antonio Gondi that Michelangelo intended to give the cartoon of the *Noli me tangere* to him (Mini). He adds that Michelangelo had not "fornito a suo modo quest' opera." Solicited by the Archbishop of Capua, Nicolas von Schomberg, Michelangelo made the cartoon "in furia" (Daelli, no. 19, and Dorez, *op.cit.*, 1917, pp. 448*ff*, and 1918, pp. 179*ff*). In February 1532, Mini wrote to Michelangelo a second time, from Lyons, concerning this cartoon, which remained in Florence (Dorez, *op.cit.*, 1918, p. 193). The cartoon was preserved in the *guardaroba* of Cosimo I (Vasari, ed. Mil., VI, p. 575). On the basis of the cartoon, Pontormo was charged to execute a panel. This had such a success that the Condottiere Alessandro Vitelli ordered a second copy by Pontormo. Vasari (1568, pp. 375*f*) says: "Havendo il signor Alfonso Davalo, Marchese del Guasto, ottenuto per mezzo di Fra Niccolò della Magna da Michelagnolo Buonarroti un cartone d'un Christo, che appare alla Madalena nell' orto, fece ogni opera d'havere il Puntormo, che glielo conducesse di pittura, havendogli detto il Buonarroto, che niuno poteva meglio servirlo di costui. Havendo dunque condotta Jacopo questa opera a perfezione, ella fu stimata pittura rara per la grandezza del disegno di Michelagnolo e per lo colorito di Jacopo. Onde havendola veduta il signor Alessandro Vitelli, ilquale era allora in Fiorenza Capitano della guardia de' soldati, si fece da Jacopo un quadro del medesimo cartone, il quale mandò e fe porre nelle suo case a Città di Castello." From this text it is clear that Pontormo executed two copies after the cartoon of Michelangelo, one for the Marchese del Vasto, and one for Alessandro Vitelli.

The Venetian Battista Franco also copied the cartoon; this copy is mentioned in the

inventory of the *guardaroba* of Duke Cosimo I in the Palazzo Vecchio, 1553-1568: "Uno quadro el Noli me tangere del Venetiano [i.e. Battista Franco] con ornamento di noce e cortina di seta pagonazzo vecchio" (published in Steinmann, *Bibliographie*, p. 432, doc. XVI). The same copy is mentioned also by Vasari 1568, p. 381 (*Vita di Battista Franco*). According to Vasari, Battista Franco first made a cartoon after that of Michelangelo but with larger figures, and then made a painting of it. Concerning the history of the cartoon and painting, cf. Thode, *Kr.U.*, II, pp. 446*ff*, and Steinmann, "Cartoni di Michelangelo," *Boll.d'arte*, 1925, pp. 8*f*.

290, 291 2. COPIES: Two copies after the lost cartoon were published by C. Gamba, "Una Copia del Noli me tangere di Michelangelo," *Boll.d'arte*, III, 1909, pp. 148*ff*. These copies are now in Florence, Casa Buonarroti. Gamba tries to identify the better copy
290 with that of Battista Franco, saying of the other copy (with the landscape after Dürer's
291 St. Eustachius) that it is probably from the school of Bronzino, and made after the cartoon of Battista Franco, "essendo simili i difetti di proporzione."

290 The better copy, however, is in the style of Pontormo, though it has not the quality of his original works; so it seems to be a replica of one of Pontormo's lost copies. The
291 weaker copy, on the other hand, seems to be that of Battista Franco. It corresponds well in its style with the Allegory of the Battle of Montemurlo in the Pitti Gallery, and with his fresco in the Oratorio della Misericordia in Rome.

Berenson (no. 1539) and Frey (*Handz.*, 77 and 78) connect with the *Noli me tangere* composition a drawing of the late period of Michelangelo. Thode (*Kr.U.*, III, no. 367) rejects this connection, and rightly so. Cf. also F. M. Clapp, *Jacopo Carucci da Pontormo*, New Haven, 1916, pp. 259*f*.

XXI. NOTES ON CHAPTER XX: DRAWINGS
FOR CAVALIERI

1. Cavalieri was a great amateur of classic art, and the possessor of a notable collection of ancient statues, the list of which is given by Ulisse Aldroandi, *Antichità*, pp. 225*ff*, reprinted in *Rep.f.Kw.*, XXIX, 1906, pp. 502*f*.

2. The "teste divine" or idealized heads of young women and men are all lost, but some of them are known through copies. Among these the most celebrated are the so-called Cleopatra (Casa Buonarroti, Berenson, no. 1655, Thode, *Kr.U.*, III, no. 12), the so-called Zenobia (attributed also to Bacchiacca; Berenson, no. 1626, Thode, *Kr.U.*, III, no. 206), and the so-called Count Canossa (London, British Museum, Berenson, no. 1688, Thode, *Kr.U.*, III, no. 343). Concerning the whole question, cf. Thode, *Kr.U.*, II, pp. 331*ff*, who, however, considers most of these copies as originals by Michelangelo. Berenson, I, pp. 359*ff*, attributes these drawings to his "Andrea di Michelangelo"; this Andrea di Michelangelo is, however, identical with Antonio Mini.

3. Concerning the portrait of Cavalieri by Michelangelo, cf. the important marginal note in the copy of Vasari's *Vite* (1568) in Rome, Biblioteca Corsiniana 29E.6, p. 775, reprinted in *Rep.f.Kw.*, XXIX, 1906, p. 506.

4. The best replica of the Ganymede, of which the original is lost, is No. 116. For [154] other copies, cf. Thode, *Kr.U.*, II, pp. 350*ff*. A classical prototype is mentioned by Hekler, "Michelangelo und die Antike," *Wiener Jahrbuch für Kunstgeschichte*, VII, 1930, p. 220.

Wickhoff, *Bildungsgang*, p. 433, has already called attention to the similarity of the content of the drawing with the second stanza of the sonnets, Frey, *Dicht.*, XLIV, and Frey, *Dicht.*, CIX, 19.

Borinski, *Rätsel*, p. 142, quotes Landino. According to Panofsky, *Iconology*, p. 216, the Ganymede represents "the enraptured ascension of the mind."

5. Further references concerning the Tityos in Thode, *Kr.U.*, II, pp. 350 and 356*ff*. [155] (The reproduction in Frey, *Handz.*, 6 is reversed.) An interpretation is given by Panofsky, *Iconology*, pp. 216*ff*: "Tityos symbolizes the agonies of sensual passion enslaving the soul and debasing it even beneath its normal terrestrial state."

6. Concerning the earlier representations of the Fall of Phaeton, cf. M. D. Henkel, [297] "Illustrierte Ausgaben von Ovids Metamorphosen im XV, XVI und XVII-ten Jahrhundert," *Vorträge der Bibliothek Warburg*, 1926-1927, pp. 58*ff*. For further references concerning Phaeton, cf. Thode, *Kr.U.*, II, pp. 358*ff*. Here the correct sequence: Nos. 117, [151] 118, 119. Panofsky, *Iconology*, pp. 218*ff*, gives the following interpretation: "The Phae- [152, 153] ton composition is understandable as an expression of the feeling of utter inferiority manifested in Michelangelo's first letters to the young nobleman." Michelangelo's self-assumed "presumptuousness" can be compared with the temerity of Phaeton.

The connection of the content of the composition with Frey, *Dicht.*, CIV, has been

noted by Borinski, *Rätsel*, p. 35. Landino's Commentary on Dante, *Inferno*, XVII, 106, has been quoted by Panofsky, *Iconology*, p. 219.

153 7. The connection of the figure of a genius of a spring in the Phaeton composition with an ancient fountain figure of the Giardino Cesi was first observed by Grünwald, *Münchner Jahrb.*, VII, 1912, pp. 165*ff*.

8. The erotic symbolic meaning of the Fall of Phaeton was widespread in the sixteenth century, and appears also in a poem by Francesco Maria Molza; cf. Panofsky, *Jahrb.f.Kg.*, N.F., I, 1921-1922, "Buchbesprechungen," col. 50.

9. Concerning the forms of friendship in the circle of Lorenzo de' Medici, cf. Ph. Monnier, *Le quattrocento*, II, pp. 95*ff*, and I, p. 19.

156 10. The best copy of the Children's Bacchanal is No. 120. This drawing was considered as an original by Michelangelo, but was recognized as a copy by the author in *Thieme-Becker*. For other copies, cf. Thode, *Kr.U.*, II, pp. 363*ff*. For an interpretation, cf. Panofsky, *Iconology*, pp. 221*f*.

157 11. The best copy of the Saettatori is No. 121. That the drawing is only a copy was first pointed out by Popp, *Belvedere*, VIII, 1925, "Forum," pp. 72*ff*, and *idem, Z.f.b.K.*, LXII, 1928-1929, pp. 54*ff*. For an interpretation, cf. Panofsky, *Iconology*, pp. 225*ff* (who connects the drawing with a passage by Pico in *Opere di Giovanni Benivieni*, Venice, 1522, II, 2, fol. 18*f*). Less convincing are the earlier interpretations by Borinski, *Rätsel*, pp. 63*ff*, and Förster, *Neue Jahrbücher für das klass. Altertum*, XXXV, 1915, p. 573.

12. The drawings for Cavalieri were celebrated already in Michelangelo's lifetime, and copied many times. Vasari (1568, p. 386) mentions a copy of the Phaeton by Francesco Salviati. The Phaeton and the Tityos were also copied in "intaglio in cristallo" by Giovanni Bernardi da Castelbolognese (Vasari 1568, p. 342; a copy after the Fall of

298 Phaeton is preserved in the Walters Art Gallery, Baltimore). There are also many bronze plaques of the sixteenth century representing these compositions (cf. Thode, *Kr.U.*, II, p. 362).

XXII. CATALOGUE OF DRAWINGS

PREFACE

This catalogue lists the drawings executed by Michelangelo between 1520 and 1534. It contains also a few important drawings by pupils. Unless otherwise indicated, the drawing is considered as authentic.

Since the drawings listed are treated in the text, we have limited ourselves here to the statement of the measurements, the technique, the state of preservation, and the bibliography.

The list is divided into five parts: Ground Plans and Tomb Projects for the Medici Chapel; Other Related Tomb Projects by Michelangelo; Studies of Architectural Details for the Medici Chapel; Figural Sketches and Studies; Compositional Drawings. Within each part the drawings are arranged in approximately chronological order.

N.B.—Drawings Nos. 1 through 35 are listed in the catalogue
of Volume I, pp. 175*ff*; Nos. 36 through 47 (and Nos. 1 A
through 28 A) are listed in the catalogue of Volume II, pp.
199*ff*.

CATALOGUE

48. *Ground plan of the Medici Chapel.* Red chalk (the scratches at the right in black **79**
chalk). Florence, Archivio Buonarroti, Cod. 1, fol. 98, folded sheet p. 2.

Berenson, Frey, Thode, Popp *vac.* Published and identified by the author, *Arch.
Buon.*, pp. 379*ff.*

On the verso is a *ricordo*, probably from 1519-1520. The two lateral chapels with
three round niches are probably not by the hand of Michelangelo.

Analysis in text, p. 29.

49. *Ground plans of the choir of the Medici Chapel* by a garzone and by Michelan- **80**
gelo, *and computations* of the garzone. Pen in bister (the pen drawing left top and the
computations, both by the garzone) and red chalk (the sketch left bottom by Michel-
angelo). Florence, Archivio Buonarroti, Cod. 1, fol. 98, folded sheet p. 4.

Berenson, Frey, Thode, Popp *vac.* Published and identified by the author in *Arch.
Buon.*, p. 380 n. 5.

In the sketch by the garzone, the note: "el bracio degli tavolati della capella d[ucati]
28." In the red-chalk sketch, Michelangelo tried to correct the clumsy drawing of the
garzone. The basic form is taken over, the niches are deeper. Both sketches are a proof
that Michelangelo took the Sagrestia Vecchia as a point of departure.

In the computations of the garzone are mentioned architectural parts of the *pietra
serena* architecture of the lowest zone of the Chapel: "pilastri della capella," "pilastri
da canti la cornicie"; parts of the architecture in white marble: "dopio capitello e
baso," "l'una delle porticelle"; parts of the intermediate zone and the lunette zone:
"una delle fenestre," "la cornicie di sopra"; and finally round windows, probably for
the lantern: "uno degli ochi, lavorato di dentro e di fuora."

50. *Ground plan [of the conus of the lantern of the Medici Chapel* (?)]. Black chalk. **118**
Florence, Casa Buonarroti. H. 172 mm. W. 135 mm.

Berenson, von Geymüller *vac.*; Frey, *Handz.*, no. 267c (ground plan of a cupola,
probably for the cupola of the Medici Chapel); Thode, *Kr.U.*, III, no. 121 (ground plan
of a cupola).

Probably a plan sketch of the conus of the lantern of the Medici Chapel (cf. the eight
columns).

51. *Free-standing tomb project for the Medici Chapel.* Black chalk. London, British **81**
Museum. H. 274 mm. W. 191 mm. On the verso of drawing No. 52.

Berenson, *Drawings*, no. 1495; von Geymüller, p. 16; Burger, *Flor.Grab.*, Plate XXXII;
Frey, *Handz.*, no. 48 (in the text described as 47); Thode, *Kr.U.*, III, no. 318 (verso);
Popp, *Med.Kap.*, pp. 126*ff*; Tolnay, *Cappella Medicea*, pp. 15*ff.*

On the same sheet, seen upside down, a project for the double tomb of the Dukes;

and seen from the left, a project for a wall tomb with one sarcophagus, also probably for the Dukes.

Analysis in text, p. 35.

82 52. *Project for the double tomb of the Dukes.* Black chalk. London, British Museum. H. 274 mm. W. 191 mm. On the recto of drawing No. 51.

Berenson, *Drawings*, no. 1495; von Geymüller, p. 16, Figs. 16 and 17; Burger, *Flor. Grab.*, Plate XXXII, 2; Frey, *Handz.*, no. 47 (in the description in the text, no. 48); Thode, *Kr.U.*, III, no. 318 (recto); Brinckmann, *Zeichnungen*, no. 35; Popp, *Med.Kap.*, pp. 126ff; Tolnay, *Arch.Buon.*, pp. 384ff; *Cappella Medicea*, pp. 15ff.

On the same sheet, upside down, a sketch for one of the Allegories, with the motif of the Aurora in mirror image.

Analysis in text, p. 37.

83 53. *Projects for the Medici tombs.* Black chalk and pen in bister. Florence, Casa Buonarroti. H. 185 mm. W. 235 mm. On the lower edge of the sheet a piece has been pasted in.

Berenson, *Drawings*, no. 1440; Burger, *Flor.Grab.*, pp. 353f, Plate XXXII, 4, and XXXIII, 3; Frey, *Handz.*, no. 70; Thode, *Kr.U.*, III, no. 134; Popp, *Med.Kap.*, p. 126; Tolnay, *Cappella Medicea*, pp. 15ff.

According to Popp, the sketches are projects for the free-standing tomb of Pope Paul III Farnese. The wall tabernacle at the left top is according to her a project for the tomb of Cecchino Bracci. In the opinion of Berenson, Burger, Frey, Thode and Tolnay, they are projects for the Medici tombs. That the two drawings at the right are related to the *arcus quadrifrons* project has been shown by the author in *Cappella Medicea*.

On the verso, the fragment of a poem written in black chalk, published by Frey, *Handz.*, text, p. 39.

Analysis in text, p. 36.

85 54. *Projects for the Medici tombs.* Black chalk. Florence, Casa Buonarroti. H. 103 mm. W. 156 mm. Sheet cut up and pasted together.

Berenson, *Drawings*, no. 1419; Burger, *Flor.Grab.*, p. 351, Plate XXXIII, 4; Frey, *Handz.*, no. 125a; Thode, *Kr.U.*, III, no. 77; Popp, *Med.Kap.*, p. 126; Tolnay, *Cappella Medicea*, pp. 15ff.

According to Popp, projects for the free-standing tomb of Paul III. The wall tabernacle, according to her, is a project for the Cecchino Bracci tomb. According to the earlier scholars and the author, these are projects for the Medici tombs. The sketch at the left has been identified as belonging to the project of the *arcus quadrifrons* by the author in *Cappella Medicea*.

Analysis in text, p. 36.

55. *Projects for the Medici tombs.* Black chalk. Florence, Casa Buonarroti. H. 144 *84*
mm. W. 121 mm. Sheet cut and restored at the left top.

Berenson, *Drawings*, no. 1435; von Geymüller, p. 18; Burger, *Flor.Grab.*, p. 352,
Plate xxxiii, 1; Frey, *Handz.*, no. 267b; Thode, *Kr.U.*, iii, no. 122; Popp, *Med.Kap.*, p.
126; Tolnay, *Cappella Medicea*, pp. 15*ff*.

Analysis in text, p. 37.

56. *Projects for the Medici tombs.* Black chalk. London, British Museum. H. 223 *86, 88*
mm. W. 212 mm.

Berenson, *Drawings*, no. 1494; von Geymüller, p. 16, Fig. 15; Burger, *Flor.Grab.*,
Plate xxxii, 1 and 2; Thode, *Kr.U.*, iii, no. 287; Frey, *Handz.*, no. 39; Popp, *Med.Kap.*,
p. 126; Tolnay, *Cappella Medicea*, pp. 15*ff*.

According to Popp, projects for the free-standing tomb of Pope Paul III. According
to the earlier scholars and the author, for the Medici tombs. The projects for the *arcus
quadrifrons* identified by the author in *Cappella Medicea*.

On the verso, the study of a head (Frey, *Handz.*, 38), in our opinion not by Michel-
angelo.

Analysis in text, p. 36.

57. *Project for the Medici tombs.* Black chalk. London, British Museum. H. 288 mm. *89*
W. 207 mm. On the verso, blots of ink, one of which has come through.

Berenson, *Drawings*, no. 1497; von Geymüller, p. 17, Fig. 23; Burger, *Flor.Grab.*, Plate
xxxiv, 3; Frey, *Handz.*, no. 55; Thode, *Kr.U.*, iii, no. 319; Popp, *Med.Kap.*, pp. 127*f*
and *passim*; Tolnay, *Cappella Medicea*, pp. 15*ff*.

On the verso, our No. 100.

The most developed among the preserved projects of the Ducal tombs.

Analysis in text, p. 38.

58. *Project for the Magnifici tombs.* Pen in bister. London, British Museum. H. 216 *90*
mm. W. 169 mm. On the verso, our No. 59. Damaged and restored sheet.

Symonds I, p. 380; Berenson, *Drawings*, no. 1496; von Geymüller, p. 17, Fig. 22;
Burger, *Flor.Grab.*, p. 357, Plate xxxiv, 2; Frey, *Handz.*, no. 9a; Thode, *Kr.U.*, iii, no.
285; Popp, *Med.Kap.*, pp. 128*ff* and *passim*.

Inscription published by Frey, *Dicht.*, no. xviii and p. 313.

Analysis in text, p. 39.

59. *Project for the Magnifici tombs.* Pen in bister. London, British Museum. H. 216 *91*
mm. W. 169 mm. On the recto, our No. 58.

Berenson, *Drawings*, no. 1496; von Geymüller, p. 17, Fig. 21; Burger, *Flor.Grab.*, p.
357, Plate xxxv, 1; Frey, *Handz.*, no. 9b; Thode, *Kr.U.*, iii, no. 285; Popp, *Med.Kap.*,
p. 128 and *passim*.

The chronology of the drawings on the recto and verso of this sheet, and analysis, in
text, p. 39.

119 60. *Project for a wall-tabernacle or altar probably for San Silvestro in Capite, Rome.* Lapis. Florence, Casa Buonarroti. H. 397 mm. W. 243 mm.

Berenson, *Drawings*, no. 1430; von Geymüller, p. 40; Frey, *Handz.*, no. 285; Thode, *Kr.U.*, III, no. 445; Popp, *Med.Kap.*, p. 127.

The drawing shows two versions. First, at the right, Michelangelo drew lower double columns, then at the left he corrected the proportions, making taller double columns.

The purpose of the drawing is unknown. According to Berenson and von Geymüller, it is the project for an altar. According to Thode, it is a project for the altar of Santa Apollonia. Frey questions whether it may not be a project for a wall tomb. Popp correctly recognized the similarity with the wall tabernacle projects of our Nos. 53 and 56. She concluded that it was a project for the tomb of Cecchino Bracci (1544). Stylistically, however, the drawing is to be dated around 1520, and so it may be a project for the *120* altar of San Silvestro in Capite in Rome (1518). The executed altar has also a triangular pediment like the drawing; the individual forms, however, are different and greatly simplified in comparison to the drawing.

116 61. *Project for a ciborium, and other sketches, among others a sarcophagus probably for San Silvestro in Capite, Rome.* Black chalk. Florence, Casa Buonarroti.

Berenson, *Drawings*, no. 1454; Frey, *Handz.*, no. 73; Thode, *Kr.U.*, III, no. 160.

According to Berenson, this is a project for a baptismal font. According to Frey, it is a project for a ciborium for the relics of the Medici family, ca. November 1525-February 1526. The sarcophagus is according to him related to the tomb of the father of Bartolomeo Barbazza (Bologna). Thode has with good arguments refuted these assumptions, and connected the drawings with the ciborium and the sarcophagi of San Silvestro in Capite. This hypothesis is supported by the *ricordo* on the verso from December 5, 1516 to February 25, 1518.

114 62. *Projects of sarcophagi for San Silvestro in Capite.* Pen in bister. Florence, Casa Buonarroti.

Berenson, Frey *vac.*; Thode, *Kr.U.*, III, no. 164; Popp, *Münchner Jahrb.*, IV, 1927, pp. 452*ff*.

Published and identified for the first time by Popp. Popp proves that the projects were made for San Silvestro in Capite. The two tombs were apparently to contain the bones of St. Stephen and St. Silvester. On the verso are *ricordi* from 1518-1519. Recently Kriegbaum, in *Mitteilungen des Kunsthist. Instituts in Florenz*, VII, 1941, p. 143, related these sketches to the tomb of Leo X and Clement VII.

92 63. *Project for a tomb, possibly the tomb of the Barbazza family* (Bologna). Pen in bister, and red chalk. Florence, Casa Buonarroti. H. 195 mm. W. 179 mm. Cut sheet.

Berenson, *Drawings*, no. 1445; von Geymüller, p. 22; Burger, *Studien*, p. 34; Frey, *Handz.*, no. 125c; Thode, *Kr.U.*, III, no. 139; Popp, *Münchner Jahrb.*, pp. 389ff.

According to Frey, this is a wall tomb project for the Medici Chapel. According to Thode, it is a free-standing structure conceived for the Medici tombs. Berenson considers it an altar project for the Medici Chapel or for the Church of San Lorenzo. For Popp it is a project for the tomb of Leo X and Clement VII of 1524. In the author's opinion (cf. text), probably a project for the family of Bartolomeo Barbazza (Bologna).

64. *Project for the tomb of Leo X and Clement VII in the Sagrestia Vecchia by a* *93*
pupil. Pen in bister and washed. Red-chalk corrections. Dresden, Kupferstichkabinett. H. 369 mm. W. 279 mm.

For the first time published and identified by Popp, *Münchner Jahrb.*, pp. 389ff.

There exists a copy of this *concetto* by Aristotile da Sangallo, Lille, Musée Wicar, *94*
no. 744, published for the first time in Tolnay, *Arch.Buon.*, p. 410.

65. *Project for the tomb of Leo X and Clement VII in the choir of San Lorenzo.* Pen *95*
in bister. Florence, Casa Buonarroti. H. 141 mm. W. 145 mm.

Berenson, *Drawings*, no. 1424; von Geymüller, p. 22; Frey, *Handz.*, no. 125b; Thode, *Kr.U.*, III, no. 96; Popp, *Münchner Jahrb.*, pp. 399f.

Thode already was inclined to consider this a project for the Papal tombs in Santa Maria sopra Minerva. Popp has shown that it is a preliminary study for the Papal tombs in the choir of San Lorenzo.

65a. *Project for the tomb of Leo X and Clement VII in the choir of San Lorenzo;* *325*
caricaturized physiognomy. Tomb project in black chalk, caricature in pen in bister. Florence, Archivio Buonarroti, Cod. v, fol. 38 recto.

Berenson, von Geymüller, Frey, Thode, Popp *vac.*

The drawings are hitherto unpublished. The letter was published by Milanesi, p. 425, who does not mention the drawings.

The black-chalk sketch shows, with slight variants, the same tomb monument which Michelangelo drew in No. 65. At the top, quite clearly visible, the beginning of the segment pediment. At the left, a column.

In the center below, there is a trapezoid, which may be in relationship with the projects in Frey, *Handz.*, 138c and 186 (?).

The caricature Michelangelo drew in the architectural profiles. This may be compared with the head which Michelangelo made from the lines of the bases of a pilaster *104*
in his drawing No. 72.

66. *Project for the tomb of Leo X and Clement VII in the choir of San Lorenzo.* Lapis *96*
and pen in bister. Florence, Casa Buonarroti. H. 400 mm. W. 272 mm.

Berenson, von Geymüller *vac.*; Frey, *Handz.*, no. 14; Thode, *Kr.U.*, III, no. 88; Popp, *Münchner Jahrb.*, p. 398.

According to Frey, a different hand has added a sarcophagus in lapis below the niche at the right. Frey assumes that this is a project for the Medici Chapel. Thode emphasizes the fact that it must be a project for a Papal tomb. Popp assumes rightly, in our opinion, that it is a project for the Papal tombs in the choir of San Lorenzo.

121 67. *Projects for the Julius Tomb 1525-1526.* Pen in bister, and lapis. London, British Museum. H. 210 mm. W. 280 mm. On the verso, a weak study of drapery by a pupil.

Berenson, *Drawings*, no. 1499; von Geymüller, p. 16, Fig. 18; Burger, *Flor.Grab.*, Plate XXXII, 5; Thode, *Kr.U.*, III, no. 301; Frey, *Handz.*, no. 106; Popp, *Med.Kap.*, pp. 167*ff*; Tolnay, *Arch. Buon.*, pp. 409*ff*.

Contrary to the older view that it is here a question of projects for the Medici tombs (von Geymüller, Burger, Thode, Frey), or of the project for the altar wall of the Sagrestia Nuova (Berenson), or of the tombs of Leo X and Clement VII in Santa Maria Maggiore (Popp), the author has demonstrated that these are projects for the Julius Tomb of 1525-1526.

Analysis in text, p. 77.

122 68. *Project for the Julius Tomb 1525-1526.* Lapis. Florence, Archivio Buonarroti, Cod. IV, fol. 539 verso.

Berenson, Frey, Thode, Popp *vac.*; Tolnay, *Arch.Buon.*, pp. 409*ff*. Here for the first time published and identified as a project for the Julius Tomb of 1525-1526.

Analysis in text, p. 77.

124 69. *Projects for the tomb of Cecchino Bracci.* Black chalk. Florence, Casa Buonarroti. H. 199 mm. W. 191 mm.

Berenson, *Drawings*, no. 1660 (according to Berenson, not an original sketch); von Geymüller, p. 29; Steinmann, *Mh.f.Kw.*, 1908, pp. 963*f*; Burger, *Flor.Grab.*, p. 312 and Plate XXXIII, 2; Frey, *Handz.*, no. 236; Thode, *Kr.U.*, III, no. 75.

The identification of the sketches reverts to Steinmann, whose results are followed by Frey and Thode. The seated figure was interpreted by Frey as one of the blessed souls of the Last Judgment. (It seems more probable that the sketch should be connected with a St. John the Baptist composition—cf. also Frey, *Handz.*, no. 280b—copied by Daniele da Volterra.) The double stairway in the middle of the sheet is, according to Frey and Thode, a project for the stairway of the Senatorial Palace on the Capitol. On the verso, our No. 70.

Analysis in text, p. 81.

125 70. *Projects for the tomb of Cecchino Bracci.* Black chalk. Florence, Casa Buonarroti. H. 199 mm. W. 191 mm.

Berenson, Burger, Frey, Thode *vac.*; published for the first time and identified by Tolnay, *Arch.Buon.*, p. 397.

The seated figure of St. John the Baptist for the same composition as on the recto.

In the center of the sheet, a figure recalling one of the figures of the Crucifixion of St. Peter of the Cappella Paolina (left background, in mirror image). On the recto, No. 69.

71. *Projects for triumphal-arch tombs by a pupil of Michelangelo*. Lapis. Oxford, *123* Christ Church (DD 24 verso).

Unpublished.

In Oxford attributed to Michelangelo, but very probably not by him. It seems to be made under the influence of Michelangelo's triumphal-arch tombs, Nos. 67 and 68. Probably projects for the tombs of Leo X and Clement VII in Santa Maria Maggiore.

STUDIES OF ARCHITECTURAL DETAILS FOR THE MEDICI CHAPEL AND OTHER CONTEMPORARY WORKS

72. *Profiles of bases for the architecture of the Medici Chapel*. Red chalk (the in- *104* scription in pen). Florence, Casa Buonarroti. H. 283 mm. W. 214 mm.

Berenson, *Drawings*, no. 1459; Frey, *Handz.*, no. 162; Thode, *Kr.U.*, III, no. 177; Popp, *Med.Kap.*, p. 129.

Popp observed that the sketch in the center is a preparatory study for the executed pilaster bases on the tombs of the Dukes.

Analysis of the inscription in text, p. 73.

73. *Six profiles of bases, probably for the Medici Chapel*. Red chalk. Florence, Casa *105* Buonarroti. H. 282 mm. W. 213 mm.

Berenson, *Drawings*, no. 1458; Frey, *Handz.*, no. 163; Thode, *Kr.U.*, III, no. 176.

The sheet is closely connected with the preceding number.

74. *Sketches for fluted pilasters*. Pen in bister. Florence, Archivio Buonarroti, Cod. v, *109* fols. 66-67 verso (on the recto the letter Milanesi, p. 468, from July 28, 1533).

Berenson, Frey, Thode, Popp *vac.*

First published in Tolnay, *Arch.Buon.*, pp. 420*ff*.

Probably executed around summer 1533, date of the letter on the recto.

Analysis in *op.cit.*, pp. 420*ff*.

75. *Studies of capitals and bases by a pupil of Michelangelo*. Pen in bister. London, *106* British Museum. H. 278 mm. W. 216 mm. Cut and pasted sheet.

Berenson *vac.*; Frey, *Handz.*, no. 241; Thode, *Kr.U.*, III, p. 290; Popp, *Med.Kap.*, p. 129.

According to Popp, the capital at top left is for the *pietra serena* order of the Medici Chapel, the capital at bottom right probably for the decoration of the Magnifici tombs. The sketches were considered up to now as originals, but they have not the quality of Michelangelo's hand and seem to be only by a pupil.

107 76. *Profile of the base of a column of the Magnifici tombs.* Pen in bister. Florence, Casa Buonarroti. H. 322 mm. W. 142 mm.

 Berenson *vac.*; Frey, *Handz.*, no. 175; Thode, *Kr.U.*, III, no. 82; Popp, *Med.Kap.*, p. 129.

 Inscription in Michelangelo's hand quoted in the text.

 The profile has been cut out, and was probably used as a model.

111 77. *Project of a cornice resting on columns, probably upper part of the doors of the Medici Chapel.* Pen in bister. Florence, Archivio Buonarroti, Cod. IX, fol. 524 verso.

 Berenson, Frey, Thode, Popp *vac.*; first published by the author, *Arch.Buon.*, p. 386.

 On the verso, a letter by Vieri de' Medici, of October 13, 1518, published in Frey. *Briefe*, p. 120.

 This project of the doors with columns corresponds to the early phase as designed in the ground plan of the Chapel in the Archivio Buonarroti (No. 48).

112 78. *Projects of the door and tabernaculum of the lateral fields of the Medici Chapel, in profile.* Red chalk. Florence, Casa Buonarroti. H. 156 mm. W. 101 mm. Cut paper.

 Berenson *vac.*; von Geymüller, p. 12; Thode, *Kr.U.*, III, no. 112; Frey, *Handz.*, no. 282a; Tolnay, *Arch.Buon.*, p. 385.

 According to Frey and Thode, the drawing is related to the left corner of the façade of San Lorenzo. This hypothesis is incorrect, because the intermediate zone of the Lorenzo façade is lacking here. In all probability it is an early project of the doors and tabernacles of the lateral fields of the Medici Chapel, when Michelangelo projected the doors enframed by columns. Cf. Michelangelo's ground plan in the Archivio Buonarroti and the preceding drawing. This identification has been expressed by the author, *op.cit.*

102 79. *Project for the tabernacle niches of the Medici Chapel.* Red chalk. Florence, Casa Buonarroti. H. 294 mm. W. 213 mm.

 Berenson, *Drawings*, no. 1455; Thode, *Kr.U.*, III, no. 162; Frey, *Handz.*, no. 177a; Tolnay, *Arch.Buon.*, pp. 385f.

 On the verso a fragment of a letter from Michelangelo to Piero Gondi, January 26, 1524 (Milanesi, p. 433). The letter was written on the sheet later than the drawing. Frey doubts the authenticity of the drawing, and emphasizes that the motif undoubtedly goes back to an ancient prototype. Thode connects the project with the villa of the Marchese Federico di Mantova in Marmirolo. The author has hypothetically connected this drawing with the tabernacle niches above the doors of the Medici Chapel, of which it would be a first version.

233 79a. *Project for an urn, probably for the tabernacle niches of the Medici Chapel; torso and legs of a seated nude figure; bust of a youth probably by a pupil.* Black chalk and pen in bister. London, British Museum. H. 122 mm. W. 124 mm. Cut sheet.

Berenson, *Drawings*, no. 1488; Thode *vac.*; Frey, *Handz.*, no. 137a.

Berenson gives no date. Frey dates the sketches rightly in the period of the Medici Chapel. The sketch of the urn probably by Michelangelo, the other sketches by a pupil.

On recto and verso, writing in the hand of Michelangelo, most of it scratched out (cf. Frey, text, p. 65).

80. *Project for the windows of the lunettes of the Medici Chapel.* Red chalk. Florence, *103*
Casa Buonarroti. H. 188 mm. W. 129 mm.

Berenson, *Drawings*, no. 143; Thode, *Kr.U.*, iii, no. 129; Frey, *Handz.*, no. 177b;
Popp, *Med.Kap.*, Plate 21b.

Project in Michelangelo's hand for the lunette windows, probably from the beginning of 1524.

There are published here also two drawings by garzoni of the same window, pre- *214,215*
served in the Uffizi.

81. *Project for the thrones over the double pilasters of the Ducal tombs.* Red chalk. *108*
Florence, Casa Buonarroti. H. 167 mm. W. 132 mm. Cut.

Berenson, *Drawings*, no. 1436; von Geymüller, p. 27; Burger, *Studien*, pp. 27f;
Thode, *Kr.U.*, iii, no. 123; Frey, *Handz.*, no. 266a; Popp, *Med.Kap.*, Plate 64.

Analysis in text, p. 41.

82. *Projects for the altar of the Medici Chapel.* Red chalk. Florence, Casa Buonarroti. *101*
H. 273 mm. W. 205 mm. Cut sheet, mended at lower right.

Berenson, *vac.*; von Geymüller, p. 34; Frey, *Handz.*, no. 123 (recto) and 124 (verso);
Thode, *Kr.U.*, iii, no. 117.

According to von Geymüller and Thode, the drawings are related to the drum of the cupola of the Florentine Cathedral. The round form in the center is interpreted by them as a round window (oculus). Frey relates the drawings to the drum of the cupola of the Medici Chapel. It would be according to him an early, unexecuted project for the interior of this drum. The author has tried to show in the text, p. 32, that it is an early project for the altar of the Medici Chapel.

On the verso, a fragment of a letter, probably from June 1520 (Milanesi, p. 413, and *100*
Frey, *Handz.*, text p. 57). Michelangelo recommends Sebastiano del Piombo for the Vatican frescoes.

83. *Project for the altar of the Medici Chapel* (detail). Black chalk. Florence, Casa *99*
Buonarroti. H. 248 mm. W. 204 mm.

Berenson *vac.*; von Geymüller, p. 34; Thode, *Kr.U.*, iii, no. 78; Frey, *Handz.*, no.
174.

According to von Geymüller, project for the *ballatoio* below the cupola of Santa Maria del Fiore. According to Frey, for the drum of the cupola of the Medici Chapel. According to the author, project for the altar of the Medici Chapel.

On the recto (Frey, *Handz.*, 173), a project in all probability in relationship with the *ballatoio* of the cupola of Santa Maria del Fiore. It seems that Michelangelo was busy with this project at the same time (1520) as he made the drawings for the altar of the Chapel. Concerning the *ballatoio* project, cf. Vasari, ed. Mil., v, p. 353.

113 84. *Project for the decoration of one of the coffers of a cupola, probably the cupola of the Medici Chapel* (not by Michelangelo, probably by Giovanni da Udine). Lapis and wash. Florence, Casa Buonarroti.

Berenson, Frey, Thode *vac.*; hitherto unpublished.

Probably ca. 1532 (cf. Frey, *Briefe*, p. 280), when Giovanni da Udine began the decoration of the cupola.

97 85. *Project for a fountain with bowl or a* lavamano *and two bowls.* Pen in bister. Florence, Casa Buonarroti. H. 118 mm. W. 165 mm. Restored sheet.

Berenson, *Drawings*, no. 1437; Frey, *Handz.*, no. 137b; Thode, *Kr.U.*, III, no. 124.

According to Thode, these are perhaps studies for the "vaso o piatto" which was being made in 1521 in Carrara for Domenico Naldini (Frey, *Briefe*, p. 173). Frey says: "Zweck und Anlass unbekannt."

98 The project of the *lavamano* is in close connection with the *lavamano* attributed to Donatello and Verrocchio in the left side-room of the Sagrestia Vecchia. Michelangelo took this as his prototype, and took over the total articulation, but slenderized the proportions. Possibly Michelangelo planned such a *lavamano* for one of the small side-rooms adjoining the choir of the Sagrestia Nuova. This *concetto* had a great influence on the Roman fountains of the Baroque. Giacomo della Porta's fountains on the Piazza Colonna and the Piazza del Popolo show that he must have known this or similar sketches. Cf. the engravings by G. B. Falda.

At the left, a fragment of a barque-like fountain bowl can be seen. This probably reverts to the *Navicella* before S. Maria in Domnica, Rome—copy after an ancient *ex voto* made under Leo X—and is a forerunner of Pietro Bernini's famous *Barcaccia* in Rome.

FIGURAL SKETCHES AND STUDIES

126 86. *Studies for the Christ of the Minerva by Michelangelo and a pupil.* Red chalk and pen. London, Collection Brinsley Ford. H. 241 mm. W. 213 mm. Damaged sheet, patched at edges and corners.

Berenson, *Drawings*, no. 1543; Thode, *Kr.U.*, III, no. 372; Frey, *Handz.*, no. 36; Popp, "Garzoni Michelangelos," *Belvedere*, 1925, pp. 23ff.

Frey relates the pen drawing to the first, uncompleted figure of 1514, which seems to be convincing. Contrary to all earlier scholars, who had considered all the drawings as originals, Popp has correctly shown that only the pen drawing on the recto is by Michelangelo.

The sketches on the verso of this sheet (Frey, *Handz.*, 37) are also by a pupil.
Analysis in text, p. 89.

87. Sketch of a seated nude youth blowing a horn. Lapis. London, British Museum,
Add. MS. 21, 907 recto.

Berenson, *Drawings*, no. 1538; Frey, *Dicht.*, p. 403; Thode, *Kr.U.*, III, no. 366; first
published in Tolnay, *Arch.Buon.*, p. 474.

The figure of the youth is seated on a throne with a high back, and is holding a horn
to his mouth. Possibly planned for the upper part of the Medici tombs, where, accord-
ing to No. 57, the attica thrones have a high back.

On the verso, sketch of a bent left leg and of the head of a youth, neither by Michel-
angelo. Published by Tolnay, *op.cit.*, p. 475.

88. Two sketches of the Virgin. Pen in bister (the lapis and red-chalk sketches by
Antonio Mini). London, British Museum. H. 407 mm. W. 269 mm. Cut sheet, mended
at the left bottom.

Berenson, *Drawings*, no. 1502; Thode, *Kr.U.*, III, no. 314; Frey, *Handz.*, no. 251;
Popp, *Med.Kap.*, p. 141.

On the verso, indefinable scratches in lapis and red chalk, and *ricordi* by Michel-
angelo from October 4 to October 8, 1524 (Milanesi, p. 595, and Frey, *Handz.*, text
p. 121).

The sketches served as models for Michelangelo's pupil, Antonio Mini, who copied
both Madonnas in red chalk. In Michelangelo's handwriting at right bottom: "disegnia
Antonio disegnia Antonio disegnia e non perder tempo." Frey already relates these
sketches to the Medici Virgin. Berenson and Thode emphasize the Donatellesque
character of the head in profile. The upper sketch is related in motif to the Virgin of
the Tomb of Julius II. The drawings in the Louvre (Thode, *Kr.U.*, III, no. 478) and
in the Albertina (Thode, *Kr.U.*, III, no. 526) are not by Michelangelo.

Analysis in text, p. 46.

89. Study of a hand. Pen in bister. Florence, Archivio Buonarroti, Cod. XIII, fol. 169
verso.

First published in Tolnay, *Arch.Buon.*, p. 430.

Probably made around 1524.

A stylistic analysis of the drawing can be found in Tolnay, *op.cit.*, pp. 429*f.*

90. Half-length figure of a woman, probably by a pupil of Michelangelo. Sketched in
red chalk, gone over with pen in bister. London, British Museum. H. 326 mm. W.
258 mm.

Berenson, *Drawings*, no. 1482; Thode, *Kr.U.*, III, no. 289; Frey, *Handz.*, no. 184;
Brinckmann, *Zeichnungen*, no. 29.

First the red-chalk lines were made, then the small nude figure which is inclined for-

ward, and finally the large sketch in pen. Thode, Frey and Brinckmann relate the drawing to the Sibyls of the Sistine Ceiling. Brinckmann dates the drawing ca. 1509-1510. The small nude figure is, according to Brinckmann, the first-idea for the Eve in the Creation of Eve.

Berenson, in his new edition, Vol. I, p. 362, dates the drawing more convincingly around 1530, and concludes that the drawing might be by his Andrea di Michelangelo (especially the drawing of a young woman on the verso, Frey, *Handz.*, 185). This "Andrea di Michelangelo" is identical with Antonio Mini. (Independently of Berenson, the attribution of this drawing to Michelangelo was doubted by Robert Oertel, in an unpublished paper read in the Michelangelo seminar of the author in Hamburg University, 1930.)

The author formerly considered the drawing as authentic with the exception of the red-chalk lines, but since also the pen sketch does not have the quality of Michelangelo's original drawings (cf. the sketches for the Medici Virgin), he is now inclined to doubt its authenticity.

135, 140 91. *Projects for masks and for the group of Hercules and Antaeus.* Red chalk. London, British Museum. H. 250 mm. W. 339 mm.

Berenson, *Drawings*, no. 1490; Thode, *Kr.U.*, III, no. 299; Frey, *Handz.*, no. 31; Popp, *Med.Kap.*, p. 156; Brinckmann, *Zeichnungen*, no. 43; Wittkower, *Journal of the Warburg Institute*, I, 1937, p. 183.

On the verso of the sheet (Frey, *Handz.*, 32), sketches by a pupil.

On the basis of the Hercules and Antaeus sketch, the drawing may be dated around 1525 (on July 20, 1525, the large block for this group arrived from Carrara; cf. Gaye

191 II, p. 464). The connection of two of the masks with the masks on the capitals of the double pilasters at the right in the Giuliano tomb has been recognized by Popp.

A copy of the drawing is preserved in Lille, Musée Wicar; cf. Berenson, *Drawings*, no. 1475.

139 92. *Two sketches for Hercules and Antaeus and several sketches by a pupil.* Red chalk. Oxford, Ashmolean Museum. H. 283 mm. W. 423 mm.

Robinson, no. 45; Berenson, *Drawings*, no. 1712; Thode, *Kr.U.*, III, no. 428; Frey, *Handz.*, no. 145.

On the recto, Frey, *Handz.*, 144. Berenson attributes the drawings to Raffaello da Montelupo. Thode considers all the sketches to be originals. Frey attributes the pupil's sketches to Antonio Mini. According to him, not only the Hercules and Antaeus sketches are by Michelangelo but also the study of the left leg; however, this latter attribution is incorrect. On the recto, the stanze are in the handwriting of Michelangelo, and written, according to Frey, later than the sketches, ca. 1531-1533.

134 93. *Study for a mask of the Medici Chapel.* Black chalk. Windsor, Royal Library. H. 250 mm. W. 121 mm.

Berenson, *Drawings*, no. 1610; Thode, *Kr.U.*, III, no. 535; Frey, *Handz.*, no. 212a; Popp, *Med.Kap.*, p. 156.

On the verso (Frey, *Handz.*, 213b), sketches not by Michelangelo.

This is a project for one of the masks for the frieze below the Capitani. The lines *196-200* show a certain lack of spontaneity. The possibility is not to be excluded that this is a copy after a lost original.

94. *Rapid sketch of the torso of the Notte*. Lapis. Florence, Archivio Buonarroti, *129* Cod. XIII, fol. 150 verso. On the recto of this sheet there is the sonnet, Frey, *Dicht.*, XXXIV, and a *ricordo* from January 6, 1529 (st. c. 1530), published in Frey, *Dicht.*, p. 317.

The drawing was first published in Tolnay, *Arch.Buon.*, p. 438. (There the sketch was related to the Leda, but the motif is closer to the Notte.) The sketch seems to have been first on the sheet; consequently the date of the *ricordo* on the recto is only a *terminus ante quem* for the sketch.

95. *Working sketch for one of the river gods of the Medici Chapel*. Pen in bister. Lon- *131* don, British Museum. H. 138 mm. W. 210 mm.

Berenson, *Drawings*, no. 1491; Thode, *Kr.U.*, III, no. 268; Frey, *Handz.*, no. 60; Popp, *Med.Kap.*, p. 146 and Plate 46; Brinckmann, *Zeichnungen*, no. 42.

Meder, *Handzeichnungen*, p. 306, recognized that both sketches show the same fig- ure from two different views. Popp dates the drawing in the winter of 1525-1526, and considers it, rightly in our opinion, as a sketch for the river god below the tomb of Giuliano. The sketches served for a stonecutter in the breaking and rough-hewing of the block.

96. *Three studies of a horse and a sketch for a battle scene*. Pen in bister. Oxford, *142* Ashmolean Museum. H. 405 mm. W. 262 mm.

Robinson, no. 18; Berenson, *Drawings*, no. 1558; Thode, *Kr.U.*, III, no. 402; Frey, *Handz.*, no. 141; Popp, *Med.Kap.*, pp. 159*f*, Plate 60.

The battle sketch is a first draft for the composition, No. 106. All the sketches have *143* been considered by the earlier scholars (Frey, Thode) to be related to the Battle of Cascina. Popp dated it rightly around 1525, and related it to the projects for the lunette frescoes of the Medici Chapel.

97. *Studies after a horse*. Black chalk (a few red-chalk lines over the feet of the cen- *141* tral sketch by a different hand). Florence, Casa Buonarroti. H. 400 mm. W. 255 mm.

Berenson, *Drawings*, no. 1659; Thode, *Kr.U.*, III, no. 22; Frey, *vac.*; first published by Tolnay, in *Old Master Drawings*, X, 1935, Plate 41 and p. 43.

Closely related to, and from the same time as, No. 96. According to Berenson and Thode, copy of a lost original from the time of the Battle of Cascina; but the quality leaves no doubt that it is an original executed around 1525.

130 98. *Study of the legs of the Leda.* Pen in bister. Florence, Casa Buonarroti. H. 149 mm. W. 192 mm. Written in Michelangelo's hand: "mi soviene."

Steinmann, *Sixtinische Kapelle*, II, p. 597, Fig. 36; Berenson, *Drawings*, no. 1409a; Thode, *Kr.U.*, III, no. 40; Frey, *Handz.*, no. 114; Popp, *Med.Kap.*, pp. 56*f* and 143, Plate 43; Brinckmann, *Zeichnungen*, no. 40.

According to Steinmann and Frey, studies for the legs of the Eve in the fresco of the Fall of the Sistine Ceiling. According to Brinckmann, studies for the Notte; according to Thode, executed in the period of the Medici Chapel. According to Popp, a preliminary study for the Leda.

47 99. *Study of a hand, probably for the right hand of Giuliano.* Black chalk. Florence, Casa Buonarroti. H. 371 mm. W. 280 mm.

Thode, *Kr.U.*, III, no. 104; first published in Tolnay, *Arch.Buon.*, p. 431.

From the style, the drawing seems to have been executed around 1530.

On this sheet there was already the drawing of an architectural detail, probably the project for one of the enframing blocks of the baluster of the stair of the Ricetto, not unlike that in the central sketch of Frey, *Handz.*, 165.

On the recto of the sheet (reproduced in *Arch.Buon.*, p. 432) there is the project of one of the upper story windows of the Ricetto, and a sketch of the pediment of a door frame. This drawing is related to Frey, *Handz.*, 209 and 210. A stylistic analysis of the drawing can be found in *Arch.Buon.*, p. 433.

136 100. *Sketches for two vases and sketch for figure in the pose of the Vittoria (not by Michelangelo).* Black chalk. London, British Museum. H. 288 mm. W. 207 mm.

Berenson, *Drawings*, no. 1497; von Geymüller, p. 17, Fig. 23; Burger, *Flor.Grab.*, Plate XXXIV, 3; Frey, *Handz.*, no. 56; Thode, *Kr.U.*, III, no. 319.

On the recto of this sheet is the most developed project for the Ducal tombs (No. 57). The sketches have been considered up to now as originals, but the timid manner of drawing of the lines gives reason for doubt. The figure at right, according to Berenson, is a sketch for the Vittoria. (Unconvincing are the hypotheses of Frey that it is a sketch for a Virgin, and of Thode that it is the first sketch for the Pensieroso.) *234* The vases are probably to be connected with the vases on the tabernacle niches of the Medici Chapel. The verses in Michelangelo's handwriting were on the sheet before the drawings. They are published in Frey, *Dicht.*, XIX-XXI.

138 101. *Sketches with the motif of the Vittoria, made by a pupil, the right sketch gone over by Michelangelo.* Red chalk. Florence, Archivio Buonarroti, Cod. I, fol. 98, folded sheet p. 3.

Berenson, Thode, Frey *vac.*; first published by the author in *Arch.Buon.*, pp. 433*ff.*

The red-chalk sketches are probably by Mini.

Cf. text, p. 92.

[216]

102. *Sketches of Putti*. Pen in bister and black chalk. Florence, Uffizi.

Berenson, *Drawings*, no. 1641; Ferri-Jacobsen, p. 9; Frey, *Handz.*, no. 54; Thode, *Kr.U.*, III, no. 205.

According to Berenson, by a pupil, and a copy after the Children's Bacchanal in Windsor. According to Frey, the standing putto an original, the other sketches copies after the Children's Bacchanal. According to Thode, all the sketches originals, made ca. 1522. In our opinion made ca. 1530.

The Latin hexameter is modeled on Petrarch's elegy on Vaucluse found in a letter written in 1357 to Philippe de Cabassoles. Cf. Panofsky, *Iconology*, p. 179 n. 22.

103. *Sketch of a guard for the Resurrection*. Red chalk. Florence, Archivio Buonarroti, Cod. I, fol. 96 verso. On the recto, an undated *ricordo* by Michelangelo, probably ca. 1531. First published and identified by Tolnay, *Arch.Buon.*, pp. 441*ff*. The sheet is cut at the top.

Copy of this drawing in Florence, Casa Buonarroti, Frey, *Handz.*, 155c. Frey considers it erroneously as original, Berenson as the work of a pupil, Popp, p. 162, also as a copy, but erroneously as having been made after the guard at right of Frey, *Handz.*, 59. She did not know the original in the Archivio Buonarroti.

104. *Sketch for a Slave of the Julius Tomb, sketch of the torso of a seated male figure, sonnet fragments, all by Michelangelo, other sketches by a pupil*. Pen in bister (originals), red chalk (sketches by a pupil). London, Sir Robert Witt. H. 282 mm. W. 210 mm.

First attributed to Michelangelo and published in Tolnay, *Sklavenskizze*, pp. 70*ff* (formerly attributed by Sir Robert Witt to Bandinelli).

On the recto of this sheet there is a sketch of a left leg, also by Michelangelo, and a large composition representing Christ before Pilate, by a pupil. (The recto has been erroneously attributed to Michelangelo by A. Venturi, *L'arte*, 1928, p. 155, and *L'arte*, 1935, p. 265.)

In his second edition, Berenson accepts our attributions (*Drawings*, nos. 1543a and 1696a). He considers the sketch to be not for a Slave, but possibly for the Haman of the Sistine Ceiling; the style, however, indicates a later date. Baumgart, *Marburger Jahrb.*, x, accepts the attribution, and considers the drawing also as a sketch for a Slave, but tries to date it in 1516 instead of ca. 1532.

105. *Small sketch of a raven*. Pen in bister. Florence, Archivio Buonarroti, Cod. XIII, accompanying the verses, Frey, *Dicht.*, LXXIII, 45. Michelangelo signed: "vostro Michel-[agniolo] al macel de [instead of *corvi* he drew in jest a raven]"; ca. 1544-1545.

Hitherto unpublished.

143 106. *Battle scene.* Pen in bister. Oxford, Ashmolean Museum. H. 182 mm. W. 254 mm.

Robinson, no. 16; Berenson, *Drawings*, no. 1556; Thode, *Kr.U.*, III, no. 400; Frey, *Handz.*, no. 132; Popp, *Med.Kap.*, pp. 159*f* and Plate 61.

According to Frey and Thode, studies for the Battle of Cascina. Berenson doubts this, and dates the sheet ca. 1532. Popp rightly dates it ca. 1525, and recognizes the simi-

142 larity of several motifs with the upper sketch of the Brazen Serpent, No. 107. A preparatory sketch for this composition is No. 96.

Analysis in text, p. 49.

150 107. *Two sketches for the Brazen Serpent: Attack by the Serpents, and Healing.* Red chalk. Oxford, Ashmolean Museum. H. 247 mm. W. 338 mm.

Robinson, no. 29; Berenson, *Drawings*, no. 1564; Steinmann, *Sixtinische Kapelle*, II, pp. 295*f* and 596; Thode, *Kr.U.*, III, no. 417; Frey, *Handz.*, no. 51; Popp, *Med.Kap.*, p. 159; Brinckmann, *Zeichnungen*, no. 45.

Frey dates the drawings in the fourth decade of the sixteenth century. Popp dates them around 1530 and supposes them to be projects for the lunettes above the Ducal tombs of the Medici Chapel. She emphasizes that the scene of the Healing was developed from earlier drawings like Nos. 24 and 25, and the scene of the Attack from the battle scene, No. 106.

There is a copy, attributed to Aristotile da Sangallo, in the Uffizi, no. 606. Another copy in Düsseldorf Akademie is mentioned by Thode, *Kr.U.*, III, no. 417.

Analysis in text, p. 48.

144 108. *Resurrection of Christ.* Red chalk. Paris, Louvre. H. 152 mm. W. 171 mm.

Berenson, *Drawings*, no. 1580; Thode, *Kr.U.*, III, no. 464; Frey, *Handz.*, no. 40; Popp, *Med.Kap.*, p. 162; Brinckmann, *Zeichnungen*, no. 48; Tolnay, *Arch.Buon.* pp. 438*f*.

Concerning the chronology of the three Resurrection drawings, cf. Tolnay, *loc.cit.* This is the first sketch for the composition which Michelangelo developed in the Windsor drawing. (This is also the opinion of Berenson and Thode, in contrast to the chronology proposed by Frey, Brinckmann, and Popp.) According to Popp, this is a project for the lunette above the Magnifici tombs.

145 109. *Resurrection of Christ.* Black chalk. Windsor, Royal Library. H. 241 mm. W. 349 mm.

Berenson, *Drawings*, no. 1612; Thode, *Kr.U.*, III, no. 537; Frey, *Handz.*, no. 19; Popp, *Med.Kap.*, p. 162; Brinckmann, *Zeichnungen*, no. 47; Tolnay, *Arch.Buon.* pp. 438*ff*.

On the verso, studies of a right shoulder, not by Michelangelo (Frey, *Handz.*, 224). Michelangelo followed Matthew 27: 60-65 and 28: 2-4. He has suggested the rocky cave in the background, but characteristically has not represented the angel of the Lord who

should have rolled away the stone from the sepulcher. An elementary force of nature seems here to burst the tomb. While in the Louvre sketch the guards form a sort of circle around the grave, here Michelangelo groups them in two triangles at right and left of the sarcophagus, and within the triangles the figures correspond to each other by contrast. It is the principle of composition of the Medici tombs. The movement and emotion in the center of the composition—that is, the movement and emotion of Christ—are the most intense, and both become less intense toward the periphery. The sheet may have been made about 1526; cf. Popp, p. 162 (Frey's dating, ca. 1536-1538, is in our opinion too late). According to Popp, project for the lunette above the Magnifici tombs.

Analysis in text, p. 49.

110. *Ascension of Christ*. Black chalk. London, British Museum. H. 327 mm. W. *146*
289 mm.

Berenson, *Drawings*, no. 1507; Thode, *Kr.U.*, III, no. 328; Frey, *Handz.*, no. 59; Popp, *Med.Kap.*, p. 162; Brinckmann, *Zeichnungen*, no. 46; Tolnay, *Arch.Buon.*, pp. 438*ff.*

According to Popp, project for the lunette above the Magnifici tombs. Revised and new composition of the two earlier versions, made probably in Rome in the second half of 1532.

The figure of Christ copied in a panel by Marcello Venusti, formerly in the collec- *149*
tions of the Duke of Candia and Fairfax Murray (London), then Collection Winthrop (Boston), today in the Fogg Museum (Cambridge). The guards are copied from No. 109. The painting is mentioned in Frey, *Handz.*, text, p. 33, and analyzed in Tolnay, *Art in America*, XXVIII, 1940, pp. 169*ff.*

Analysis in text, p. 50.

111. *The Risen Christ* (by a pupil of Michelangelo). Black chalk. Florence, Archivio *158*
Buonarroti, Cod. XIII, fol. 148 verso.

First published by the author in *Arch.Buon.*, pp. 471 and 475.

On the recto, the sonnet fragment, Frey, *Dicht.*, LXI, in red chalk. According to the handwriting, middle of the 1520's. Represented in the drawing is the Saviour rising from the grave, and pointing with the right hand to his wound. Not by Michelangelo, but probably after his *concetto*.

112. *Ascension of Christ*. Black chalk. Oxford, Ashmolean Museum. *159*
Berenson, *Drawings*, no. 1713; Frey, *Handz.*, no. 136; Tolnay, *Arch.Buon.*, pp. 445*ff.*

Berenson attributes this sketch to Montelupo. Thode and Frey consider the drawing original; Thode dates it rightly ca. 1531-1532, Frey ca. 1534-1538. The outlines have been retraced, so that it is difficult to determine whether it was an original or a copy. The pose is similar to the verso of the Tityos drawing (Frey, *Handz.*, 219).

160 113. *Ascension of Christ*. Black chalk. Florence, Archivio Buonarroti, Cod. VI, fol. 24 verso (on the recto a letter from Bartolomeo Angiolini to Michelangelo, September 19, 1532; cf. Symonds II, p. 390; this is a *terminus post quem* for the drawing).

First published and identified by the author in *Arch.Buon.*, pp. 444*ff*.

At right angles at the left of the drawing in Michelangelo's handwriting in pen: "Le lectere de dugento ducati." In the motif Michelangelo reverts to the Haman of the Sistine Ceiling. Probably a project for the lunette of the entrance wall of the Church of San Lorenzo. Cf. Tolnay, *op.cit.*, p. 449.

161 A copy of this composition is to be found on the verso of Frey, *Handz.*, 20, with the general sketch of the Last Judgment, Florence, Casa Buonarroti, published by Tolnay, *op.cit.*, p. 447. A freer copy can be found in the Risen Christ of Vasari in Santa Maria Novella in Florence; cf. Tolnay, *op.cit.*, p. 448.

Analysis in text, p. 104.

114. *Ascension of Christ* (copy). Black chalk, partly gone over. Rotterdam, Boymans Museum. Formerly Collection Franz Koenigs. H. 354 mm. W. 172 mm. Formerly property of the Grand Duke of Weimar.

This seems to be a copy after an Ascension of Christ by Michelangelo of about 1530-1532. There exists another, inferior, copy in the Uffizi, Collection Santarelli, no. 1450, there erroneously attributed to Alessandro Allori.

155 115. *The Punishment of Tityos*. Black chalk. Windsor, Royal Library. H. 192 mm. W. 333 mm.

Berenson, *Drawings*, no. 1615; Thode, *Kr.U.*, II, pp. 350*ff* and III, no. 540; Frey, *Handz.*, no. 6 (here reproduced in mirror image); Panofsky, *Zeichnungen*, no. 12, and *Iconology*, pp. 216*ff*; Brinckmann, *Zeichnungen*, no. 54.

Made for Cavalieri at the end of 1532. The motif recalls, as Panofsky has observed, Raphael's Heliodorus and also, especially in the position of the legs, the Adam of the Sistine Ceiling. Michelangelo used the motif again later in the figure of St. Paul in the Conversion of St. Paul.

On the verso (Berenson, *Drawings*, no. 1615, Frey, *Handz.*, no. 219, Panofsky, *Zeichnungen*, no. 13), the Ascension of Christ, not by Michelangelo. The draftsman traced the torso after the Tityos and changed the lower body only slightly. It is a characteristic example of the transformation of mythological subject matter into Biblical.

Analysis in text, p. 111.

154 116. *Ganymede* (copy). Black chalk. Windsor, Royal Library. H. 192 mm. W. 262 mm.

Berenson, *Drawings*, no. 1614; Thode, *Kr.U.*, II, pp. 350*ff* and III, no. 539; Frey, *Handz.*, no. 18; Brinckmann, *Zeichnungen*, no. 88; Panofsky, *Iconology*, pp. 215*f*.

The original was presented by Michelangelo, at the same time as the Tityos, to Cava-

lieri. Several copies known. Among them the best is that in Windsor. This has often been considered as the original, but already Frey rightly pointed out the weakness of the drawing and considered it a copy.

Analysis in text, p. 112.

117. *The Fall of Phaeton*. Black chalk. London, British Museum. H. 313 mm. W. 217 mm. *151*

Berenson, *Drawings*, no. 1535; Thode, *Kr.U.*, II, pp. 358*ff*, and III, no. 363; Frey, *Handz.*, no. 57; Panofsky, *Zeichnungen*, no. 9, and *Iconology*, pp. 218*ff*; Brinckmann, *Zeichnungen*, no. 55.

First version, made fall 1532-spring 1533.

Analysis in text, p. 112.

118. *Fall of Phaeton*. Black chalk. Venice, Accademia. H. 394 mm. W. 255 mm. *152*

Berenson, *Drawings*, no. 1601; Thode, *Kr.U.*, II, pp. 358*ff*, and III, no. 518; Frey, *Handz.*, no. 75; Panofsky, *Zeichnungen*, no. 10, and *Iconology*, pp. 218*ff*; Brinckmann, *Zeichnungen*, no. 57.

In places drawn over by a later hand. Badly preserved. Second version.

Analysis in text, p. 113.

119. *Fall of Phaeton*. Black chalk. Windsor, Royal Library. H. 416 mm. W. 238 mm. *153*

Berenson, *Drawings*, no. 1617; Thode, *Kr.U.*, II, pp. 358*ff*, and III, no. 542; Frey, *Handz.*, no. 58; Panofsky, *Zeichnungen*, no. 11, and *Iconology*, pp. 218*ff*; Brinckmann, *Zeichnungen*, no. 56.

The last definitive version.

Analysis in text, p. 114.

120. *Children's Bacchanal* (copy). Red chalk. Windsor, Royal Library. H. 274 mm. W. 390 mm. *156*

Berenson, *Drawings*, no. 1618; Thode, *Kr.U.*, II, pp. 363*ff*, and III, no. 543; Frey, *Handz.*, no. 187; Panofsky, *Iconology*, pp. 221*f*.

The drawing has been considered as an original, but the author has emphasized in *Thieme-Becker* that it is only a copy.

Another copy, preserved in Oxford (Robinson, no. 52). There exist three engravings, one by Enea Vico of 1546 (Bartsch XV, no. 48), one by N. Beatrizet of 1553 (Bartsch XV, no. 40), and one by an unknown engraver published by Lafreri in 1553.

121. *The Saettatori* (copy). Red chalk. Windsor, Royal Library. *157*

Berenson, *Drawings*, no. 1613; Thode, *Kr.U.*, III, no. 538; Frey, *Handz.*, no. 298; Förster, *Neue Jahrbücher für das klassische Altertum*, XXXV, 1915, pp. 573*ff*; Brinckmann, *Zeichnungen*, no. 52.

Popp has pointed out that the drawing is only a copy. Cf. *Belvedere*, VIII, 1925, pp. 72f, and *Z.f.b.K.*, LXII, 1928-1929, pp. 54ff. Panofsky, who considered the drawing as an original, *Z.f.b.K.*, LXI, 1927-1928, p. 221, revised his judgment after Popp; cf. *Iconology*, pp. 225f, where an interpretation of the content is given.

286 122. *Venus and Cupid*. Pen in bister. London, British Museum. H. 86 mm. W. 122 mm.

Berenson, *Drawings*, no. 1504; Frey, *Handz.*, no. 212c; Thode, *Kr.U.*, III, no. 295; Popp, *Med.Kap.*, p. 147.

Fagan, *The art of M. B. in the British Museum*, London, 1883, no. 52, first related this sketch to the cartoon of Venus and Cupid, an opinion with which Thode agreed. Berenson believed the drawing to be a project for a Samson and Delilah composition. Frey did not accept either hypothesis, leaving the question open. Popp supposed it to be a project for a David and Goliath, which Michelangelo later, when he received the commission from Bartolomeo Bettini, used in his Venus and Cupid cartoon. Her hypothesis is based on the argument that the outstretched figure has masculine forms. This, however, is not conclusive, because Michelangelo often used masculine forms in his projects for female figures. In all probability the sketch is the first *pensiero* for the Venus and Cupid cartoon.

APPENDIX

PREFACE TO THE APPENDIX

In this appendix are united extracts of letters written to Michelangelo between 1520 and 1534. They are presented in three groups: letters concerning the Medici Chapel, letters concerning the Christ of the Minerva, and some miscellaneous ones.

Besides the letters which are published here for the first time, there are here reprinted three letters by Domenico Buoninsegni and seventeen letters by Topolino, which the author previously published in *Cappella Medicea*, but which have not been reprinted since that time. Unless otherwise noted, a letter is hitherto unpublished.

My sincere thanks are due to Soprintendente Commendatore Giovanni Poggi, who kindly gave me the permission to examine, copy, and publish these letters, and also to Professor Mary Pittaluga and to Professor Cesare Fasola, Director of the Library of the Uffizi, who did much to facilitate my research.

DOCUMENTS CONCERNING THE MEDICI CHAPEL

1. 1520. December 14. Domenico Buoninsegni in Rome to Michelangelo in Florence

"Con una lettera di Bernardo Niccolini s'è avuto una vostra poliza, e si vede quanto vi lamentate delli scarpellini, e tutto s'è mostro al Cardinale. E' m'ha detto vi facci intendere che se Cieccone e li suoi ministri non servono, che voi li mutiate e pigliate un altro che serva. E non tanto si dicie inverso di Cieccone, ma ancora inverso delli muratori, perchè el Cardinale intende esser servito presto e bene; e però correggiete senza alcun rispetto.

"El Cardinale mi dicie aver lettere dal Comissario di Pietrasanta come Cieccone aveva rotta una colonna; e pure debbe essere el vero, benchè costì l'andassino ricoprendo. Stimo sia bene lo diciate a Galeotto o a Taddeo, e che tocchino fondo se così è vero; e se par loro di mandare qualcuno a Pietrasanta a vedere donde dipende el disordine, che se ne lascia la cura a loro, a causa che non si strazi quell'altre che vi sono da cavare. Io ò parlato con el Cardinale del disegno che voi facievi circa el mettere le sepulture in mezzo la cappella, c'assai li piacie, ma dubita non si occupi lo spazio di tal cappella che non li pare che quattro braccia di larghezza basti. Agli detto che quando fussino braccia sei che avanzerebbe braccia sette per banda d'andare all'intorno. Diciemi che vi priega li mandiate un poco di schizzo d'una sola di quelle quattro faccie fatto in el modo che disegneresti che le fussino mettendole in mezzo; e così dicie anche o vogliatele mettere in el mezzo in el modo che dite o pure nelle faccie della cappella, che se ne rapporterà a voi, e che voi ve ne risolverete in el modo che meglio vi pare, e avisate.

"Valerio [Belli] non mi lascia vivere, e non altrimenti si priego Domenedio che lui priega voi che presto li mandiate quello disegno, e che non gli dà noia più sacrifizio che altra materia, e li basta solo sia di man vostra; e pigliate la fantasia a vostro modo.

E però vi piacerà almanco avisarmi quello che li ò a dire, perchè non à altra faccienda che sollecitarmi.

"Nè altro. Son vostro. Xº vi guardi. E rispondete, a causa che possa rispondere al Cardinale."

Note: Partly published in *Cappella Medicea*, p. 38, Doc. 1.

The Valerio mentioned in the letter is probably Valerio Belli.

2. *1520. December 17. Domenico Buoninsegni in Rome to Michelangelo in Florence*

"Io vi scrissi l'ultima alli xv di questo. Dipoi ò la vostra, e non so di che dì nè mese si sia, ma l'ho avuta con lettera di Bernardo Niccolini delli xiii di questo. E per detta ultima mia vi dissi come avevo parlato al Cardinale delli tristi portamenti delli scarpellini. Del che lui mi disse, e così mi rafferma che sanza alcun rispetto correggiate e scarpellini e muratori in quelli modi che a voi pare, pure che siamo ben serviti. E però doverà esser arrivato Cieccone, e doverete aver parlato con seco, e aviserete el seguito.

"Dissivi per l'ultima come el Cardinale aveva lettere dal Commissario di Pietrasanta che quella ultima colonna era rotta: che sarà pure stato vero quello che costì mi fu detto. Parlatene con Taddeo e Galeotto.

"Ancora vi dissi per l'ultima ch'el patrone desiderebbe aver un poco di schizzo d'una faccia di quelle sepulture che disegnavi fare in mezzo, e che desidera che vi resolviate dove debbino stare o in mezzo o dalle faccie.

"Valerio non mi lascia vivere di quel poco del disegno. E però avisate se lo manderete, e quando stimate mandarlo, che mi basta levarmelo da dosso.

"Intendesi come avete presso che finito el modello, del che el Cardinale n'à piacere.

"Nè altro. A voi mi raccomando. Xº vi guardi di male."

Note: Partly published in *Cappella Medicea*, p. 38, Doc. 2.

The "modello" mentioned in the letter as "presso che finito" is probably a model for the whole Chapel. Cf. text, p. 52.

3. *1520. December 28. Domenico Buoninsegni in Rome to Michelangelo in Florence*

"Per la vostra delli xxj di questo intendo el seguito, e con essa ò avuto el disegno della faccia della sepultura, el quale disegno subito portai al Cardinale, e li detti la vostra lettera e la lesse tutta, e tutto li piace. Ma dubita che quello spazio dintorno non resti meschino. E per questo aveva pensato se in tutta la macchina della sepultura fussi da fare in el mezzo uno arco che traforassi, che verrebbe a essere in ogni faccia uno arco, e intersecherebbonsi li anditi di questi archi in el mezzo e passerebbesi sotto; e in detto mezzo disegnava che in terra fussi la sepultura sua, e le altre sepulture li pare deverebbono stare alte sopra li detti archi. Nondimeno dicie che sa che ve ne intendete più di lui, e a voi se ne rapporta.

"Quanto alli casi di Cieccone, fate che a ogno modo s'assetti la cosa delli macingni affine che non s'abbi più a disputare o con lui o con altri, perchè el Cardinale vuole esser servito presto e di buono lavoro. E quanto alle cose delli marmi à visto e letto tutto, e per alora non m'à resoluto altro. Vedrò d'intendere sua fantasia, e per altra vi darò aviso se arò da dirvi cosa alcuna.

"Ancora Sua Signoria Reverendissima à inteso come el modello è finito e ne à avuto piaciere assai, e non m'à anche detto dove lui voglia che si metta. Farò d'intenderlo e ve ne darò aviso: benchè penso che di corto saremo costà. E ancora che io non sappi el quando, tamen, per quanto posso immaginare nonne staremo molto.

"A Valerio farò la vostra imbasciata, benchè penso starà poco qui, perchè è stato espedito dal Papa perchè due giorni fa fu espedito dal Papa, che ebbe da lui ducati seciento d'oro che restava avere.

"Nè altro. Son vostro. X° vi guardi."

NOTE: Partly published in *Cappella Medicea*, pp. 38f, Doc. 3.

The "Cieccone" mentioned in the letter was a stonecutter. The model mentioned is the same as that referred to in the preceding letter.

4. *1521. April 25. Donato Benti in Seravezza*
to Michelangelo in Carrara

". . . e' (il) caval[l]o venne ieri da Pisa. [He has paid 8 soldi.] . . . c'è Nicolao da Pisa qua, quelo vuole cavare le colone."

NOTE: After July 1 (cf. letter below), Donato Benti was to be "riveditore de' marmi" in Seravezza. This letter should be compared with the letter of July 1, 1521, published below, and with the letter of July 7, 1521, published by Pini, Plate 124. The columns mentioned in these three letters may be already intended for the Magnifici tombs, although it is also possible that they still have to do with the façade of San Lorenzo, despite the fact that the contract for this work had been annulled in 1520.

5. *1521. June 18 or 15? Rede d'Alamanno Salviati & Co. in Pisa*
to Michelangelo in Florence

". . . Noi abiamo fatto venire qui e' le pezzi di marmi de Carrara grandi da fare figure. [The expenses incurred of] ducati 33, soldi 10, den (ari) 6 di larghi . . . [should be paid by Michelangelo to Salviati in Florence]."

NOTE: The figures mentioned are the first figural blocks shipped from Carrara for the Medici Chapel.

6. *1521. July 1. Donato Benti in Seravezza*
to Michelangelo in Florence

". . . ò avuto una lettera da reverendissimo Mons. de' Medici, che voi mi avete fatto

riveditore de' marmi si fanno qua per voi o per l'opera di S° Lorenzo. Ora non so le misure avete dato. . . . Qua dicano pare istrano avere a trovare colonne sanza peli o stianti. . . ."

NOTE: Cf. letter of April 25, 1521.

7. *1521. July 7. Scipione [in Carrara]*
to Michelangelo in Florence

"Marco recò carrate 20 a la marina e vorrebbe ducati 500."

NOTE: Scipione was a garzone whom Michelangelo took with him to Carrara to supervise the extraction and cutting of the marble.

8. *1521. July 10. Marcuccio in Carrara*
to Michelangelo in Florence

". . . m'a ditto Baccio da Montelupo da parte vostra che noi facciamo le figure. Non dubitate, che non mancarà quello che noi ve abbiamo impromesso.

". . . abbiamo uno sasso che vi serà una bella figura; subito li darò ispidimento."

NOTE: Marcuccio (i.e. Marco di Bernardo Girardi) was a stonecutter in Carrara who worked together with Francione.

9. *1521. September 24. Pollina, Leone, Il Bello, Quindici, and Jacopo Dito in Carrara*
to Michelangelo in Florence

". . . Sappiate come de le figure ce sono cavate, noi cominciamo al presente a abbozzarla, e tireremo tutta via lavorando . . . noi attendemo a cavare di continovo."

NOTE: The same company worked also for Vettorio Ghiberti in Naples (cf. the unpublished letter of November 9, 1520). The figures mentioned here, however, are for the Medici Chapel.

10. *1521. November 11. Marcuccio and Francione in Carrara*
to Michelangelo in Florence

We learn from this letter that Michelangelo had complained to Mgr. di Cortona concerning the work of the stonecutters. They declare that they have performed their duty. They have not been able to cut the 6 carrate "per lo mal tempo." They ask for money.

11. *1521. November 18. Marcuccio and Francione in Carrara*
to Michelangelo in Florence

"La presente si è per avvisarvi, come qui è venuto Topolino. Avete da sapere che tutti li marmi che noi aggiamo cavati istanno tutti a vostra pidicione. . . ."

12. 1521. December 11 (15?). Domenico di Giovanni di Bertino, called Topolino, in Carrara to Michelangelo in Florence

"Avisovi come le cose anderano bene se i tempi ci danno uno poco di spacio, se non in tutto; sapate che quae si lavora sollecito quanto si po' a tempi boni, d'ognoni parte. Mecho a mutato chava, perchè e pare migliore materia di marmi e maggiore pezi. Sapate che Berto non c'è a[n]chora to[r]nato, ma e' Polina non resta di lavorare quanto che poue e ogni die impromete di fare meglo e' po se tempi ci lasano lavorare. Egli anno abociato uno pezzo di marmo di quattro braci giusto, d'uno bracio e quanto (quarto?) largo, groso dua terzi, e anno mandato du'è ravaneto dua altri beli pezi, e ano fondato uno maso trene braci e a[l]ti e largo quattro mezo, gros[o] incirca. . . . et era belo quanto potesi volere. Per quello si vede chostoro anno uno aviamento se vognono. Anno da chavare lla vostra logagione. Se tempo istessi chom'è stato egleno arebeno (caro) che voi fussi venuto quae a la presente, che arebeno pure, non di meno vi dicho no mando a dire perchè ne la meto in vostra libertà: Quando sarà tempo di venire io mandarone a dire [o] io ne verò insino a voi. Non altro. E Dio ve sia mertorio ne la grazia in questo mondo [e] 'n altro."

NOTE: Partly published in *Cappella Medicea*, p. 43, Doc. 4.

The block mentioned in the letter has almost identical measurements with the block mentioned by Michelangelo March 31, 1524 (Milanesi, p. 584), which served for the fluted double pilasters of the tombs.

13. 1522. December 1. Topolino in Carrara
to Michelangelo in Florence

"La presente si è per avvisarvi come io ci sto bene, e così spero in Dio de voi. Sapiate come io o gia fato conto con M° Lione e con Quindici delli marmi che loro anno fato. Sonno restato avere docati ventiquattro donde ne ò dato loro quatordici, lo resto mi ritengo in manno per potere caricare sei peci di marmi che sonno ancora in sulla marinna, a ciò che io non vada dereto loro. Marco atende a lavorare e così Francione. Mi pregorno che li dessi tanta docati, donde hone dato loro, aciò che lavorino galliardi. E somi acordato con M° Pietero Curto de marmi della cava della Signioria. Mi paiono marmi soficienti al preposito. E ho dato loro parecchie docati: torronne parecchi pezzi secondo che mi parà che siano buoni. Anche ne ho tolti dal Moro [Marco?] qualche pecio, che saranno bonni, e ò dato loro parechi docati. E questo ò fato che io mi sono levato da' Quindici e da Lionne per le istranezze che m'anno fato de' marmi. Sapiate che i' mi vi sonno levato con vostero consentimento, se voi volete non v'ànno cavato una scallia de marmi che fia al perposito vostero. Micheangello, pregovi, in quanto che vi piace, siate con Domeneco che facia quella letera che io li o dito, che' mandi uno poco di fede. Se voi vollete che Lionne e' Quindici non cavinno più marmi per el Cardinale, vorrebenno oni hora denari e poco lavorare. Fate il sì e il no come voi vollete. Michello

Angello, io mi v'arecomando. Io anatendo a sollicitare e fare el bisognio nostro. Altro per questo. Dio di malle vi guardi. . . .

"Michello Angello. Del sald (saldo?) di quelli marmi de Pietero, che mi fue dito che aveva dato a Vetore, non trovo homo che mi sapia dare noticio quanti marmi dete Pietero a lui se uno de carate tre; ma pure se io poterò lo spero di avere in mano. Bello ci è unome à dito con li compagni de vollere sodisfare in tutto quello che sonno l'obrigato.

"No altero."

NOTE: Partly published in *Cappella Medicea*, p. 43, Doc. 5.
The Domenico mentioned is probably Domenico Buoninsegni.

14. 1523. January 16. Marcuccio and Francione in Carrara to Michelangelo in Florence

". . . circa al fato del vostero lavoro noi nonn abiammo mai abandonnato, né mai fato altero. . . . Ora, del fato delli marmi che agiamo fato che sonno all'Ape, che sonno de tirare, non li abiamo tirati perchè si sonno guaste le vie. . . . [They ask for money]."

15. 1523. March 17. Topolino in Carrara to Michelangelo in Florence

"Io ve avisso comme Lionne e Quindici si sonno accordati inseme, e ànno fato uno contrato in modo che la cava si è restata a Lionne e Quindici, e ista in questo modo: che lo dito Lionne e Quindici ànno da dare al Pollinna quatordici docati: si che el Pollinna non à ssentire niente delli obrigi fati con vui per lo passato; e loro sonno atenuto a sodosfarvi oni cossa. Si che laie vennerà il Pollinna, e se voi li vollete dare li quatordici docati voi ne sete padronne. Ancora vienne Lionne in compagnia del soprascrito Pollinna. Non altro per questo.

"Io atendo a fare tirare. Non ò potuto fare tirare più presto per le vie che sonno istate isfondate, ma inse non se perderà tempo. Niente di menno ho fato lavorare all'Alpe.

"Non altro. Dio di malle vi guardi."

NOTE: Partly published in *Cappella Medicea*, p. 43, Doc. 6.

16. 1524. January 31. Marcuccio in Carrara to Michelangelo in Florence

[He asks for money.]

17. 1524. March 17. Topolino in Carrara to Michelangelo in Florence

"Avisovi come e marmi sono al fine, salvo che due coperchi che non sono ancora cavati, ma credo che inanzi Pascua saranno cavati: si che in brieve tempo sarebbe ogni cosa finita. E marmi sono tutti alla marina, salvo che questi nove pezzi e carate sei che

n'à a portare Marcuccio. Avisovi come a dì soprascritto Marcuccio e Francione ànno portato una figura d'otto carrate per forza, e non l'anno voluta finire d'abozzare: si che per questo me n'andai alla Signora. Mi rispose che io volevo pilare (pigliare?) molto sottile: e questa fu la risposta che ella mi dette, e questa si è la ragione e la giustizia che ci si tene. E io le dissi che ell'era opra della Santità del nostro Signore. Io non la volevo acciettare per conto d'otto carrate, che io avevo a fare con uomini che vogliono vedere e riprovare molto bene el conto de' marmi, sicondo che dicie il contratto che aveva fatto Michelagnolo, vi prego che voi riferiate a Bernardo Nicolini, o facciate dire a Steffano come queste cose io iscrivo e come io sono trattato, si che tutti mi vogliono trattare tutti a un modo, tanto che io ho paura di non inpazare. Si ch'io vi priego che voi facciate fare una lettera a Bernardo, che la scrivi alla Signora che mi sia fatto il debito del fatto contratto che voi avete fatto. Dubito e è cierto che qua bisognerà più danari per amore de coperchi, che sono multiplicati, che non n'erano messi a conto. E se non fussi che io non voglia uscire di vostra voluntà, io ne sarei venuto a Firenze, tanto son venuto oramai in disperazione con questi ribaldi carrarini. Vi raccomando che alla marina sono molte carate di marmi, e tutte sono di marmi grossi da tre carrate insino a otto, si che bisogna che voi procacciate altre barche che lievino (tirino?) da sei a sette o otto carrate, se voi volete ch'e marmi vengino a Pisa; altrimenti e' non verranno vanna (?). Vi priego, per l'amore di Dio, che voi mi caviate di qui, perchè chi mi minaccia ecci che mi darebbono, se nonne mi riguardano che io sono vechio, e degl'altri mi riguardano perchè io sono compare, e questo fu Francione e Marcuccio, in casa la secola. E questo è vero. Si ch'io vi priego che voi diciate a Bernardo un'altra volta come di sopra è scritto, che mandi una lettera a Roma a Domenico (Buoninsegni), e conti tutto quello che dicie la lettera, e che lla (Meo?) venga alla Signora, acciò che la Signora faccia il debito suo, e così agli iscarpellini.

"Non altro. Dio di male vi guardi et voi vi racomando. Salutate Istefano per mia parte."

NOTE: Partly published in *Cappella Medicea*, p. 43, Doc. 7.

The block of eight carrate for a figure is also mentioned in a letter of April 4, 1524 Frey, *Briefe*, p. 223.

18. 1524. March 20. Battista Figiovanni in San Lorenzo
to Michelangelo in Florence

[He recommends a stonecutter to Michelangelo.]
NOTE: Battista Figiovanni was the Prior of the Church of San Lorenzo.

19. 1524. March 25. Topolino in Carrara
to Michelangelo in Florence

"Vi fo a sapere come la letera e' memorialli che voi desti a Stefano, o veramente a Lapo, non sono venuti; e lo Frigido, secondo che l'oste m'à areferito, e' dice non l'avere

auto mai letera nesuna che lui abbia a mandare a Carrara ne' anco da Pietrasanta. Sapiate che lo coperchio è guasto, che avevano cavato; non ci manca se non e dua casoni. La figura è trovata, e ò cominciato a cavare de' marmi de le porte e de' tabernacoli, e n'è già abozati parechi pezi. Io vi fo avisato come lo Bello è tornato da Roma, e dicemi che se voi volete el Mosca che voi li mandiate qualche ducato, perchè dice che sentì dire per Roma che non si aretrovava uno quatrino, che bisogna che voi li mandiate qualche ducato e averetello.

"Non altro. Di continuo mi aricomando a voi. X° da male vi guardi."

NOTE: Partly published in *Cappella Medicea*, p. 43, Doc. 8.

Cf. the letter by Topolino of April 4, 1524, published in Frey, *Briefe*, p. 223.

20. 1524. April 21. Topolino in Carrara
to Michelangelo in Florence

"Vi fo avisato in questo dì soprascritto come io o ricevuto una vostra lettera, la quale l'ò auta molto cara, sapiendo voi essere sano, e che voi avete cominciato a lavorare, e che vi manca quattro pezzi di marmo. Delle tutte (?) misure che voi avete iscritto non cie n'è menzione nessuna in sul memoriale, si che e' bisogna cavarle. Credo cavare le mani presto: e ci è il modo 'abozzargli in un tratto, si che io mi sforzerò di mandargli più presto ch'io potrò. Voi m'avete iscritto ch'avete mandato el memoriale delle porticiole e de' tabernacoli; si che io non gl'o mai auti. Io manderò uno a posta che porti la lettera di tutte le cose che mi bisognano. Io ò fatto conto de' marmi quello che montono con tutti quegli ch'io ò a fare e con quegli quattro grandi che voi avete mandato a chiedere non si sono cavati mai perchè non sono iscritti in sul memoriale. Ci manca infine tutti i marmi con quegli de memoriali e de' due coperchi e delle quattro priete [pietre] che voi mandate a chiedere, e ancora la pila di Domenico Buoninsegni, che mi manda a chiedere ducati ciento sesanta quattro infra tutti. Se voi volete ch'io cavi e' marmi de le porticciole e de' tabernacoli, mandate il memoriale per l'aportatore della lettera. Sapiate che non ci fu, è parechi anni, la più bella sorta di marmi per simile opre: si che mandatelo che saranno fatto presto. S'io gli avessi auti ne sarebbe abozzate dua gran parte (porte?). Vi prego che voi facciate il conto delle carrate che vi vanno, il prezio e la somma de' ducati che montano, perchè non vorre' avere andare più di qua e di là; perchè quando io non ci sono non c'è uomo che lavori, e non mi posso difendere da loro. Si che io vi priego che voi mi spacciate questa tella somma per conto de' tabernacoli. La somma de' marmi che sono alla marina e a l'Alpe non sono tanti che se Gregorio potessi navicare, gli portere' via in quattro viaggi. Ancora non s'è potuto cavare e dua coperchi e una figura che vanno a piè de' detti coperchi. Ma io credo, se piace a Dio, che in quindici dì, se nonne accade rotture o altre tristizie saranno cavate. Spaciatelo o fatelo espacia' a Bernardo Nicolini, perchè costoro ànno avere novantasei ducati, si che e' lavorano malvolentieri. Io non o più nè oro nè argento; e se non fussi

[232]

perchè si lavori presto, egl'è parecchi dì ch'io me ne sarei venuto costà. Si ch'io vi riprie-
go che voi mi facciate levare di qua. Io ò una iscrisa (iscesa?) guadagnata in negl'oci
per andare a questa Alpe ch'i'ò paura che non me ne incogga male. Gino d'Antonio di
Giovanlorenzo iscarpellino da Settignano in propria persona s'è ritrovato testimonio a
questi conti, e àgli fatti lui. Il quale sarà testimonio inanci a voi, quando e' bisognassi,
della verità. Mandate l'aportatore il più presto che voi potete. Date la lettera a Bernardo
Nicolini acciò che e' sappia come le cose stanno. A voi mi racomando. Salutate Stefano.

"[Da] Bernardo, voi m'avete mandato a dire della lapide d'Antonio Michi: sappiate
ch'egl'è più di sei mesi ch'ella fu a Pisa, si che io credo ch'ella sia al porto di Signa, e
forse è a Firenze. Ancora mandate iscritto della pila di Domenico: costerà el prezio sui
ducati quatordici col piè, posta in barca. Si che se voi la volete, mandatelo a dire. E
detti quatordici ducati sono nel numero di ducati soprascritti. Mandate più presto che
si può voi avete trovato di sopra che voi mi spacciate e mandate le lettere de' danni a
Pisa al Salviati.

"Non altro. X° di male vi guardi."

NOTE: Partly published in *Cappella Medicea*, p. 43, Doc. 9.

The letter is important because it gives the date of the beginning of Michelangelo's
work on the figures. The figure not yet extracted "che va a piè de' detti coperchi" re-
fers evidently to one of the river gods. The "pila" may be the block for the holy water
basin.

21. 1524. June 6. Topolino in Carrara
to Michelangelo in Florence

"Io vi foe avissato comme io sonno sanno, e cossì ispero in Dio che sia de voi. Qua si
lavora forte, e sonno comme voi vollete e marmi belli e bonni, sichè si caverà presto
onni cossa. E dua coperchi ancora non sonno cavati: espero per tuta questa setimana,
dove noi sianmo presente, seranno cavati e darassi loro fornimento. Io vi prego che vui
diciate a Bernardo Nicollinni o fatelli dire, che mi mandi, al più presto che può, el nu-
mero de' docati che io li ò mandato a dire, a ciò che io possa finnire e marmi. Se non
velli manda, io vennerò costà questo Sangiovanni, e non vi tornerò insino a questo
setembre.

"Non altro. Dio vi guardi da malle."

NOTE: Partly published in *Cappella Medicea*, p. 43, Doc. 10.

22. 1524. June 21. Topolino in Carrara
to Michelangelo in Florence

"Io ò cavatto già circa a trenta 5 caratta di marmori, e ce n'è de l'altra. Le dette ca-
ratta trenta sono a Pisa condocte, beli marmi quanti fosine mai cavatti. E ss'è cavato uno
coperchio e presso aboziatto, e fanole e figolo d' Polina, e l'altro cava Lione e' compagni.
E' quadro grando n'è uno a Pixa, uno ne fa Marcuzo, li altri due lo fo atacallo inseme,

perchè no zi vego comodittà a cavarli da questo tenpo. Non mi gosterano più che l'ordinario che serà a raxone di 8 ducatti a 9 ducatti per pezo.

"Michelagiolo, io vi prego per carittà che voi disiatte a Bernardo Nicolini che mi spagni (spacci?) più presto che si pò l'aportatore di questa letra di questa d' Bernardo Nicolini, che serà Carlino da Carara l'aportatore di questa lettra. Io vi prego che fazia più presto che si pò. Io non vorò stare più qua, perchè io ò paura di non zi lasare la pela. Sapiatte che io son pure sanno; coxì spero di voi. Io prego Idio ogni dì per voi vi mantega sano. Io mi ricomando a voi. Non altro. Xº ve guarda di malo. . . ."

"Michelagolo. I' credo che vi scrivise di mormeriae come io andai al Frigido a domandare a l'oste si gi ava auto da l'oste di Pietasatta nesuna letera che gi avese a mandare a Carara. Disseme di noi. Pensate che male è statto in Fiorenza."

NOTE: Partly published in *Cappella Medicea*, p. 43, Doc. 11.

23. 1524. June 21. Michele di Andrea di Guido in Carrara to Michelangelo in Florence

". . . io sono statto cum Mº Domenico vostro qualche volta a ragionare de questa facata (facciata?), se s'à a fare; e lui me à ditto più volte che sì. [He asks Michelangelo if it is true. Asks for money.]"

NOTE: The Domenico mentioned in the letter is Topolino. It seems there is a question of hiring Michele for the work, but it is not absolutely sure whether the work in question is the Medici Chapel, the Papal tombs, or the Libreria di San Lorenzo.

24. 1524. August 2. Topolino in Pisa to Michelangelo in Florence

"Questo per farvi inttedere come voi m'avette mandatto a dire per Carlino che voi voreste e quadri che vanno a le sipolture di trene bracia e mezo e largi dua e mezo. N'è uno a Pisa e un altro alla marina, venutto a dì ultimo del mese passato. Sapiatte che gliène grande fattica a trovargli, che sono venutti meno li sasi. Io vedrone se io potronne fare ttornare li barcaroli, perchè l'altro che (ch'è) all'Avenza, cioène quel'altro quadro che s'i' avesi autto danari sarebe istiatto (stato) ancora quel altro quadro in Pisa; perchè se io n'avessi autti, Marcucio e Fracione arrebono carico ogni cosa che gl'ano fatto; che gi àno paura di non esere pagatti. Io m'igiegnerò ch'e barcaroli verano per quel altro quadro. Mi dicie Carlino che quella figura istiortta ch'è a San Lorenzo no vi piacie che ci sarane fattica a cavarla se no l'ane Carlino, e sarà in lungo tempo. Si che madattemi a dire il più prestto che si puone che e marmi dalle porticiole sono preso che asomatte e sarano bele ogniuno copercio abozatto, e l'altro ci sarane fattica d'averlo a questo dì, perchè l'ène sconcia pietra, e volette che siano bele. Madattemi a dire quello che io òne a fare de la figura che non vi piacie. Salute. Io Domenico mi racomando a voi."

NOTE: Partly published in *Cappella Medicea*, p. 44, Doc. 12.

25. 1524. August 11. Marcuccio and Francione in Carrara
to Michelangelo in Florence

". . . noi avemmo tirati li marmi in marrinna . . . [but they had not yet received any money]."

26. 1524. August 13. Topolino in Carrara to Michelangelo in Florence

"Voi vi dolete che li marmi vi ho mandati non sono secondo la intenzione vostra: il che benissimo credo, ma avete da credere che se più belli si avessino potuti avere da quelli che hanno e contratti con voi, più belli ve li averemo mandati. E' sono marmi che di fuori mostrano avere bella pella, e poi drento non respondano. Marcucio hae adesso certi marmi inel Alpe del Voliaccio, in quello luogo difficile dove sapete che sono di buona sorte; ma volendo di quelli, bisogna cavarsi la berretta a rinverso per lo pericolo che c'è, et ancora ci bisognerà longheza di tempo. Carlino di Ulivieri ne averà qualche pezo di bello, et adesso ha cavato uno papa qual finisce adesso de abozarlo, che è bello, et hallo cavato sotto alla Pietà che faceste a Roma; e Meo la vidde e portovene un sagio, et è abozata, e sarebbe ita alla marina se non fusse la pietra grossa che tira Mº Nicolò. E tutte quelle che sono all'Alpe sarebono alla marina se non fusse lo impedimento della guerra. Quindici, Lione e Mariano hanno cavato l'altro papa, chè secondo si vede sarà una cosa bella. Bisogna che voi mandiate a dirmi come volete io abozzi quelli due coperchi, che qua credo dureremo gran fatica a cavarli con quella bernoca. Se voi gli volete sanza quello rilievo, ci sono d'abozare in un tratto, che sono de' marmi medesimi de' cassoni. L'altri marmi sono a buon punto: salvo che quella colonna, perchè vorrei fussino de marmo bello. Il coperchio che i' ò abozato mi conviene pigliarlo, che sapete quando l'om piglia un pezo di marmo bisogna pagarlo, perchè egli è iusta cosa. Voi sapete che quando voi pigliavi un pezo di marmo bisognava voi lo pagaste o buono o cativo. Vi mando Carlino e lui vi riferirà sopra questo. Io vi scrivo come le cose passano. Qua bisogna denari infino a centocinquanta ducati per sovvenire a ditti marmi. A bon conto a' 25 dì di questo io arò avere ducati 18 d'oro per mio salario. Mandatimi questi 18 ducati nel numero delli 150 scritti, e spaciate lo aportatore di questa che sarà Carlino. Io seria tornato a casa come vi mandai a dire per Meo, ma non mi sento da caminare. Vi priego che spaciate Carlino presto, e che gli diate ditti denari o faciate dare a Bernardo Nicolini, a ciò io non abia andare a Pisa che io non sono se non ossa diventato per fatica et affanni. Ogni ora mi par cento di tornare a casa mia se piace a Dio. Mandatimi a dire se voi volete che si cavino queste figure di quello di Marcucio o no, o vogliamo aspettare che Carlino le cavi lui. Credo o l'uno o l'altro abino a cavare. Sarà longo tempo a poterli a avere, tamen mandatimi a dire quello ho a fare."

NOTE: Partly published in *Cappella Medicea*, p. 44, Doc. 13.

The statues of the Popes mentioned in this letter and in two following letters must be identified with the seated statues for the tombs of Popes Leo X and Clement VII.

Cf. text, p. 173. The column mentioned in this letter refers probably to one of the columns of the Magnifici tombs.

27. 1524. August 24. Topolino in Carrara to Michelangelo in Florence

"Avisovi come io ò visto quello papa. Sarebevi drento una di quelle storte, ma io spero che noi àremo in pochi dì marmi per le figure nude. Voi (?) dite saranno una cosa bella, sì che per questo non voglio guastare questo papa; quali in poco tempo saranno alla marina; et ogni volta che sarà scaricato il mazacavallo a Pisa, Gregorio barcaiolo la caricherà in un tratto, e tutte le altre. Sì che se voi le volessi e potessi portare su per Arno, le averete a Firenze per tutto settembre. Io ci hone misso suso Marcucio e Francione per avere di quel marmo, da l'altro canto Carlino: si che noi vedremo di spazare ogni cosa presto, se fusse alcuno che vi avesse riportato qualche favola il fino fu (?) tutto.

"Non altro. A voi di continuo mi raccomando, che Dio di male vi guardi.

"Michelagnolo, io vi racomando il mio genero e Biancalena se gli è possibile che egli entrono a lavorare alli marmi, se none almeno alla pietra forte. Io ve ne priego se il prego è degno."

NOTE: Partly published in *Cappella Medicea*, p. 44, Doc. 14.

The figure of the Pope mentioned in this letter is identical with that mentioned in the previous letter. The "figure nude" refer to the Allegories.

28. 1524. December 6. Topolino in Pisa to Michelangelo in Florence

"Questa per dirvi come sono statto a vedere el pezo di marmo vostro, el quale è da la casa de la Santità di nostro Signore; el quale è lungo braccia 4 2/3 e largo braccia 3/4, grosso braccia 2/3. Ma e' mi pare sia rotto, perchè per l'alegreza del Papa si fece fuochi grandi intorno a ditta casa, del che misono più stipa adosso a detto marmo; e parmi sia rotto, se none in tutto, in parte; e io ò gridato loro che l'àno pegiorato scudi 60. Si che riparatte voi. Non altro per questa. Dio vi guardi."

NOTE: Partly published in *Cappella Medicea*, p. 44, Doc. 15.

The sentence "per l'alegreza del Papa si fece fuochi" refers very probably to the block of the Pope's statue.

29. 1524. December 25. Topolino in Carrara to Michelangelo in Florence

"Vi aviso come sono sano, grazia di Dio, e così credo sia di voi. Io sono stato a l'alpe, et ho veduto per ancora non ci essere modo di avere alcuna figura. Se non che bisogna levare terreno assai alla cava di Lione e compagni. Credo, se questo faranno, ve ne aranno qualcuna; et ancora nella cava del Mancino se ne potrebe cavare una o due. Io solliciterò ogni dì a l'alpe, quando sarà possibile andarci. Dite a Biancalena, se voi volete o voi gliene fate dire a Bernardino che dica alla mia donna che io son sano. Non

altro. A voi mi racomando. Io ho cominciato a mandare de' marmi a Pisa. Ser Galvano se ricomanda pur assai a voi, e dice che gli comandiate, che egli è per servirvi pur che possa."

NOTE: Partly published in *Cappella Medicea*, p. 44, Doc. 16.

The "Ser Galvano" mentioned in the letter was a notary in Carrara.

30. 1525. January 11. Marcuccio and Francione in Carrara to Michelangelo in Florence

". . . Questo lavoro el qualle voi ne allocasti per lo passato noi (l') avemmo finnito: salvo uno pecio ne manca ancora a fare. . . ."

31. 1525. March 4. Topolino in Carrara to Michelangelo in Florence

"La presente si è per avvisarvi comme Marco e Francionne ànno livero lo lavoro che loro avevanno da fare alle figure el quadero; e si ve ànno servito benne delle figure. Si che loro non n'anno altero lavoro alle manno per ora. Se voi avete auta la letera della porta, mandate el memorialle, perchè Marco e Francionne ànno li sassi al prepossito e belli quanto dire se poe. Non altero per questo. Loro ànno da tirare certi peci in questo mezo. Se voi mandate el memorialle, loro aranno tirati quelli pochi marmi che ànno da tirare. Non altero. Dio di malle vi guardi."

NOTE: Partly published in *Cappella Medicea*, p. 44, Doc. 17.

32. 1525. May 23. Topolino in Carrara to Michelangelo in Florence

"La presente per dirvi chome io chredo per quello che si vede ch'egli è cavato una fighura, in quanto per le misure e per quelo che si può vedere per la beleza del marmo; e se altro non achade, o peli o altre rotture, chredo che ve ne sarà una e'n fra 15 dì o ventti sarà chavato 2 (?). Anchora, se non achade trestizia alchuna, coè peli o isforzatture, a me mi pare che sieno bianchi e begli al posibile. E se le chaverano, io ve lo farò intendere, e per aventura verò fino chostì per referirvi meglio la chosa chome la sta. E gli scharpelini lavorano forte, ma no le vogliano abozare se no venitte voi. Non altro per questa. A voi mi rachomando."

On the verso:

"Sappiate che io sono venuto in Pisa per mandarvi le dette lettere sichure."

NOTE: Partly published in *Cappella Medicea*, p. 44, Doc. 18.

33. 1525. August 10. Topolino in Carrara to Michelangelo in Florence

"Alli 26 del mese passato, per una mia vi feci intendere come alla marina erano condocte due figure grosse et due picole: de le quale figure grosse ciascuna è carrate nove; et le due picolle furono conducte col carretto ad un tracto, et sono carrate 7. Si che vedete tra voi quello montano. Et il coperchio sarà lunedì sera alla marina, se altro si-

nistro non accade. Di quello medesimo marmo sono li cassoni, bello al possibile. Il simile di bellezza vi si dice delle decte figure. Per il che costoro che lavorano vi pregano, Michelagnolo, che venite o vero mandiate, et mandiate denari a ciò possino lavorare. Hanno cominciato a cavare le altre due figure che saranno di quel medesimo marmo avesti voi la prima volta. Io arei caro che voi venissi o mandassi presto, che me ne vorrei venire insino a casa, che qua per due mesi non so che mi fare. Le barche non si possono charichare, perchè non è aqua in Arno. Io mi trovo senza denari, perchè bisogna lasciarmene a casa. Io non ho chi guadagna se non io, et ho delle spese assai. Venite al più presto potete overo mandate. Non altro per adesso. A voi mi racomando."

NOTE: Partly published in *Cappella Medicea*, p. 44, Doc. 19.

The "due figure grosse," each nine carrate, and "due piccole," each seven carrate, are mentioned in a letter of the company of Pollina and Bello, November 14, 1520, published by Wolf, p. 50.

34. 1525. November 3. Leone and Quindici [in Carrara] to Michelangelo in Florence

". . . abiamo cavato el saso el quale avemo comisione da Sandro vostro fatore . . . noi priegamo vostra magnificencia che ce voglia dare aviso quello che noi avemo affare."

35. 1526. January 24. Topolino in Carrara to Michelangelo in Florence

"Giunto io fin a Carrara, cercai di expedirmi di quelle pietre erano a l'alpe, procurando di farle tirare alla marina et poi caricarle in barca: il che volendo fare sono stato impedito da questi tutti che danno li marmi; dicendo volere denari, e che restano havere bene ducati 40. E io, per farli intendere il loro errore, li ho monstro li conti, et habiamoli facti non una volta ma dieci, hora in presentia di più e più persone di Carrara et hora dinanci al Vicario: adeo (?) che è aparuto molto bene che non restavano havere nulla anci restavano a dare ducati dieci computando ducati 12 io gli ho dato loro ultimamente, a ciò tirassino alla marina li marmi erano a l'alpe, perchè non li volevano tirare se non havevano denari. Et non hanno voluto mai stare a dicti contracti, et hanno ordinato venirvi a trovare et vedere costà questi loro conti.

"Circa al facto delle figure, Francione et Marcucio sono per cavarne una et forsi dua; et secondo si può vedere saranno bellissime. Et a Mariano et Lione ancora loro ne faranno un'altra, se non ci apare in questo mezo altra tristizia. Delle colunne, ancora non ha cavato nessuna, ma se 'l tempo stesse bono, infra uno mese si caverebono tutte. Il coperchio non si hè ancora trovato. Caricai 4 barche di marmi già sono 22 dì, et non so se sono ancora arivate a Pisa. Il numero de' marmi erano carrate 28. Io sono diventato come una lanterna sopra e conti di costoro: sì che mi par mille anni di tornare a Firenze. Et ogni homo vole denari inanci: mi riparo al meglio io posso. Non altro. Idio vi sia aiuto, et a voi mi racomando."

NOTE: Partly published in *Cappella Medicea*, p. 44, Doc. 20.
This is the last preserved letter by Topolino.

36. 1526. March 10. Piero di Filippo Gondi in Ancona to Michelangelo in Florence

". . . Io vi conforto a stare di buona voglia e sanza passione, e confortovi a tirare innanzi l'opera cominciata che farete buona opera. . . ."

NOTE: Piero Gondi, a friend of Michelangelo, is mentioned in several published letters, Frey, *Briefe*, pp. 197ff, and Milanesi, p. 598. Cf. also Appendix No. 49 (April 7, 1524). The "opera cominciata" is probably the Medici Chapel.

37. 1526. December 16. Simone Bisdomini Tortigiani, n.p., to Michelangelo, n.p.

[Concerning a controversy between Tortigiani and Cosimo, a woodworker.]
NOTE: The letter refers probably to a dispute concerning the execution of the models.

38. 1532. August 10. Figiovanni, n.p., to Michelangelo in Florence

". . . andai a Chiappino per quelle taglie per non le scordare. . . . Ma invano fu la gita mia sanza la poliza.

"La Santita di Nro Sre comette al servo Figiovani che io paghi a Mro Silvio [Silvio Cosini] la provisione che da voi mi sarà ordinato.

". . . Maestro Giovanni da Udine è qui e ch'è per fare lavorare di stucco o con lui o con voi non avendo che fare. . . ."

NOTE: The Silvio mentioned in the letter is Silvio Cosini, who executed the frieze of masks, and since the Pope wishes a fee to be paid him, it may be supposed that he had finished his work by the date of this letter.

39. N.d. (probably November 1532). Battista Figiovanni, n.p., to Michelangelo, n.p.

"Avvertite che forse la tribuna arà danno nella sua summità stare questa vernata senza murarvi li embrici o quelli lastroni sotto quale v'è certe buche dove l'acqua à causa fermarsi; perchè Mo Baccio la scarpellò et ruppe per far luogo alli due lastroni. Et vorrebbesi, se vi pare, dare commissione che li embrici si facessero. Apresso le doccie credo siano ripiene, e vedesi traboccare in più luoghi quando piove forte. . . . arò caro mi sia detto le volte che s'à fare sopra le camere e sotto la libreria, che lavoro a essere se nostrale o campigiano e quello arò a provedere. . . ."

NOTE: The allusion to the danger that rain water will leak into the Chapel suggests the date November 1532.

In the Archivio Capitolare of the Church of San Lorenzo in Florence, important documents concerning the history of the Medici Chapel must formerly have been pre-

served, especially in Vol. v of the *Ricordi 1480-1530*. This volume, however, was already missing from the archives in 1936 when the author made a search for it.

In the *Feste e Ufici 1521-1525* the name of "Michelagniolo" is many times recorded under the rubric of "Uffitio" (for example, 1521, June 8, 12, 13, 14, 17, 18, etc.)

In the *Libro della Collegiata Chiesa di Sancto Lorenzo di Firenze dal 1505 al 1523*, on fol. 201, May 31, 1521, there is recorded under the rubric of "Uscita" a payment to Michelangelo of 31.6 ducats.

DOCUMENTS CONCERNING THE CHRIST OF THE MINERVA

40. 1521. September 22. Giovanni de Rezo [da Reggio], painter, in Rome to Michelangelo in Florence

"Io vi aviso como io ho auto una litera vostra . . . noi altri abiamo fato la diligentia de quelo che avemo potuto et saputo, e siamo per farla, donde vada l'onore vostro et utile.

". . . E per darvi aviso del Friza [Frizzi], finise la vostra ficura con grande diligentia.

"Et portatore de la litera è uno Domenico da Forli che lavora de stuchi che vene per lavorare a Monsignore rev.ssmo de' Medici et è el primo maestro che lavora de stuco. . . ."

NOTE: Giovanni Trignoli da Reggio was a painter who worked September 1510 as a garzone with Michelangelo on the Sistine Ceiling. Further references concerning him can be found in A. Mercati, *Atti e memorie della Regia Deputazione di storia patria per le province modenesi*, XII, 1919, pp. xlviiff; XIII, 1920, pp. 142f; and II, pp. 7 and 115. The letter should be compared with those of Frizzi of September 7 and 14, 1521, where he communicates his intention of finishing the figure. He says also that Sebastiano del Piombo and Giovanni da Reggio will inform Michelangelo of this fact. Sebastiano's letter, of September 6, 1521, is published in Milanesi, *Corr.*, p. 28. The letter of Giovanni da Reggio is perhaps identical with the one given here, unless there was another letter from the beginning of September which has now been lost.

41. 1521. November 14. Metello Vari in Rome to Michelangelo in Florence

"Sono parecchi dì che ebi una vostra lettera ad me gratissima et in quella scrivendome della figura, ad noi mandata per voi, del Christo, se era al proposito, et se non, in un altro lavoro averessivo satisfatto."

NOTE: A few other lines from this letter are quoted in Gotti I, p. 143.

42. 1522. March 23. Leonardo Sellaio in Rome to Michelangelo in Florence

"Metello [Vari] è stato col Cardinale di fresco, e vuole io gli vadia a parlare, per fare quella Nostra Donna, e per sapere l'animo vostro, del prezo o del tempo.

"Metello vorebe voi gli facessi una fede de' danari avete avuti per conto del Cristo, perchè dice vuole mostralla a non so che romano, che atiene a questa materia. . . ."

NOTE: Leonardo Sellaio Borgherini was a close friend of Michelangelo and belonged to the same informal society in Rome. Other letters by him from 1522 are published in Frey, *Briefe*, pp. 185ff.

The "Nostra Donna" mentioned in this letter very likely refers to the Virgin of the Medici Chapel.

43. 1523. June 27. Metello Vari in Rome
to Michelangelo in Florence

"Che più ancora, avemo bisogno di voi perchè averia caro me mannasivo una poliza, quanno ve sia de piacere, come avete auti da me per via del banco de' Balducci ducati cento cinquanta d'oro. Et questo perchè avemo ad fare conti con li eredi de Messer Pietro Paulo Castellano et dicono, come quelli che non sanno nè ancora non ce sonno stati, che ditto Messer Pietro Paulo ne aveva pagati la metà, como loro hanno pagato la metà delli cinquanta ultimi. Et per questo abisogna una fede da voi; e quando quella non fosse, me bisognerà averla dalli Balducci. . . ."

NOTE: The letter is mentioned but not published by Frey, *Briefe*, p. 196.

44. 1526. April 7. Metello Vari in Rome
to Michelangelo in Florence

"Amico carissimo salutem. . . . avemo ad far certi conti con li eredi di Messer Piero Paulo Castellano . . . supra la figura del Cristo qual fu fatta per man vostra; è necessario averne una fede de 175 ducati. . . ."

NOTE: The letter is mentioned but not published by Frey, *Briefe*, p. 196.

45. 1532. July 5. Metello Vari in Rome
to Michelangelo in Florence

Asks again a receipt for the money "pagati ad voi" for the Christ of the Minerva . . . "farla scrivere una quitanza delli danari ve s'è dati. . . ."

NOTE: The letter is mentioned but not published by Frey, *Briefe*, p. 196. There are two later letters in which Metello Vari asks for the receipt, from July 13 and August 2, 1532.

MISCELLANEOUS DOCUMENTS FROM 1520-1534

Here are united extracts from unpublished letters between 1520 and 1534, in so far as they have not already been published in Vol. I. The documents concerning the Tomb of Julius II, the façade of the Church of San Lorenzo, and the Biblioteca Laurenziana, from this period, will be published in subsequent volumes.

In the case of letters which have no direct connection with Michelangelo, but which concern only the private affairs of the correspondent, only the name of the writer and the date of the letter are given.

46. 1520. April 22. Giovanni Gellesi da Prato in Rome
to Michelangelo in Florence

"... voi eri malato grave.... Ora ... state bene...."
NOTE: Giovanni Gellesi was a friend of Michelangelo in Rome. His earlier correspondence with Michelangelo between 1515 and 1517, is published in Frey, *Briefe*, pp. 23, 24, 31, and 80. Two later letters by him (from 1521) are published in Frey, *Dicht.*, p. 504.

47. 1520. November 9. Pollina, el Bello and Lione in Carrara
to Michelangelo in Florence

[They have received a letter from Michelangelo.] "... (tutti) marmi sono pezzi 55 et crediamo che a questa ora diti marmi a Napoli (saranno)."
NOTE: The marble pieces mentioned in this letter are evidently those cut for Vettorio Ghiberti in Naples, mentioned by the latter in his letter of October 21, 1520, as not yet arrived, and in his letter of November 30, 1520, as having arrived in Naples. Cf. Vol. I, p. 244.

48. 1523. August 9. Neri (Donato?) del Sera, n.p.,
to Michelangelo in San Lorenzo

NOTE: Letters of Donato del Sera from July 7 and July 10, 1523, are published in Vol. I.

49. 1524. April 7. Piero Gondi, from his shop,
to Michelangelo in San Lorenzo

"Io feci stamani motto a uno spagnuolo che è amico mio e di Ser Giov. Francesco."
NOTE: Piero Gondi was an intimate friend of Michelangelo, who on April 29, 1527, hid his belongings in the Medici Chapel with the permission of Michelangelo (Milanesi, p. 598). Cf. also his letter of March 10, 1526, above.

50. 1524. April 9. Leonardo (Sellaio?) in Rome
to Michelangelo in Florence

51. 1524. May 21. Antonio d'Orsino, n.p., to Michelangelo, n.p.

"... fù ieri col chompare M. Jacopo e in effetto farà tutto...."
NOTE: Antonio d'Orsino is mentioned in a letter by Fattucci, Frey, *Briefe*, p. 227. Another unpublished letter by him from March 21, 1525, is published below. The "chompare M. Jacopo" is probably Jacopo Salviati.

52. 1524. August 13. Galvanus ser Niccolai in Carrara
to Michelangelo in Florence

NOTE: Ser Galvano Niccolai was a notary in Carrara.

53. 1524. October 23. Batista Figiovanni, n.p.,
to Michelangelo, n.p.

[The rent of the house in Rome must be paid.]

54. 1525. March 21. Antonio d'Orsino, at home,
to Michelangelo in Florence

". . . Messer Francesco . . . in effetto farà tutto."
NOTE: Cf. the letter published above from May 21, 1524.

55. 1525. May 31. Bernardo Gamberelli, n.p.,
to Michelangelo, n.p.

". . . S'è obligato Salvestro di Giovanni Coli a quanto vi promesse. . . ."

56. 1526. June 2. Francesco di Guido, called Marrana, in Massa
to Michelangelo in Florence

[Asks Michelangelo to communicate with him if the workers of Santa Liberata need marble, in which case he will furnish it.]
NOTE: Francesco di Guido, called Marrana, is mentioned in the letter, Frey, *Briefe*, p. 29.

57. 1529. January 17. Donato Capponi, at home,
to Michelangelo in Florence

". . . ò parlato con Zanobi Strozzi che à e legnami a Brozzi."
NOTE: Donato Capponi was the intermediary for Michelangelo in the sale of landed property. He is mentioned in the letter, Frey, *Briefe*, p. 112.

58. 1530. November 24. Andrea di Rinieri Quaratesi in Pisa
to Michelangelo in Florence

[He has arrived in good health in Pisa. His brother is ill.]
NOTE: Andrea di Rinieri Quaratesi was a rich Florentine banker and a friend of Michelangelo in the 1520's and 1530's. In 1532, Michelangelo commissioned him to sell his house in Via Mozza, but no sale was made. He is mentioned in Frey, *Briefe*, p. 334, Frey, *Handz.*, pp. 63 and 135, and Maurenbrecher, p. 284. Cf. also the following letter.

59. 1531. June 22. Andrea Quaratesi in Pisa
to Michelangelo in Florence

[He sends some "pessi" as a gift.]
NOTE: Cf. the preceding letter.

60. 1532. April 15. Donato del Sera in Florence
to Michelangelo in Rome

[He requests that the Pope give him a receipt.]

61. N.d. (1533?). January 9. Figiovanni, n.p., to Michelangelo, n.p.

[Michelangelo has a] "debito ducati 900 dell' ultimi 1000 che vi furono posti."

BIBLIOGRAPHICAL ABBREVIATIONS

BIBLIOGRAPHICAL ABBREVIATIONS

Aldroandi (Aldovrandi), *Antichità* Ulisse Aldroandi, "Delle statue antiche, che per tutta Roma, in diversi luoghi & case si veggono," in Lucio Mauro, *Le antichità della città di Roma*, Venice, 1556.

Berenson, *Drawings* B. Berenson, *The Drawings of the Florentine Painters*, 2nd ed., Chicago, 1938.

Bocchi-Cinelli M. Francesco Bocchi, *Le bellezze della città di Firenze, dove a pieno di pittura, di scultura, di sacri templi, di palazzi, i più notabili artifizj, e più preziosi si contengono*. Scritte già da M. Fr. Bocchi, ed ora da M. Giovanni Cinelli ampliate ed accresciute. Florence, 1677.

Boll.d'arte Bollettino d'arte.

Borghini, *Riposo* R. Borghini, *Il riposo*, Florence, 1584.

Borinski, *Rätsel* K. Borinski, *Die Rätsel Michelangelos. Michelangelo und Dante*, Munich, 1908.

Bottari, *Raccolta* G. Bottari, *Raccolta di lettere sulla pittura scultura ed architettura scritte da' più celebri professori che in dette arti fiorirono dal secolo XV al XVII*, Rome, 1754-1773.

Brinckmann, *Zeichnungen* A. E. Brinckmann, *Michelangelo-Zeichnungen*, Munich, 1925.

Brockhaus H. Brockhaus, *Michelangelo und die Medici-Kapelle*, Leipzig, 1909.

Burger F. Burger, *Geschichte des florentinischen Grabmals von den ältesten Zeiten bis Michelangelo*, Strassburg, 1904.

Burl.Mag. The Burlington Magazine.

Busini *Lettere di G. B. Busini a B. Varchi*, Florence, 1860.

Condivi *Le vite di Michelangelo Buonarroti scritte da Giorgio Vasari e da Ascanio Condivi*, ed. K. Frey, Berlin, 1887.

Daelli G. Daelli, *Carte Michelangiolesche inedite*, Milan, 1865.

Dorez, *Nouv.Recherches* L. Dorez, "Nouvelles recherches sur Michel-Ange et son entourage," in *Bibliothèque de l'École des Chartes*, LXXVII, 1916, pp. 448*ff*; LXXVIII, 1917, pp. 179*ff*.

Frey, *Briefe* K. Frey, ed., *Sammlung ausgewählter Briefe an Michelagniolo Buonarroti*, Berlin, 1899.

Frey, *Dicht.* K. Frey, ed., *Die Dichtungen des Michelagniolo Buonarroti*, Berlin, 1897.

Frey, *Handz.* K. Frey, *Die Handzeichnungen Michelagniolos Buonarroti*, 3 vols., Berlin, 1909-1911.

Frey-Knapp, *Handz.* F. Knapp, *Die Handzeichnungen Michelagniolos Buonarroti. Nachtrag*, Berlin, 1925.

Frey, *Reg.* K. Frey, "Studien zu Michelagniolo. II," in *J.d.p.K.*, XVII, 1896, pp. 5*ff* and 97*ff*.

Gaye G. Gaye, *Carteggio inedito d'artisti dei secoli XIV, XV, XVI*, Florence, 1839-1840.

G.d.B.-A. Gazette des Beaux-Arts.

Gotti A. Gotti, *Vita di Michelangelo Buonarroti*, Florence, 1875.

J.d.A.K. Jahrbuch der Kunsthistorischen Sammlungen des Allerhöchsten Kaiserhauses, Vienna.

J.d.Kh.Slg.Wien Jahrbuch der Kunsthistorischen Sammlungen in Wien, N.F.

J.d.p.K. Jahrbuch der preussischen Kunstsammlungen, Berlin.

Justi, *Ma.N.B.* C. Justi, *Michelangelo. Neue Beiträge zur Erklärung seiner Werke*, Berlin, 1909.

Kaiser V. Kaiser, "Der Platonismus Michelangelos," in *Zeitschrift für Völkerpsychologie und Sprachwissenschaft*, XV, 1884, pp. 209-238; XVI, 1886, pp. 138-187, 209-250.

Kleinenberg V. von Kleinenberg, "Zum Geheimnis der Mediceergräber," in *Z.f.Ae. u.Kw.*, XXIII, 1929, pp. 113*ff.*

Knapp, *Ma.Kl.d.K.* F. Knapp, *Michelangelo* (Klassiker der Kunst), 4th ed., Stuttgart and Leipzig, 1912.

Kriegbaum F. Kriegbaum, *Michelangelo Buonarroti. Die Bildwerke*, Berlin [1940].

Mackowsky H. Mackowsky, *Michelangelo*, 4th ed., Berlin, 1925.

Mh.f.Kw. Monatshefte für Kunstwissenschaft.

Milanesi *Le lettere di Michelangelo Buonarroti edite ed inedite coi ricordi ed i contratti artistici*, ed. Gaetano Milanesi, Florence, 1875.

Milanesi, *Corr.* G. Milanesi, *Les correspondants de Michel-Ange, I. Sebastiano del Piombo*, Paris, 1890.

Milanesi, *Prosp.Cron. Vasari*, ed. Mil., VII, pp. 337*ff.*

Panofsky, *Handz.* E. Panofsky, *Handzeichnungen Michelangelos*, Leipzig, 1922.

Panofsky, *Iconology* E. Panofsky, *Studies in Iconology*, New York, 1939.

Pastor L. von Pastor, *Geschichte der Päpste im Zeitalter der Renaissance*, III, 8th ed., Freiburg i.B., 1924-1926.

Popp, *Med.Kap.* A. E. Popp, *Die Medici-Kapelle Michelangelos*, Munich, 1922.

Popp, *Münchner Jahrb.* A. E. Popp, "Unbeachtete Projekte Michelangelos," *Münchner Jahrb.*, IV, 1927, pp. 398*ff.*

Rep.f.Kw. Repertorium für Kunstwissenschaft.

Robert C. Robert, *Die antiken Sarkophagreliefs*, Berlin, 1890*ff.*

Robinson J. C. Robinson, *A critical account of the drawings by Michel Angelo and Raffaello, in the Galleries in Oxford*, Oxford, 1870.

Springer A. Springer, *Raffael und Michelangelo*, 3rd ed., Leipzig, 1895.

Steinmann, *Bibliographie* E. Steinmann and R. Wittkower, *Michelangelo Bibliographie, 1510-1926*, Leipzig, 1927.

Steinmann, *Geheimnis* E. Steinmann, *Das Geheimnis der Medicigräber Michelangelos*, Leipzig, 1907.

Steinmann, *Sixtinische Kapelle* E. Steinmann, *Die Sixtinische Kapelle, II. Michelangelo*, Munich, 1905.

Symonds J. A. Symonds, *The Life of Michelangelo Buonarroti based on Studies in the Archives of the Buonarroti Family at Florence*, 3rd ed., London, 1901.

Thode H. Thode, *Michelangelo und das Ende der Renaissance*, 2nd ed., Berlin, 1912.

Thode, *Kr.U.* H. Thode, *Michelangelo. Kritische Untersuchungen über seine Werke*, Berlin, 1908-1913.

Thode, *Reg.* H. Thode, *Michelangelo und das Ende der Renaissance*, I, 2nd ed., Berlin, 1912, pp. 343*ff*.

Tolnay, *Arch.Buon.* C. de Tolnay, "Die Handzeichnungen Michelangelos im Archivio Buonarroti," in *Münchner Jahrb.*, v, 1928, pp. 450*ff*.

Tolnay, *Cappella Medicea* C. de Tolnay, "Studi sulla Cappella Medicea," in *L'arte*, n.s., v, 1934, pp. 5*ff* and 281*ff*.

Tolnay, *Sklavenskizze* C. de Tolnay, "Eine Sklavenskizze Michelangelos," in *Münchner Jahrb.*, v, 1928, pp. 20*ff*.

Tolnay, *Thieme-Becker* Thieme-Becker, *Allgemeines Künstlerlexikon* (1930), sub Michelangelo.

Varchi, *Due lezzioni* B. Varchi, *Due lezzioni di M. Benedetto Varchi, nella prima delle quali si dichiara un sonetto di M. Michelagnolo Buonarroti*, Florence, 1549.

Vasari 1550 and 1568 *Le vite di Michelangelo Buonarroti scritte da Giorgio Vasari e da Ascanio Condivi*, ed. K. Frey, Berlin, 1887.

Vasari, ed. Mil. *Le opere di Giorgio Vasari*, 9 vols., ed. G. Milanesi, Florence, 1878-1885.

Vasari, *Carteggio* *Il carteggio di Giorgio Vasari*, ed. K. Frey, Munich, 1923*ff*.

Venturi, *Storia* A. Venturi, *Storia dell' arte italiana*, IX, Milan, 1925*ff*.

Wickhoff, *Bildungsgang* F. Wickhoff, "Die Antike im Bildungsgange Michelangelo's," in *Mitteilungen des Instituts für Österreichische Geschichtsforschung*, II, Innsbruck, 1882.

Wilde J. Wilde, "Zwei Modelle Michelangelos für das Juliusgrabmal," in *J.d.Kh.Slg. Wien*, 1928, pp. 199*ff*.

Wilson C. H. Wilson, *Life and Works of Michelangelo Buonarroti*, London, 1876.

Wolf R. Wolf, *Documenti inediti su Michelangelo*, Budapest, 1931.

Wölfflin, *Klass.Kunst.* H. Wölfflin, *Die klassische Kunst*, 6th ed., Munich, 1914.

Z.f.Ae.u.Kw. *Zeitschrift für Aesthetik und allgemeine Kunstwissenschaft.*

Z.f.b.K. *Zeitschrift für bildende Kunst.*

Z.f.Kg. *Zeitschrift für Kunstgeschichte.*

INDEX

INDEX

Palazzo Vecchio, 147 n.44, 148 n.46, 157 ns.1,2, Fig. 267

Vasto, Marchese del, 12

Vecchietta, Lorenzo, Christ, Siena, Cathedral, 91

Vecchietti, Bernardo, 191, 192

Venice, Academy, Michelangelo, drawing No. *118*, 112*ff*, 199, 221, Fig. 152; Mus. Correr, copy of Leda, 192*f*, Fig. 283; Palazzo Gussoni, Tintoretto, fresco on façade, 156; Ponte del Rialto, 16; St. Mark's, reliefs on façade, 144 n.34

Venusti, Marcello, 18, 196; drawing, Cambridge (Mass.), Fogg Mus., 158 n.6; Ascension, Cambridge, Fogg Mus., 219, Fig. 149

Verazzano, Bartolomeo, 16

Verrocchio, Andrea del, 26; *lava-*

mano, Florence, S. Lorenzo, 212, Fig. 98

Vico, Enea, engraving of Leda, 193; engraving of Children's Bacchanale, 221

Vienna, Albertina, drawing after Medici tombs, 40, 150 n.49; Kunsthistorisches Mus., Paduan bronze relief, Fig. 263; bronze copy of Aurora, 155; Antico, Hercules and Anteus, 101

Vinci, Pierino, Death of Count Ugolino, Florence, Bargello, 186

Virgil, 64, 68, 70, 165 n.4

Vitelli, Alessandro, 197

Viterbo, Sebastiano del Piombo, Pietà, 20*f*

Vouet, Simon, Temptation of S. Francis, Rome, S. Francesco in Lucina, 147 n.44, Fig. 268

W

Weinberger, 168 n.12

Wickhoff, 62

Wilde, 147 n.44, 185

Windsor, Royal Library, drawing, Deeds of Hercules, 185; drawing after Ganymede, Fig. 154; Michelangelo, drawing No. *93*, 41, 215, Fig. 134; drawing No. *109*, 49*f*, 157 n.3, 218*f*, Fig. 145; drawing No. *115*, 220, Fig. 155; drawing No. *116*, 199, 220*f*; drawing No. *119*, 112, 114, 150 n.48, 199, 200, 221, Fig. 153; drawing No. *120*, 221, Fig. 156; drawing No. *121*, 221*f*, Fig. 157

Wittkower, 152 n.54

Wölfflin, xii, 61, 116, 149 n.47, 152 ns.54,55, 163 n.7

LIST OF ILLUSTRATIONS

LIST OF ILLUSTRATIONS

36. Detail from the Giorno: the head.
37. Detail from the Giorno: the left foot.
38. Lorenzo de' Medici: frontal view.
39. Lorenzo de' Medici: back view.
40. Detail from the Lorenzo: head in profile.
41. Detail from the Lorenzo: head in frontal view.
42. Giuliano de' Medici: frontal view.
43. Giuliano de' Medici: back view.
44. Detail from the Giuliano: head in profile.
45. Detail from the Giuliano: head in frontal view.
46. Detail from the Giuliano: the left hand.
47. Michelangelo, Sketch for a left hand. Florence, Casa Buonarroti. (No. 99.)
48. Detail from the Giuliano: the right hand.
49. The Virgin of the Medici Chapel: frontal view.
50. The Virgin of the Medici Chapel: back view.
51. The Virgin of the Medici Chapel: seen in profile.
52. The Virgin of the Medici Chapel: seen from the right side.
53. Detail from the Virgin: head in profile.
54. Detail from the Virgin: head in frontal view.
55. Detail from the Virgin: the Child seen from the back.
56. Detail from the Virgin: the Child seen in profile.
57. Crouching Youth: seen in profile. Leningrad, Eremitage.
58. Crouching Youth: seen in profile. Leningrad, Eremitage.
59. Crouching Youth: frontal view. Leningrad, Eremitage.
60. Crouching Youth: back view. Leningrad, Eremitage.
61. Model of a river god: frontal view. Florence, Accademia delle Belle Arti.
62. Model of a river god: view of the other side. Florence, Accademia delle Belle Arti.
63. Detail from the model of a river god: back view. Florence, Accademia delle Belle Arti.
64. Model of a river god: seen from the small side. Florence, Accademia delle Belle Arti.
65. The Virgin and Saints Cosmas and Damian.
66. Saint Cosmas, by Montorsoli.
67. Saint Damian, by Raffaelle da Montelupo.

OTHER SCULPTURES EXECUTED DURING THE PERIOD OF THE MEDICI CHAPEL

68. The Christ with the Cross: frontal view. Rome, Santa Maria sopra Minerva.
69. The Christ with the Cross: side view. Rome, Santa Maria sopra Minerva.
70. Detail from the Christ in Santa Maria sopra Minerva: the head.
71. The David-Apollo: seen slightly from the left. Florence, Bargello.

72. The David-Apollo: seen in diagonal view from the left. Florence, Bargello.
73. The David-Apollo: frontal view. Florence, Bargello.
74. The David-Apollo: back view. Florence, Bargello.
75. The David-Apollo: seen in profile from the right side. Florence, Bargello.
76. The David-Apollo: seen in one-quarter profile. Florence, Bargello.

DRAWINGS

77. Michelangelo, Sketches of marble blocks with measurements. Florence, Archivio Buonarroti (Cod. 1, fol. 103, p. 1).
78. Michelangelo, Autograph note. Florence, Archivio Buonarroti. (No. 105).
79. Michelangelo, Sketch of the ground plan of the Medici Chapel. Florence, Archivio Buonarroti. (No. 48.)
80. Michelangelo and pupil, Ground plan sketches of the choir of the Medici Chapel, and notes of a pupil. Florence, Archivio Buonarroti. (No. 49.)
81. Michelangelo, Sketches for the free-standing tomb of the Medici. London, British Museum. (No. 51) Frey 48.
82. Michelangelo, Project for the double wall tombs. London, British Museum. (No. 52) Frey 47.
83. Michelangelo, Sketches for the Medici tombs. Florence, Casa Buonarroti. (No. 53) Frey 70.
84. Michelangelo, Sketches for the Medici tombs. Florence, Casa Buonarroti. (No. 55) Frey 267b.
85. Michelangelo, Sketches for the Medici tombs. Florence, Casa Buonarroti. (No. 54) Frey 125a.
86. Michelangelo, Sketches for the Medici tombs. London, British Museum. (No. 56) Frey 39.
87. Lafreri, The Janus Arch in Rome. Engraving.
88. Michelangelo, Sketch for the Medici tombs. Detail of Fig. 86. London, British Museum. (No. 56) Frey 39.
89. Michelangelo, Project for the Medici tombs. London, British Museum. (No. 57) Frey 55.
90. Michelangelo, Project for the Magnifici tombs. London, British Museum. (No. 58) Frey 9a.
91. Michelangelo, Project for the Magnifici tombs. London, British Museum. (No. 59) Frey 9b.
92. Michelangelo, Project probably for the tomb of Bartolommeo Barbazza. Florence, Casa Buonarroti. (No. 63) Frey 125c.
93. Pupil of Michelangelo, Project for the tombs of Leo X and Clement VII, 1524. Dresden, Kupferstichkabinett. (No. 64.)
94. Aristotile da Sangallo, Copy after the project, Fig. 93. Lille, Musée Wicar, no. 744.

95. Michelangelo, Project drawing for the monuments of Leo X and Clement VII in the choir of San Lorenzo. Florence, Casa Buonarroti. (No. 65) Frey 125b.

96. Michelangelo, Project drawing for the architectural articulation of the choir of San Lorenzo, with the tombs of the Medici Popes. Florence, Casa Buonarroti. (No. 66) Frey 14.

97. Michelangelo, Projects for *lavamani* inspired by the *lavamano* of the Sagrestia Vecchia. Florence, Casa Buonarroti. (No. 85) Frey 137b.

98. Verrocchio, *Lavamano*. Florence, San Lorenzo, Sagrestia Vecchia.

99. Michelangelo, Sketch for the altar of the Medici Chapel. Florence, Casa Buonarroti. (No. 83) Frey 174.

100. Michelangelo, Sketch for the altar of the Medici Chapel. Florence, Casa Buonarroti. (No. 82) Frey 124.

101. Michelangelo, Sketch for the altar of the Medici Chapel. Florence, Casa Buonarroti. (No. 82) Frey 123.

102. Michelangelo, Project for the tabernacle niches of the Medici Chapel. Florence, Casa Buonarroti. (No. 79) Frey 177a.

103. Michelangelo, Project for the windows of the lunettes of the Medici Chapel. Florence, Casa Buonarroti. (No. 80) Frey 177b.

104. Michelangelo, Projects for pilaster bases and autograph text by Michelangelo. Florence, Casa Buonarroti. (No. 72) Frey 162.

105. Michelangelo, Projects for bases of columns or pilasters. Florence, Casa Buonarroti. (No. 73) Frey 163.

106. Pupil of Michelangelo, Studies of capitals, partly for the Medici Chapel. London, British Museum. (No. 75) Frey 241.

107. Michelangelo, Profile of the bases of the columns for the Magnifici tombs. Florence, Casa Buonarroti. (No. 76) Frey 175.

108. Michelangelo, Projects for the thrones of the attica of the Ducal tombs. Florence, Casa Buonarroti. (No. 81) Frey 266.

109. Michelangelo, Sketches of pilasters. Florence, Archivio Buonarroti, Cod. v, fol. 66-67 verso.

110. Michelangelo, Sketch of a door frame. Florence, Archivio Buonarroti, Cod. v, fol. 67-68 verso.

111. Michelangelo, Sketch of the upper part of a door frame, probably for the Medici Chapel. Florence, Archivio Buonarroti, Cod. IX, fol. 524 verso. (No. 77).

112. Michelangelo, Profile view of the doors and tabernacle niches of the Medici Chapel. Florence, Casa Buonarroti. (No. 78.)

113. Giovanni da Udine (?), Project drawing for the decoration of the coffers of a cupola, probably that of the Medici Chapel. Florence, Casa Buonarroti. (No. 84.)

114. Michelangelo, Sketches for sarcophagi, probably for San Silvestro in Capite. Florence, Casa Buonarroti. (No. 62.)

136. Pupil of Michelangelo, Projects for vases, probably for the Medici Chapel, sketch of a figure, and sonnet fragments by Michelangelo. London, British Museum. (No. 100) Frey 56.

137. Michelangelo, La Vittoria. Florence. Palazzo della Signoria.

138. Michelangelo and pupil (probably Antonio Mini), Sketches in connection with La Vittoria. Florence, Archivio Buonarroti, Cod. 1, fol. 98-99, p. 3 (No. 101).

139. Michelangelo, Sketches for the Hercules and Antaeus group. Detail. Oxford, Ashmolean Museum. (No. 92) Frey 145.

140. Michelangelo, Sketch of Hercules and Antaeus. Detail of Fig. 135. London, British Museum. (No. 91.)

141. Michelangelo, Studies of a horse. Florence, Casa Buonarroti. (No. 97.)

142. Michelangelo, Studies of a horse and rapid sketch of a battle scene. Oxford, Ashmolean Museum. (No. 96) Frey 141.

143. Michelangelo, Rapid sketch of a battle scene. Oxford, Ashmolean Museum. (No. 106) Frey 132.

144. Michelangelo, Resurrection of Christ. Paris, Louvre. (No. 108) Frey 40.

145. Michelangelo, Resurrection of Christ. Windsor, Royal Library. (No. 109) Frey 19.

146. Michelangelo, Ascension of Christ. London, British Museum. (No. 110) Frey 59.

147. Michelangelo, Sketch for a guard of the tomb for the Ascension of Christ. Florence, Archivio Buonarroti, Cod. 1, fol. 96-97 verso. (No. 103.)

148. Pupil of Michelangelo, Copy after the preceding drawing. Florence, Casa Buonarroti.

149. Marcello Venusti, Ascension of Christ. Copy after the drawings, Figs. 145 and 146. Cambridge, Mass., Fogg Museum of Art.

150. Michelangelo, The Attack of the Serpents and the Healing through the Brazen Serpent. Oxford, Ashmolean Museum. (No. 107) Frey 51.

151. Michelangelo, The Fall of Phaeton. London, British Museum. (No. 117) Frey 57.

152. Michelangelo, The Fall of Phaeton. Venice, Accademia delle Belle Arti. (No. 118) Frey 75.

153. Michelangelo, The Fall of Phaeton. Windsor, Royal Library. (No. 119) Frey 58.

154. Copy after Michelangelo, Ganymede. Windsor, Royal Library.

155. Michelangelo, Tityos. Windsor, Royal Library. (No. 115) Frey 6.

156. Copy after Michelangelo, The Children's Bacchanal. Windsor, Royal Library. (No. 120) Frey 187.

157. Copy after Michelangelo, The Saettatori. Windsor, Royal Library. (No. 121) Frey 298.

158. Pupil of Michelangelo, Resurrection of Christ (?). Florence, Archivio Buonarroti, Cod. XIII, fol. 148 verso. (No. 111.)

159. Michelangelo and pupil, Ascension of Christ. Oxford, Ashmolean Museum. (No. 112) Frey 136.

160. Michelangelo, Ascension of Christ. Florence, Archivio Buonarroti, Cod. VI, fol. 24-25 verso. (No. 113).
161. Pupil of Michelangelo, Ascension of Christ. Florence, Casa Buonarroti.
162. Michelangelo, Sketches of children. Florence, Uffizi. (No. 102) Frey 54.
163. Michelangelo, Sketch of a hand. Florence, Archivio Buonarroti, Cod. XIII, fol. 169-170 verso. (No. 89).

DETAILS OF AND WORKS RELATED TO THE ARCHITECTURE OF THE MEDICI CHAPEL

164. Matteo Nigetti, Ground plan of San Lorenzo (early seventeenth century). Florence, Uffizi.
165. Mid-sixteenth century, Ground plan of the Medici Chapel. New York, Collection János Scholz.
166. The Medici Chapel: exterior view of the east wall.
167. The Medici Chapel: exterior view of the west wall.
168. The Medici Chapel: exterior view of the north wall.
169. Brunelleschi, The lantern of the Sagrestia Vecchia.
170. Michelangelo, Detail of the lantern of the Sagrestia Nuova.
171. A lunette window of the Medici Chapel seen from outside.
172. An angle of the Medici Chapel seen from outside, corresponding to the pendentives inside.
173. The Medici Chapel: view of the west side.
174. A lunette window of the Medici Chapel seen from outside.
175. Detail of the entrance wall of the Medici Chapel.
176. Interior view of the Medici Chapel.
177. Drawing of the sixteenth century of the entrance wall of the Medici Chapel. Florence, Uffizi.
178. Giuliano da Sangallo and Cronaca, The Sacristy of Santo Spirito. Florence.
179. Brunelleschi, Interior of the Sagrestia Vecchia. San Lorenzo, Florence.
180. Brunelleschi, Interior of the Sagrestia Vecchia. San Lorenzo, Florence.
181. Michelangelo, A tabernacle niche of the Medici Chapel.
182. Michelangelo, A door of the Medici Chapel (at the left of the Notte).
183. Cronaca, San Salvatore presso San Miniato, Florence: detail of the second floor.
184. Michelangelo, Window of the second zone of the Medici Chapel.
185. Michelangelo, Architectural detail from the tomb of Giuliano de' Medici.
186. View of the small side of the sarcophagus of Lorenzo de' Medici.
187. View of the small side of the sarcophagus of Giuliano de' Medici.
188. Detail of the small side of the sarcophagus of Lorenzo de' Medici.
189. Detail of the small side of the sarcophagus of Giuliano de' Medici.
190. Detail of the architecture of the tomb of Lorenzo de' Medici.
191. Detail of the architecture of the tomb of Giuliano de' Medici.

219. Free version of the architecture and the figures of the Magnifici tombs. Oxford, Ashmolean Museum.

220. Free version of the Magnifici tombs. Paris, Louvre.

221. Attributed to Aristotile da Sangallo, Free version of the Magnifici tombs. Florence, Uffizi.

222. Vincenzo Danti, Free paraphrase of the Magnifici tombs. Detail. Paris, Louvre.

223. Aristotile da Sangallo, Free paraphrase of the Magnifici tombs. Florence, Uffizi.

224. Cornelius Cort, Engraving after the tomb of Giuliano de' Medici, 1570.

225. Cornelius Cort, Engraving of the Medici Virgin and Saints Cosmas and Damian, 1570.

226. Cornelius Cort, Engraving of the tomb of Lorenzo de' Medici, 1570.

227. Pupil of Michelangelo, Sketch for the double tomb of the Dukes. Florence, Casa Buonarroti. Frey 214b.

228. Vincenzo Danti, Free paraphrase of a Ducal tomb of the Medici Chapel. Oxford, Ashmolean Museum. Frey 214a.

229. Follower of Michelangelo, Free paraphrase of the Ducal tombs. Paris, Louvre.

230. Follower of Michelangelo, Free paraphrase of the Ducal tombs. Dresden, Kupferstichkabinett.

231. Aristotile da Sangallo, Free paraphrase of the Ducal tombs of the Medici Chapel. Munich, Kupferstichkabinett.

232. Detail of the base of the *pietra serena* pilaster at the left of the tomb of Giuliano de' Medici.

233. Michelangelo, Sketch of a vase, probably for the Medici Chapel, and sketches by a pupil. London, British Museum. (No. 79a.)

234. Detail of a door frame with volute and a tabernacle niche of the Medici Chapel.

WORKS RELATED TO THE SCULPTURES AND PAINTINGS OF THE MEDICI PERIOD

235. Michelangelo, The Christ of the Minerva.

236. Nicolas Beatrizet, Engraving after the Christ of the Minerva.

237. T. Landini, Copy of the Christ of the Minerva. Florence, Santo Spirito.

238. Pietro da Barga, Copy of the Christ of the Minerva. Florence, Bargello.

239. Jacob Matham, Engraving after the Christ of the Minerva.

240. Late sixteenth century, Drawing after the Christ of the Minerva. Florence, Uffizi.

241. J. Duquesnoy, Christ with the Cross, from the tomb of Cardinal Antonio Triest. Ghent, Cathédrale Saint-Bavon.

242. Free copy of the Christ of the Minerva. Bruges, Cathédrale Saint-Sauveur.

243. A river god of the Arch of Septimius Severus.

244. Michelangelo, The Abia lunette. Rome, Sistine Ceiling.

245. Michelangelo, Aurora.

246. Michelangelo, Bronze-colored nude. Rome, Sistine Ceiling.
247. Michelangelo, Bronze-colored nude. Rome, Sistine Ceiling.
248. Michelangelo, Crepuscolo.
249. Michelangelo, Bronze-colored nude. Rome, Sistine Ceiling.
250. Sixteenth century drawing after an ancient Leda relief. Berlin, Staatsbibliothek, Codex Pighianus.
251. Michelangelo, Notte.
252. The Torso Belvedere. Rome, Vatican.
253. Michelangelo, Bronze-colored nude. Rome, Sistine Ceiling.
254. Michelangelo, Giorno.
255. Michelangelo, The Prophet Isaiah. Rome, Sistine Ceiling.
256. Michelangelo, Lorenzo de' Medici.
257. Michelangelo, The Prophet Joel. Rome, Sistine Ceiling.
258. Michelangelo, Moses. Rome, San Pietro in Vincoli.
259. Michelangelo, Giuliano de' Medici.
260. G. A. Amadei, Detail from the Colleoni monument. Bergamo, Colleoni Chapel.
261. Michelangelo, The Medici Madonna.
262. Michelangelo, The Joseph lunette. Rome, Sistine Ceiling.
263. Paduan bronze relief, second half of the fifteenth century. Vienna, Kunsthistorisches Museum.
264. "Idea," from C. Ripa, *Iconologia*.
265. Bronze copy of the torso of the river god of Michelangelo. Florence, Bargello.
266. Bronze copy of a river god of Michelangelo. Florence, Bargello.
267. G. Vasari, Detail of the ceiling of the Sala del Cinquecento (with a copy of the river god of Michelangelo). Florence, Palazzo della Signoria.
268. Simon Vouet, Detail of the Temptation of St. Francis. Rome, San Lorenzo in Lucina.
269. Nicodemo Ferruzzi, Detail of a painting representing the artists and the works of Michelangelo, showing the river god of Michelangelo. Florence, Casa Buonarroti.
270. C. Allori, Detail of a painting representing Michelangelo as poet (showing the river god of Michelangelo). Florence, Casa Buonarroti.
271. Pierino da Vinci, The death of Count Ugolino. Detail. Florence, Bargello.
272. Attributed to Rosso Fiorentino, Copy after Michelangelo's David-Apollo. New York, Collection János Scholz (by courtesy of Mr. János Scholz).
273. Pontormo, Crouching Youth. Drawing. Paris, Louvre.
274. Michelangelo, Clay model for the Hercules and Cacus group, seen from the left. Florence, Casa Buonarroti.
275. Michelangelo, Clay model for the Hercules and Cacus group, principal view. Florence, Casa Buonarroti.

276. Michelangelo, Clay model for the Hercules and Cacus group, seen from the back. Florence, Casa Buonarroti.
277. Samson and the Philistines, copy after Michelangelo. Florence, Bargello.
278. Samson and the Philistines, another copy after Michelangelo. Florence, Bargello.
279. C. Bos, Engraving of the Leda of Michelangelo. London, British Museum.
280. Rosso Fiorentino, Cartoon after the Leda of Michelangelo. London, Royal Academy of Arts.
281. Sixteenth century drawing after an ancient Leda relief. Berlin, Staatsbibliothek, Codex Pighianus.
282. Rosso Fiorentino, Copy of the Leda of Michelangelo. London, National Gallery.
283. Venetian master of the mid-sixteenth century, Copy of the Leda of Michelangelo. Venice, Museo Correr.
284. School of Rubens, Copy of the Leda of Michelangelo. Dresden, Museum.
285. Ammannati, Marble copy of the Leda of Michelangelo. Florence, Bargello.
286. Michelangelo, Sketch for the Venus and Cupid. London, British Museum. (No. 122) Frey 212c.
287. Copy (probably by Bronzino) after the cartoon of Michelangelo's Venus and Cupid. Naples, Museo Nazionale.
288. Attributed to Daniele da Volterra, Copy of Michelangelo's Venus and Cupid. Florence, Uffizi.
289. Attributed to Bronzino, Copy of Michelangelo's Venus and Cupid. Naples, Museo Nazionale.
290. School of Pontormo, Copy after Michelangelo's *Noli me tangere*. Florence, Casa Buonarroti.
291. Battista Franco, Copy after Michelangelo's *Noli me tangere*. Florence, Casa Buonarroti.
292. Ancient sarcophagus with Poseidon and Gaia and the image of the dead in a clypeus. Rome, Palazzo Mattei.
293. Ancient sarcophagus with the door of Hades. Florence, by the south entrance of the Baptistry.
294. Ancient sarcophagus with the Fall of Phaeton. Florence, Uffizi.
295. Ancient gem representing the Fall of Phaeton. Florence, Uffizi.
296. Moderno, Bronze relief after an ancient sarcophagus. London, Victoria and Albert Museum.
297. Woodcut representing the Fall of Phaeton, from Ovid, *Metamorphoseos Vulgare*, Venice, 1522, p. 9 verso.
298. Giovanni Bernardi da Castelbolognese, Rock crystal engraving after Michelangelo's Fall of Phaeton. Baltimore, Walters Art Gallery.
299. Ancient mosaic representing Ganymede, from Sainte Colombe.

300. Ancient Ganymede group. Rome, Vatican.
301. B. Perruzzi, Ganymede. Rome, Farnesina.

TOMBS RELATED TO THE MEDICI CHAPEL

302. G. A. Dosio, Niccolini Chapel. Florence, Santa Croce.
303. G. A. Dosio, Niccolini Chapel. Florence, Santa Croce.
304. Giovanni da Bologna, Sant' Antonino Chapel. Florence, San Marco.
305. Interior of the Confraternità di San Luca, 1561. Florence, SS. Annunziata.
306. Michelangelo and Urbino, Monument of Cecchino Bracci. Rome, Santa Maria in Ara Coeli.
307. Drawing after the Cecchino Bracci monument. Florence, Uffizi.
308. Mid-sixteenth century drawing for a Papal monument. Munich, Kupferstich-kabinett.
309. Monument of the Cardinal Raffaello Riario. Rome, SS. Apostoli.
310. Michelangelo, Drawing for the top of a mantel or for a funeral monument. Florence, Archivio Buonarroti, Cod. XIII, fol. 160-161 recto.
311. Project for the monuments of the Medici Popes. Oxford, Christ Church College.
312. Attributed to Bandinelli, Project for the tombs of the Medici Popes. Munich, Kupferstichkabinett.
313. Attributed to Bandinelli, Project for the tombs of the Medici Popes. Berlin, Kupferstichkabinett. (Second garniture.)
314. Leone Leoni, Monument of Gian Giacomo de' Medici. Milan, Cathedral.
315. Antonio da Sangallo and Bandinelli, Monument of Pope Clement VII. Rome, Santa Maria sopra Minerva.
316. Ponzio, Monument of Pope Paul V. Rome, Santa Maria Maggiore.
317. Fontana, Monument of Pope Sixtus V. Rome, Santa Maria Maggiore.
318. Giacomo della Porta, Monument of Luisa Deti. Rome, Santa Maria sopra Minerva.
319. Giacomo della Porta, Monument of the Cardinal Alessandrino. Rome, Santa Maria sopra Minerva.
320. Domenico Fontana, Monument of Pope Nicolas IV. Rome, Santa Maria Maggiore.
321. Rainaldi, Monument of Pope Clement IX. Rome, Santa Maria Maggiore.
322. Guglielmo della Porta, Monument of Pope Paul III. Rome, St. Peter's.
323. Gian Lorenzo Bernini, Monument of Pope Urban VIII. Rome, St. Peter's.
324. Ricordo from Fra Giampietro Caravaggio, Prior of San Martino, Bologna, made for Michelangelo (1529). Florence, Archivio Buonarroti, Cod. VI, fol. 39; cf. Frey, *Briefe*, p. 300.
325. Letter from Michelangelo to Giovanni Spina. Florence, Archivio Buonarroti, Cod. V, fol. 38 recto.

PHOTOGRAPHIC SOURCES

PHOTOGRAPHIC SOURCES

The following photographs were made especially for this work mostly under the author's direction:

By Alinari in Florence: no. 7; by Brogi in Florence: nos. 2, 10, 13, 18, 21, 22, 24, 25, 32, 33, 47, 52-56, 64, 114, 125, 141, 182, 186, 188, 200; by Carboni in Rome: nos. 3, 35, 74; by Ciacchi in Florence: nos. 77-80, 92, 109-111, 122, 129, 138, 147, 158, 160, 163, 310; by Cipriani in Florence: nos. 4-6, 40, 45, 46, 113, 164, 166-168, 177, 208, 210-217, 307, 324; by Faraglia in Rome: no. 243; by Gevaerts in Bruges: no. 242; by Macbeth in London: nos. 132, 133; by Marquette in Lille: no. 94; by Rigal in Paris: nos. 87, 165; by Sansaini in Rome: nos. 246, 247, 249, 253; by Scherb in Vienna: nos. 224, 225, 226, 236; by Tolnay: nos. 169-174, 183, 187, 189, 232; by permission of His Majesty the King of England, Windsor Castle: nos. 153, 155; by courtesy of Mr. János Scholz, New York City: nos. 165, 272; by courtesy of the Kupferstichkabinett, Berlin: nos. 239, 313; by courtesy of the British Museum: nos. 81, 82, 86, 88, 89, 117, 136, 279; by courtesy of Christ Church, Oxford: nos. 123, 218, 311; by courtesy of the Kupferstichkabinett, Munich: nos. 231, 308, 312; by courtesy of the Metropolitan Museum, New York: no. 209.

For the following photographs thanks are due to:

Alinari in Florence: nos. 16, 27-30, 37, 48, 98, 115, 120, 178, 180, 181, 185, 207, 238, 260, 265, 266, 271, 277, 278, 302, 304, 305, 306, 309.

Anderson in Florence: nos. 8, 9, 11, 12, 14, 17, 19, 23, 31, 38, 41, 42, 44, 49, 68-70, 252, 282, 283, 289, 300, 301, 315-321.

Les Archives Photographiques, Paris: no. 273.

Brogi in Florence: nos. 34, 51, 62, 63, 65-67, 71, 72, 75, 76, 184, 204-206; by courtesy of Johannes Wilde: 274-276, 285, 293, 294, 303, 323.

Buyens in Ghent: no. 241.

Sopraintendenza alle Gallerie di Firenze (Cipriani) in Florence: by courtesy of Giovanni Poggi, nos. 15, 20, 26, 36, 39, 43, 50, 201-203, 240, 325-330.

Giraudon in Paris: nos. 144, 220, 222, 229.

Manelli in Florence: nos. 1, 73, 175, 179, 190, 191, 193-199.

By courtesy of the Kupferstichkabinett, Dresden: no. 230.

By courtesy of the Eremitage, Leningrad: nos. 57-60.

By courtesy of the British Museum: nos. 90, 91, 121, 131.

By courtesy of the Royal Academy of Arts, London: no. 280.

By courtesy of the Victoria and Albert Museum: no. 296.

By courtesy of the Walters Art Gallery, Baltimore: no. 298.

The following illustrations are from publications:

Altmann, *Antike Grabsarkophage*: no. 192.

Bollettino d'arte, V, 1925, (Steinmann): no. 287.

von Geymüller, *Michelangelo Buonarroti als Architekt*, Munich, 1904: nos. 176, 234.

Lippold, *Gemmen und Kameen des Altertums*, Stuttgart, n.d.: no. 295.

Münchner Jahrbuch der bildenden Künste, I, 1906 (Gottschewski): no. 61; *ibidem*, N.F. IV, 1927 (Popp): no. 93.

PLATES

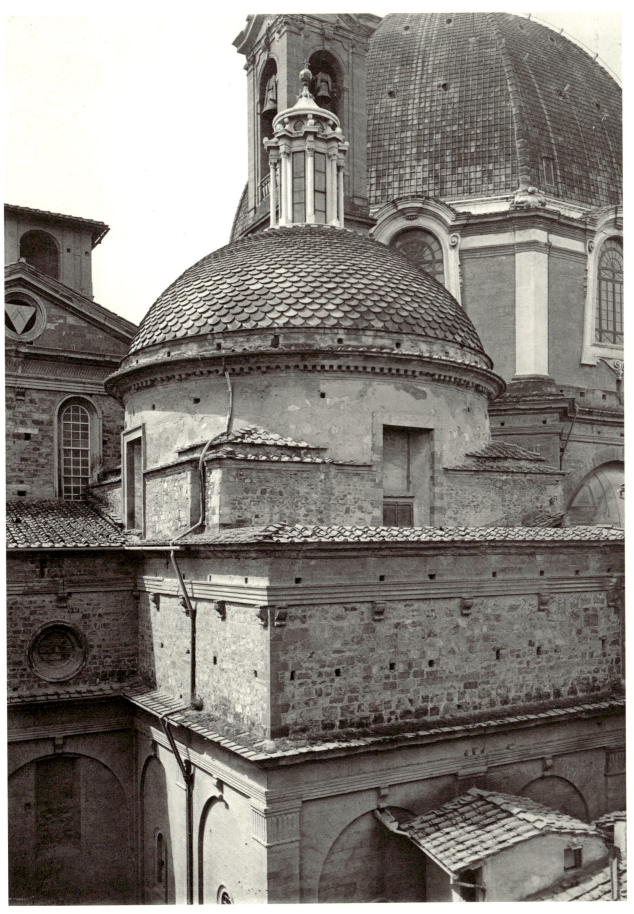

1

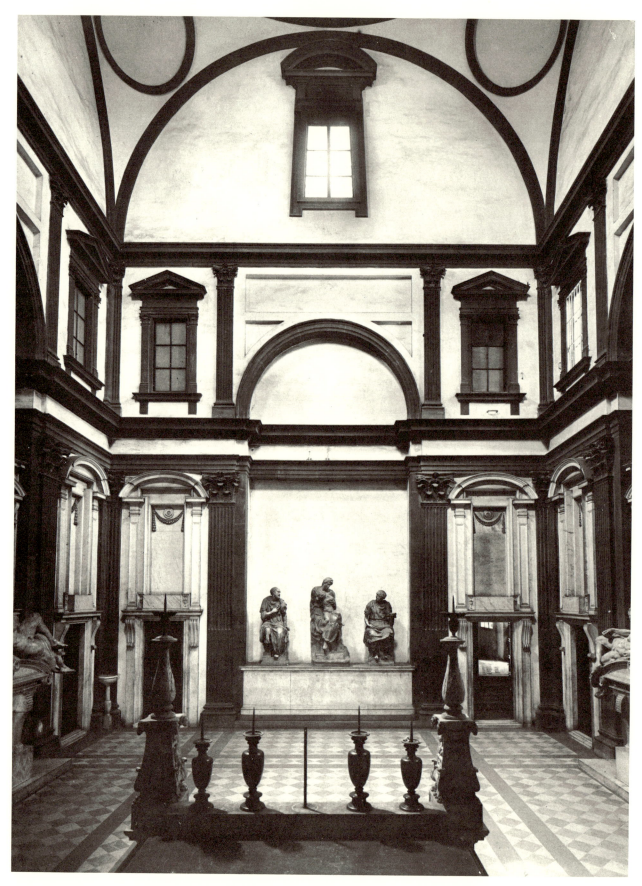

2

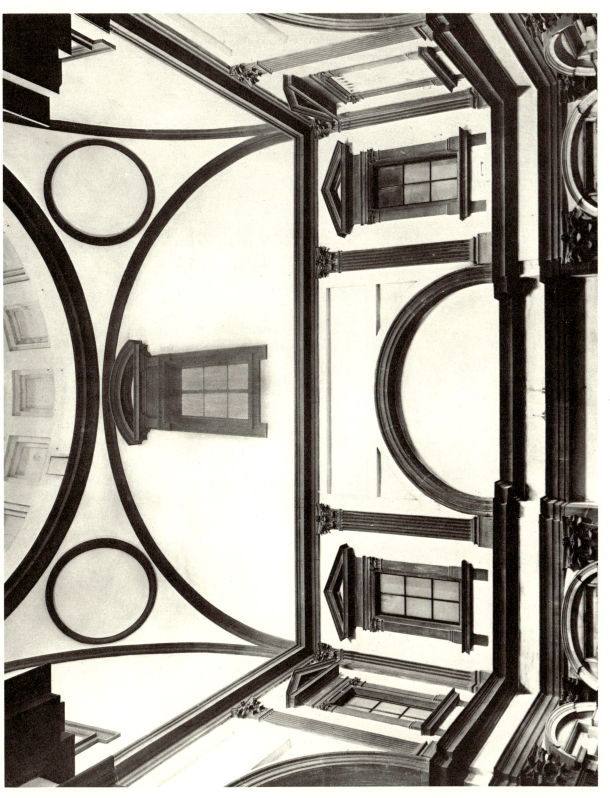

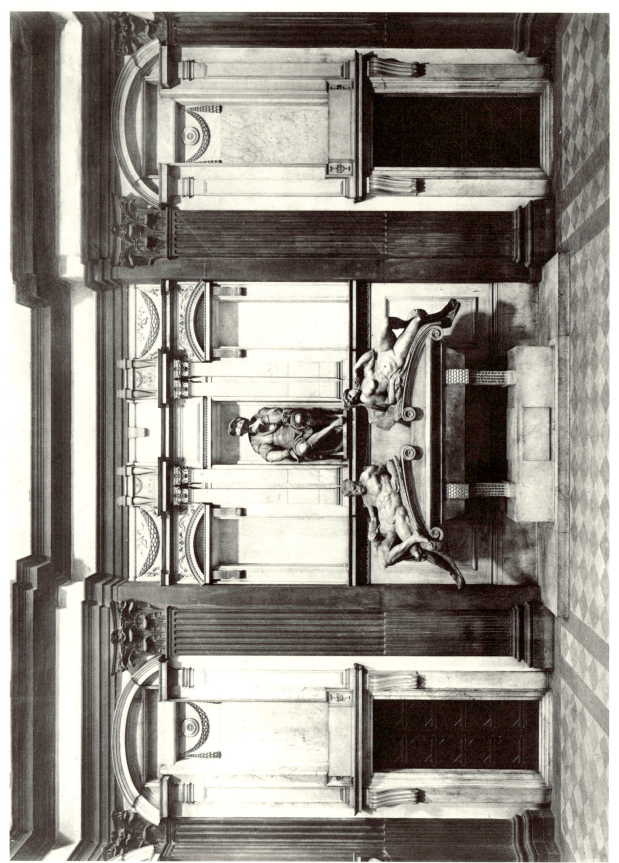

4

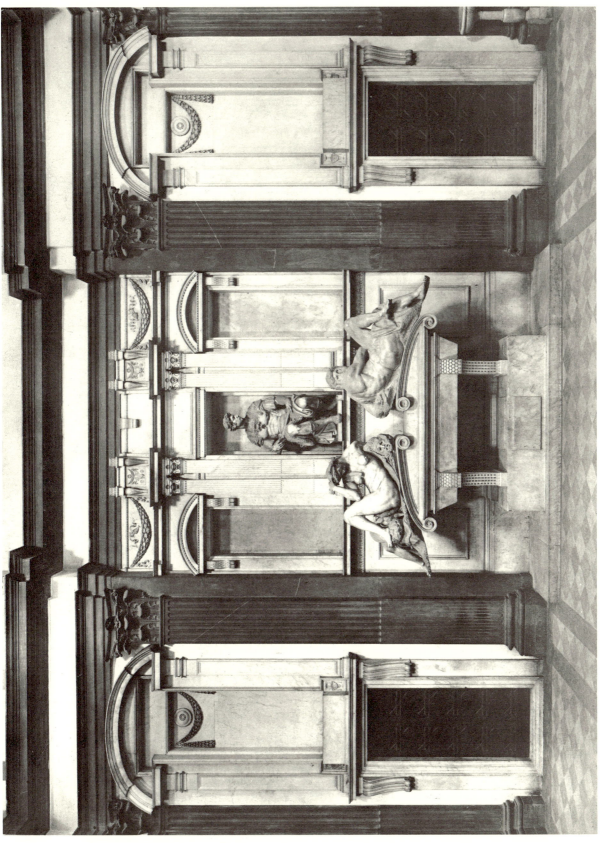

5

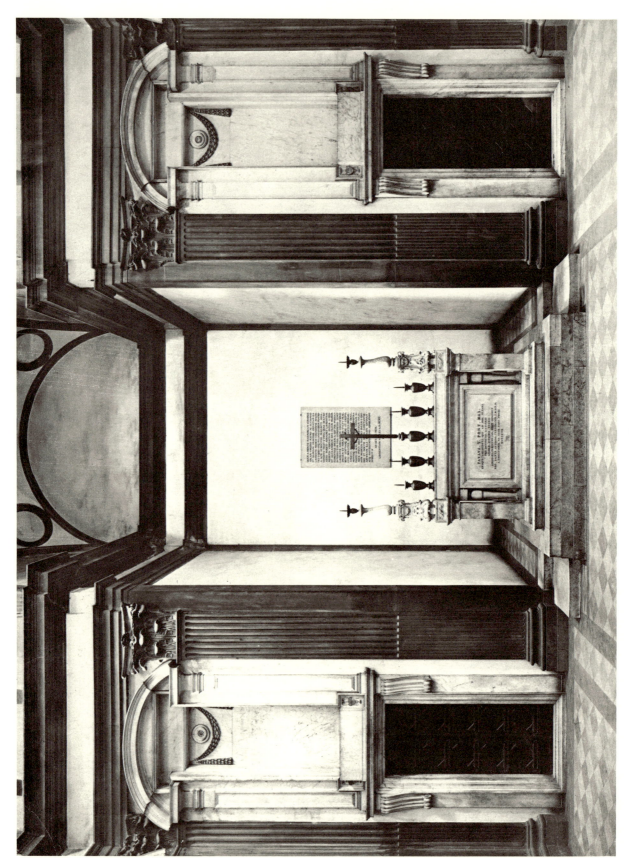

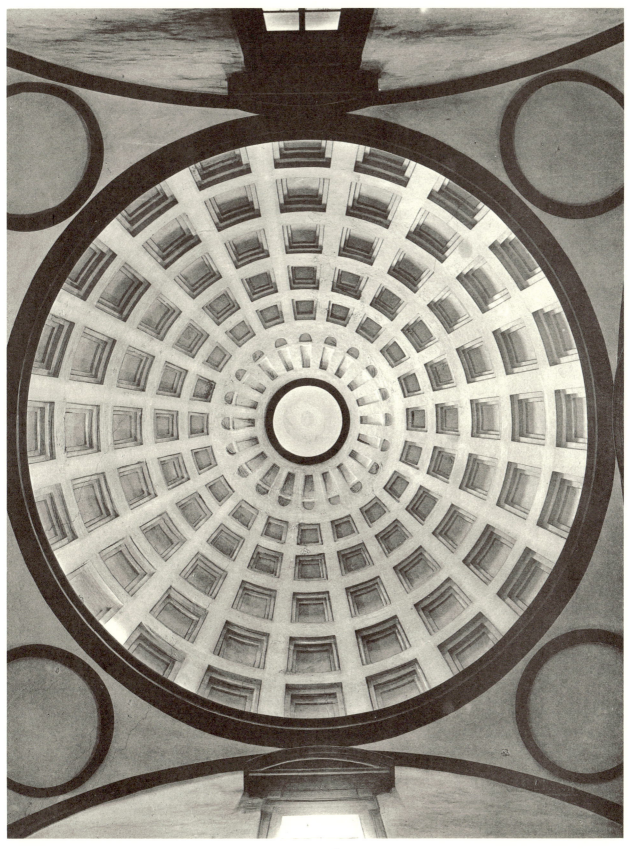

7

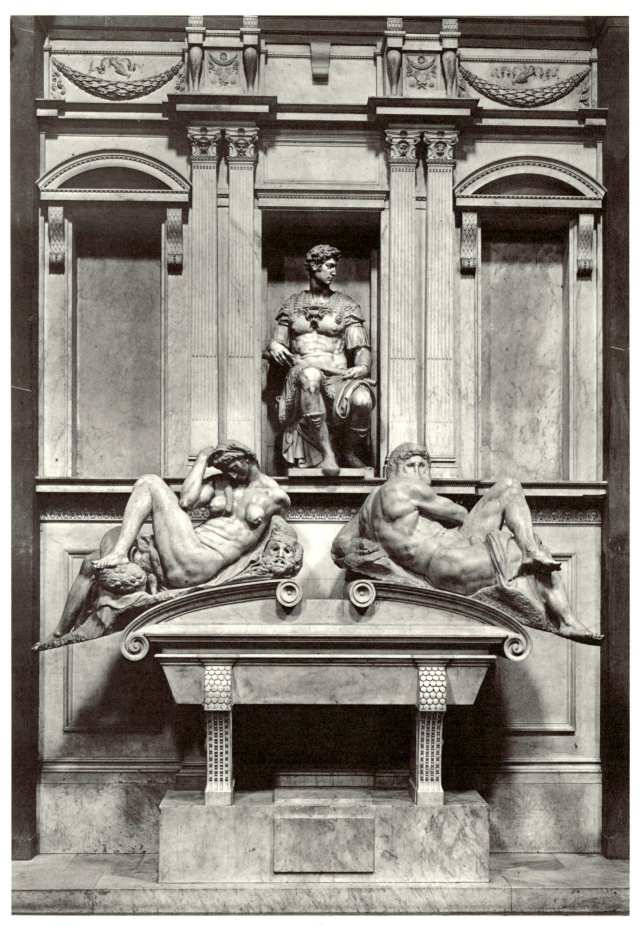

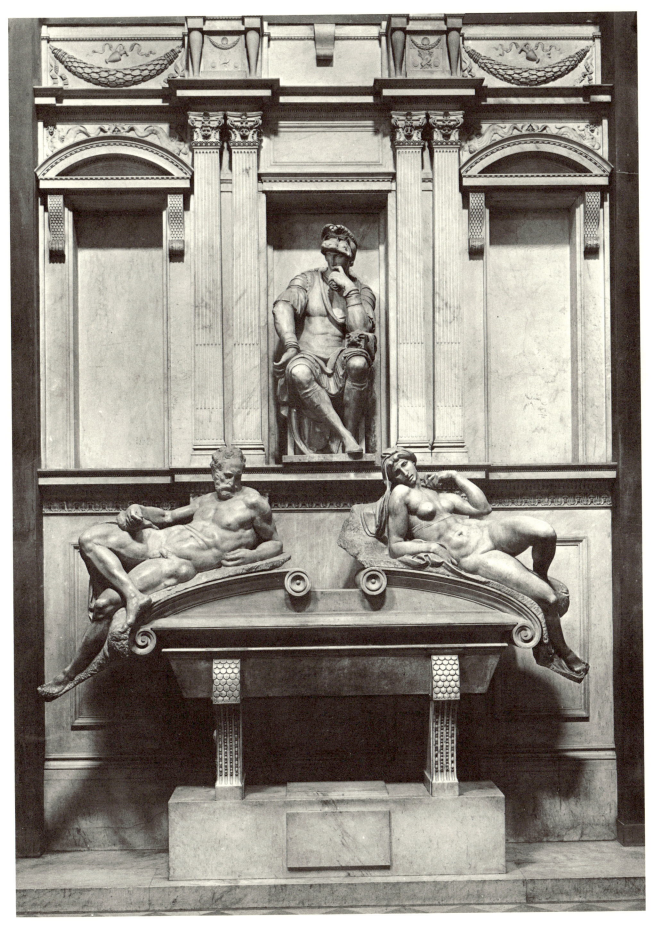

9

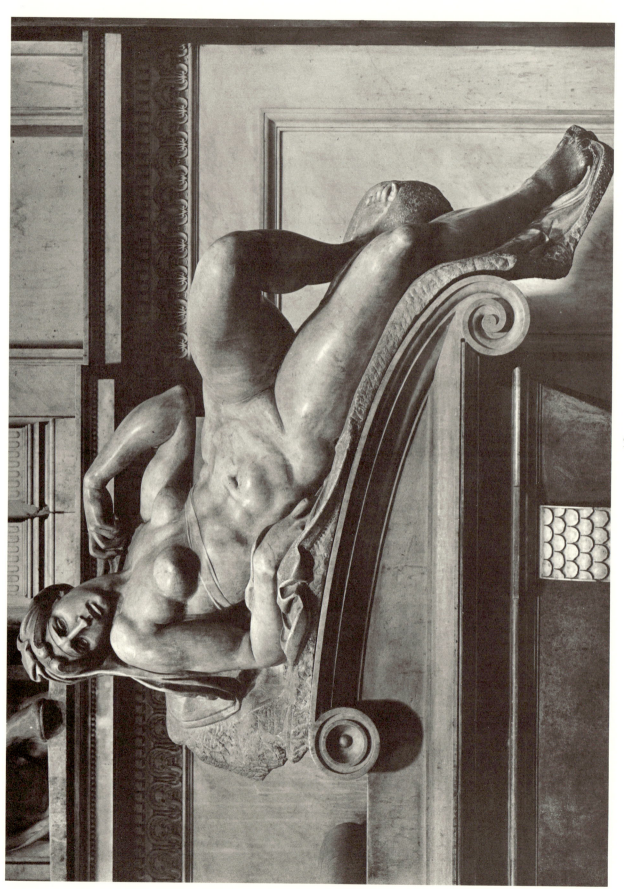

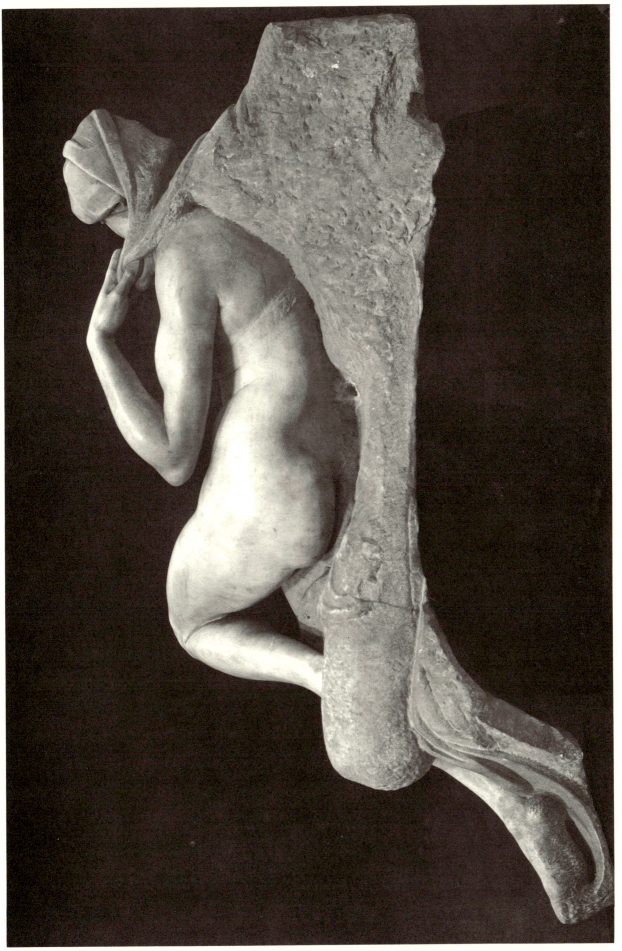

11

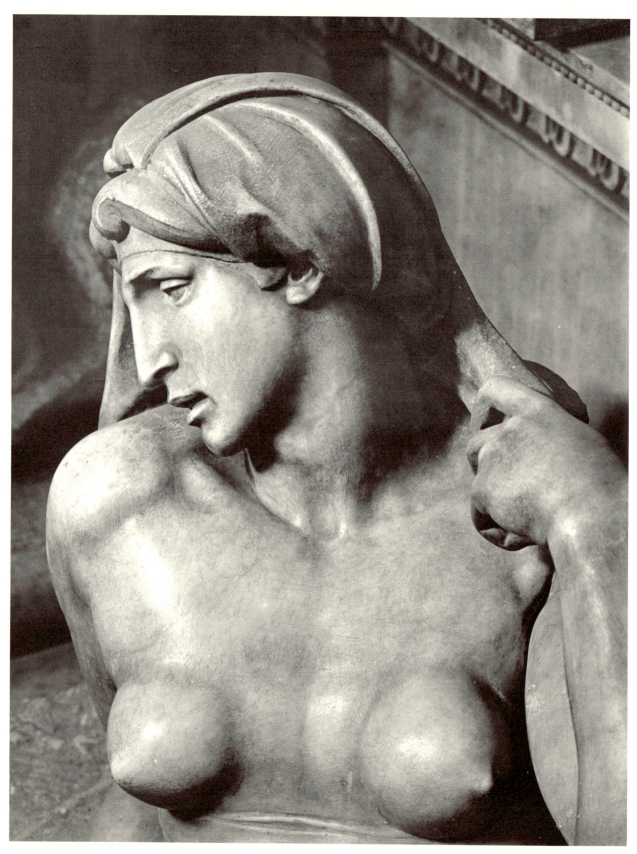

12

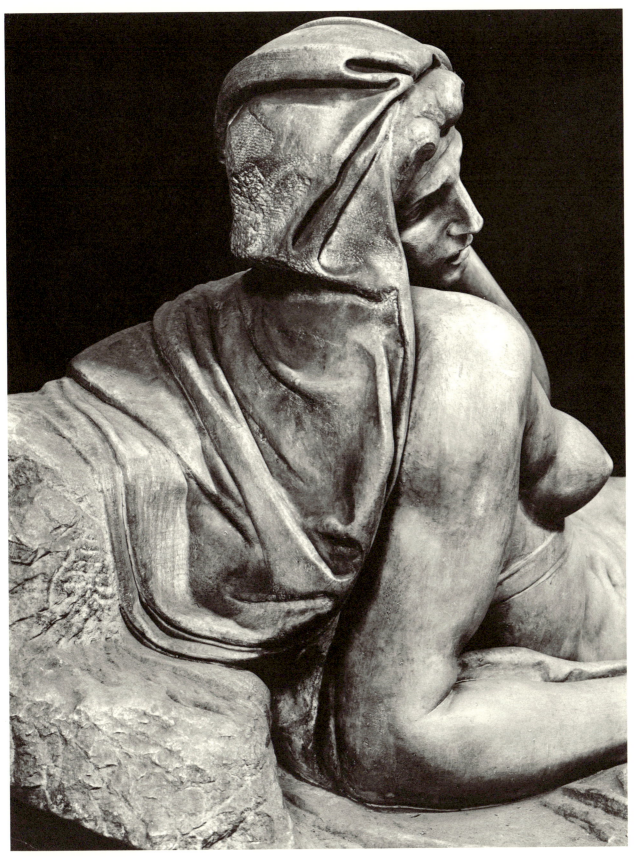

13

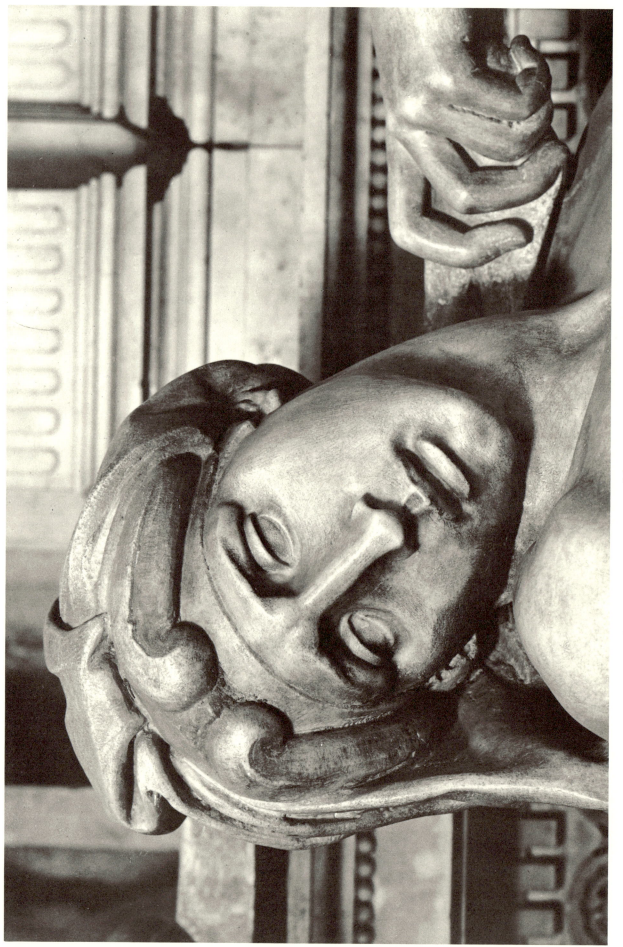

14

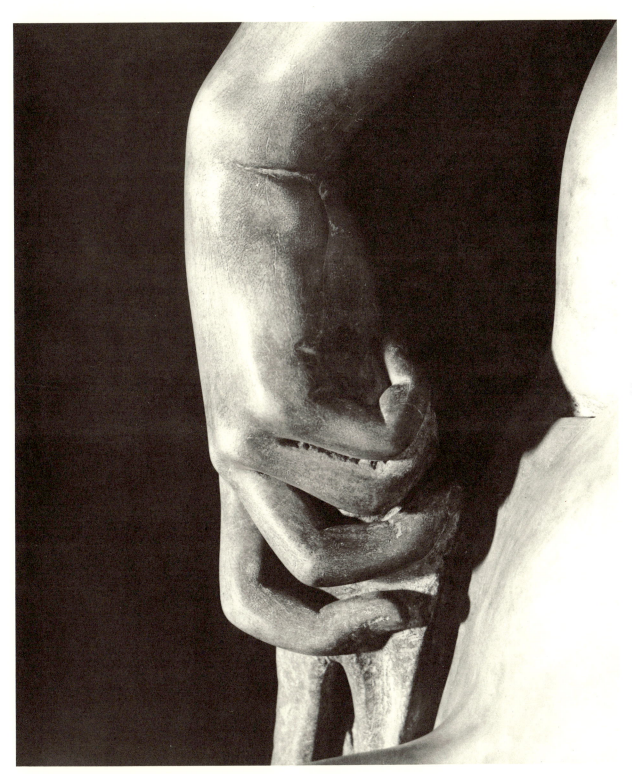

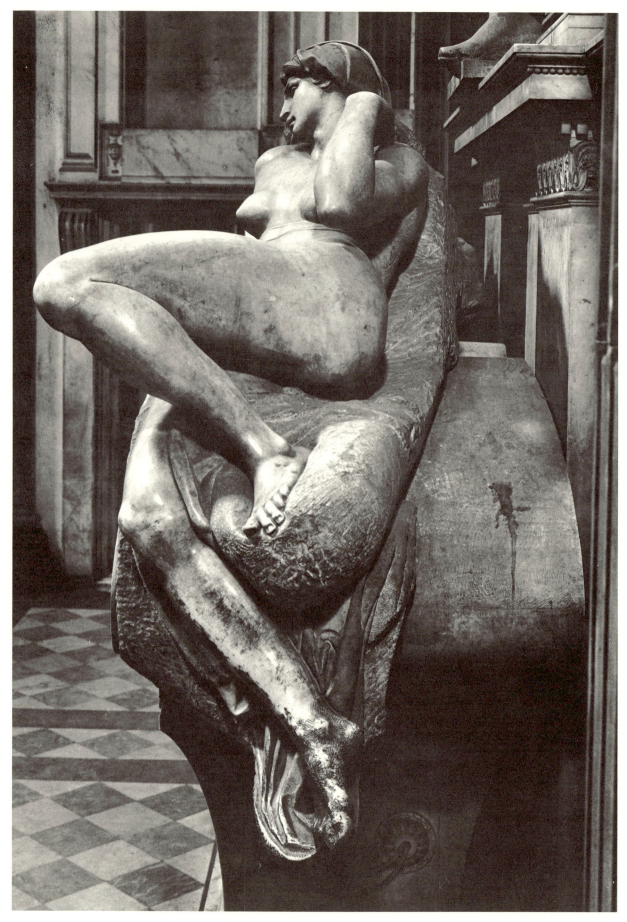

16

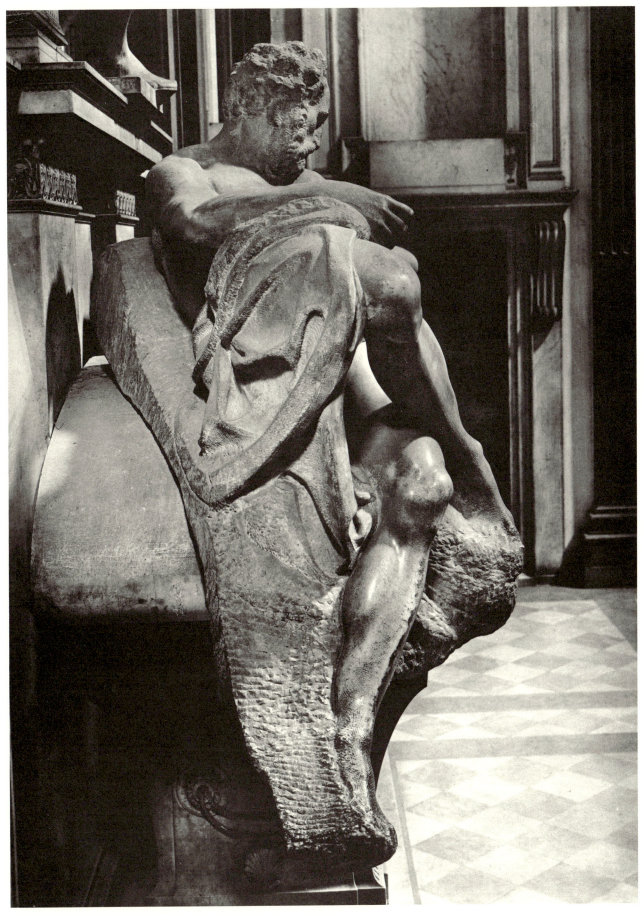

17

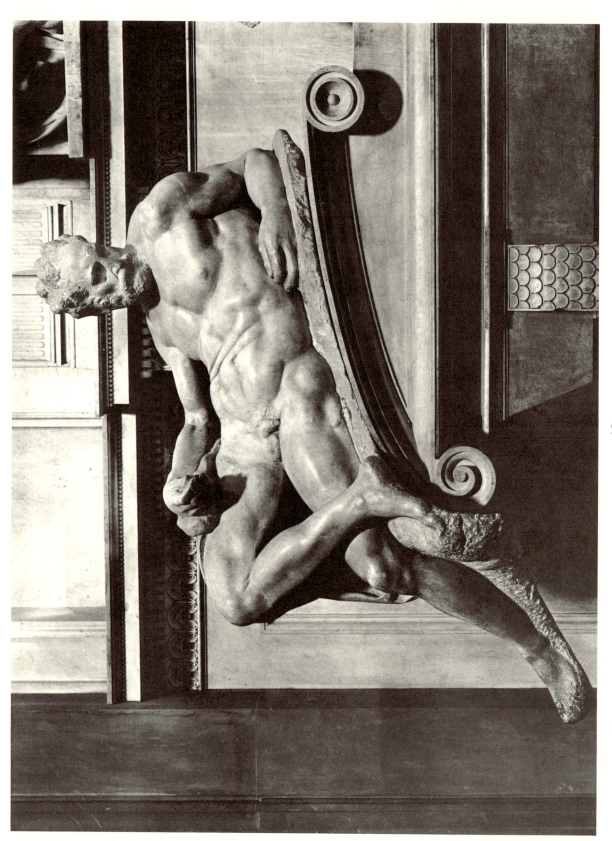

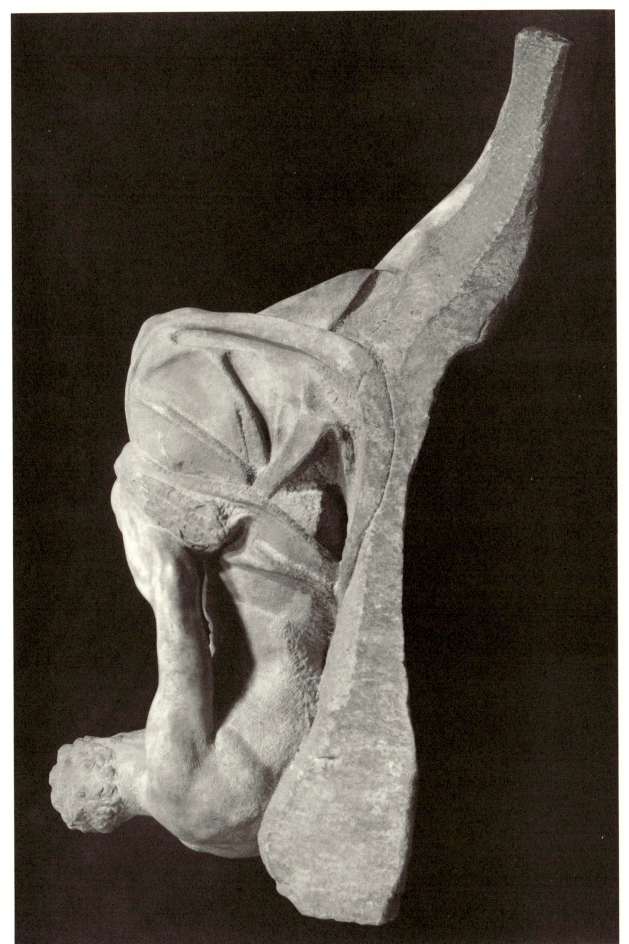

19

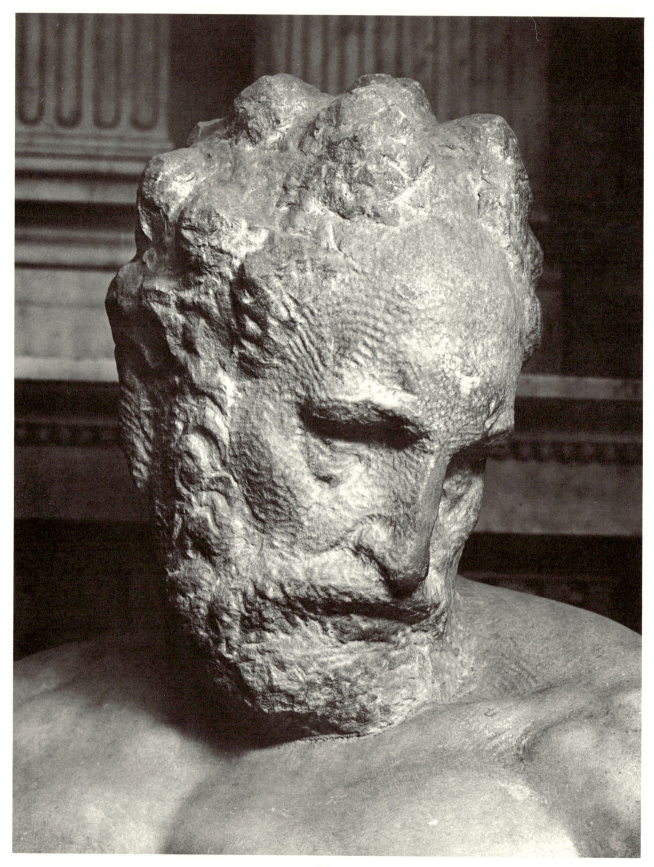

20

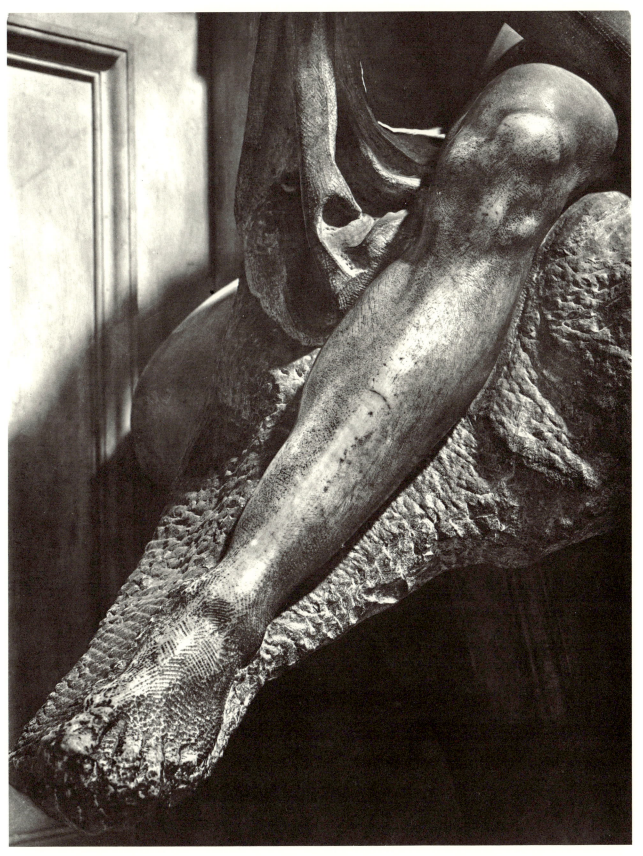

21

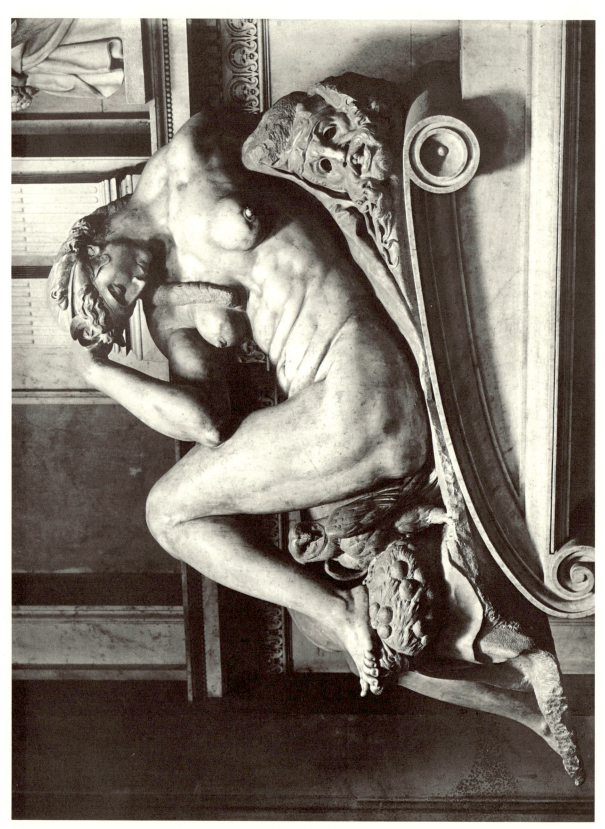

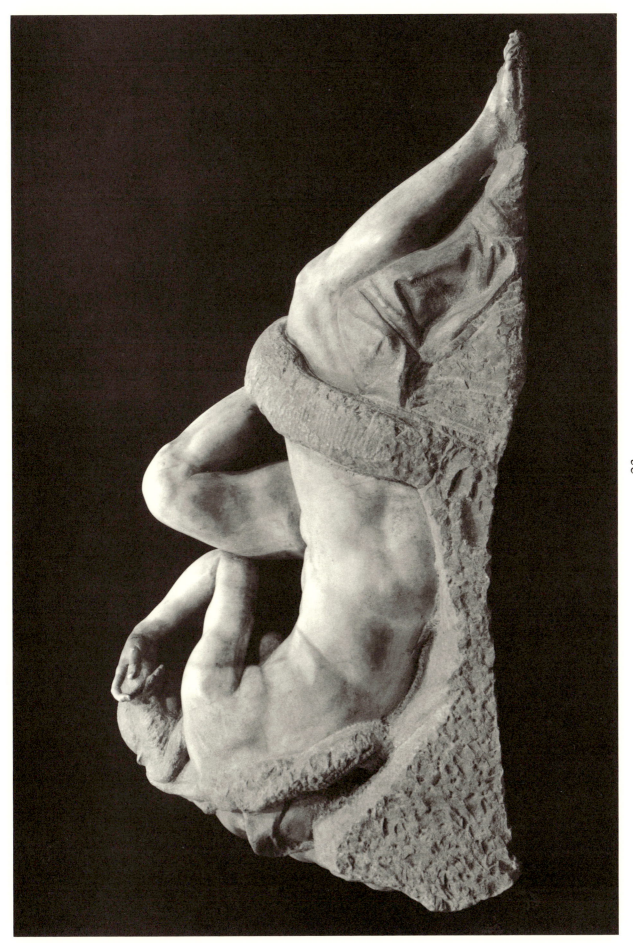

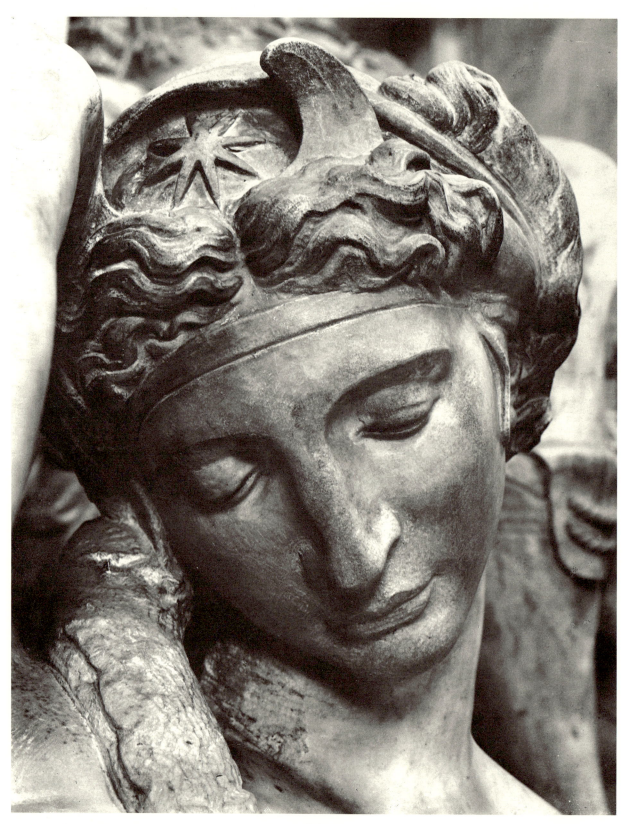

24

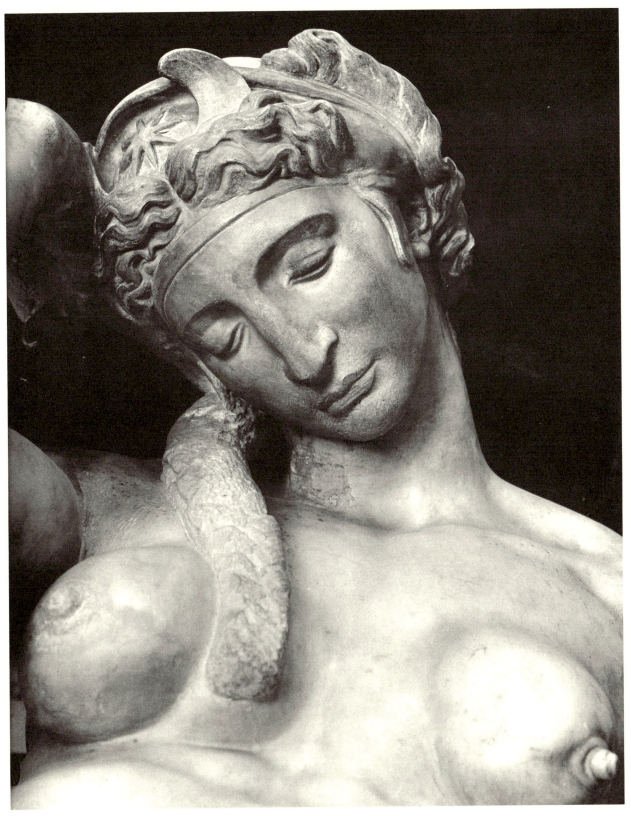

25

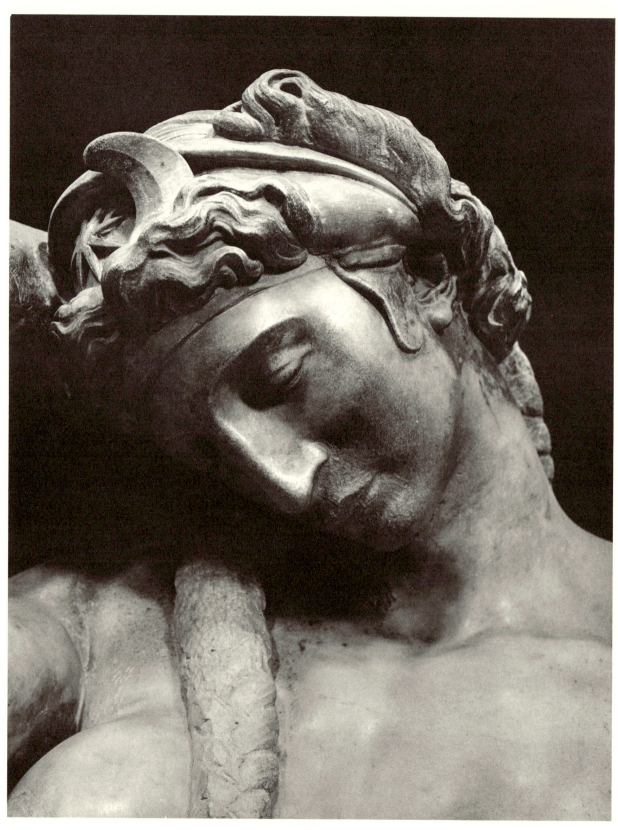

26

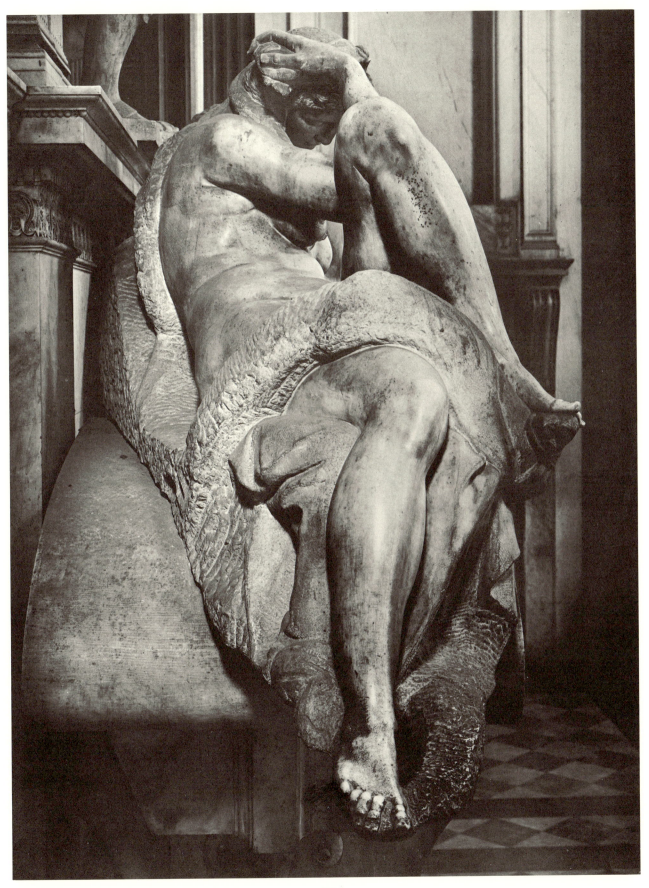

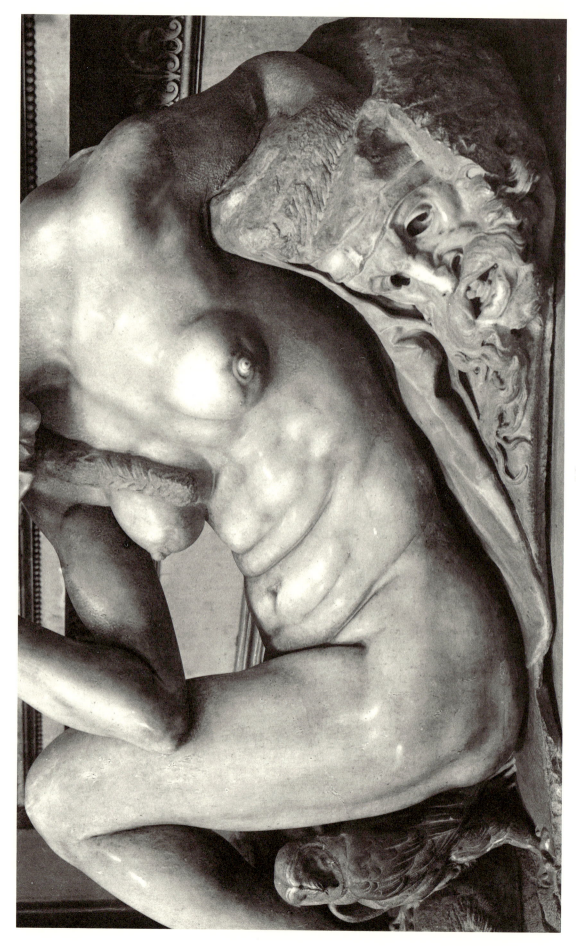

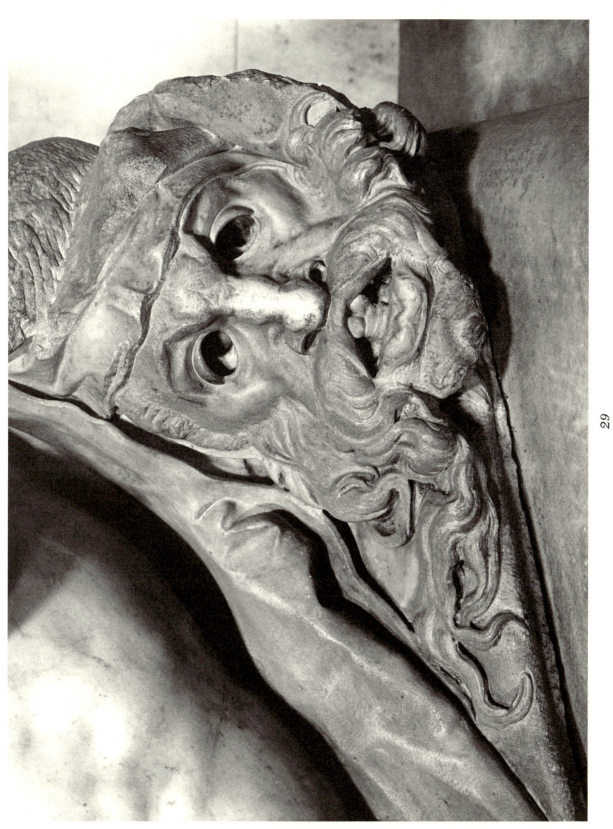

29

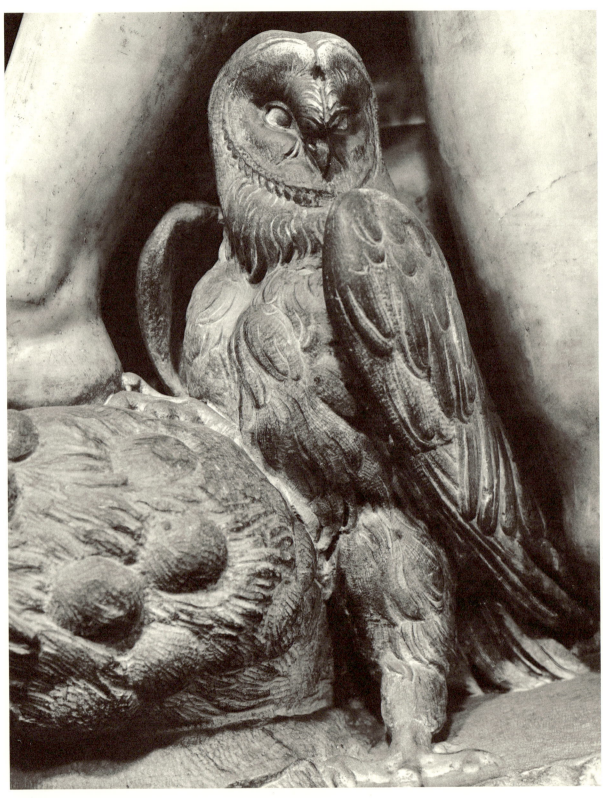

30

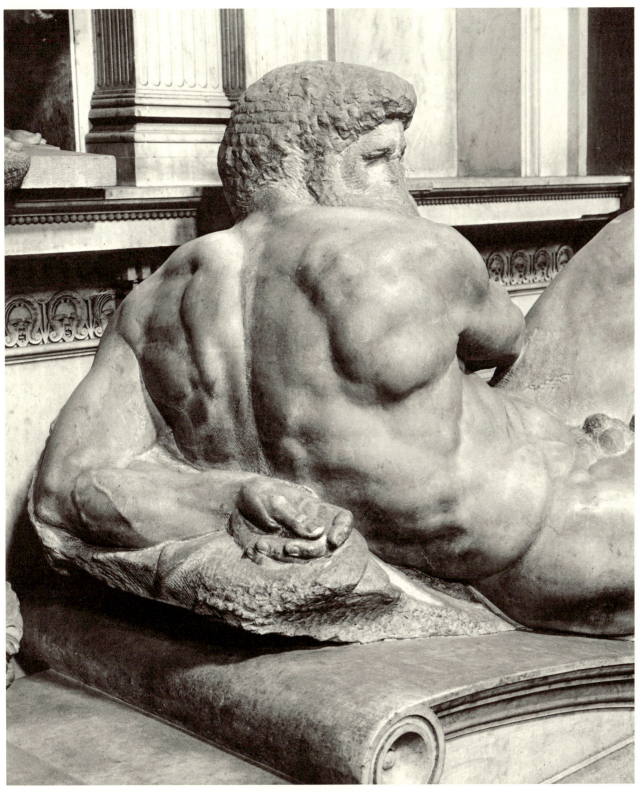

31

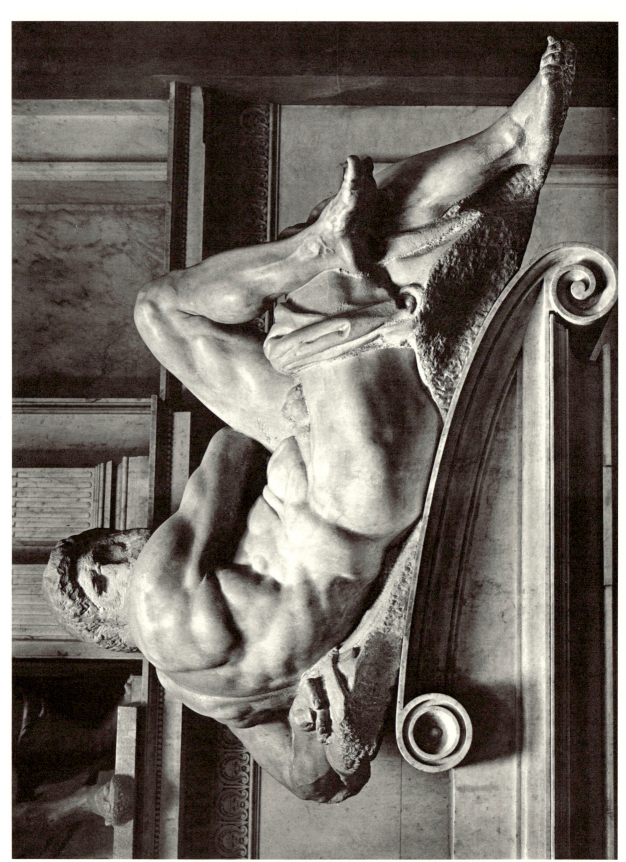

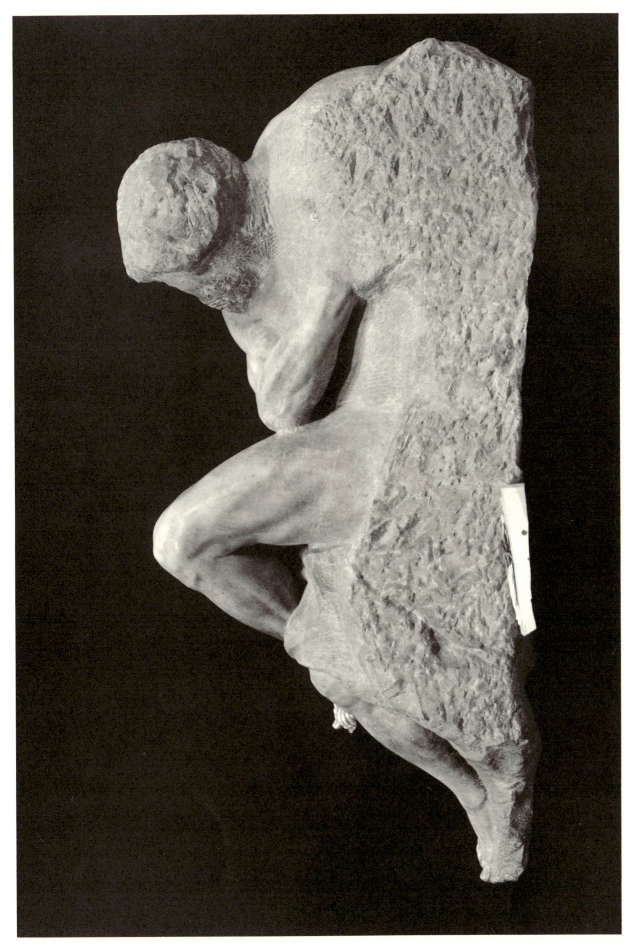

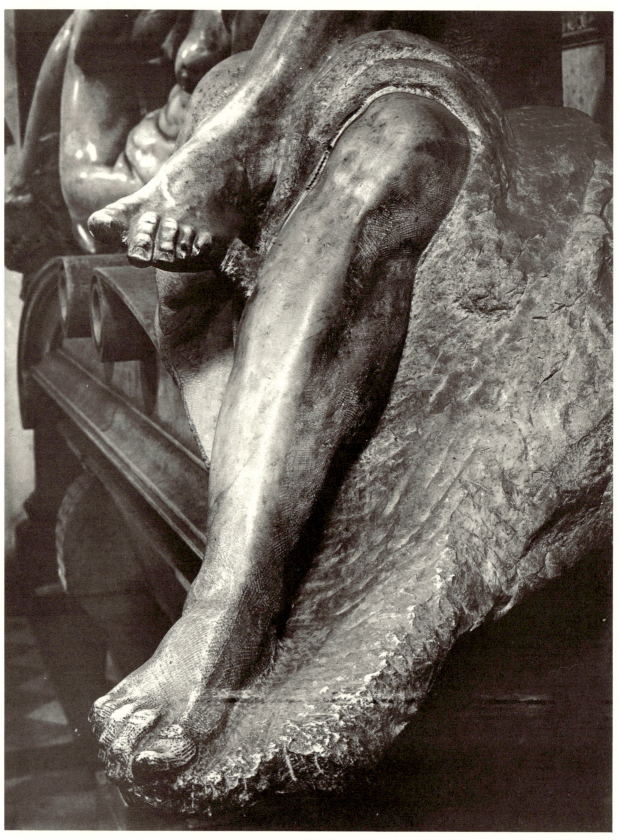

34

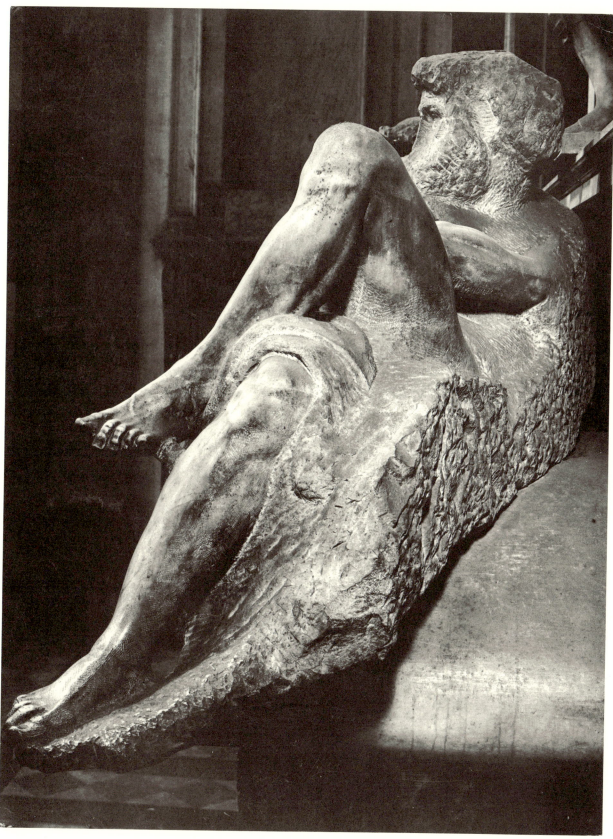

35

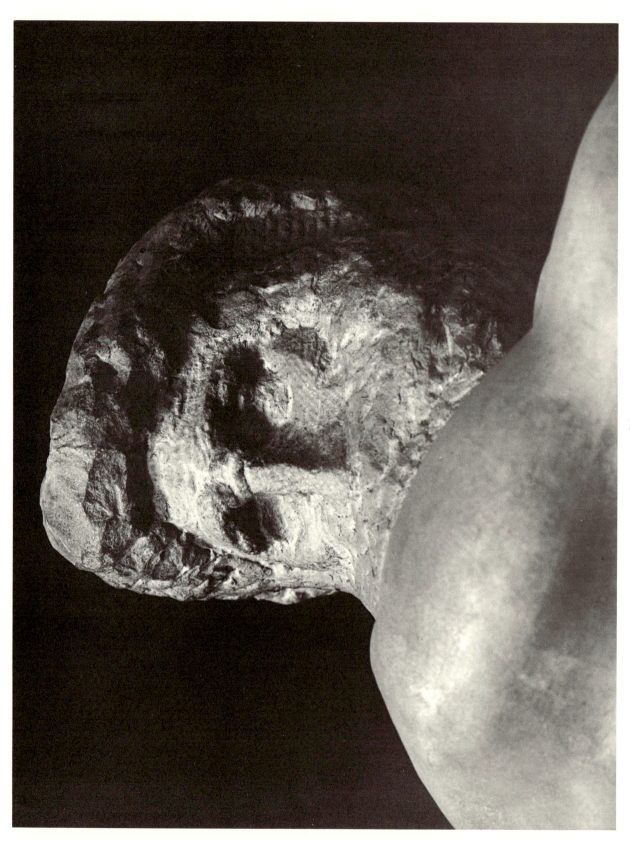

36

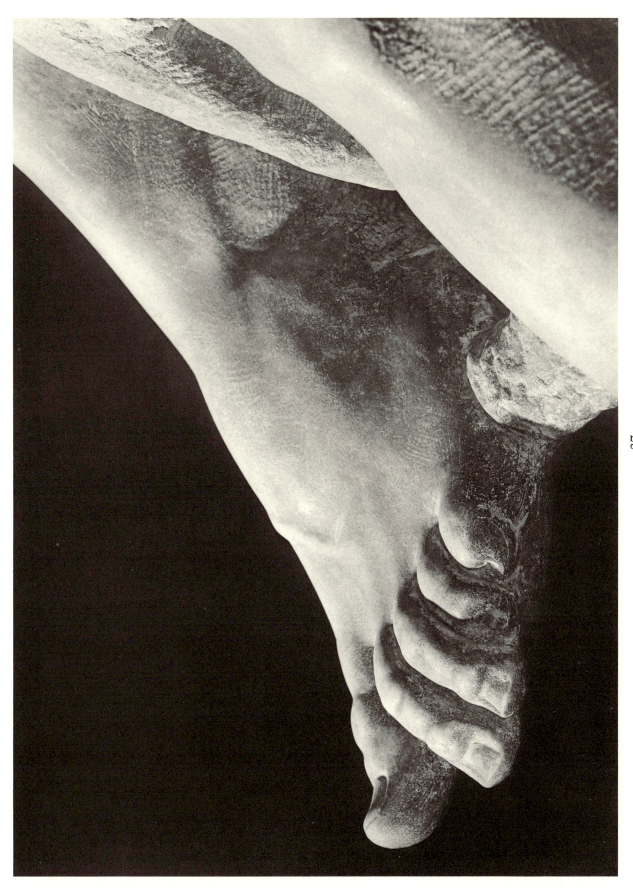

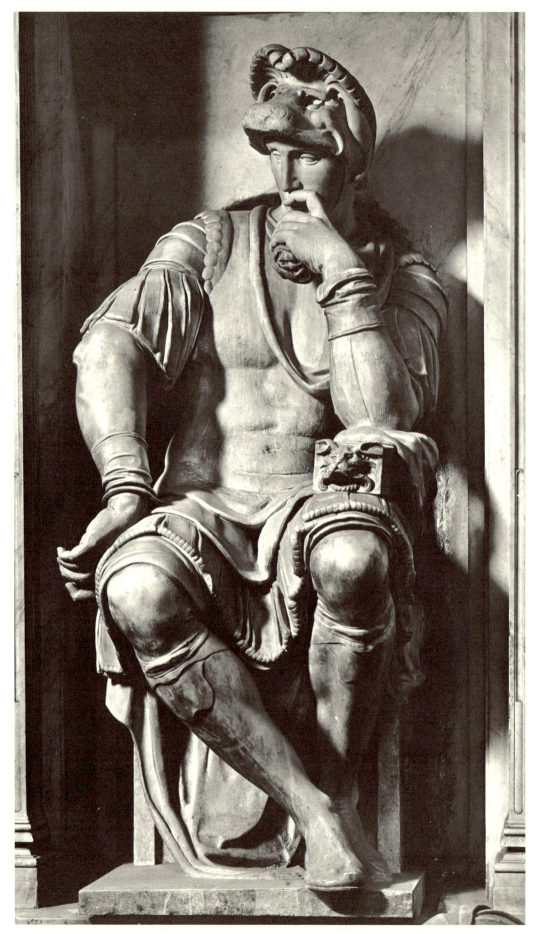

38

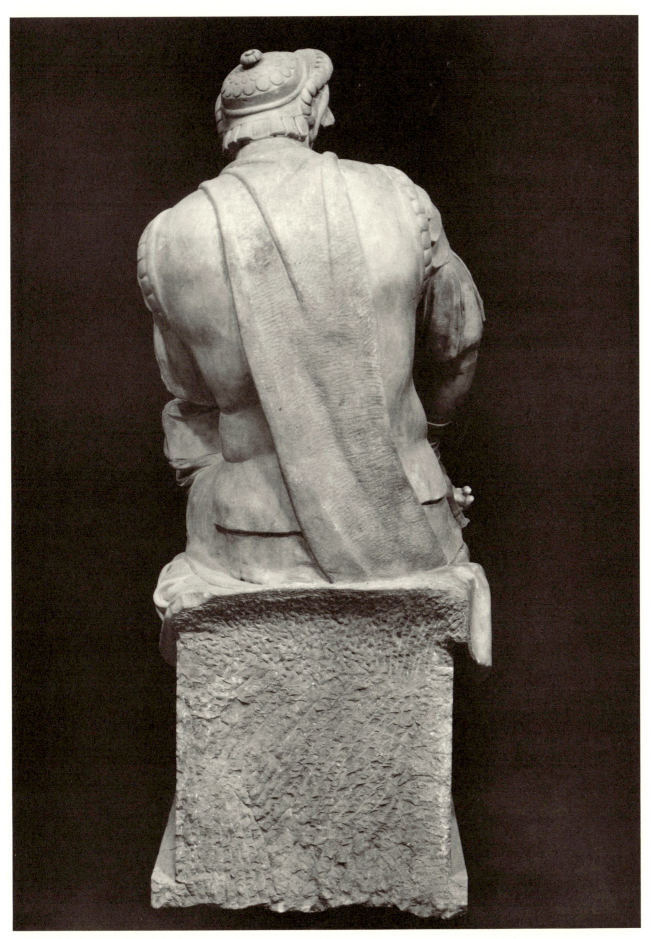

39

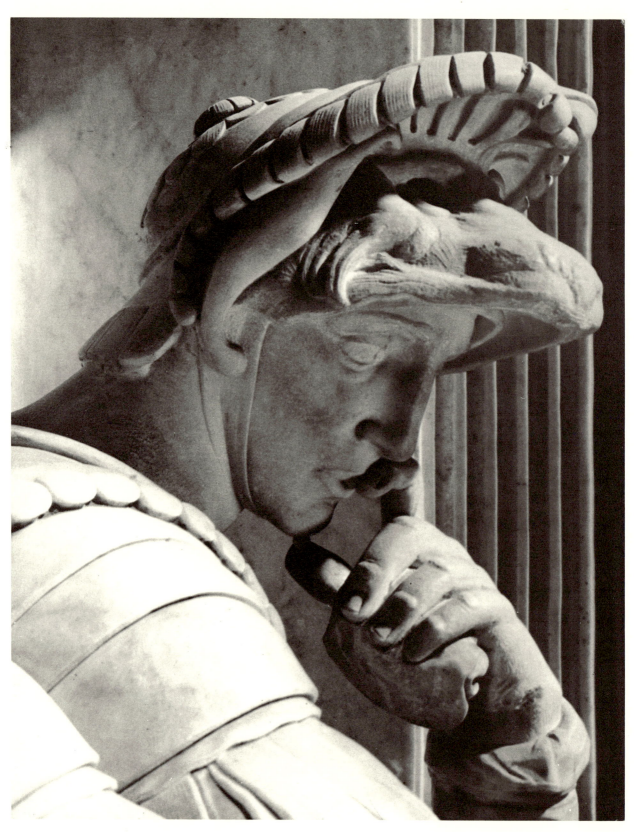

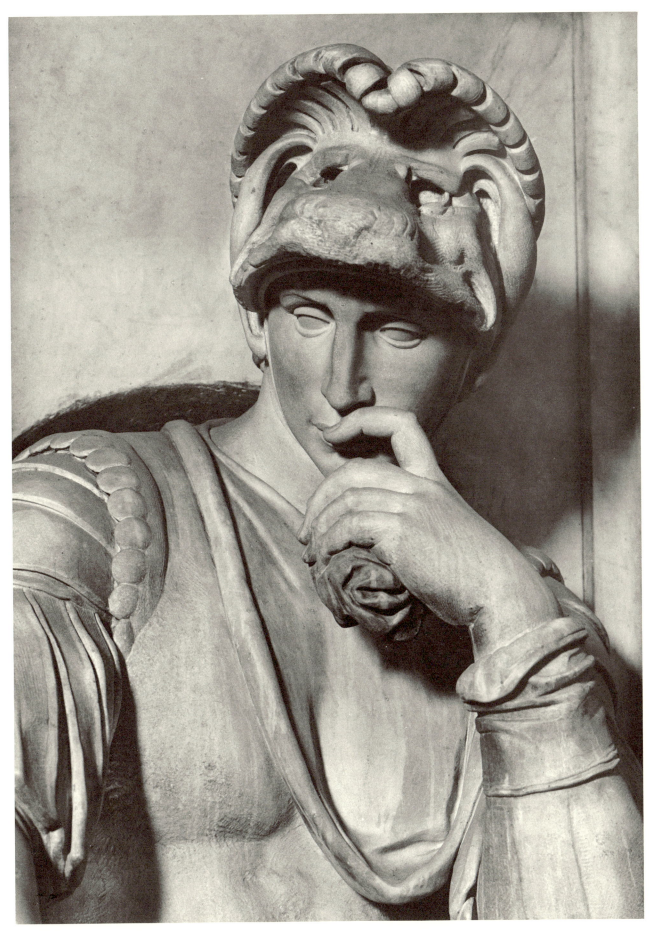

41

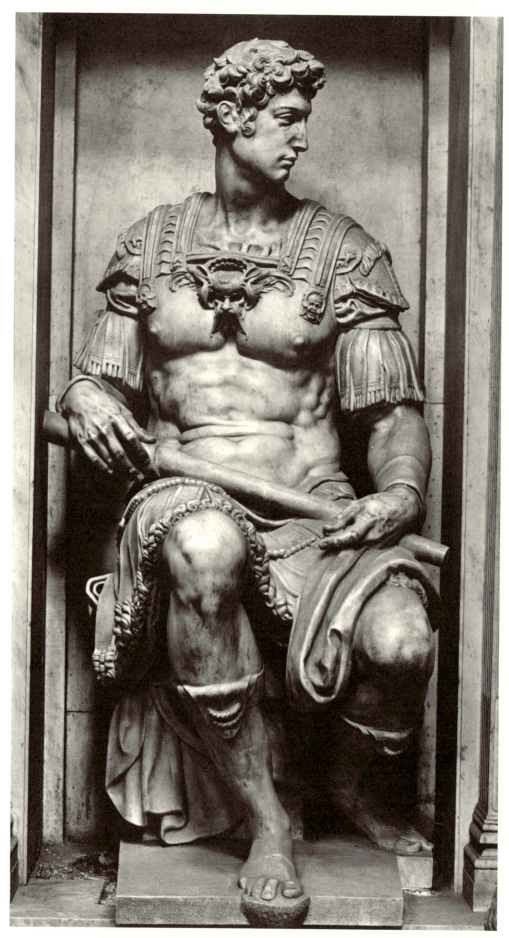

42

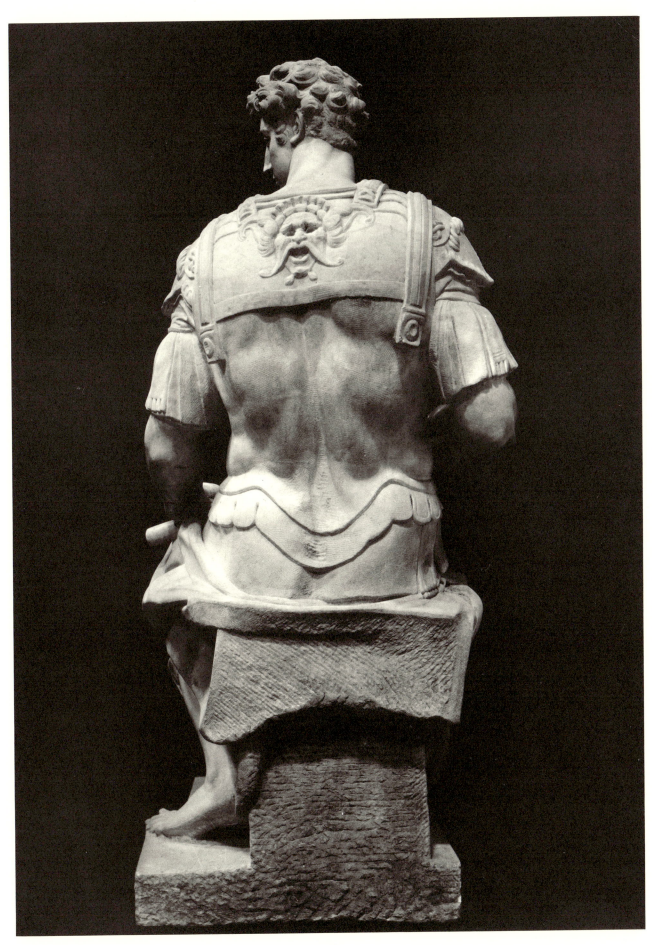

43

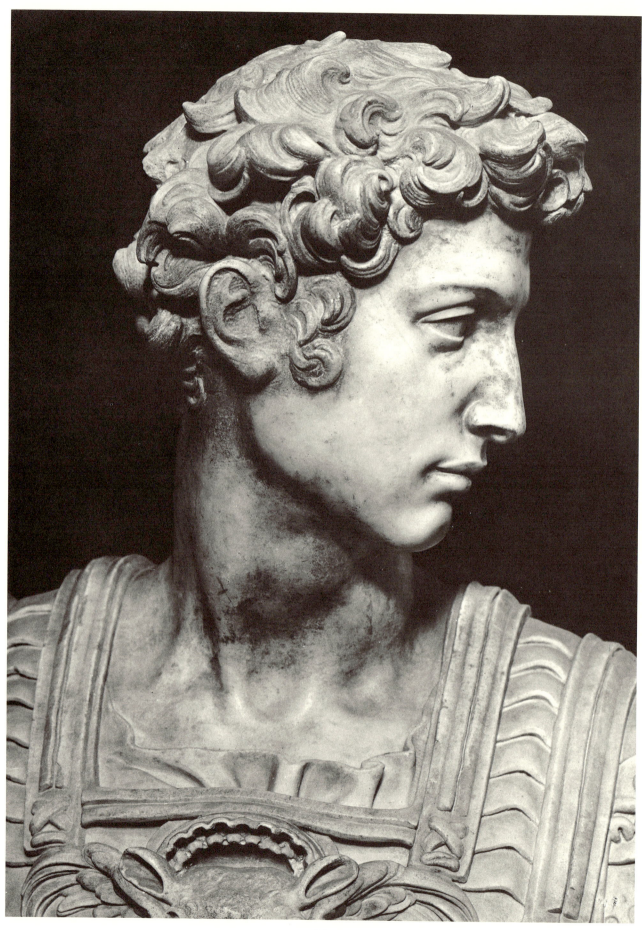

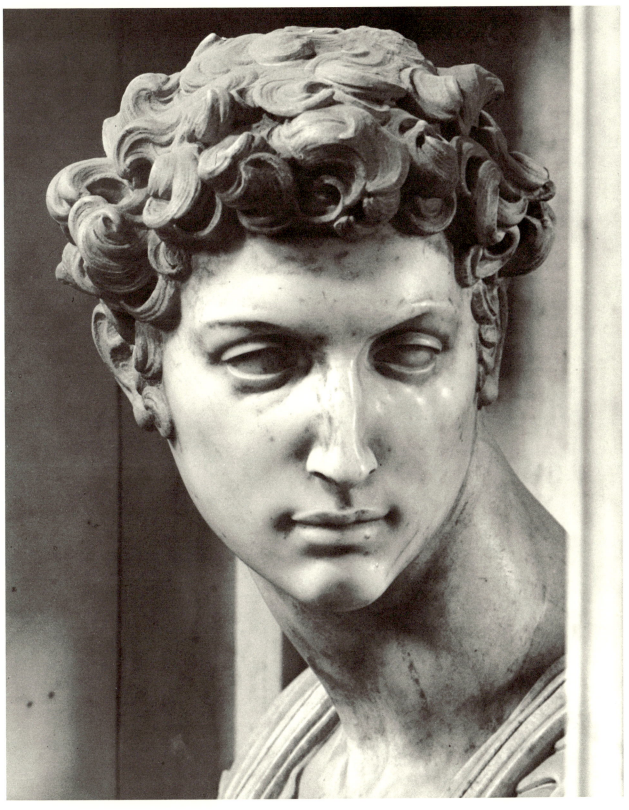

45

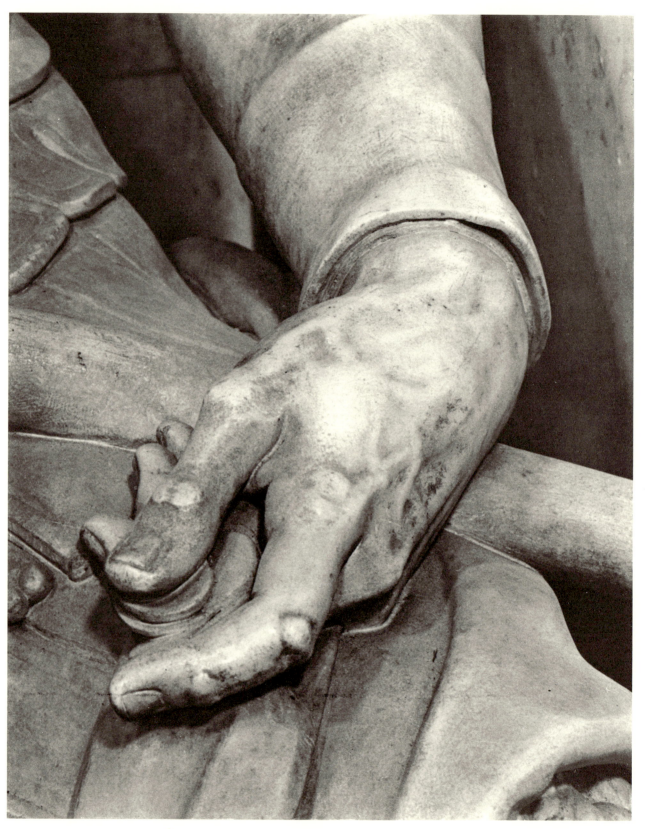

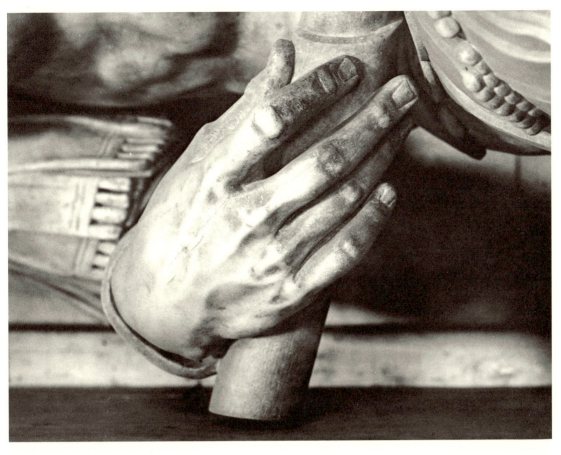

48

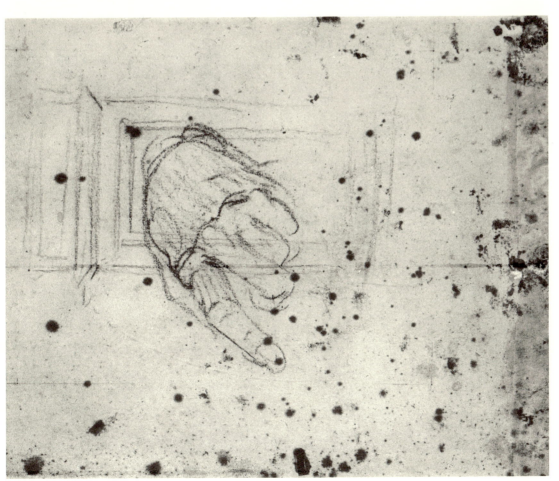

47

49

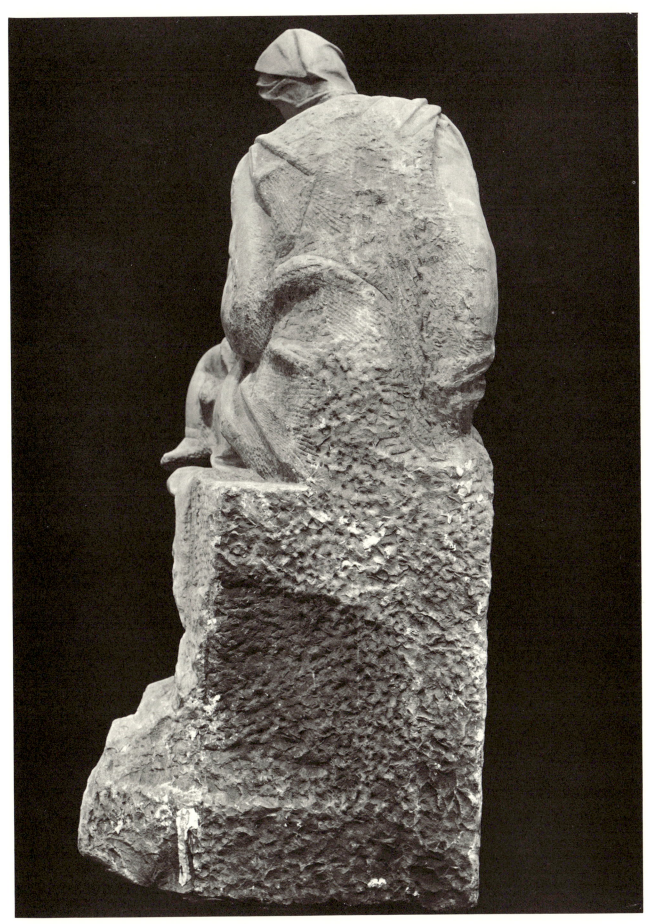

50

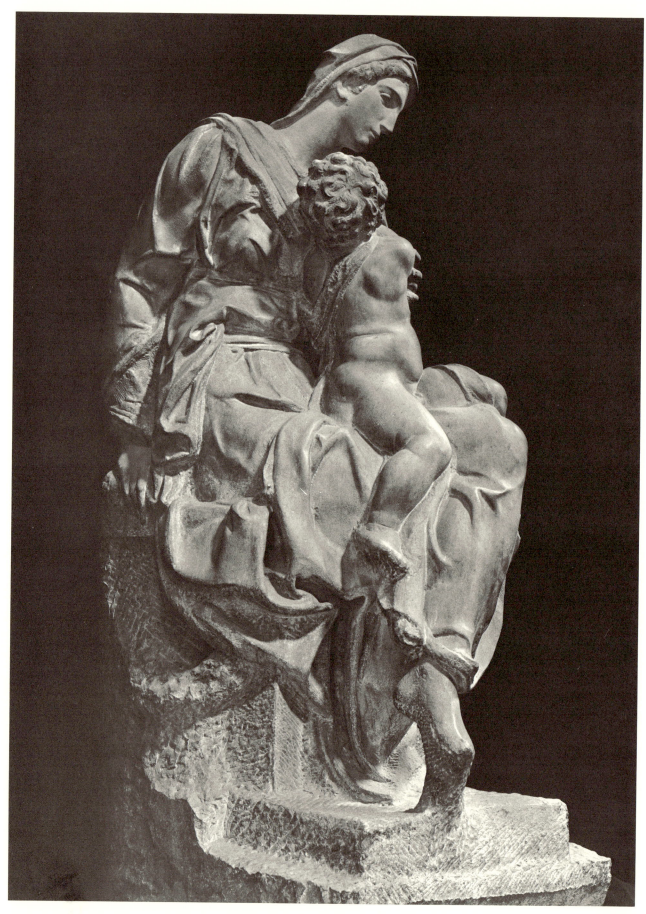

51

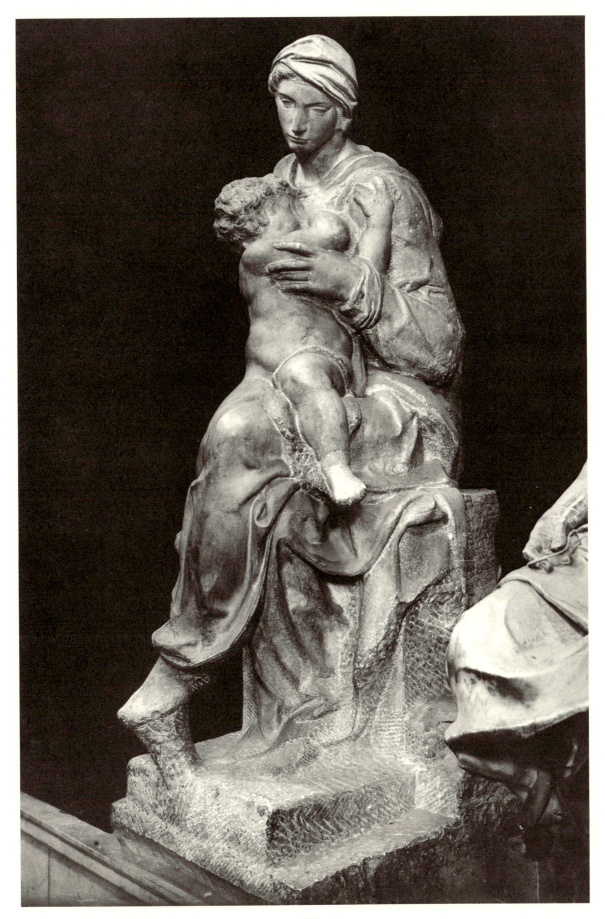

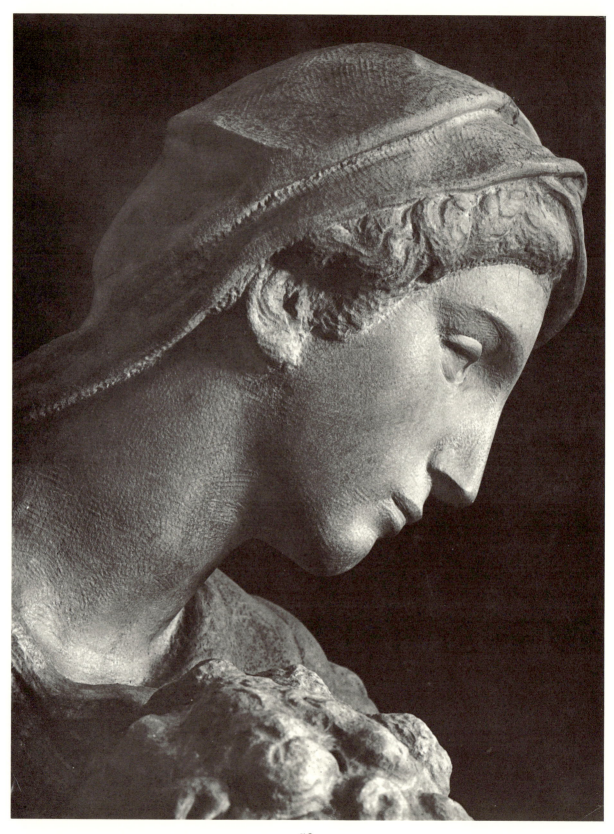

53

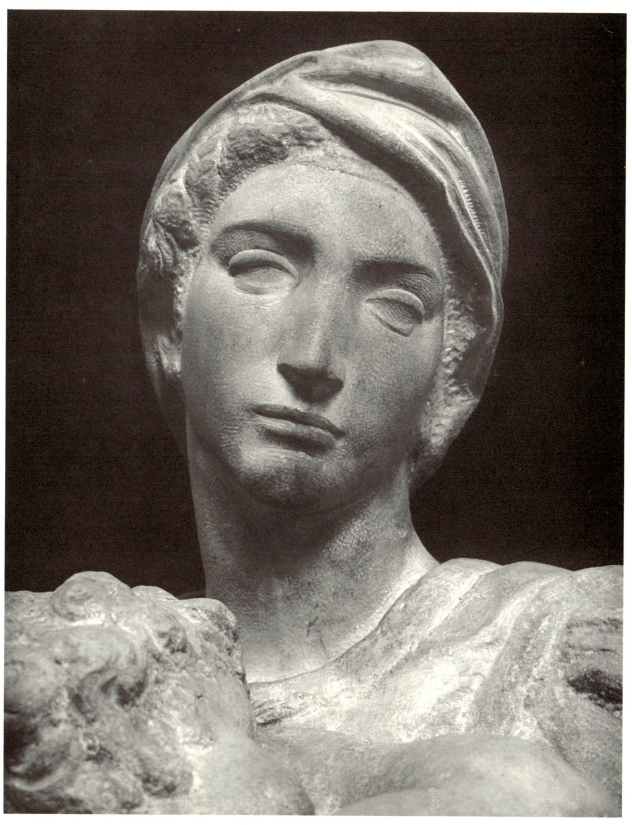

54

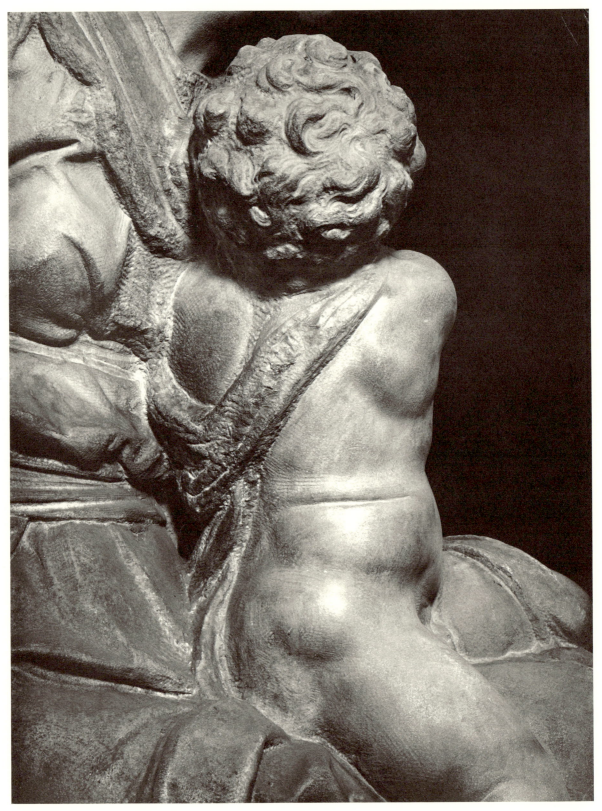

55

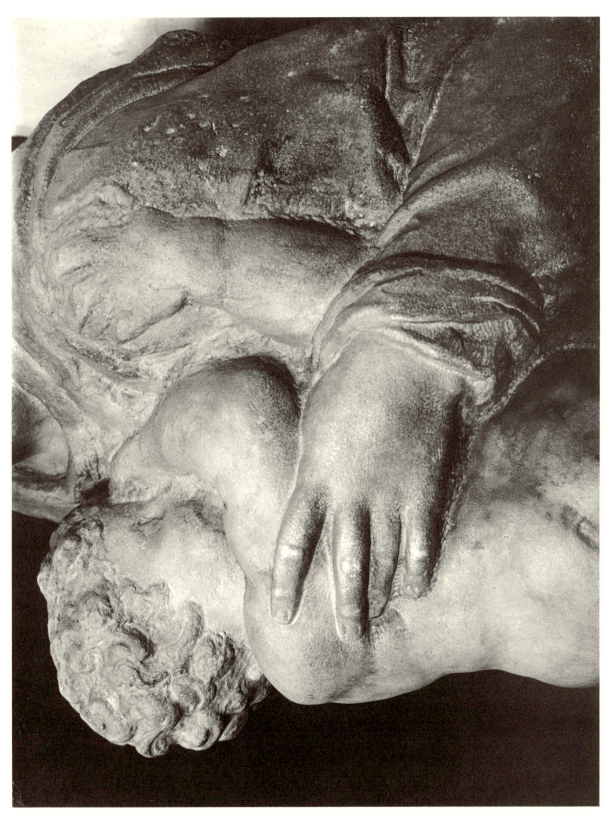

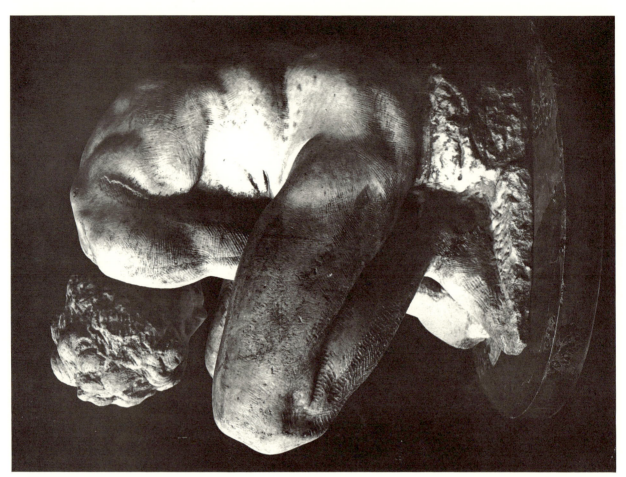

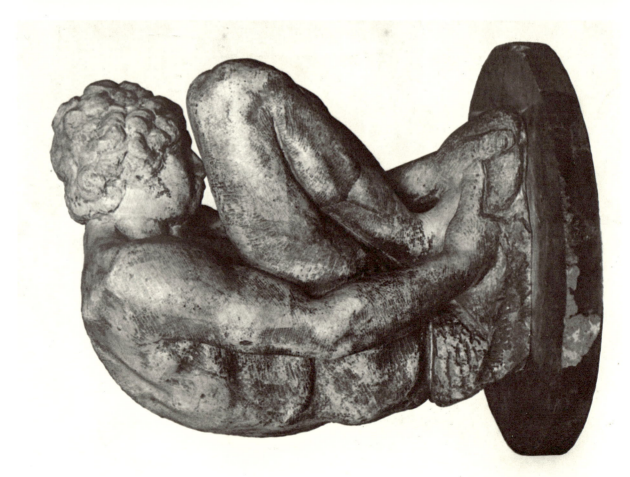

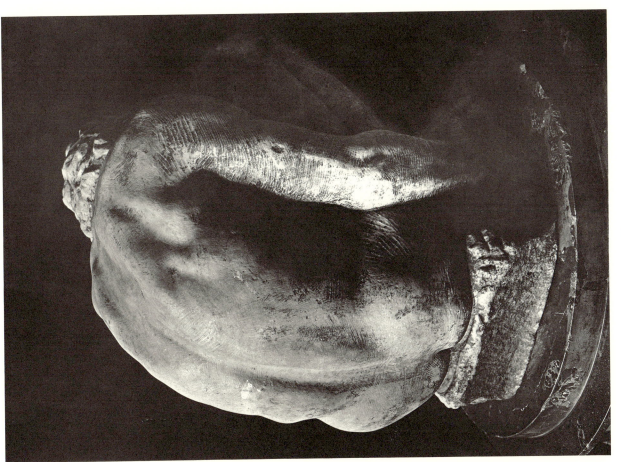

60

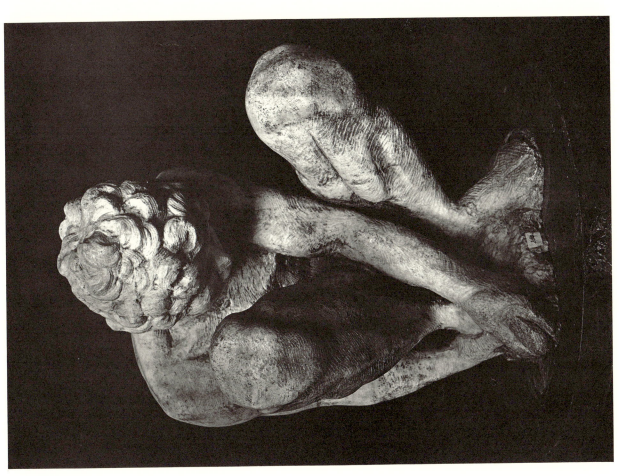

59

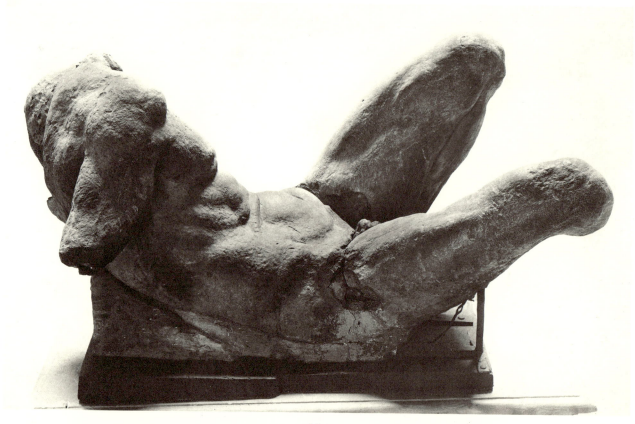

61

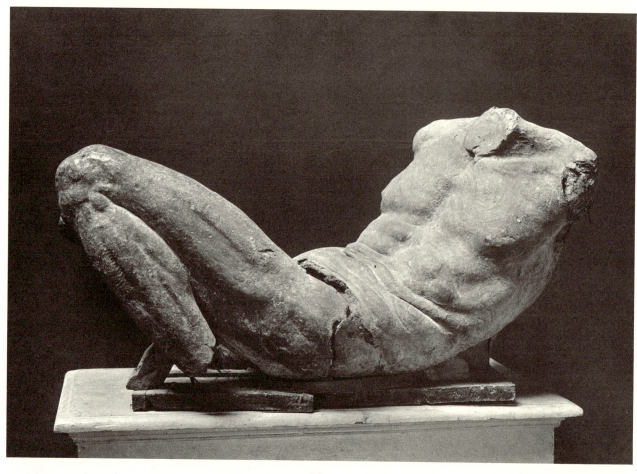

62

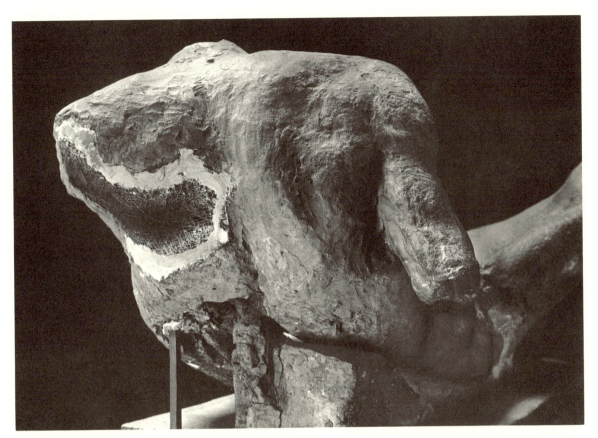

63

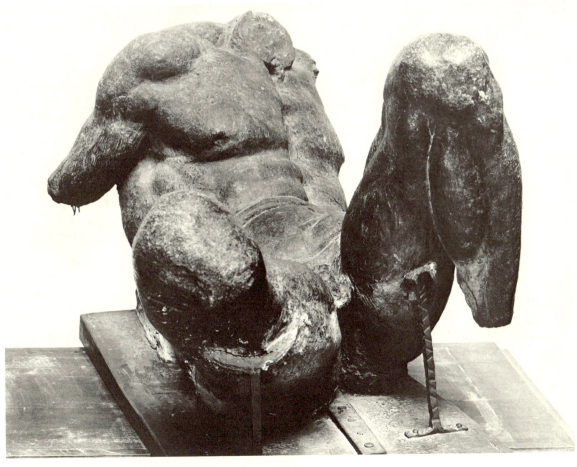

64

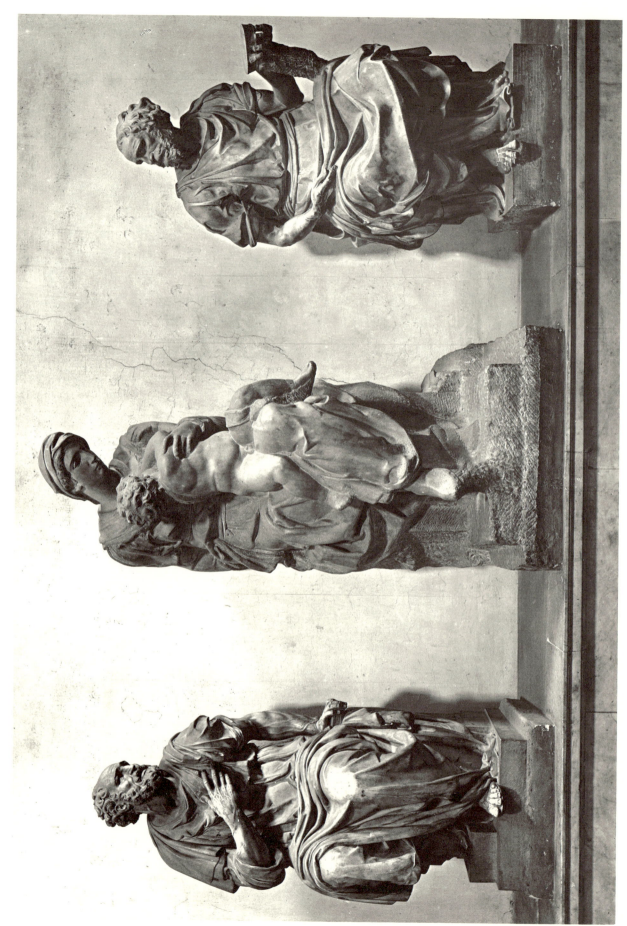

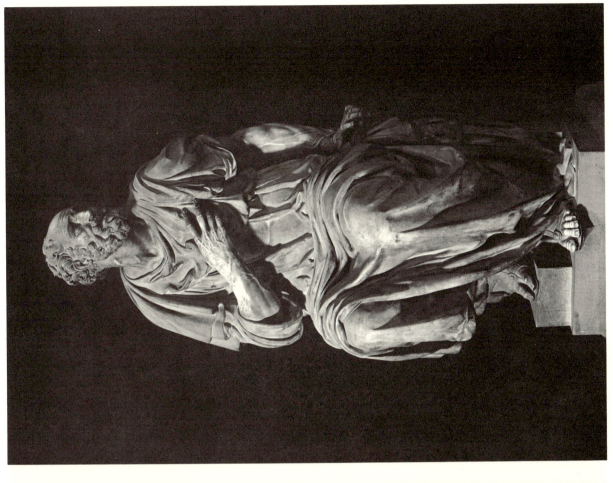

67

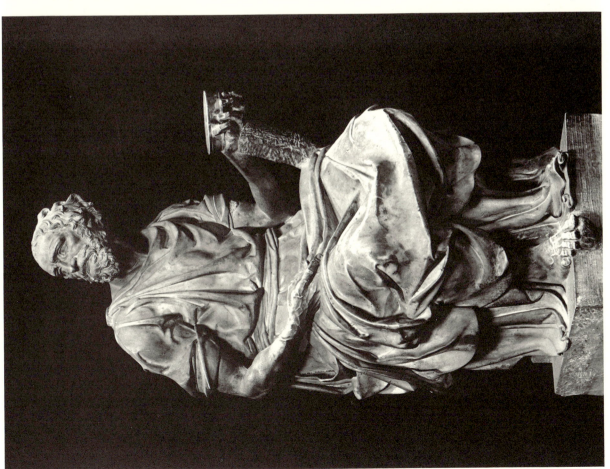

66

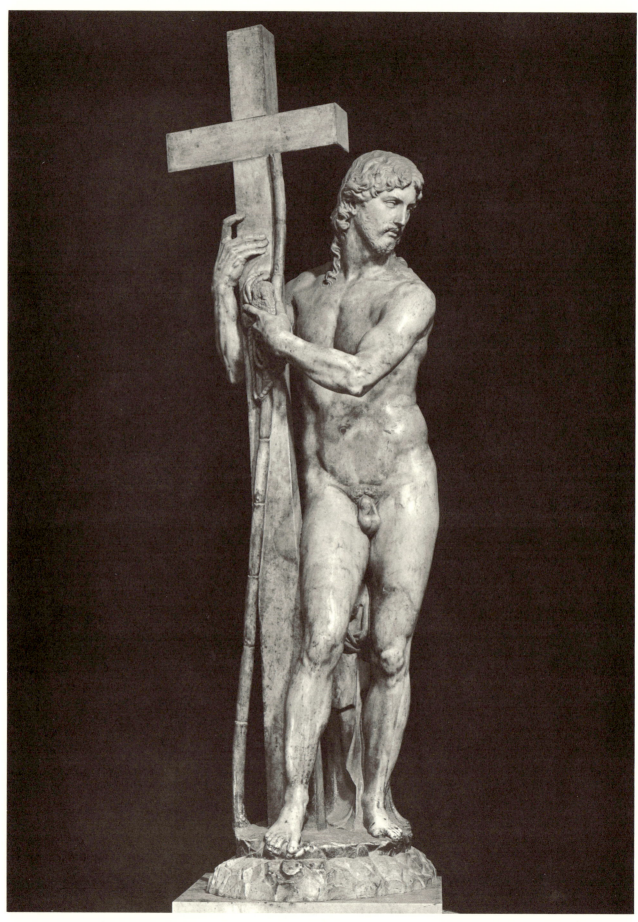

68

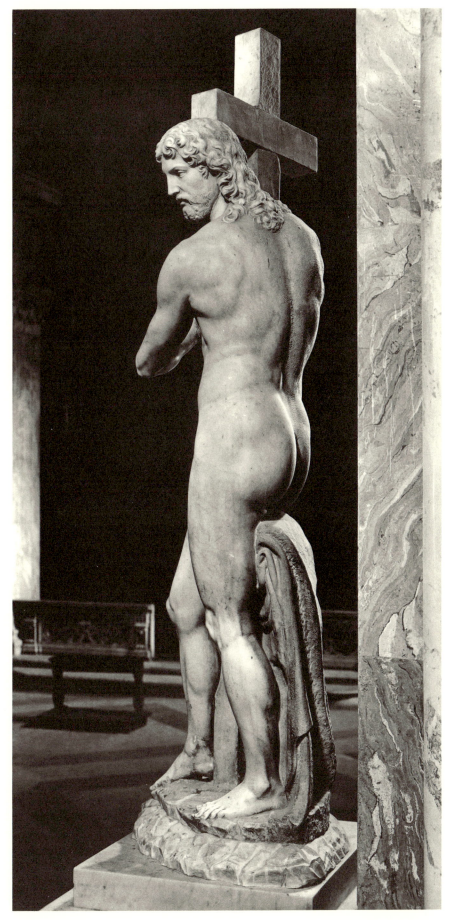

69

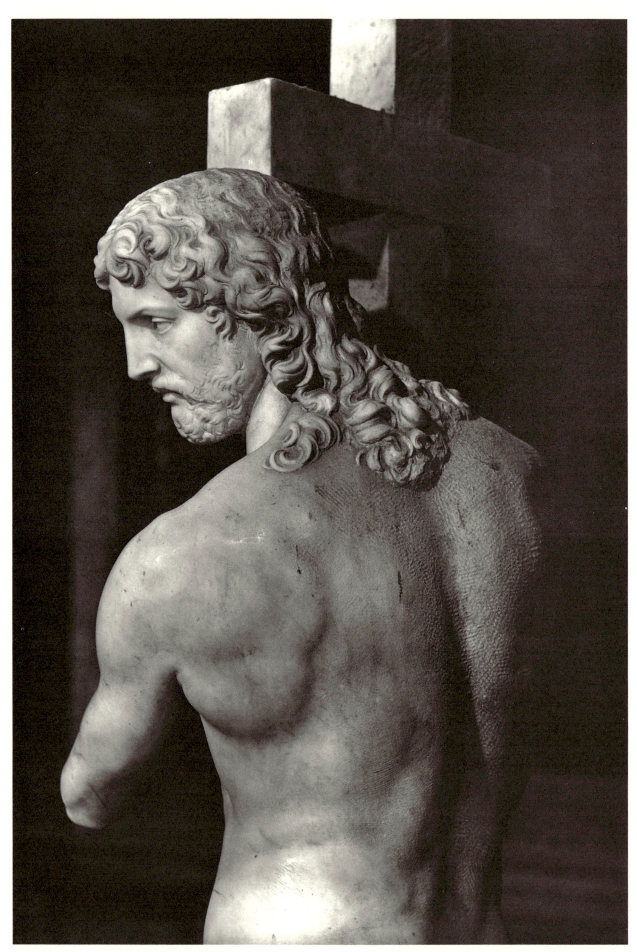

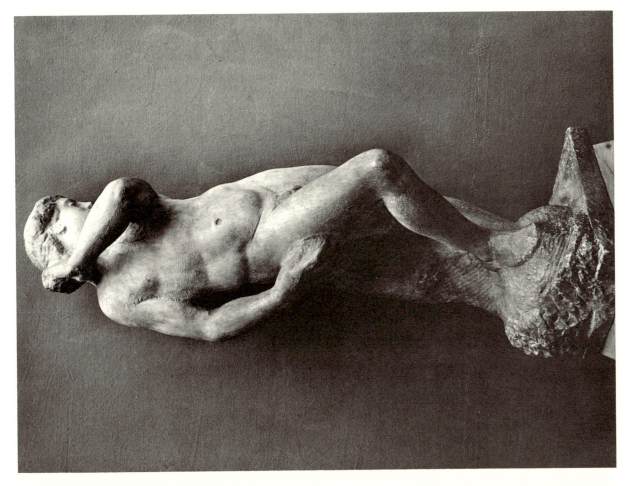

72

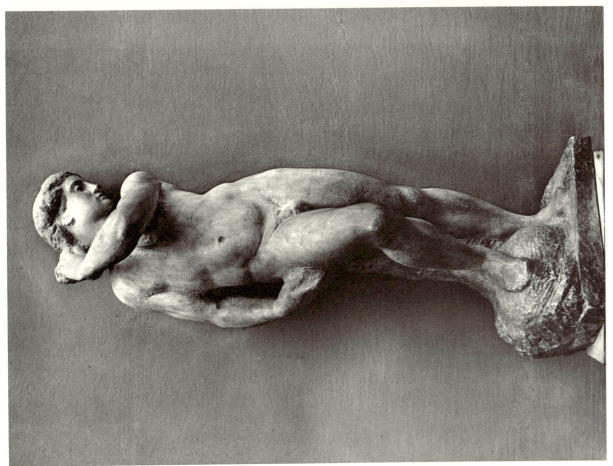

71

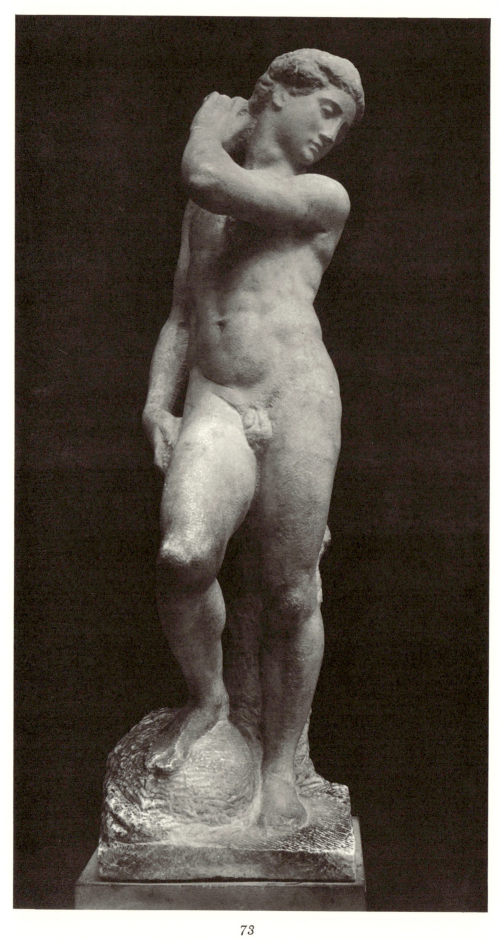

73

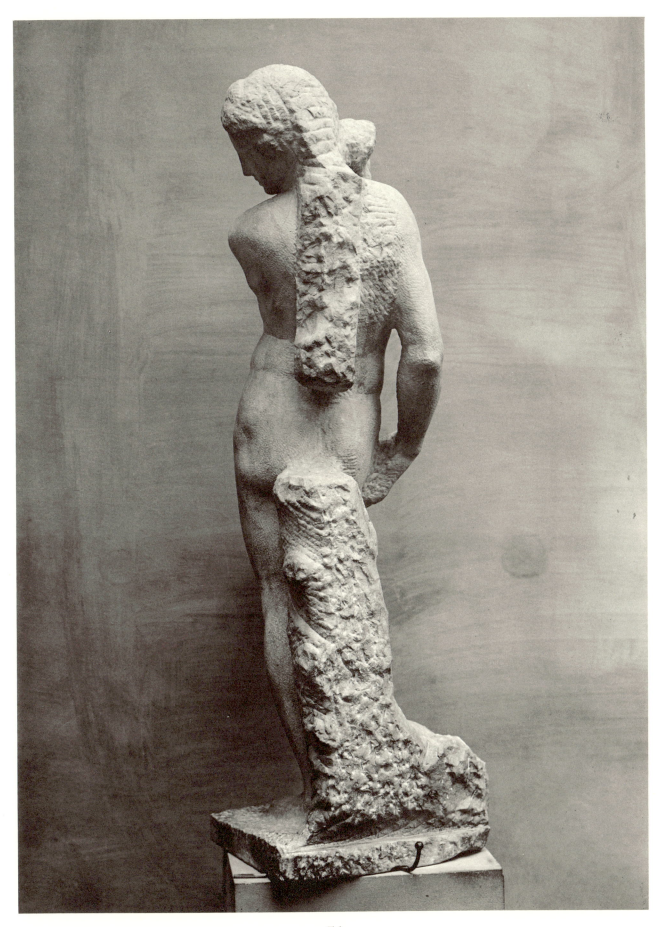

74

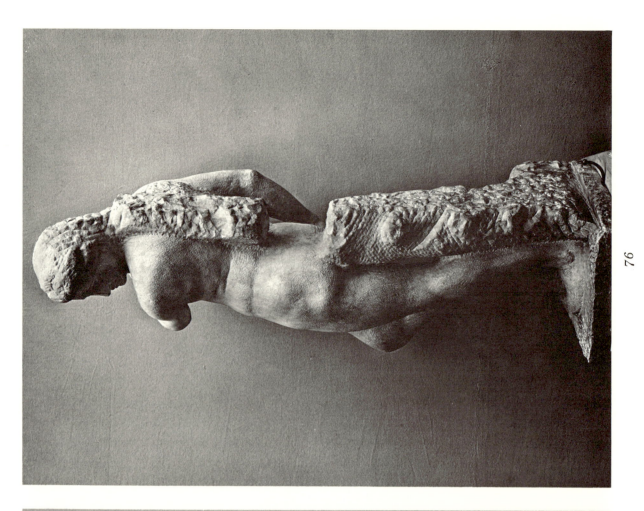

76

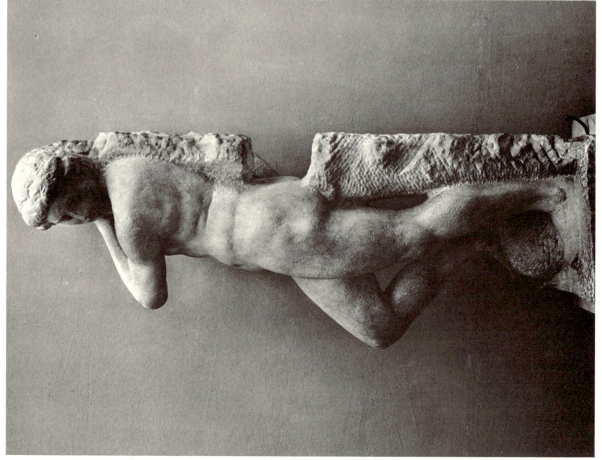

75

77

78

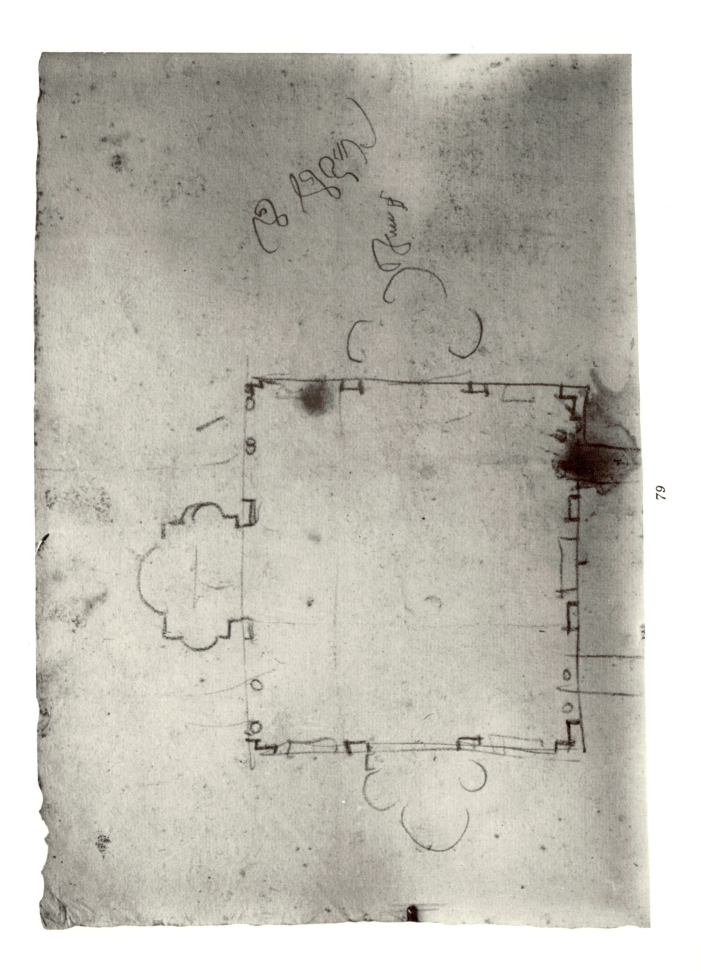

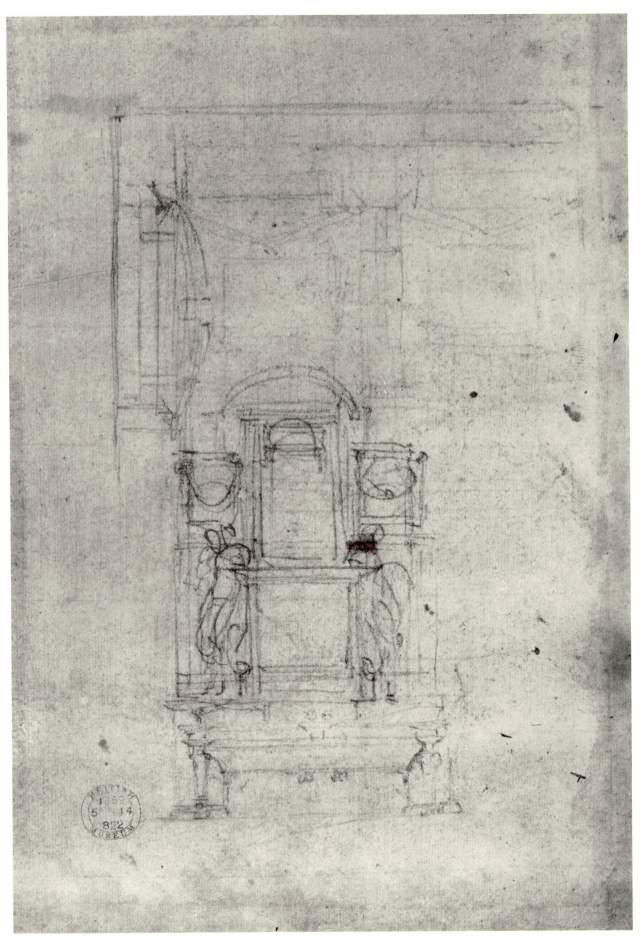

81

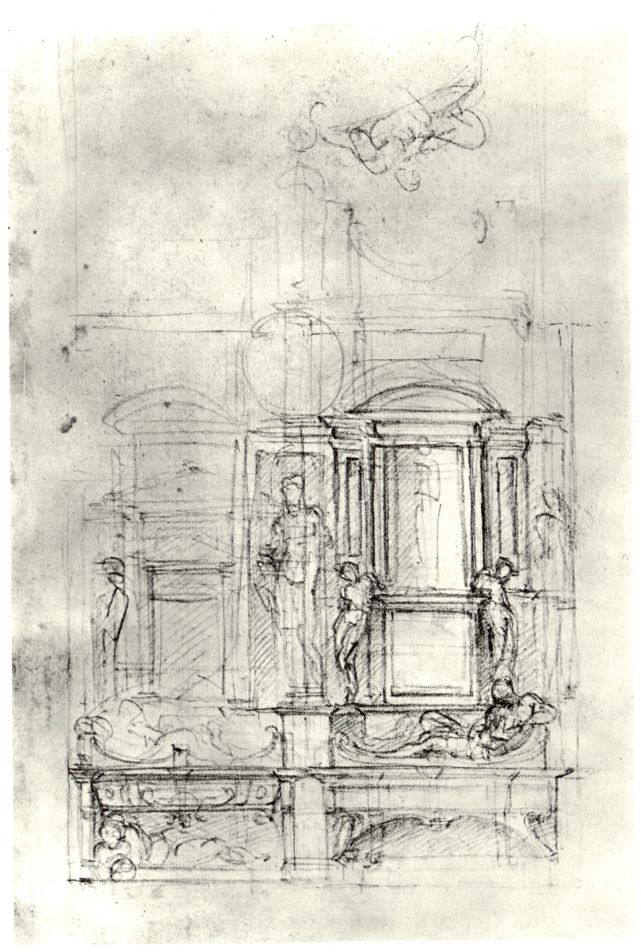

82

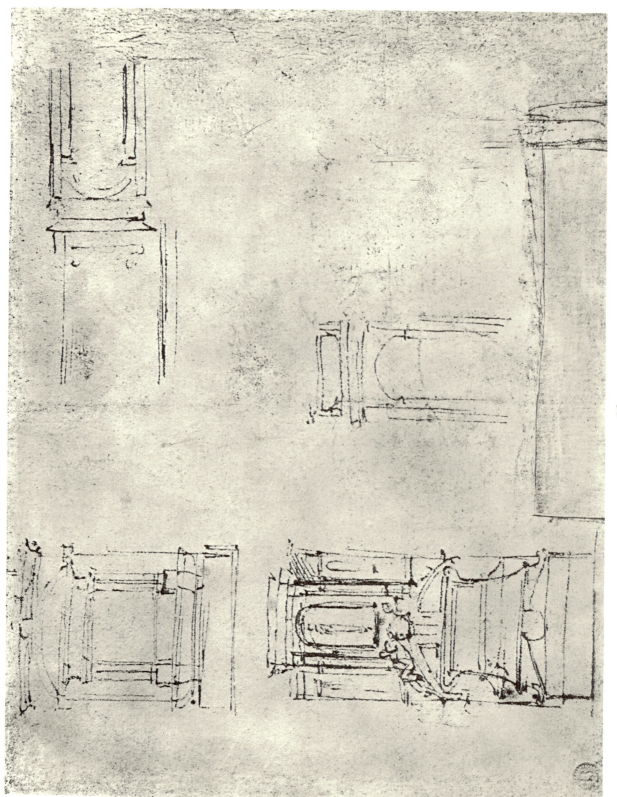

83

84

85

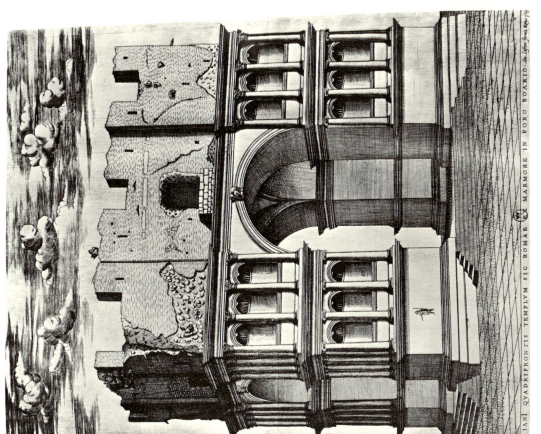

87

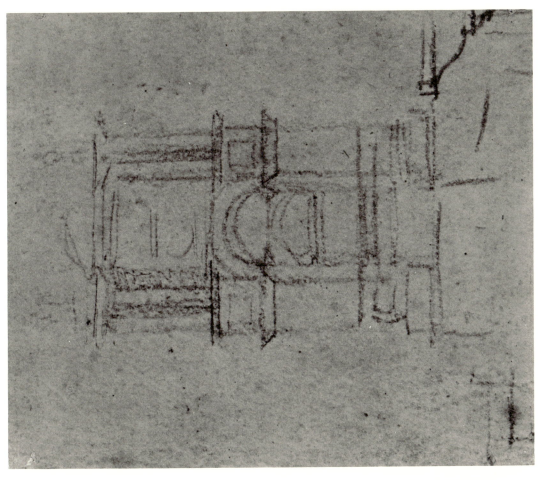

88

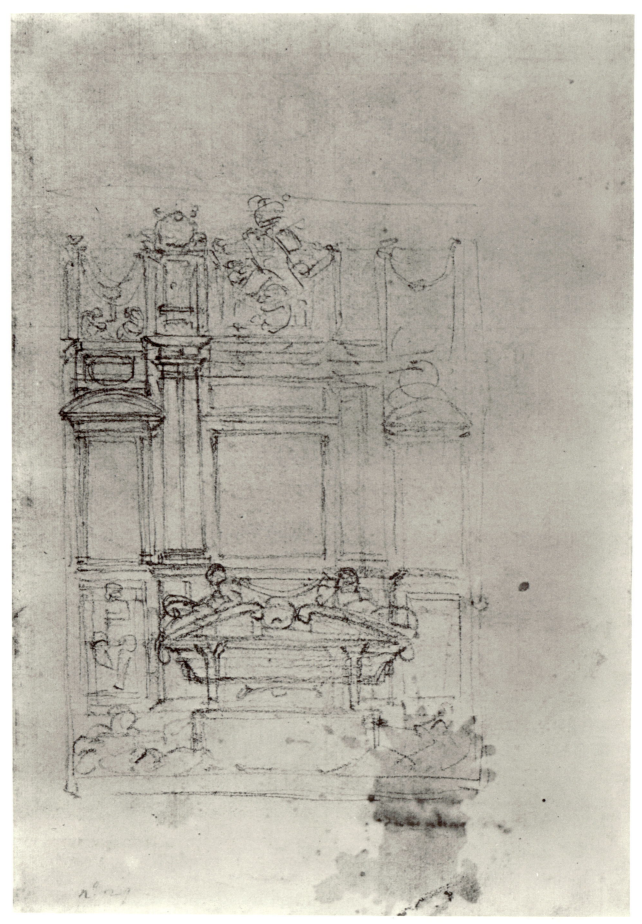

89

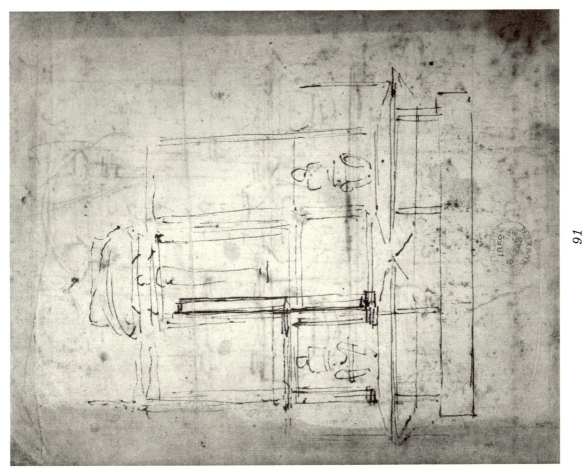

91

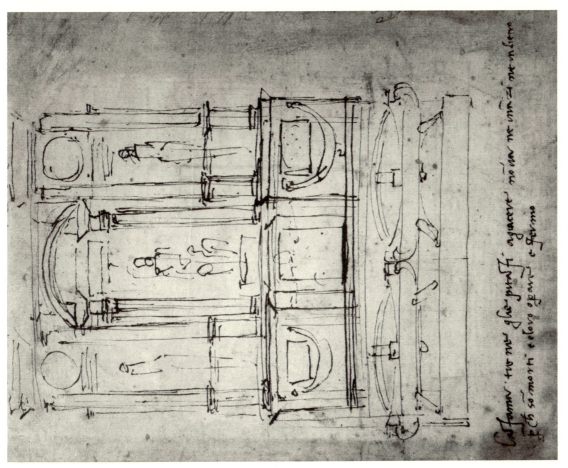

90

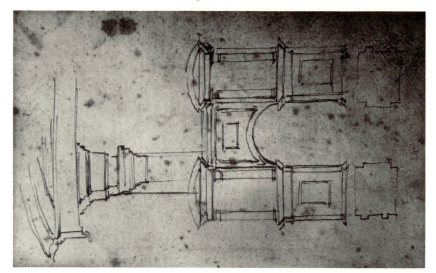

94

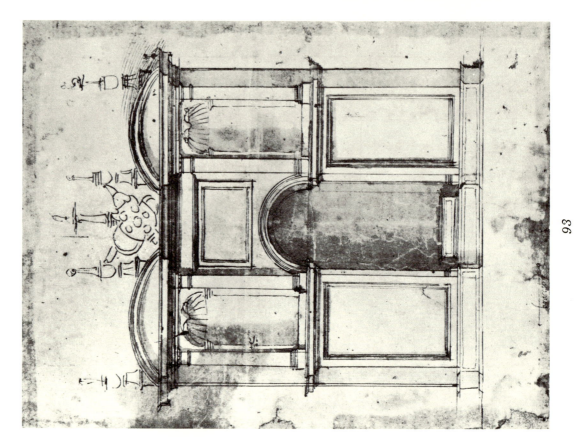

93

92

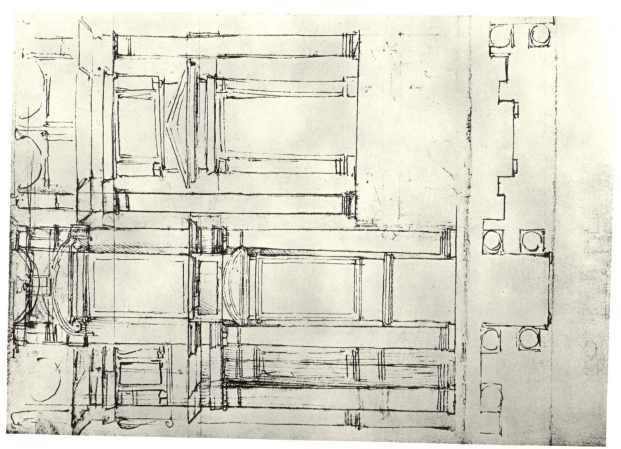

96

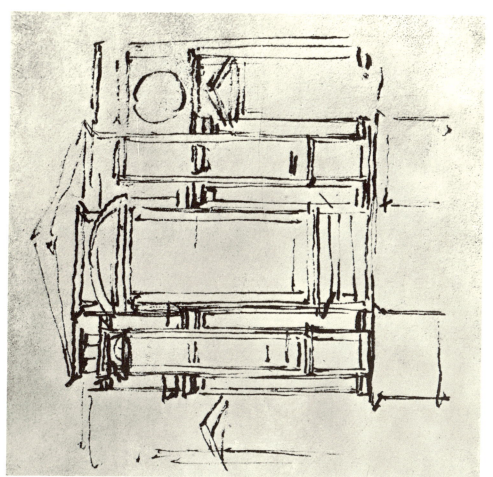

95

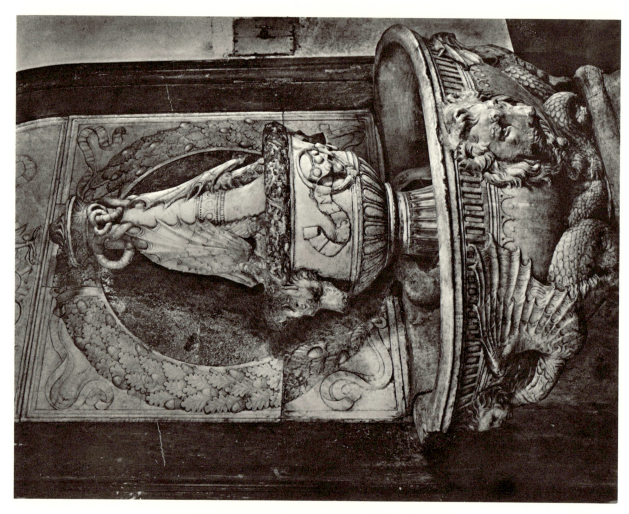

98

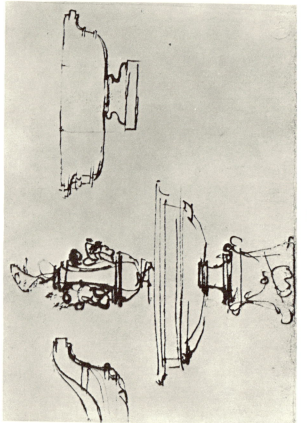

97

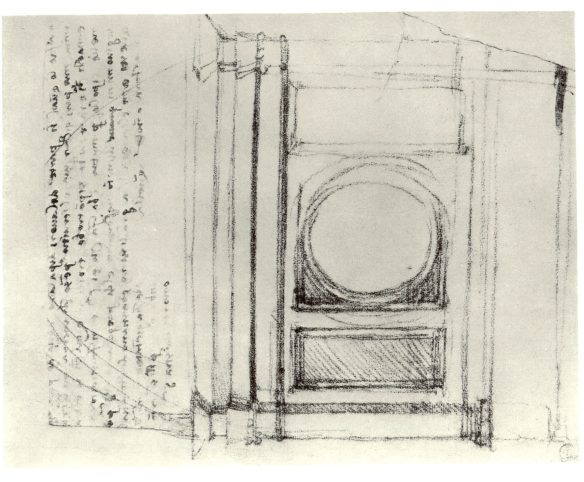

101

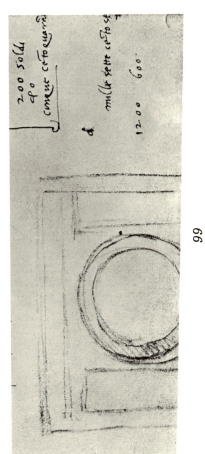

99

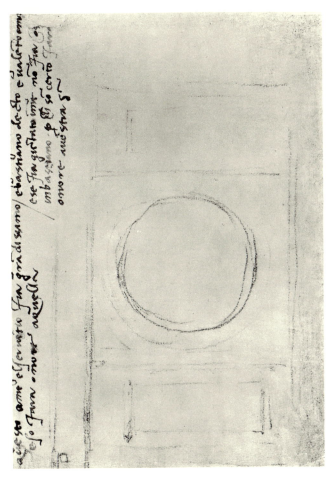

100

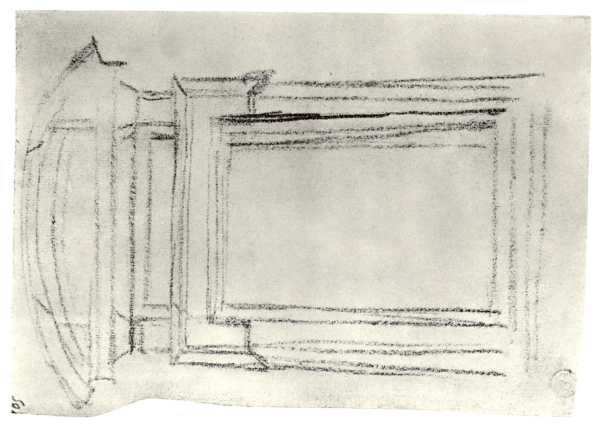

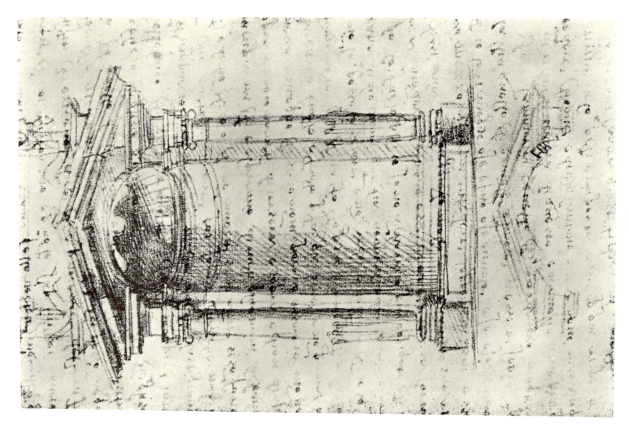

109

108

112

110

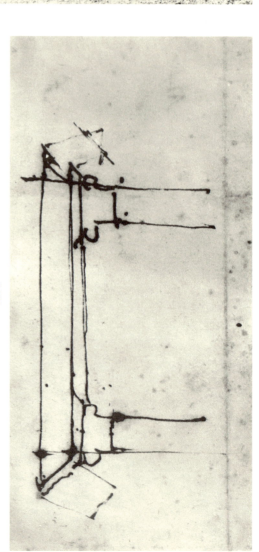

111

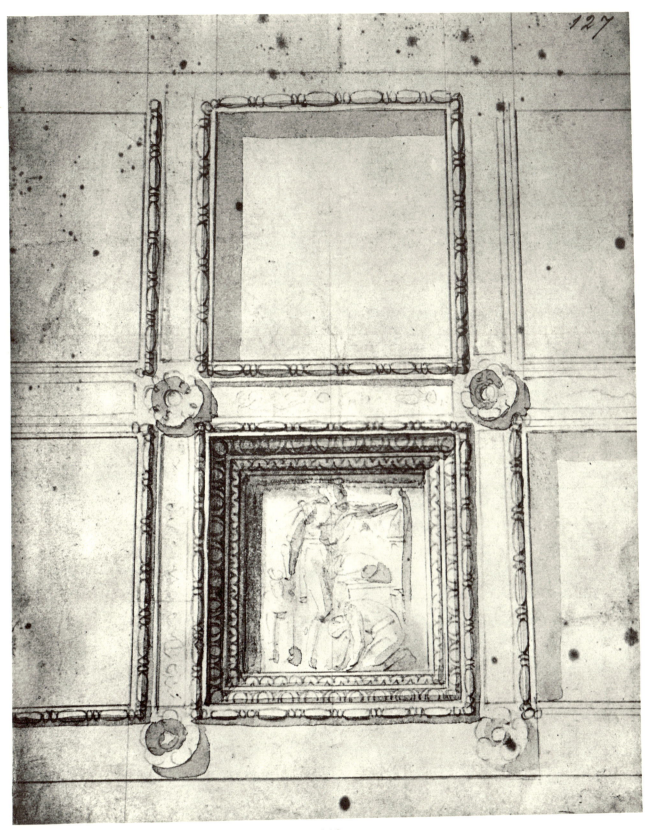

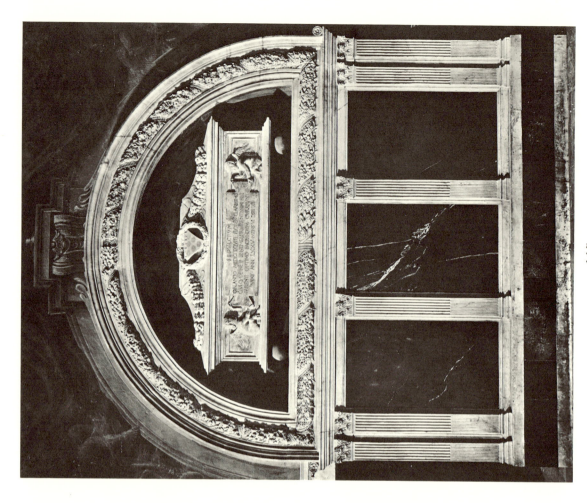

115

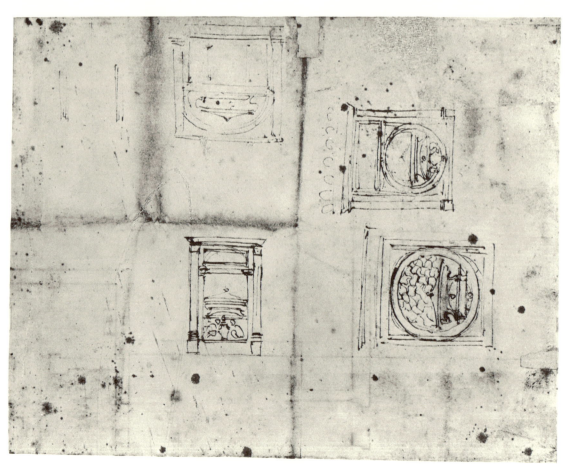

114

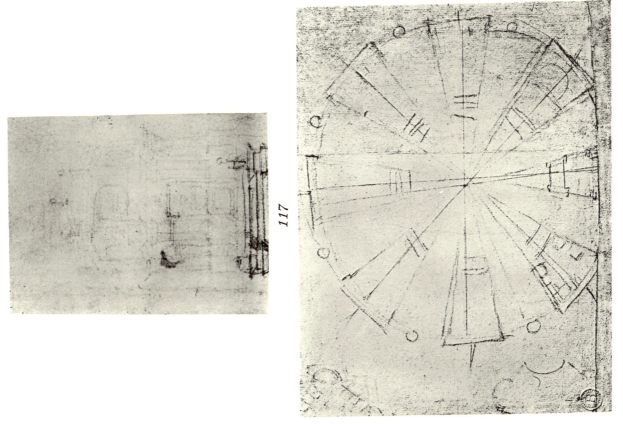

117

118

116

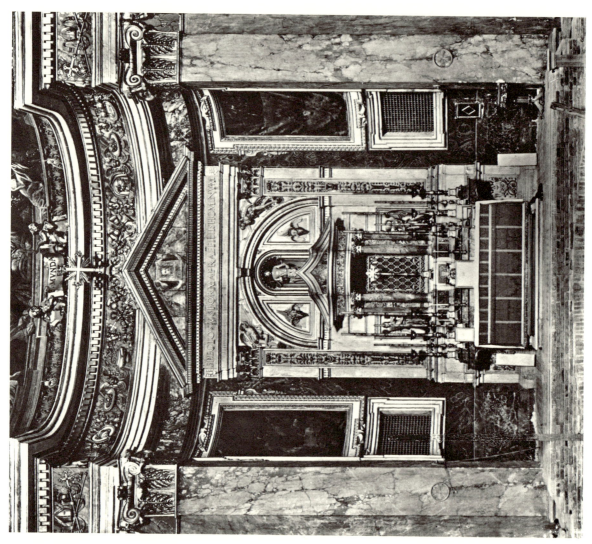

120

119

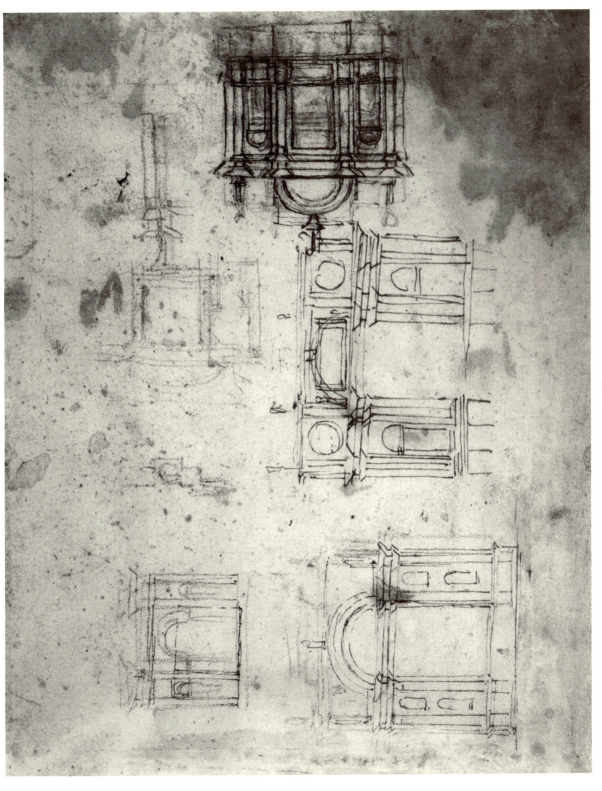

121

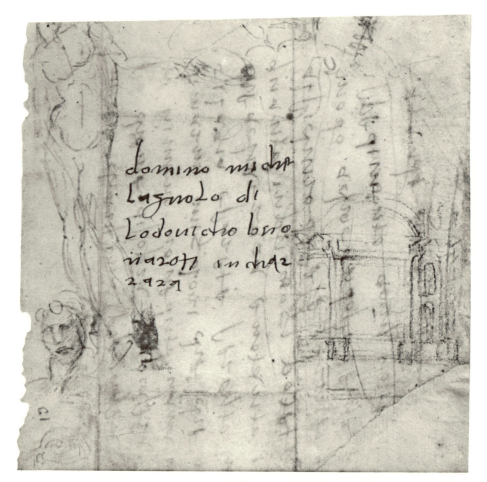

122

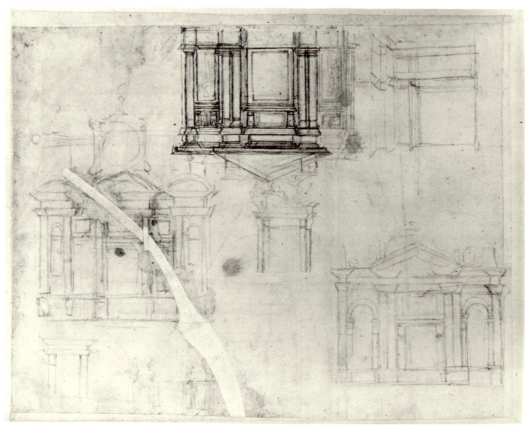

123

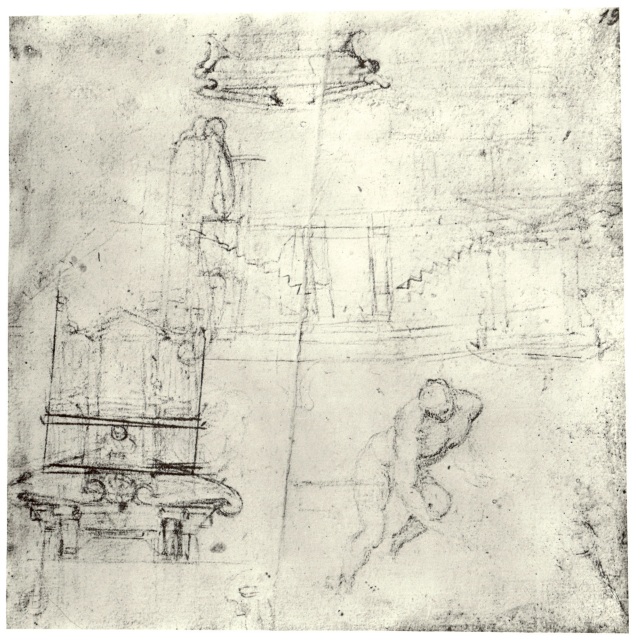

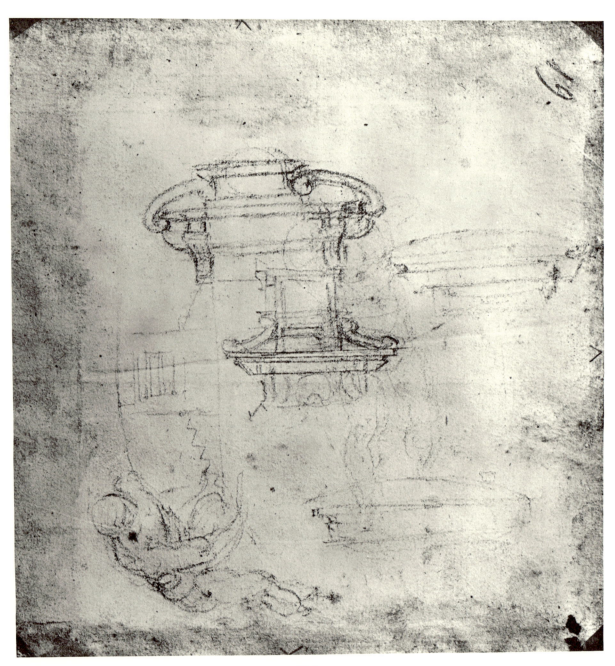

125

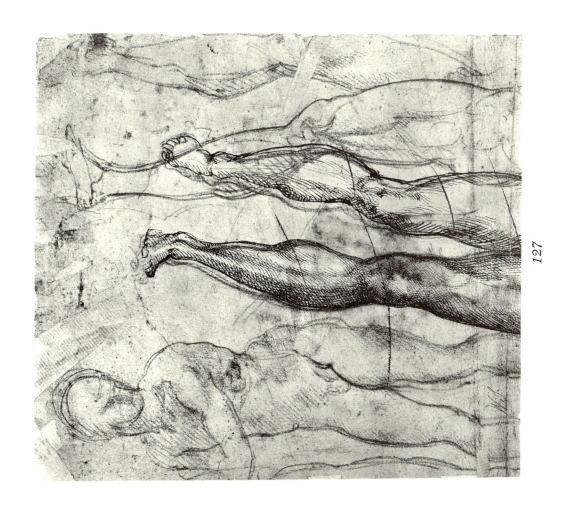

127

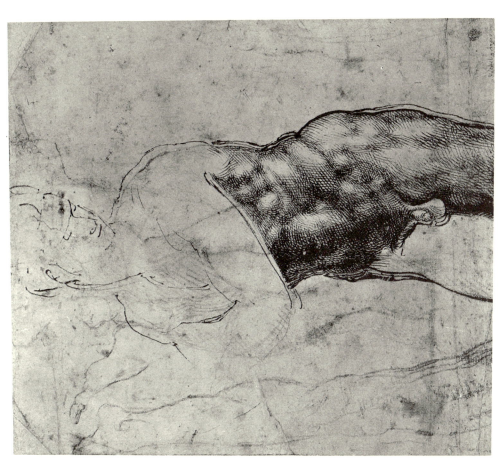

126

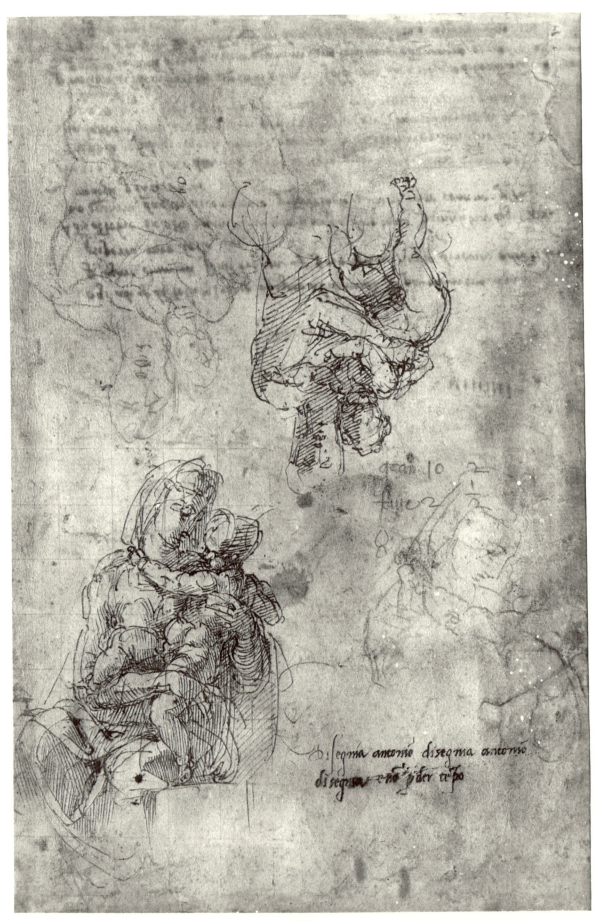

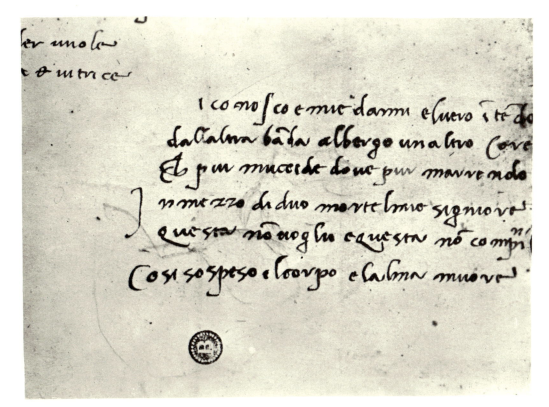

i co no f co e mu danni el uevo i te do

daltalma bada albergo un altro Cove

El piu mutesse dove piu mavrendo

I n mezzo di duo morte lmo signove

questa no uoglio e questa no compi

Cosi so speso el corpo e l'alma muove

129

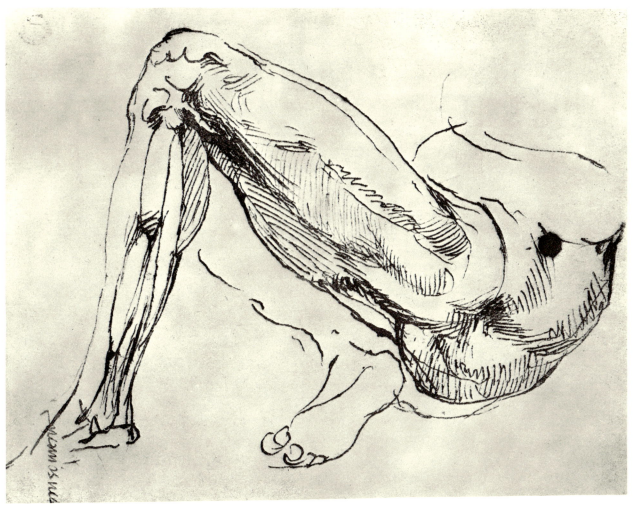

130

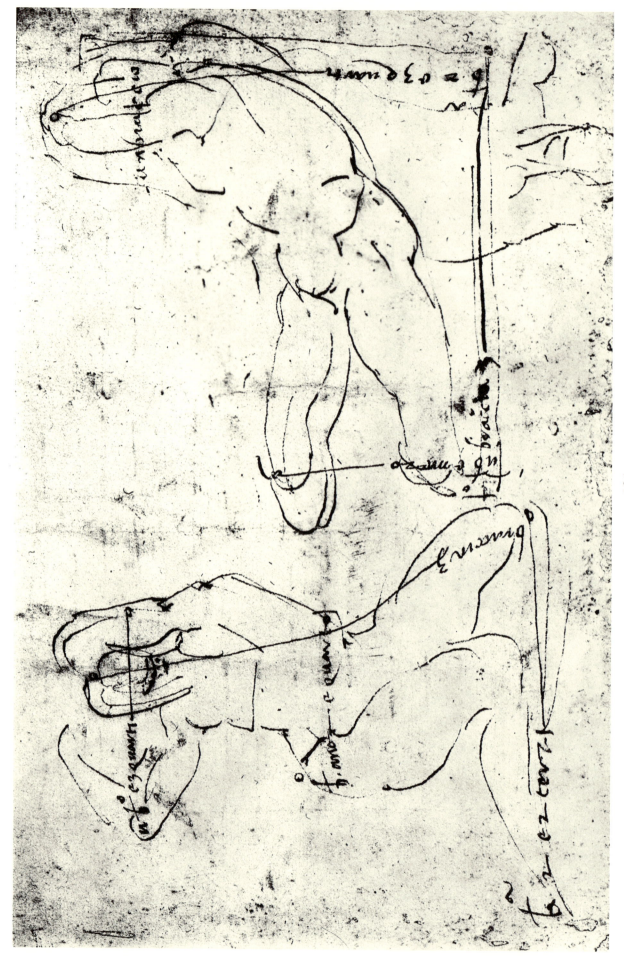

132

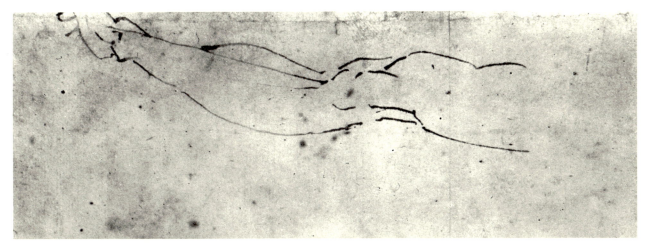

133

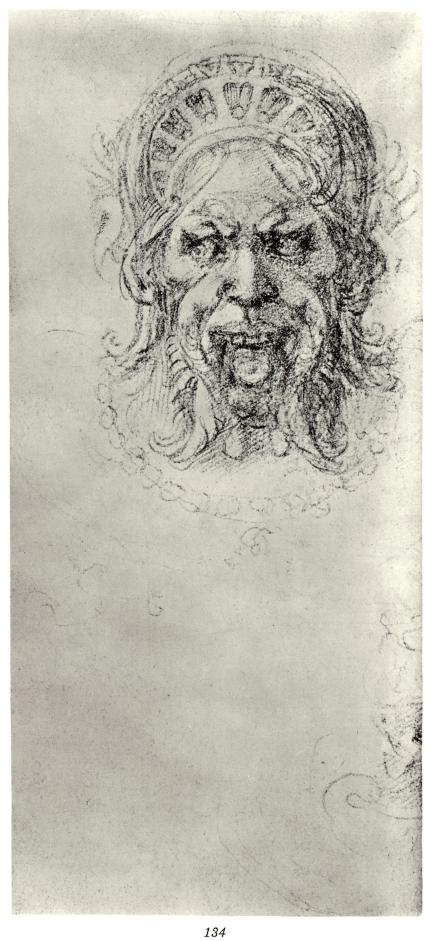

134

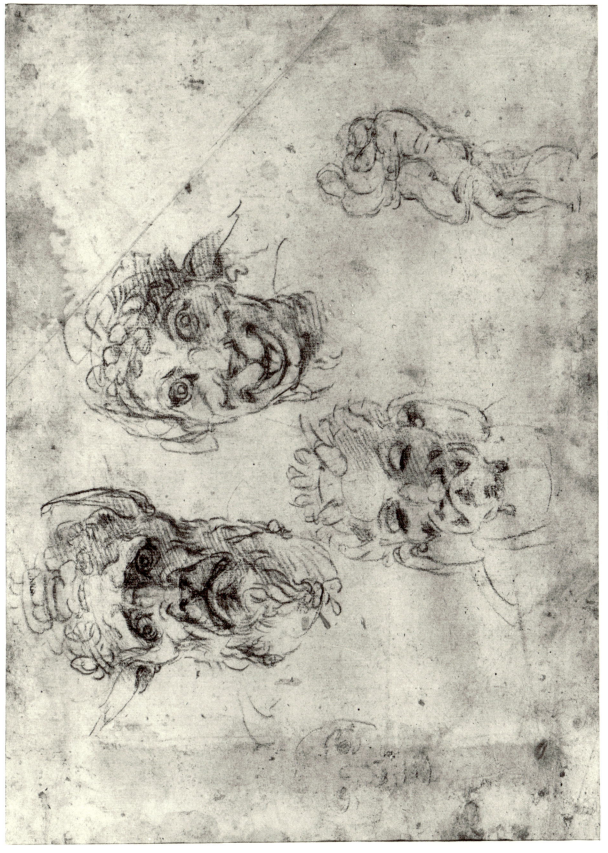

135

138

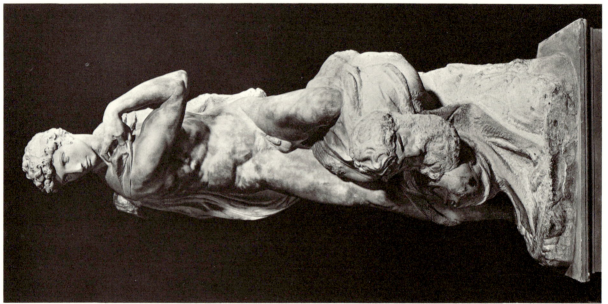

137

136

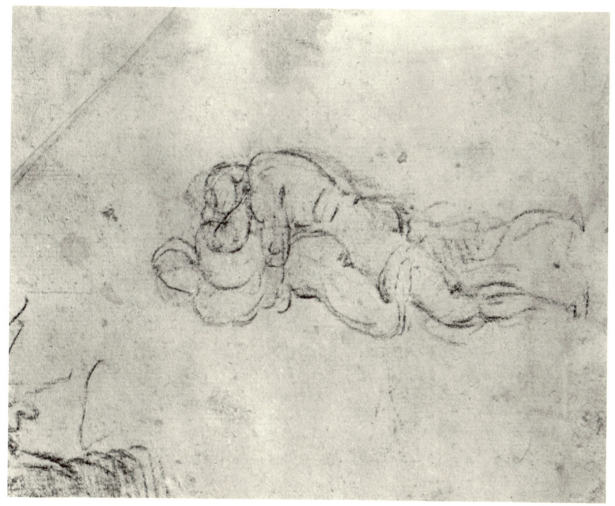

140

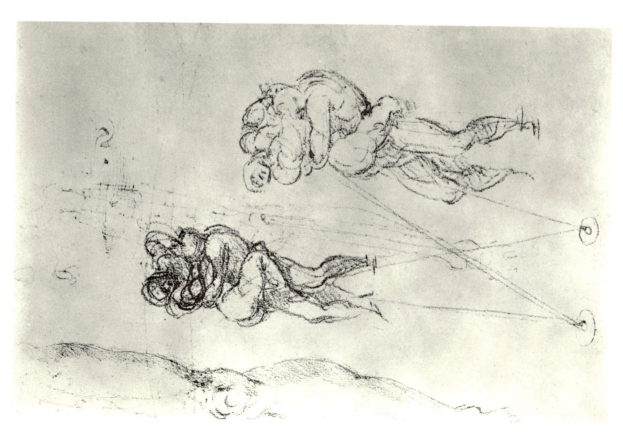

139

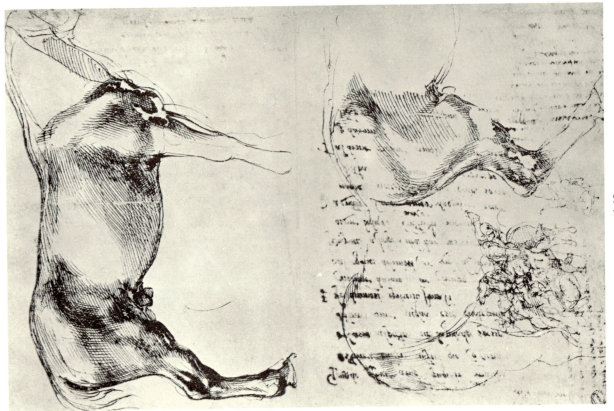

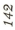

142

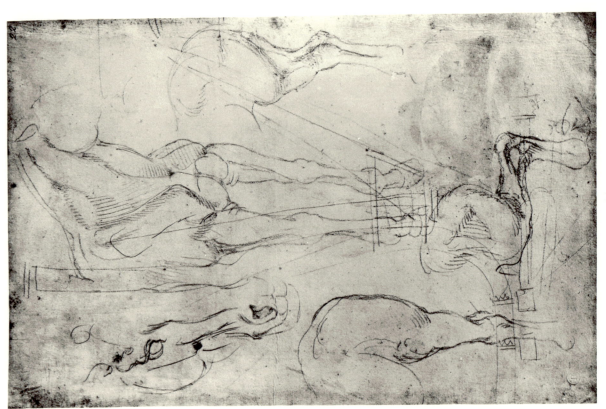

141

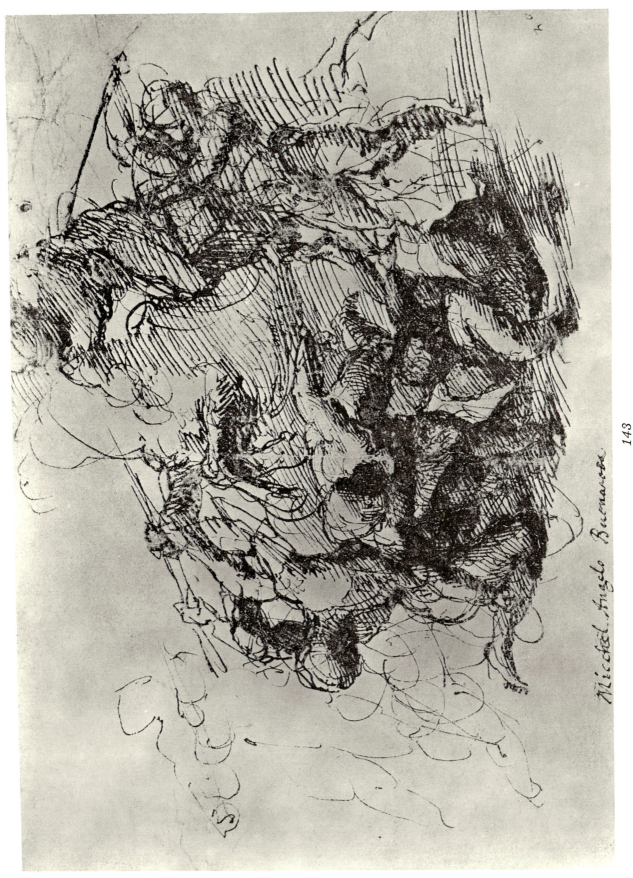

Micchel Angelo Bonaroti

143

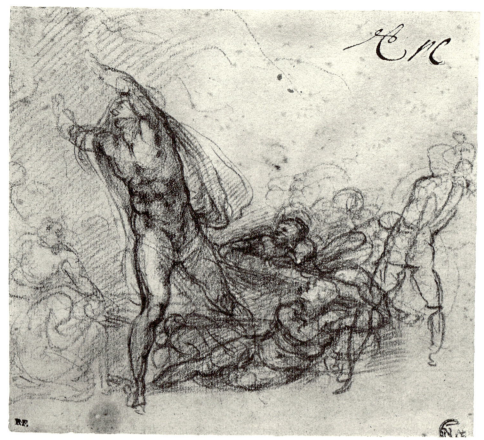

144

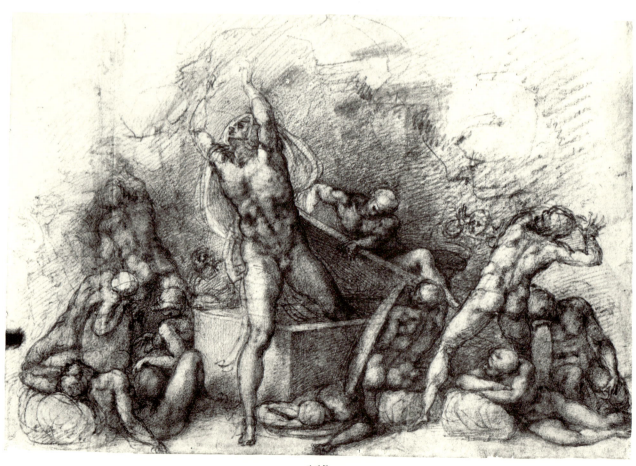

145

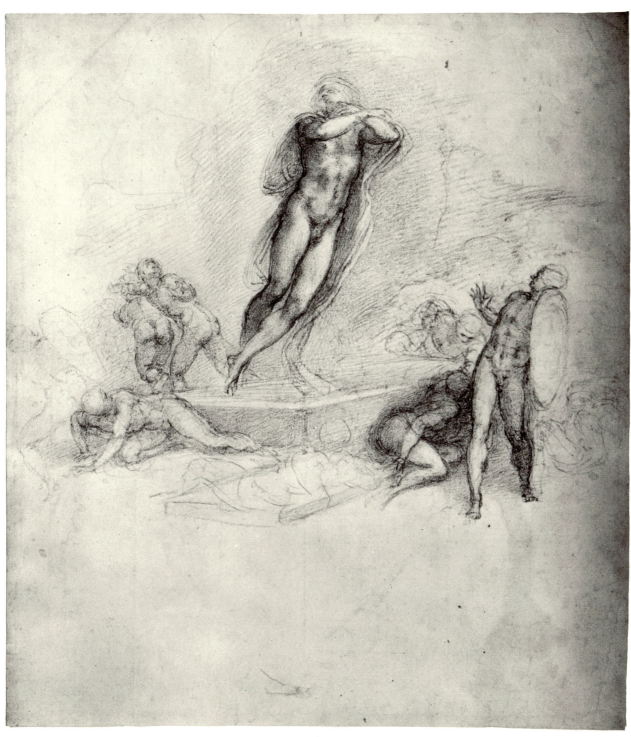

146

148

147

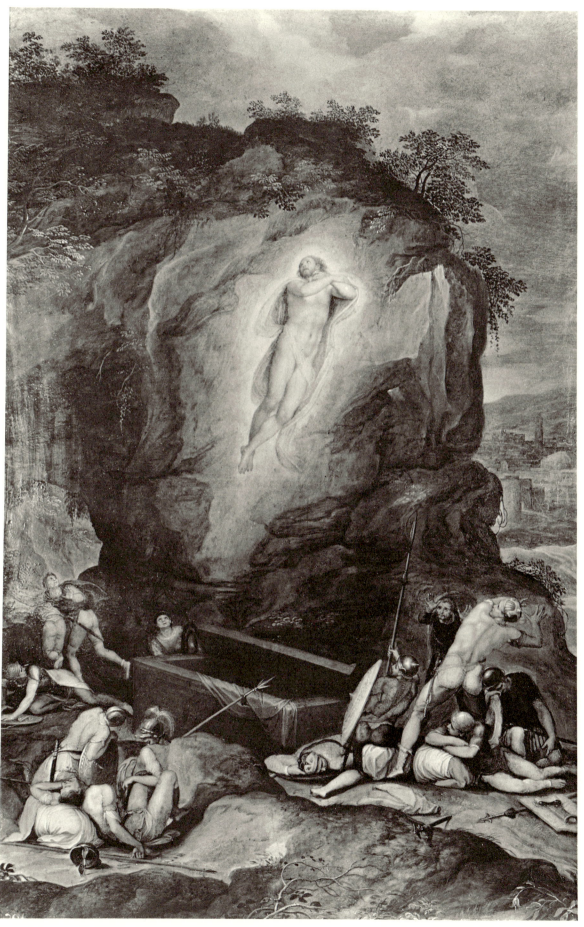

149

150

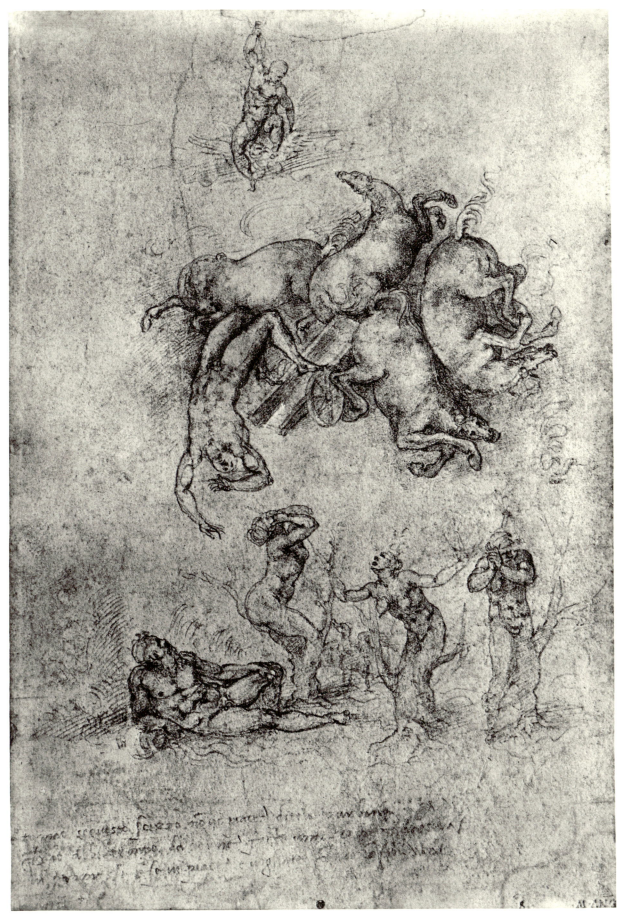

151

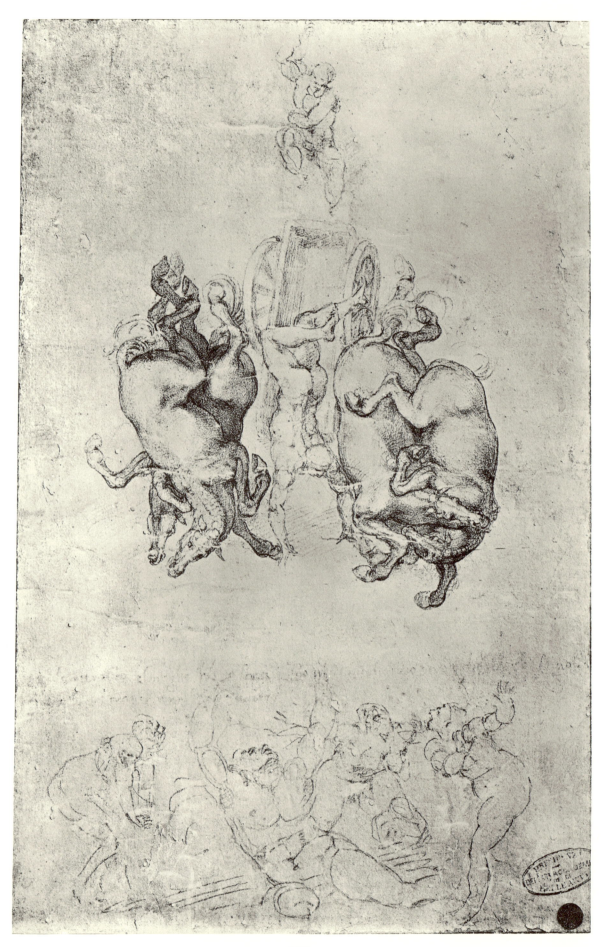

152

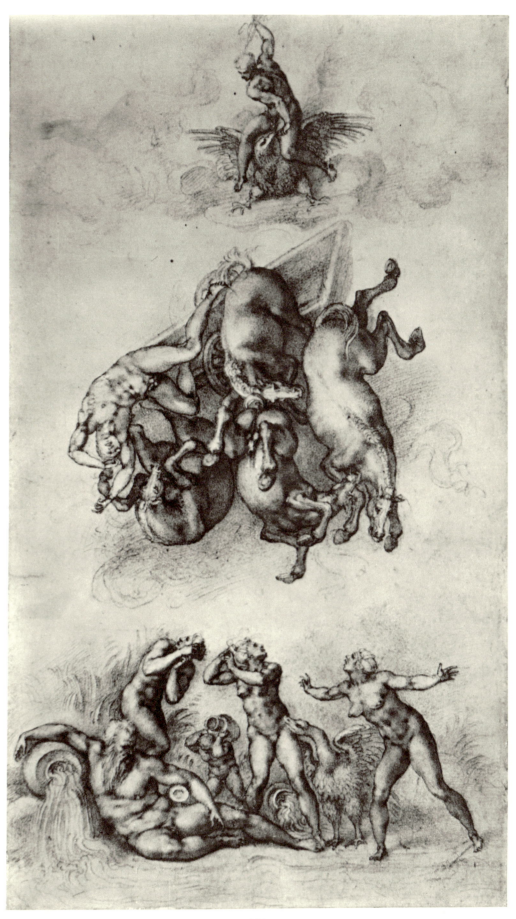

153

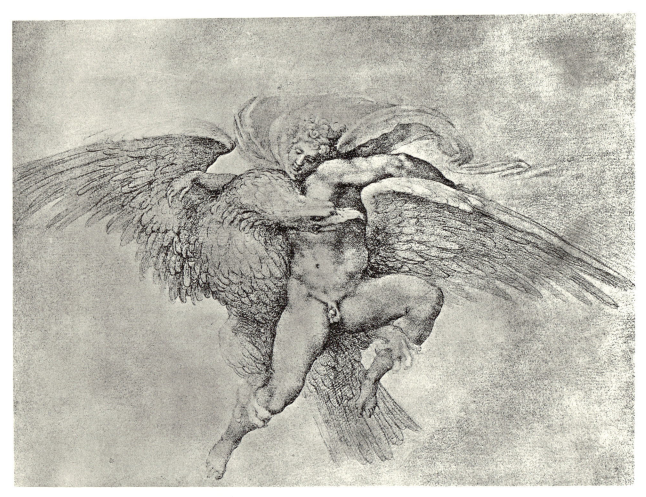

154

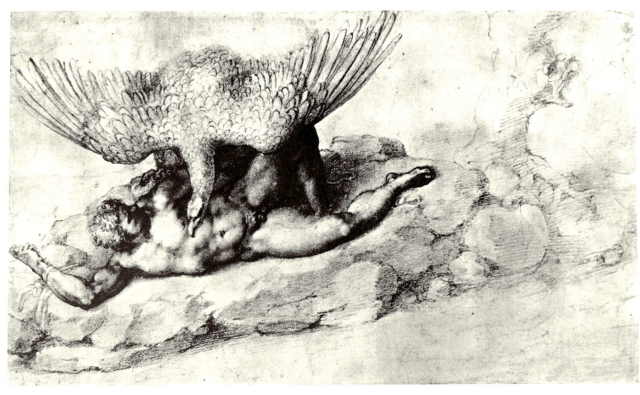

155

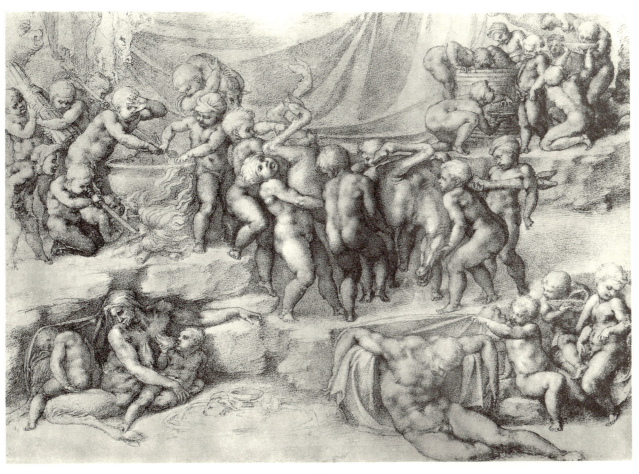

156

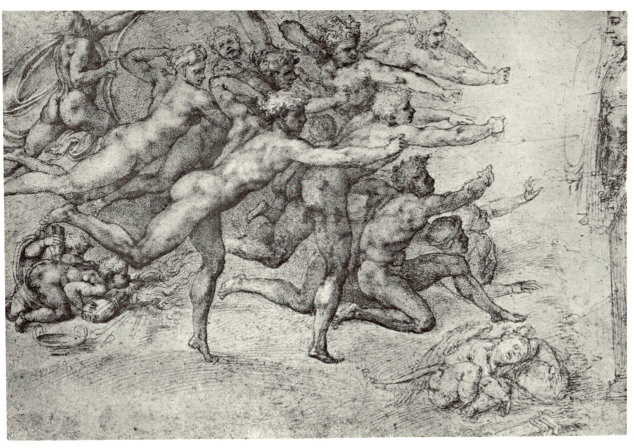

157

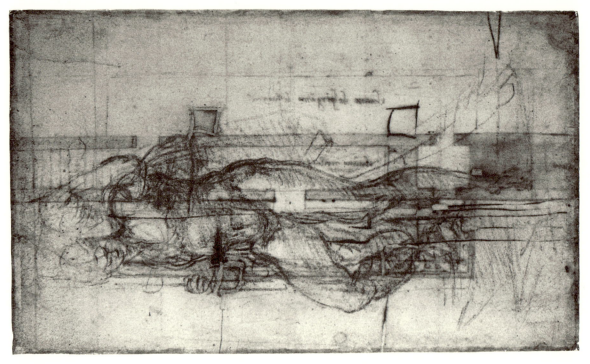

159

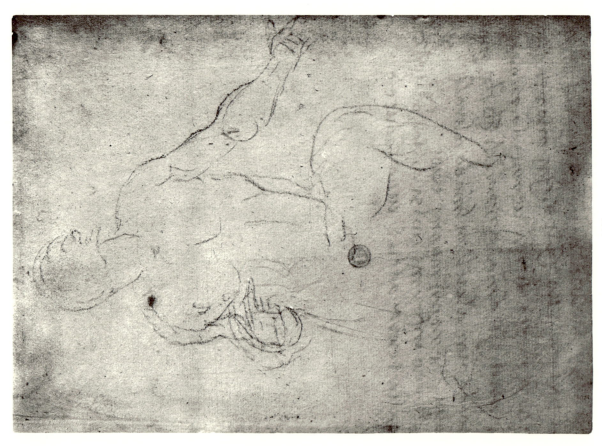

158

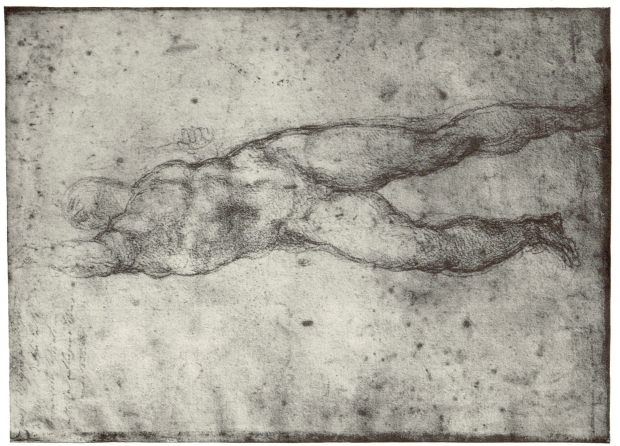

161

160

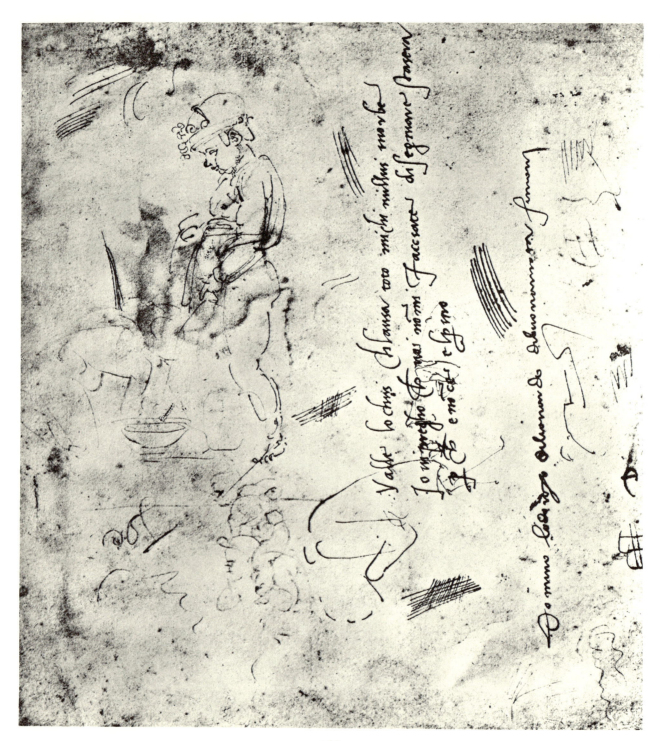

162

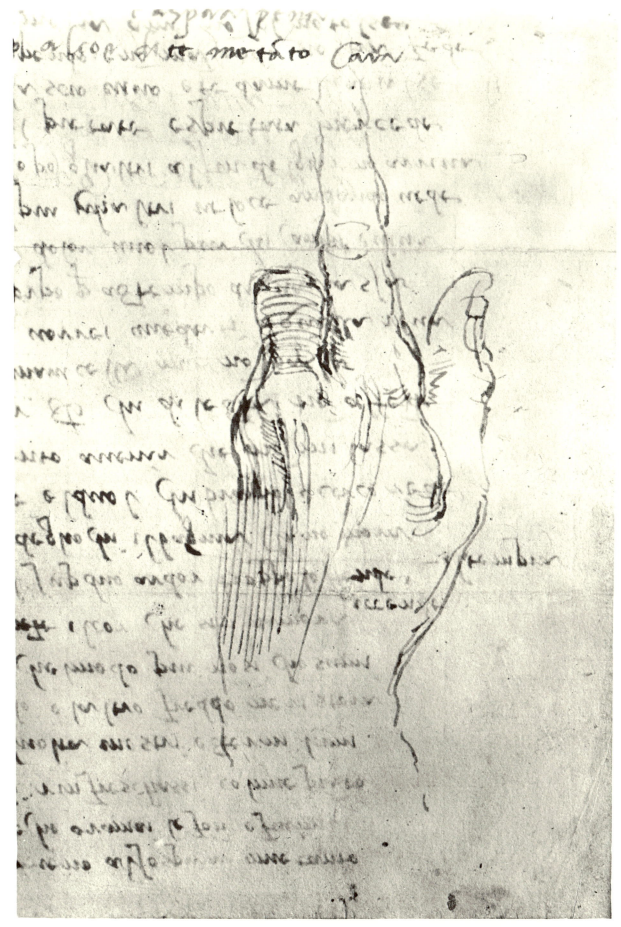

163

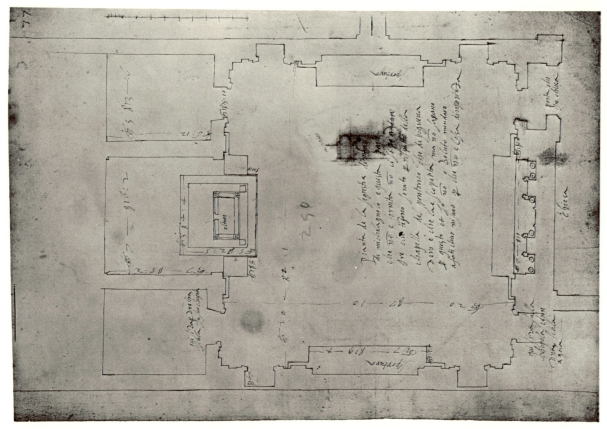

165

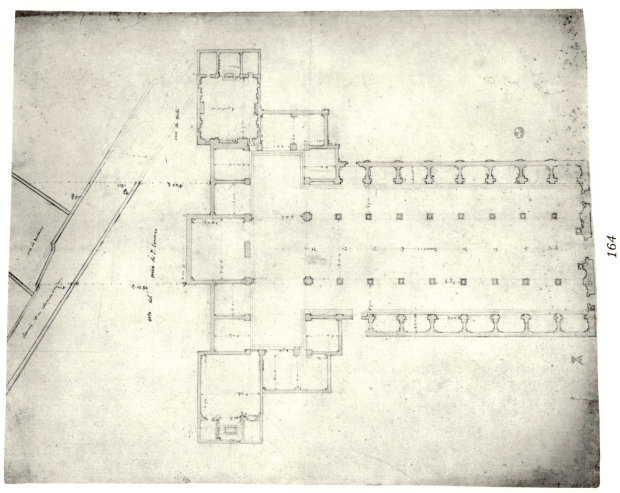

164

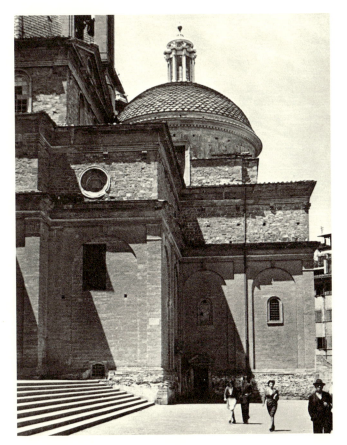

166

167

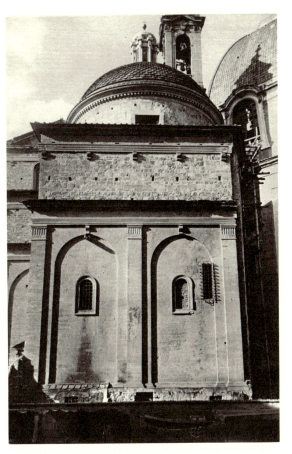

168

169

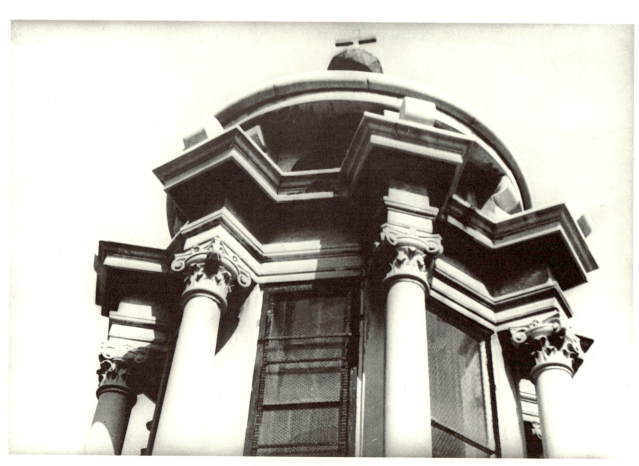

170

172

174

171

173

176

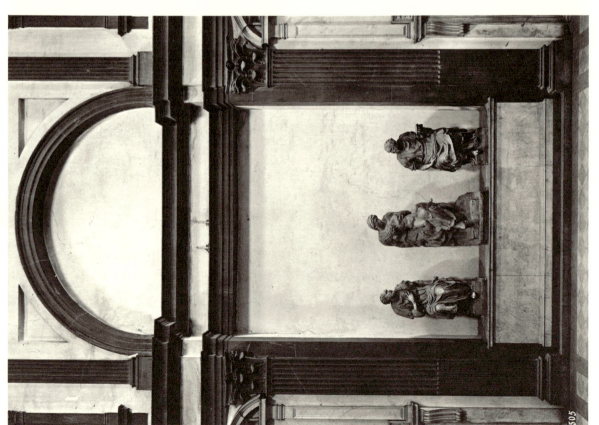

175

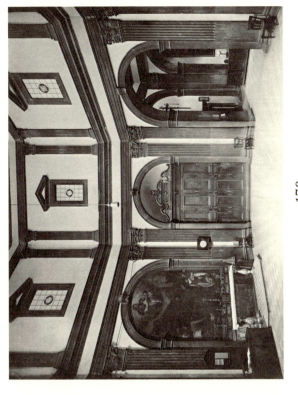

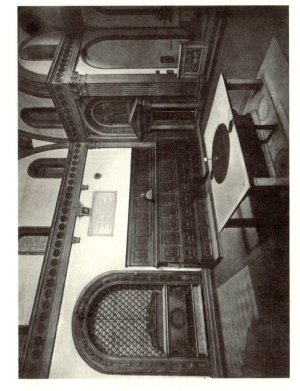

178

180

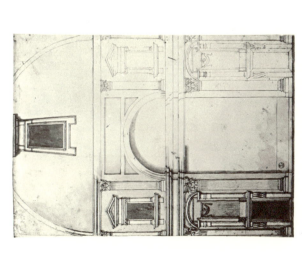

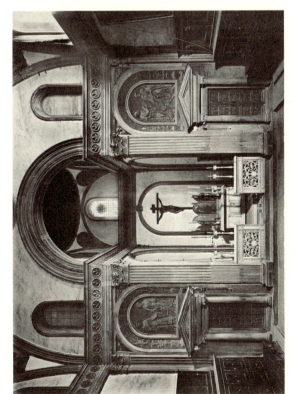

177

179

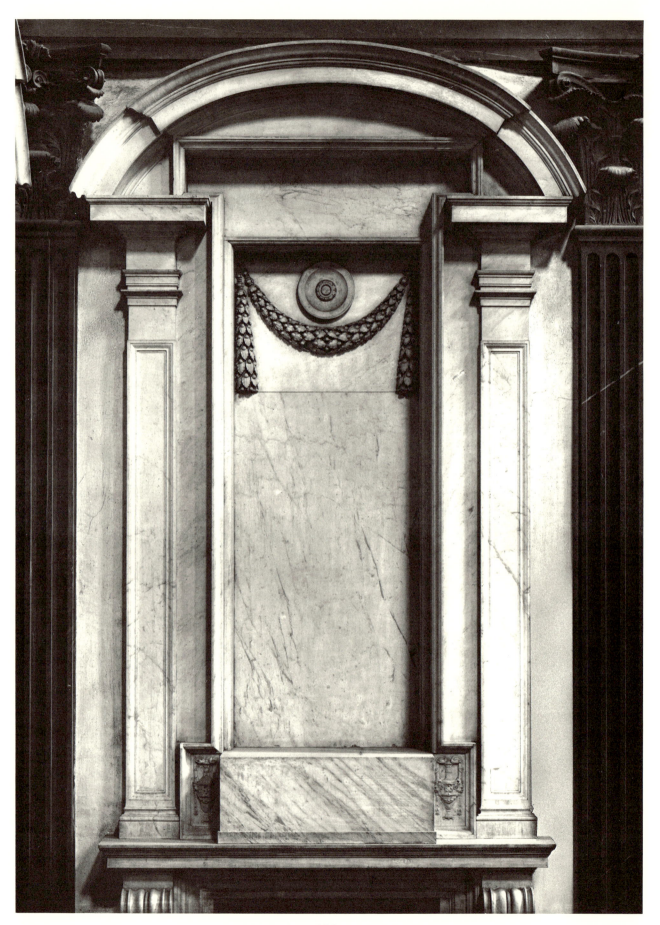

181

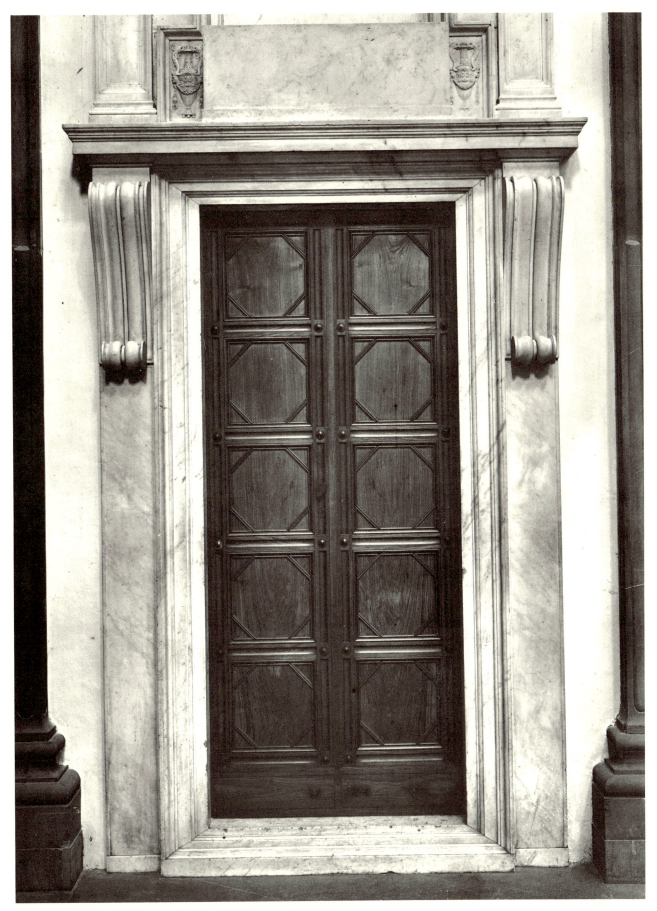

182

183

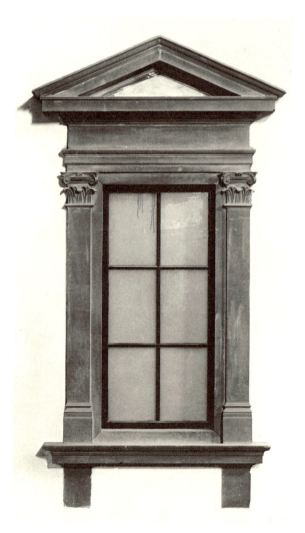

184

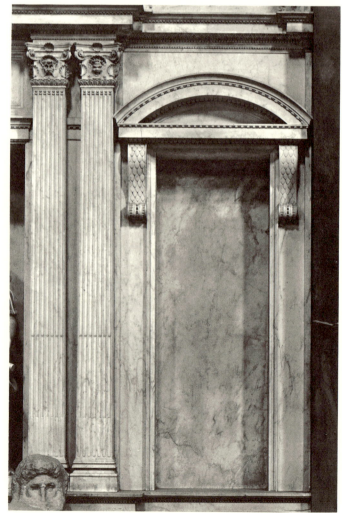

185

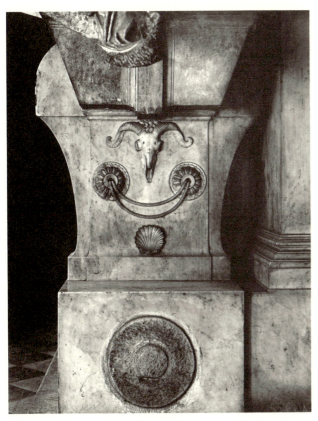

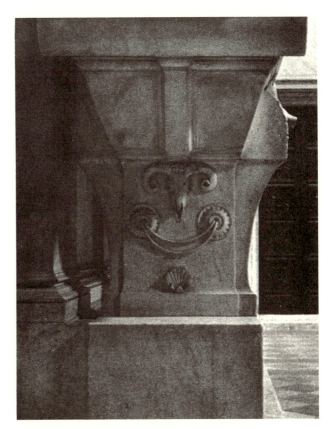

186

187

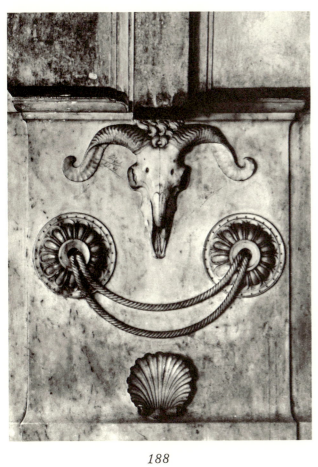

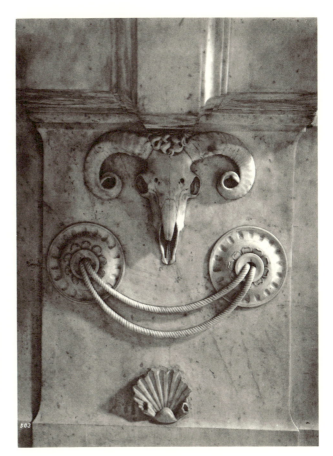

188

189

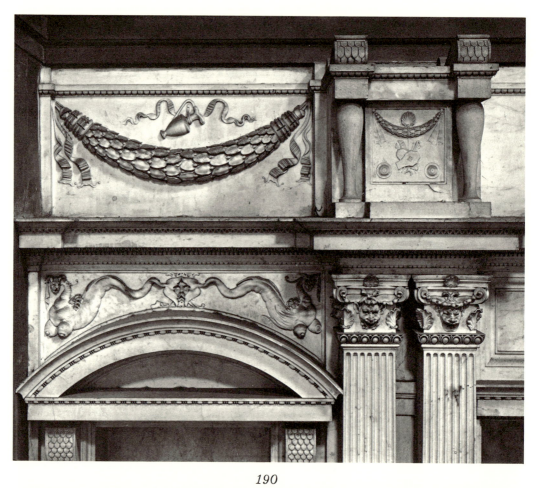

190

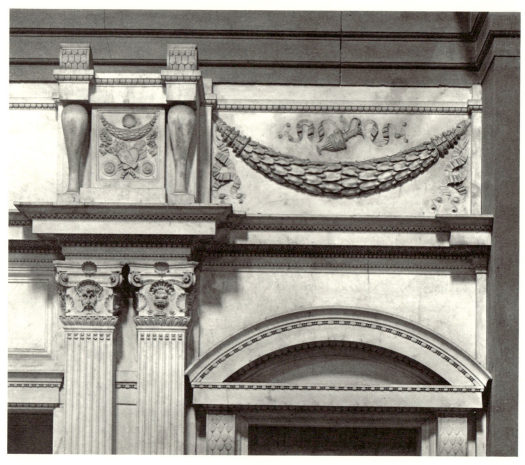

191

193

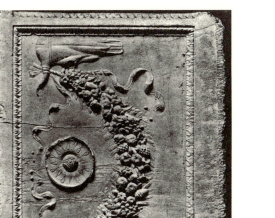

192

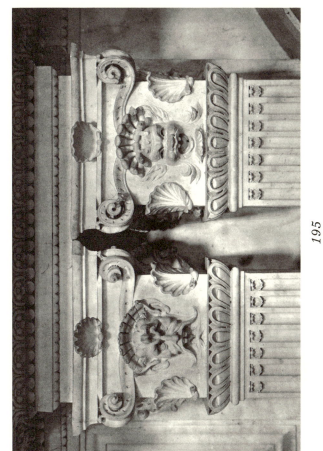

195

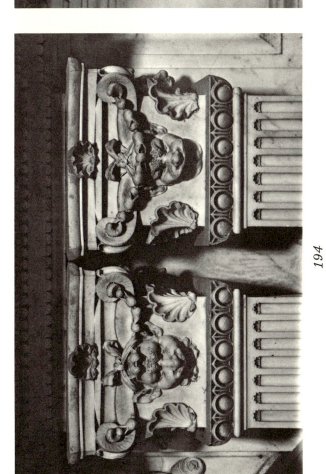

194

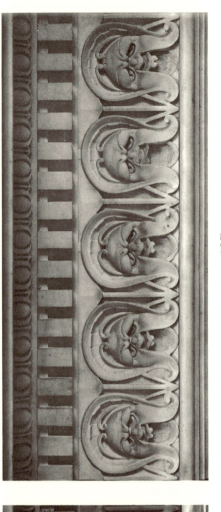

197

196

199

198

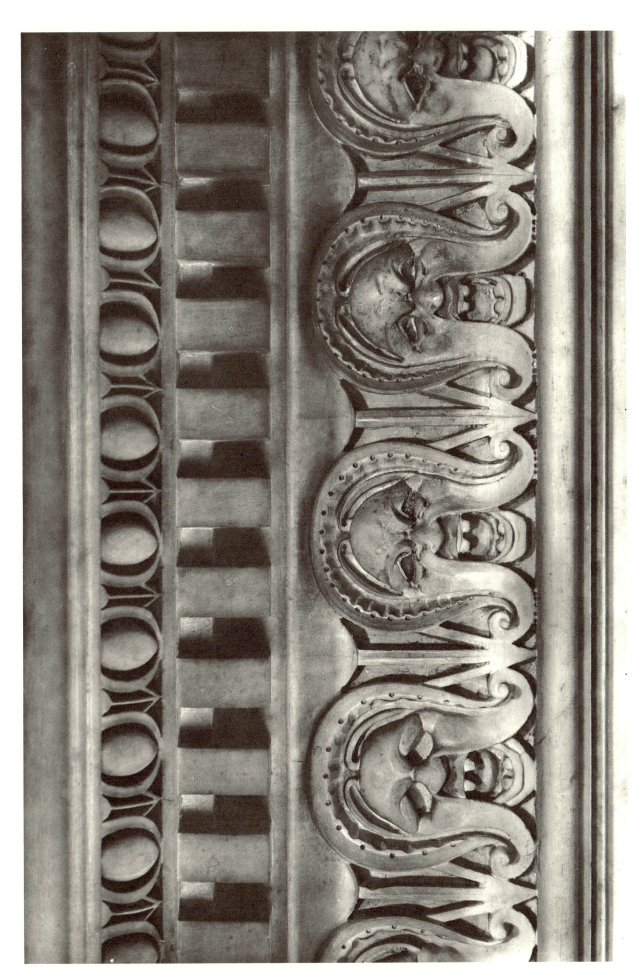

203

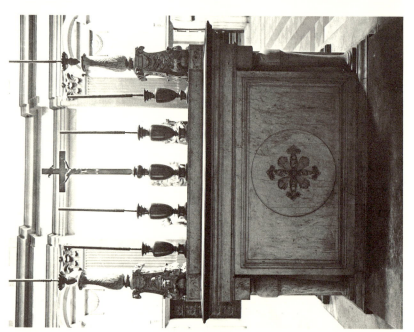

202

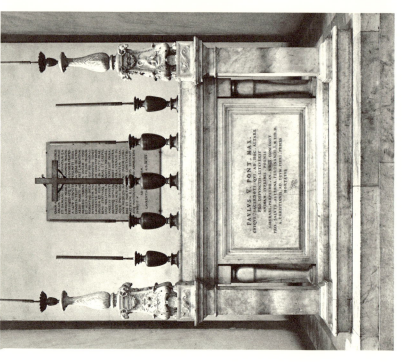

201

205

204

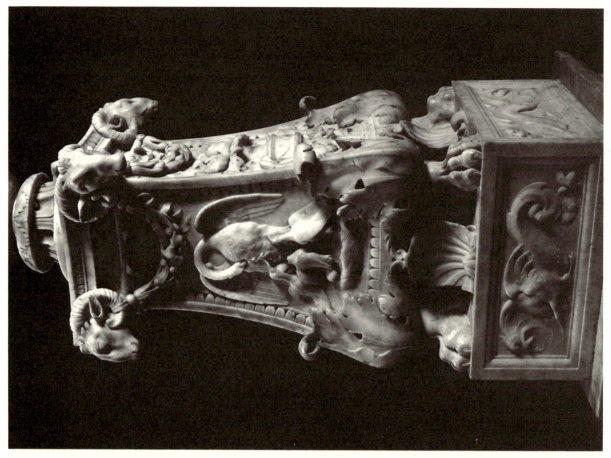

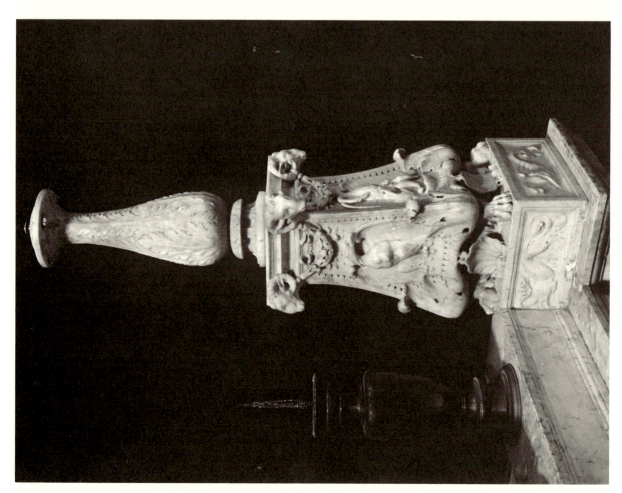

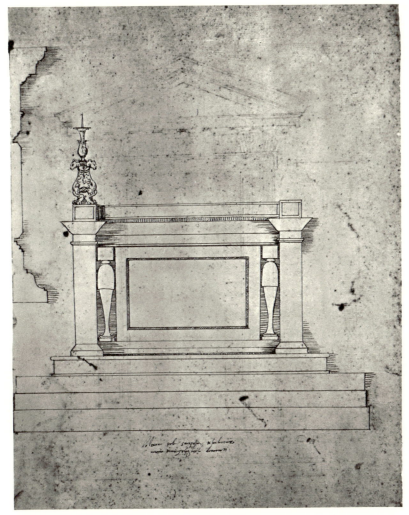

208

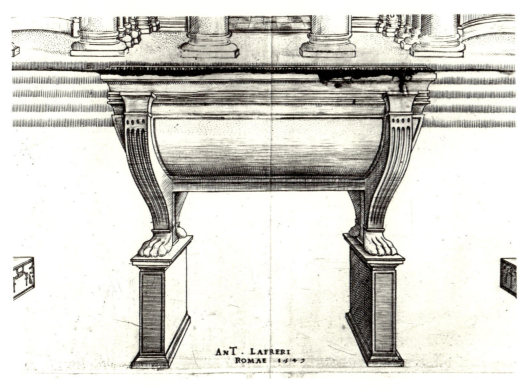

AnT. Lafreri
Romae 1549

209

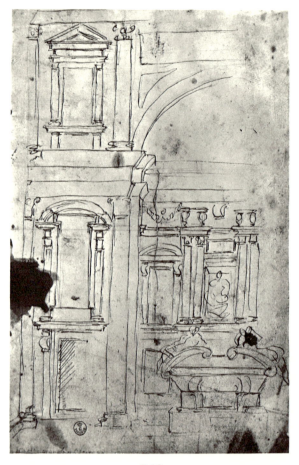

210

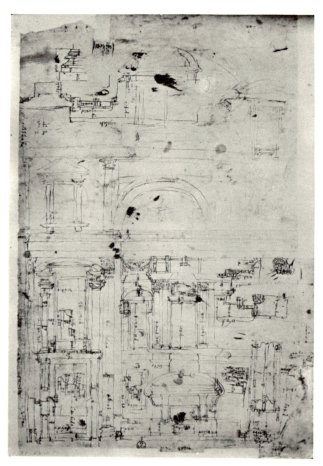

211

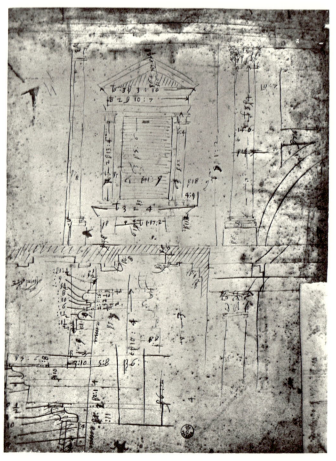

212

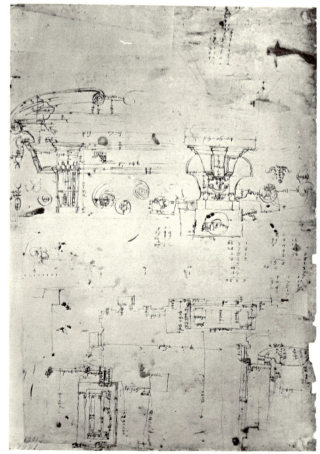

213

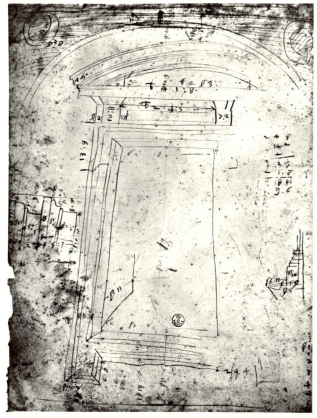

214

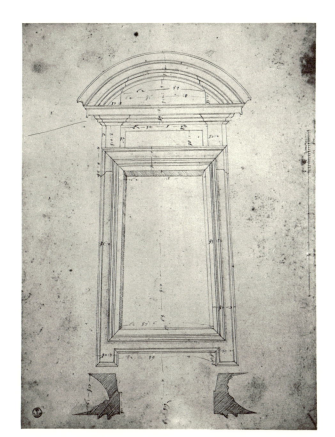

215

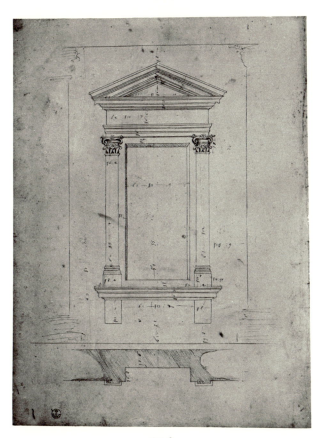

216

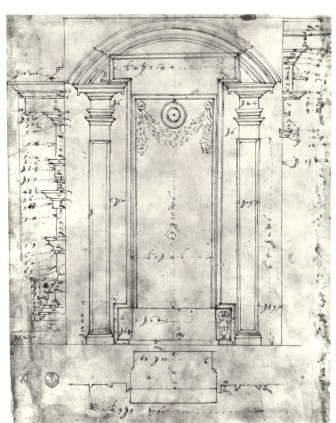

217

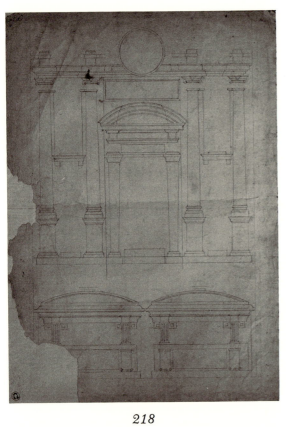

218

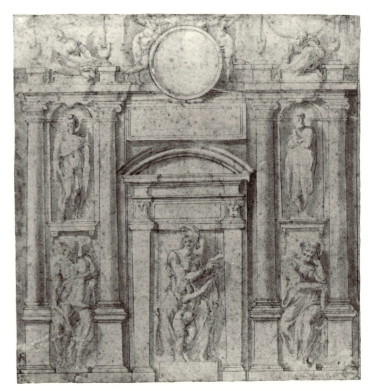

219

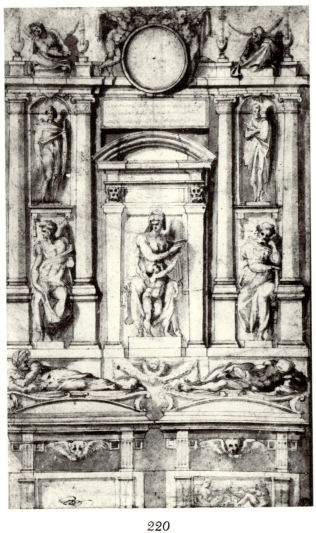

220

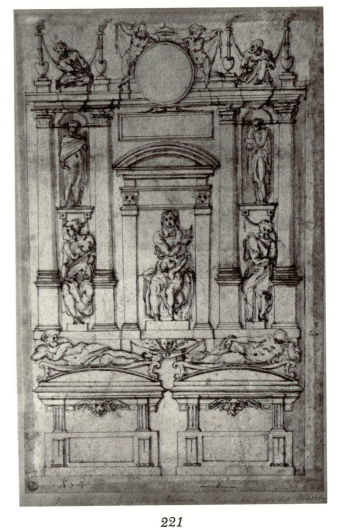

221

222

223

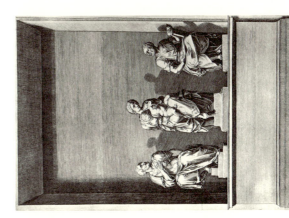

225

226

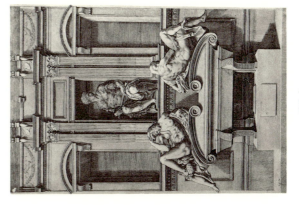

224

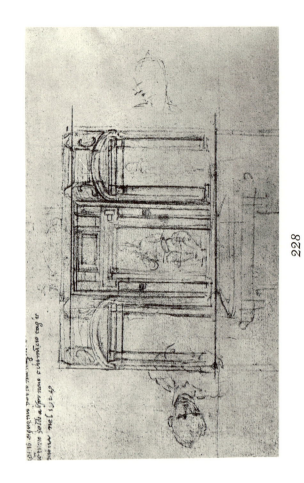

227

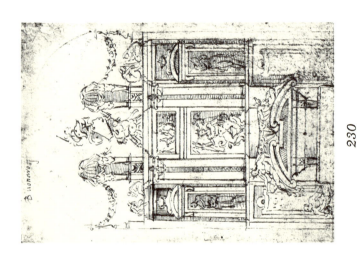

228

229

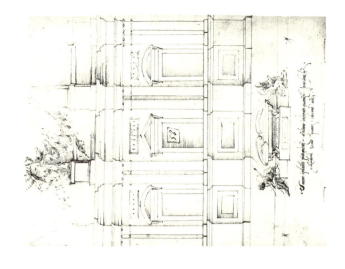

231

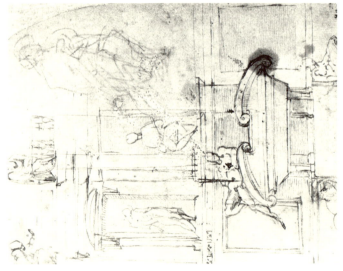

230

232

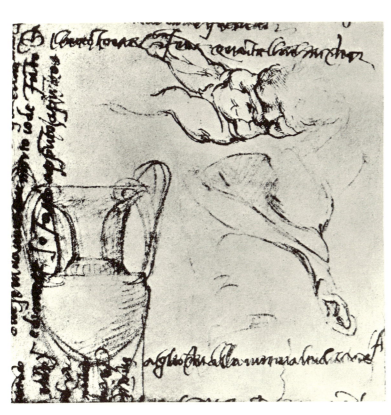

233

234

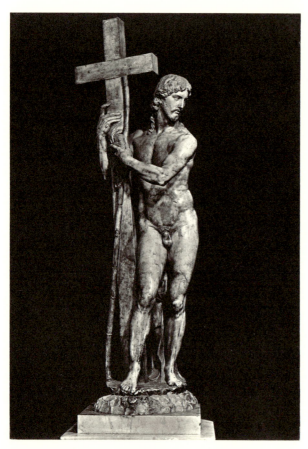

235

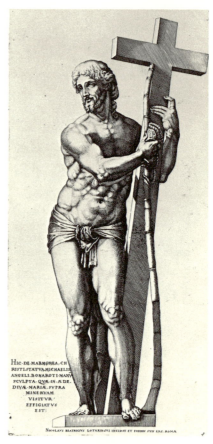

HIC·DE·MARMOREA·CH
RISTI·STATVA·MICHAELIS
ANGELI·BONAROTI·MANV
SCVLPTA·QVÆ·IN·ÆDE·
DIVÆ·MARIÆ·SVPRA
MINERVAM·
VISITVR·
EFFIGIATVS
EST·

NICOLAVS BEATRICIVS LOTARINGVS INCIDIT ET FORMIS SVIS EXC·ROMÆ

236

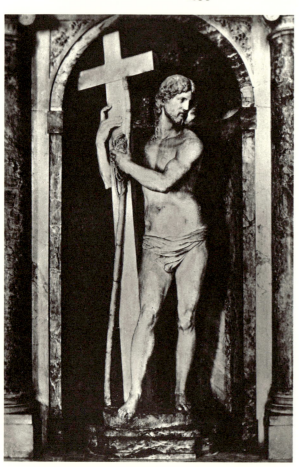

237

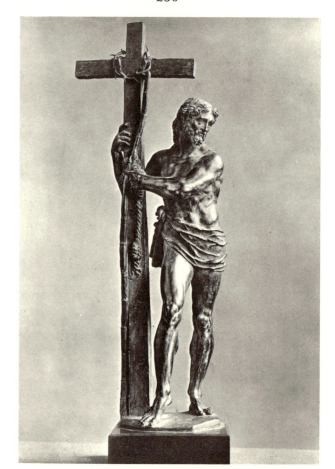

238

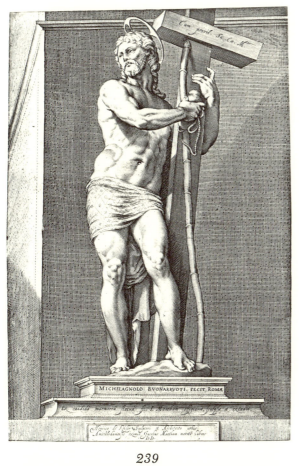

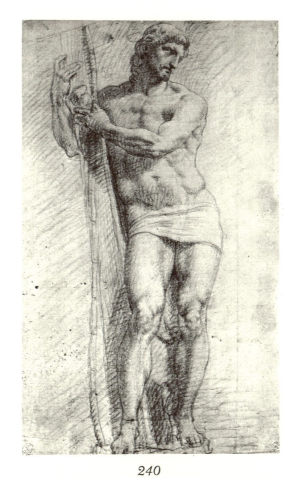

239

240

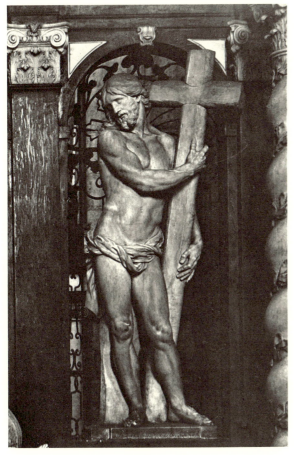

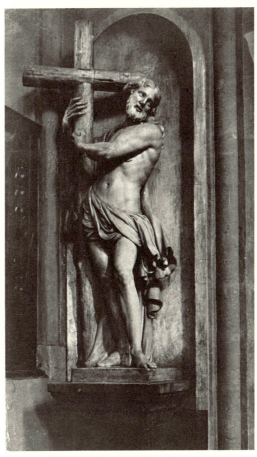

241

242

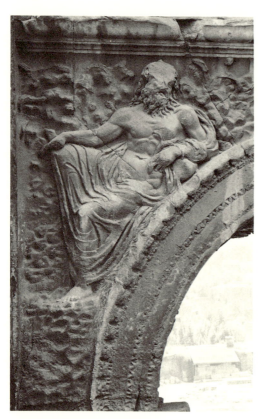

243

244

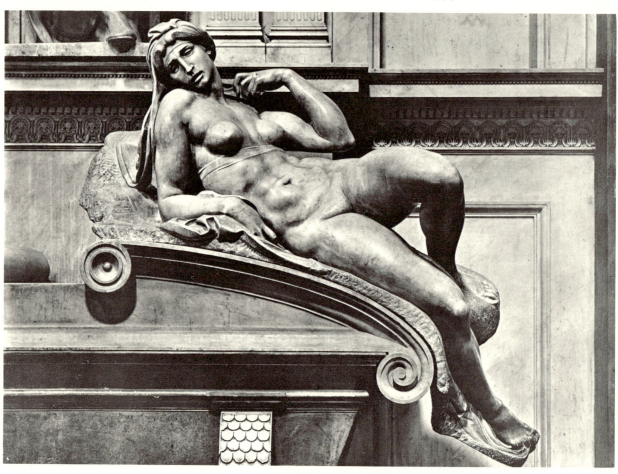

245

246

247

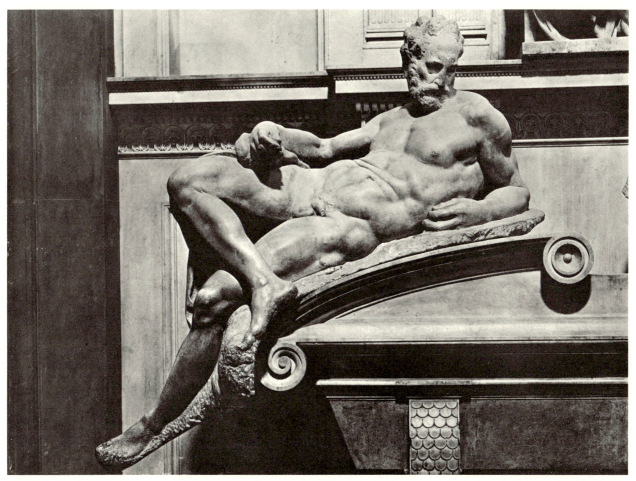

248

249

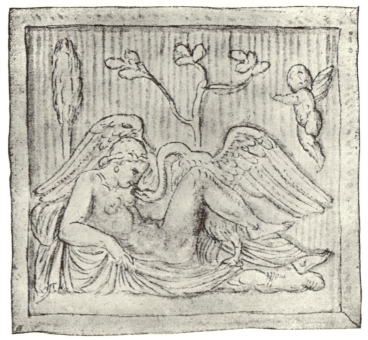

250

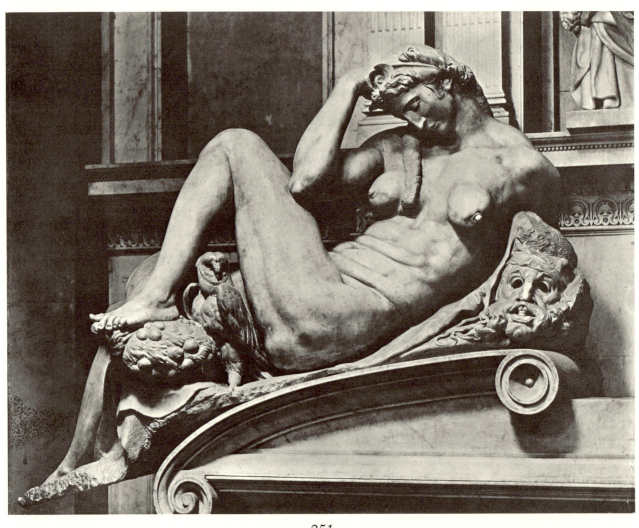

251

252

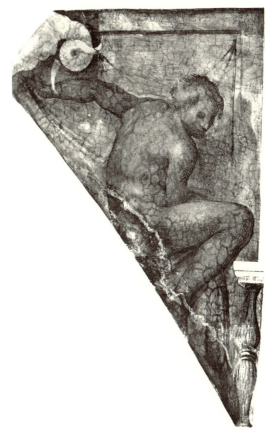

253

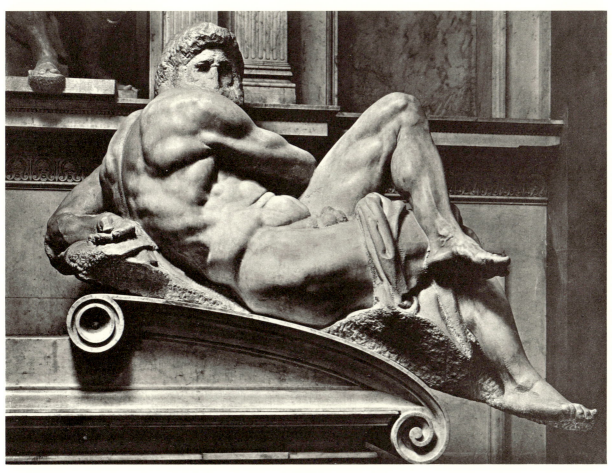

254

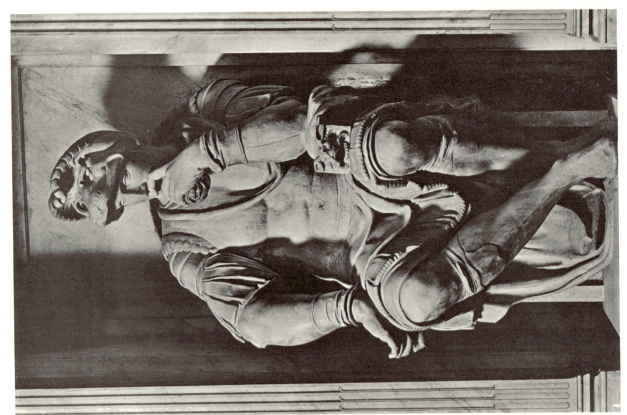

256

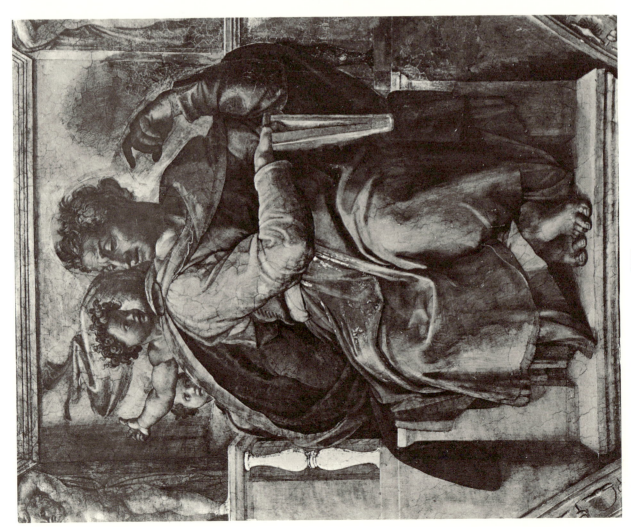

255

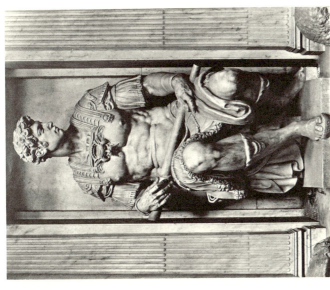

259

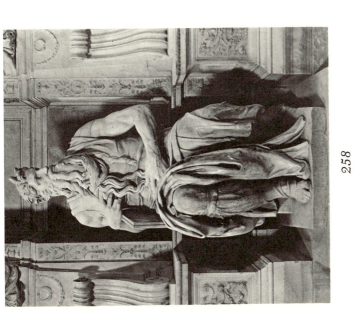

258

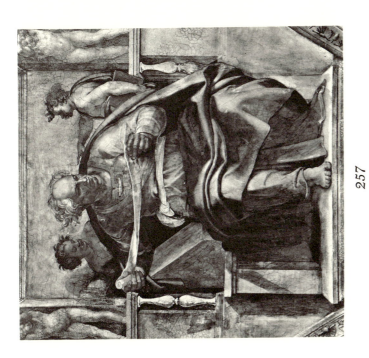

257

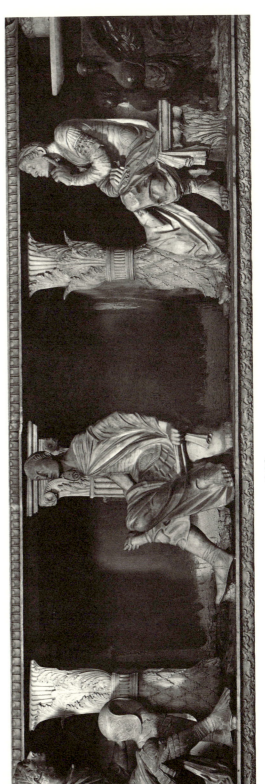

260

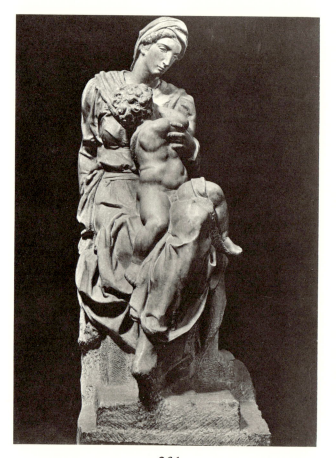

261

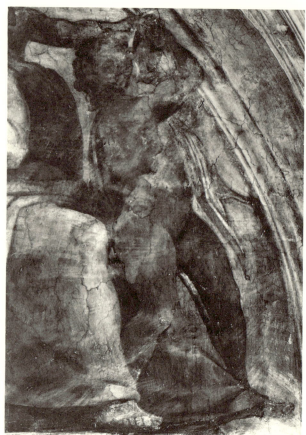

262

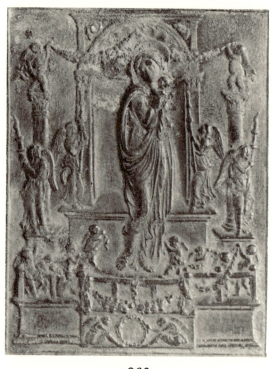

263

264

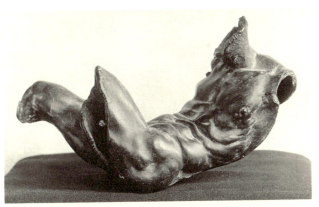

265

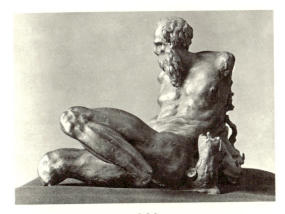

266

267

268

269

270

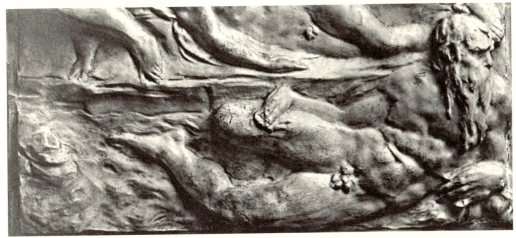

271

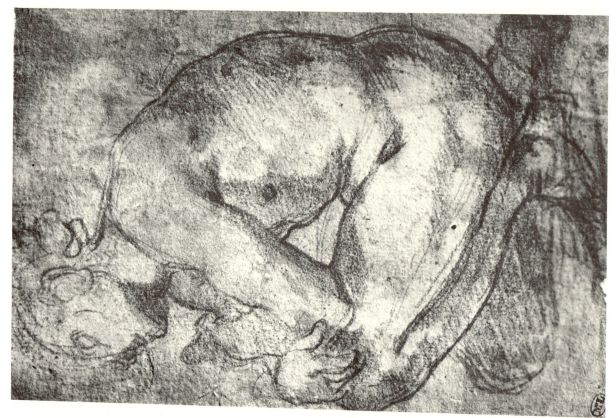

273

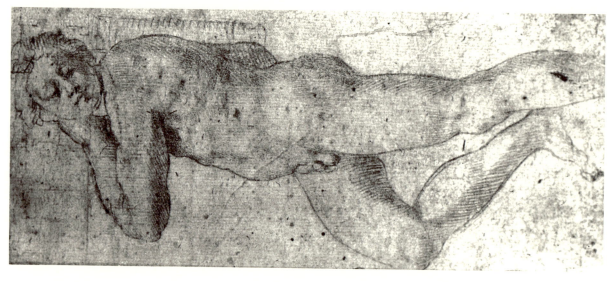

272

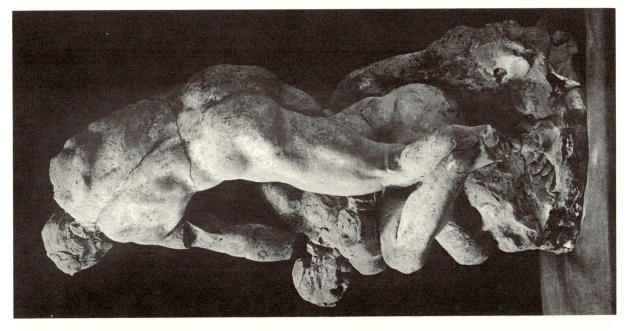

276

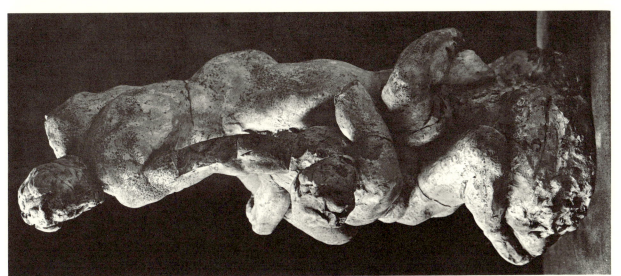

275

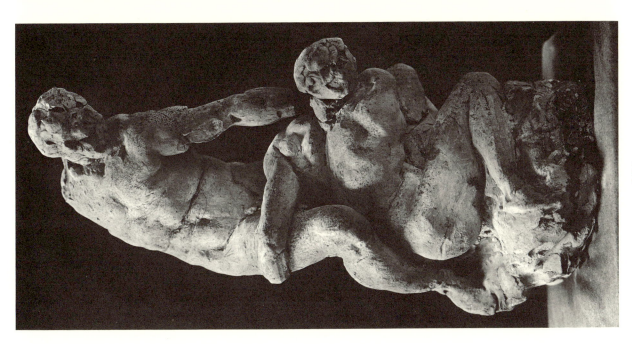

274

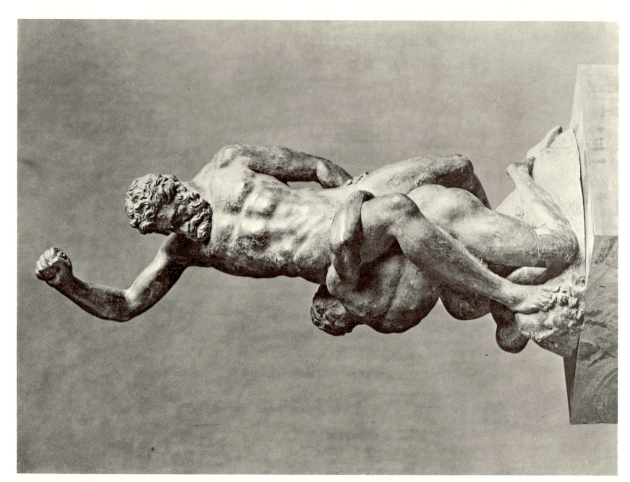

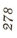

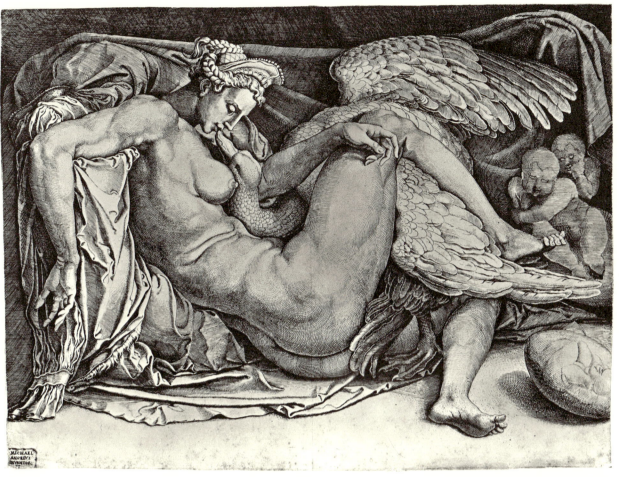

279

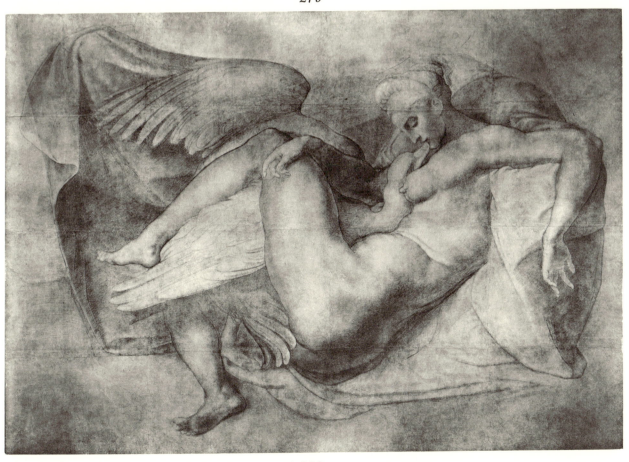

280

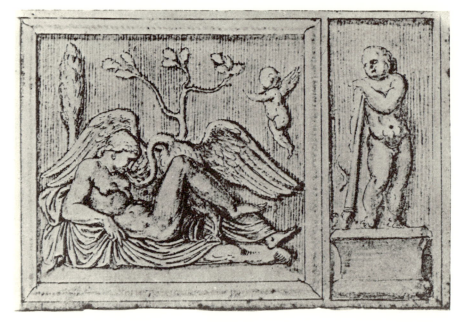

281

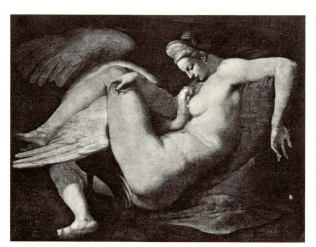

282

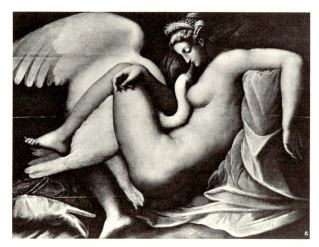

283

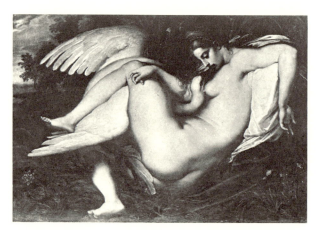

284

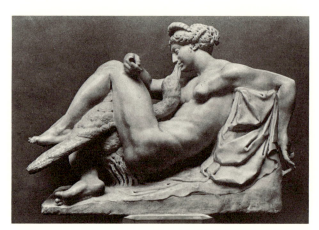

285

287

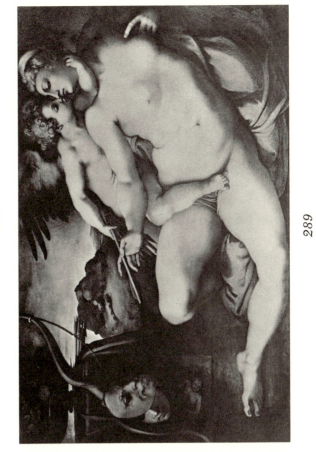

289

286

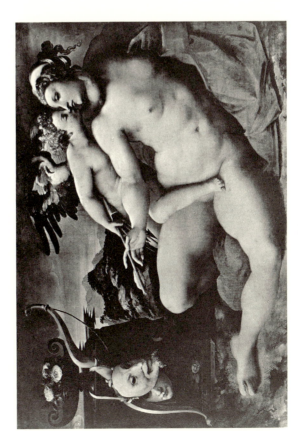

288

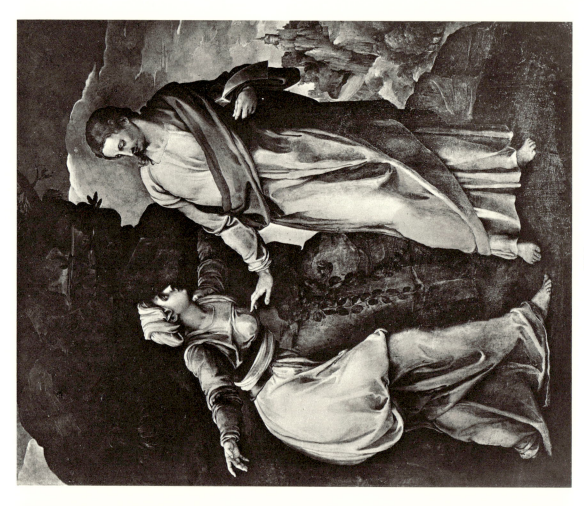

291

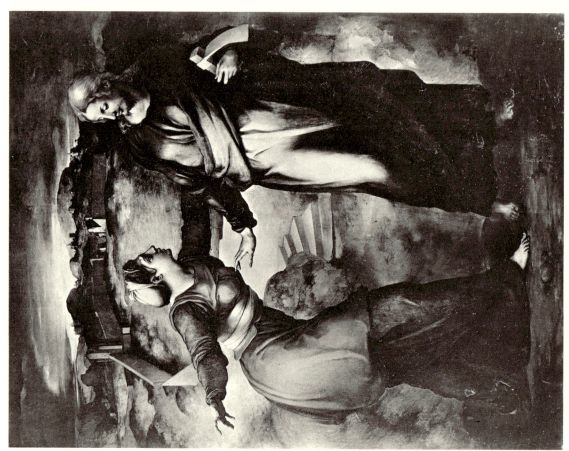

290

292

293

294

295

296

297

298

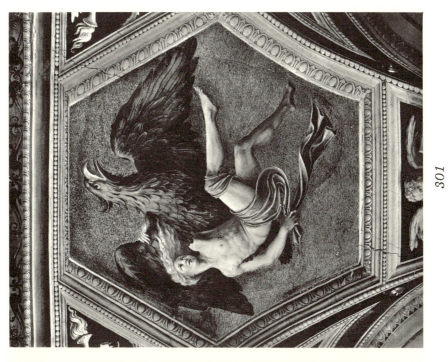

301

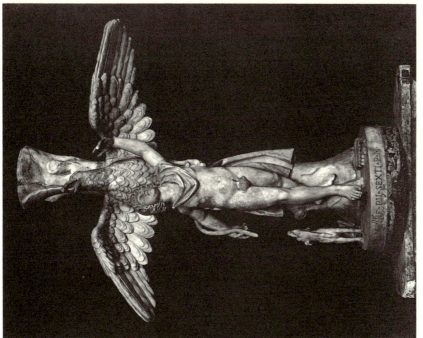

300

299

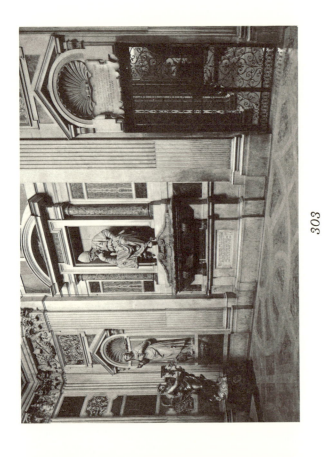

302

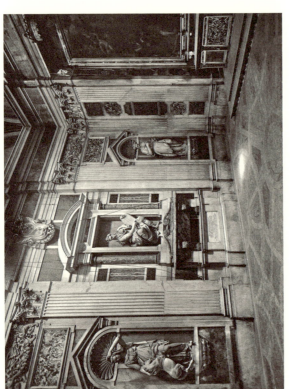

303

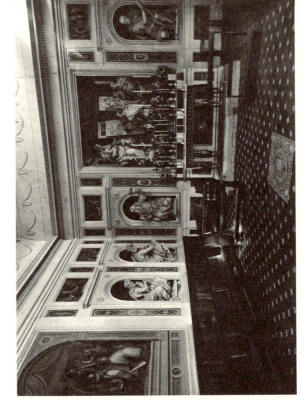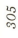

305

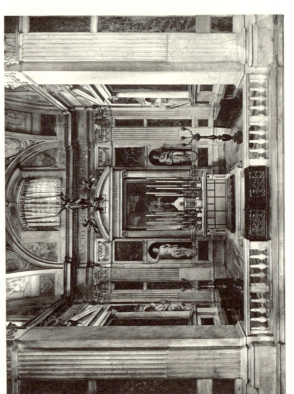

304

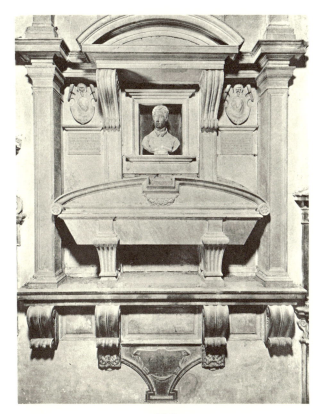

306

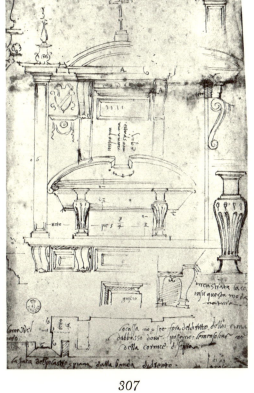

307

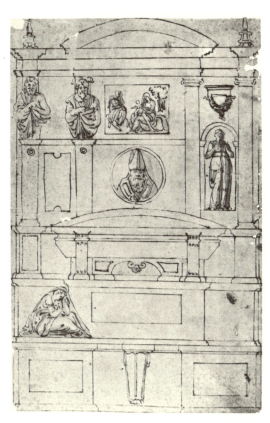

308

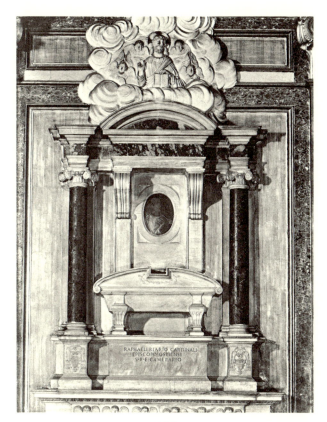

309

310

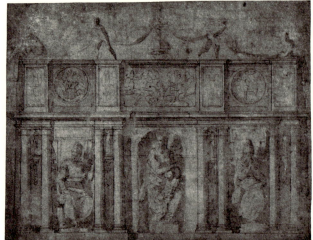

311

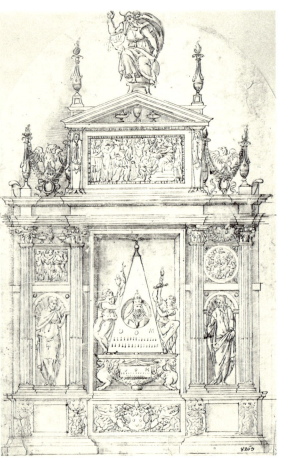

312

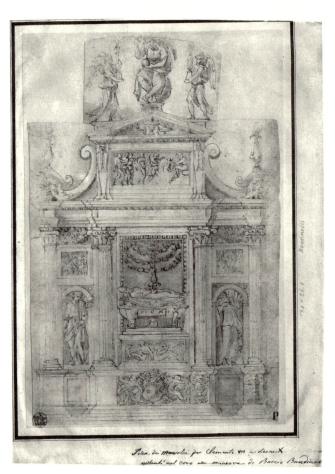

313

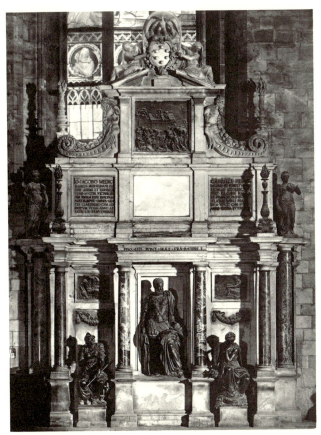

314

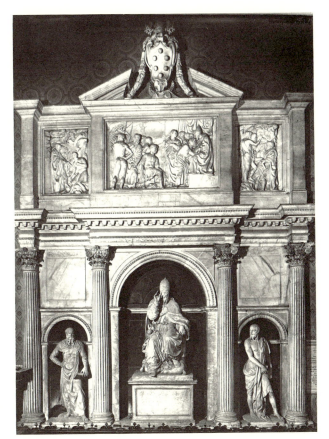

315

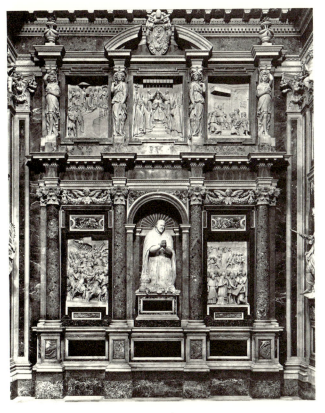

316

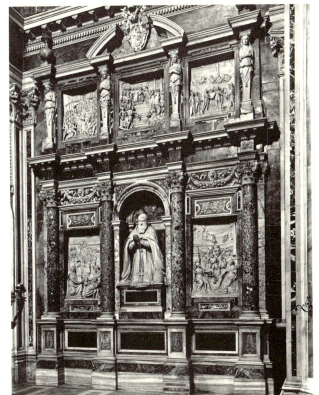

317

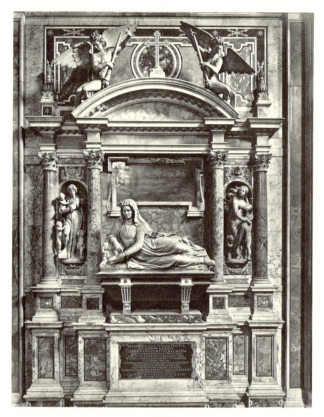

318

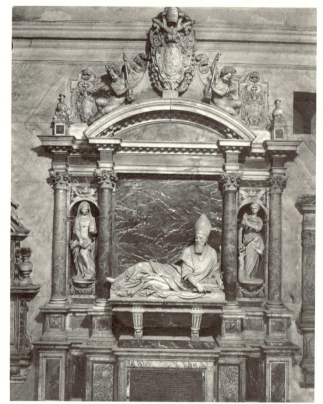

319

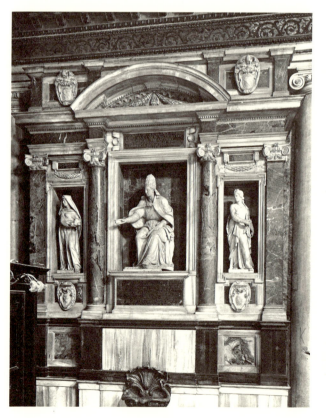

320

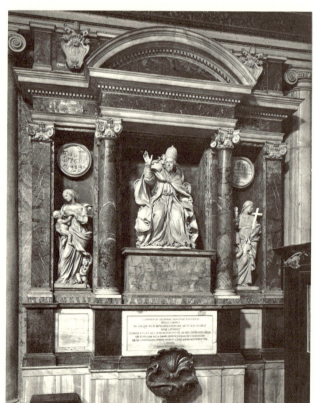

321

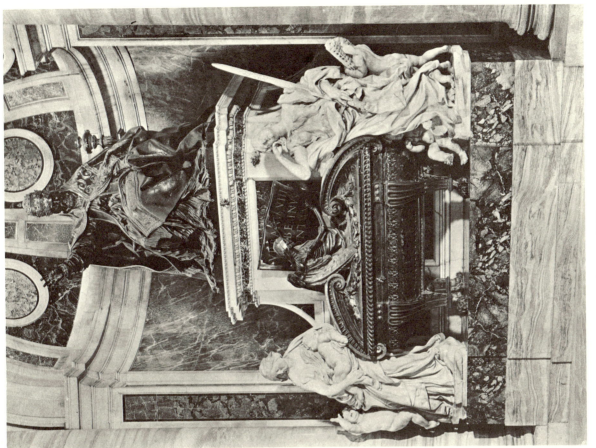

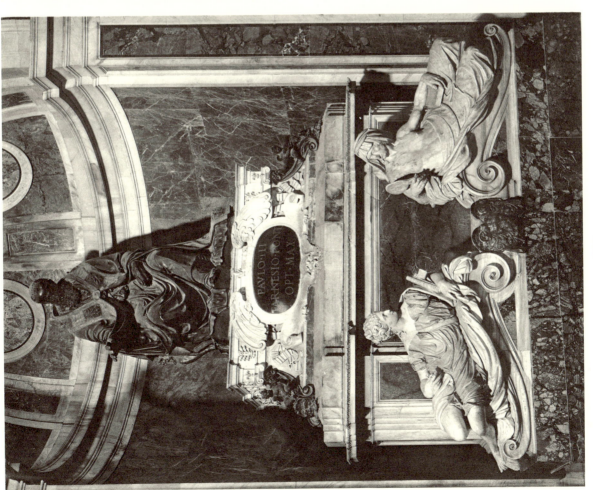

Ms Michelagnolo questa sie p memoria a Vra Sgnia circa il fatto del quatro de la tauola
de laquale a Vra Sgnia ano parlato li frati carmelitanj che va a bologna
e prima la fantasia de dicta tauola Et la mizura de essa Et anchor il
lume de la capella doue a ad andar dicta tauola secondo il quale Vra Sgnia
fara tal opera La fantasia secondo il desiderio del patrone sie questa sua Sgnia voria
una nostra donna cu u putino in braço e quatro figure due de gun et due de la
da la nostra donna la qualita de laqual quatro figur sie quelle che piu piaçeno a
Vra Sgnia secondo che tornino meglio a uoj Et similmente de atitudine Et
de posar de tutte le figur secondo piaçe e par a Vra Sgnia Il quatro sie mezo
tondo disopra Et e longo da la sumitade del mezo tondo insino al disotto piedi otto
e onçe quatro e meza Et e largo piedi çinqui e onçe tre e meza Intendendosj
secondo la nostra mizura laquale dentro questo foglio in figura e disegnata
çio e u piedi che sono onçe dodeçe Il lume de la capella sie questo La
capella sie posta aloriente Et a il lume dal mezo giorno

Lungo p. 8. o. 4 ½

Largo · p. 5 · o 3 ½

Giovanni mio charo e comparo e compare più amo so et la imagin' in si chomincia quello et
più no stet' aquesti di nom' sono andato e rispos to qui ti tempi dhora a po con e questo et et
... visto e tempi chome o dett' potrem' villanit' ma no so fare io mo disporar' più pongiom'
quando fussi certo no la ueno più aucro no restorci gia chosa aptet' questo dolideto et io fa
... spesa tutto quello et io potessi ma no terrci giacha son a prisposto dolideto et io fa
... pete chio o aui to do ue to rimarom' che ma lo mio cho spesa e questi d'chara si lauerini
... fanosa della piro me e questo loma promigiom' per seguiti io staro en chom' sono sta
... to congegner o m' fare e lda bito mio e pro io va borgo et uoi m' dicaue questo et uoi m'
... mandor e voco chio pos la pesare affast' m' n' sta do ni o brigati ssimo io uni
... no dio questo fece ni ma m' n d' fiore

Vostro Michelagniolo Scultore

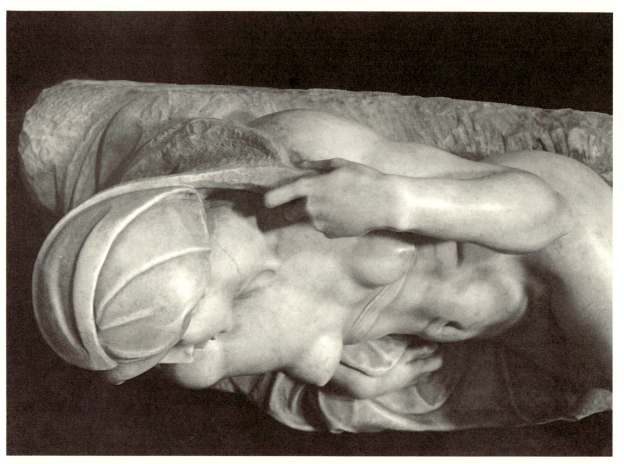

327

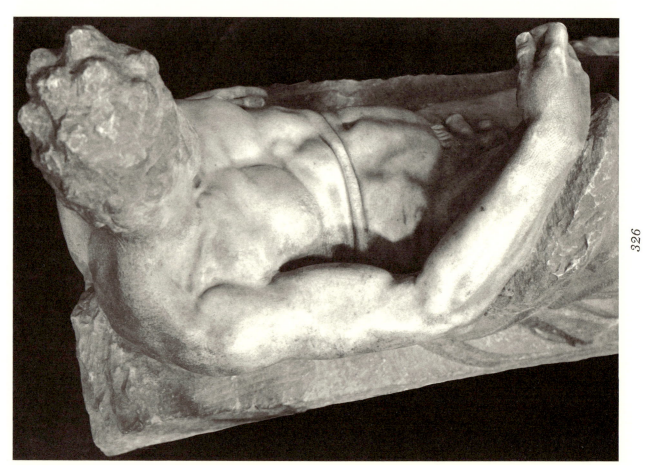

326

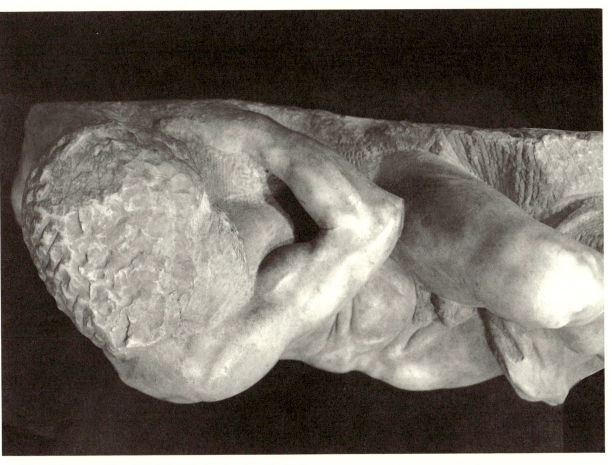

329

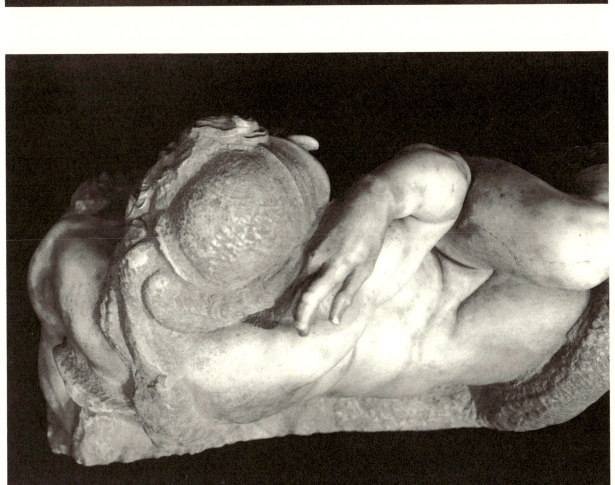

328